The Wider Sea

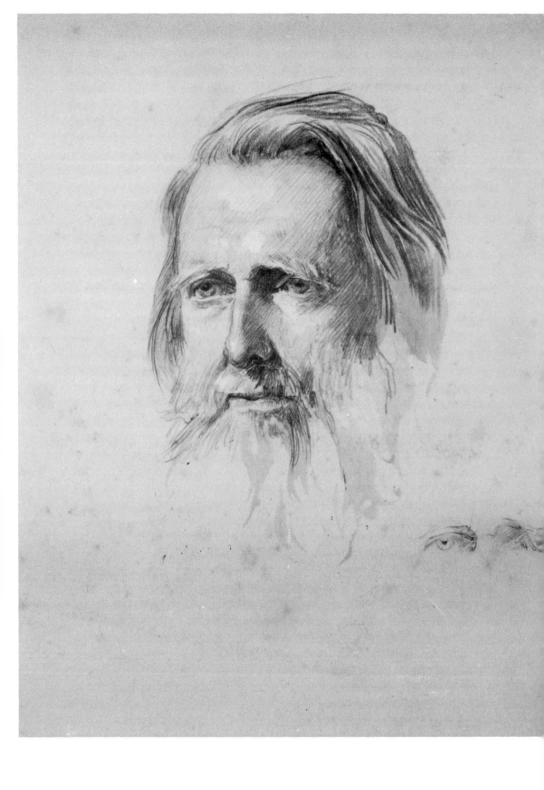

The Wider Sea

A Life of John Ruskin

John Dixon Hunt

J M Dent & Sons Ltd
London Melbourne Toronto

First published 1982
© John Dixon Hunt 1982

This book is set in 11 on 12½pt Linotron 202 Bembo by
Western Printing Services, Bristol
Printed in Great Britain by
Richard Clay Ltd, Bungay, for
J. M. Dent & Sons Ltd
Aldine House, 33 Welbeck Street, London W1M 8LX

British Library Cataloguing in Publication Data

Hunt, John Dixon
 The wider sea.
 1. Ruskin, John
 2. Authors, English – 19th century – Biography
 I. Title
 828'.9'09 PR5263

ISBN 0–460–04547–4

For Michael Ratcliffe

Sempre si fa il mare maggiore

<div align="right">Tintoretto</div>

'John and I tried to walk as far as the sea this evening but the sand deceives one so that you walk and walk . . .'

<div align="right">Effie Ruskin, 1848</div>

'Who is there that has not felt that the mind can have no rest among a multitude of objects, of which it either cannot make one whole, or from which it cannot single out one individual, whereupon may be concentrated the attention divided among or distracted by a multitude?'

<div align="right">Wordsworth</div>

'Seeing that we digress in all the ways of our lives – yea, seeing that the life of man is nothing else but digression – I may be the better excused in writing their lives and actions.'

<div align="right">Sir Walter Raleigh</div>

'Genuine taste is always imperfect taste – but we are all, as a matter of fact, imperfect people.'

<div align="right">T. S. Eliot</div>

'Sometimes I believe most in the imagination for a long time and then, without reasoning about it, turn to reality and believe in that and that alone. But both of those things project themselves endlessly and I want them to do just that . . .'

<div align="right">Wallace Stevens</div>

'But it's a wide world, and there's a great deal in it, and one's head is but a poor little room to study in after all.'

<div align="right">Ruskin to Norton, 1866</div>

Contents

Preface

In the 1873 edition of *The Crown of Wild Olives* Ruskin remarked that 'it is one of my bad habits to put half my books into preface'. I shall try to avoid doing so myself; but since books on Ruskin look like becoming the storm cloud of the twentieth century, it is perhaps necessary to explain briefly here what this one attempts. It began existence as a commissioned life of John Ruskin and has grown as straight as any work on that subject is liable to do, but has veered slightly during composition towards an intellectual biography. As almost every writer on Ruskin tells his readers, it is impossible to read Ruskin's work apart from his life or vice versa; I would also affirm that. But the trouble has been, I think, that we have tended to perpetuate stereotyped views of his life and work: that his career somehow divided in 1860, that his great weakness is an inability to avoid digressions, that (to quote the editors of his diaries) he 'continued to write briefly on many subjects in a rather purposeless fashion'. What I think is needed and what I have tried to provide, while fulfilling the necessary obligations of any biographical narrative, is a life which is based upon re-assessment of Ruskin's mind and imagination; we have needed some fresh model of that complex personality by which his writings and his daily living may be reinterpreted. This does not mean that the reader will find here masses of 'unpublished, new materials'; though I have spent many (and enjoyable) hours in some of the major archives of Ruskin papers, it soon became clear to me that the magical 'open sesame' of academic research, 'hitherto unpublished', would not reveal any new Ruskin. If such could be discovered at all, it would come from a serious scrutiny of the masses of publications that we already have from and about him, occasionally supported by extracts from those rich archival resources. So that is what I have attempted to do and present. (More about the fascinating and exciting problems posed by this wealth of material for a Ruskin biographer will be found in my introduction.)

Yet many hours reading manuscripts and letters, only the tip of which iceberg will show in the pages that follow, cannot but shape one's thinking about the subject of a biography. So my first and foremost debt of gratitude to be expressed is to those magnificent collections of Ruskiniana where I have spent so much time in the last

six years: in the United States, the Pierpont Morgan Library, the Beinecke Library at Yale University, the Huntington Library, Princeton University Library, the Rosenbach Museum and Library in Philadelphia, the Houghton Library; in the United Kingdom, above all the Ruskin Galleries at Bembridge, the Bodleian Library, the National Library of Scotland, and the John Rylands University Library, Manchester. To their curators and staffs I owe many thanks for their kindnesses and skill at making often very hurried visits so smooth and profitable. I am also indebted to many private individuals, who have allowed me access to papers or drawings in their possession. To them all, whenever applicable, I am grateful for permission to quote material in their respective collections; I owe thanks, also, to George Allen and Unwin Ltd, the Literary Trustees of John Ruskin, for permission to use previously unpublished writings.

I am further indebted to libraries and museums where my work has taken me. Apart from those already mentioned, I am obliged to the library at Bedford College, the University of London Library, the British Library, the London Library, the University of York Library, the Ruskin Museum at Coniston, the Fondazione Cini, the Guild of St George (Reading University), the New York Public Library, Vassar College Library, the Fogg Museum at Harvard, and the libraries of the Johns Hopkins University.

No biographer of Ruskin can be anything but overwhelmed by his obligations to the distinguished set of scholars and critics who have worked before him. Above all, there is the debt to Ruskin's first editors, E. T. Cook and Alexander Wedderburn, whose 'Library Edition' of *The Works* is a mine of riches; more recent Ruskinians, without whose labours my own book would have been impossible, include J. L. Bradley, Van Akin Burd, J. G. Links, Mary Lutyens, John D. Rosenberg, Harold I. Shapiro, Virginia Surtees and Helen Gill Viljoen. Among previous biographies I am conscious of being most indebted to the two which are, in my opinion, the best: those by E. T. Cook of 1911 and that by Derrick Leon of 1949.

To innumerable individuals I have incurred debts as different as detailed help with, and comment upon, early versions of my book, hospitality during many excursions on the track of Ruskin, the stimulus of conversations or even chance remarks, and assistance in finding materials. They must forgive me if I simply set out their names alphabetically, for to detail their various kindnesses would be impossible in even a Ruskinian preface. My warm thanks, then, to Michel and Giselle Baridon, Alan Bell, B. K. Bilton, Mary Burkett, Herbert Cahoon, John Currey, J. S. Dearden, Ronald and Pamela Dickinson,

William Drummond, Tim Hilton, Hugh Kenner, Denis Lambin, Dorothy Mack, Charles Mann, Richard Ormond, John Parker, Jeffrey L. Spear, Robert Walk, Gail Weinberg, and Marjorie G. Wynne. To Mary Montaut I owe the skilful typing of a large part of this book and some equally painstaking research help at a crucial moment.

The writing of this biography was started during the course of an unpaid leave of absence from Bedford College, for which I thank my colleagues, and while I was visiting the Humanities Center at the Johns Hopkins University (for one semester) and the Institute for Advanced Study, Princeton (for a second). The opportunity to teach a graduate course entirely on Ruskin as a critic of art and architecture, which Hopkins allowed me, followed by the unimaginable stimulus plus time for writing without interruption, which a visiting member of the Institute enjoys, was a benefit for which I am deeply grateful. I am further obliged to the Central Research Fund of the University of London for providing one return transatlantic air fare, which enabled me to return for more research at a crucial time, and to the Gladys Keble Delmas Foundation for a small fellowship which took me to Venice.

Finally, there can be no book like this without a publisher: to the patience and encouragement of mine, Peter Shellard, I am profoundly grateful. And I must offer to my wife, an ex-publisher, loving thanks for *her* patience, devoted service to a figure about whom she was not always as enthusiastic as I, and affectionate support over these last years.

18 January 1981

List of illustrations

Cover photograph of Ruskin, taken at Brantwood, probably in September 1873, by the Yorkshire photographer, Frank Meadow Sutcliffe (see p. 414) (*The Sutcliffe Gallery, Whitby*)

Frontispiece Theodore Blake Wirgman, preliminary studies for portrait of Ruskin which appeared in *The Graphic* on 2 April 1886. (*Courtesy William Drummond, Covent Garden Gallery. Photograph: National Portrait Gallery*)

Between pages 80–81

Illustrations in the text

By way of Introduction

An author who composes a biography can try to *live* his subject or else to *construct* him, and there is a decided opposition between these two courses. *To live him* is to transform oneself into what is necessarily incomplete, since life in this sense is composed of anecdotes, details, moments. *Construction*, on the other hand, implied the *a priori* conditions of an existence that could be completely different.

> Paul Valéry, 'The Method of Leonardo'.

You think that I am one thing and my writing is another. But my writing is the whole of me.

> Tolstoy in 1885

Biography is not in my way.

> Ruskin to his father in 1852

The biographer of Ruskin faces competition from *Praeterita*, his own autobiography, probably the most read of his works and one of the few kept accessible in a cheap, paperback edition. The other major challenge, as it was to Ruskin when he composed *Praeterita*, is the vast quantity of available material, a *mare maggiore* of manuscripts, watercolours, letters and published work of all kinds in many editions.

Much of what Ruskin wrote throughout his career was by implication autobiographical. But, partly at the urging of Charles Eliot Norton,[1] he began to think of writing something explicitly about his life and by the late 1870s readers of *Fors Clavigera* were learning about his family background and childhood. These autobiographical passages in their turn were lifted from *Fors* to constitute the opening issues of *Praeterita*. This in itself was a typical Ruskin manoeuvre, remaking his *oeuvre* and moving sections from one part of it to another. Then *Praeterita* offers to gloss and expand the chapters removed from *Fors*: 'I fear the sequel may be more trivial, because much is concentrated in the foregoing broad statement, which I have now to continue by slower steps.'[2] Furthermore, *Praeterita*, by its own declaration, eschewed anything 'disagreeable or querulous',[3] and we have become wary of accepting its accuracy. Yet in essence it is, despite

1

factual errors and omissions, often symbolically true; Ruskin's phrase for it was 'vital fact'.[4] He avoids, for instance, any mention of his marriage to Effie; but this six-year interlude was as wasted time to him, a useless digression from his life's mainstream and therefore not worth rehearsing. So, despite the need to treat *Praeterita*'s version of events with caution, any biographer is bound to submit to comparisons with it.

But *Praeterita* provides other intriguing lessons for a biographer of Ruskin. The distancing and lapidary tones of its Latin title are succeeded by a more personal, warm subtitle – *Outlines of Scenes and Thoughts Perhaps Worthy of Memory in my Past Life*. This recollection of first things was undertaken among the last things that Ruskin did, in lucid moments of a steadily encroaching mental blackout. The enterprise is characteristic. It reveals his instinct for myth, for re-ordering the world of experience into sustaining wholes and healing visions. It also declares one last determination to create some liaison between his living self and his writing self. Since it is the task also of his biographer to relate these two, Ruskin's endeavours may serve as example as well (inevitably) as complication.

Ruskin had an instinct for completeness which was forever threatened by his polymathic pursuits. Hence, I think, his constant delight in looking backwards:

> it is odd you always think it would be very pleasant to be where you are not; it can't be helped, but it is very provoking, the charms of a place always increase in geometrical ratio as you get farther from it, and therefore 'tis a rich pleasure to look back on anything . . .[5]

The pleasure of looking backwards is also the delight in (the pretence of) seeing whole. A leitmotif of Ruskin's life was his delight in returning to spots of earlier time: on 7 September 1888 he was 'here in my old room' at Bonneville and is recognized by the landlady of the inn after twenty-four years.[6] Such recurrent pleasures are especially acute when no change at all is apparent; therefore no revision of the past is required, and the living self of the present and the lived self of the past whose patterns are already constructed are happily one. The writing of *Praeterita* in the 1880s was a final attempt to lay hold of an ineluctable yet elusive whole; to shape a *gestalt* that was life and work all together, all complete and all restorative. This strong sense of recovering the past in some palatable whole is suggested by the 'Preface', dated Herne Hill, 10 May 1885, where the pattern of life's composition is established: 'I write these few prefatory words on my father's birthday, in what was once my nursery in his old house.'

Prefacing past things with late retrospection was Ruskin's peculiar and modern neurosis, as it tends to be his biographers'.[7]

Ruskin often assessed his career as some struggle between two mutually dependent, yet often mutually pre-empting, selves, one acquiring knowledge, the other explaining it to his public. From Venice in 1852 he wrote to tell his father that 'I shall some day – if I live – write a great essay on Man's work, which will be the work of my life.'[8] Thirty years later he vouchsafed to Kate Greenaway that 'the truth is my *Life* never went into my books at all. Only my time.'[9] These analyses, patterns of self-explanation, are the inevitable result of his evangelical upbringing combined with an aesthetic delight in form. *Praeterita* was just one last effort to honour both instincts.

When he was composing *Praeterita* he had available many documents in his family archives.[10] Yet he chose not to use them, even complaining that he really knew little about his parents.[11] Apart from drawing on his own (unpublished) diaries and some *juvenilia*, he utilized none of the family papers which could have allowed him to construct a more accurate model of his youth. It was one of the daunting tasks for Ruskin, as it continues to be in increasing profusion for his later biographers, that he could sometimes not establish an effective relationship between the raw materials of his researches and some achieved statement about them. He was an omnivorous seeker after facts; but the universe of innumerable data, to be carefully gathered and annotated in countless memoranda, an empirical world without end, has still to be organized at some stage into coherent, general principles. Research and travel must be interrupted in order to yield some published statement; but the act of defining and writing only revealed new problems, new ignorances. In Ruskin's case, this produced a pattern of books, beginning with essays on *The Poetry of Architecture* (unfinished for once by no fault of their author's), leading through two volumes of *Modern Painters*, then into *The Seven Lamps of Architecture*, then into three volumes of *The Stones of Venice*, before he could resume *Modern Painters* for two further volumes. He then needed to write *The Political Economy of Art*, and only seventeen years after the first volume of *Modern Painters* was he able to bring it to something like a conclusion with a fifth and final volume.

In sketching this excursion I have necessarily neglected, for the sake of coherence, all Ruskin's other writings during those years, letters, lectures, journals. In the second half of his career the 1870s saw him attempting a radically different scheme of organizing his writings. As many as seven books were then kept going at the same time in serial form; distinctions between public and private utterances were

deliberately blurred, connections were made between all the strands of his working life. But even then, though it was openly acknowledged, publications were at best only interim reports, interrupted or invalidated even before completion, re-worked, re-edited and re-adjusted whenever possible to accommodate new knowledge and above all self-knowledge:

> It is the worst of the minor incapacities of human life [he wrote on the last day of 1853] that one's opinions ought, by rights, to be tested and refitted every five years. They are the soul's clothes – and a healthy soul is always growing too big for its opinions and wanting them to be let out.[12]

Such a Carlylean metaphor, however, disguises a central Ruskinian problem, revealed elsewhere more nakedly: 'as soon as I begin to dwell on any bit carefully, thoughts come into my head about other parts – unfinished – which I am afraid of losing and then I go away and touch upon them'.[13] He refers, as it happens, to the first volume of *The Stones of Venice*. But it could well be any other enterprise of his writing or his living. The world of experience seems endless and endlessly fragmentary, splinters and shards of a reality never fully mastered, disconnections and ruins that the 'imagination' hopes to 'restore'.[14] Yet their completion and restoration are frustrated by the very act of writing, so artificially unilinear, about which Ruskin increasingly complains. This restless partnership between the self that lives and learns piecemeal and the self that proposes discrete, whole narratives lies at the centre of Ruskin's life and imagination.

Even while composing *Praeterita* he encountered a last example of these dilemmas. In 1886, when sixteen chapters of the autobiography had been issued, Ruskin began to publish selections of 'primary materials' (as we would call them); they consisted of 'Correspondence, Diary Notes, and Extracts from Books' to illustrate and gloss *Praeterita*. But, he told his readers, the 'letters will not be arranged chronologically, but as they happen, at any time, to bear on the incidents related in the main text'.[15] The completion of both *Praeterita* and *Dilecta* (as this second compendium was called) was frustrated by Ruskin's final illness. Yet it is, in fact, true to say that neither could ever have been satisfactorily ended. *Dilecta* especially could never have gathered all that we need to read, all that still remains – published and unpublished – beyond the scope of *Praeterita*'s pages. It is as Ruskin's favourite, Tintoretto, said of the study of painting – 'E faticoso lo studio della pittura, e sempre si fa il mare maggiore' ('The study of painting is exhausting, and the sea always gets larger'). Ruskin was

particularly fond of the remark, quoting it on several occasions,[16] so exactly did it register his own excitement and bewilderment at the expanding objects of his study. Accordingly, I have adapted it for the title of this life of Ruskin.

I have explored some of the intricacies and complications of Ruskin's *oeuvre* because they pose similar problems and excitements for any writer about Ruskin. To start with, there is the sheer profusion: thirty-nine volumes of the *Works*, but close on as many more collections of diaries, letters and other primary materials. Beyond that are seemingly endless archives of Ruskin papers, drafts and unpublished letters. The editors of the *Works*, against the advice of Charles Eliot Norton, one of Ruskin's executors, wanted to make their edition *all* of Ruskin – accordingly they included all books then available in other editions, and all those no longer in print or privately printed. They collected all of Ruskin's occasional articles and letters to newspapers, and reproduced not only all the illustrations which Ruskin had inserted in his publications but also added large numbers of his drawings, and drew upon hordes of photographs of Ruskin's 'haunts'. They provided facsimiles of letters and manuscripts and, for the introductions to each of the thirty-odd volumes, drew upon further papers and holographs. Awe-inspiring as this edition is, it nevertheless often makes coherent what in the process of publishing by instalments was not, so that sometimes we may only recover a true sense of living with Ruskin if we return to the original texts and editions.[17]

Ruskin was also prone to establish cross-references and connections between his various works. As early as November 1849 his father was complaining that 'your books will resemble a conjuror's box which you open expecting one thing and find another'.[18] This would not have surprised their author, who frequently found that he had to write of one topic in order to reach another; but increasingly he came to signal these indirections and interconnections to his readers. As we shall see, his own preferred model of coherence was some *Kunst-und-Wunderkammer*, a gallery, museum and cabinet of curiosities all combined and organized on Ruskin's own principles so that fine art, geology, mineralogy, botany, economy, philology and ornithology were shown to be interdependent and mutually illuminating.

A writer on Ruskin cannot, inevitably, be as self-indulgent as was his subject. Nor can he be as radical and experimental, for obligations of narrative and coherence must be honoured. Yet to smooth over the disjunctions, ellipses, the multiplied and parallel endeavours which are endemic to Ruskin's mind and life would be to lose an essential aspect of the subject. Accordingly, I have tried to accommodate what

Valéry calls *living with* one's biographical subject as well as *constructing* it.[19] This involves admitting both Ruskin's muddles as well as my (attempted) order, and giving his apparent incoherences room and scope to reveal themselves as submissive to a more spacious harmony than we can sometimes perceive. The ultimate unity of all Ruskin's ideas and therefore the essential cohesion of all his life's endeavours was what Marcel Proust clearly understood: 'If reality is one and undivided, and if the man of genius is he who perceives it, what does it matter whether the material in which he expresses his vision is paint, stone, music, laws or actions?'[20] In some attempt not to lose such perspectives entirely while chronicling Ruskin's daily existence, I have begun each part of this biography with a brief summary of what is to come, an overview of the years ahead. Similarly, an occasional chapter stands outside the chronology to survey some theme or preoccupation of Ruskin's that transcends historical sequence; especially after 1870 these cuts across narrative form occur within chapters. I have also taken a hint from Ruskin's own formal technique with *Praeterita/Dilecta*: to avoid clogging the main text with materials, especially Ruskin's own remarks, often eminently quotable and *à propos*, I have used the notes not only to identify my sources in the conventional way but as spaces where further 'raw material' of the biographical narrative can be less disruptively stored.

Charles Eliot Norton, as I have already mentioned, was the first to persuade his English friend to try autobiography. And it is Norton who recalls in his edition of Ruskin's letters that

> His mind was of 'a temper so interwoven', to use his own words again, so open to strong impressions from widely different objects, that there was an extraordinary variety in his interests, both personal and intellectual, and little consecutiveness in his occupations.[21]

Norton suffers, as do subsequent commentators, from too ready an admission of Ruskin's lack of consecutiveness; but he still identifies the difficulties of describing this interwoven temper. He also alerts us to its rewards.

Part I

'Early Lessons'

The echoes of my life which I find in my early childhood are too many to be dismissed as vain coincidences; but it is perhaps my conscious life which is the echo, the only real experiences in life being those lived with a virgin sensibility – so that we only hear a tone once, only see a colour once, see, hear, touch and smell everything but once, the first time. All life is an echo of our first sensations, and we build up our consciousness, our whole mental life, by variations and combinations of these elementary sensations. But it is more complicated than that, for the senses apprehend not only colours and tones and shapes, but also patterns and atmosphere, and our first discovery of these determines the larger patterns and subtler atmospheres of all our subsequent existence.

Herbert Read, *The Innocent Eye*

Ruskin uttered a commonplace when he said, writing of Walter Scott in Fors Clavigera *in 1873, that 'Youth is properly the forming time – that in which a man makes himself, or is made'. Yet it is a remark notably true of himself. The outlines of his adult imagination and career were established very early by his parents' direction of his education and his own self-determined curriculum. Above all, he was brought up in a religious atmosphere, at once intense and instinctive, in which all activities were readily and automatically dedicated to God.*

His lessons were patchy and eclectic in their range. They initiated and confirmed his virtuoso-like interest in a multiplicity of subjects. During a visit to the Lakes in 1830 he was taken to Crosthwaite's Museum in Keswick, the first of many cabinets of curiosities which he would encounter or arrange during his life; its mixture, even muddle, of items answered Ruskin's juvenile absorption in a host of activities – drawing, botany, writing, astronomy, minerology – and such a museum may well be invoked as a model of Ruskin's adult mind.

By the time he was fifteen he had published both poetry and scientific papers. In all important matters he was largely self-taught and had established an early independence from others; this solitariness, even a selfishness, was largely the result of his mixing only infrequently with boys and girls of his own age, but it too became a dominant element in his mentality. The Ruskin family, uneasy about its new-found social position and assured only in its financial wealth and independence, drew its circle tight in the interests of the cherished only child. Their riches provided the means by which the Ruskins could raise themselves and their son above trade: hence the lavish provision of books, pictures, painting lessons and – above all – travel.

A continental tour 'was a thing to be thought of only by persons of high rank, or at least of great wealth and respectability' – so Ruskin wrote in a youthful narrative, obviously influenced by family discussions. But after some years of annual summer tours around Great Britain the family's excursions were extended into Europe. The sacred places of his adult imagination – Rouen, Geneva, Chamonix, Verona, Venice – were all reached and registered while he was still a boy. The combination of travel with sketching, writing, architectural and geological researches, which filled so much of Ruskin's life, was firmly established among the 'Early Lessons' he most appreciated and from which he learnt most.

Chapter 1

The Scottish Inheritance

If origin, if early training and habits of life, if tastes, and character, and associations, fix a man's nationality, then John Ruskin is a Scotsman . . .

Collingwood, *Life of Ruskin*

Ruskin's parents were first cousins ('my Mother's name was Margaret Ruskin *unmarried*'[1]). They first met when Margaret came to Edinburgh, probably in 1801, aged twenty, to reside with her aunt and uncle, Catherine (Tweddale) and John Thomas Ruskin. Their son and her cousin, John James, was then sixteen. They became engaged in 1809 and were married nine years later, at which point they moved to London whence John Thomas had himself come over thirty years before. Of this Scottish heritage of John Ruskin we now know probably as much as patience and persistence in research can reveal.[2] And since Ruskin always valued his Scottish ties, even despite one disastrous attempt to bind them tighter in his own marriage to a Scotswoman, and since Ruskin's life was so penetrated and conditioned by parents whose early years of friendship were passed in Edinburgh (hence, in part, their son's disastrous marriage), it is necessary to rehearse these first Scottish connections.

John James, Ruskin's father, born in Edinburgh on 10 May 1785, was conscious of coming from very mixed and unequal stock, just as he was to feel that he provided similar inequalities for his son. Catherine Tweddale, the mother of John James, was the daughter of a minister; other members of her family had connected themselves with preachers of God's word. Her religion was to sustain her during the tribulations of marriage to John Thomas: 'We can only submit our reason to the obedience of Faith and adore him as an infinite wise God and as the Author of our life and Salvation.'[3] This faith was shared with her future daughter-in-law while she lived with them in Scotland. Catherine's maternal connection with the Adairs of Galloway gave her, in addition to the consolations of her faith, a sense of superiority over her husband. One of these Galloway relations, Dr John Adair, had attended General Wolfe as he lay dying at Quebec in

9

1759, and later rose to be Surgeon-General. He remembered Catherine in his will, and this legacy allowed the family – perhaps with fatal consequences – to move to the fringes of Edinburgh New Town and conduct themselves like the gentry which her family had been.

Catherine's husband, John Thomas, came from a very different background, being well connected neither with county nor with kirk. A Londoner, he had been apprenticed to a City vintner, apparently never completing his full seven years. His sister, called Margaret, as her daughter – John Thomas's future daughter-in-law – was to be, married William Cock, a Croydon 'victualler'. Headstrong and irresponsible, John Thomas Ruskin left London in the early 1780s and established himself as a grocer in Edinburgh. How he met and married Catherine Tweddale is unclear, though some clandestine intrigue, even elopement, is hinted at by their grandson.[4] By 1785, when Ruskin's father was christened, John Thomas was ambitiously styling himself 'merchant'.

For a former apprentice the status of merchant was itself the highest eminence to be contemplated. But equally, as the *Monthly Magazine* remarked in 1798, 'every little retail shopkeeper is dignified by the title Merchant'.[5] Yet neither grocer nor merchant could aspire, in Edinburgh at that time, to the status of 'Gentleman'. Even when Catherine's legacy enabled the family to move in 1796 across the North Lock onto Multrees Hill,[6] no amount of lavish entertainment ('so indiscriminate and boundless . . . hospitalities') and no portraits of his son by distinguished painters like Sir Henry Raeburn could effect John Thomas's longed-for transformation into gentleman.[7] He seems to have ruined himself by these efforts, but that did not deter his son, John James, from trying to achieve the same desired status for *his* son, once he had paid off the debts that John Thomas eventually accumulated in Edinburgh. In John Ruskin, established as a gentleman commoner of Christ Church, Oxford, his father vicariously achieved some of the social ambitions that had eluded his own father and, through that father's ineptitudes, himself. Such concerns permeated the Ruskins' social thinking: John Thomas, married to a lady socially his superior, and then John James, also allying himself with a cousin from precisely the background that his father would least tolerate (which is, perhaps, explanation enough of John Thomas's hostility towards Margaret Cock). Both men needed to redeem themselves from social and economic positions which they found humiliating or restricting.

Margaret Cock became 'Cox' soon after her arrival in Edinburgh; except for one (deliberately hostile?) recall of the *infra dig* form by John

Thomas in July 1809,[8] she was known as Cox thereafter. But even this change could not conceal the doubtless disagreeable fact that her mother kept the King's Head Tavern in Croydon (destroyed in 1890). Many years later Ruskin was to recall his father's hurt pride at having to show him such a 'birthplace'.[9] For John James such symbolic matters as his wife's birth in a tavern loomed large; almost as distressing was the fact that Margaret's sister, Bridget, had married a baker, George Richardson, who lived over his shop, also in Croydon. John James reported to his mother in October 1812 that 'I should not have slept at Mr. Richardsons . . . for I never feel well or fancy so in that house the proximity of the oven and closeness affects me'.[10] The victualler father of Margaret and Bridget Cock was metamorphosed by John James, while preparing his son's birth certificate for use – significantly – at Oxford, into 'Master Mariner' – Captain Cox of Yarmouth! Doubtless these parental adjustments of shameful connections left their mark on Ruskin's own version of his maternal grandfather as 'a sailor, who used to embark, like Robinson Crusoe, at Yarmouth, and come back at rare intervals, making himself very delightful at home'.[11] Or perhaps it was an almost unconscious defence of George Richardson against his father's remembered snobbery that led Ruskin in *Praeterita* to recall him as a baker of 'altogether excellent bread'.[12]

There were always such ghosts to exorcise, memories and disagreeable facts to keep at bay. Margaret's lack of social ease would always be with her, though disguised in later years, as visitors testified,[13] by a formidable 'presence' that simply eliminated the need for such relaxation. Coming to Edinburgh as a young woman with few accomplishments, she obviously took advantage of the opportunities to improve herself – proudly determining to be 'worthy' of the cousin she grew shyly and steadily to love. When John James left in May 1814 to start his own business in London, Margaret wrote to tell him that

> I pray almost every hour to be made more deserving of your affection when you are from me, for when you are with me I forget everything disagreeable in the happiness of having hearing and seeing you, and I reflect upon what you are in abilities person and age I feel most sensibly the difference between us the fear that you may become equally sensible of the difference and cease to love sometimes distresses me greatly heaven preserve me from that worst of all miseries being the cause of misery to you which I must be now should you cease to love me never my best love pass over without checking the most trifling thing either in my words or conduct that

you disapprove. I would be all you wish I will control myself to
the utmost to be so what would I not do to please you oh my
own John you know not the delight that filled my heart when you
praised nor the pain I felt when you were compelled to blame me
were I praised by all the great and learned in the world it would not
afford me half the pleasure one commending word from you does
I should improve if you were with me[14]

At this point their engagement had lasted probably four years,[15]
and their 'dreadful' separation would continue for almost another
four. In April 1815 John James was reassuring his 'best beloved' that
'you are mine in Feb[ruar]y next';[16] but the marriage did not take place
then.

There were various reasons for the delay. John James wished to
pay off his father's debts before assuming his own family responsi-
bilities, and after the onset of his father's insanity in the summer of
1815 he was also sending his mother additional sums of money, which
drained even further his personal resources. But there is also evidence
that John James and Margaret encountered stiff opposition from his
parents. John Thomas seems to have been the main obstacle: 'I said
enough last night to satisfy my Father that he will find it his Interest to
desist from interfering,' John James wrote and told Margaret.[17] Yet
Catherine Ruskin is also included in her son's expostulations – by
April 1815 he had to protest that both Margaret's and his own health
were jeopardized by the parents' hostility in addition to their own
long separation. He had told Margaret that he would not count the
cost – 'My Love if I now saw it would lead to irremedial ruin I would
not forego the fixed purpose of my Soul'; now he threatened his
parents with their responsibility for Margaret's very life, the integrity
of the whole family ('Oh if you expect me to make some efforts to
keep the family united') and – shrewd even in his distress – 'The State
of our worldly matters'.[18]

The inclusion of Catherine in her son's unhappy and passionate
protest against parental hostility may well have been simply good
tactics, for the poor woman was presumably torn between placating a
'Father so unstable as yours' and her own apparent affection for 'both
My Darlings'.[19] It seems possible that she had even herself encouraged
her son and niece, only to discover her husband's unreasonable,
maybe snobbish, opposition – 'your Father seldom knows his own
mind two hours together'.[20]

Between Catherine and Margaret had grown close and intimate
bonds – the elder woman described her niece as 'the half of myself' and
much lamented her absences on visits to family in Croydon.[21] The

younger woman in her turn must have modelled herself upon her aunt, sharing from the start a truly religious temperament;[22] indeed, Margaret absorbed to an even fuller extent perhaps than Catherine an unshakeable confidence in God's watchful ordering of their lives. And if Catherine's life, coping with her husband's wilful extravagance, was 'calculated to have burned away frivolity',[23] her niece's was also moulded in a similar fashion. In the determined administration of John Ruskin's spiritual well-being, in the schooling of his speech and enunciation during the daily Bible readings and in the management of her household for God, her husband and son Margaret showed the fruits of her sojourn in her aunt's home.

That Margaret pleased her aunt and mentor seems in no doubt. So it is not particularly surprising that when Catherine Ruskin, alarmed at her son's apparent determination to remain a bachelor in the interests of family finances, urged upon him the glowing idyll of the ideal wife, the picture she painted should be strikingly like Margaret Cock: or, that Margaret, in love perhaps with John James before his parents had registered anything, strove to emulate her aunt's declared notions of a suitable daughter-in-law:

> But I will not have My Son an old Bachelor – believe me my beloved Child I feel the full force and value of that dear affection that could prompt to such a plan – Dear as your society is to me it would then become the misery of my existence – could I see My Child so formed for Domestick happiness – deprived of every blessing on my account No my Dr. John, I do not know a more unhappy being than an old Bachelor The friends of his youth must pass away, and instead of the affectionate Wife and the dutiful Child to cheer his declining years, he stands alone in the World surrounded with Mercenary strangers without a being to love or be regarded by. God preserve my Child from realizing this dreary picture as soon as you can keep a Wife you must Marry with all possible speed – that is as soon as you [can] find a very Amiable Woman – she must be a good daughter and fond of domestick life – generous and pious, without ostentation, for remember no Woman without the fear of God, can either make a good Wife or a good Mother – free thinking Men are shocking to nature, but from an infidel Woman good Lord deliver us – I have thought more of your Wife then you have done – for I have two or three presents carefully hoarded by for her, and I have also been so foresightly as to purchase two Dutch toys for your Children, in case you might Marry before we had free intercourse with Country – indeed my Dr. John the greatest happiness I look forward to in life is to see you with an Amiable Wife and a sweet young [child][24]

An interesting aspect of such a maternal programme is whether

Catherine was at all conscious of promoting Margaret as early as 1808, when she wrote the letter.

By July the next year Catherine was writing to her husband in terms that suggest that the two of them had already discussed a marriage between the young people:

> I wish my two darlings as you call them were secured to me in the very way you mention. I can assure you money would be no obstacle to me and God grant our Dr. John had so valuable a Wife but that is what I am affraid he will never meet with – What are the young Women of the present day but a sett of giddy nothings Equally unfit for Wives or Mothers or for any purpose in life that I know of beyond the gaity of a Ball Room or the Parade of a Fashionable street – If Men would act more like rational Creatures Women would be better too as it is they are exactly on A parr and till heads of Familys think of reforming there can be little good expected from the younger branches of them[25]

What is not so clear about her second sentence is whether the 'so valuable a Wife' that their son would never meet with is, in fact, Margaret Cock, the other darling of the previous sentence; or whether, though a model, she was for other reasons (background? closeness of blood ties?) unacceptable as a wife. The letter was sent on to Croydon, where Margaret was visiting her family, and was endorsed by John Thomas – 'Miss Margaret Cock must bring this Carefully down, with her to Scotland, after Peruseing it Only Herself . . .' So Margaret must have read the letter. Since it is presumed to have been during this visit south that Margaret and John James agreed on on engagement,[26] the encouraging construction it is possible to put upon Catherine's words cannot be underestimated. What other hints and fragments certainly declare is that the parents' discussions of separate marriages for John James and Margaret (if that *is* the drift) must have been especially intolerable for the two people who had already made up their minds to marry each other; if the parents, however, recognized their mutual affection, the difficulties with John Thomas declare themselves the more.

The man whom Margaret waited for and schooled herself to deserve had hoped to follow the profession of the law, a traditional occupation for a Scots gentleman.[27] Instead, like his father, it was to trade that he committed himself. We do not know why. 'I am perfectly satisfied (after missing the profession of a Lawyer) with the employment of my youth', he wrote to his mother in 1812 during the course of a long defence of his extended stay in London:

> I am grateful to the Almighty & to you & to my Father for the

opportunities afforded me of escaping from that state where my Lot first threw me – had you not possessed the means & then the inclination to give me an Education such as I had my existence had been deprived of half its pleasures – because in the absence of my friends & relations. I have no lasting happiness on which I can repose myself but what is materially connected with that education.[28]

He refers, undoubtedly, to his time at Edinburgh Royal High School and to the continuing faith in self-education which he had imbided there. Its headmaster, Dr Alexander Adam, inculcated the 'love of independence, the duty and comfort of making one's own fortune, and relying on one's self alone'.[29] Such lessons impressed themselves forcibly upon a tradesman's son, who was probably subjected, because of that social stigma, to all the hostilities of a notoriously brutal school. The careful, sheltered education of his son at home, with tutors or in small schools, must have been John James's deliberate search for an alternative to his own upbringing. Yet, as he explained to his mother, he left Edinburgh with artistic and literary tastes formed sufficiently to maintain them himself – he had performed in theatricals, much to Margaret's admiration,[30] had taken lessons in landscape-sketching from Alexander Nasmyth, and had begun to read in the literature of the Scottish 'renaissance' – the appearance of Scott's *Waverley* in 1814 would be a high point in his reading. All these pastimes were to leave their mark upon John Ruskin himself. Meanwhile, they sustained John James in dreary London lodgings and in 'the limited share of time any business in London leaves at my disposal'.[31] The Raeburn portrait, painted during his early years of struggle, has him pausing dreamily in his reading of a book.

He left for London probably in 1802, armed with introductions from Galloway relations to others with business connections in the English capital. Since there was no apparent financial bar at this stage to his proceeding to university, John James's departure for England is unexplained. Perhaps he was simply unable to tolerate his father's erratic and overbearing temperament,[32] since his own was not particularly retiring and accommodating. Or perhaps it was, as he himself explained many years later, 'the charming but false light with which my Prospects of Life in London were gilded by my Father & Mother – I was told of high connections & people whose houses would be open to me – & of Pleasures of being noticed by many a friend, whose notice was honour, but whose Houses or whose faces, eventually I never saw . . .'.[33] No wonder then that he would vicariously delight in the notice taken of his son, admitted – as John James would always emphasize – among the great of the land.

Prospects were at first bleak and even humiliating; failing to obtain any post at all, he returned to Scotland. But in 1804 or 1805 he went back to start, at £100 p.a., in the firm of Amyand Cornwall. Probably in 1808 he moved to Gordon Murphy's, where he managed the cash and the clearance of cargoes through customs. His rise in the firm came through a classic instance of shrewd opportunism, as he explained forty years later:

> Sir Wm D Gordon managed the English Correspondence with Jamaica & Cadiz but he was [the M.P.] from Worcester & much engaged – I heard him one night say he would write on an important Subject next day to Cadiz – I knew his Sentiments – I wrote a Letter at night & placed it before him next day – He read & signed & from that day I had Cadiz & Jamaica Correspondence to myself except when Farrell wrote a Letter – They raised my salary to £300 & gave me Rooms in the House with the Junior Partner where I also dined every day he was at home – Having Cash, Correspondence & Customs House I was safe enough if the House had been so.[34]

Despite a fifty per cent increase in wages and those other bonuses, Ruskin's relationship with the firm was not permanent. A recklessness and extravagance among its 'Princely Brothers' made the business increasingly unsteady – it must have been a double burden upon John James to know that both his father and his employers were ruining themselves.

John Thomas finally failed in business in 1808 and his son, perhaps to avoid his father being made bankrupt, determined to pay off all his debts; indeed, he even told his father, 'long have I seen the Storm from a distance – & it was to prepare an asylum if possible for you and my Dr Mother that I fled from my Home'.[35] His mother's pride in this filial sacrifice ('the Goodness of my Child shall not be concealed') was matched by her son's encouragement of her plans to remove to a more modest home away from Edinburgh ('a neat House & . . . plainly furnished & live in a manner equally genteel with your present Stile only without Company').[36] It was a preview of his own domestic habits and mercantile probity.

While the family removed from Edinburgh to Dysart in Fife – 'tho a very shabby little Town there is a number of Gentlemans seats close beside it, and a variety of beautifull walks'[37] – John James in London escaped from Gordon Murphy's into his own firm. But before that he decided to take a holiday and return to Scotland; not unexpectedly, since it was his first holiday in nine years,[38] he fell ill of typhus fever at Ferrybridge in Yorkshire. Margaret, who had already tended him during an illness in London a few years before, was dispatched to

16

nurse him and fetch him home. Home was by now in Perth, since Dysart had proved a great disappointment to Catherine,[39] and the Ruskins had resettled near Janet Richardson, John James's married sister, first perhaps with her and then in a house called 'Bowers well'.

Recovered, John James returned to London in 1814 and in May established at 11 Billiter Street in the City the offices of Ruskin, Telford and Domecq. The last named partner, Juan Pedro Domecq, had been a fellow clerk at Gordon's and about 1813 had sought out John James and asked if he would act as agent for the wines of his Spanish uncle, Haurie. Domecq and Ruskin had set up business together and introduced a largely sleeping partner, Henry Telford, whose capital was the basis of the enterprise.[40] The experience of importing gained in Ruskin's previous job, the luck at taking away from Gordon's the Haurie concession, plus his anxious and driving energies, contrived to make the new firm a slow success. Not that it was anything but a difficult period: 'what people call a nice pleasant Business has not been arrived at with little trouble & that in fact I am more like one navigating on a plank saved from the wreck of several larger Vessels'.[41] John James was energetic and strong-willed ('*Will* and Power to Seize upon what a hundred Competitors are Striving to keep from you'[42]) and determined not only to excel but to prove his moral standing in the ruins of his father's hopeless and untrustworthy career. But the making of one's honest fortune was hard, often depressing work. Wine had to be sold in 'every town in England most in Scotland and some in Ireland';[43] but the annual sale of 20 butts was raised to 3,000. The ceaseless travelling inaugurated a habit that would become a pattern in his son's life. In Spain Haurie's financial affairs were precarious and threatened the London firm. In Scotland, where the father's hostility to John James's proposed marriage with his cousin continued, John Thomas's erratic moods disintegrated into despondency after the financial collapse of 1808 and finally in 1815 into insanity. His son's reaction, after first expressing his shock and concern, was to worry that it was 'a very serious thing for me & may injure me in business'.[44]

If John Thomas's vice was, in his wife's words, 'self-love' and 'self-indulgence',[45] his son's was, most negatively, a lack of self-confidence: in 1847 John James explained his 'malady or weakness' as 'arising from want of self-respect'.[46] But the corollary was an enormous pride, the need to prove himself superior to all around him, from his wife, humbling herself to the man about whose home and son her whole life was to revolve, to his clerks, whom he appointed,

according to his son,[47] because of their *in*capacity over which he could conspicuously rise. Still at Gordon's in 1812 he had told his mother

> it vexes one to see, besides unavoidable misfortunes, a train of evils brought on an establishment by imprudence & mismanagement & downright negligence . . . I could have averted half the misfortunes now befallen us.

And since the firm could not be one in which 'a young man should adapt his plans with a view to forward himself',[48] he had been only too willing to pull out. To succeed, to keep ahead of an inferior world – either himself or vicariously through his son – was John James's constant concern.

But with such high standards of self-regard and in a position as head of one's own firm, with no superiors to blame, the drive often seemed to fail, and depression and gloom invaded his mind. A pattern of 'habitual gloom' and 'weak nerves' ran from John Thomas through John James to John Ruskin.[49] The minds of the first and third eventually succumbed to pressures upon them. Manic-depressive patterns would determine much of John Ruskin's career – 'I wonder what star you were born under – Mine's Saturn & means – always too late and out of any sunshine worth speaking of.'[50] Between first and third generations John James seems to have managed his depressions better: 'first blessed with habits of Industry',[51] which he certainly passed on to his son, he had always before him the warning of his father's wayward example as well as his mother's exhortation to behave like a rational creature. Hard work for the firm gave him generally the required peace of mind, the relief from thoughts that 'only harrass & destroy'.[52] His inferiority complex, what he called 'that timidity which makes me displeased with myself & uncomfortable wherever I am',[53] could often be solaced by the contemplation of the steadily growing business: 'You know little of my Disorder when you recommend me to be idle for a month. The more overwhelmed I am with business the better I am.'[54]

But he was still separated from Margaret, by the self-imposed obligation to pay off a father's debts, by distance and by paternal disapproval of the match that did not soften after John Thomas's insanity. Letters to Scotland – especially, it seems, those to Margaret herself – were associated with his states of anxiety; sometimes they were written and not posted.[55] In 1817 he is apologizing to his betrothed for not writing and confesses to a period of liver illness (even in his account, clearly psychosomatic). What he dreads above all, he says, is 'the mind destroying the Body altogether'.[56] Margaret, for her

part, seems to have felt helpless so far from the man she loved and wanted to cherish and sustain. She was also in daily contact with a Ruskin whose mind had collapsed and would, literally, destroy its body by suicide in 1817. Even allowing for some later exaggeration, or retrospective magnification, we can see how much these years in Perth were a misery to Margaret by her inability to contemplate returning there in 1848 for her son's marriage.[57] The consolations of her life were, increasingly, her faith and its instruction to her that no trials were ever sent in vain or accidentally: she would make her son memorize the 119th Psalm which spoke her belief so eloquently – 'Trouble and anguish have taken hold on me: yet Thy command-ments are my delights'.[58] A more mundane delight was her greater intimacy with her future sister-in-law, Jessie (Janet) Richardson. Visits to her house nearby at Bridge-end would have occasionally taken Margaret away from the burdens of Bowerswell; but they would also have introduced her to a world sadly punctuated with the deaths of Jessie's children, for half of the ten died in infancy.

At last Margaret made her escape, leaving for Edinburgh and London with her new husband on the morning of 3 February 1818; but not before death and distress had formed yet another circle around them. In the previous September her mother had died in Croydon. The following month, maybe while she was still down south, her aunt died suddenly from apoplexy during the christening of one of her grandchildren, on 13 October. Then on 30 October John Thomas followed, almost certainly by suicide. Some were to say it was caused by 'grief over his wife';[59] others spread it about that the 'reason old Mr. John Ruskin took his life was . . . because his only son . . . had married his first cousin, who had lived with them'.[60] Such gossip, ten years after the event, muddles the chronology (John James married Margaret three months after his father's death) but dramatizes the known hostility of John Thomas to the match. Whatever the facts and atmosphere surrounding their union, it was certainly undertaken in the shadow of death, if not also in the knowledge that it disobeyed parental wishes. Collingwood records that Margaret would have preferred to delay further, but that John James persuaded her.[61] They were married quickly and quietly in the evening of the 2nd February; according to their son not even the servants of the house knew what was happening until the couple drove away from Bowerswell the following morning.[62] John James was thirty-three and Margaret was thirty-seven.

Chapter 2

The Family Circle: 1818–1823

in infancy you may form a very correct Judgement of a child
Catherine Ruskin to John James Ruskin (18 April 1805)

John James and Margaret Ruskin set up house at 54 Hunter Street, Brunswick Square, in a yellow brick Georgian terrace house (demolished in 1969), 'eminently suitable for . . . a modestly prosperous and wholly respectable vintner'.[1] From the few letters between husband and wife that survive from these early years of their marriage a picture of their domestic and personal relationships clearly emerges. John James's often flamboyant epistolary style ('you my dearest Love send forth each year some Loveliness unknown before some Beauty fresh & new until I'm dazzled with the sight & scarce dare longer look'[2]) contrasts with Margaret's humble yet resilient piety ('I feel deeply all your kindnesses my beloved and to the utmost of my power I will do to make you happy'[3]). The letters that survive are inevitably those exchanged when John James was away on business trips; they epitomize the mutually disagreeable, even painful, separations, his concerns with a flourishing business, hers with the minutiae of domestic economy and the long-distance care for his welfare and health, and – after the birth to them of a son on 8 February 1819 – their shared devotion to his promise and well-being: 'were he Son to a King more care could not be taken of him and every day gives proof of possessing quickness memory and observation not quite common at his age'.[4]

When John Ruskin was born, his mother was attended by Ann Strachan, the Scots nurse of John James when he returned from England with typhus fever in 1813 and now removed with them to London along with 'her little library of Puritan theology'.[5] Ann ('Old Mause') was 'never quite in her element unless some of us were ill', Ruskin would recall, and her unsmiling 'Scottish Puritan spirit in its perfect faith and force' was a presiding genius in the family until her death, still with them in 1871, at the age of seventy-two.[6] Margaret Ruskin seems never to have been at ease with Ann; her son explained it as her Saxon incomprehension of northern puritanism, but the

chances are rather that his mother felt uncomfortable as mistress of her own household with the constant presence of one who had been a daily witness of her uneasy, anomalous position (part companion, part domestic servant) in John Thomas's home. Ann had a talent for being disagreeable,[7] but Margaret's distaste does not seem explicable simply on that score. Ann's passionate devotion to John James and John, recalled by Lady Burne-Jones,[8] may well have implied the exclusion from her approbation of the third member of the family. She must have been, too, a perpetual reminder to Margaret of aspects of her life in Scotland she would rather have left behind.

John Ruskin's birth was not easy,[9] but characteristically his mother gloried in the trial and within two months was once again in full control of her household – not entirely trusting a servant's account of burning '5 chaldron [of coals] in 3 months' – and even travelling twice in one week to spend the day in Croydon with her sister, Bridget, 'whose disorder was nothing like my aunts and seeing this made me the more easy'.[10] More unnerving memories. But generally the new home and especially the arrival of a son held the promise of leaving far behind a life of financial failures, insanity, suicide and infant deaths.

The problem, of course, was that neither parent was carefree by temperament. And Margaret's self-appointed role of caring easily slipped into worrying: that her housekeeping was extravagant, that her husband would over-indulge and catch cold bathing in the sea at Weymouth; more crucially, that their only son would be taken from them, as some of her sister-in-law's had been; or that – and here there was another family precedent – he would wear out his brains.[11] In the shadow of such prospects Margaret dedicated her son to God, like Hannah with her cherished Samuel, and her house also, endlessly echoing Solomon's prayer 'I have surely built Thee an house to dwell in, a settled place for Thee to abide in for ever'.[12]

For Margaret, upon whom inevitably fell the far larger share of guiding their son in these earliest years, this role was a strange mixture of toughness and sentiment, neither quality perhaps especially unusual in mothers with their firstborn. Just as she continued to feel humble before John James's loving enthusiasm, she was determined that John would 'make up in some degree for his Mother's deficiences';[13] on several occasions he is 'Your boy' rather than 'ours'.[14] She worries lest she should become too proud of him,[15] and one suspects that the intermittent severities are really punishments of her pride by attacking the boy's qualities that provoked it. She notes in her letters how John

is 'very self-willed and passionate' and is characterized already by 'temper and cleverness', but trusts that 'this will . . . be cured by a good whipping when he can *understand* what it is for properly'.[16] That she anticipated his understanding, at least in other matters, is equally clear: he would recall being taken to chapel when he 'didn't understand English', yet apparently behaving perfectly and being afterwards 'quite conscious of . . . having behaved as he was desired and of deserving commendation'.[17] Within another year he knew 'all the commandments but the second perfectly and the Lords prayer'.[18]

But, while these procedures raise eyebrows a hundred and fifty years later, they were not exceptional then in parents both devout and ambitious. There is equal evidence in the *Family Letters*, which Ruskin himself did not draw upon for *Praeterita*, for his enjoyment of more recognizable childhood pursuits, notably when on frequent visits to his young cousins at Croydon:

> we have been these three days to Duppas Hill (writes Margaret to John James) and you never saw any little creature enjoy itself more than your boy he rolls stones gets sticks & runs & laughs says it is like Sandgate and so fine and so beautiful instead of unwillingness to go out and teasing to get home as in London we have some trouble to get him to come home after he has been three hours out.[19]

From this same letter we learn that on these outings Margaret carried in her muff 'a pennyworth of Captains biscuits' in case her son's outdoor exercise made him suddenly hungry. Indoors he is drawing (in March 1823), trying to play a flute, and childishly imitating his mother in an activity that he must have seen her often engaged in – writing to his father. So the boy, too, pretends to write, and Margaret copies out what he wants to say, and he adds his signature on 15 March 1823:

> My Dear Papa
> I love you – I have got new things Waterloo Bridge – Aunt brought me it – John and Aunt helped to put it up but the pillars they did not put right upside down instead of a book bring me a whip coloured red and black which my fingers used to stick to and which I pulled off and pulled down – tomorrow is sabbath tuesday I go to Croydon on monday I go to Chelsea papa loves me as well as Mamma does and Mamma loves me as well as papa does –
> I am going to take my boats and my ship to Croydon I'll sail them in the Pond near the Burn which the Bridge is over I will be

very glad to see my cousins I was very happy when I saw Aunt come from Croydon – I love Mrs Gray and I love Mr Gray – I would like you to come home and my kiss & my love.[20]

It is probably as compact a synopsis of his current world as he would ever achieve. The healthy exuberance, the toys, visits to and from his young cousins and the family friends (the Grays from Camberwell – also Scots and the husband in business with some Spanish firm) – all reveal a thoroughly normal childhood pattern: 'dear lamb he has got one tooth and very nearly another'.[21] John's first letter also announces an early fascination with doing things for himself – and doing them *better* than others! The contacts with Croydon, that John evidently enjoyed, were organized when his father was away on business trips; Margaret appreciated the fuss that was made over her child there: 'you know how bridget loves him she even put a stop to cleaning that the servants might enjoy themselves [on John's third birthday] and every one of the children brought him something'.[22] Yet John James must have expressed reservations, for his wife had to argue that a change of air would suit her son and herself when, a year later, she plans another visit to Croydon – 'I trust you will not think I do wrong in going for a day or two to Croydon'.[23] It is the first indication of that paternal snobbery that would gradually cut his son off from any 'undesirable' society.

John James was not eager to mix with those whom he considered beneath him; yet being equally sceptical of other *nouveaux riches* like themselves and insecure in his dealings with social superiors, he contrived to isolate his family in the interests of the son through whom he was determined to achieve a vicarious cultural and social position. Margaret evidently learnt to subdue her family feelings to her husband's social protocols – by May 1826 she is herself admitting the undesirability of a stay of more than a day or two in Croydon, despite Bridget's pleas, for John 'observes so closely and left were he any time there together the ways and manners might effect him'.[24] Yet these were hard sacrifices for her to make, since she evidently loved her sister's company, found the occasional change of scene healthful and might even have approved, despite herself, the relaxed and unforced world of her son's Croydon cousins.

The famous story of the rejection of the huge Punch and Judy theatre brought by Aunt Bridget for John's birthday, but hidden away unused once suitable thanks were given, sounds like the deliberate elimination of a Croydon reference.[25] But it cannot be construed as the

emblem of a toyless, joyless childhood, though Ruskin wanted to use it so in *Praeterita*; the *Family Letters* declare otherwise in tone and detail. There were the models of Waterloo Bridge, other building bricks, drawing materials, frequent presents from his father, including a dog and a sheep,[26] and trips to Sandgate and, later, to the pantomime. It adds up to a creative rather than a crushed boyhood, in which toy theatres, besides being uncomfortable when derived from Croydon (vulgar also?), would be considered insufficiently educative.[27] And this, in its self-determined seclusion, was above all the emphasis of the Ruskin *ménage* – learning and self-improvement. Nearly thirty years later Ruskin told a correspondent that 'I have to thank her [his mother] for not giving me foolish – or many toys – but the simplest possible'.[28] Self-improvement, too, was the tenor of Margaret's and John James's existence: we catch a glimpse of them, on a rare trip together before their son was born, reading Elizabeth Hamilton's *Memoirs of the Life of Agrippina* (in three volumes) together in a Peterborough tea-room. Or, left behind after John's birth, Margaret would read *Marmion* in the places her husband's pencil had marked. Then began John's own instruction in religion and in reading and writing (he was bribed with books to take his medicine[29]). Soon there developed the pattern of family evenings, with the parents reading aloud and their son drawing or copying the printed letters from one of his books.

This was the domestic scene for which John James always yearned to return as quickly as possible and which Margaret carefully worked to ensure would be there to greet him: 'you are missed and longed for by the whole household'.[30] Two years later he wrote from Cumberland, 'oh! how dull & drear & unsatisfactory is the best Society I fall into compared with the Circle of my own Fire Side with my Love sitting opposite irradiating all around her & my most extraordinary Boy filling his nook but making a more important figure by my chimney side than Gog or Magog Giants vast in Guild hall'.[31] The circle was traditionally a figure of perfection; but John James behaved as if the metaphor were realized, literally closing himself and his family off for the better protection, education and perfecting of their little boy.

The family moved from Hunter Street to Herne Hill, near Dulwich, some time after March in 1823. By that date John's skills and predilections were already declaring themselves: he could read by the time he was four; he liked drawing – and had difficulty with memorizing the second commandment which forbade the worship of graven images; he was, as his mother noticed at Croydon, very

observant – a fact he has himself mythologized in tales of spending his days

> contentedly . . . tracing the squares and comparing the colours of my carpet; – examining the knots in the wood of the floor, or counting the bricks in the opposite houses; with rapturous intervals of excitement during the filling of the water-cart, through its leathern pipe, from the dripping iron post at the pavement edge; or the still more admirable proceedings of the turncock, when he turned and turned till a fountain sprang up in the middle of the street. But the carpet, and what patterns I could find in bed covers, dresses, or wall-papers to be examined, were my chief resources, and my attention to the particulars in these was soon so accurate, that when at three and a half I was taken to have my portrait painted by Mr Northcote, I had not been ten minutes alone with him before I asked him why there were holes in his carpet.[32]

Though he fictionalizes the sparsity of nursery resources – 'I had a bunch of keys to play with', he tells us earlier in that section (but what child does *not*?) – he was on the right lines in recording how he practised his own self-reliance within the larger family one. In infancy and childhood he became in large measure self-contained, having servants to minister to his regular needs, using companions mainly to provide admiration or to be instructed by him, but requiring little exchange and mutual involvement with others, except perhaps his parents; even they served rather as promoters and regulators than as sharers of his special worlds. In the review of his upbringing that Ruskin conducted in letters to Miss Sarah Corlass around 1850 he reports his mother as confessing 'to a great error in having made me too independent of other people'; he himself did 'not agree with her', though he continued by acknowledging that 'I care very little for any body . . . but I believe this to be ascribed to my naturally hard & selfish temperament'.[33]

We may see the three-year-old boy, 'dressed in a white frock like a girl', in both the Northcote portrait described in *Praeterita*[34] and in a silhouette of the same year, 1822. Both show him with a companionable little dog that *Praeterita* ignores; in the silhouette John is engaged in one-sided discourse with this creature, apparently reprimanding or perhaps already engaged in pedagogy with the best available pupil. The Northcote portrait, about which the author of *Modern Painters* was suitably sceptical in old age, is interesting because its distant hills, 'as blue as my shoes', were put there at the sitter's request; not only an early example of Ruskin's delight in joining the

visual to the verbal, but – as he also suggested – it was prophetic of his life's most secure happiness:

> for I had already been once, if not twice, taken to Scotland; and my Scottish nurse having always sung to me as we approached the Tweed or Esk, –
>> 'For Scotland, my darling, lies full in thy view,
>> With her barefooted lassies, and mountains so blue',
> the idea of distant hills was connected in my mind with approach to the extreme felicities of life . . .[35]

Chapter 3

Childhood at Herne Hill – English Travels: 1823–1832

I find [time] now still more scarce than ever for what with Livy, and Lucian, Homer, French, Drawing, Arithmetic, globe work, & mineralogical dictionary, I positively am all flurry, all hurry
Ruskin to his father, 20 February 1832

– 1 –

The Ruskins' move to 28 Herne Hill took them into a newly fashionable middle-class suburb. It was within easy reach of the City for John James, who transacted his business there in the morning and was home punctually for dinner at 4.30 every afternoon. But the house was peaceful, with open spaces around it and long vistas into the surrounding countryside – promise to a young boy of exciting excursions through Britain and eventually through Europe, which were to become an annual family ritual. The house was a broad, semi-detached building with three storeys plus a garret, shallow iron balconies across the first-floor windows and a modest flight of steps up to the front door. Ruskin's nursery was apparently on the front of the top storey and his study, later, on the floor immediately below. But it was above all the gardens and the views that made Herne Hill so Edenic for John Ruskin – 'wholly beneficent', as he would record.[1]

There were gardens on both sides of the house, 'old evergreens, and well-grown lilac and laburnum' at the front, and an orchard and fruit garden ('seventy yards long by twenty wide') at the rear. Here were the pears and apples, 'renowned over all the hill', 'a strong old mulberry tree, a tall white-heart cherry tree, a black Kentish one, and an almost unbroken hedge, all round, of alternate gooseberry and currant bush'. Beyond the immediate garden was the larger, but still intimate, landscape of the Hill itself: at its southernmost end was a field sloping down into the Dulwich valley, and in his autobiography Ruskin makes it almost preternatural, like some suburban Samuel Palmer:

27

open field animate with cow and buttercup, and below, the beautiful meadows and high avenues of Dulwich; and beyond, all that crescent of the Norwood hills; a footpath, entered by a turnstile, going down to the left [i.e. east], always so warm that invalids could be sheltered there in March, when to walk elsewhere would have been death to them; and so quiet, that whenever I had anything difficult to compose or think of, I used to do it rather there than in our own garden [this would be, of course, when he was older]. The great field was separated from the path and road only by light wooden open palings, four feet high, needful to keep the cows in.

And, lastly, as he implies there, beyond the house and its garden and beyond the pastoral slopes of Herne Hill itself were lovely views – westward over 'twenty square miles of politely inhabited groves' was the Thames Valley, with Windsor and Harrow visible from the top of the house on clear days; eastward were the woody Norwood Hills, 'with so much space and height in their sweep, as gave them some fellowship with hills of true hill-districts'.

It would be an inevitable part of *Praeterita*'s fictions that this paradise would be flawed, then and later.[2] The chapter on 'Herne Hill Almond Blossoms' is scattered with allusions to subsequent air pollution, railways, the 'stupidity' of the 'hollow bulk' of the Crystal Palace dwarfing the Norwood Hills, the 'meagre Gothic' church 'with a useless spire' built beside the sloping field. Eventually, what with the excursion crowds and floods of pedestrians flocking to the Crystal Palace, the beloved path itself was enclosed by brick walls and 'a six foot high close paling'. None of this is particularly astonishing, for the quiet and convenient spot chosen by John James for his home in 1823 was bound to be engulfed by the expanding metropolis and its increasingly mobile inhabitants. But Ruskin also announced first in *Fors Clavigera* and later in *Praeterita* that the little domain of the Herne Hill garden 'answered every purpose of Paradise to me', except that '*all* the fruit was forbidden'.

The routines, occupations and prohibitions of his young life were not as sombre as this latter guilty need to paint his childhood as 'at once too formal and too luxurious' would suggest. Mornings were invariably filled with lessons, his mother acting as his teacher until in the late 1820s some of the instruction was taken over by their local preacher, Rev Edward Andrews. Margaret's famous pedagogical enterprise was the daily Bible reading, continued without intermission until John went up to Oxford. They began with Genesis and, three chapters a day, reading alternative verses to each other, made their way through to the Apocalypse. And then they started all over

again. 'If a name was hard, the better the exercise in pronunciation, – if a chapter was tiresome, the better the lesson in patience, – if loathsome, the better lesson in faith that there was some use in its being so outspoken.' This daily exercise and devotion, which servants were not allowed to interrupt, and which visitors might join or wait elsewhere until it was concluded, determined Ruskin's fine ear for the tonalities and sonorities of the English language and ensured his almost instinctive recall of Biblical sentences which by allusion or direct quotation constitute an ineluctable element of his own thought and expression. It also quite probably contributed to his own characteristic and polymathic conviction that nothing in the world was without point or purpose.

Besides the daily readings Ruskin was required to memorize selected Biblical texts and 'the whole body of the fine old Scottish paraphrases' of the Psalms. Other lessons were assigned, enough to learn, 'if set myself honestly to work, by twelve o'clock'; then he was examined to see if it was 'rightly said'. If it were, he was then free till dinner at 1.30 and for the rest of the afternoon; as he rhymed in 1829 –

Although when I have work to do I never am at play
When my work is all oer then I dance on the green.[3]

Left to his own devices, John early manifested the zeal, industry and inventiveness to contrive dozens of projects for himself as well as the attendant inability to bring most of them to completion. As he reported to his father in May 1829, 'I have had more to do than I could do without all possible cramming and ramming and wishing days were longer and sheets of paper broader'.[4] Earlier that year came the first of a lifetime's declarations how 'time is most precious with me'; yet despite colds and minor ailments his projects kept him 'wild with spirits'.[5] Letters to his father, away on business, are full of jocular assessments of his own multifarious world which is mimicked in epistolary terms:

Well then to begin, but what shall I begin with I dont know, I have so many things to say, Which shall I put first. . . .

by the by my discourse is not a regular one it is irregular, a cannonading as doctor andrews says with different subjects. . . .

After all I shall not get what I have to say into this letter Things come pouring in upon me from all sides and after deafening me with their clamour fall to fighting who shall get first . . .[6]

Between Dr Andrews, his tutor by then, and his own self-criticism of

the orders and patterns of his intellectual life we have a facetious diagram for all future projects.

His occupations during the 1820s at Herne Hill stemmed largely from a constant imitation of the literary world around him at the time: he would fabricate his own story books, copying their printed type and illustrations for such productions as "The Puppet Show: or Amusing Characters for Children. With Coloured Plates by John Ruskin, 1829", a more 'creative' enterprise altogether than playing with a lifesize Punch and Judy theatre and one in which he declared an early interest in St George as well as Dame Wiggins of Lee. But he also imitated the more adult tastes of his parents, making, with his cousin, their own guidebook to the Lake District along the lines of those presumably used on family tours,[7] copying the poetic styles of family poetry readings or producing maps of Italy and Switzerland at the age of ten ('I am extremely happy I have found out a way of doing the meridians in my map'[8]).

Such mimicry is normal childish activity. But it was intensified in Ruskin's case by his parents' general approbation of almost any manifestations of talent – 'Any Children I see appear half idiots compared to him or I am at length becoming a very natural & silly papa who can see nothing to compare to my John,' wrote John James in 1827 to his wife. He continued –

> He is surely the most intellectual creature of his age that ever appeared in any age – I mean in his general Bearing & [word missing] & Demeanour & giving out & especially in his manner of Keeping in. There is . . . in his hours of saying little or in total Silence a Tom Brownishness about him – the air of a Professor that has not yet taken the Chair – at least not yet a high Chair – a most mother wit about him & no ordinary mother wit but the wit & the tutorage of such a mother as he may thank God for bestowing on him – I mean genius by wit or the Tact of rearing the tender thought & teaching the young idea.[9]

Even allowing for John James's florid style and, equally, for natural parental pride, this seems rather inflated, and versions of these encomiums were reproduced for John himself –

> I must commence this Letter exclaiming wonderful, wonderful wonderful – Do you ask what is so very wonderful – your Latin Lesson sent to me – If you do all without being told it is as much of a wonder as any thing I have met with – it is very correct & very long
>
> I do not mean free of error but nearly So & the Latin being somewhat difficult I am astonished at your understanding it so well & writing so like a Classic Author. You are blessed with a fine Capacity & even Genius & you owe it as a Duty to the author of your Being &

the giver of your Talents to cultivate your powers & to use them in his
Service & for the benefit of your fellow Creatures.[10]

The coda reads like a respectful bow in the direction of his wife's piety;
the pride and encouragement, by contrast, declare the father's impul-
sive enthusiasm. Indeed, it is doubtful whether John James was at all
qualified to make such judgements upon his son's latinity, for on
another occasion he confesses that he cannot be certain about a point of
syntax.[11] John had already progressed beyond both parents' abilities –
Dr Andrews had been invoked in 1829 to supplement Margaret's
teaching – and, the wisdom of his father's expressions of pride not-
withstanding, he was repaying his parents' dedication with genuine if
undirected ability. No expense, as no praise, was spared – the copy of
Robinson Crusoe, bought for the seven-year-old, cost two guineas, the
monthly wages of one of their most valued servants.[12]

What John James encouraged in his son, thereby determining
John's lifelong interests in reading, writing and sketching, were his
own pastimes. *Praeterita* gives a glimpse both of their sharing these
and of the important picturesque connection of words and images:
Ruskin tells of being allowed to watch his father shaving each morn-
ing before a dressing table over which hung a watercolour by John
James, done under the tuition of the elder Nasmyth; it represented
'Conway Castle, with its Frith, and, in the foreground, a cottage, a
fisherman, and a boat at the water's edge'. Before this quintessentially
picturesque scene the young boy would pose innumerable questions
('whether the fisherman lived in the cottage, and where he was going
to in the boat') so that his father was forced to expand its visual image
into a whole other, verbal dimension. And John James's interests,
shared with his son, tempered the rather more austere régime of his
wife's morning instruction and of her general outlook ('Mother so
regularly counts each minute'[13]). It is little wonder that John re-
sponded so warmly to his father's praise and generosity, contrasting if
only unconsciously, the focus of his mother's concerns, Sunday
chapel, with the paraphernalia of the interests shared with his father –
'There never were gifts more useful to me than . . . my pens my
instruments my box my pencils my portfolio my paints my atlas and
my paper'.[14] *Fors Clavigera* would announce Ruskin's retrospective
dread of Sundays – 'a lurid shade was cast over the whole of Friday and
Saturday by the horrible sense that Sunday was coming, and inevi-
table'.[15] This recollection of his childhood is perhaps less of a fiction
than others and it was not absorbed into the patterns of *Praeterita*; in his
first surviving letter (see above p. 22) he already senses certain distinct

contrasts – 'tomorrow is sabbath tuesday I go to Croydon'. In the years following John came to miss his father increasingly, 'especially on sunday'.[16]

There is evidence that Margaret, despite her studied dedication to the superior being of her husband, did not altogether approve of his share in their son's education. John James maybe glances at this in 1831 when he writes to John that their letters 'may be strictly *confidential* – you know you & I are often greatly amused with trifles'.[17] Margaret was sceptical, above all, it seems, of John's endless versifying – 'I do not think it will be easy to stop his rhyming', which she told her son was a waste of time.[18] Looking at some of his compositions, we may well applaud Margaret's critical shrewdness.[19] But she must also have spotted her son's early propensity for excessive wordiness, encouraging him, vainly, to compose 'small letters',[20] and realized that she and her husband did have a responsibility for his future work patterns. She disapproved of John's 'beginning too eagerly and becoming careless towards the end of his works as he calls them . . . he is never idle and he is even uncommonly persevering for a child of his age but he often spoils a good beginning from not taking the trouble to think and concluding in a hurry'; but – since the 'works' were evidently encouraged by her husband – she requests him to remonstrate in his next letter; he did as she asked, but only in a brief postscript ('You have been at your Works with great Spirit & they commence so well that the end rather disappoints that is if they get to an end . . .'), the force of which was probably lost since it came after another passage of paternal praise.[21] Restraints and sober advice had to compete against a father's contrary instincts – that they had a child prodigy on their hands, who must be encouraged at all costs, including paying him one penny for every twenty lines of verse composed – as well as against John's own native exuberance and growing self-importance. Symbolic perhaps of these competing reactions was the table set aside in the parlour where John could be absorbed in his 'works as he calls them' while his father read aloud from Scott, Byron or Pope.[22]

Ruskin's childhood was marked by exposure to a dizzy range of literature that begins to explain the eclectic range of references in his own later writings. Books were evidently an eloquent part of the family's sense of status: Margaret put herself through a rigorous programme, which could include Christoph Christian Sturm's *Reflections on the Works of God and of His Providence* or Charles Rollin's *Ancient History of the Egyptians . . . and Grecians*, and which occasionally baffled her resolution; however, as she asked her husband, 'how can people who are *not always occupied in business* and society exist

without reading or hearing reading?'.[23] She extended the same perseverance with difficult material to John and his cousin, to whom after breakfast in March 1829 she began reading Adam Smith's *Theory of Moral Sentiments*, even though perfectly aware that 'the children may not at present understand much of [it] but it may be the means of making them even now observe something of the working of their own minds and this may lead in time to more & more knowledge of themselves . . . at present they appear both to understand and to like it but as I said I read a very little at a time'.[24]

Purchases for the family library are regularly recorded in John James's account books, through which we can trace something of John's reading. It ranged from the classics – the *Iliad* in Pope's translation he knew well enough to have much by heart – through English authors like Byron and Scott; by the age of nine he was imitating the first's *Childe Harold* and translating the latter's *Monastery* into verse; then a gamut of books that included children's works like *Harry and Lucy* and Robert Jameson's *System of Mineralogy* in three volumes, both of which, as we shall see, were also imitated. In addition, he listened to his parents reading aloud; this way he heard, not only the Bible and Adam Smith, but '*Humphrey Clinker* . . . long before *I* was able to understand either the jest or the gist of it',[25] Cervantes, Erasmus Darwin (with some long-term effects upon his own botanical writings?), Samuel Johnson, and Hugh Blair's *Lectures on Rhetoric*.

The most crucial of these early reading experiences (probably at the age of seven) was Joyce's *Scientific Dialogues* and, two years later, Maria Edgeworth's *Frank* and *Harry and Lucy*.[26] This last consisted of discussions between a rather belletristic sister and her older, scientific brother – Ruskin, of course, performed *both* roles in his afternoons. They discuss and observe the world together, with much emphasis upon self-instruction and understanding everything for themselves – they visit cotton mills or ruined castles; they construct thermometers and hydrometers; their fields of enquiry are essentially adult, the skill of Edgeworth's composition being to address young readers without excessive simplification. *Harry and Lucy*, then, exactly mirrored John's own absorption in writing, in sketching, in learning about geography by making maps or about the movement of planets by constructing an orrery,[27] in establishing his own mineralogical dictionary. But it also offered him a model for his own activities – supplying not only suggestions for projects but also the pattern of his responses: Harry and Lucy visited cotton mills, while John and his cousin, in 1830, went to a pin factory in Birmingham and were 'very much pleased with seeing the number of processes the wire has

to go through before it becomes the bright smooth pointed pin'.[28]

John even planned his own *Harry and Lucy* books, with facsimile titlepages and accompanying vignettes, though (typically – as he later acknowledged) out of the four projected parts of *Early Lessons*, as it was called, only just over one-fourth was completed. Yet what did get finished reveals with marvellous clarity the temper and constituents of his intellectual life in his early teens as well as betraying something of family relationships: Ruskin's 'Harry' is disappointed of a swing in his friend's garden when a visit was cut short after dinnertime (shades, perhaps, of Croydon). Lucy is told by her mother to do 'one thing at once'. Harry breaks a square bottle by withdrawing its air, explaining to Lucy that a round one, like an arch, would have sustained the pressures; the manner and tone of such instruction are never entirely lost in Ruskin's later relationships with his readers. Lucy's mother rewards their honesty for admitting that they had broken a window. Dinnertime is a 'hindrance' to drawing. Harry sketches the constellation, Charles' Wain, as an introduction to astronomy for Lucy and 'though Lucy liked astronomy very much yet she asked harry why he did not go on with pneumatics'. Harry decides to 'allot his time to various employments', teaching science to Lucy before breakfast, spending the morning at his lessons, correcting 'some of Virgil for his papa' and drawing after tea while his father reads *Don Quixote*. Another passage offers an obviously authentic glimpse of a family walk and of Ruskin's lifelong ability to profit by what lies to hand:

> such a fine day that they all got out and walked a good way they had intended to walk very quick but they did not for they were attracted by such variety of objects such as the white major convolvolus in the hedges the black & white broad beans the butterfly like pea's the sparkling rivulets and winding rivers all combined their forces to make them walk slowly.

It is a clear glimpse of his ready response to the surrounding world which he would enunciate as a principle to Selwyn Image in 1871: 'At every place, and time, throughout your life, take frankly what that place and time can give you, and think of its limitations as advantage rather than harm.'[29]

In addition to what his *Harry and Lucy* imitations convey, we can supply further details of these early years at Herne Hill. Margaret Ruskin yielded some of her tutorial duties to Dr Andrews, who instructed John in the classics and in Hebrew, though she continued to participate in his lessons ('Mamma and I have begun our Hebrew and are making some progress in the characters'[30]). John evidently enjoyed

Andrews' thrice-weekly sessions enormously, for the doctor made him laugh and compared 'Neptune's lifting up the wrecked ships of Aeneas with his trident to my lifting up a potatoe with a fork'.[31] Andrews was also renowned for his florid and evangelical sermons, which the Ruskins heard on Sundays at the Beresford Chapel in Walworth and which John had then to paraphrase during the week as part of his lessons.[32] From the nine small volumes that survive with his summaries we can see how the eight- and nine-year-old boy was regularly exposed to fairly orthodox dissent, though Andrews skirted the particularly Calvinist doctrine of predestination and limited grace, for (as Ruskin paraphrased him) '*All* should reach for the sacrifice of Christ which if we do of our own free will, we should be found in the presence of God'.[33] One of these summaries, of a sermon on sacrifice, can be heard reverberating years later in *The Seven Lamps of Architecture*; while already the distribution of these sermon abstracts among latin grammar and catalogues of minerals in the various notebooks reveals an early and typical interpenetration of various departments of his curriculum.

But Dr Andrews did not really provide the instruction that Ruskin's parents deemed sufficient to distinguish their son in later life (a bishopric, at least, seems to have been projected for him). So in 1831 a Mr Rowbotham was introduced to teach some English with mathematics, and about September John was rhyming –

> When Mr. —— What d'ye call him? —— Bottom-roe?
> No, that's not it . . . Oh ay, it is Rowbotham –
> Has ceased his parallelograms to show
> And t'other thingumbobs – I have forgot 'em!
> With latitude and longitude, you know,
> And all the other things. . . .[34]

He came two evenings a week from his academy for boys near the Elephant and Castle and after his walk uphill had to be revived with cups of tea.[35] He continued to instruct John till at least 1834.[36] In 1832 the Ruskins also decided to give some direction to John's sketching proclivities and he was sent to Charles Runciman, who specialized in teaching perspective; at first Runciman insisted upon him mastering the pencil (as opposed to pen and ink which, like his father, he preferred), but, after being surprised at the boy's talent, changed his methods and introduced him to water-colours 'as a basis for oil'.[37] These lessons also continued into 1835. So, by 1832, John was receiving instructions from Andrews, Rowbotham and Runciman as well as from his mother – 'I am expecting [a lesson from Runciman] with

great pleasure next Friday. Mr Rowbotham continues the same regular routine, of Exercises, globe work, dialogues, verbs, copies, & sums, in the latter I have positively got to the Rule of three, & Dr Andrews is bringing me on with the Lucian, while Mamma wishes me very much to get into Xenophon . . .'; John James also entered some expenses for fencing lessons in his accounts for November of that year.[38]

The great loss of these years, we may see with hindsight, was regular companionship of his own age. Some of the morning study was shared with a Richard Fell, whose family lived nearby on Herne Hill and who would sometimes, after studying, stay on to walk with John in the afternoons. We get glimpses, too, of facetious pranks the two boys engaged in – 'Master Fall was pushing [Dash, the Ruskins' dog] by the ears in the middle of the road to kiss him yesterday'.[39] But generally John lacked the opportunities for unabashed and unsupervised play that young people generally enjoy – those later romps with the girls, the hide-and-seek through the attics of Winnington Hall, the 'Playhouse' of Ruskin's fifties,[40] may well represent the late recovery of high-spirited play he lacked as a boy among his peers. What with his mother's anxious concern for his health or his safety, the Ruskins' social snobbery and its attendant diffidence towards other 'new' families and the increasing reluctance to have anything to do with the Croydon cousins, John was sheltered from the whole world (sometimes untidy, sometimes anarchic) of *homo ludens* that today we recognize constitutes a crucial part of our healthy makeup. Even his childish sketching and verses are rather the imitations of adult styles and tastes than the playful and inventive pastimes of a child.[41]

He was whipped if he tumbled and grazed his knees or fell downstairs; boating was dangerous because he might drown; boxing, simply a vulgar form of exercise; he was adjured not to lean against carriage doors lest he tumble out; on the annual family excursions he was forbidden to fold the chariot steps in case 'I should pinch my fingers'.[42] Yet there was a Shetland pony which he *did* get to ride, despite his mother's fear of horses after her father died as a result of crushing his leg against a wall while riding into Croydon.[43] So while it is simply untrue, as stated in *Praeterita*, that he had 'no companionable beasts' and was forced to have converse only with 'inanimate things – the sky, the leaves, and pebbles',[44] nevertheless he had few close friends either as a boy or even later at Oxford. He expressed his disappointment on the rare occasions when Herne Hill would have welcomed young guests and they failed to arrive – 'I am a good deal disappointed that Mr Domecq's little girls are not coming, but we

must put up with it'.[45] And it is about one of those little girls, among others, that he was probably thinking in *Praeterita* when he argues that, because 'I had nothing to love' in his childhood, when 'affection did come, it came with violence utterly rampant and unmanageable, at least by me'.

Croydon continued to be a vexing problem not so far to the south of the paradisal Hill. Margaret Ruskin's visits still had to be justified; she even tried to woo her husband's approbation by flattering him with her family's 'regard' for him.[46] In 1829, on one of John James's business trips, Margaret explains that she has always gone down to Croydon during each of his absences and on this occasion wants to entertain her relations at Herne Hill, lest they get the feeling that 'their less prosperous circumstances' prevented return visits; yet she still seeks what amounts to John James's permission.[47] Two years later she lets her husband know that 'in every thing I shall study your wishes with regard to Croydon'.[48] By an amusing irony, after Bridget Richardson's death in 1830 the Ruskins acquired her spaniel, Dash, and this companionable animal caused Margaret much domestic annoyance by its evidently plebeian ways: some while after its arrival her son is recounting her determined efforts to discipline it ('And so papa you really thought that Dash's disposition was changed'[49]).

There is some evidence that the Croydon relations hoped that a daughter could live at Herne Hill; but this invitation was extended to the (safely?) distant Perthshire Richardsons, whose Mary came down to live with the Ruskins in 1828.[50] She was four years older than John and did not – despite some collaborative enterprises – provide him with anything like a Lucy for his Harry; indeed, he recalled in *Praeterita* that although he was allowed on their family travels to explore places with Mary 'we generally took old Anne [Strachan] too for better company'. Mary was plain, good-natured, eminently dull and commonplace and no doubt made to feel how inferior she was to her prodigy cousin, who himself seems to mock her ordinary painting and careful French in the course of rather pretentious epistles to John James. Her schooling was undertaken, not with John, but at a local academy run by a Miss Williamson. She lived with the Ruskins until her marriage in the late 1840s.

So life at Herne Hill turned smoothly and – barring two incidents – safely around John. About the age of five he was bitten on the lip by the watch dog at Herne Hill, the left side of his mouth thereafter being slightly disfigured. He also fell head-first into a large water-barrel, but had the presence of mind (for which he was obviously much applauded) to push himself up from the bottom with the watering-can

he was holding.[51] Otherwise Margaret's smooth domestic economy ensured, in the first place, that her husband was the official centre of their world ('the servants . . . are so wearying for your coming home everything they say is unsettled and uncomfortable and the House is not like itself and they do wish Master was home'[52]); but this was both a temporary and purely domestic strategem while their son was gradually nurtured towards fame. Although upon John James's return from the City at 4.30 she would dine alone with him and provide a sympathetic ear for news of the sherry business, they gathered afterwards for tea with their son – in summertime under the whiteheart cherry, in winter in the parlour where John installed himself at his own table in the window. There he would work away at his various projects, while John James would read – Sunday evenings requiring a replacement of Scott or Byron by such suitable material as Foxe's *Book of Martyrs*, Margaret's choice, or a sermon of Blair's.[53]

John's education, so far, was extraordinarily patchy – 'history was never thought of', except what could be derived from Scott – and undisciplined in any but minor ways; it was calculated – as he realized himself less than twenty years later[54] – to promote his vanity. Nowhere perhaps does this self-esteem reveal itself more than in John's letters to his father, who thought them 'expressed with ease & gaiety'.[55] They seem, on the contrary, facetious and often excessively exuberant, as if the ten-year old boy's energies could not find enough exercise:[56]

> Hollo hollo papa allow me to solicit your attention for a few minutes for I dont think it will take much more time to read what a gooses quill from a goose back in a boys hand has scratched for perhaps you will not call it writing upon these dirty rags for paper is but dirty rags that may have been lying upon a dunghill cleaned and stuck together . . .

Later on he admits that there may be 'too much of myself' – one suspects an echo of maternal criticism. Margaret even wondered sometimes whether it was worth forwarding John's effusions, but did so in the certainty that her husband would of course be 'aware that John does not know there is any difference in putting things on paper from saying them'.[57] Her son's fluency, she realized, was her husband's ('he promised to inherit your talent of writing letters with astonishing ease – indeed of expressing all he wishes on paper with all his papas superiority'[58]). It is evident that John used this facility most enthusiastically precisely when he responded to his father's gifts and encouragements:

On the afternoon of that day my portfolio arrived and O delightful thankyou thankyou papa. What two pockets and a place between them crimson on the outside covered with flowers O delightful exquisite delicious most astonishing strings to tie with and and and and and O thank you thank you thank you papa pardon this effusion of delight and nonsense . . . [59]

– 2 –

These favourite pastimes of John James, encouraged in his son, were to determine a large part of John's own style of life and so, by extension, the very things he wrote. For writing and sketching, soon to be associated with travel, were the basis of almost all of Ruskin's work until 1860 and much of it afterwards. The pursuits in which John was encouraged by his father were the most useful ones on the family's annual excursions, undertaken largely to allow John James to solicit orders for wine. Their calls upon various customers in country seats up and down the country gratified John James's love of pictures as well as his snobbery. On these trips into his father's world, it was his father's interests that predominated over his mother's; indeed, the excursions necessitated some relaxation of the domestic pattern of Herne Hill, especially its daily routines of learning, over which Margaret presided.

There were other jaunts – to see a panorama of Sydney in Leicester Square or to visit the pantomime, for the theatre was another taste of his father's which John would inherit, even to the point in 1871 of trying to tempt Carlyle (of all people) to the Drury Lane pantomime – 'Nobody would see him and he would see . . . some fairly good fooling'.[60] But the really vital and exciting excursions out of Herne Hill, beyond the family circle though still in fact within it, were their summer travels.

They first travelled together on a visit to the Lake District and then by sea to Scotland, probably in 1822 – among those Cumbrian hills Ruskin was to recall that 'I was born *again*, at three years old!'.[61] Earlier there had been removals to summer lodgings in the country near Hampstead or Dulwich or during the spring cleaning of Hunter Street. The pattern of a two-month journey by private carriage, hired or borrowed from Mr Telford, was established in the mid 1820s and by an early age, as *Praeterita* was to recall, Ruskin had seen all the highroads and most of the cross-roads of England, Wales and lowland

Scotland, visited many of their cathedrals and castles, and inspected innumerable noblemen's houses ('speaking a little under our breath to the housekeeper, major domo, or other authority in charge'[62]). The pattern was varied once in 1825 by a trip to Paris, Brussels, Ghent, Bruges and Calais. But until the death of John James's sister, 'Aunt Jessie', in 1828, the Ruskins would make their way to Perth.

Three visits to Perth (1824, 1826 & 1827) established it as a fabulous place for John – a Croydon unspoilt by the Ruskins' sense of superiority; among its treasures a 'garden full of gooseberry bushes', the deep and swift-flowing River Tay ('an infinite thing for a child to look down into') and his cousin Jessie. She was the nearest John Ruskin ever came to a loved companion and, child-like, they promised to marry each other when they were older; meanwhile they played and romped and 'baked' inedible cakes of pepper bread, and John's summers blossomed in ways that Herne Hill rarely knew. But Jessie was not only just a summer companion, but a short-lived one as well; she died when John was eight. The pain must have been deep, for three years afterwards he wrote some Ossian-Psalmic lines "On the Death of my Cousin Jessie"; they are imitative still, but the form permits some personal cry to be heard through the mimicry.[63]

In less troubled ways the summer journeys produced innumerable sketches and verses, while a visit to the Waterloo battlefield in 1825 prompted "A Play in Two Acts" on the subject that got as far as a pastiche titlepage of 1829.[64] Various sightings of Lake District mountains en route to Scotland actually produced Ruskin's first published work – verses "On Skiddaw and Derwent Water" in *The Spiritual Times* for February 1830 – as well as the most sustained poetic performance of these years, the two thousand lines of *Iteriad*.[65] His earliest surviving drawing, of the ruins of Dover Castle, together with these topographical verses, declare his absorption of the eighteenth-century taste for the sublime and the picturesque which his father obviously cultivated and communicated to his son.[66]

Both the sublime and the picturesque were ways of responding to scenery, of providing a ready-made language (visual and verbal) for such encounters, and – inevitably, of course – *faking* such responses by simply mimicking their languages. The sublime, of which in his earliest publication Skiddaw was an apt example, evoked the deeper emotions – awe, fear, terror, – which were often beyond explicit narration: so, when the summit of Skiddaw is hidden by clouds, the young boy would happily imagine its 'giant-nature' which gives greater 'scope to fancy's play'. The picturesque, as the word itself

suggests, defines an area of experience altogether more amenable to art; indeed, the term began as meaning whatever would look well in a picture and such emphases still occur in the Derwent Water section of his first published poem:

> a looking-glass
> Wherein reflected are the moutain's heights;
> For thou'rt a mirror, framed in rocks and woods.
> Upon thee, seeming mounts arise, and trees
> And seeming rivulets, that charm the eye;
> All on thee painted by a master hand . . .

But the picturesque also came by the early nineteenth century to involve an appreciation of the rough and fragmentary details of the natural world – an ideal taste for a young boy who not only prided himself on his close scrutiny of minute particulars, but was liable also to neglect whole or finished work in preference for intensely registered fragments.

The family's summer tours were therefore calculated to suit these tastes which both father and son shared. They set off to discover material for sublime sensations – the *frissons* of civilized man faced with images of nature's power, which itself derived, as Margaret Ruskin must often have insisted, from God's awe-inspiring might. The intrinsically religious meaning of the natural sublime produced in John some early penchant for *paysages moralisés* – Skiddaw, again, teaches that all 'but the soul' must submit eventually to dust and death. Picturesque scenery lent itself rather to the exercise of the sketchbook than the moral commentary; but ruins – especially of castles and churches – invited the mind to complete their fragments by recalling their histories. But above all, picturesque scenery encouraged the eye to play over its rugged fragments, picking out the suggestive detail, or to glimpse half-concealed vistas; the playfulness of the picturesque mode – relishing the sudden, unexpected or dislocated item – must have answered John Ruskin's own bumptious style. The carriage windows afforded a permanent frame for picturesque views, while the family's progress from place to place, through a leisurely itinerary, was also enough regulated to prevent too thorough a commitment to any one spot; so that sketches and notes were often rapidly taken and worked up, if at all, in the evenings or after the whole trip was over.[67] The education by landscape, which Ruskin was to champion in *The Poetry of Architecture* in the late 1830s,[68] therefore began early. It extended his home-based curriculum, notably by providing some emotional outlets, more *foci* for his curiosity and attention to natural

things. Yet it also confirmed the lessons of Herne Hill: when he wrote in an early sermon resumé – 'that to show the truth of the bible, it is necessary to look into the minute particulars'[69] – he also spoke of his early reading of God's other book, nature, where details declare as much as majestic panoramas. Something of these early lessons may be judged from a page of one of his early notebooks on which touring notes – lists of sights or fine views – mingle (the other way up) with mineralogy.

With its nostalgia for a past era, before railways, *Praeterita* described the chariot in which these annual excursions were made. Even in 1831 John was telling his father that he would not particularly like 'the steam travelling fizzing along . . . I guess I would rather be going decently along in our nice green carriage or chariot and enjoying ourselves'.[70] It was hung high upon its wheels, affording magnificent views over hedges towards what one of John's *Harry and Lucy* imitations spelt out as 'hill hillocks mounts rivulets rivers ponds lakes all in profusion sometimes high on a hill sometimes low in a valley';[71] but there was the even better elevation obtained by those who sat, like John and his nurse, on the 'dickey' seat above the 'rearward miscellaneous luggage'.

The daily routines of their travels tended to be as ritualistic as those of Herne Hill: an early start, several hours on the road before stopping for breakfast, then on to arrive in the late afternoon at some place which could be visited while their dinner was being prepared at the best inn or hotel and again afterwards in the lengthening summer evenings of May and June when the excursions generally took place. On Sundays they did not travel, always trying to reach by Saturday evening a place that could provide them with religious services and enough interests to fill the next vacant day. The itineraries were all probably carefully planned well in advance – at least by 1831 the family had learnt to do so, for John writes to his father in March that 'you'll find your Welch [tour, taken that summer] so beautifully planned now just consider by our mode of travelling we shall only leave our carriage for little Welch ponies by reason of the badness of the road . . . for thirteen days'.[72]

Ruskin was to spend much of his life in hotels and was able to use their temporary lodgings as a makeshift study with astonishing ease. His enjoyment of peripatetic hotel life was fostered on these early trips, which made enough impression on him for precise recollections years later: in 1872 he wrote in his father's diary of their 1825 continental journey – 'I remember Paris well, and our rooms there'; in 1871 he stopped in the same King's Arms at Lancaster that the family

had used on their tour of the Lake District in 1830 and wrote to tell his mother of his fondness for its 'ups and downs of stairs and black wood panels and lovely old silk samplers in the bedrooms'. Hotels were just another example of his perpetual skill in seizing advantages and pleasures from what lay to hand and of his preference for situations which made, in their turn, little demand upon him.[73]

A glimpse of the family's behaviour during one of the stops in their journey and of the serendipity nature of John's absorption in what they saw can be had from an incident devised for his "Early Lessons" and obviously based on actual experience. A stop is made at Tintern Abbey, the famous tourist spot, celebrated not only in Wordsworth's lines but in many other visual and verbal records of picturesque taste. 'When they had reached the place where Tintern Abbey was to be seen they got out and walked to it . . .'; the experience is focused at the start by seeing the ruins from a proper picturesque 'station'. But then Harry and Lucy are distracted by some beehives; when they eventually reach the abbey it is the proper picturesque textures of roughness that they admire. 'It had a most beautiful window for first there was an arch and then by its sides and top there were all kinds of figures. The door was in this shape . . . and when their guide had opened it they found themselves in a large abbey with two rows of pillars one on each side of them but broken and ruined. Their guide showed them some key stones of the arches that had fallen down and harry wondered why the arches did not fall with them . . .'[74] Here is an early fascination with architectural elements which must be properly understood, though on this occasion Harry's father is preoccupied with something else and the young boy is thrown back on his own resources.

Ruskin's early prose reveals him more vividly, accurately and economically than the facile, often egregiously padded verses of something like the *Iteriad*, the mini-epic of the family's 1830 visit to the Lake District. If John 'danced with joy' when the tour was proposed, he was 'cutting capers all the remainder of the evening' after he had done 'the notable deed' of finishing the 'elephantine' poem in January 1832.[75] One interest of *Iteriad* is that of seeing how versifying in a Hudibrastic or *Don Juan*ish vein over-indulged Ruskin's facetious bent.[76] He knew it well enough, for the poem starts by noting how 'vain rhyme . . . wastes paper and time' and elsewhere he asked his father to excuse 'The capricolings of the muse / Whose fancifullic frolics spring / High on her unbounded wing'.[77] But not only does showing-off obtrude in *Iteriad* to the general detriment of his real interests; the verses, committed to regular (if frequently awful) rhymes and rhythms, are simply not flexible enough to register the scattered

absorptions of John's life, except perhaps in throw-away asides –

> Now surveying a streamlet, now mineralizing, –
> Now admiring the mountains, and now botanizing, –

or –

> We gathered the moss to distinguish its kind[78]

And the months spent on bringing the poem to a conclusion, trying to maintain its impetus and to honour the facts of a prose narrative written jointly with Mary Richardson towards the end of the tour,[79] also meant that *Iteriad* did not really record Ruskin's constantly growing and strengthening interests and skills. Between it and the prose account of the tour, however, we can glimpse that divided literary impulse which Derrick Leon pointed to in Ruskin's work – the expression of essential emotions and perceptions (at this stage usually in prose) and the repetition (usually versified) of acquired ideas and studiedly adult reactions.[80]

The prose narrative, unlike the *Iteriad*, also covers the five weeks of touring before the Lakes were reached. It summarized – John's bits especially in a facetious parody of guidebook style – all the sights, places visited, sermons heard ('the preacher had a beautiful voice, but the sermon was nothing particular') and the contents of country houses. The father's 'cultural' tastes probably dictate many of the observations, as of a 'fine Bacchanalian piece by Rubens' at Blenheim, of the Chatsworth collection of sketches by the 'best masters' such as Carlo Dolci, Claude or the Carraccis – none of them later to be among Ruskin's favourite artists – or of 'a library with a good many volumes in it by the best authors' at the inn at Gerrards Cross, where they stopped for breakfast on their first morning out of London, Tuesday 18 May 1830.

They had seen the Lakes briefly in 1824, when Ruskin (he recalled in *Modern Painters* III) was taken by Anne 'to the brow of Friar's Crag on Derwentwater; the intense joy mingled with awe, that I had in looking through the hollows in the mossy roots, over the crag into the dark lake, has ever associated itself with all twining roots of trees ever since'.[81] Again in 1826, when Skiddaw and the same Derwentwater occasioned the verses later to appear in *The Spiritual Times*, the area attracted them en route for Perth. A major trip was therefore planned for 1828, but while making their roundabout way for John James's business purposes, which were the occasion and excuse for these summer excursions, news reached them in Plymouth of Aunt Jessie's death in Perth, so that the rest of the journey was abandoned. The

build-up of excitement, then, when they did finally reach Kendal on Monday 21 June 1830, was intense; the opening of the *Iteriad* captures it well.

The delay in reaching the Lakes doubtless meant that the eleven-year-old boy had meantime learned much more of Wordsworth's poetry; enough, perhaps, to make him conscious of his own inadequate verbal skills –

> Now were I, oh, were I a proper lake-poet, –
> (Although you will say, ''This in vain, – that', I know it!)
> But I cannot do what I know that I should, –
> Pop in an address to the nymph solitude.

There are other conventional laments at the inefficacy of words, though the prose version manages some eloquent moments:

> the glassy waters of Thirlmere, reflected the mountains above like the smoothest mirror, so that instead of looking like a lake, it appeared, as if we were looking down into a deep dell, so plainly were they reflected[82]

True to the poem's obligations to *Hudibras* and *Don Juan*, there is also much play with bathetic disappointments of sublime expectations – sometimes bad weather spoilt excursions, as it did John's very first visit to Coniston in Book IV; sometimes literary expectations proved too high, as when Wordsworth's appearance at Rydal Chapel didn't live up to his reputation: 'This gentleman possesses a long face and a large nose with a moderate assortment of grey hairs and 2 small grey eyes not filled with fury wrapt inspired with a mouth of moderate dimensions that is quite large enough to let in a sufficient quantity of beef or mutton & to let out a sufficient quantity of poetry'[83] Otherwise the high-spirited excitements of youth mingle with activities prophetic of the mature Ruskin. His fascination, for example, with what the "Tour" reports as 'various shades thrown by the clouds on the mountains' or the genuine respect for the sheer rockface of Honister Crag, which so thoroughly confounded picturesque prescriptions –

> He's none of your beauties, – no elegant wood
> With romantical glades on his summits upstood;
> No softening the scene, or enlivening the view,
> No fading in distance the mountains so blue:
> No cockneys could find in its dread rocks so antique
> The fair picturesque or the rural romantic;
> No silly school-bred miss just turned seventeen
> Can affectedly say of't – "How charming a scene! ! !"[84]

As a result of which reaction the 'romantical' sketches of the land-lady's daughter at the Fish Inn in Buttermere, shown to the Ruskins some hours later, seemed absurdly inadequate; *Modern Painters* would also spring from the conviction that the natural world surpassed most artistic languages devised to record it.

One last item in their Trip is worth mentioning, because again it reveals at an early stage something essential in the mature Ruskin's makeup. The family visited Crosthwaite's Museum in Keswick, better reported in prose than in the *Iteriad*. In this bewilderingly eclectic display were presented, *inter alia*, 'some wonderful petrifications of tropical plants', 'several old manuscript books, written before printing', 'the rib of a man, 21 feet high! !' and some 'musical stones' of the sort that Ruskin was to have made for himself in the 1880s. Faced with this indiscriminate profusion of objects collected and lovingly displayed by one man, it is difficult to talk of incoherence or irrelevance. The same dedication to a seemingly inchoate mass of items, ideas and pursuits, which apparently delighted John in 1830, never ceased to enthrall him; so that the present Ruskin Museum in Coniston, with his early manuscripts, its mineral cases, stone harmonica, local history displays and boat models, is still today the most authentic memorial of him. Such a cabinet of curiosities, as these collections would have been called earlier, is the apt emblem of a mind for which 'digression' is virtually a meaningless term. The *Iteriad* perplexes itself often, in a trivial way, with its frequent digressions; but John concludes by the fourth book (line 142) that 'I'm digressive when I do but talk of digression'. It would prove a prophetic insight.

So the family returned to London and the composition of the *Iteriad* began. It was, altogether, a momentous trip. Not only did it produce Ruskin's first completed long work – and completed according to its ambitious plan – but it implanted in him a permanent affection for mountains and lakes. The English Lake District, moreover, would always provide some kind of standard by which to test all others. Continental tours were soon to lead this intrepid family across France and Switzerland to Italy – from drawing maps to exploring the actual terrain being in fact a short if brave step; yet their English excursions, especially this of 1830, would provide an emphatic point of comparison as well as a model of behaviour. The first important work that Ruskin was to publish by the end of the 1830s, essays on *The Poetry of Architecture*, was dedicated to a comparison of English and foreign domestic architecture.

Chapter 4

'My Destiny fixed': Alps, Italy, Adèle Domecq. 1832–1836

Why should we travel to see less than we may?
Ruskin's father, quoted in *Praeterita*

On a pillar was Lord Byron's name cut by himself. Salvador cut John's name on same pillar but opposite side. May he be the opposite of his Lordship in everything but his Genius & Generosity
Ruskin's father's 1833 diary, recording visit to Chillon

– 1 –

The family was thinking of their first major tour on the continent by March 1831 ('our Switzerlandish outlandish tour to Italy'[1]); it did not take place until 1833, but plans, projections and excitements continued. Their various English and Scottish travels had led them through a whole anthology of picturesque scenes: in 1831 alone they visited Stonehenge, Tintern Abbey, Chepstow Castle, the Avon Gorge at Bristol, and saw Cader Idris and Snowdon, among many other items that constitute an essential roll-call of late eighteenth-century and Romantic *loci*, where the personal enterprise of a tourist merged with his confidence that he was responding to authenticated spots, visually celebrated in paintings, watercolours and engravings and elaborated in poems and picturesque handbooks.[2] So it was simply an extension of the Ruskins' habits to be tempted into Europe by two picturesque publications: Samuel Prout's *Sketches in Flanders and Germany*, and the edition, illustrated mainly after Turner, of Rogers's poem, *Italy*.

Prout's *Sketches* was a momentous purchase of 1833. Ruskin and his father went together to see a specimen print (of a turreted window at Coblenz, overlooking the River Moselle) at a London shop, subscribed to the edition,[3] and received the book sometime before May. As Margaret Ruskin watched her husband's and son's enthusiasm for 'the wonderful places', she asked – according to *Praeterita* – why they

47

should not go and see some of them 'in reality'. Since it is clear that such a trip was being planned two years earlier, it is more probable that what Prout's volume determined was an itinerary to take them through the scenes he illustrated: not so much seeing them 'in reality', as seeing them through the picturesque vision of Prout's engravings. Ruskin was ready to report that at Strasburg, for instance, though he 'was already wise enough to feel the cathedral stiff and iron-worky', he was greatly excited by the steep roofs and richly-carved wooden house fronts which he saw as 'so admirably expressed by Prout in the 36th plate'.[4]

If Prout's *Flanders and Germany* sent them down the Rhine, Rogers's *Italy* carried them over the Alps (Prout's *Sketches in France, Switzerland and Italy*, issued in 1839, was bought promptly by John James,[5] but of course postdates their continental tours of 1833 and 1835). Samuel Rogers's verses on Italy had appeared in 1822 and 1828 with little effect upon a reading public whose taste (rightly) preferred Byron's *Childe Harold*; so he produced a lavish and revised edition, illustrated with twenty-five plates from Turner drawings and others from work by Prout and Stothard (two others were taken from works by Titian and Vasari). The volume was an immense success, and lent itself exactly to being presented as a gift between well-to-do folk. John Ruskin received it in 1832, on his thirteenth birthday, as a present from his father's partner, Henry Telford. It 'determined the main tenor of my life', being his first introduction to Turner, to Italy and to work where word and image collaborated in a joint endeavour where 'the art of poetry', according to Sir Walter Scott, 'can awake the Muse of Painting'.[6] Since John had finished his own *Iteriad* only a few weeks before, Rogers's poem must have seemed the work of a fellow spirit, however lofty. The vignettes, though, were something else entirely, and the boy set himself to produce facsimiles with 'fine pen shading'; their format would be used to record impressions of Europe in the forthcoming tour and, like Prout, they prepared the eye to see around the lake at Como the 'terraced gardens, proportioned arcades and white spaces of sunny wall' of Turner's renditions of those scenes.[7]

The summer of 1832, between the expensive and exciting Welsh tour the previous year and the projected European trip the next, was quiet. John was at Dover sketching the castle, and he had been looking forward to the visit and to trying out his improved painting techniques since February: 'Oh if I could paint well before we went to Dover I should have such sea pieces, taken from our windows, such castles & cliffs – hanging over the ocean'.[8] The cultivation of his art in order to 'carry off' the places visited became all the more urgent after

the example of Prout and Turner and in the face of the visit abroad. Otherwise the regular routines of Herne Hill were maintained; there was some drudgery with algebra, which Mr Rowbotham had introduced, and with French irregular verbs; even longer and more exuberant letters ('no friction to contend with in my mind'[9]) went off to an admiring father. John James's pride in 'Talents . . . great for his age' was just occasionally – in deference perhaps to Margaret's perspective – accommodated within a larger and less comforting scheme: 'If the Almighty preserves the Boy to me, I am richly blessed but I always feel as if I *ought* to lose him & all I have.'[10]

Some of the Ruskin family's favourite reading was eighteenth-century periodical literature – *The Spectator, The Rambler, The Idler*; collections of the last two were John James's choice of reading on the continental tours. Great names had contributed and written for them – Addison, Steele, Johnson – and the modulation of John Ruskin's prose often declares their influence, above all Dr Johnson's.[11] But perhaps their real importance to him has been neglected – the cultivation of a habit of looking at, of treating with, of discovering the world. As their titles imply, the periodicals' attitude towards life is that of onlooker, informed certainly and involved much in the art and act of being a spectator, but equally that of one who takes his time, who rambles and idles, and *as a consequence* claims that he misses less and sees more wisely. Now John Ruskin's mature career was punctuated by his complaints that he never had enough time – 'I found out 2 or 3 beautiful things in the corner of the porch in ten minutes – any one of which would take a day to draw or to explain'.[12] But these subscriptions to a personal myth of ceaseless pressure and to the Victorian experience, in Arnold's words, of 'sick hurry and divided aims' cannot disguise an important core of old-fashioned spectating, a penchant for idling and rambling around the stones of Chamonix or Venice, noting isolated features here, curiosities there. In short, the whole conduct of a virtuoso towards life that informs Ruskin's adult experience must have been strengthened, at the very least, by the family's holiday reading and confirmed by their translation into action of those Addisonian and Johnsonian attitudes.

In Europe the routines were substantially those of their English journeys. Regular stages each day, except Sunday, in the specially equipped and rented coach, which abashed 'plebeian beholders' with its 'general stateliness of effect'.[13] They made leisurely stops at all 'the proper sights', on which they were advised by their courier, Salvador, as much as by their dedication to Prout and Rogers. There were some tensions between those members of the party who wished to keep

going, not to be late for meals and not to jeopardize the elaborately calculated timetables for posthorses, ferries and the closing of city gates for the night, and those – mainly John – who would have lingered endlessly over 'Distant Alps and handsome cities', 'Gems and marbles rich and rare'.[14] As much as possible the Ruskins maintained a luxurious cocoon of English gentility – curious about obviously important fellow travellers, dubious about foreign food, careful of their time, health and money, proud of their son whose enthusiastic appreciation of it all made these efforts on his behalf the more worthwhile.

John's reactions were, indeed, ecstatic; he relished as much as his father the 'change of sensation from his suburban life'. Years later he remembered 'certainly more passionate happiness, of a quality utterly indescribable to people who never felt the like, and more, in solid quantity, in those three months, than most people have in all their lives'.[15] This plenitude was 'carried off' in rapid sketches and memoranda; his diary is crammed with geological notes.[16] In the evenings during the journey and back home at Herne Hill after the three-month tour ended on 21 September John tried to translate his many, rapid impressions into more permanent shape. Two of his early notebooks that survive tell something of the effort. In one, the end papers record over a hundred places which were to be the subjects of verse or prose passages; the sheet is dense with calculations and then further lists of required vignettes to be copied from Prout or made up from John's own sketches, one of which is incorporated among the lists. In all, a hugely ambitious survey of their journey, that did, in fact, take a lifetime to review and complete. Then in another notebook the completed sections were faircopied and vignettes, executed before, pasted in. One of these shows a facetiously rendered British couple whose *'tout ensemble'* is the object of a native Frenchman's amazement, while their child (John?) raises his arms in wonderment at the picturesque old houses of Calais; the text, however, sees it all with British eyes.

They were in Calais on 11 May, relishing – as Ruskin always would – its instant declaration of Frenchness, of being 'abroad'. And so on to Cassel, Lille, Tournay and Brussels. The *longueurs* of northern France were relieved by enthusiasm for Gothic details (at Lille and later at Aix-la-Chapelle) and sudden anticipations of the south – 'The day . . . was almost Italian, the sky was of such a deep and unbroken blue, and a stream of rich, glowing, tawny light shot upon the full fretwork and elaborate carving.'[17] Some Catholic liturgy at St Omer and a sight of the supposed skulls of the three Magi in Cologne cathedral provoked some of the 'rabid Protestantism' Ruskin would decry later;[18] the pieties of Alpine shrines and wayside crucifixes

seemed more palatable. They reacted with appropriate literary associations – at Calais recalling Sterne's Yorick on his sentimental journey, citing Quixote as they passed the windmills of northern France, and remembering Byron at Brussels.[19] Thus he displays an early inclination, about which he wrote in *Modern Painters*, to draw upon his reading 'to give me associations with all kinds of scenery'; such literary extensions of visual, picturesque taste were to be one of the continuing eighteenth-century habits of Ruskin's mind. In purely visual ways, too, his debts are clear: as they drove along the valley of the Meuse he was taken with 'the infinite variety of scenery . . . never were rocks more beautifully disposed, more richly and delicately wooded, or more finely contrasted with the amazing richness of the surrounding scenery'. But he also noted 'the impossibility of seeing every successive change as you feel that it ought to be seen'. The Meuse thus established itself in picturesque terms ('variety', 'disposed', 'contrasted') as an essential school for artists, to which Ruskin was to send his protegé, William Ward, in 1867.[20]

Other habits and patterns of his later career were established in 1833. His fondness for the fells of English Lakeland (he thinks of Striding Edge on Helvellyn while descending the Splügen Pass) is extended infinitely in Europe – 'What is it that makes the very heart leap within you at the sight of a hill's blue outline; that so aetherializes the soul and ennobles the spirit; that so raises you from the earth and from aught of the earth?'[21] And then, after descending the Rhine and crossing eastwards through the Black Forest, at Schaffhausen, one memorable Sunday, he saw the Alps. When he recreated this some short time afterwards there is a quickening, a tautening in the usually flaccid verses –

> The Alps! the Alps! – Full far away
> The long successive ranges lay.
> Their fixed solidity of size
> Told that they were not of the skies.
> For could that rosy line of light,
> Of unimaginable height, –
> The moony gleam, so far that threw
> Its fixèd flash above the blue
> Of the far hills and Rigi's crest
> Yet russet from the flamy west, –
> Were they not clouds, whose sudden change
> Had bound them down, an icy range?[22]

The view from the terrace promenade high above the Rhine, after what was perhaps a rather desultory Sabbath, and as sunset was

approaching, was one to which 'my heart and faith return to this day', as *Praeterita* put it over fifty years later. By the time Ruskin came to review these first things for his autobiography the far line of Alps had come to be 'the seen walls of lost Eden'. But in the 1830s it was a paradise which he would, from that moment, enter and enjoy, as *Praeterita* more accurately noted, 'with so much of science mixed with feeling'. The 1833/4 verses insist much upon the Alpine vision's taking place upon the sabbath and offering an appropriate epiphany – 'the revelation of the beauty of the earth, the opening of the first page of its volume'. And what the required leisure of a Sunday provided by chance in the glorious book of nature necessitated a whole lifetime to read and see, so much so that even Sundays were later used for this 'work'.

The traditional notion of the earth as, after the Bible, God's second book together with Ruskin's own commitment to the verbal–visual bifocalism of the picturesque determined his attention not only to what he saw but to the 'voice' of the Alps. 'Their fixed solidity of size / Told . . .', as the verses put it, is the first of innumerable recognitions of a language in things; 'not a leaflet', he would write later about gothic ornament, 'but speaks, and speaks far off too'.[23] Schaffhausen fixed Ruskin's destiny as the reader and translator of these languages of stones. And of clouds, too: though the Alps declared themselves immediately as 'not of the skies', their affinity was with clouds visually and spiritually. What was not clear in 1833, at least until they had entered the Via Mala ('the grandest pass into Italy'), was the essentially *ruined* nature even of cloud and Alp.

Ruins were a prime ingredient of the picturesque; they were perhaps integral to an evangelical view of the world; ruined at the Fall, perpetually incomplete even in the anticipation of God's restoring grace, the human being, too, was only a fragment of an ideal perfection. Such parallels doubtless never emerged into the clarity of formal connection for Ruskin or his mother. But along the Rhine they encountered a 'tiresome repetition of ruins, and ruins too which do not altogether agree with my idea of what ruins ought to be'. It is the fourteen-year-old picturesque connoisseur who speaks, as also at Andernach: 'they are mighty in their ruin, and majestic in their decay, but their Lords are departed and forgotten'. Their incompleteness, their loss of a former glory, without which they would, of course, cease to impress, *is* like man's. So that the 'humanity' of the Alps, averred in *Praeterita* explicitly, was at least an implicit recognition among what the 1833/4 verses called 'the scathed old rocks'. The Italian Lakes, when they reached them, were 'peaceful' and 'clear' spaces among the 'ruined universe' of the ancient hills.[24]

Yet even these lakes mirrored the 'precipices sharp and sheer', which seemed to flow upward 'from the crystal depth'. Ruskin would soon be writing obsessively about such mirroring in *The Poetry of Architecture* and eventually in *Modern Painters* tell how 'the soul of man is still a mirror, wherein may be seen, darkly, the image of the mind of God'.[25] In this early encounter with the intensity of depth in Alpine waters he displays both a conventional picturesque taste for mirroring – in Claude glasses or in lakes – and some recognition, like Wordsworth's, that the reversed images upon the surface of water, answering the similarly reversed images upon our retinas, are an image of the creative mind.[26] When the watery reflections display 'Another heaven 'neath our feet / Of deeper, darker, lovelier blue', then the mind is calmed; but they can also image the 'spirits of gigantic things', troubled mountain ruins and vertiginous cliffs – an abyss of thought.

In the 1833/4 records of their journey, Italy figures less sharply than Chamonix, which significantly is treated in both prose and verse. The valley from St Martin and Sallanches up to the town of Chamonix would be one of Ruskin's sacred places, the ground of his greatest enjoyment, even by 1849 a 'home', and one of the sites which he considered for a house in middle age.[27] In 1833, although the 'blue mountains' reminded him of the English Lake District, they revealed 'another world . . . an aetherialness that can never be joined with reality'. On their last day the mountains conspired to dramatize this instinct – alternating cloud and sunshine produced a terrifying thunder storm, then a glowing sunset; during which – "Voilà les aiguilles" – and before 'me' (at the high point of the epiphany the syntax isolates Ruskin from the familial 'we' of the start of the passage),

> before me soared the needles of Mont Blanc, splintered and crashed and shivered, the marks of the tempest for three score centuries, yet they are here, shooting up red, bare, scarcely even lichened, entirely inaccessible, snowless, the very snow cannot cling to the down-plunging sheerness of these terrific flanks that rise pre-eminently dizzying and beetling above the sea of wreathed snow that rolled its long surging waves over the summits of the lower and less precipitous mountains.[28]

His prose captures the vertigo of sight and insight more nakedly than the conventional verses which follow; their vague anthropomorphism ('the cliffy diadem' of the 'gloomy tyrant in his pride') moves too readily to accommodate the experience. What is striking about Chamonix for Ruskin is the contrast of that 'impending magnificence' and of the 'strange, cold rigidity of the surgy glaciers' with the lower pine

forests and 'the luxuriance of the cultivated valley'. As he would report to a friend by letter in 1842, Chamonix offered 'an inconceivable mixture of love and power – of grace with glory';[29] it baffled the small world of suburban evangelicalism. The 1833/4 passage is full of biblical resonances, not least the sense that if God was not in the 'desolate dominion of the snow', if there was 'no voice from the chasmy glacier', then 'the air' was still 'full of spirits'. These allusions to Shelley's poem on Mont Blanc, which show up much more in Ruskin's verses (not surprisingly), were his search for an alternative explanation of the extraordinary and various appeal of Chamonix. 'There is not another scene like Chamouni throughout all Switzerland'; or the rest of Europe, he might have added. In person and imagination he would perpetually return to its (paradoxical) 'heaven-like dwelling place'.[30]

Chamonix came at the very end of their tour. They had re-entered Switzerland from the Italian Lakes, stayed at Geneva before returning to Turin, whence they crossed the Great St Bernard Pass into the Vaud, gone north to Interlaken and then south again to reach Chamonix. A seemingly roundabout route, though not particularly absurd in view of their mode of transport, the actual geography and the available roads. But from Chamonix it was straightforwardly back to Paris, when they visited the family of John James Ruskin's partner, Pedro Domecq, his English wife and their five daughters who were all at home.

It was a strange encounter, this, between a sophisticated, catholic and cosmopolitan family, living in the Champs Elysées, their eldest daughter about to marry a Count Maison, one of Napoleon's officers, and a Scottish, newly middle-class, evangelical couple from Herne Hill, with their precocious only child, all probably overwhelmed and fatigued towards the end of their first full-length European tour. John found his French inadequate to treat with the lively, convent-bred girls, who played dance-melodies to which he could not dance, and organized a game of "la toilette de Madame", 'only I couldn't remember whether I was the necklace or the garters'.[31] The parents talked of the death of Bellini and of his *I Puritani*, which the family heard while in Paris; but John, bemused by his first contact with young girls since the death of Jessie Richardson in Perth, was evidently much disconcerted by his own inability to communicate and by no longer being the centre, as in his own family circle, of attention and admiration. When the other sisters, whom he obviously watched with fascination, gave up their attempts to amuse this abashed boy, the youngest of all – Elise – 'came across the drawing room to me in my desolation, and

leaning an elbow on my knee, set herself deliberately to chatter to me mellifluously for an hour and a half'. Among the many topics she touched upon were the joys of a return to the Champs Elysées and 'the general likeness of Paris to the Garden of Eden'.[32] John Ruskin resolved that evening to learn French.

– 2 –

The family returned to Herne Hill on 21 September. Their next continental trip would be taken in the summer of 1835. Meanwhile John tried to formalize his impressions and memoranda of the first journey into poems and scientific papers. He also determined to extend his knowledge of places visited and of the skills (language, geology, topography) he now realized that he would need for further journeys. For his birthday in 1834 he asked to have Saussure's *Voyages dans les Alpes*, and his over-generous father ('Mamma says you are spoiling me'[33]) also gave him William Brockendon's *Illustrations of the Passes of the Alps*. These were designed to assist his fourfold pro-gramme for private study that winter: this comprised the literary expression of sentiment, drawing – especially in the manner of engraving, a 'violent instinct for architecture', and his 'unabashed' geological studies. The gift of Saussure helped the latter, and with the aid of an earlier acquisition, Robert Jameson's three-volume *System of Mineralogy*, and of visits to the minerals in the British Museum, he continued his elaborate dictionary – exhaustive accounts of mineral specimens partly written in his privately invented shorthand, with many symbolic characters that nobody, including himself, could de-cipher later.

The other three of his 'four distinct directions' had in common the need to come to terms with the highly emotional experiences of the summer tour. Three months of constantly changing, but always stimulating scenery, of existing at a sustained high pitch of interest and absorption, loomed as an essential – perhaps *the* important – constituent of his life. But since such experience was also transient and intangible, the urge to fix it, 'to express sentiment in rhyme' or in sketch before the memories faded, was compulsive. His 'instinct' for architecture, unsatisfied by building or carving for which he said he had no talents, was captured in word and image. The pattern of most of his work is therefore adumbrated in *Praeterita*'s account of this winter of 1833/4 – the translation into something permanent, something 'worthy' and tangible, of his instincts for landscape and old buildings.

55

The books that he received from his father on his fifteenth birthday or the writing that he undertook himself this winter were therefore ways of fixing, focusing, important but volatile emotions. At this time, *Praeterita* tells us accurately, if rather portentously, that John had 'vialfuls, as it were, of Wordsworth's reverence, Shelley's sensitiveness and Turner's accuracy all in one'.[34] It is the last quality that works to fix and hold the experience of the first two. In 1834, long before *Modern Painters* chose to argue for Turner's accuracy of vision, it would have been the steel engravings in Rogers's *Italy* which yielded that impression; it was these that Ruskin's own drawings at this time, 'so entirely industrious in delicate line', were imitating. It was those and his careful catalogue of minerals that constituted his 'effort to *express* sentiment' and to give permanent and comprehensible shape to evanescent excitements. For this reason, too, he appreciated the books his father gave him: Brockendon's *Illustrations* carried him 'again over the summits of the higher Alps, over the winding paths of Splügen, and the glaciered crest of Simplon'; its vignettes were 'all splendid magnificent *remembrances* of more than magnificent scenes'.[35]

But nothing more reveals the beginnings of Ruskin's lifelong habit of referring his emotional life to scientific or quasi-scientific analysis than two papers, "Enquiries on the Causes of the Colour of the Water of the Rhone" and "Facts and Considerations on the Strata of Mont Blanc . . . etc", written during 1834 and published in Loudon's *Magazine of Natural History* in September and December respectively. Their tone and style are carefully 'objective'; even similes – there are no really metaphorical images – invoke scientific analogies. But the first piece is simply an "Enquiry" as to why the Rhone, flowing through the streets of Geneva, is 'so transparent, that the bottom can be seen twenty feet below the surface, yet so blue, that you might imagine it to be a solution of indigo'. It seems as if Ruskin wants his delight in gazing into its 'iridescent rush' to be grounded upon a sound factual explanation. Years later in *Praeterita* he wrote again about this phenomenon in a long, almost visionary, passage, which at one point actually uses the unscientific idea, rejected in 1834, that the Rhone is blue because it obtains the colours of the glaciers whence it flows:

> Fifteen feet thick, of not flowing, but flying water; not water, neither, – melted glacier, rather, one should call it; the force of the ice is with it, and the wreathing of the clouds, the gladness of the sky, and the continuance of Time.
>
> Waves of clear sea are, indeed, lovely to watch, but they are always coming or gone, never in any taken shape to be seen for a second . . . the ever-answering glow of unearthly aquamarine, ultramarine,

violet-blue, gentian-blue, peacock-blue, river-of-paradise blue, glass of a painted window melted in the sun and the witch of the Alps flinging the spun tresses of it for ever from her snow.[36]

We respond to that vision, quoted here only in rather demeaning fragments, not because it is 'fine writing', but because in contrast to his scientific earnestness of 1834 it honours as well his own emotional and imaginative response to the Rhone. At least the piece on the strata of Mont Blanc expresses the excitements as well as offers analysis ('mica slate resting on the base of Mont Blanc, and which contains amianthus and quartz, in which capillary crystals of titanium occur'[37]). The reconciliation of these two instincts for fact and fancy is of perpetual urgency for Ruskin (as, indeed, for many of his contemporaries). In 1834 he composed his poem on "The Crystal-Hunter": when first published in the *Poems* of 1891, it was aptly enough subtitled a 'fantasy', though one suspects that the choice of eponymous hero was somehow designed to accommodate the divergent impulses of mineralogist and of the boy who found Chamonix 'a more heaven-like dwelling place'.

In other respects Ruskin organized his responses and prepared himself for further continental excursions: he worked hard at his French and – on his mother's report – 'misses his . . . dancing' lessons when weather interfered.[38] His education was extended, probably from the start of 1834, to include daily lessons at a school run in Camberwell by the Rev Thomas Dale.[39] Dale had been the incumbent of St Matthew's Chapel, Denmark Hill, since 1830, and before that the Professor of English literature and language at King's College, London, a post to which he would return in 1836. A poet and translator of Sophocles, a 'high church evangelical' according to the *Dictionary of National Biography*, Dale was a severe and 'chiefly antagonist master', from whom Ruskin learnt largely because 'he had to', and then only the classics.[40] He had few opportunities to mix with Dale's other boarders, who treated Ruskin 'as I suppose they would have treated a girl', and having walked down in the morning with his father, John returned to Herne Hill by 1.30 pm, 'the fountain of pure conceit in my own heart sustaining me serenely against all deprecation, whether by master or companion'.

The Ruskins cautiously opened their family circle to selected visitors who might bring their son some advantages. In the past their own insecurities had probably discouraged callers: Telford, Ruskin's partner in the sherry firm, would pay courtesy calls upon Mrs Ruskin, especially when her husband was away on business trips.[41] And there

were visits paid to Dr and Mrs Grant – Ruskin later remembered their breakfasts, because he had the rare treat of 'a new French roll' – and to Mr and Mrs Richard Gray, probably the closest friends of the Ruskins.[42] At least according to *Praeterita*, such visits were less frequently returned, the 'formalities' of Herne Hill being 'inviolable'. But two contacts must have been encouraged because of their connections with the arts which John was himself practising: James Hogg, the 'Ettrick shepherd', and J. C. Loudon, landscapist and horticultural writer.

Hogg was shepherd-turned-poet, the friend of Scott, which must have given him much prestige in the Ruskins' eyes, and the author of *The Private Memoirs and Confessions of a Justified Sinner* (a novel of 1824, much neglected at the time, but a powerful, horrifying picture of an extreme Calvinist faith in the grace of its own redemption). He visited Herne Hill sometime before January 1833, when he had written to a mutual acquaintance enquiring after the Ruskins. John James, apparently at his family's instigation, though it would seem that he needed no encouragement, determined to bring John's poetical gifts to the notice of Hogg; in January 1834 he is writing on the flimsy excuse of Hogg's enquiry a year before to tell him of 'the youth you were kind enough to notice':

> [he] gives promise of very considerable talent. His faculty of composition is unbounded; without, however, any very strong indication of originality. He writes verse and prose perpetually, check him as we will . . . the rapidity of composition is to us (unlearned in the ways of the learned) quite wonderful. He is now between fourteen and fifteen, and has indited thousands of lines. That I may not select, I send his last eighty or a hundred lines, produced in one hour, while he waited for me in the city.[43]

This often-quoted letter mixes shrewd judgement (that his son's compositions have little indication of originality) with a touching naivety (that the family was unlearned in the ways of the cultured). The parental pride that nevertheless sends a random sample of John's verses has also to discipline itself as much, I suspect, for his own as for Hogg's consumption:

> Do not suppose we are fostering a poetical plant or genius, to say *we keep a poet*. It is impossible for any parents to make less of a gift than we do of this: firstly, from its small intrinsic value, as yet unsuspected in him; and, next, because we dread the sacrifice of our offspring by making him a victim to the pangs of despised verse, a sacrifice to a thankless world, who read, admire, and trample on the greatest and the best.

Again it is the astonishing conjunction of palpable untruth, for John James *did* make much of John's gifts, as we have seen and as John's own letter to Hogg a few weeks later reveals, and of calm business-like appraisals of the world's favours. John James ends his letter by sympathizing with Hogg's reported 'inflammation of the chest' and advising him to put his faith in 'a good substantial bookseller . . . cash is the word'.

Hogg's response must have been to invite John up to Scotland, a temporary breaking of the family circle that could only have done good. The rather unctuous terms of John's reply reveal that he can compose a fluent, flattering letter, but that he cannot, or was not allowed to, divorce himself from Herne Hill: 'I do not wish to leave my parents, and they are equally tenacious of me, and so I can do little but thank you again, again and thrice again'.[44]

J. C. Loudon, presumably because he was not offering to take Ruskin away from his parents, but merely to publish his youthful pieces, was a better 'friend'. Loudon must have pleased the circle at Herne Hill with his praise of their 'greatest natural genius that ever it has been my fortune to become acquainted with' and with his encouragement of Ruskin's less fanciful work.[45] The scientific papers which Loudon published in his *Magazine of Natural History* and *Architectural Magazine* during the 1830s helped to define this side of Ruskin's intellect and confirmed his lifelong habit of approaching topics empirically and methodically for at least as long as such approaches either provided forms of expression or stabilized his normal *lack* of method.[46] Yet, as he would note in *Modern Painters* III in 1856, though science helps to raise us 'from the first state of inactive reverie to the second of useful thought', scientific pursuits may well check our 'impulses towards higher contemplation . . . having a tendency to chill and subdue the feelings, and to resolve all things into atoms and numbers'.[47]

The man who had arranged the Ruskins' introduction to James Hogg was also responsible for taking John on a 'sacred Eleusinian initiation and Delphic pilgrimage' to Samuel Rogers, whose *Italy* had already shaped and would always direct his attitudes to that country.[48] John's egotism, controlled in his letter to Hogg by a florid patter of homage, managed less smoothly with 'the polished minstrel of St James's Place'; their encounter, eloquent of Ruskin's self-absorptions, was retold in *Praeterita* with a mixture of retrospective chagrin and a still lively confidence in the shrewdness of that younger self. First, Ruskin congratulated Rogers on the engravings to *Italy* but neglected to mention the verses; when the conversation was tactfully switched

to Africa, Ruskin conspicuously directed his attention to the pictures around the walls. Afterwards he was advised 'that, in future, when I was in the company of distinguished men, I should listen more attentively to their conversation'. The man who so admonished him was an exceedingly minor poet, Thomas Pringle, a pious Scottish missionary and editor of the annual, *Friendship's Offering*.

Pringle had been introduced into the Ruskin circle – ironically enough, as Leon observed[49] – by one of the Croydon cousins, Charles Richardson. John must have found this cousin especially attractive, idolizing him for his 'fearless' physical exploits – 'an admirable revelation of the activities of youth to me' – and grateful for Charles' kindnesses and 'brotherly tenderness'.[50] Charles had acquired enough education and polish ('grammatical, polite, and presentable in our high Herne Hill circle') to be helped in establishing himself in the City with the publishing house of Messrs Smith, Elder & Co. and to be asked to dine every Sunday with the Ruskins. Smith and Elder were the publishers of *Friendship's Offering*, one of those 'delicately printed, lustrously bound, and elaborately illustrated' Christmas anthologies so redolent of Victorian drawing rooms.[51] Charles Richardson talked to its editor about his talented and poetical cousin. So Pringle visited Herne Hill, expressed some interest in the 'further progress' of Ruskin's 'literary life' about which he continued to advise John James, but otherwise seemed less than overwhelmed by John's talents. With the result that, though he continued to be an occasional guest at their table, he was 'never quite cordially welcomed'. Yet he was tolerated because, for the Ruskins, he represented the 'literary world' and because he could arrange for their son access to the homes of the mighty. Samuel Rogers may now be unread and even a figure of fun, but he had been at the centre of cultivated and intellectual London for many years when Pringle introduced Ruskin to him. There were many who clamoured unsuccessfully for such a visit.

But Pringle and – with hindsight – Rogers represent something even more crucial in Ruskin's career: his love of the 'third rate'.[52] Not only did Pringle misrepresent true literary standards for the Ruskins (despite his just scepticism about John's verses), but he somehow endorsed the endless efforts at versification, which his successor as editor of *Friendship's Offering*, W. H. Harrison, would soon be publishing. The very nature of these annuals, which Ruskin was allowed to read for 'so long . . . in that drawing-room corner' probably because his parents considered them to be the heights of artistic success ('a nice ornament for my Drawing Room table' was Margaret's Judgement[53]), further endorsed Ruskin's

very unsteady judgements of value as well as his penchant for the miscellaneous:

> a little pastoral story, suppose, by Miss Mitford, a dramatic sketch by the Rev. George Croly, a few sonnets or impromptu stanzas to music by the gentlest lovers and maidens of [the editor's] acquaintance, and a legend of the Apennines or romance of the Pyrenees by some adventurous traveller who had penetrated into the recesses of those mountains, and would modify the traditions of the country to introduce a plate by Clarkson Stanfield or J. D. Harding.[54]

Such productions by and for 'meekly-minded persons' were to mingle with other attitudes and tones – his "Harry and Lucy" and his penchant for cabinets of curiosities – to condition much more of his later work than has generally been recognized.

Charles Richardson, for these services as well as for his uniquely human warmth, became a dearly loved, if older, companion for John. His stalwart and intelligent work as an apprentice to Smith and Elder ('knowing well both his books and his customers') must also have recommended him to John James. But, since prospects with the firm were not promising, it was determined that Charles should join an elder brother in Australia. As the time for his departure approached, the 'Christmas time of 1833 passed heavily', and by early January he had gone down to Portsmouth to await his ship. But it could not sail because of a west wind – in *Praeterita*'s remembrancing, 'exactly the kind of breeze that drifts the clouds, and ridges the waves, in Turner's Gosport'; one day, with a heavy sea running, Charles asked the captain's permission to go ashore in a small cutter, and, fearless and athletic as always, went over the ship's side. Within fifty yards the cutter capsized, and 'every soul was saved, except Charles, who went down like a stone'. The writer of *Praeterita* could still hear the sobs of Charles' father as he explained to the stunned relations at Herne Hill that 'They caught the cap off of his head, and yet they couldn't save him'.[55]

The loss of this companion and friend, mythologized by John Ruskin in terms of his gaiety, prowess and bright complexion ('crisply Achillean curls of hair') and lost, too, because of a need to get ahead in the business world (though this point was never raised at Herne Hill), created a vacancy in Ruskin's heart which would be filled in the coming years only at the expense of further heartache.[56]

Not surprisingly, 1834 was, according to Ruskin's editors, 'less productive of poetry . . . but busier in study', an altogether quieter year. Schooling with Dale and Rowbotham continued; so did his own

self-instruction in drawing and mineralizing, which involved visits to the collections at the British Museum to supplement those of his own, like the copper pyrites found on Snowdon or the iron oxide with bright Bristol diamonds found at Clifton ('I think the first stone on which I began my studies of silica').[57] He read extensively in his three volumes of Saussure and (at least later) came to think that he could have become 'the first geologist of my time in Europe'. Further specimens ('the most beautiful vein-stones of Copaipo') had been contributed by the family's friend, Dr Grant, and before his death cousin Charles had tried to share the younger John's ecstasy with their 'foliated silver and arborescent gold'.

In the spring of 1835 an attack of pleurisy took him out of Dale's school for a while, but on 2 June that year the family set out on a second tour of the continent. The itinerary had obviously been a matter of much debate during the winter: a verse epistle to his father in February argued

> What care we for Germany, leave her, oh leave her
> We will dash down to Paris, and jump on Geneva[58]

which, though more leisurely, was exactly what they did, reaching Switzerland via the Jura, with fruitful consequences. After their first taste of continental travel in 1833 the Ruskins evidently talked end-lessly about the experience, and in February 1835 Mary Richardson reported to her uncle that Salvador, their courier, had been out to Herne Hill with three papers, 'the first containing the names of the different towns between this and Geneva, the second includes Switzerland, the third is confined to Italy'.[59] With sherry sales prosper-ing, John James evidently felt that he could leave England for even longer this year (they would be away, in fact, from the beginning of June until 10 December). It is clear that he yearned as much as his son to get away from his desk and from the cold of an English house in winter: in a dialogue written by John and sent on New Year's Day 1836, *after* their trip, the enthusiasms of father and son for travelling are, however, set against Margaret Ruskin's objections that, while draughts can be kept at bay in Herne Hill, in Italy

> on whistling wings the wind blows
> Through cracking walls and open windows
> Bringing over the Adriatic
> To the tourist so exstatic
> Colds, catarrhs & pains rheumatic.[60]

– 3 –

John's double treaty with the world on this second major continental trip was carefully planned during his recovery from pleurisy. On the one hand, as *Praeterita* reported, he

> shaded in cobalt a 'cyanometer' to measure the blue of the sky with; bought a ruled notebook for geological observations, and a large quarto for architectural sketches, with square rule and foot-rule ingeniously fastened outside.

On the other, he determined that the events of their journey 'should be described in a poetic diary in the style of Don Juan, artfully combined with that of Childe Harold'.[61] Much of the former activity has survived, including his prose diaries, annotated in April 1836 to the effect that they had been lent to J. C. Loudon 'to see if there is any thing in them' for the *Magazine of Natural History*. The poetic effusions, composed this time as the journey proceeded, petered out by the time they reached Chamonix because he found that 'I had exhausted on the Jura all the descriptive terms at my disposal, and that none were left for the Alps'. The journey was selectively mythologized in a modest way a few years later for essays in *The Poetry of Architecture* and then, many years afterwards, for one of *Praeterita*'s most resonant chapters, "The Col de la Faucille".

John's activities on the trip were all essentially solitary – geologizing and writing up his reports in his prose journal, architectural sketching, or composing his verses. These last two must have been readily appreciated by his parents; but the geologizing, though it doubtless impressed them with another example of their son's genius, must have been increasingly incomprehensible to them. On the edges of the forest of Fontainebleau, as he recorded in his diary for 17 June, he was astonished by simple blocks of sandstone:

> Their surface was worn into the most grotesque shapes resembling knots of serpents, or masses of aggregate fossils, and in some places even annulated, like ammonites. But this structure did not extend into the interior of the stone. I broke several of the blocks, the sandstone was coarsegrained, and very soft, and on the fresh fracture nearly of a pure white colour. It crumbles down very easily, and the result is a very fine white quartzose sand, with which the road is a foot deep, where it passes through this part of the forest. None of the other blocks had this singular appearance, presenting only the usual form of half flat, half rounded masses.

Such intense, concentrated study was not readily intelligible to his parents and it is from this journey of 1835 that Ruskin first derived a conviction of his own essential solitariness. 'My entire delight was in observing without being myself noticed.'[62] Though he would never lose his dependence upon the accompanying 'support party' – whether parents, valets, guides, or secretaries – he wanted their various aids without his own occupations being diminished or modified on their account: 'My times of happiness had always been when nobody was thinking of me.' His real need was *not himself* to have to bother with others – 'the only qualification of the entire delight of my evening walk at Champagnole or St. Laurent was the sense that my father and mother *were* thinking of me, and would be frightened if I was five minutes late for tea'. It was a need and habit of self-absorption, at best, or wilful egotism, at worst, which was one of the main contributions to the failure of his only attempt to *share* his life and time with anyone, his marriage with Effie.

This 1835 journey established several of Ruskin's later preoccupations, and he recognized instinctively at that time how various places – visited, for the most part, because of the accidents of their itinerary – identified and localized his interests. It was left to later works like *Praeterita* to sharpen the patterns of the past, where he would come to identify 'in sum, three centres of my life's thought: Rouen, Geneva, and Pisa'.[63] If Geneva is allowed to include Chamonix and if we ignore his strange devaluation of Venice ('All that I did at Venice was bye-work'), the statement has at least that symbolic force for which we have learnt to look in the autobiography.

His diary for their stops at Abbeville and Rouen, apart from some observations upon frogs in the moat at the latter, is largely devoted to the weather and to noting measurements on his cyanometer: even at this age his meteorological interest was almost obsessional. But he drew the cathedral spire at Rouen, seen down various streets fraught with picturesque detail, what the Byronish cantos called 'rich street-pictures'.[64] Yet these verses give very little hint of the importance which *Praeterita* would later ascribe to this trip's first encounter with two rich Gothic cathedrals. At Abbeville, according to the cantos, the Ruskins 'Marvelled to see the carving rich, and talked of / The figures standing with their noses knocked off',[65] but they were disgusted with the filth and dirty people inside the cathedral. Only in the later autobiography could memory fully establish Abbeville as 'the preface and interpretation of Rouen' and as the place where 'on that 5th of June' he 'felt that here was entrance for me into immediately healthy labour'.[66] By the time he could look back to the family's first entrance

by horse and carriage into Abbeville and realize its importance to his thinking about gothic architecture and society the railways had ensured for 'the modern fashionable traveller, intent on Paris, Nice, and Monaco', a 'useless stop' at a place where if he bothers to catch a glimpse of 'two square towers, with a curiously attached bit of traceried arch', that traveller will be satisfied. I suspect that this is still so. But Abbeville became for Ruskin – perhaps when he had forgotten their initial reactions to the filth – a supreme example of the 'perfect harmony' of 'art (of its local kind), religion, and present human life'. But characteristically, even as he claimed that Abbeville introduced him to the study of Rouen, a few paragraphs later he has to admit that what he wants to say about Rouen and its cathedral 'remains yet to be said, if days be given me'.

The carving of Abbeville, Rouen, Rheims and Nancy attracted Ruskin's picturesque eye, but his judgements upon it were erratic, partly because they were based on comparisons with Roubiliac. Once again we encounter a striking disparity between what Ruskin wrote or drew by way of imitating his parents' adult tastes and what came more instinctively and with youthful enthusiasm to him. At Nancy on 24 June he made a hasty memorandum in pencil of the gate of the ancient palace;[67] with time so precious at each stop this was generally the way he would record his sightings of important monuments (or geological formations); they would then be worked up at a later stage. But what he drew quickly that day at Nancy shows a quite astonishing eye for the richly soaring arches, bulky balconies and the variety, intensity, of the gothic style; in contrast, some of the Proutian facsimiles he carefully 'got up' after leaving Rouen are dull, mannered, carefully attentive to his skill with pen rather than to the experience of the towering cathedral at the end of streets.

The next major *locus* of this journey, evidently urged upon his parents prior to departure, was the Jura. His readings in Saussure had made the young geologist place a huge importance upon this high ridge that lies directly between the 'cultivated champaigns of France' to the south-east of Dijon, and Geneva. Even at Nancy he was anticipating the sight of them: 'From the top of a hill above Nancy the north Jura, or those chains of mountains near Strasburg which run down to, and join the Jura, are distinctly discernable.' A week later, with a perceptible quickening, almost a lyrical cadence, in the spare prose of geological explorations, the diary records the family's arrival among

the beautiful pasturages which extend along the Jura from the base of

the Dole, rich with a thousand flowers, dark with forest, or green with young corn, and dotted with detached cottages, here and there sprinkled along the heights, or gathered into small clusters. The hills become more peaked and sprinkled with snow as we advanced, until, after passing along an immense gallery, high above the precipices of the Dole, we turned that illustrous corner, that looks across the broad and beautiful valley of Geneva to the eternal ramparts of Italy, to the 'redoutables aiguilles' and glittering aetherial elevation of Mont Blanc.[68]

The Jura establishes itself firmly in the prose, exhaustively – with disproportionate Alpine sublimity – in the verses, as a magical centre. Partly for its own intrinsic pastoralism, partly for the belvedere it provides from which to view the promised land of Chamonix, the Jura would be one of Ruskin's treasured spots, perfect territory for his solitary eye and his selfishness: 'Among the greater hills, one can't always go just where one chooses, – all around is the too far, or too steep, – one wants to get to this, and climb that, and can't do either; – but in Jura one can go every way, and be happy everywhere.' Thus, *Praeterita* glosses the Jurassic *liberty* as Ruskin's own private freedoms rather than the political liberties which others might associate with the anteroom of Switzerland.

The modern traveller may, indeed, share some of Ruskin's interest in the Jura – it is the first major climb for his automobile after crossing France, the first intimation that Switzerland and (via the modern tunnels which even Ruskin's "Crystal-Hunter" would despise) Italy are at hand. Ruskin, more leisurely, was also able to appreciate the Jura for its own sake. Though neither prose nor verses do more than mention cottages in 1835, his essay on "The Mountain Cottage – Switzerland" in *The Architectural Magazine* for February 1838 already adopts the Ruskinian mode of preternatural memory:

Well do I remember the thrilling and exquisite moment when first, first in my life (which had not been over long) I encountered, in a calm and shadowy dingle, darkened with the thick spreading of tall pines, and voiceful with the singing of a rock-encumbered stream, and passing up towards the flank of a smooth green mountain, whose swarded summit shone in the summer snow like an emerald set in silver; when I say, I first encountered in this calm defile of the Jura, the unobtrusive, yet beautiful, front of the Swiss cottage. I thought it the loveliest piece of architecture I had ever had the felicity of contemplating; yet it was nothing in itself, nothing but a few mossy fir trunks, loosely nailed together, with one or two grey stones on the roof: but its power was the power of association; its beauty, that of fitness and humility.[69]

The language is more studied and more 'literary' ('voiceful', 'swarded') than in the prose diary three years before; but he recaptures, nevertheless, something of his keen and instinctive admiration of these pastoral uplands. Yet fifty years later he could note with something like concern how strange it was that he never 'looked into a single cottage to see its mode of inhabitation!' In 1835 the cottage was a picturesque object not simply to the eye, but, in the true picturesque tradition, to the mind as well. And Ruskin's mind instinctively registered that the Jura, compared perhaps with Herne Hill and their hotels across Europe, was liberty and humility. It was associated, on the one hand, with botanizing and geologizing – local pieties – and, on the other, with its view of Mont Blanc.

In *Praeterita* the lessons are more explicitly announced. The chapter builds to its climax on the Col de la Faucille by means of comparisons with English scenery – in Yorkshire the 'system of streams' is everywhere visible, in the 'enchanted silence of open Jura' rainwater and dew drain off and vanish through 'unseen fissures and filmy crannies'; yet 'far down in the depths of the main valley glides the strong river, unconscious of change'. An old man remembering found this geological contrast and Jura's emblem of un-change his 'earliest lesson' of the journey. Then from the Col itself a vista opens of 'Alps along a hundred miles of horizon'. On 1 July 1835 not only was the view perfect ('never seen that view perfectly but once – in this year'), but Ruskin realized that this 'station' (a technical picturesque word) afforded another lesson: in 1835 this meant that 'Nothing could better *illustrate* the form of these minor ranges of mountains';[70] in *Praeterita* it 'opened to me in distinct vision the Holy Land of my future work and true home in this world'. The cantos written at the time seem to transpose something of that vision, which must have confirmed the same ecstatic sighting of the Alps two years before at Schaffhausen, into their account of the Jura itself: his joyous celebration of the latter's fecundity is compared to visiting a cathedral, perhaps his very first declaration of the community of Alp and gothic:

> First, you admire what people call the style
>> And massive wholeness of the monument, –
> Magnificent effect of dome and aisle, –
>> And next, you view the lavish ornament
> That's carved on every part, but all intended
>> To make the general effect more splendid.

These verses already declare what *Modern Painters* would proclaim – 'a stone, when it is examined, will be found a mountain in miniature'[71]

Give me a broken rock, a little moss,
. for I would dream
Of greater things associated with these, –
Would see a mighty river in my stream,
And, in my rock, a mountain clothed with trees.[72]

At the next main stage of their journey, the 'Holy Land' of
Chamonix, Ruskin's diary reveals just as evidently a grasp of larger
geological structures. Spending an energetic week exploring the val-
ley and its approaches, he now establishes one of his characteristic and
more slippery habits, a determination to subject all important matters
to various perspectives: 'it requires to see strata on two sides at least,
before you can determine if they dip at all'.[73] He was determined to
know the place, to trace all its roads and rivers, to view it from as
many vantage points as possible ('The rest of the Aiguilles of Cha-
mouni cannot be separately distinguished from the Col de Balme'[74]).
So he initiated his systematic study: 'At the Cabinet of Natural history
on this mountain I obtained what I had long wished for – a large
octohedric crystal of rose fluor. Returned to Chamouni. And watched
the sun go cloudlessly down upon Mont Blanc.'[75]

The family wandered for two months in Switzerland after leaving
Chamonix. Sometimes they would descend onto the Italian side of the
Alps, finding the inhabitants of Aosta 'by no means healthy or cleanly'
('Aosta is a very bad place to begin Italy at'[76]). They were soon back for
what the diary of 5 September called 'a good round of Switzerland'.
Indeed, their leisurely wanderings often brought them back through
places already visited. It was an excellent way of getting to know the
territory; John's careful diary entries, read in conjunction with a map
or, better still, while following the Ruskins' trail, demonstrate a
thorough grasp both of local details – whether the exact disposition of
the Martigny valley or the strata of the cliffs between Altdorf and
Brunnen on the Lake of Lucerne[77] – and of the larger geography,
where facts seem infused with Ruskin's imaginative projections:

> The col St. Gothard is a plain, small, and elevated, and on which are
> five lakes, green, clear, and rock bordered. There is a small marsh
> within a fathom of the highest, and the stream which trickles from it
> falls into the Reuss, and the Aar, and the Rhine, and the German
> ocean, while the little lake within a fathom of it empties its waters into
> the Tessin, and the Po, and the Gulph of Venice.[78]

His vision is equally sensitive when focused in close-up or from a
distance, and he moves between them with obvious ease. Near scru-
tiny beside the Glacier du Trient rewarded him with 'a regularly

stratified granite, not foliated granite, a mass, with its component minerals disposed in parallel lines, but a granite, unfoliated, disposed in thin and distinct beds'; yet he also admired the larger prospect – 'a thoroughly picturesque road; a most beautiful ruin, a superb desolation, a most admired disorder'.[79] The rigour of self-instruction is enormous in a sixteen-year-old; the language of self-improvement either slightly romantic – 'These veteran crags remain . . . telling to every traveller a wonderful tale of ancient convulsions' – or, already, after the manner of Harry or Joyce's *Scientific Dialogues*, pedagogic – 'it will be observed that . . .' or 'Break one of the large parallelopipeds into smaller ones if you can'.[80]

From Switzerland the Ruskins went east into the Austrian Tyrol, then southwards over the Stelvio pass to Bormio ('you had better hold your nose on first entering'[81]) and so to Como and into Italy for several weeks. According to a prose postscript to a rhyming letter sent by John to Richard Fell, his occasional playmate at Herne Hill, the family had possibly planned to go as far as Rome; but an outbreak of cholera dissuaded them. Instead they visited Milan, Verona (where 'Mr and Mrs Ruskin and family' professed themselves 'bien satisfaits' in the guest book of the Due Torri), and Venice, where they spent six days.

The future author of *The Stones of Venice* and *St. Mark's Rest* responded less carefully or enthusiastically to Venice than to Alpine geology (indeed, the last entry in his diary as they leave the mountains on 24 September was 'Geology today calcareous and nothing interesting'). But in retrospect Ruskin inevitably gave this visit greater importance, even making it two years earlier in an unused draft of the preface to *St. Mark's Rest* in 1877. Here he wrote of how he had been prepared for his first encounter with Venice:

> My father had trained me well in Shakespeare I knew the Two Gentlemen, the Merchants of Verona and Venice, better than any gentlemen or merchants in London and had learned most of Romeo and Juliet by heart; and all the beautiful beginnings of Othello. From Byron though with less reverence, I had received even deeper impressions – nor can I to this day be enough thankful for the glorious ideal of Venetian womanhood and patriotism which he gave me in Faliero and the Foscari, as I became capable of receiving it in later years Add to them Rogers poems, with Turner vignettes – and Shelleys Julian and Maddalo, Prout drawings in the Watercolour Room of the Old Society and the list of my first tutors in Venetian work will be full . . .[82]

He came, then, to Venice and Verona with ready-made literary and visual associations by which to judge and absorb them. Saussure may just as thoroughly have directed and conditioned his scientific vision,

but it still left him to work out his own personal treaty with the stones of Chamonix. In Venice, by contrast, he responded with facsimile Proutian drawings and through his father's tastes: 'Romantic, innocent and in full health and brought to Venice by a father & mother who rejoiced in all my pleasure – there is no speaking of what Venice was to me in that year'. He would later discover a way of speaking. But the distinctly different approaches to Venice and to geology which he manifested on this trip were, as we have seen, deliberately prepared in advance. Such an unnerving separation of his intellectual and his emotional existence, apparently established in 1835, was clearly announced five years later in his diary for 31 March – 'I have determined to keep one part of diary for intellect and another for feeling'.[83]

– 4 –

His memories of Venice, in that unused preface for *St. Mark's Rest* of 1877, are significantly juxtaposed to his infatuation with Adèle-Clotilde Domecq:

> I recollect of the bewildering Paradise, little of separate impressions – though well the burst of sobbing in which I left it – my old nurse vainly trying to comfort me. In the next two years, the mischiefs and sorrows of life began upon me. To begin (– indeed to end – all) I fell in love, at Paris, with a Catholic girl.

His chronology is wrong, of course, but symbolically right. The visit to the Domecqs in Paris had been in 1833; this visit to Venice two years later. They coalesce perhaps in his recollection of the 'feeling' half of his existence then. For with Adèle as with Venice he responded on the basis of a richly stored romantic sensibility.

Soon after the Ruskins reached home, the Domecq girls came to stay at Herne Hill, while their father made a tour of his English buyers. Mrs Ruskin managed to accommodate these four cosmopolitan young ladies into the domestic economy of Herne Hill, but necessarily they were thrown much in the path of John, who had just celebrated his seventeenth birthday. Starved of companionship among young people of his age, still perhaps with obscure affections for Jessie in Perth, certainly with a deep sense of Charles's loss, Ruskin fell in love – generally with 'the circlet of [the] sisters' beauty', specifically with the fifteen-year-old Adèle-Clotilde; her family used the second name and Ruskin, the first, 'because it rhymed to shell, spell, and knell'.[84] He could be ironic at his own expense later, though even

then without entire detachment; but in the early months of 1836 he was 'reduced to a mere heap of white ashes in four days. Four days, at the most, it took to reduce me to ashes, but the Mercredi des cendres lasted four years'.

When he came to speculate about his parents' innocence in allowing such a female invasion, he guessed they 'had never seen me the least interested or anxious about girls'. What happened, of course, was that, innocent himself of the language and topics which would have made the encounter with four French girls somewhat more 'relaxed', he simply took Adèle as an audience for his habitual enterprises, entertaining her 'with my own views upon the subjects of the Spanish Armada, the Battle of Waterloo, and the doctrine of Transubstantiation'. But it was not that such subjects, as he later thought, were ill-chosen for a Spanish-born, French-bred, Catholic; it was rather that he had no small talk, nothing except 'my own views'. The most that his egocentric habits of mind could do by way of venturing out towards Adèle was to compose for her a gothic romance about a bandit, "Leoni. A Legend of Italy", which found an entirely suitable home in *Friendship's Offering* the following year. In a note to its editor, dated 30 June 1836, Ruskin explained that 'the only thing a bandit can do to ingratiate himself with a lady is to be desperately over head and ears in love'.[85] Adèle laughed uproariously and rightly at Leoni's passion and at the self-conscious, serious auto-didact that penned it. There were also poems that he could not show her, though they duly appeared in *Friendship's Offering*; indeed, John James Ruskin seems to have indulged his son's passion because it would produce pieces like –

THE LAST SMILE

She sat beside me yesternight,
With lip and eye so sweetly smiling,
So full of soul, of life, of light,
So beautifully care-beguiling,
That she had almost made me gay,
Had almost charmed the thought away
(Which, like the poisoned desert wind,
Came sick and heavy o'er my mind),
That memory soon all mine would be,
And she would smile no more for me.[86]

He did explain in a long, seven quarto-page letter, sent to Adèle in Paris after her departure, how desolate and solitary he was on Herne Hill without her; he got word from her youngest sister, to whom he seems to have turned for support, that she had 'laughed immensely at

the French'.[87] He spent the summer, he recalled, writing a Venetian tragedy under the mulberry tree in the back garden.

But because Ruskin's passion could find expression only in second-hand language out of Byron and Shakespeare that his father had taught him, it did not mean that his soul had not been deeply moved. Often such adolescent infatuation ruffles surfaces and blows itself out; but Ruskin's being, unprepared and unaccustomed to any passion save the geological, was more thoroughly disturbed. Furthermore, his parents took it seriously, though in different ways. John James encouraged it for artistic reasons and perhaps because, like M. Domecq, he saw good business reasons for an alliance between their families. Margaret overacted the other way – appalled at the prospect that her only child would marry a Roman Catholic. Given these different, yet anything but *in*different, responses, it is not surprising that John himself also took his affections seriously. What is worse is that his parents, two years later, should have allowed Adèle back into the orbit of their son's life.

At any rate his destiny was in many respects 'fixed' by 1836. Perhaps it was already too late to turn him from the self-educating, self-absorbed, even self-congratulating young man, designed for fame, into someone for whom human love and involvement would have been welcome and creative. Perhaps, too, Adèle, so evidently mirthful at the expense of his most cherished occupations, was an ill-chosen partner. Yet she had intruded upon his mental and emotional scenery. The ambitious drawing Ruskin undertook as a result of the family's visit to Venice in the autumn of 1835 was, he tells us in *Praeterita*, a *landscape without figures*:

> The drawing still exists . . . with the diaper pattern of the red and white marbles represented as a bold panelling in relief. No figure disturbs the solemn tranquility of the Riva, and the gondolas – each in the shape of a Turkish crescent standing on its back in the water – float about without the aid of gondoliers.

But then Adèle disturbed his landscape; even though she may have been only a romantic figure, her shape, its surrogates, or its absence more sharply registered, would nevertheless haunt many of Ruskin's familiar landscapes –

> Nature has lost her spirit stirring spell,
> She has no voice, to murmur of Adèle.[88]

Part II

'A Graduate of Oxford'

Verse cannot contain the refining and subtle thoughts which a great prose writer embodies; the rhyme eternally cripples it; it properly deals with the common problems of human nature which are now hackneyed, and not with the nice and philosophizing corollaries which may be drawn from them: thus, though it would seem at first a paradox, a commonplace is more the element of poetry than of prose.

Bulwer-Lytton, quoted by Ruskin in an essay of 1836

Ruskin's time at Oxford, a matter of pride and vicarious pleasure to his father, was not particularly momentous or important to himself. It was a period not so much of expansion but of assimilation. During it he tried unsuccessfully to come to terms with his loss of Adèle, while in intellectual matters he turned his English and continental travels to good use in The Poetry of Architecture. *Writing these essays must have convinced him that prose, not verse, would be his forte, though in deference to his father's tastes and out of an established mechanical aptitude he continued to produce poetry. Oxford gave him a few new friends and, setting him among many social superiors, it taught him to move easily among people beyond the close Ruskin family circle. However, this family cohesion was maintained, despite some slight strains, by Margaret Ruskin's living in Oxford during term, and by continued family tours.*

What dominate the years at Oxford and afterwards are his health and his uncertainties about what direction his life should take. Tensions, excitements and the enthusiasms of intensive mental work began to produce their inevitable counter-swing into depression, actual physical illness, which absolute rest and recuperation would cure until the cycle repeated itself. A good deal of these pressures and anxieties derived from Ruskin's uncertainty about what he would do with his life. His parents had destined him for the church, but his own inclinations led him more and more to concentrate his energies where his obsessions were – visual arts and mountain scenery. The very important early work, The Poetry of Architecture, *took rural architecture as its theme and its reception encouraged Ruskin to contemplate another project, which defined itself eventually, but not without difficulties and much self-examination, as a defence of Turner's art against his critics. So* Modern Painters *was begun, though not in fact to be completed until 1860.*

Chapter 5

'I assume my seat of learning' – Oxford: 1836–1840

he began to speak of a certain insignis juvenis – &c ex superiore ordine – of the upper rank of his college – uniting an intense degree of intellect & morality; who having acquired extensive knowledge of men and manners and natural phenomena – during protracted travel – uniting refined taste with extensive knowledge of polite literature – summe something – or other – and then maxima facundia atque lepore, &c – had been successful in certamine poetico – victoriam meritam &c – to the great joy of his college friends and tutors

John Ruskin to his father, 5 December 1839

– 1 –

Ruskin's passion for Adèle Domecq interrupted and then, in its disappointments, continued to cloud his studies throughout 1836. In February he had enrolled as an occasional student at King's College, London, attending lectures in association with extra lessons at Dale's London lodgings; these lasted until December. In October he matriculated at Oxford, and in January 1837 went into residence. The academic life, which John James had foregone years before, could now be enjoyed by his son; even John, encouraged by his father, began to feel its attractions as much as Adèle's. At King's and at Dale's lodgings in Lincoln's Inn Fields he caught the excitements and the preliminary aura of academe, 'the sudden elevation of mind and stirring up of one's faculties which takes place upon entering the classic precincts of King's College'. In this letter to his father of 10 March, he continued with a contrast designed at once to appeal to John James as well as, unconsciously, to hurt him:

> It is a very sudden change from the unlearned, mercantile money-making, abominable bustle, which prevails in the Strand, to the sublimity of silence which reigns in that spacious court: long vistas of Corinthian columns, lofty arches and tall porticoes echo your tread and when you enter the tall door way, mount the noble staircase, and leaning against the base of a massive column, whose richly carved

capital extends above your head the graceful leaves of its acanthi, look down long passages on either side, arch beyond arch retiring in infinite perspective, the light falling with variable force through the upper windows, and striking on the figures of the gownsmen flitting up and down among the shadows of the corridors in silent and abstruse meditation. . . .[1]

John James's ambition for his son was intense and touching. When they had received tickets to the private view of the Society of British Artists, John told his father how much he would miss 'you and your purse' on that occasion; but Margaret, in her husband's absence, had discouraged John from going because the view was intended primarily for purchasers. John James commented that he

> was disappointed at your not going to Suffolk St the *artists & public Characters* never assembling after first day but I forgot to say how much I wished you to go & If I put my Vanity aside I acknowledge Mama judged more wisely, because Tickets on such days are intended for *probable* purchasers only.[2]

There seems to have been some debate in the family about picture buying, for John urges his father rather archly to buy more ('This it is to have pictures in a room, this it is which the drawing room wants, but it is a mendable fault'[3]), as if there were some contrary arguments from Margaret.

Collecting pictures, the approaching enrolment at Oxford, even perhaps John James's acquiescence in John's love for Adèle, all explain the noticeable increase in affection between father and son. It is a leitmotif in Margaret's letters to her husband during the mid-1830s ('he certainly loves you better than the whole of the rest of mankind put together'[4]). The long letters John addressed to his father in 1836 reveal an increased warmth and closeness in their relationship, while on his part John James begins to look forward with small enthusiasm to his separation from John at Oxford.[5]

What with the outlet they provided for his feelings for Adèle as well as his father's absurdly inflated encouragement, John continued to produce verses. Soon his strict division of imaginative work into 'Rhyme' and 'plain prose'[6] would begin to break down; it begins, perhaps, with the first essays on *The Poetry of Architecture* towards the end of 1837, when the habits and disciplines of both 'feeling' and 'intellect' start to coalesce in studies of landscape and architecture. But in 1836 he continued to apostrophize his love –

> A throne where Memory sits immortal,
> And points to dreams of joy, – and thee![7]

while seeking other modes of communication for his, still largely geological, studies. If geology was his enthusiasm, mathematics was where he showed most talent.[8] But painting and sketching also continued, with lessons from the president of the Old Water-Colour Society, Copley Fielding. The Ruskins had purchased work by Fielding as early as 1833 and two years later John started lessons with him: he

> taught me to wash colour smoothly in successive tints, to shade cobalt through pink madder into yellow ochre for skies, to use a broken scraggy touch for the tops of mountains, to represent calm lakes by broad strips of shade with lines of light between them, . . . to produce dark clouds and rain with twelve or twenty successive washes, and to crumble burnt umber with a dry brush for foliage and foreground.[9]

Thus instructed, Ruskin typically began to copy one of Fielding's own water-colour drawings. Yet it was soon abandoned, because – and it is equally typical of his self-education – Fielding's method was simply 'inapplicable to the Alps . . . scraggy touches did not to my satisfaction represent aiguilles, nor my ruled lines of shade, the Lake of Geneva'.

Altogether it was an uneasy interval between, on the one hand, an erratic education and a sheltered existence – private tutors, parental enthusiasm – and, on the other, many new experiences – Adèle, lectures at King's, first encounters with the adult world of scientific societies like the Geological or Meteorological. The two worlds sometimes overlapped uneasily, for while he was attending lectures at King's his lessons continued with Rowbotham. The self-confidence of 'I am preparing a superb paper for the Meteorologicals – which will no doubt be put in the Transactions' was not matched by the approbation of the Society itself, which heard the paper, but did not publish it.[10] The huge experience of the continental tours of 1833 and 1835, in which we must include his affection for Adèle, was still being assimilated; in fact, there were no more visits to the continent until 1840, which gave him some opportunity to adjust. The 'short excursions during summer' of 1836–9 were emotionally and physically less demanding.[11]

The imminence of Oxford must have been the greatest pressure upon him, though little of the strain surfaces. Not only was it an entry into the most learned society that John had yet encountered; but his father entered him as a gentleman commoner at Christ Church, where his one strength – a precocious, if patchy, scholarship – conflicted directly with the *mores* of the young noblemen whom John James's

snobbery procured as company for his son. Furthermore, Margaret Ruskin determined to accompany him and establish herself in lodgings, at least for his first few terms.[12] She argued that she could in that way supervise his health – *Praeterita* subsequently approved that determination, but only after Margaret's presence had actually proved to be necessary in 1840. One wonders whether Ruskin felt so acquiescent in 1837, especially since he had experienced in Europe the hindrances to his work that an accompanying middle-class family sometimes posed.[13] The rigour and conscience of Margaret's health care must at times have been exasperating for her son – not letting him walk on Herne Hill because of slippery conditions, then prescribing 'a walk these two last days fearing his health might suffer for want of exercise'.[14] At least one contemporary of Ruskin's at Oxford thought this maternal solicitude rather odd.[15] And to add to these pressures upon a young man whose very self-confidence (arrogance was how he himself later explained it to Oxford audiences[16]) obviously concealed a large insecurity, he was receiving the usual, rather daunting, advice that is customary upon a young man's translation into the groves of academe. Dale, visited in his rooms towards the end of the Michaelmas Term 1836, delivered himself of the lengthiest homily:

> Then he said that I must always take two hours of exercise in the day, be it cold or warm, wet or dry . . . I had no excuse at Oxford – for there were so many cloisters and arcades – (full of delightful draughts of air – by the by – I should almost think it safer to get wet) the necessity of which perambulations he demonstrated by arguments, & illustrated by examples, for which I have no room – then he remarked that I must be select in my society, must be careful in wine parties – &c – & asked how long I usually slept – said it was quite enough – that if I went to bed at 10, I might always be up at 6. I made an inward comment, that I should go to bed at 11, & rise at 7, as the evening was my best and brightest time. Then he gave me some directions about study . . . Then he gave me some directions for gaining Oxford poetical prizes which were very excellent directions for writing bad poetry . . . We had a long discussion on rhyming and measures – for which I have no room. This was the sum & substance of our conversation. I bade Mr Dale Farewell[17]

As the interview is rehearsed for his father's amusement, we see John's self-confidence, his sense of superiority to Dale, whom he had previously dazzled – so an earlier section of the letter implies – with his knowledge of the classics and his choice of 'light' reading (Saussure, and Alexander von Humboldt's *Personal Narrative of Travels to the Equinoctial Regions of America*). Dale was probably right to be surprised

at John's reading, but, as John James wryly noted in a letter to his wife, that a tutor should wait almost two years before ascertaining 'through what books his pupil had previously marched'[18] was also surprising. Yet Dale's criticism of John, that his 'principal deficiency arises from not having read correctly, and [from] . . . ignorance of grammatical niceties . . . [and] of the quantities of words',[19] shrewdly identified his main weakness – carelessness in details which failed to interest him. On the other hand, Dale's critical views, as expounded in his preface to John Todd's *The Student's Guide*, were limited and unimaginative; so that Ruskin's last essay for Dale, who had set the question "Does the perusal of works of fiction act favourably or unfavourably on the moral character?", adopts a proper assurance in its defence of Scott, Byron and Bulwer-Lytton. All the same, it is one of Ruskin's more questionable habits to adopt that strain of irreproachable security in his own judgement *whatever* the merits of the cause.

Todd's *Guide* and Dale's preface had concurred in finding those three novelists immoral. Beneath the froth and facetiousness of Ruskin's 'dexterities of disputation' (ironically disclaimed) and his evident delight in mocking Dale's preference for 'the thick water-gruel of sapient, logical and interminable folios', there are sensible ideas which will form the nucleus of later, more serious writings.[20] There is his plea for the imagination as something totally separate from and superior to falsehood, which will determine much of the argument in *Modern Painters*; though in his essay for Dale the truths which imagination yields are essentially those of conservative eighteenth-century aesthetics, Reynolds's or Johnson's truths of general and immutable human nature. The mind's encounter with works of literature (Scott is the example being discussed) 'improves' it – humanizes, cultivates, polishes, refines:

> Its moral principles and benevolent feelings have been as much encouraged as its selfishness has been neutralized. This effect has been accompanied with a sharpening of intellect and an accession of ideas, and this has been accomplished, not by severe study, or intense thought, but by the repose of a wearied brain and the relaxation of a leisure hour.[21]

Again, it is entirely characteristic that for Ruskin our best thoughts are the product of leisure, as in real life they were for him throughout a career where he never had to work for his living. Eighteenth-century, too, is Ruskin's rescue of sentiment ('real, refined feeling') from the puerilities of contemporary culture, which are characterized in a style and with a graphic panache similar to that which Dickens was then

using for his *Sketches By Boz*. Though this humour is not always very agile, its presence – plus the supporting appeal for amusement in and by art – will always be typical of Ruskin, whose sense of fun is not much appreciated by those who write about him.

The other prose composition of this year, which has obvious prophetic interest, was a spirited defence of Turner against an attack in *Blackwood's Edinburgh Magazine* for October. After some preliminary showing-off (rather misguided, perhaps, in its defence of Murillo from the charge of vulgarity) Ruskin quickly establishes some of the central themes that would emerge more thoroughly in *Modern Painters*. Turner's *Juliet and her Nurse* is praised for its confident use of Venetian topography:

> it is a view taken from the roofs of the houses at the S.W. angle of St. Mark's place, having the lagoon on the right, and the column and church of St. Mark in front. The view is accurate in every particular, even to the number of divisions in the Gothic of the Doge's palace.

But it is not simply the accuracy of Turner's vision that Ruskin defends, but his imagination that utilizes that carefulness – and 'imagination . . . Shakespearean in its mightiness':

> he has filled his mind with materials drawn from the close study of nature (no artist has studied nature more intently) – and then changes and combines, giving effects without absolute causes, or, to speak more accurately, seizing the soul and essence of beauty, without regarding the means by which it is affected.[22]

He readily identifies Turner's handling of colour and light ('this power of giving light and shade by pure colour') as his most important formal achievement and his powerful promotion of associations ('as it were the voice of a multitude entering by the eye') through those painterly means. Ruskin's letter was intended for *Blackwood's*, but with John James's unfailing need to involve the great in his son's activities the piece was first sent to Turner for the painter's approval. His reply took the form of thanking them for the 'zeal, kindness, and the trouble . . . taken in my behalf', but then intimating that to 'move in these matters' was never his practice nor his recommendation.

For the young man who could so confidently take on one of the leading reviews of the time, the world of Oxford would provide both easy opportunities and uncomfortable snubs. Ruskin himself was to decide that his time at the university contributed little to his career. In some ways this was a sufficiently symbolic truth; for he arrived at university with so many tastes as well as the enthusiasm for study so firmly fixed that he was impervious to the generally unscholarly

The Quadrant, Telescope, and Weathercock,

A LITTLE BELOW THE MIDDLE OF THE

TOWN OF KESWICK.

JUNE 9th, 1842.

CROSTHWAITE'S CELEBRATED

MUSEUM.

DANIEL CROSTHWAITE,

(Son of the late PETER CROSTHWAITE, Establisher of the Museum at Keswick, in the Year 1780; formerly a Naval Commander in the East Indies; Surveyor and Seller of the Maps of the Lakes in Cumberland, Westmorland, and Lancashire, attestations of the accuracy of which are given under able hands, and may be seen at the Museum,)

With much gratitude, returns his most grateful thanks to the Nobility, Gentry, and others, for the great encouragement which he has received; and from his unremitting attention in procuring every desirable addition to his Collection of CURIOSITIES, he hopes to merit their future favours and attention.

THE MUSEUM

Consists of rare CURIOSITIES, both of Art & Nature, viz:--Antiquities, Coins, Medals, Arms, Petrefactions, Fossils, Minerals, Quadrupeds, Birds, Insects, Fishes, Serpents, Shells, Grottos, and many Models and Useful Inventions, &c., &c., &c., contained in five rooms. Two New Zealand Chieftains' Heads in excellent preservation. The Geology, Minerology, and Botany of Cumberland. A number of Trophical and other Fossil Plants; also various Antiquities; as Roman, Celtic, and Ancient British Armour, Battle Axes, Swords, Spears, and other Weapons; all found in Cumberland.

MUSICAL STONES.

The First Set of Musical Stones ever found,

Were discovered by the late Mr. P. CROSTHWAITE, June 11th, 1785, and consist of sixteen regular notes, upon which a number of tunes on the natural key can be heard at the Museum.

Admittance to Ladies and Gentlemen, 1s. each; Servants, 6d. each; and open from Seven in the Morning until Tea in the Evening; or at any other time if particularly requested.

His Maps are engraved by the best Artists, and every addition thought necessary has been added, viz.:—the Sounding of the different Lakes in Fathoms, contiguous Roads, West's finest Stations for Prospects, with many others of the Author's own choice, all distinctly marked out. The Maps are sold at the Museum, at 9s. per set, bound; and 8s. per set unbound. The Æolian Harps of his late Father's Invention, at 7s. each. Otley's, Baine's, Wordsworth's, Ford's, and Scott's Guide to the Lakes. Minerals, Fossils, Spars, and Shells. Also Sells the best improved hard and other kinds of Black Lead Pencils, &c., all of which he sells on reasonable terms.

Westall's, Farington's, and other Views of the Lakes.

D. C. has on Sale, on the most reasonable terms, (being the latest new discoveries in Cumberland,) Blue Calamine and Phosphate of Lead, the Calsite of Barytes, the Murio Phosphate of Lead, the Blue Carbonate of Lead, Arseniate of Lead, the Tabular Crystals of the Sulphuret of Iron, and the Slip Shift in Shistos, which defines the Mining System the best of any thing that has been discovered, and all the other scarce Minerals the produce of Cumberland; either in Collections or single Specimens.

He has also lately collected the Geological or Rock Specimens, which he sells in sets to his numerous Visitors.

☞ *The Museum continues to be exhibited in the same house where his late Father and himself have resided for the last Fifty-eight Years.*

Catalogues of the Curiosities are sold at the Museum.

T. BAILEY & SON, PRINTERS.

1 Handbill for Crosthwaite's Museum at Keswick, visited by the Ruskins on their tour of the Lake District in 1830.

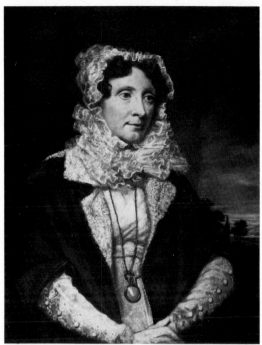

2a James Northcote, portrait of Margaret Ruskin, 1825.

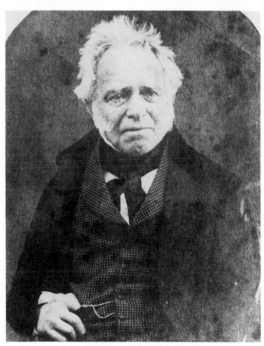

2b Photograph of John James Ruskin, probably June 1863.

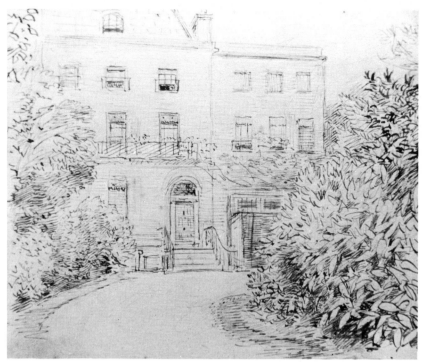

3a Ruskin, drawing of Herne Hill from the front.

3b Alexander McDonald, watercolour of Denmark Hill from the rear garden, after 1842.

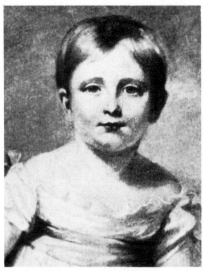

a In 1822 – detail of oil portrait by
James Northcote.

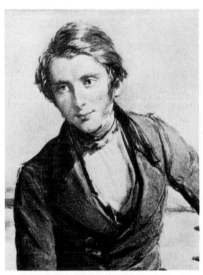

b In 1842 – 'The Author of *Modern Painters*' by George Richmond.

c In 1840s – miniature, perhaps
copied from the previous portrait.

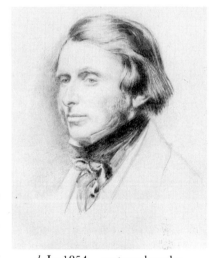

d In 1854 – watercolour by
J. E. Millais.

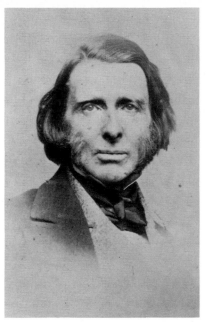

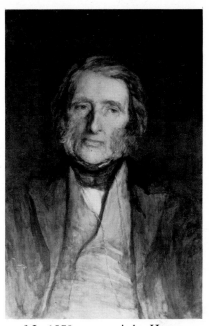

e In 1867 – photograph by Elliott and Fry.

f In 1879 – portrait by H. von Herkomer.

g In 1886 – from *The Graphic*, 2 April 1866.

h In 1890s – with Joan Severn in the grounds at Brantwood.

beautiful window for first there
was an arch and then by it
sides and top there were all
kinds of figures. The door was
in this shape ⬚ and when their
guide had opened it they found
themselves in a large abbey with
two rows of pillars one on each
side of them but broken and
ruined. Their guide showed
them some keystones of the
arches that had fallen down
and harry wondered why the
arches did not fall with them
He looked up and saw no-
gap in the arch and he asked
his father what was the
reason of all this but his
father was busy looking at other
things and so Harry was-
obliged to go to the same

ones. After looking for a
good while at these Harr
y and Lucy began to get-
tired but soon their guide
took them through a passage.
which led them past several-
ruined rooms. Going through
-through they found them
-one of these they found them
selves on a little green with
a hillock ⬭ on on one side
of it from the green nothing was
seen but a stone Wall but
when harry ascended the
hillock no view couldbe
more beautiful they then
Went out of the abbey
and went on to wind
cliff having gone through
a cottage they saw a high
rock as perpendicular-
as the Wall of a house

5 Harry and Lucy at Tintern Abbey: a narrative from one of Ruskin's juvenile compositions, presumably based on his own experience: see p.43.

6a One of Ruskin's early notebooks, with memoranda on places and minerals: see p.42.

6b Ruskin's list of places and subjects to write up after the family's continental tour: see p.55.

7 A page from Ruskin's early geological dictionary.

ambience, the perfunctory performance of academic work by his fellow students ('living in quite his own way among the odd set of hunting and sporting men'[23]). Mrs Ruskin, watching carefully from her lodgings in the High Street, supplementing her own observations with intelligence from John's servant, Thomas Hughes ('all we could desire very quiet, attentive, obliging'[24]), dispatched regular reports to her husband. As parents, they had much to be proud of, for John adapted well to life in college, yet without losing the distinctive qualities of moral probity and instinct for work which they had watched him acquire. The whole mode of existence in college, however, was not calculated to preserve John's established habits; that they survived was due as much to his own imperturbability and buttressed self-concern, a curious sort of selfishness that could readily ignore whatever bored or irked him, as to the maternal sentinel on the High.

Sometimes, indeed, John seems implicitly to have rejected his mother's role, for there are many occasions when he simply did not show up as promised. The story that has most frequently been told by biographers is of his dutiful attendance upon his mother for tea at her lodgings each day. The family letters, however, reveal – even in his first term – a series of broken appointments. On 9 March 1837 John apparently gave a wine party in his rooms and Margaret provided what was virtually a running commentary in her daily epistle to John James: 'The four Lords accepted most readily. I shall keep this open to the last, that I may let you know exactly names and number John says I am so particular in my narrations'. After other matters she reiterates that 'if John comes in any time before post goes you shall have as many particulars as I can give'; but by nine o'clock she has virtually given up – 'John has not yet come in or sent so I suppose the party are enjoying themselves more than common at wine parties but they are seldom so large. John promised to be particularly careful what he took.' Almost immediately that was written, John's servant, Hughes, arrives to say that the party has indeed finished ('Not a single glass broken'), but that John has stayed to play chess with a companion. And there are similar disappointments for his mother.[25]

Doubtless these were only trivial anxieties, though they would have been much more acute if John James had not been engaged in the wine trade and therefore given his son some opportunity to get used to modest drinking. But the dogged intensity of Margaret's watchfulness ('I have nothing particularly interesting to communicate but judging by myself I think you will feel easier when you know John is safe and well this morning'[26]) must have irked her son, who was

finding himself for the first time in his life among young men of his own age.

Of his own age, but far less of his own temperament. His father's snobbery had thrust him into the midst of those whom Matthew Arnold would call 'young Barbarians'; as gentleman commoner, in silken robe and with a golden tassel to his velvet cap, John dined daily with noblemen's sons. In *Praeterita* he would be gently ironic at the expense of his father's ambitions for him:

> His ideal of my future, – now entirely formed in conviction of my genius, – was that I should enter at college into the best society, take all the prizes every year, and a double first to finish with; marry Lady Clara Vere de Vere; write poetry as good as Byron's, only pious; preach sermons as good as Bossuet's, only Protestant; be made, at forty, Bishop of Winchester, and at fifty, Primate of England.[27]

But there is little sense that at the time of his first residence in college in 1837 Ruskin was himself anything but gratified with this circle of acquaintances – the inhabitants of those very country houses into which, 'speaking a little under our breath to the housekeeper, major domo, or other authority' the family 'reverently' penetrated on their summer excursions.[28] Nor is it surprising that some of his father's snobbery would communicate itself to John, whose social round ('went to Ld. Desarts at ten, found about twenty Lds'[29]) was suddenly and flamboyantly extended. Properly supplied from Ruskin, Telford and Domecq, John entertained as was expected of him, though modestly and presumably with regular promises to be 'particularly careful what he took'. But he participated sparingly – perhaps in the interests of courtesy only – in the more exuberant social round ('John says he did not hear a word in language or conversation that could not be repeated to me'[30]) and not at all in the rowdy pastimes of hunting, shooting and racing. Margaret reported proudly to John James that John had been offered a horse by Lord Carew and invited to dine after the races but *'refused, without even applying to me'*.[31] He seems, in fact, to have tried to pursue his own interests in the face of some persistent attempt to influence him otherwise. Again, Margaret told her husband that John had sported his oak in order to have an afternoon for his own work and ignored some gentle taps against it, only to be interrupted by the figure of Lord Desart, who had negotiated the outside of the building in full academic dress in order to enter at Ruskin's window with 'how do Ruskin your poor friend Grimston is at the door, dying to see you, I must let him in'.[32]

Margaret recounts such incidents, I think, in a rather uncertain

way – unsure whether to disapprove of such disruptions for her son or to acclaim his popularity with the lords of Christ Church. Her inability to adjudicate, even understand, the details of her son's university experience is one of the more pathetic aspects of her daily bulletins; yet the astonishing waves of Oxford broke against her staunch principles without dislodging them ('I may venture to prophesy that his future conduct will not differ from the past'[33]). She hated the separation from John James, but typically chose to consider it as a 'trial' or 'sacrifice' demanded of their love and faith and rewarded by an eventual increase in both. Nevertheless she entered into elaborate calculations from time to time of how many days apart were still required of them before John graduated.[34] She obviously found John's academic exercises beyond her – 'his arguments for and against the truth of the axiom, are to me too complex but I cannot follow any length of reasoning, and therefore to others they may appear both simple, and perspicuous';[35] she reported as best she could to her husband whose superior ability in these matters was her constant delight.

Without the household at Herne Hill to manage, Margaret was left with too much time on her hands for anything except anxiety and endless reflection upon parental duties:

> I trust the motives of devoting John to his God, were in the main pure, that he might be wholly His child, and servant, employing all his powers in Glorifying his Maker and benefitting his fellow creatures, I do not think any anticipation of fame, or riches, or any worldly honour, had the least to do with my desire, to give him to his God, but a deep sense of the infinite goodness of God in giving me a child, and a desire to express as much as I had in my power, my gratitude for that . . .[36]

Doubtless such reflections, though habitual, were especially provoked by the society in which their son was now moving. She obviously deferred to her husband's snobbery, perhaps even sharing it; a year after John went up to Oxford she is reassuring John James that 'I think I must leave him to remove your fears about his losing ground with the higher class – he does not now as formerly when it was a rarity mention when he is with any of this class because it is now so common so much a thing of course but from what I hear in the course of ordinary detail I think he is quite as much with them as formerly and on a more intimate footing.'[37] Yet she was very much an outsider – socially as well as personally – in John's college existence and often bewildered among his various companions ('I hear so many names'[38]). Yet she took a strongly independent line of disapproval, especially on

the rowdiness of the gentlemen commoners, whom she generally considered a 'sad set', whose parents (not, presumably, in attendance upon their sons at university) did not take 'proper care' of their offspring.[39] As late as John's third year Margaret was still anxious about the behaviour of those young men among whom her son moved – 'a most delightful party according to Johns talk' signifying for her 'sufficiently riotous without much mischief to the glasses &c and no personal damage'.[40] Again she attributed wild behaviour to absence of parental control at home, for most gentlemen commoners had been away to school:

> I am thoroughly content that our boy should remain wholly undistinguished in College, except for upright conduct, and gentlemanly feeling and manner, rather than that he should attain its highest honours with the depraved tastes, and disipated habits of the generality of public school Boys. I do not blame public schools alone for the entire want of principle in most of their pupils. The greater proportion are the children of parents whose moral code is not of the highest, who see and hear at home many things that are the very reverse of either good principles or habits, if the many are of this order the few are soon corrupted, and thus it is that so much of folly and vice prevails in our colleges.

Her defence of the moral regimen at Herne Hill was not, however, undertaken in November 1838 simply in opposition to the Oxford *mores* which she had so much leisure and opportunity to consider. It grew out of her need to defend her son in advance of his failing to secure the high academic honours upon which her husband and presumably John himself had set their hearts. In the same letter she quotes one of John's companions as saying that only a public school boy could expect more than a third-class degree. Now, according to her reports, John was working very hard, no doubt to compensate for his patchy education before coming up; but Margaret's strictures against parents of public school boys ('no parent can be justified who commits to another the charge of children early in life') were much involved in her defence of John against possible failure in his examinations:

> tho' John Should take no class I shall never regret his having been kept at home good Morals, good habits, and the various knowledge and acquirements which may be attained in a private education must be cheaply rated, indeed, if they are not considered of more value than the mere knowledge of Greek and Latin Grammar[41]

One wonders if John James had been intimating any regrets about the wisdom of having educated John at home.

His academic work, in fact, prospered well enough, if not spectacularly. The required reading in classical literature and history, which would always prove a rich fund of reference in his writings, was extensive; but it was largely a continuation of his work with Dale. His translations were usually highly rated – his instinct for philological accuracy and his curiosity about linguistic origins showing itself now; but his own Latin was inadequate – maybe 'the worst in the University', as he later thought.[42] Otherwise, he read philosophy, theology and mathematics; this last continued to prove his most promising subject ('the natural instinct in me for pure geometry'), and he could 'refresh himself' by solving abstruse questions in trigonometry.[43] His tutor in mathematics, the Reverend Edward Hill, was one of those whom he liked, even visiting him in his rooms in February 1837 when Hill was sick – a small example both of Ruskin's ready kindness and of his inherited penchant for courting 'important People'; John James actually quoted for his wife from a biography of Wilberforce the dictum, 'Never omit any opportunity of getting acquainted with any good or useful man'.[44]

Hill turned out to be interested in geology, which, although not an examination subject, continued to absorb John's enthusiasm in equal measure with sketching Oxford's picturesque buildings. He went early to lectures by the geologist, William Buckland ('very delightful – kept us laughing all the while – saw some splendid specimens'[45]) and quickly became intimate with him, in part because John had such a fine collection of specimens himself. Margaret reported:

> he took his Spar to Dr Bucklands who was much pleased with it, said he had never seen a more perfect crystal, and something about some other minerals which John saw plenty of at Lucerne and which the Dr. has not been able to procure, John says his own Switzerland specimens are finer than any of the same kind that Dr. B has, so you have not paid so much value as we thought.[46]

John James's generosity in supporting his son's pursuits seems to have boggled only over this taste for minerals.[47] I suspect that this may have stemmed from his fear that geological studies in some way threatened the ecclesiastical career envisaged for his son. Buckland, whom John was obviously coming to admire, was both a divine and a scientist. In the year before John came up he had contributed a famous essay to the *Bridgewater Treatises* on the relations of geology and mineralogy to 'the power, wisdom, and goodness of God, as manifested in the Creation'. But despite Buckland's reconciliation of belief and new scientific discovery – he had produced another essay in 1832 on the

evidence for a Universal Deluge to be derived from the fossils of extinct animals discovered in a cave in Kirkdale, Yorkshire – the endeavour *in itself* obviously aroused Margaret Ruskin's anxieties:

> we had an excellent sermon from a Brazen-Nose Man, purely evangelical the Text "What think you of Christ" John liked it very much – both Mr Newmans & Dr Bucklands Doctrines commented on and opposed – but I must tell you of this when we meet. Dr Buckland attempted to prove, this morning, in his sermon at Ch Ch that animals had died before the fall of man.

Her husband in his reply tried to smooth away the awkward implications:

> I can only say – The monsters as we must let them live by Geologists Chronology – ceased to live by the power of Deity but in a way not yet called dying. It was not what we understand by Death – & these few required an accountable moral Being. I don't think those monsters that John has crawling on a sheet of paper look like accountable Beings.

But Margaret was not readily persuaded, even while acknowledging that the problem was beyond her – intellectually and providentially:

> The question is a very puzzling one – it is a great mercy that neither our welfare here nor our happiness hereafter depend on our solving it – it would I think be wise in the Dr. and his compeers I think if they would let the Bible alone, until they had gained sure knowledge on the subject.[48]

Buckland's interest in John was, however, notably gratifying for father and son: 'what a prodigious privilege you possess in frequenting the society of . . . such a man', John James enviously wrote in 1840,[49] when John was long since established as a regular and obviously valued guest at the Bucklands'. In his first year (April 1837) he had, besides encountering the extraordinary chaos of Buckland's study – 'frogs cut out of serpentine – broken models of fallen temples, torn papers – old manuscripts – stuffed reptiles', also met Charles Darwin.[50] There were other 'large and choice' parties before 1840, when his diaries record lectures and dinners with Buckland.[51] John's habits of mind, the formation of essential and abiding interests, must have been strengthened in Buckland's richly anarchic study – another virtuoso's cabinet, a more scholarly Crosthwaite's Museum – and by Buckland's absolute confidence in his subject – 'he believed it would be utterly impossible to knock into the head of any one of [the three first Greek Scholars in Oxford] the difference between one stone

and another'. And perhaps in such of Buckland's more eccentric moments as sending a young lady to a ball with a live snake as her bracelet, there may be rooted Ruskin's own oddities, not least dressing his wife in dead animal and snake skins to be sketched by Millais.[52]

Margaret's doubts about Buckland's faith, and her 'consistent anxiety' about broken glassware or John's catching cold watching boat races on the river in May must have forced her son into his own life and friendships, from which he could 'run in to show me he was safe' without too much disruption.[53] His life was, as always, exceptionally full. He debated in the Union, defending both the 'reading of good and well-written Novels' as he had done in his essay for Dale, and the benefits offered by 'Theatrical Representations . . . to the character of the Nation'. He was remembered for a lyrical pronouncement on alpine scenery as well as 'a very ingenious and somewhat sarcastic speech' on the Devil, full of 'circumlocution and innuendo', which 'excited much laughter'. He served on the committee of the Union during Michaelmas Term 1838, and in college sang Florentine canzonets and Bellini songs with the musical society, played chess often (though 'he does not think he has his match . . . among the young men'), and was elected to the exclusive Christ Church Society, the first advantage of which, John announced, was that its rooms offered 'a very picturesque view' of the Porch of St Mary's.[54] It was the kind of remark, I suspect, by which he cloaked his real enthusiasms beneath pretended affectation in order to amuse his fellow gentleman commoners. But that he was elected so early (May 1837) seems to prove that he was an accepted and respected member of their circle. That he was occasionally given a rough time was presumably inevitable in such a group and probably showed that he continued to be regarded as something of an oddity. He was hounded for writing an exemplary essay and reading it aloud in Hall, thereby betraying, as it were, the studied philistinism of gentlemen commoners; he was ridden like a donkey around Tom Quad and invaded in his rooms, so the story goes, by a drunken group bent upon demolishing the furniture, from which they were distracted by Ruskin's cool rejoinder that 'my father, who is engaged in the sherry trade, has put it in my power to invite you all to wine tomorrow evening'.[55] A tradesman's son, and there could only have been some awkwardnesses over this with his fellow students, he nevertheless was able to look after himself during the wine parties, though on at least one occasion this entailed having to dispatch the punch down his waistcoat rather than his throat and on another, when he had not been so prudent or so lucky, he was able to

speculate drunkenly upon certain trigonometrical side-effects as he zig-zagged to his rooms.[56]

He survived largely by being imperturbably himself. When, with a typical desire to pursue some intricate problem further, he questioned their tutor, he was hailed for his 'consummate flooring' of the instructor. He was quickly recognized as a talented artist – the Dean was much impressed by his sketches – and he affected, not only a fastidiously elegant *tenue*, but a blue neckcloth, a gesture of particular aestheticism. He worked hard, would often refuse to join in the rowdier activities of the gentlemen commoners, and gave his own chess parties or more subdued wine gatherings. And his mother added that 'fortunately neither ladies or singing are any temptation'. He probably kept from his parents how much he was still thinking of Adèle, just as they kept from him news of her (see below pp. 98ff.). There are hints, too, that, though he worked hard and had to study hard to keep up, he could use his studious habits as a barrier against his mother's daily inquisitions – Margaret tells her husband that 'John is in one of his most studious moods and it is quite a labour to get a word from him';[57] but since they were so concerned that he do well for himself at university, such excuses were not to be reprehended.

John's ease and directness of manner meant that he got on quickly and readily with his fellow students. Margaret reports a typical vignette: 'Crossing to New College first came Ld K. one on each side of him then Ld. Cranley and John arm in arm, a very elegant looking party I assure you, the gold tassels make much show.'[58] Though the golden tassels obviously appealed to John as well, his friendships meant more to him. He still felt the loss of Charles Richardson, drowned in 1834; he even saw in Lord Kildare a likeness to his much loved cousin, though Margaret Ruskin, still suffering from her husband's friction with 'the Croydon people' did not.[59] John found, inevitably, that some of his noble friends also collected watercolours – he tells his father of Nashes and Prouts in Lord Carew's rooms[60] – and that others shared his architectural and geological interests. He became a founder member of the Oxford Society for promoting the Study of Gothic Architecture (Buckland was elected a Vice-President).

Perhaps the most substantial and certainly the most lasting friendship was established with Henry Acland. It was he who proposed Ruskin for membership of the Christ Church Society, was a fellow member of the Oxford Apiarian Society (for the promotion of knowledge 'concerning the natural history and cultivation of Bees') and who shared his interests, more importantly, in painting. Acland went on to study medicine in London and, back in Oxford, was

eventually appointed Regius Professor of Medicine in 1857. He became Ruskin's only Oxford friend with whom there was increasing intimacy, and it would be to Acland (and only one other) that Ruskin confided his own fullest version of the breakdown of his marriage with Effie in 1854. What they shared immediately, as *Praeterita* recalled, was 'the manner of English youths of good sense, good family, and enlarged education; we both of us already lived in elements far external to the college quadrangle'.[61] Their Oxford friendship received the approval of Margaret Ruskin, who rejoiced that Acland was 'pious' and came of a family 'estimable in all its branches'.[62] Yet Acland was a less conspicuous element in Ruskin's student life than others who did not survive the show of golden tassels.

– 2 –

The 'elements far external to the college quadrangle' which drew Ruskin and Acland together were largely Ruskin's painting and writing. Both had been established in London circles before he came up to college and both were drawn upon during his first two years as an undergraduate for the series of papers published in J. C. Loudon's *Architectural Magazine* and later given the title of *The Poetry of Architecture*; these appeared under the pseudonym of "Kataphusin" (according to Nature). They seem to have been composed with relatively little trouble – compared, say, with his work on Newdigate Prize poetry submissions (see below pp. 99ff.), which occupy much more of his parents' correspondence than his writings for Loudon. But *The Poetry of Architecture* represents, I feel sure, his own most committed work at this time.[63] In these fourteen essays, published between November 1837 and December 1838, Ruskin gets his first public opportunity to organize his views on architecture and landscape. And, though a perplexing feature of his intellectual life is his beginning without adequate information and then learning extensively and having to change his opinions, *The Poetry of Architecture*, in both its explicit formulations and its often more suggestive asides, did determine the direction of a larger part of his later writings than is generally allowed.[64]

The essays draw upon Ruskin's already considerable experience of travel in England and Europe. Indeed, he claims as a major justification of the work – as it had been of the family's journeys – that landscape educates:

89

The nobler scenery of that earth is the inheritance of all her inhabitants: it is not merely for the few to whom it temporarily belongs, to feed from like swine, or to stable upon like horses, but it has been appointed to be the school of the minds which are kingly among their fellows, to excite the highest energies of humanity, to furnish strength to the lordliest intellect, and food for the holiest emotions of the human soul.[65]

The family's summer tours of 1837, to the Lake District, and of 1838, through the Lakes to Scotland, were the immediate inspiration for his essays ('the ideas had come into my head in the summer of '37, and, I imagine, rose immediately out of my sense of the contrast between the cottages of Westmoreland and those of Italy'[66]). Ruskin was by now trained to see picturesque potential in natural scenery; so that when he offers to describe a typical English cottage, his own sharp observations, which the graphic records of these tours clearly reveal, are nevertheless made subservient to the essentially *generalizing* effect of picturesque work, whether registered in the Prout drawing of a cottage, bought by Ruskin's grandfather and claimed to have exercised 'a most fateful and continual power over my childish mind',[67] or in innumerable rural pieces shown at the Academy and Watercolour Society – to which the last phrase of this passage alludes:

> The principal thing worthy of observation in the lowland cottage of England is its finished neatness. The thatch is firmly pegged down, and mathematically levelled at the edges; and, though the martin is permitted to attach his humble domicile, in undisturbed security, to the eaves, he may be considered as enhancing the effect of the cottage, by increasing its usefulness, and making it contribute to the comfort of more beings than one. The whitewash is stainless, and its rough surface catches a side light as brightly as a front one: the luxuriant rose is trained gracefully over the window; and the gleaming lattice, divided not into heavy squares, but into small pointed diamonds, is thrown half open, as is just discovered by its glance among the green leaves of the sweet briar, to admit the breeze, that, as it passes over the flowers, becomes full of their fragrance. The light wooden porch breaks the flat of the cottage face by its projection; and a branch or two of wandering honeysuckle spread over the low hatch. A few square feet of garden, and a latched wicket, persuading the weary and dusty pedestrian, with expressive eloquence, to lean upon it for an instant, and request a drink of water or milk, complete a picture.[68]

But Ruskin seeks to make some interesting adjustments to the rather empty, mindless vogue for the picturesque, which is surely gently satirized there.

What this adjustment is becomes clear in another ironic passage, which draws upon the family's current delight in the language of *The Pickwick Papers* for its description of 'edificatorial fancies':

> the humour prevailing at the present day among many of our peaceable old gentlemen, who never smelt powder in their lives, to eat their morning muffin in a savage-looking round tower, and admit quiet old ladies to a tea-party under the range of twenty-six cannon, which, it is lucky for the china, are all wooden ones, as they are, in all probability, accurately and awfully pointed into the drawing-room windows. [69]

Ruskin's whole burden is that because landscape is 'a science of feeling more than of rule, a ministry to the mind, more than to the eye', buildings must appeal to the mind's sense of proprieties and apt associations. [70] His own treasury of associations was drawn upon fully, though it is again interesting to observe how the tendency of all picturesque association to move into generalization also effects Ruskin; even though he declares in an early essay that his readers must 'cast away all general ideas', [71] within a page of that pronouncement he himself utilizes one, derived from Byron, Rogers and Turner:

> the principal glory of the Italian landscape is its extreme melancholy. It is fitting that it should be so: the dead are the nations of Italy: her name and her strength are dwelling with the pale nations underneath the earth; the chief and chosen boast of her utmost pride is the *hic jacet*; she is but one wide sepulchre, and all her present life is like a shadow or a memory. And, therefore, or, rather, by a most beautiful co-incidence, her national tree is the cypress; and whoever has marked the peculiar character which these noble shadowy spires can give to her landscape, lifting their majestic troops of waving darkness from beside the fallen column, or out of the midst of the silence of the shadowed temple and worshipless shrine, seen far and wide over the blue of the faint plain, without loving the dark trees for their sympathy with the sadness of Italy's sweet cemetery shore . . .

It is yet another identification of ruin, an obsession of Ruskin's which united picturesque taste and religious idea. *The Poetry of Architecture* finds further opportunities for this preoccupation; cottage landscapes are appreciated most for their intimations of lost Eden, and when the essays move, as planned, from cottage to villa, the distance from that forfeited paradise becomes even greater – 'We shall have less to do with natural feeling, and more with human passion; we are coming out of stillness into turbulence, out of seclusion into the multitude, out of the wilderness into the world.' [72]

Ruskin's implicit contradictions, which show that his mind was as

yet more fertile in producing ideas than skilled in ordering them, are of more consequence than the question whether or not 'general ideas' may be part of landscape associations. One of the difficulties with which he grappled in *The Poetry of Architecture*, the question of our ideas and associations and the 'objective status' of landscape, would continue to cause problems in his whole treatment of the topic. On the one hand, the picturesque mode often implied that nature itself is active and that picturesque subjects are 'ready-mades': 'the picturesque blue country is sure to present some distance of this sublime kind, so as never to be without a high and ethereal mystery'.[73] And this mystery seems inseparable from such scenery. Elsewhere, a similar assumption is made about landscape items that have a voice to 'tell' some 'tale of venerable age'.[74] But on the other hand such qualities of landscape seem to have been put there by the observer himself. Though the passage on the cottage, quoted above, implies specifically inherent qualities, it ultimately yields to each reader the exact realization of such a cottage. This strategy is central to Ruskin's initial emphasis on feeling, on the poetry of architecture with which each person animates a building and landscape, registering as elements of a scene what are constituents of that person's consciousness. It is, in fact, Ruskin who narrates what tale an old building tells and who gives the voice to 'character . . . written on the fronts of the respective cottages'.[75] His preferred landscapes are those with 'power of association' – Italy has a backdrop of mountains which 'become part of the picture of associations'.[76] However, his generalizing tone actually conceals the extent to which it is Ruskin's own feelings that provide the 'poetry' of landscape and architecture. Yet this strains against his other assumption that 'meaning', which a critical eye can readily elucidate, is endemic to a landscape.

This uncertainty – central to much late eighteenth-century and Romantic aesthetics and psychology – is announced whenever Ruskin talks of landscape and/or architecture 'rousing certain trains of meditation in the mind'.[77] The ambiguity of fastening ideas and feelings upon apt objects, which yet have partly authorized that attachment, is taken up in an essay on "The Studies of Painting and Music" also written in 1838. Rusking makes much the same uncertain emphasis: an 'immortal' painter must

> be capable of experiencing those exquisite and refined emotions which nature can arouse in a highly intellectual mind; he must feel his heart bound with the cheerfulness of the morning, or floating away into a calm ocean of deep thought, in the half sad and gentle light of the setting sun, or the reverential still of the dying twilight; he must

feel the soul of joy and sorrow, the life and thought with which nature is filled at all times and at all seasons, and he must be capable of putting that soul upon his canvas; he must have meaning in his heaven, meditation in his air; and he will never do this, unless his mind were among the mighty.[78]

Art is not therefore a servile imitation of nature, but the record of a 'soul' or 'meaning' that already exists within it. Yet the great artist must be capable of deep feelings for which nature evidently provides the apt imagery: Claude and Ruysdael, in the same essay, are 'distinguished by the soul which *they put into nature*' (my italics).[79] This soul-giving power is what the architect may contribute to a landscape. Early in *The Poetry of Architecture* Ruskin says that cottages 'give animation' to a scene and that this aspect of landscape architecture is the theme of his essays. They speak powerfully of Ruskin's own complex response to landscape and buildings, giving early hints of that aspect of his imagination that he wrote of much later: 'there is so much in all that concerns the arts, dependent on early associations that I sometimes question whether anybody even understands exactly what it is that the person beside them is enjoying – or even perceiving.'[80] The whole aesthetic problem touched Ruskin in a most personal way: for his own possible career as commentator upon landscape and architecture depended upon whether the inherent qualities of things needed explication or whether it was what a writer brought to his interpretation of them that mattered. The Oxford undergraduate responds, I think, more surely and instinctively to an essential ambiguity in the exchange between mind and landscape than did the 'Graduate of Oxford' who would stigmatize the 'pathetic fallacy' in *Modern Painters* III.

Indeed, in this work of the late 1830s Ruskin probably succeeds more by muddle and uncertainty than by clear, scientific distinctions. And this was despite his pretence to careful and systemized discriminations, what he would later call getting 'one step to follow from another in true geometrical series'.[81] Ruskin's was not a mind that took things one at a time, so that elaborate divisions and sub-divisions of landscape character may have been his own means of ordering materials;[82] he came to pride himself upon a logic that other writers lacked.

This attempt to control the essays of *The Poetry of Architecture*, together with the general tone of studied objectivity, is part of the nineteen-year-old's search for a suitably public voice in prose. His imposition of impersonal and judicious analysis upon what are really personal reminiscences of travel is not always easily maintained: par-

ticularly facetious passages were eliminated in manuscript,[83] but some survived, as did some rather pompous generalities ('a lamentable deficiency of taste and talent among our architects'[84]). Also precarious, as the essays continued, was Ruskin's control over the topics he had proposed to cover; indeed, he announced so many that, unable to treat them all before the essays were brought to a stop, they came to constitute an agenda for many future projects.

The Poetry of Architecture initiates one such motif in its preliminary attempt to offer advice on contemporary building designs. At the nearly finished National Gallery in Trafalgar Square

> We have Corinthian columns placed beside pilasters of no order at all, surmounted by monstrosified pepper-boxes, Gothic in form and Grecian in detail, in a building nominally and peculiarly national; we have Swiss Cottages, falsely and calumniously so entitled, dropped in the brickfields around the metropolis; and we have staring, square-windowed, flat-roofed gentlemen's seats, of the lath and plaster, mock-magnificent, Regent's Park description, rising on the woody promontories of Derwent Water.[85]

But the ostensible endeavour in the following essays to prescribe for proper architecture and its relationship to landscape (he complained to his father of the 'dreadful want of . . . association in the modern city'[86]) remains nominal: there is an occasional and categorical foot-note ('In leaving simple blue country, we hope it need hardly be said that we leave bricks at once and for ever'[87]) and other gestures towards 'use'; but otherwise simply ironic castigation of current architecture and even self-absolution from the duty of formulating principles ('It is utterly impossible to give rules for the attainment of these effects'). It is only in the penultimate footnote, significantly, that he finally returns to the opening concern with contemporary styles:

> It is utter absurdity to talk of building Greek edifices now; no man ever will, or ever can, who does not believe in the Greek mythology; and, precisely by so much as he diverges from the technicality of strict copyism, he will err.[88]

A similar inability to maintain the scope of the original scheme, announced as moving from 'the lower class of edifice, proceeding from the roadside to the village, and from the village to the city',[89] was not entirely due to Ruskin himself; in fact (for the first and almost last time *not* his fault), the essays were never completed as planned, since Loudon's *Architectural Magazine* folded. But as the instalments were written, Ruskin's characteristic habits asserted themselves ('I thus deviated from the general rule which I hope to be able to follow'):

chapters were not long enough to contain his discussion as it had evolved ('We had hoped to have concluded the Villa in this chapter'); in the eighth – significantly perhaps on "The Mountain Villa: Lago di Como" – appears the first of his absorbing and telltale footnotes on the character of mountain scenery, which is followed rapidly by another on avalanches ('There are two kinds of winter avalanche . . .'). And from that point onwards he is frequently beguiled into footnotes where ideas he cannot possibly accommodate in the main text are entertained with such verve that one wonders which – text or note – really absorbs him more. One footnote, by a publishing accident, actually came to be printed separately.[90] The essays were written by "Kataphusin", Ruskin later explained, because 'the manner of his discourse' was also 'according to Nature'.[91] Later in *Praeterita* he identified three modes of his writing; it was increasingly the third which came to be used in the essays for the *Architectural Magazine*:

> three different ways of writing – one, with the single view of making myself understood, in which I necessarily omit a good deal of what comes into my head; another, in which I say what I think ought to be said . . . and my third way of writing is to say all that comes into my head for my own pleasure, in the first words that come . . .

The 'digressions' and footnotes of *The Poetry of Architecture*, actually encouraged by J. C. Loudon who said that his contributor could not be too diffusive,[92] reveal Ruskin's early absorption in many things simultaneously or at random, which his prose, dedicated to sequence and progression, could not always manage.

In much else these essays offer hints of the mature Ruskin, and are worth noticing for that reason. First, it is not the provision of shelter that constitutes 'the high and ennobling' business of architecture for Ruskin; rather, it is the provision of ornament for buildings – 'giving to buildings, whose parts are determined by necessity, such forms and colours as shall delight the mind, by preparing it for the operations to which it is to be subjected in the building';[93] ornament, further, must be apt for and spring from the context of the building. It is easy to see that this particular emphasis, which largely avoids the questions of structure and form, grew out of Ruskin's own delight in picturesque detail, which the summer tours of 1837 and 1838 record in sketches. Secondly, his identification of 'the operation of eternal influences, the presence of an Almighty hand' in the natural world looks forward to many later theophanies.[94] Yet in some ways the religious temper of these essays is not remarkable, for, as his mother quickly noticed, Ruskin was less eager about his faith during the time at Oxford ('his

principles of religion are firm, though his feelings seem dead enough'[95]). Nevertheless many future works are intimated in his declaration, first, of the community between minerals and the mountains whence they came and then of their 'design which no architect on earth could ever equal, sculptured by a chisel of unimaginable delicacy, and finished to a degree of perfection, which is unnoticed because it is everywhere'.[96] Otherwise what emerges are glimpses of temperament: the conservative ('The man who could remain a radical in a wood country is a disgrace to his species') and the snobbish, especially in his predilection for Europe ('the mind of the inhabitant of the continent . . . is capable of deeper and finer sensations than that of the islander'[97]). And in stray formulations we catch the engaging mixture of self-assured undergraduate, pretending to more extensive knowledge of European architecture than he yet had, or aping the tones of long-established authorities ('We have always disliked cylindrical chimneys, probably because they put us in mind of glasshouses and manufactories'[98]), yet with some genuine concern to instruct architects' visual taste and a startlingly personal eclecticism of learning:

> Aristotle's definition of pleasure, perhaps the best ever given, is, "an agitation, and settling of the spirit into its own proper nature"; similar, by the by, to the giving of liberty of motion to the molecules of a mineral, followed by their crystallisation, into their own proper form.[99]

Only Ruskin would combine Aristotelean psychology (judging it on the way) with the analogy from mineralogy. It indicates, equally categorically, something of *his* 'own proper form'.

These essays were apparently written by Ruskin with far less parental advice and research than his poetry. The long suffering Mary, in residence at Oxford with Mrs Ruskin, made fair copies for Loudon;[100] but the materials were entirely John's own – his notes, sketches and other memorials of the family tours, including books like Prout's *Sketches in Flanders and Germany*, from which he casually and silently lifted a chimney design to discuss as something the author had observed. So *The Poetry of Architecture*, the first hint of the mature writer, was aptly his own work, even had himself as its own best subject. The poetry for Adèle, by contrast, did not; neither did the prize poetry, laboriously worked over for three successive attempts at the Newdigate Prize, have any autobiographical impulse.

Over both areas of John's poetic endeavour his father presided with a pride still rather painful to observe. Though Loudon had told

John James that 'Your son is certainly the greatest natural genius that ever it has been my fortune to become acquainted with',[101] the father was nonetheless pleased that the *Architectural Magazine* came to an end in 1839: 'Oxford must now be attended to, for it is no joke, and he has but two years. Everything else save F[riendship's] O[ffering] must be dropped.' The pressures were certainly upon John to work for a first, and during the Long Vacation of 1839 Osborne Gordon, a Greek don at Christ Church, read with him at Herne Hill. Earlier in April Mary Richardson writing to a Scots friend obviously voiced the concentrated family effort to ensure suitable academic honours for her cousin:

> John is very busy with his studies, as the time draws near for his final examinations, his labours increase, he goes up (if all is well) this term, next year, for his degree; very few privately educated young men succeed in taking honours, but with John's abilities, if his health will stand it, he ought to try . . .[102]

As she indicates, John's health was always a concern whenever he was forced to exert himself – Margaret reported during one such bout of extra study with Gordon in December 1838 that 'John assures me he has never felt the slightest degree of head ake fatigue or weariness of Brain from what he does at present'.[103] In November 1839 John James raised with another tutor at Christ Church, W. L. Brown, the possibility of his son postponing finals –

> fears that he might not be able to continue to read ten hours daily without which application he did not think he could get through books sufficiently perfectly to enable him to go up for a class.

Brown advised against, and John James derived from their exchange – at least, what he wanted to hear – that the college entertained hopes of a first for his son.[104] Eventually, in March 1840, a combination of nervous ambition and concern for John's health prevailed; John James told W. H. Harrison, editor of *Friendship's Offering* and the correspondent to whom the father now frequently communicated his hopes and fears for his son, that 'He is not going up for a Degree until later which is a great relief to us as he was Killing himself with reading'.[105]

Yet it is doubtful whether overwork was entirely the cause of postponement. Ruskin himself acknowledged in his diary for 7 December 1840 that the 'University . . . nearly floored me, but it had other things allied with it'. Eight days after John James wrote to Harrison he learnt that Adèle Domecq was to be married the next day, 12 March, in Paris.[106] Earlier John had been asking his father whether

he knew the date of her marriage, trying to penetrate the conspiracy of silence about Adèle that his parents had recently adopted. They had made the whole situation worse by their clumsy handling of John's fondness for her. Margaret's confidence, quoted earlier, that 'ladies' were not a 'temptation', may have blinded her to the one girl who was; or she tried to block out the idea, just as she collaborated with her husband's quite strenuous efforts to keep knowledge of Adèle's engagement and marriage from their son.

After Adèle's visit to Herne Hill with her sisters in 1836, John's imagination was obsessed by memories of her, and as late as December, just before coming up to Oxford, he was still sending letters to Paris in an effort to win her esteem. M. Domecq replied only that these 'amused them all very much' and that John's 'Ideas are beautiful and original'.[107] Yet, knowing full well at that stage about their son's passion, John James and Margaret still made no attempt to prevent further contacts: during their summer tour of 1838 the Ruskins visited the Domecq girls at their convent near Chelmsford, Essex, and received them again at Herne Hill that Christmas. In the New Year John James visited the girls' convent by himself, but Margaret is soon writing from Oxford to say that '*We* were not quite satisfied with what of your visit to New Hall you gave us account of – *We* should like to have heard . . .'[108] M. Domecq's death in February 1839 sent John James again to the convent and produced another invitation to Herne Hill, which took place at Easter. Thrown together with her like this, there was no way that John could lose his fancy for Adèle, despite her mirthful scorn and despite her engagement to a Baron Duquesne. John James knew of this development early in January 1839 and commented immediately that 'I wish John could have seen enough of Adèle to cure him of the romance and fever of the passion'.[109]

But he also asked Margaret not to 'say anything till we know more'. From then on the parents tried to see what a total silence ('saying nothing of . . . the Domecqs') could – rather belatedly – achieve; it is possible that they kept Adèle's engagement from John for almost a year. On 28 December 1839, at eight-thirty in the morning, John's diary records simply 'I have lost her'. Two days earlier Adèle had left the convent to return home and prepare for her marriage. In the following February, John James anxiously asks his wife whether she knows how John's 'thoughts are now on a particular subject & how he is prepared to hear of *A*'s marriage. I am anxious about him – because I do not know the depth of the Impression';[110] John James's uncertainties now derived from their campaign of silence. And once

again they kept the news from him – 'say nothing till I have seen my Boy in better health. He cannot hear of it just yet'.[111] They even seemed to blame 'those cursed people' in Paris for their son's ill health and for jeopardizing his academic prospects;[112] but there was no thought that they themselves had acted inappropriately since 1836.

They tried to divert John's attention to other girls – a Miss Wardell and a Miss Withers – but to no avail. John James, of course, in the early stages had been not entirely averse to the idea of a match and as late as January 1839 told his wife how much he liked Adèle (this only three days before he learnt of her engagement).[113] Above all, absurd as it may seem, he approved of her stimulus to his son's muse. In February 1839 the *London Monthly Miscellany* published two poems of John's ("Memory" and "The Name"), both connected with Adèle; John James's comment was 'two beautiful pieces of Johns . . . truly Byron & better than Byron by far'.[114] Either he simply did not read them adequately to register John's unhappiness through their conventionality or, on the vague assumption that the best poets should be tragic, he did nothing to alleviate the young man's afflictions. Verses were sent as regularly as possible to Harrison for *Friendship's Offering* both by John himself ('you will have the positive sweepings of my books'[115]) and more enthusiastically by John James. Harrison himself gladly put the verses into his collections because he calculated on readers admiring their beauties if not always penetrating their sense.[116]

But even more crucial for the father's ambitions and initially, it is fair to say, for his son's, was the Newdigate Poetry Prize in the University. John competed for this in three successive years, winning on his third attempt with a poem on an Indian subject, "Salsette and Elephanta". He himself acknowledged that he 'must give an immense time every day to the Newdigate – which I must have – if study will get it'.[117] The task of refurbishing his verses to suit the rather prescriptive demands of a university prize poem did not always suit either Ruskin's temperament or his poetic tastes. He had received Dale's advice on prize poetry in 1836 with mixed feelings:

> imitate Pope. Now, when I write poetry, I like to imitate nobody. However, one piece of counsel was excellent, viz, to write two poems – one in my own style, the other polished and spoiled up to their standard – so that If I failed to carry all before me with my own, I might be able to fall back upon the other.[118]

The family urged him on with their interest, with appeals to Harrison for his advice,[119] and even contributed research; John James himself seems to have ransacked innumerable tomes of Indian history for the

sake of the successful poem.[120] They were rewarded by the college's acclaim of its author (quoted in the motto to this chapter) and the public reading by John himself in the Sheldonian Theatre, which Margaret was too nervous to attend. John James proudly described the occasion to Harrison:

> There were about 2000 Ladies & Gentlemen to hear it. He was not at all nervous & it went all very well off. The notice taken of him is quite extraordinary. We were taken to meet Wordsworth yesterday & getting next to him I had a delightful hour. His Mother did not venture to go to the Theatre. Oxford is very full & very gay.[121]

John James, understandably, fails to make quite clear to his correspondent that the large attendance had gathered to see an honorary degree conferred upon Wordsworth!

John's self-possession on such an occasion was of a piece with his own judgements upon his work in prose and poetry. A letter of Margaret's during his first year at University (October 1837) suggests that John could see his poetasting simply as something to make his father proud, while he himself maintained his own private valuation of its worth:

> John desires me to say [Margaret is writing to her husband] he most heartily congratulates you on the honourable mention of these poems – the knowing they were so noticed did not appear to affect himself, in the slightest degree – when I said I was glad to see it did not seem to excite him or make him vain, he replied, I am proud enough of my poetry already, I form my own estimate of its worth . . .[122]

Ruskin's own tastes in writing were, I suspect, slowly moving away from his father's; not only did they often disagree about the time to be spent upon it and about matters of style and content ('John begins to soar into that felicitous Region where no Sound of Censure disturbs'[123]), but John's own energies were more excitingly and easily harnessed to work on landscape and architecture for J. C. Loudon. Doubtless the slow success with the Newdigate compared unfavourably with the monthly appearance of his work in the *Architectural Magazine* – Ruskin would always like visibility as a writer and the chance to reach a wide audience; but the praise which *The Times* of 2 February 1839 conferred upon his essays ('most remarkable series . . . the mind of a poet as well as the eye and hand of an artist') must have been sweeter than even the university's acclaim. Ironically, *The Times* praised *The Poetry of Architecture* on the very day that John James was writing enthusiastically to Margaret of his son's Byronish verses. Apart from remaining a conventional and convenient vehicle, either

for his passion for Adèle or to satisfy his father's ambitions, poetry came to offer far less opportunity for the 'refining and subtle thoughts which a great writer embodies'.[124] Within three years the first volume of *Modern Painters* would provide proof even to John James of the accuracy of his son's judgement of his own literary powers.[125]

What with these extra–academic productions, the intensive work on the Newdigate, the extra study which was deemed essential if a privately educated boy should achieve a first-class degree, and his disappointments over Adèle which were finally sharpened at the time of her marriage in March 1840, the strain on Ruskin became too great. One evening at the start of the summer term he was surprised 'by a short tickling cough . . . preceded by a curious sensation in the throat, and followed by a curious taste in the mouth, which I presently perceived to be that of blood'.[126] He went round to his mother's lodgings and she, her vigilance finally justified, put him to bed and sent for the doctor. With the reluctant consent of his college, Ruskin postponed taking his degree and was removed indefinitely to recuperate at Herne Hill.

Chapter 6

'My two bournes of earth' – Italy and Switzerland : 1840–1842

> how often, in the monotony of English scenery, I shall remember that
> panorama of snow and marble, with the wild, sick yearning – the
> desire of the moth for the star, of the night for the morrow.
>
> Ruskin, diary for 23 November 1840

– 1 –

Ruskin's departure from Oxford to recuperate at Herne Hill meant
renewed opportunities to see and think about pictures, all of which
were seized energetically during the spring and summer, simply
because nobody realized at that stage how ill in fact he was. This was
also the time of his momentous meeting with Turner, at a dinner party
on 22 June, laconically recorded in his journal the following day:

> Yesterday at Griffith's at dinner: J. M. W. Turner, Jones, Dr Fitton of
> the Geological, Augustus Liddell. All worked well together, Jones
> laughing at Cambridge and some others of the Royal Dukes, for
> passing over one of his largest pictures, because there was a Chalon [a
> fashionable portrait painter] on each side of it. They knew no more of
> painting than so many infants. Turner talking with great rapture of
> Aosta and Cormayeur.

It epitomizes Ruskin's whole world at this stage of his life – the picture
dealer, Griffith, who was also Turner's agent, the Keeper of the Royal
Academy – George Jones, the President of the Geological Society, a
college friend, the deprecation of the contemporary taste and
Turner's enthusiasm for Alpine scenery.

The social life of this summer of 1840 was doubtless a means of
preventing him from studying, which was forbidden by the doctors,
or from worrying that he was not. Yet it was always exceedingly
difficult for Ruskin to be idle, and 'work' for him encompassed all the
activities of his waking life. He wrote about this self-imposed curricu-
lum of 1840 to his college friend, Clayton: the 'train of work' he had
established involved daily visits to the Academy, when it was open,

'to study Turner', and recording his ideas when he got home; every day he drew a 'little bit of close, hard study' from nature, outdoors or from selected leaves and plants indoors; this in its turn led to his 'ascertaining . . . botanical names and a little microscopic botany'. In addition he read some Renaissance history and art history, which 'involves me also in ecclesiastical questions, requiring the reading of the Fathers (which, however, I have not entered on yet, but am about to do so)'. These studies – which also included 'a little anatomy', technical aspects of painting, geology as a 'corrective' to art, chemistry, Plato in Greek, Tasso to improve his Italian, and some French – are announced with something of a wish, doubtless, to impress his friend; but nonetheless Ruskin set himself a considerable and varied daily programme and it is not surprising that his condition deteriorated.[1]

Social encounters for their own sake he never enjoyed, for he found that he did not 'get much information from general society but I suppose that is my own fault'.[2] But gatherings where he could hear Turner talk, or opportunities to go back to Oxford for a day's sketching with Acland or meet college friends at the British Museum and attend the Geological Society, of which he was made a Fellow in 1840, were so much of a temptation that he overdid things and brought on a second haemorrhage. He was taken to see the Queen's physician, Sir James Clarke, who banned study absolutely unless Ruskin wanted his 'death before you get your degree' and recommended a warner climate. The family made hasty plans for a long winter in Italy; the Christ Church authorities were sent 'fine medical certificates'.[3] Ruskin wrote Clayton that he had 'thrown up reading altogether', but planned to return from Europe with 'quantities of sketches'.[4] As a parting gift Clayton received the latest number of *Friendship's Offering*, which contained six of Ruskin's poems. But the letter which announced that the verses represented 'much lubrication of mine' also contained some interesting remarks on painting; from these it is clear that, despite his illness, Ruskin had, if only vaguely, set his mind upon some larger enquiry into 'high art' that would be written in prose. This enterprise would preoccupy him, even to the point of depression, during the months in Europe.

John James delivered over the sherry business into the hands of his competent clerks and his partner Telford, arranged for the forwarding of all mail from the office in Billiter Street, and set out with his family on 25 September 1840. They would not return to Herne Hill until 29 June the following year; meanwhile they travelled leisurely, nervously attending to John's precarious health, and impressing

themselves upon fellow countrymen as a 'father, a good honest north-countryman, and at the same time London merchant; the son, an Oxford prizeman who draws beautifully'.[5]

Ruskin's illness dogged them throughout the year they were away. The physical symptoms were complicated by unavailing memories of Adèle and the frustrations of having had to give up study and work for the foreseeable future. The general tenor of their recuperative progress across Europe is conveyed in a letter John wrote on the last day of 1840 from Rome to his old tutor, Dale. They had 'sauntered leisurely enough through France, taking some six weeks from Calais to Nice', but Ruskin, though 'certainly better' by the year's end, was

> much checked in all my pursuits from a little inconvenient roughness about the chest, which renders it improper for me to read or draw to any extent, or to do anything that requires stooping, and equally so to take violent or prolonged exercise, or to go out at night, or to saunter in cold galleries, or to talk much, or walk much, or do anything "much", so that I am subject to perpetual mortification in taking care of an absolute nothing, as far as it goes at present.[6]

His remarks probably echo Margaret's constant watchful prohibitions and his resentment of them: 'I can hardly venture anywhere, or do anything, though I am so used to perpetual checks in all I wish to do that I feel it less than others would.'[7] Yet when his health seemed to improve he was able to determine some of his own activities – Rome was not conducive to 'driving, with excited expectations, to particular points' (the parents' preferred mode), but provided much greater delight if 'you saunter leisurely up one street and down another, yielding to every impulse, peeping into every corner, and keeping your observation active'.[8] But he was subject to colds, eye-strain, fevers – from 'sketching in a damp place' or 'from a course of Italian dinners'.[9] After visiting Naples and especially after his ascent of Vesuvius, the 'enormous mass of sulphurous vapour . . . half killed my father, and did not do me much good, for on the way back to Rome I had the most serious attack of the chest affection I have had at all, blood coming three days running . . .'[10] The family waited anxiously at Rome for a month and then decided that they had chosen entirely the wrong climate in which to effect a cure and set out slowly for Switzerland. At last, among mountains to the west of Turin in early June 1841, Ruskin experienced in some kind of epiphany his 'old joy in the Alps' – 'Hughes threw the window open: I looked out and caught the blaze of the pyramid of snow which closes the vally, full fronting

the east sun, and staggered back into the room.' He dressed, rushed down the village street and was quickly 'among the dewy rich pasture – the blaze of the snow on every side, the rocks clear against the heaven and red and steep, and my eyes strangely well'. Thus much his diaries tell us; years later in *Praeterita* he wrote that he descended 'thankfully' from that alpine pasture to his parents and 'told them I was sure I should get well'.[11]

It might be a justifiable conclusion to draw from Ruskin's accounts of his poor health that his illness was deeply rooted in anxieties about his future. It had always been assumed in the family that he would become a clergyman, but at Oxford (as his mother perceived) there was probably some slackening in his own convictions. In a letter to Clayton of 3 June 1840 he epitomized 'the duties of a Clergyman' as 'looking for the old women as they come home with their faggots & asking whether they stole them and then giving them a commentary on the 8th Commandment';[12] the facetious tone of the whole letter makes it difficult to focus Ruskin's own attitudes (as was perhaps intended). But certainly during the continental tour he discovered serious obstacles to a priestly life in his own state of health: 'The least speaking or reading makes me hoarse', he told Clayton from Naples, 'and if I go on for a quarter of an hour my throat gets irritated and makes me cough; so how I am to preach I cannot tell.'[13] Ruskin obviously appreciated Clayton's willingness to listen to his anxieties ('it is nearly impossible to get any quiet or candid criticism'[14]) and wrote him some of the most revealing letters of this time. Ruskin's worries about his health were centred upon what he would do with his life: his illness, he tells Clayton,

> checks one in taking up any design that requires time. I have begun a work of some labour which would take me several years to complete; but I cannot read for it, and do not know how many years I may have for it. I don't know if I shall even be able to get my degree; and so I remain in a jog-trot, sufficient-for-the-day style of occupation – lounging, planless, undecided, and uncomfortable, except when I can get out to sketch – my chief enjoyment. I am beginning to consider the present as the only available time, and in that humour it is impossible to work at anything dry or laborious or useful. I spend my days in a search after present amusement, because I have not spirit enough to labour in the attainment of what I may not have future strength to attain; and yet am restless under the sensation of days perpetually lost and employment perpetually vain.[15]

The letter circles, unconsciously at least, around something crucial, however difficult Ruskin found its expression. When first published in

105

1894 the editor footnoted the phrase, 'a work of some labour', as signifying *Modern Painters*. Correct though that is, the gloss is nevertheless misleading, for Ruskin simply did not know in 1841 that *Modern Painters* would be what he would 'have future strength to attain'.[16]

It would be more accurate to say that he was trying to discover two related modes in which to live his life. One was a suitable literary form in which to express all his ideas on painting, landscape and geology and which would draw substantially upon his 'chief enjoyment', sketching. The other was to provide both himself and his parents with a convincing alternative to the envisaged career in the church. Inasmuch as many Victorian clergymen found time to write, and write voluminously, there was no reason why he could not be both priest and author. But, with his growing unease at the prospect of entering the church, Ruskin needed an alternative career which would absorb *all* his time and energies, allowing him to conduct his life of travel and private absorptions for professional, as it had hitherto been for personal, ends. His Oxford studies he always felt were particularly useless, no doubt because they were the direct and essential route at that time into the church.

'A work of some labour', then, meant nothing very precise to Ruskin during the winter of 1840–1. The dim intuition of some large ambitious project in the letters to Clayton is balanced by the diaries of this continental trip which simply suggest the analytical endeavours of his eye ('the main good of my face, as of my life, is in the eyes'[17]):

> The waves all perfectly clear, and as smooth as glass on their surface; no wind; the swell coming in in waves two hundred yards long, rising six or seven feet, yet with that hesitating fluctuation given to the crest of advancing waves by back water, where the sea is shallow: first sharp and high and nodding, then extending for a moment, then rising again to break, showing the sunlight clear through their body as they bent over, and five or six ranges of them coming in at a time.

Yet it is out of this visual attentiveness, as *Praeterita* admits in the two 'tiresome' chapters rather defensively devoted to this winter abroad, that some of his major work would later emerge.[18] We may see with hindsight that Ruskin had much of the material, including his knowledge of Turner and his 'constant watchfulness',[19] to start on *Modern Painters* as early as 1840–1. That it did not all cohere at this point was recognized by *Praeterita*'s record of 'self-reproach . . . for my idling' at that time.[20] The autobiography extracted from the diaries various manifestations of unease, including his instant dislike of Florence

('barbarous' architecture of the Duomo and the 'nasty muddy ditch' of the Arno[21]) and of Rome ('mummery with Pope and dirty cardinals', 'rubbishy' Capitol, St Peter's 'would make a nice ballroom'[22]). But one passage, also extracted from the journals of 1840–1, reveals more deeply his state of mind:

> I have been walking backwards and forwards on the Pincian, being unable to do anything else since this confounded illness, and trying to find out why every imaginable delight palls so very rapidly on even the keenest feelings. I had all Rome before me – towers, cupolas, cypresses and palaces, mingled in every possible grouping – a light Decemberish mist, mixed with the slightest vestige of wood smoke, hovering between the distances, and between the eye and the sun, giving beautiful grey outlines of every form; the sun itself a little watery, forcing through heavy fleecy fragments of broken cloud covering the whole sky. St Peter's clear, and the masses of the Vatican running white along the hills beside it; St. Onofrio and its hills very indistinct, but the uppermost line of pines showing their broad tops against a line of silver light; the Colonna palace and its pine coming dark against the sun, and the tower of the Capitol rising conspicuous over the city, the centre of interest if not of form. There was a very perfect piece of tower above, broken and varied in form, with a cypress or two; and the marble balustrades of the hill grouped well with the tops of the churches in the Piazza del Popolo. What was more than all to me, on the other side, seen over the rich evergreen oaks of the Borghese gardens, rose a range of dark blue Apennines, with one principal pyramid of pure snow, central and highest, lighted by unbroken sun: for the veil of clouds overhead stopped suddenly at the horizon, and the white mountain caught the full blaze of the noon, and glowed like a piece of sudden comet light fallen on the earth. It was not like moonlight, nor like sun, but as soft as the one and as powerful as the other. And yet with all this around me, I could not *feel* it. I was perfectly well; had no blueness about me, nor anything to prevent me from enjoyment . . . all was exquisitely beautiful, nevertheless; and I saw this, though I could not feel it, and got into a rage with my-self . . .[23]

The trip was full of such moments when he thought he had lost all his 'zest for scenery'. He stood at his window in Naples 'rather with the sense of discharging a duty in drinking the draught of beauty than because it gave me pleasure'.[24] His delight in the Alps, in Italian scenery, in Venice – all seemed diminished.[25] These typically romantic variations on the theme of failed imagination, experienced so sharply on the Pincio, are similar, even indebted, to Wordsworth's "Immortality" or Coleridge's "Dejection" odes.[26] We may not think of Ruskin

in these terms; because his imagination had not yet shown itself capable of major creation, this power could not be thought to have failed; anyhow, medical problems loomed more largely. Yet physical disabilities, as Ruskin occasionally acknowledged, betrayed psychological anxieties.[27] At that window in Naples his sense of simply dutiful, mechanical admiration is explicitly connected with his recognition of a Turner effect on Monte Angelo and his immediate disgust that he 'could not sketch' it. His realization that early childish modes of responding to landscape or early recollections of places visited on previous tours would not suffice him as an adult is another romantic *motif*. Indeed, his diary occasionally reads like a distant echo of Wordsworth's lines on Tintern Abbey, as when in Rome on 4 December he laments 'How every thing loses its delight with its novelty! . . . I admire a good deal more than I did when I was a child, but without the passionate thrill of delight'. Like Wordsworth, if less securely, he will come to recognize the sustaining and restorative powers of memory; but unlike Wordsworth's version of his return to the Wye Valley, Ruskin's meditations in 1840–1 are random and uncertain.

His diary is full of things well seen without concern for feeling. Being written 'neither to please Papa, nor to be printed – with corrections – by Mr Harrison',[28] it was largely the record of 'constant watchfulness', which became his selfish retreat from any other engagement with people or society. He remarked elsewhere that 'My entire delight was in observing without being myself observed – if I could have been invisible, all the better'.[29] Throughout the family's long perambulation, it was into observation that he retreated for privacy and because it made no demands on him in the form of parental anxiety about his health or his future. Indeed, it required little in the way of imaginative resources:

> Saw a great deal of new object about Vesuvius yesterday. The space between the Somma and the cone is a noble extent of drifting ashes, a complete desert, the small craters rising very beautifully; one with an excessively well formed pipe, about two feet wide only, but – from the sound of the stones – fifty or sixty feet deep, the lava rising in a wall round it and hanging over it in a vault, dripping in *form* with stalactitic lava. The communications with each other very distinct, the highest serving to pass on the force from the great crater to the one below it.[30]

Not surprisingly the observations of his 'practised eye' failed to satisfy and the diary itself became 'a great bore to keep'.[31] Even the chief enjoyment of sketching palled during the long trip, largely for similar

reasons. It, too, was obviously a cherished privacy – during the family's trip to Fiesole he sulked because he 'wanted to get back [to Florence] to draw';[32] when he did get the time to himself he 'was as happy as I have been for this last year'.[33] But, increasingly, he became 'disgusted' that he could not sketch.[34] Since the sketches themselves show 'a comparable increase of confidence and skill',[35] his dissatisfactions could only be with his inabilities to break through into a personal style. The diary for 1 February 1841 noted that sketches were satisfactory 'in the inverse ratio of pains taken'; 'pains' meaning careful imitation of others' styles, it reveals his distress that no strictly personal treaty with landscape was yet available to him. Just as he draws with what he later came to call 'the stupid landscape conventionalism'[36] of Prout or David Roberts, he found that often all he could notice in various landscapes were other people's effects, duly noted in the diaries:

> the sun suddenly catching the near woods at their base, already coloured exquisitely by the autumn, with such a burst of robing, penetrating glow as Turner only could even imagine, set off by the grey storm behind.
>
> a thoroughly cold, Copley Fielding hailstorm on the sea
>
> There was an effect on St. Elmo I would have given anything to keep: its beautiful outline was dark against streaks of blue sky and white cloud – horizontal – and yet its mass was touched with sun in places, so as to give it colour and solidity; clouds like smoke, hovering on the hill below, and enclosing the sky opening and the square masses of the city in shade . . . The smoke from the palace manufactory close to me rose in an oblique column, terminating the group with a lovely line of blue mist. It was a Turner.[37]

Furthermore, what was momentary in nature seemed to mock what was timeless or time-taking in art – 'gone before I could sketch' is a frequent refrain.[38] And if nature herself could manage these painterly effects, why sketch at all in visual image or verbal impression?

The Ruskins followed the route of the classical Grand Tour – down the Italian riviera from Genoa to Lucca, Pisa, Florence and Siena; then southwards to Rome, on to Naples, back to Rome; then eventually to Venice, leaving Italy via the lakes and Milan. Such a tour had been calculated to enlarge the traveller's mind, albeit in predictable ways. Typically, Ruskin's experience was a revised version of the usual grand tour education, unsettling his artistic habits, making him more restless than simply anxiety about his health would have done.

Rome and Naples in particular contributed to the tearing of his 'chrysalid envelope'.[39]

Rome disturbed his protestantism and his Proutism. This was due in large measure to a change in the Ruskins' travelling habits. Their social life along the road was cautious, even stand-off-ish in its own approaches, and though Ruskin did not share his father's and mother's inhibitions about their class, he probably did take to a life which absolved him from 'entering into society': he told Clayton after he got home that he much preferred writing a letter to 'uttering absolute truisms' in company.[40] But he had received from Henry Acland two introductions to English artists in Rome, where, since the later eighteenth century, it had been an obligation for most painters and sculptors to visit or live for a while.[41] Contact was accordingly established with Joseph Severn, the companion twenty years before of the dying Keats, and with George Richmond, sometime friend of William Blake. The family was on good terms with them very quickly, and the two artists took their Christmas dinner with the Ruskins. But their patience was obviously sorely tried by John's parade of his odd ideas – 'appalling heresy' to men whose tastes were still loyal to the high academic traditions of eighteenth-century art. John found boring and insincere almost everything that was 'sacred in their sight', what *Praeterita* was still to term 'the autocratic masters and authentic splendours of Rome'. Ruskin's diaries do not chart their difference of opinion, except, early in their acquaintance, to record a 'Long discussion about the beautiful and the picturesque' with Richmond's brother, Thomas, who was 'disagreeable in manner'.[42]

In defiance of the Richmonds' reverence for Titian, Raphael, Domenichino or classical sculpture like the Apollo Belvedere, Ruskin went off to make a 'careful study of old clothes hanging out of old windows in the Jews' quarter'; Thomas Richmond called it his 'Proutism'. Their scepticism made some headway against his prejudices, though Ruskin does not acknowledge it openly. At first, accompanying the Richmonds to museums and galleries, he would make nothing of what they asked him to admire. But by 14 January, now in Naples, he notes how much he could derive from museums 'Had I but time and power to obtain some real knowledge'. Back in Rome he found both the Sistine Chapel and Correggio began to grip him, and further north at Bologna in the 'perfect quiet' of the Accademia (now the important Pinacoteca Nazionale) he was 'raised . . . and put . . . into good emotion' by Raphael's *Ecstasy of St. Cecilia* and work of the Carracci and Guido Reni: 'I never felt as much of reality', he confessed in some of his highest terms, 'in the creations of the great painters or so

much disposition to enter into their enthusiasm.'[43] The Richmonds had at least inaugurated his belated education in art history, though its completion would be always thwarted by a combination of Ruskin's faith in personal judgement, his dogmatism, and the pressure upon his local opinions of the theoretical apparatus that *Modern Painters* established.

With his 'Proutism', some of his protestantism also began to erode, though less significantly. *Praeterita* credits his time in Rome with eventually 'convincing me how guiltily and meanly dead the Protestant mind was to the whole meaning and end of mediaeval Church splendour'.[44] Not that this led him to see contemporary Catholic practice as anything but excessively and corruptly *visual* and with little appeal to the soul. This visual contradiction apart, however, there was an obvious connection between his Proutism and his protestantism: both clung stubbornly to personal judgement, resenting the 'autocratic masters and authentic splendours' of high art and high ritual; both sought out corners where 'little bits of contrasted feeling'[45] could be appreciated. But, just as Proutism lost ground to Raphael or even Guido Reni, so did his protestantism yield, above all, to the music of Italian services. This was due not simply to what, years later, he called 'my native taste for Gregorian chants'; but because he discovered in Rome that the 'voices in the Trinità di Monte did not sing to deceive me'. Ruskin found that the 'complacency of my Puritan creed' was startled; now, for instance, it could recognize that 'the kneeling multitude before the Pontiff were indeed bettered and strengthened by his benediction'.[46] Yet these are the distant perspectives of *Praeterita*, which the diaries do not much confirm except to record his fascination with the music in Roman churches. Occasionally he notes his irritation with their attendance at English services and such entries contrast significantly with his astonishingly favourable response to the Gesù Church ('Lapis lazuli and gold . . . noble forms of silver and bronze') and the 'most exciting, the most tender, and the most sublime' experience of a New Year's Eve service there.[47]

Of all the year away it was probably Naples – surprising as this may be – that proved a turning-point in more ways than one. Even *Praeterita* senses this across the years, though it fails to pin Naples down with Ruskin's customary skill in autobiographical fictions and promotes into the role of major epiphany the decision *in 1842* at Geneva to initiate *Modern Painters*. But at Naples, the landscape asserted itself more strongly against his customary habits: he saw in the distant Capri – never visited – and in Monte S. Angelo mountain

forms that 'were new to me'.[48] His sketches could not 'carry off' their brooding and volcanic sublime, their insistent sense of 'evil, unredeemed'. Even his picturesque habits were abandoned in face of Neopolitan baroque; here perhaps we may also detect some influence of the Richmonds.

At Naples were started those 'trains of thought' which *Praeterita* considered 'did not take clear current till forty years afterwards'; we may perhaps see their eddies and dark whirls much sooner. *The Poetry of Architecture* had celebrated the 'sweet melancholy' of 'Italy's sweet cemetery shore'; now he saw its 'wreck' and its ruin speaking of more crucial matters than delicious nostalgia. 'All the modern life of Italy' began to seem a crime against 'the honour of her ancestors, and the kindness of her God'. The romance of Venice, when they reached it in May 1841, also faded, and he wondered in his diary for the 14th 'why two of the chief corner stones of the Doge's palace should be representations of human weakness'.[49] And he begins to move towards an appreciation of what the first page of *The Stones of Venice* would identify as ruin. Picturesque terminology still, no doubt; but the attitude for which that language spoke, much emancipated.

If the trip abroad started to enlarge his opinions of art and religion, it also worked to confirm him in some narrower habits of living. The relative lack of social life when the Ruskins were on tour – to which their time in Rome proved something of an exception, thanks to Severn and the Richmonds – allowed John, as already stated, to enjoy his own company more often. He came, indeed, to crave the impersonality of non-human society. The diaries have an amusing leitmotif in his fondness for dogs: 'fine black dog visits us here, and came to tea. I must get me a large dog – I value their affection; it is pure gratitude'. Affection from dogs is both undemanding of the human partner ('made acquaintance with a dog by means of some pieces of stray cheese') and rewarding to his ego ('pure gratitude'). At Salerno he found a 'fine, thin, dark-eyed dog, as kind a creature as ever I patted' and other canine bonds were established on the Italian journey.[50]

These might be unremarkable displays of affection from a sickly and lonely young man, whose aimlessness found a casual, answering image in handsome, stray dogs. But at Naples, under the influence of much brooding on Adèle, and 'disgusted with everything but Vesuvius', Ruskin commits to his diary the desire – 'I wish Vesuvius could love me, like a living thing; I would rather make a friend of him than any morsel of humanity'.[51] Its occasion and even its emphasis may be exceptional; but I think it also registers an essential element in Ruskin's make-up: his ultimate preference, not necessarily for the

non-human – on the contrary, he was an enthusiastic and often de-lightful friend – but for relationships on *his* terms. Dogs and volcanoes have in common the advantage that Ruskin's treaty with them is essentially one-sided, the conduct and intensities of which are deter-mined by him alone. He would always resent any social contacts which required of him responsibilities, time and energies that he was unable to proportion and adjudicate. Much travel abroad in the 1840s would confirm this trait alarmingly.

But if your bonds are with places and things which are chosen because they cannot reciprocate, yet you value affection, then almost necessarily a restlessness will set in, urging you on from place to place to claim those bonds. The Ruskins' fairly luxurious travel, with its ceaseless forward momentum and no precise destination or schedule, did nothing to allay John's dissatisfactions: one day he 'never can enjoy any place till I come to it the second time', and five days later he is 'disappointed with [Itri, north of Naples] – always am with second sights'.[52] Sometimes he would respond with the reiterated wish to stay in one place, when their progress determined otherwise. But on other occasions there would be an insistent longing for any scenery other than what was around him – at Salerno, for instance, he was 'always wanting to get to any part of the coast than that I have reached'.[53] He quickly became self-conscious about this restlessness: 'I am getting tired of Rome as I thought I should, and long for Venice and the Alps. When I get there I shall long for home; and when I get home, for Rome.'[54] Much of this feeling was due to the circumstances of his poor health on this trip, but two aspects were more permanent.

One was his need for known places. On the slow journey north from Rome, when it had been decided to make for the mountains, but they were still some way from the familiar Padua, he complained at Foligno that 'I am sick of strange places'; and arriving at Venice, he knew at once that 'This and Chamouni are my two bournes of earth'.[55] But the image strikingly reveals how much his nomadic instinct was essential to him. From 1840 until 1888, when he was brought back for the last time from the continent, he was never in England for very long at a time.[56] Two bournes were exactly what Ruskin needed. He could think of one when at the other. Indeed, from Venice he often enjoyed seeing the mountains to the north beyond Murano, confident that he would have to cross them later. At the lowest moments of his 1840–1 trip, when he thought he might die or lose his sight, it was 'in Italy or Switzerland'[57] that he felt he would remain, for 'What have I to go home for?' Yet 'home' turned out to be the place where he would go 'to get up the steam again' for more travelling, and when he

wearied of this journey he 'would hardly stop, even in Switzerland' until he had reached the comfort and predictable contexts of his own house with its inner sanctum of study.[58] And there the cycle of longing and then departing began over again. It was a human pattern of behaviour which he generalized about in his journal, without entirely registering either his own particular addiction to it or his own good fortune in being able to do what so 'few of the inhabitants of earth' actually achieve – spending 'even the thousandth of their lives' in such Edenic places as the lakeside near Geneva with its view of Mont Blanc:

> And of those who can – how few know what is in their power! Many living there in the sulky necessities of economy, pinching and puling in Paradise, for the sake of a month's ostentation in a very different place – the Champs Elysées . . .

where Adèle had lived, in the elysian fields of Paris, which he realized might have been another 'bourne of earth', except that it 'has become all pain' –[59]

> others to boast of their villa at Geneva – others to yacht, or to fish, or settling by mere chance; born about the place, and having their country house as a matter of course; perhaps not one of the whole set in the slightest degree aware of what he has in his power – and how many thousand hearts would die of delight in an hour's habitation of such a spot.[60]

Ruskin would enjoy many such an hour's delight, at Geneva, up at Chamonix or on the other side of the Alps at Venice. But two bournes, he discovered in 1841, were a necessity, it being always essential to have a place elsewhere. This is why he delighted so much in hills and mountains, endlessly suggestive of unseen, yet to be explored, heights and valleys beyond,[61] and why, too, during his time in Rome when still brooding on the loss of Adèle, he could be tempted to church in the hope of glimpsing

> at intervals, above the bowed heads of the Italian crowd, for an instant or two before she stooped – or sometimes, eminent in her grace above a stunted group of them, a fair English girl, who was not only the admitted Queen of beauty in the English circle of that winter in Rome, but was so, in the kind of beauty which I had only hitherto dreamed of as possible . . .

He never got 'nearer than within fifty yards of her'; one of Ruskin's biographers writes that it did not seem to occur to him that 'Severn could easily have arranged an introduction'.[62] But surely it was precisely the 'mere chance glimpses of her far away' that mattered to him,

not acquaintance. As it happened she would enter his life again some twenty years later; but not then as the agent of 'light and solace' which, unencountered, and seen like mountains at a distance, she was for him in Rome.

His constant pining for Adèle was metamorphosed into a similar yearning for the unattainable. On the one hand he worked on the long poem, "The Broken Chain"; on the other, with less effort, he gave his failed romance its own mystery and cult, as he honoured the anniversaries of his grief.[63] The language of his recollections becomes utterly sentimental when – a year after Adèle's marriage – Ruskin notes that 'she cast from her the truest heart – as true at least as ever man gave'.[64] He discovers her face among people he meets on the Naples streets, and this evidently factitious emotion reaches a peak when he arrives in Venice, a city where he had woven his love for Adèle with second-hand impressions out of Byron, Rogers and Shakespeare: 'the outlines of St Mark's thrill me as if they had been traced by A[dèle']s hand'.[65] Now the sketching metaphor is unconsciously apt – for what he sees and recalls are really not his own recollections. Just as seeing Europe through painters' eyes began to bore him, so did memories of cities where fancy had assumed priority over the true, factually-based work of the imagination. And significantly he soon discovered that all went 'wrong with my drawing' in Venice.[66] Neither Adèle's hand nor Prout's could recreate an image of a scenery that demanded a far more strenuous, first-hand involvement.[67]

When they moved on to Milan from Venice, this same lack of lustre in favourite places began to find hints of a solution:

> What a strange place this is to me – strange, I mean, in the alienation sense. I remember it, well [from his 1835 visit]; I am disappointed – on the contrary – in nothing; but it seems a totally different place. It is the utter change of feeling I suppose, but it is odd that the sight of the actual place has thrust away the memory of the old feelings totally.[68]

He goes on at once to adjure himself to 'note facts and let fancies alone'. Later still, at Geneva, on Sunday 6 June, he resolved to 'be always trying to get knowledge of some kind or other . . . some real available, continuing, good, rather than the mere amusement of the time'.[69] So he returns to his favourite perusal of the river's colours:

> Rhone has been green all day instead of blue. Looking through it, the colour is decided green; but along the surface it is blue – very like fluor spa. Notice effect: reflection taking off light from ripple, shows in transparent green, very slightly affected by colour of object. The

chimney of steamer opposite is rich brown inclining to red, but its
reflection is still green, a little dirtied by the red colour.

This resolution to attend to the facts of the natural world, always – as
he notes – slipping afterwards, is forced upon him as a direct result of
the family's habitual Sunday observances, despondent records of
which punctuate his continental diary: 'slow extempore sermon from
a weak-voiced man in a white-arched small chapel, with a braying
organ, and doggerel hymns'. One suspects that Ruskin saw his own
future self in these pathetic clergy and dispiriting protestant cells
across catholic Europe and made prompt resolutions to escape. Yet to
avert the prospect he must discover and devote himself resolutely to
'some real available, continuing good'.[70]

The search for some access to that dimly recognized alternative
preoccupied him throughout Europe, both openly, in the course of
letters to Clayton, and more unconsciously in his journal. He
chronicles almost every day, for instance, some perfect experience in a
flood of superlatives too numerous to tabulate here:

Altogether the happiest day, as far as employment or scenery can go, I
have had for these five years . . .

one of the purest skies I ever remember . . .

the richest thing I have yet seen for colour . . .

olives the largest I have yet seen . . .

rising by a beautifully contrived crescendo into a crash of music as
exciting as any I have yet heard . . .[71]

And so on. Even days of particular frustration and disillusion yield
their saving perfection. They slacken off only when the momentum of
rival disappointments becomes too insistent at the end of a long and
wearing trip. While they last they have often the air of being induced
or seized as intimations of the longed-for rekindling of his imagina-
tion. But his desperate need to be moved by some special quality of
experience turned frequently into a recognition of his passivity: at
Naples, for example, he experienced 'a quarter of an hour, perhaps, of
nearly perfect contentment, wonder, and observation, and full and
easy mental occupation'.[72] The easiness disturbed him and he soon
succumbed to a new 'restlessness, the desire to see something finer,
newer, different'.

All his former uncertainties about centring his interests on the
study of landscapes were revived. From Naples he argues with
Clayton about the religious nature of such a discipline:

You say that infinity of conception ought to belong only to religion. Granted. But what object or sensation in earth or heaven has not religion in it – that is, has not something to do with God, and therefore with both infinity and mystery?[73]

A determination to acknowledge the infinite and mysterious presence of God in experience may well explain some of the superlatives in Ruskin's diary. But, as *The Poetry of Architecture* had tentatively discovered, response to landscape was a two-way process: if infinity and mystery were already part of scenery, was the spectator, as Ruskin sometimes seemed to be, merely passive? Were they facts, not to be intermeddled with fancies? On the contrary, Ruskin's own fervent involvements and associations with landscape showed him that he, too, contributed to the experience; the problem was what and how. He took up that problem in another, long letter to Clayton from Venice, in which he tried to organize his ideas on the 'very ambiguous word . . . association'.

He distinguished four meanings: a 'legitimate historical interest', whereby our connecting some scene with a historical figure or event enhances our pleasure, but does not make the stones or the grass 'one bit prettier'; seeing 'God's power in the great deep', which is apparently 'actual observation of interesting fact'; aesthetic beauty; and the one usage of the word *association* which he does think proper, namely to describe a quite 'illegitimate connection' between 'some stick or stone of particular form' and 'some particularly pleasurable passage or moment of your life' when that chance sighting of the object occurred.[74] Theoretically, this letter to Clayton is a very satisfactory account of something that 'not one of our tastes is entirely free from'. But in practice Ruskin had tended to rely largely upon the fourth of his associative modes, the arbitrary connections he had made between himself and places visited; with the result that cities like Milan and even Venice itself, around which old fancies had curled during the 1830s, simply disappointed: 'the whole [of Venice] is not up to my recollections of it, and a little of my romance is going'.[75]

The problems with his sketching, with his responses to landscape and with his recollections and associations, all seemed to come to a head as Ruskin neared home. His memory failed him persistently now – at the very end of their journey he had 'forgotten half of what I saw in France already'[76] – or became very erratic. Thus a late afternoon on the beach at Naples on the eve of his twenty-second birthday, with Capri in the distance, seemed unforgettable: 'These pleasures are always moments – I had no time to stay; obliged to leave it, but shall not forget it.' Two months later in Venice, however, he can recall it no

longer. A year later at Herne Hill, re-reading his diaries, 'I remember it again now. Odd'.[77] He lost the flavour of what had hitherto been his greatest stimulus, the serendipity of picturesque travel, chance encounters of leisurely sauntering, the '*yielding* to every impulse' or to 'little bits of contrasted feeling' among Roman streets, or waiting for a scene to afford 'instant' compositions of grouping and finish.[78] He began to record that he was finding 'several first impressions on this journey woefully false'.[79] It was partly that he settled for what he called 'exaggerations' of items like the Trevi fountain,[80] partly that he opted for visual notations that seemed to prove right those Oxford friends who had thought his sketches useless for serious architectural study.[81] Visual facility, especially in landscape, but in Italian townscapes as well, prevented him discovering a less mediated response – 'As I get experience in scenery, however, I find it more and more difficult to get a strong impression; partly because there is, and must be, a sameness in all, even mountain scenery; the same great outlines perpetually recurring.'[82]

<center>– 2 –</center>

From Venice in May 1841 he wrote to Clayton to say that he did not know what he would do when he got home; his eyes were too weak for him to think of settling back into work for a degree – 'nor have I much cause so to do for a year or two, as I can undertake no duties'.[83] To Dale he also wrote during the last weeks of their European trip to say that he was 'obliged, for the present, to give up thought of University or anything else'; he offers in rather nervous defence of this decision that 'hard mental labour of any kind hurts me instantly'.[84] Despite Ruskin's confidence in this 'simple physical fact', it is not clear that the medical state he describes ('during laborious thought the breath is involuntarily held and the chest contracted for minutes together') is unconnected with worries over the future. He assured Dale that some drawing at the easel (which 'requires neither stooping nor labour of mind'), a little geology, chemistry and Greek ('to give some steadiness to the day') would continue. But to Clayton, who had not been his teacher, he was much more revealing:

> I was thinking of getting some small place in Wales for a laboratory, and to hold my minerals, among the hills, where I could have a poney [sic] and grow my own cabbages; and then you must come and stay with me, and plan rooms and put up bookcases together.[85]

It was a vision of hills, of his own cabinet of curiosities, his own self-sufficiency (funded, of course, from Herne Hill), and of being away from his parents and with a companion of his own.

He spent a month at home, dining out at Griffith's with Turner once again and making some small excursions. And the Ruskins entertained the family of George Gray, an old solicitor friend and distant relation of John James. The Gray's daughter, Euphemia (known as Effie), was obviously intrigued by the brilliant, rather sickly, young son of the house, who displayed his drawings, mineral specimens and other precious souvenirs of his continental tours. Being only thirteen, she wished rather that he would compose fairy tales, and, with his instinct for pleasing and instructing, he promised to do so.[86]

Ruskin's Welsh dream materialized to the extent that his parents allowed him to travel for the first time without them (but not apparently to take a cottage); his childhood companion, Richard Fell, replaced Clayton as the sharer of these new freedoms. But he also promised his parents to call at Leamington Spa en route for Wales to consult a Dr Jephson, 'called a quack by all the Faculty',[87] but of whom the Ruskins had heard good things. Jephson recognized at once what John himself had told Dale in the letter from Lausanne – that 'perfectly regular habits of life, the direct contrary of those necessarily induced by travelling, with fresh air and easy occupation' would restore him. Ruskin wanted to undertake Jephson's course of treatment on *his* terms – namely, while continuing with the Welsh journey; but the doctor said that his cure would only work if the patient stayed in Leamington. Seeing merely the reputed quackery, Ruskin left, wrote a full account of the interview to his father and travelled to join Fell in Wales. Soon, however, a letter from Herne Hill ordered him back to Leamington.

What he missed, as a consequence of his filial obedience, and postponed until 1845 was the delightful experience of exploring alone (excepting always the presence of his valet, John Hobbs, known as 'George' to save confusions in the family). Two surviving diary entries suggest the joys of his brief freedom in Wales, making 'the most', as he recorded, of daylight hours, rambling with 'an old horse . . . and . . . with George' until they found, down a narrow lane of copse and nuts, a 'dingle between two bare and pretty bold rocky hills' and then a mill-race with a precarious trunk thrown across; among these suggestive scenes he was 'happier than I had been for five years'.[88]

53 Russell Terrace, Leamington ('a small square brick lodging-

house, number what you will of its row, looking out on a bit of suburban paddock, and a broken paling; mean litter everywhere about'[89]) was, however, an experience altogether new. The doctor's régime was calculated to subdue Ruskin's 'luxurious life' to a simple, healthy normality that he later compared to the family's 'Croydon level':

> Salt water from the Wells in the morning, and iron, visibly glittering in deposit at bottom of glass, twice a day. Breakfast at eight, with herb tea – dandelion, I think; dinner at one, supper at six, both of meat, bread, and water, only; fish, meat or fowl, as I chose, but only one dish of the meat chosen, and no vegetables nor fruit. Walk, forenoon and afternoon, and early to bed.

And Ruskin rather enjoyed it. His health improved; he put on weight, read in his usual eclectic fashion – Agassiz's *Poissons Fossiles*, Marryat, Scott's *Kenilworth* and Alison's *History of Europe* – painted the Château of Amboise at sunset 'in Turner's grandest manner' – and, between letters home which took the place of his diary entries at Leamington, re-read the journal of his last continental journey. In the 'uncommonly monotonous' days at Leamington he began to relish the memories of his time abroad almost as much as actually jogging 'over the dusty roads and jolting pavés':

> I am very glad to find that if I was pretty well satiated with the nine months abroad, I am recovering my fresh feeling very fast. I am nearly ready for another start already. I feel rather poetical about Naples and Rome, and yearn for Milan again, and my beloved Alps. I turned quite sick with longing this afternoon when I looked round and round the horizon and found not one rising ground to refresh the eye, or relieve the dead flatness of country and emotion.

Since the retrospect was so pleasing, his Leamington journal took the characteristic form of glossing and annotating the record of his time abroad, expanding and clarifying what his memory now registered as more important.[90]

During this period of rest, which he would always need after particularly hard or exhausting travel and work, he was not only getting up steam for further excursions, but reassessing himself and his various activities. He seemed especially distressed at his failure to advance in 'real laborious knowledge'. His careful plodding through Agassiz made him realize that it was no way to pursue the study of geology ('it didn't matter a stale herring to any mortal whether [the fish fossils] had any names or not') and that the artist who had engraved Agassiz's book was the 'real genius'. Better to learn to see

and draw clearly or to catch a chub in the nearby Avon and cook it 'spicily and herbaceously, so as to have pleased Izaak Walton, if the odour of it could reach him in the Anglers' Paradise'.[91] There would always be this physical and practical side to Ruskin – yearning for an energetic life of swimming and climbing, nostalgic for a skilled occupation of builder or carver; yet it would dwindle into ineffective projects or the slightly silly recommendations to readers of St. Mark's Rest to learn for themselves about the carving of capitals by experimenting with a pound of Gruyère cheese.[92]

His own work, too, failed to satisfy as much as had Agassiz's learned classifications. A drawing of the Château of Amboise, to illustrate his poem "The Broken Chain", was as meticulously Turnerian, second-hand and laboured as the other's numbering of fishes' scales. Even the fairy tale he was writing for Effie Gray was pastiche Grimm and Dickens, though 'mixed with a little true Alpine feeling of my own'. The King of the Golden River, written at Leamington but not published until 1850, certainly puts its Turnerian mountainscapes at the centre of the tale; in descriptions of the sublime mingling of cloud and crag or the plunging Golden River with the 'double arch of a broad purple rainbow stretched across it' Ruskin seems to be seeking verbal equivalents for Turner's effects, which even include apocalyptic imagery of a fatal sunset, 'a mist . . . the colour of blood' and a fascination with phosphorescence. The characters serve largely as mythological dramatizations of attitudes towards this scenery. In such emphases Ruskin reveals himself clearly, as he does in the whole plot, which records the destruction of an Edenic happy valley and its recovery through charity. This virtue is significantly exercised by the good brother, Gluck, upon a 'Poor beastie' of a dog; Good Samaritan-like, he turns aside from his search for the gold to succour it with the last of his precious water; his elder, wicked brothers were not vouchsafed this canine encounter at the climax of their quests.[93]

Behind these literary productions and self-assessment lurked always the larger concern with his career. On 22 September he wrote about it to Dale in reply to what appears to have been an invitation to discuss the whole problem with his former tutor. Ruskin's main argument, shrewdly carried even to tendentiousness, is that since the major Christian duty is to save souls, no real distinction can be made 'between laymen and churchmen with regard to the claims of this duty'. Thus anyone who believes in Christ is 'called upon to become a full and perfect priest'. Having thus deployed the evangelical argument, he seems next to give away a position that he had taken against his teacher in 1836 and would presumably still wish to hold:

does the pursuit of any art or science, for the mere sake of the resultant beauty or knowledge, tend to forward this end? That such pursuits are beneficial and ennobling to our nature is self-evident, but have we leisure for them in our perilous circumstances? Is it a time to be spelling of letters, or touching of strings, counting stars or crystallising dewdrops, while the earth is failing under our feet, and our fellows are departing every instant into eternal pain?[94]

It was a question that Ruskin found himself confronting in various guises throughout his career, an inescapable legacy of his evangelical upbringing. In addressing Dale, he allows that the Christian potential of a Galileo, Raphael or Handel was better employed than it would have been in 'direct priestly exertion'; but he does this only to raise – with himself in mind – the question of men with no more than 'average intellect'. They have so little chance to become a Newton or a Michelangelo that it seems better to take up their 'plain duties in which *all* can be of effective service'. The questions seem level and neutral, attentive to Dale's obvious attitudes; but the initial premise – that in following the prime obligation to save souls we are all perfect priests – allows Ruskin room to save souls, so to speak, in his own way, which would be the central if always constantly adjusted basis of *Modern Painters* and *The Stones of Venice*. He closes the letter to Dale by admitting his 'little pleasure in the idea of entering the Church', his long and 'settled' desire to study art and science, yet his fear that a career which was dedicated to those would be simply 'biassed by inclinations'. Above all the letter suggests dutiful submission as well as a mind largely determined to save fellow humans in its own way. The choice of Dale as a disputant implies a deliberate choice of an opponent whose scepticisms of the moral efficacy of novels were known and – since Ruskin loved arguing[95] – an opponent who could be relied upon to provide the very arguments which Ruskin had himself rejected.

Perhaps it was no accident that after Jephson's cure was completed ('Set free at last . . . from this confounded hole'[96]) Ruskin went to stay with his college tutor, Walter Brown, who was now rector of Wendlebury, north of Oxford. Did he want to test his resolution not to become a clergyman at first hand? *Praeterita*, with its rather condescending narrative of the visit, certainly implies that; his diary merely records – not at all an insignificant fact, if Ruskin were contemplating vicarage facilities – that he could only write in his bedroom and that when he accompanied Brown on some pastoral calls, he was not enamoured of 'cottage life', although the cottages were picturesque.[97]

By 16 November he was back at Herne Hill and had 'got my

rooms in order at last', a nervous habit of reorganization that he indulged from time to time whenever he wished to postpone the next batch of work ('there is something for a studious person in the arrangement of his room'). He admits in *Praeterita* that they were never tidy three days later.[98] But with the study in order, he 'set to work on my reading . . . methodically, but not hard'.[99] Osborne Gordon, who had been his tutor at Christ Church and who had visited him at Leamington, was invited to coach him for his Oxford finals. To sweeten the pill of all this, J. D. Harding was also tempted to give John drawing lessons. So the winter passed in preparing for a degree, one consequence of which would be the need to make a final choice about entering the church. There was some social life – dinners at Herne Hill, taking the Severns to visit Turner, studying Claude drawings at the British Museum with college friends – but not enough either to divert his main energies or to impose upon him. If a final realization at Leamington was that he became 'tired of living alone – a wonder for me',[100] then a return to Herne Hill, where everything was organized to please and sustain him without much obligation, provided the ideal compromise. There was the underlying anxiety about the future, and the infuriating failure to buy Turner's *Splügen* watercolour. This had a double consequence: a recognition, intenser because of the loss, of a new Turner mode – 'straight impressions from nature' – and the sense of some rift between father and son; John James, in fact, spent many years trying to gain the *Splügen* until, when its owner asked 400 guineas, he gave up.[101]

In April 1842 John went up to Oxford once more and in May sat his examinations. He entered simply for a pass degree, but the examiners were impressed and he received the unsolicited honour of being given a complimentary fourth class in both classics and mathematics. The whole Oxford episode, in part simply an extension of his father's ambitions, led Ruskin to develop an intense and, in later life, much reiterated dislike of competitive examinations.[102] He had already, in a letter to Dale from Rome in 1840, when the completion of his Oxford studies still hung over him, expressed a desire 'to see the class system abolished at Oxford':

> For those who obtain honours are usually such as would have been high in scholarship without any such inducement, who are, in fact, above their trial and take their position as a matter of course and a thing of no consequence. To these the honour is a matter of little gratification and of less utility. But the flock of lower standard men of my stamp, and men below me, who look to the honour at the end, and strain their faculties to the utmost to obtain it, not only have to sustain

hours of ponderous anxiety and burning disappointment, such as I have seen in some, enough to eat their life away, but sustain a bodily and intellectual injury, which nothing can ever do away with or compensate for.[103]

Doubtless the depressions of that winter and his own uncertainties as to how and where to make his mark contributed to that analysis. But in a sense he was also right: not only about his scholarship, which was always of a 'lower standard', but also about the irrelevance to his career as writer and critic of this struggle through the Oxford curriculum.

His first reaction to having Oxford behind him was to 'walk in the fields north of New College . . . happy in the sense of recovered freedom, but extremely doubtful to what use I should put it'.[104] This purposeless freedom was extended by his 'utterly indulgent father', who once again took the family across France – Rouen, Chartres, Fontainebleau, Auxerre – to spend the summer at Chamonix, one of his son's 'two bournes of earth'. To make the journey easier, the old family travelling coach, something of an encumbrance on bad roads or in narrow streets, was replaced by a 'light two-horse carriage', in which rode John James and Margaret, and a second one, made to Ruskin's own design, for himself: 'front and side pockets for books and picked up stones; and hung very low, with a fixed side step, which he could get off and on while the horses were at the trot; and at any rise or fall of the road, relieve them, and get his own walk, without troubling the driver to think of him'.[105] A yet more important advantage was the freedom it gave to Ruskin to pursue his own explorations along the route without delaying or treating for extra time with his parents.

So it was a relaxed holiday of indulgent nostalgia ('walked up the same path I climbed seven years ago, and have longed for ever since'[106]) and careful scrutiny of natural effects. His diary, which he gave as a present to Charles Eliot Norton in 1872, is carefully written in the parts that concern the outward journey and their stay at Chamonix, as if fair-copied or written up selectively from notes. At Lausanne on the way home Ruskin noted that 'I have lost a good deal of information because I wanted to write it more legibly than usual';[107] from then on the handwriting deteriorates. But the neatly rendered sections are also conspicuous both for their precision of verbal commentary on visible forms and the careful collaboration in his notations between verbal and visual:

Flower of Jura pasturage gathered at Les Rousses; [illustration in text i] creeping root; leaves at bottom, as at *a*, top *b*; great deal – complete

covering of white wool on stalk; some on under side of leaves. Each floweret forming cluster composed of a central bundle of straight,

This appears to be the Gnaphalium loicum, a mountain cotton weed

white, silky hairs, with flat top; taper leaves emerging from sides, as *c*, perhaps some thicker in proportion, passing from green through white to pink. I think they, or some of them, are cloven at the top, but can't make out. Seems an everlasting; at least, has been in my pocket all night, is not withered now.[108]

These records, with their renewed eagerness of attention and transcription, were unavailable to Ruskin when he wrote the relevant sections of *Praeterita* (by then he had forgotten the gift of the diary to Norton). But with his instinct for symbolic truth in history – personal or public – he invented the two most resonant of the autobiography's 'epiphanies' in order to signal his recollection of this important summer, when he decided to write *Modern Painters*. These incidents were both connected with precision in sketching natural forms and with his acknowledging a subject's *quiddity* or *haecceitas* as opposed to merely arranging it in an acceptable 'composition'.[109] Both fictions were doubtless elaborated in the 1880s out of memories of real events, which may or may not have occurred about this time. Neither, it is now agreed, is documented by the diaries; but that is not always an infallible test with Ruskin, and the second, at least, has some support in the journal. Both the episodes may be seen as clarifying the set of mind which mattered most to him in 1842 and exemplifying a 'nature . . . interpreted and rendered stable by art',[110] which he would soon be writing about in *Modern Painters*.

The first of these 'epiphanies' supposedly occurred just before he went back to Oxford to sit his examination and involved sketching a 'bit of ivy round a thorn stem' on the road from Herne Hill to Norwood; the second was his drawing of a 'small aspen tree against the blue sky' of Fontainebleau during their journey across France a few

months later.[111] On both occasions, so *Praeterita* has it, his old habits of picturesque draughtsmanship surrendered to 'beautiful lines [which] insisted on being traced' and to 'finer laws [of composition] than any known of men'. The ivy and the aspen yielded their lines without any apparent mediation. *Praeterita* glosses this as insight into the divinely ordained beauty of the natural world and as Ruskin's future 'bond between the human mind and all visible things'. Accordingly the name of Fontainebleau is translated ('Fountain of Fair Water') to emphasize both the 'source' of his career as critic and, with its biblical resonance, the type of all good inspiration.

Now the 1842 diary corroborates the spirit if not the facts of these later versions. At Fontainebleau itself he noted on 1 June his sighting of a 'new tree, like a sweet chestnut, not so starry in arrangement of leaves'. Six days later, by now at Foligny, he recorded 'As unprofitable a week as I ever spent in my life', *except that* 'I got some new ideas in my evening walk at Fontainbleau on the 1st'; these came from 'a most profitable half hour lying under the copse on the hill top'. Years later and without the diary before him that event was recollected and metamorphosed into *Praeterita*'s 'lying on the bank of a cart-road in the sand, with no prospect whatever but that small aspen tree'.

What is clear is that in 1842 Ruskin received a series of interrelated lessons, some of which had roots in the dissatisfactions of the 1840–1 tour: that his mannered draughtsmanship got in the way of its subjects; that things themselves had 'composition' enough; that to see and record, visually and verbally, was a sufficient service and a necessary duty. As he would write in the middle volume of *Modern Painters*, 'Hundreds of people can talk for one who can think, but thousands can think for one who can see. To see clearly is poetry, prophecy, and religion – all in one.'[112] Furthermore both the ivy and the aspen epiphanies are ways of announcing his own adjustments to Turner's fresh treaties with the natural world in the 1840s. The painter's 'straight impressions from nature', coinciding with – maybe initiating – Ruskin's own change of style, were undoubtedly the great catalyst of this summer. Provoked by the renewed hostility towards Turner in the magazines, which were forwarded to the Ruskins in Geneva by W. H. Harrison, the decision to make his 'work of some labour' into a defence of Turner's art and of its superior attention to and transcription of natural things either was taken or simply crystallized. An epilogue to *Modern Painters* II would link Ruskin's admiration for the *Splügen* drawing in 1842 with his subsequent 'mountain-studies and geological researches'.[113]

But such an enterprise was germinating throughout the previous

two years. During the winter of 1840–1 he had known his sketching was laboured but could not seem to break out of the impacted mannerism of many years. In Rome especially he had objected to the Forum's good grouping of smashed columns ('kind of thing one is sick to death of in "compositions" '[114]). All these frustrations came to a head, as we have seen, in the small chapel at Geneva, with its pitiable clergyman. There Ruskin experienced a 'fit of self reproach' for his idling, apparently more extreme than similar moments on other Sundays. An exactly similar crisis in his self-scrutiny, according to Ruskin, occurred in 1842 in church at Geneva, when the family was en route for Chamonix. The only Sunday that fits this version of events is 12 June 1842; however, the diary for that day is unusually dull and routine. But six months later, on 11 December 1842, he annotated the *1841* Geneva entry with 'Very odd: exactly the same fit came on me in the same church next year, and was the origin of Turner's Work.'[115] By the time this crucial annotation was made Ruskin was hard at work on the first volume of *Modern Painters* and had finally relinquished any thought of taking orders. Could it be that he simply gathered the whole tenor and bias of his life during 1840–2 into one dramatic episode so as to signal the beginning of what he now realized in December 1842 was his career as a critic?[116] By 1844 this version had been further stabilized and augmented with circumstantial details in a letter to Osborne Gordon,[117] even though the person to whom this elaborated narrative was addressed had actually been with him in Chamonix in 1842, a couple of weeks after the supposedly momentous Sunday, and might be expected to have shared its exciting decision.

But Ruskin's summer in Chamonix, as recorded by him at the time, was not preoccupied at all with such future projects. He explored the various parts of the valley each day, more energetic than he had been for some time, more careful to record his impressions and finds, more delighted with the constantly shifting patterns of the mountains:

> The wind changed about half past six and a succession of openings [in the clouds] took place, first on summit, then on Dome du Gouté, then on the Aiguilles, taking the Verte last, presenting on the whole by far the most magnificent series of spectacles I have seen at Chamoni or in my life[118]

On the return journey his mind was still full of Alpine wonders – 'I consider myself, looking back, as more fortunate in the single avalanche I saw from the Breven with Gordon than even in all the fine weather I had in Chamouni.'

But at Mannheim on 31 July he does record what is the most momentous entry, missed by the commentators, to the simple effect that 'I fear I shall have to give up Arch[itecture]: too many irons in fire.' The decision to concentrate on modern painting has presumably already begun to enforce its priorities. Typically, the diary goes on with architectural matters, but at Antwerp in August he makes a long and detailed memorandum on paintings. Back in England, once the family had moved to a larger house on Denmark Hill and he had presumably 'put my rooms in order', he began writing.

Chapter 7

'The Building of a Large Book' – Modern Painters

[Turner] is the epitome of all art, the concentration of all power; there is nothing that ever artist was celebrated for, that he cannot do better than the most celebrated. He seems to have seen everything, remembered everything, spiritualized everything in the visible world; there is nothing he has not done, nothing that he dares not do; when he dies, there will be more of nature and her mysteries forgotten in one sob, than will be learnt again by the eyes of a generation.

Ruskin to Edward Clayton, 3 December 1840

The book which Ruskin began to write in the winter of 1842 was to be finished only in 1860. Its 'building' was never at the start envisaged as taking so long or covering so much ground. Nor did Ruskin, of course, foresee that after its first volume was issued in May 1843 his interests and tastes would change, making the second volume of an awkwardly different character and leading him back into the architectural work which he had supposedly abandoned at Mannheim in 1842. Once *The Seven Lamps of Architecture* and the three volumes of *The Stones of Venice* were written and he returned to *Modern Painters* he found that his ideas and preoccupations had once again shifted decisively, and the final three volumes of his project had to accommodate both these and his old programme of defending Turner. The evolution of *Modern Painters* and – what are, in my opinion – its intricately related 'parallel texts', *Seven Lamps* and *Stones of Venice*, together with its 'codas', *The Political Economy of Art* and *Unto this Last*, are fundamental to understanding Ruskin's life and have important consequences, too, for our reading of the works by themselves. Yet his critics can wax severe about his inability to avoid digressions and even Ruskin himself could become defensive about his own 'diffuseness':

In the building of a large book, there are always places where an indulged diffuseness weakens the fancy, and prolonged strain subdues the energy: when we have time to say all we wish, we usually wish to

say more than enough; and there are few subjects we can have the pride of exhausting, without wearying the listener.[1]

So it is important to clarify the nature of his approach to the completion of *Modern Painters*.

Something in miniature of the book's development may be gauged from the letter he wrote to Gordon in 1844 defending the career of art critic which he had by then established for himself.[2] After trying to explain that his work was not simply the 'selfish cultivation of critical acumen' Ruskin tells of its 'consistent and important design', the notion of which has only come to him as a result of long meditation. He then rehearses the account of the inception of *Modern Painters* already referred to:

> The summer before last [i.e. 1842], – it was on a Sunday, I remember, at Geneva, – we got a paper from London containing a review of the Royal Academy; it put me in a rage, and that forenoon in church (it's an odd thing, but all my resolutions of which anything is to come are invariably formed, whether I will or no, in church – I scheme all thro' the litany) – that forenoon, I say, I determined to write a pamphlet and blow the critics out of the water. On Monday we went to Chamonix, and on Tuesday I got up at four in the morning, expecting to have finished my pamphlet by eight. I set to work, but the red light came on the Dome du Gouté – I couldn't sit it – and went out for a walk. Wednesday, the same thing happened, and I put off my pamphlet till I should get a wet day. The wet day didn't come – and consequently, before I began to write, I had got more materials together than were digestible in an hour or two. I put off my pamphlet till I got home. I meditated all the way down the Rhine, found that *demonstration* in matters of art was no such easy matter, and the pamphlet turned into a volume. Before the volume was half way dealt with it hydra-ized into three heads, and each head became a volume . . . a complete treatise on landscape art.

Although in 1844 even that was not the complete story, its constituent causes and effects would remain the same till *Modern Painters* was finally completed in 1860: his love of disputation, and his provocation by chance newspaper items – this would later, in *Fors Clavigera*, become not only a major 'inspiration' but even provide the very structure of his writing;[3] the discrepancy between his 'rage', his determination to 'blow the critics out of the water', and the actual composition of the fusillade; the delays of travel – moving on to Chamonix, descending the Rhine – and the consequent accretion of materials; the need to impose order on these and the recourse to *demonstration*, to rhetorical divisions of the topic into innumerable 'heads'. But above

all what determined the course and structure of Ruskin's work – in local details as well as over several volumes – was his ready acceptance of connections between each and every event of his life. To the imagination that responded as a child to Crosthwaite's Museum or as an undergraduate to Buckland's chaotic study the world was simply a grander, indeed infinite, cabinet of curiosities, wherein a flower, an aspen, a piece of ivy, a rock, a picture, red light on a mountain, a newspaper, or travelling from Geneva to Chamonix, all had equal status. Nevertheless, what was a temperamental, even at times pathological, condition (when Ruskin himself worried most about it) had important artistic consequences; for in his imagination ideas or images rarely retained their discrete identities.

In his new study at Denmark Hill in 1842 Ruskin began to shape the various, long-contemplated materials of *Modern Painters*. Firstly and most obviously, he must construct a work that would adequately defend Turner from the strictures of the *Literary Gazette* or *Athenaeum*[4] which found his paintings absurd – frantic puzzles and confused dreams. Today Turner needs no such defence, with the result that the elaborately theoretical apparatus which Ruskin devised as a basis for his arguments seems redundant. Yet he invoked his training and pride in logic and orderly disputation partly because he needed to *demonstrate* matters of art and partly because such rigour might help him to control the rich personal associations, which were the second major aspect of *Modern Painters*. For the work can only be properly appreciated when it is read as growing out of Ruskin's own dedication to close visual scrutiny and, in particular, out of his recent apprehension of nature's own ineffable truth of line.

His mind intuited connections between the world's events and darted purposefully about in ways which required some more orderly arrangement for public consumption. What is probably a first draft of *Modern Painters*, at the stage when it was still envisaged as one volume, tries to take control from the start: 'The ends of all landscape painting are, properly speaking, two.'[5] But that division prompts a parallel distinction between two kinds of artist, of whom the 'painters of facts' are categorized further. The fragment ends at a point when the first category (delighting by 'imitation') of the first kind of painter has been discussed to such an extent that the reader would have little recall of the divisions and the author recognized that he must *reculer pour mieux sauter*. A second draft begins again, from a rather different point of view. The first volume of *Modern Painters*, as eventually published, simply sacrificed the chance of a reader keeping the divisions and sub-divisions of the subject in mind and proposed a careful survey of

some basic ideas: of Power, of Imitation, of Truth, of Beauty and of Relation. Yet the last two categories never receive treatment in any detail, and the volume devotes itself largely to considerations of Truth.

And Truth, of course, was Ruskin's *forte*. His journal of 1842, before he settled to writing, was much more concerned with such things as the light on the Dome du Gouté than with Turner. Much as Ruskin admired that artist and was devoted to his cause, the initial impetus of *Modern Painters* was more selfish – 'The beginning of all my own right art work in life . . . depended not on my love of art, but of mountains and sea.'[6] The set of mind in which he embarked upon writing *Modern Painters*, clearly revealed in a letter to Clayton of 19 August 1842,[7] is focused on the need to put truth before beauty in one's sketching, on his admiration for any 'twig in the closest-clipt hedge' and the way that such attention will render one 'less imperfect as one of God's creatures . . . and capable of forming . . . far higher ideas of His intelligence'. It was unconsciously a justification of his own mode of becoming 'a full and perfect priest' and glorifying God's creation (botany, he advised Clayton, 'is surely a clerical science'[8]). Turner took his place in these meditations as the most accomplished celebrant of the natural world.

There were other ways in which *Modern Painters* I sprang directly out of Ruskin's life up to that point. Following a long tradition of aesthetics, he saw that art was a statement of 'exalted personal experience'.[9] And his lengthy, indirect justification of Turner's pictures was based upon their congruence with Ruskin's own experience: if he had not shared the artist's passion for mountains and sea and his numinous sense of place – the most spiritual of all dedications to *genius loci*[10] – Ruskin would scarcely have undertaken *Modern Painters*. As a consequence, it is the epiphanies and resonant encounters of his own life throughout the work that sustain its finest sections:

> Not long ago, I was slowly descending this very bit of carriage-road, the first turn after you leave Albano, . . . It had been wild weather when I left Rome, and all across the Campagna the clouds were sweeping in sulphurous blue, with a clap of thunder or two, and breaking gleams of sun along the Claudian aqueduct lighting up the infinity of its arches like the bridge of chaos. But as I climbed the long slope of the Alban Mount, the storm swept finally to the north, and the noble outline of the domes of Albano, and graceful darkness of its ilex grove, rose against pure streaks of alternate blue and amber; the upper sky gradually flushing through the last fragments of rain-cloud in deep palpitating azure, half aether and half dew. The noonday sun

came slanting down the rocky slopes of La Riccia, and their masses of entangled and tall foliage, whose autumnal tints were mixed with the wet verdure of a thousand evergreens, were penetrated with it as with rain. I cannot call it colour, it was conflagration. Purple, and crimson, and scarlet, like the curtains of God's tabernacle, the rejoicing trees sank into the valley in showers of light, every separate leaf quivering with buoyant and burning life; each, as it turned to reflect or to transmit the sunbeam, first a torch and then an emerald. Far up into the recesses of the valley, the green vistas arched like the hollows of mighty waves of some crystalline sea, with the arbutus flowers dashed along their flanks for foam, and silver flakes of orange spray tossed into the air around them, breaking over the grey walls of rock into a thousand separate stars, fading and kindling alternately as the weak wind lifted and let them fall. Every glade of grass burned like the golden floor of heaven, opening in sudden gleams as the foliage broke and closed above it, as sheet-lightning opens in a cloud at sunset; the motionless masses of dark rock – dark though flushed with scarlet lichen, casting their quiet shadows across its restless radiance, the fountain underneath them filling its marble hollow with blue mist and fitful sound: and over all, the multitudinous bars of amber and rose, the sacred clouds that have no darkness, and only exist to illumine, were seen in fathomless intervals between the solemn and orbed repose of the stone pines, passing to lose themselves in the last, white, blinding lustre of the measureless line where the Campagna melted into the blaze of the sea.[11]

This passionate affirmation of his own perception of colour is used to rebuke Gaspar Poussin's brown and grey world and to suggest that Turner's supposed excesses of colour do not belie nature's own. Such passages are not, in fact, self-indulgent reminiscence. Ruskin believed fervently that a painting must not only be, but mean; not only have marvellous shapes and colours, but speak a more than formal language. And to do so it had to address people whose own spirits were stored with answering associations. Hence his definition that

the art is greatest which conveys to the mind of the spectator, by any means whatsoever, the greatest number of the greatest ideas; and I call an idea great in proportion as it is received by a higher faculty of the mind, and as it more fully occupies, and in occupying, exercises and exalts, the faculty by which it is received.[12]

In his defence of Turner Ruskin's own presence, precisely as such a receptive faculty, is just as strong as his critique of paintings. He writes on the truth of vegetation, mountain forms, aerial space, rocks, minerals, clouds – 'watch when the first sunbeam is sent upon the silver channels, how the foam of their undulating surface parts and

passes away, and down under their depths the glittering city and green pasture lie like Atlantis . . . '. And these testify constantly to his own experience – the passage on clouds derives from the middle of August 1835, just as the verbal image of the Falls of Schaffhausen ('. . . unbroken, in pure polished velocity . . .') draws upon the Ruskins' visits of 1833 and 1842.[13] All his technical and practical observation records the conjunction of seen things with associations; paintings that equal these natural effects become even more powerful addresses to the mind. Above all, paintings which involve a careful imprecision like Turner's 'Beautiful incomprehensibility' provide the spectator's mind with apt occasion to exercise its own stored richness. So that the passages of description for which Ruskin is famous, besides having necessarily to stand in lieu of visual illustration, are narratives of insight as well as of sight.

During his analyses of painted and natural worlds Ruskin often seems to become impatient with the whole structure of categories and sub-divisions he has invented: 'a piece of the most refined truth – as which I have at present named it'.[14] Thus, in his first major work he continues with what his parents had earlier seen him doing, beginning something in ways he was not able or willing to maintain. By the time he reaches volume three in 1856 he is obliged to signal this fact by providing the sub-title, "Of Many Things".

Modern Painters has also to be read in the light of Ruskin's slow emancipation from his father's influence. Even while John was at Oxford and John James continued to frequent the Watercolour Society exhibitions it was clear that their tastes did not agree. A letter to Oxford tells of the father's purchases:

> The first I snatched was *Our Village* Nature in Simplicity – *Penley*, a sweet rural scene a perfect swarm of children – one at his porridge – another blowing a penny trumpet at him – old man & woman & poney, a couple courting – price 10Gs. I asked Allnutt afterwards & he said he had just brot a Gentleman to look at it & he would have had it if he could although he had a vast number. My next was Folkstone by *Penson*, some Body Colour but it is a Fishing street of only a few Boarded Houses exquisitely worked & dark & then all going off into sandy roads sea sand & sky in the Vignette way. I like these two particularly – this cheap at 8Gs. My next I bought rather in a hurry but only 5Gs is one of *Duncan* who Foord once told me was first rate but he is too fine for me. Subject on the Thames off Purfleet quite a calm & Sailing Boats & Robson sort of summer sky . . .[15]

His rather pathetic confidence in the 'Gentleman's' approbation is matched by his own obvious timidity and unstrenuous taste. It is

intriguing to note that neither the village genre scene nor the seaside view was still in his collections by 1843; the Penley was sold within the year, and the third picture referred to did not survive beyond 1852.[16] The conclusion that John James would not hang on to them in the face of his son's disapproval is inescapable; his letter had even admitted that 'the pictures . . . may not quite please John'. Given that *The Poetry of Architecture* had already derided the conventional sentimentalism of Victorian genre paintings ('Certain amiable white lambs and water-lilies . . . His Majesty's ship so and so lying to in a gale'[17]) John James was probably right to doubt his son's approval.

A fortnight later another letter to Oxford tells of further purchases.[18] They are all works by artists whom *Modern Painters* would in various ways find wanting. He bought Holland's *Ruins of Monastery of Alcobaca*, presumably a picturesque scene, maybe with associations of his visit to Spain to see the Domecq estates many years before; on this he was advised by various connoisseurs present at the exhibition, but was most pleased by his own shrewdness ('It is very cheap') and his prescience ('I don't think the public quite do him justice'). He hoped that the family in Oxford would obtain the opinion of 'any of John's set' who were coming up to Town. Another picture by Cattermole, which he did not buy, was the talk of the show; so he notes – a persistent fear of being thought presumptuous always complementing his snobbery – that it 'may be quite as well my name was not attached to it'; yet his letter hedges a little on what *Modern Painters* I would term Cattermole's 'violent conventionalism of light and shade, sketchy forms'.[19] A second purchase was specifically for his son:

> In the picture of [Frederick] Tayler *Knights & Pages* there is an air of Romance. It is a poets picture & I mean it for Johns study when he has a House of his own

(and when, presumably, he was an established poet). Tayler's subject was

> a high Castle & fine dark lowering sky & approaching us on a majestic fine legged Horse a true Battle Knight & after him a Squire on another Horse & bearing Helmets & Shields are two fine youths & all done with a dash & force stronger than oil.

It is all of a piece (*ut pictura poesis*) with his judgement of John's verses. The reply from Oxford, specifically written on this rare occasion by John himself ('being the person most concerned') seems dutiful and rather lukewarm: 'I am glad to have a martial bit of Tayler – it is rather

his forte, and his sparkling horseheads are always capital, looking as if the animal had been out in a thunder shower, and then sketched in a gleam of bright wet sunshine. Holland too I am very glad to hear of.'[20] John James, it is only fair to record, thought these purchases second-rate.

Although eager to gratify his son's taste for Turner, John James was apparently uncertain, like many of his contemporaries, how to react ('One *Turner* of Oxford clever'). A letter of March 1840 from Yarmouth, where he saw and described 'such a Sea View', goes on – as if continuing some family discussions – to acknowledge that he 'became *for the first time persuaded* that Turner does not outrage Nature nor exaggerate but seizes & fixes in his memory these grand displays that occur rarely & to have been seen so much by him they must have been diligently sought for'.[21] His language seems an echo now of his son's defence of Turner, and in a more practical way John James acknowledged his son's taste and insights by buying him Turners – *Richmond Bridge, Surrey* and *Gosport* during 1839, *Winchelsea* as a twenty-first birthday present the next year, quickly followed by *Harlech Castle* and *Nottingham* in that April and an Oxford drawing in August.

Yet even the *Winchelsea*, his twenty-first birthday present, did not, at least in retrospect, entirely please him, partly, I suspect, because it was far less attentive to a special sense of place than many of the others in the England and Wales series.[22] *Praeterita* called the *Winchelsea* a 'curious choice', but decided that his father had always been fond of soldiers. But it was also clear that John James's taste for Rubens and Reynolds would not allow him to attend sensitively enough to 'Turner's microscopic touch'.[23]

This gift was not an isolated disagreement. Also for his son's coming of age John James had settled upon him stocks which would bring in at least £200 *per annum*, and the first chance John had to spend some of his own money was upon a Turner of his own choice, one of the sketches of Harlech. Father and son were together at the Water-colour Society when Griffith announced to John that this was for sale; he said at once that he would have it, and then Griffith named the price – £70, more than had been asked for the other Turners bought by the Ruskins. John James decided that Griffith had upped the price and taken advantage of his son's lack of business sense. From then on he would always distrust John's competence in money matters, accusing him of being a spendthrift; while for his part John found it increasingly hard to ask his father for money for pictures, and in consequence let go many fine opportunities to acquire items where his own taste and

judgement were sound, aesthetically and (as it turned out) financially. Two years later, in 1842, John had to let pass the purchase of Turner's *Splügen*, which he considered one of the finest Swiss landscapes ever painted, simply because his father was away on business and so could not sanction an outlay of 80 guineas; nor did he feel able to write and ask permission. In 1843 there was also the chance to buy some drawings by William Blake, which Ruskin's eye recognized at once as works of genius long before they were appreciated or even known. He said he would take the whole portfolio, yet within a few days was writing in extreme distress to try and reduce his commitment to four items:

> Since I last saw you I have been looking very carefully over the portfolio of Blake's drawings, and I have got nervous about showing them to my father when he comes home, in the mass. He has been *very* good to me – lately – with respect to some efforts which I desired to make under the idea that Turner would not long be able to work – and these efforts he has made under my frequent assurances that I should never be so captivated by any other man. Now I am under great fear that when he hears of my present purchase, it will make him lose confidence in me, and cause him discomfort which I wish I could avoid . . .[24]

Since this letter was probably written about the time of the publication of *Modern Painters* I, a defence of Turner of which John James became enormously proud, it is ironic that the purchasing of work by the painter should cause a rift between father and son. Once Turner arrived at the Ruskins' carrying all the sketches for his series on the Rivers of France and said 'You shall have the whole series, John, unbroken, for twenty-five guineas apiece'. There were sixty-two items, yet since John James was aghast that his son should even contemplate the purchase the opportunity was missed, and the set eventually broken up.[25]

But when Ruskin settled down to write the first volume of *Modern Painters* his knowledge of Turner's work had increased enormously since, two years earlier, he had first met the painter and listened to him rhapsodizing about the very Alpine valleys where Ruskin himself had been so happy in 1833 and 1835. He saw his work at Academy shows, at Griffith's, in the collections of Godfrey Windus and of their Herne Hill neighbour, Bicknell, and, above all, in his own house. He studied them avidly, in the intense fashion which he also urged upon his Oxford friend, Clayton:

> get . . . Heath's "Landscape" and others, where you are sure of three or four delicate plates from him – Turner; get Rogers' "Italy" and

"Poems" . . . and the "Rivers of France", in which you get sixty engravings for a sovereign; and take them to bed with you, and look at them before you go to sleep, till you dream of them; and when you are reading and come to anything that you want to refer to often, put a little Turner in to keep the place, that your eye may fall on it whenever you open.[26]

There were, as well, further contacts with Turner himself. After another dinner party at Griffith's in July 1841, Ruskin's diary notes that 'Turner there is no mistaking for a moment – his keen eye and dry sentences can be signs only of high intellect'.[27] These meetings brought increasing intimacy between the two – one, very young and enthusiastic, winning over the other, idiosyncratic, sometimes surly and notoriously mean with money, by sheer commitment to his cause. Ruskin was soon given the run of Turner's gallery in his house at 47 Queen Anne Street, and Turner dined as an honoured guest at Herne Hill or was sent presents of fruit and vegetables from the Ruskins' garden. Yet when *Modern Painters* I came out in May 1843 and its author called upon Turner, the latter made no allusion to it at all, though by being exceptionally civil he gave Ruskin the impression that 'he must have read my book'.[28] Only on 20 October over a year later did Turner thank Ruskin 'for the first time'.

The book that grew out of so many of Ruskin's early enthusiasms and involvements – the book that in 1844 he referred to as '*Turner's Work*' – would testify throughout its long and complicated progress to the 'two great prevalent tendencies' of Ruskin's mind, as he explained them to Osborne Gordon: 'mystery in what it contemplates and analysis in what it studies'.[29] Typical, too, was the thorough reworking of first drafts, carefully fair-copied by 'George' Hobbs before Ruskin revised and corrected. At last, in the first week of May 1843, *Modern Painters* appeared under the pseudonym of 'A Graduate of Oxford', chosen because Ruskin did not wish his youth to prejudice the reception of his observations. One of the earliest reviewers recognized the book's great merit. Its author, said *The Globe*, 'has studied nature with the most enthusiastic devotion, and in localities and under circumstances especially propitious to the study . . . It is evidently the work of a poet as well as of a painter, and one of no common order.'[30]

Chapter 8

Alone in Italy at last: 1843–1845

I want to go to Italy again – I want to go everywhere at any time, and be in twenty places at once. All that I do in Switzerland only opens a thousand new fields to me, and I have more to see now than when I went.

Letter to George Richmond, 12 August 1844

During the winter of 1842–3, when *Modern Painters* was 'beginning to assume form',[1] Ruskin continued his customary social round, enjoying especially his calls upon the picture dealer, Griffith, upon Turner or Copley Fielding and at the home of Windus or Bicknell. In late January Gordon came to stay and Ruskin found his intellectual companionship as stimulating as ever, even though the distractions of entertaining him ('I am getting quite dissipated') added to the other demands upon him – attending the Geological Society or visiting the Zoo – that competed with his writing. He was always satisfied when he thought that he had learned something – at the zoo he 'saw boa take a rabbit, which gave me an idea or two' – but on other occasions away from his desk he resented the wasted days ('I learnt nothing').[2] As the writing began, inevitably, to exceed the limits he had set himself he tried to concentrate on 'the matter in hand'; but a month after complaining that '[I] Scarcely read a word now or do anything', he was reading Dumas's *Essai de Statique Chimique*, *King John* ('Constance talks too much Billingsgate') and a life of Richard Baxter.[3] From time to time a compulsive putting of his rooms in order would spur him to fresh efforts of concentration 'from six morning till ten night'.[4]

The volume was, however, eventually sent to the printers and he resumed 'running about in town at exhibitions',[5] escorting people to the Academy and dining out. He spent some of the summer in Oxford to make up the terms in residence needed for his degree and employed it particularly in studying the Raphael at Blenheim. The diary, at least that 'for intellect', petered out and he gives the impression in October 1843, when he rather wanly resolved to resume, that he was somewhat in the doldrums: 'Nothing occurring this year – hard work on art and much discouragement.'[6] The general relaxation of tension after

the strenuous task of finishing his first book and then waiting to see how *Modern Painters* I would be received were largely responsible for his sense of *malaise*.[7] But he was also beginning to realize that its sequel was attended by many more difficulties, which partly sprang from his own habits of mind and self-education.

Instead of simply continuing the discussion as initiated in the first volume – there were, after all, some sub-divisions of the section on "General Truths" still to be taken up – he began to interest himself in earlier painting and in aesthetics and to read Rio's *De la poésie chrétienne dans son principe, dans sa matière et dans ses formes*, whereupon the scope of his projected sequel enlarged dramatically. He would write 'a little, stupidly', even manage a 'chapter of book',[8] only to recognize that the rest of his day's reading and thinking made the gap between those interests and what he was getting down on paper wider and wider. Some of these false starts are printed in the *Works*;[9] they suggest that he was writing sections for different parts of the projected volume before the whole was securely thought out, and trying to cope with large aesthetic theorizing on the basis of his own personal experiences. Occasionally this emerges triumphantly, as in the long account of seeing an avalanche from the Brévent mountain near Chamonix one stormy, dark evening and realizing a rare vision of the self 'effaced in that of God'.[10] Yet despite the odd day when he thought he had written a 'first-rate chapter', he was generally unwell; on 6 December 1843 he attributed this to 'thinking too much' of Adèle, but it may also have been his own defensive reaction to writing uncertainly. Days passed in patchwork fashion – some Plato, some Pliny on natural history, some Italian, 'an investigation of foliage of Scotch fir',[11] or more visits to Griffith, this time to feast himself covetously upon Turner's oil painting, *Slavers Throwing Overboard the Dead and Dying*.

In December, while he was thinking of Adèle, Effie Gray came to stay with her brother, George. She made herself particularly agreeable, playing the piano to entertain Ruskin as soon as she came in from town; though he seems to have meditated upon Adèle throughout these musical sessions, he was nevertheless grateful that Effie played 'for me' and that her grown-up wit, the good nature and playful disposition of 'little Phemy' made the long evenings bearable: 'I shall be sorry when she goes for a little light society refreshes my stiff brains.'[12] Afterwards she wrote to say that she always thought of him when she went out. The year ended with his recognition that it had been far less well spent than 1842.

There was an auspicious and joyous start to 1844 when John James gave his son Turner's *Slavers* as a New Year gift, having paid 250

guineas for it. He spent several days 'staring at my picture'; visitors to the house suddenly seemed more entertaining, and the snow was bright for walking. But soon 'the book' began to plague him; he 'thought a little' about it, but 'wrote nothing' on the 3rd; next day he was tackled by his parents, who were obviously anxious that he maintain the reputation of the "Graduate of Oxford" – John James shrewdly required that the successor to *Modern Painters* I be the same size, while Margaret 'asked if I were not getting diffuse'. 'All confusion about my book', he wrote in his diary, then added that he expected 'my summer's trip will put me right again'. The following day he 'Got quite confused in thinking over my book' and on the 6th was bothered by 'everbody' agreeing that he should say whatever he wanted in just one more volume.

He was able to postpone an immediate decision by the need to write a preface for a second edition of the first volume; but that, too, proved a labour – not surprisingly, as he was even less sure of his book's eventual shape and scope than when he wrote the first preface. He wanted to answer the hostile critics of *Modern Painters* I, but found that he could not 'write contemptuously enough': yet he manages some withering sentences – 'Writers like the present critic of Blackwood's Magazine deserve more respect; the respect due to honest, hopeless, helpless imbecility. There is something exalted in the innocence of their feeblemindedness . . . '.[13] He is, as he had proved in the Oxford Union, a skilful debater who can make telling enough points about art critics:

> We are not so insulted with opinions on music from persons ignorant of its notes; nor with treatises on philosophy by persons unacquainted with the alphabet; but here is page after page of criticism, which one may read from end to end, looking for something which the writer knows, and finding nothing.

Yet the ponderousness of much of the preface and its length (forty pages) certainly suggest the difficulties it gave him. These derived partly from his need to square the contents of the first volume with his already enlarging and altering views and partly from a deep unease that landscape painting was not a moral enough genre to justify his career as secular priest. He recognized that the work so far published was insufficiently grounded in theory: it lacked discussions of the sublime and the beautiful,[14] and did not adequately explain how representations of scenery may be expressive of larger motives, nor how accurate 'cognizance of the form, functions, and systems of every organic or definitely structured existence' can coexist with art's tra-

ditional role of 'idealizing' or 'generalizing' about nature.[15] Rashly, given his habits of working, he promised full explorations and offered, *pro tem*, some interesting analyses of a few older pictures.

Where he had more trouble, and could really only rely upon categorical affirmations, was with the 'moral influence' of landscape art upon humanity. It has 'never taught us one deep or holy lesson',[16] he argues, because landscapists have largely paraded their virtuosities and not applied themselves to study their subject in the way that historical painters have based their art on 'perfect knowledge of the workings of the human form and human mind'. It is in the botany of Titian's *Bacchus and Ariadne* or Raphael's cartoons that we may see great art's careful attention to the natural world, which pure landscapists have failed to maintain. Ruskin shows here his own search for antecedents to Turner's 'moral vision' in the Renaissance art which *Modern Painters* II would eventually explore.

Meanwhile he was able to get the new preface finished on 14 March and on 30 March the second edition was published. 'I have nothing but my new volume [i.e. Vol. II] to attend to'. Yet in only a month's time the Ruskins were due to leave for another journey abroad and the shortage of time seemed to paralyse him. By 15 April he had decided 'to let my work alone till winter, and collect materials'. A few days later he left to spend ten days with his father on a business trip to Crewe ('have gained some knowledge of shipping etc').

Interruptions to his writing had steadily increased, for as the secret of the authorship of *Modern Painters* gradually spread[17] the "Graduate of Oxford" found himself much in demand – dinner parties, one of the famous breakfasts at Samuel Rogers's, another at Monckton-Milnes's, a *soirée* at Lord Northampton's. These all became excuses for not getting on with his preface or his second volume, but they automatically produced their own frustrations: on 31 January there was a 'Nasty crowded party at Inglis's [the M.P. for Oxford] – nothing but elbows and legs – couldn't talk to any one'. He obviously felt rather insignificant in large groups where he could neither command attention himself nor (his main consolation on these social excursions) pick up odds and ends of useful information: 'bored by a large party of people [at Acland's], none of whom I knew. Saw the circulation of blood in a frog's foot, however, which was something'.[18] Such items were stored away in the diary, along with the weight of the lower half of Nelson's statue in Trafalgar Square or bits of hunting lore from Telford. But his new fame got him to 'my first private view of the Royal Academy', where he stayed to the very end, going round with Rogers, David Roberts and Monro, the collector, and at one point

finding himself alone 'in the great room of the Academy' with 'Rogers the poet'.[19] Such were the joys of acquiring a public reputation, and they sustained him, together with designing a stained glass window for St Giles's Church, Camberwell, with an old school acquaintance, until he left once again for France.

But the cure-all of travel ('my summer's trip will put me right again') did not work very quickly. After a fortnight's journey the Ruskins reached Geneva, where John noted that he had been 'singularly down-hearted all this journey'. It was largely that he felt time was slipping away without his being able to focus upon the huge subject that *Modern Painters* I and especially its new preface had established. As if he had forgotten his similar decision six weeks before, at Geneva on 1 June he once again proposed to 'put off writing', adding the slightly enigmatic explanation, 'because the book is too good. I should have written twice as much with worst materials'. Presumably this means that he has decided that *Modern Painters* is too good to risk continuing on the basis of what he considers poor materials. Perhaps Chamonix would provide adequate bases upon which to start over again.

If he had come to something of a standstill intellectually, once he arrived in Chamonix he experienced a huge access of physical energy. Under the supervision of a guide, Joseph Marie Couttet, Ruskin was able to explore more extensively, at a greater altitude and over more dangerous terrain, than before. He was surprised and much pleased with his own stamina, as he reached the Aiguille de Charmoz or the Glacier des Pèlerins. Two glorious months, climbing the mountains with Couttet and, of course, 'George', were all the more sharply savoured for the occasional disagreeableness or inconvenience of travelling with his parents. Whereas John James and Margaret liked only short walks, could not leap over walls when it became necessary to view a break in the clouds with 'Mont Blanc . . . purple', and generally grew 'so uncomfortable' when civilized comforts were lacking at Zermatt, Ruskin and his two companions 'dined *à l'antique*, recumbent' upon a bed of Alpine roses, 'with a little rock, apparently on purpose for us, cleft, holding a little pool of cold snow water, clean by filtration through the moss, breast high, just below'.[20]

The chance of ranging higher with a qualified Chamonix guide quickly cured the 'blasé feeling' that he experienced during the first few days. His sense of missing 'the exhilaration of spirit which these scenes awakened in my childhood' gave way to the feeling that 'I am too much indulged'.[21] But the excitements of high pastures or 'enormous fields of snow' chased such misgivings away.[22] If *Modern Painters*

II did not advance in any specific way, Ruskin at least registered with obvious exhilaration daily visitations of the sublime – 'a waterfall equal in terror', a glacier 'suberb beyond measure', stars burning 'fierily' and 'the white hills, clear as crystal . . . on the deep vault'.[23] The language of his records is, as usual, largely precise and scientific; but in the frequent acknowledgements of the sublime lurks Ruskin's confident faith in its being a language of God's artistry. Whether it was the rare star gentian 'thickly scattered' on the Montaigne Bénit, the 'preternatural' clarity of Mont Blanc, clouds full of 'inside light' or the 'solemn unbroken misty sunshine of the high air', he found everywhere a silent testimony.[24] With Gordon, who joined them for a few days, it was made explicit, as the 'Matterhorn appeared in full ruby, with a wreath of fiery cloud drifting from its top – as Gordon said, like incense from a large altar'.[25] Otherwise, Ruskin was content to leave things unsaid ('It is instructive to observe . . .'[26]).

As their departure approached he had moments of doubt whether he 'had well spent my time in such hard [*sc.* physical] work, and might not, quite as well, have been meditating and writing some part of the day in my sweet room, as heating myself on steep hill sides'.[27] When they crossed to the Italian side of the Alps, which satisfied much less than Chamonix, he rowed down Lake Maggiore to visit a collector with a major Poussin painting. And then, after a return to Chamonix, the research for *Modern Painters* II began in earnest when they travelled on to Paris, where four full days were spent studying paintings in the Louvre. After weeks watching and recording – in words and sketches – the natural world of mountains, he was ready for the different riches of Perugino, Pinturicchio, Veronese. Indeed, it was exactly the force of his arguments in *Modern Painters* that he should be equipped emotionally and intellectually by nature for the larger appreciation of art. In the Alps he had drawn plants and clouds and rocks; now he suddenly felt – his protestant upbringing notwithstanding – that 'I shall try to paint a Madonna some day, I believe'.[28] Above all, his observation of Titian, Giovanni Bellini and Perugino seemed to ensure that he would be 'able to abandon everything to them' and that the impetus for continuing *Modern Painters* had been found. As they journeyed north towards Calais he made more detailed notes on the Louvre paintings.

During the autumn he continued with his study of pictures, especially Fra Angelico's, and spent hours in front of the Elgin marbles in the British Museum. But he soon encountered fresh difficulties: awkward gaps in his knowledge of topics that seemed to be presenting themselves as material for the second volume; inadequacies of nearby

collections – notably the Dulwich Gallery – for the study of early Christian art. He wanted to extend the research that Rio's volume on Christian poetry had initiated, which now took him into Dante, into Vasari's lives of the painters and into history (he was reading Sismondi's *Histoire des Républiques Italiennes du Moyen Age* by the next spring[29]). He was also studying figure painting and anatomy, which at one stage he considered including in *Modern Painters* II; for in November he writes to Acland, soon to take up a post as Reader in Anatomy at Oxford, that he has been drawing an exquisite lady's foot, 'lent' him by Richmond, 'for the book'.[30] Since neither the illustration nor any consideration of anatomy appeared in the second volume, it is clear that in the final months of 1844 Ruskin was still groping after a final plan and structure for his ideas.

But, above all, he needed to see more Italian pictures. So much of the first volume of *Modern Painters* had been written from his records – sketches and memoranda – of travels among English and European scenery; but a similarly rich fund of materials, personally gathered over many years, was simply not available to support his new interest in older painting. Another trip to Italy, specifically to study pictures, was now, in 1845, essential. Also the chance of travelling alone – that is to say, with 'George' and also Couttet, but without his parents – was tempting, for it was clear that John James could not leave the business again. It appears to have been Turner who objected to Ruskin's taking risks during the current Swiss disturbances.[31] Even Margaret Ruskin seems to have been prepared to accept that Couttet could provide necessary care and nursing services. Money was readily forthcoming, provided John James received scrupulous accounts, though this chore was soon delegated to Couttet as well, after Ruskin's singular failure to balance the books.

It was altogether a marvellous and momentous tour. After crossing France to Geneva, 'George' and Ruskin joined up with Couttet. As their 'convertible' *calèche* climbed the Salève slopes away from Geneva, the 'three of us walked' behind it 'in great peace of mind'. Some days later, after terrible stages through Savoy and Provence, they reached the Mediterranean with Couttet humming "com'è gentil" from Donizetti's *Don Pasquale* all the way down the coast. Both vignettes of these three masculine travellers, freed for once of parental Ruskins, are much later recollections;[32] nothing quite so revealing was put into the bulletins home ('I will write daily & post letters as often as possible myself'[33]). Instead Ruskin expresses his own, quite genuine, sense of strangeness at not being with his parents in Europe, yet often staying at their old hotels; he attends punctiliously, if with some

occasional irritation, to their anxieties about his health or missing correspondence ('I had no idea of the state you were in'[34]). He does mention – though it is hardly emphasized as the confession he made it years later in *Praeterita* – that they had climbed a mountain on Sunday: nothing, one would think, more wicked than the usual family walks on the Sabbath, but climbing mountains was 'work' for Ruskin and he seems duty-bound to admit it.[35] By the 1880s he could say that this trespass 'remains a weight on my conscience to this day'.

Daily letters must have added to his already heavy commitments. He sent his father, to whom most of the communications are addressed, sketches of topography and mountain ranges, architectural details and visual schemes of angels' wings in Fra Angelico, all of which were executed in addition to various 'reminiscences' of landscape, many more careful drawings and innumerable entries in his notebooks; and he noted that he had not had time to botanize across Europe. Once he was settled in Lucca, he sent home a typical daily schedule:

> at 6 precisely I am up, and my breakfast, in the shape of coffee, eggs, and a volume of Sismondi is on the table by 7 to the minute.
>
> By eight I am ready to go out . . . to the old Lombard church . . . There I draw among the frescoes & mosaics until 12 o'clock. Precisely at 12 I am ready to begin my perambulations (with the strong light for the pictures) among the other churches . . . to San Romano . . . to the Duomo . . . After two hours work of this kind, and writing as I go, all I can learn about the history of the churches, and all my picture criticism, I go home to dine – dinner being ready at two exactly. At three I am again ready to set to work, and then I sit in the open warm afternoon air, drawing the rich ornaments on the facade of St Michele . . .
>
> After working at this till ½ past five or so, I give up for the day, and walk for exercise round the ramparts . . .
>
> Finally, when the rose tints leave the clouds, I go and spend a quarter of an hour beside the tomb of Ilaria di Caretto . . . in the cathedral . . .
>
> . . . With this I end my day, & return home as the lamps begin to burn in the Madonna shrines; to read Dante, and write to you. I am falling behind with my notes however, & therefore tomorrow as you know what I am about, I will not write unless I meet with anything particularly interesting . . .[36]

As this shows, though the tour was designed largely to enable him to see paintings, not only had he formed other ambitions well before he started ('All my mountain drawings I purpose'[37]), but the usual chances of travel added new schemes and extended his timetable at every stage of the journey.

He had begun well enough at Genoa, which was included in the itinerary on account of its picture-filled palaces. His notebooks record visits to four and several excitements in front of Veronese's *Judith* and reputed Mantegnas and Michelangelos;[38] but his letter expresses extreme disappointment ('Half the pictures copies – others bad – others injured or destroyed – others shut up'[39]). He reported much more delight – as had many English travellers since John Evelyn – in the gardens of the Palazzo Doria. But after Genoa the range of his interests threatened to slow him down: at Massa and Carrara he found 'too much . . . if I began stopping at all, I might stop all May'.[40] And once settled comfortably in Lucca ('lovely city'), his concentrating on the pictures of Fra Bartolommeo was soon overwhelmed by his enthusiasm for its architecture and sculpture: 'I have discovered enough in an hour's ramble after mass, to keep me at work for a twelvemonth.'[41] After the pierced stonework of northern gothic, he was delighted by 'white marble, *inlaid* with figures cut an inch deep in green porphyry, and framed with carved, rich, hollow marble tracery',[42] examples of which, on the facade of San Michele, he drew with astonishing keenness. And his perception of such sculpture as Jacopo della Quercia's tomb of Ilaria registered both his sense of its aptness to a central thesis of *Modern Painters* I and his equally extraordinary verbal skills at explaining this without losing the visual impact:

> She is lying on a simple pillow, with a hound at her feet. Her dress is of the simplest middle age character, folding closely over the bosom, and tight to the arms, clasped about the neck. Round her head is a circular fillet, with three star shaped flowers. From under this the hair falls like that of the Magdalene, its undulation *just* felt as it touches the cheek, & no more. The arms are not folded, nor the hands clasped nor raised. Her arms are laid softly at length upon her body, and the hands cross as they fall. The drapery flows over the feet and half hides the hound. It is impossible to tell you the perfect sweetness of the lips & the closed eyes, nor the solemnity of the seal of death which is set upon the whole figure. The sculpture, as art, is in every way perfect – *truth* itself, but truth selected with inconceivable refinement of feeling. The cast of the drapery, for *severe natural* simplicity & perfect grace, I never saw equalled, nor the fall of the hands – you expect every instant, or rather you seem to see every instant, the last sinking into death. There is no decoration nor work about it, not even enough for protection – you may stand beside it leaning on the pillow, and watching the twilight fade over the sweet, dead lips and arched eyes in their sealed close.[43]

His energies and delight throughout were tempered by a charac-

teristic instinct for ruin. The very façade of San Michele is recorded in his drawings *as a fragment*. His picturesque fad was both sharpened by his historian's dismay at careless destruction of evidence – he tried collecting bits and pieces from the ground and restoring them to San Michele – and given a strange intensity by his evangelical sense of human vice and folly – the characteristic image of Ilaria is her Magdalene hair. Disintegration and sin, however repaired or repented. His helpless indecision as 'whole histories in marble' were ruined is a leitmotif of this year's Italian journey:

> wrecks of lovely things destroyed, remains of them unrespected, *all* going to decay, nothing rising but ugliness & meanness, nothing done or conceived by man but evil, irremediable, self-multiplying, all swallowing evil, vice and folly everywhere, idleness and infidelity, & filth, and misery, and desecration, dissipated youth & wicked manhood & withered, sickly, hopeless age. I don't know what I shall do.

But the following day, writing again of ruins engineered by nature as well as man, he begins to formulate his responses in which the programme, themes, even tones, of his next fifteen years' work are already distinct:

> It is a woeful thing to take interest in anything that man has done. Such sorrow as I have had this morning in examining the marble work on the fronts of the churches. Eaten away by the salt winds from the sea, splintered by frost getting under the mosaics, rent open by roots of weeds . . . fallen down from the rusting of the iron bolts that hold them, cut open to make room for brick vaultings and modern chapels, plastered over in restorations, fired at by the French, nothing but wrecks remaining – & those wrecks – *so* beautiful. The Roman amphitheatre built over into a circular fishmarket. The palace of Paul Guinigi turned into shops and warehouses. I shall have to go back to Monte Rosa, I think, or I shall get to hate the human species . . . worse than any Timon.[44]

This Timon stance, the 'swearing' and 'rages' at impossible conditions around him, continued at Pisa. Yet dismay and despair were tempered by new discoveries.

The frescoes in the Campo Santo at Pisa were a 'veritable Palestine', a visual Bible of the old painters, steeped in patriarchal history. He spent much of his time copying bits; as he told his father, it was 'the most important thing to study thoroughly in Italy at present'.[45] And he found that his 'mind is marvellously altered since I was here – everything comes on me like music'.[46] In addition, he became acquainted with the sixty-year-old art historian, Giovanni

148

Rossini, who showed him his 'divine collection' of pictures. In the company of such experts, and he met others from France, he realized his own capabilities and limitations: Rossini 'does not feel the art . . . but he has great traditional and technical knowledge of pictures'.[47] Two French artists 'had been studying the old paintings of the right sort for two years and gave me some useful renseignemens'. But the time they advised for Padua, for instance, must have made Ruskin's programme of study seem rushed and patchy: 'Good lot of pictures', he wrote later of the Uffizi in Florence, 'to be run through, but won't take me long.'[48] Indeed, he seemed to realize that it 'requires a good deal of courage . . . to work as I am working at present – obliged to take a shallow glance at everything and to master nothing . . . I have to think before everything that I see of its bearings in a hundred ways. Architecture – sculpture – anatomy – botany – music – all must be thought of & in some degree touched upon, & one is always obliged to stop in the middle of one thing to take note of another, of all modes of study the least agreeable & least effectual.' The last sentence probably defers to his father, for the whole of Ruskin's career rather enforces his own enjoyment of that method.

At Pisa he was generally more able to concentrate upon paintings. 'There is no out of door subject here', he reported thankfully on 15 May, though on his penultimate morning he struggled comically against wind, rain and passing boatmen to paint the Palazzo Agostini ('my precious old house'), which he had belatedly discovered and feared would be destroyed by his next visit. The frustrations of seeing what he was trying to copy being destroyed under his eyes exasperated him further. The one architectural monument he did allow himself to study – the chapel of Santa Maria della Spina – was threatened with destruction in order that the quay could be widened; so he climbed around the roof 'to draw the details before they throw them into the river'.[49] In the Campo Santo new monuments were being erected – 'a slab with the apothecary's name upon it and saying that it was a great pity he was dead (*I* think it's a pity that anybody here is left alive)'.[50] Holes were knocked in Antonio Veneziano's San Raniero cycle and replastered so that the damp spread further into the painting. It would cost, Ruskin calculated, £2,000 to glass in the burial ground and conserve, at least from the weather, the precious frescoes by Giotto, Simone Martini and Orcagna; he reminded his father that £2,500 had just been spent by the National Gallery for two Guido Renis 'not worth sixpence'.[51] So he planned to set up a Pisan subscription. By the time he reached Florence the fact of so much destruction seemed to be directed wholly at him, a 'demon of repairs pursuing me,

& I cannot cope'.[52] Though he deplored such depredations, decay and evanescence were a necessary condition for him to flourish in, colouring his sight even of the indeterminate fireflies on the road to Pistoia:

> One hardly knows where one has got to, between them, for the flies flash, as you know, exactly like stars on the sea, and the impression to the eye is as if one were walking on water . . . it was very heavenly to see them floating over field beyond field under the shadowy vines.

He would return to their essential 'rising and falling' in his very last June of sanity, 1889, for the final number of *Praeterita*.[53]

The fields and hillside vineyards were welcome after the flatness of Pisa, where he had missed 'a good walk in the evening'. Florence was even better, with its hill climbs to San Miniato, Fiesole or Arcetri. On one occasion in late June he joined the Franciscans in hay-making at Fiesole and walked back into Florence by the light of the moon and more fireflies; on another, Couttet gathered wild floweres among the same hills as a preliminary to Ruskin's study of their representation in 'old pictures'.[54] But before he got to walk out of the city, each long day was dedicated to the paintings. This self-education in galleries, churches and cloisters proceeded with his usual alternation of complacency and dissatisfaction. 'I still find my Michael Angelo opinions pretty settled and comfortable'; 'Raffaelle's madonna [del Cardellino] . . . is far finer than I thought'; then thrills of totally unexpected discoveries, like Gozzoli's procession of the Magi in the Medici-Riccardi chapel ('no end of treasures').[55] It was all rather haphazard, as he dashed eclectically from point to point, 'scribbling notes on my arm in the galleries',[56] relying partly on his own eye, partly upon chance encounters. He was lucky to fall in with a local engraver, G. B. Nocchi, who took Ruskin into inaccessible private collections and showed him 'wonderful things' that he would never have caught himself.

Ruskin seemed reluctant to invoke, or was rather contemptuous of the efficacy of, British contacts he had been given: a Mr Millingen promised, but delivered nothing; Lord Holland invited him to a tedious dinner, yet at least provided directions to the best well water in Florence and obtained limited permission for Ruskin to sketch in the Pitti Palace. His fund of pictorial knowledge grew extraordinarily, and notebooks were filled with praise of Fra Angelico in San Marco, Orcagna and Masaccio, and works that at that date were considered Giotto's, Cimabue's and Uccello's. 'The outpouring of *mind* . . . is something marvellous.'[57] Yet he still, as earlier on the trip, found copying Fra Angelico infinitely frustrating:

Did an angel's face seven times, and did – *for* it. Never was so plagued in all my life – got as hot as fire – and came away at last feeling as if I had been beaten all over – partly with the effort, & partly with the excitement of the heavenly thing before one – it isn't good for one at all . . .[58]

But these new perspectives, probably because they were gathered so randomly – 'running about to the different places', began to pose problems of sorting and classification: 'I have been working very hard . . . under the perpetual sense of accomplishing nothing. I have been developing stores upon stores, heaps on heaps of things that I cannot explore or learn. I have been discovering at every step new darknesses – about me – new incapacities in myself.'[59]

To those frustrations with the new material for *Modern Painters* II was added his increased Timon-like hatred of the Florentines' own attitudes to their treasures. If the Lucchese simply left things to rot and ruin, the Florentines were endlessly 'restoring' the depredations of their own thoughtlessness: 'They expose their pictures to every species of injury, rain, wind, cold, & workmen, and then they paint them over to make them bright again.'[60] At Lucca what remained was 'genuine . . . the very stones that were laid by the hands of the 10th century'; whereas in Florence it was retouched, or wheeled off in the rain to the picture 'cleaners', like the Strozzi altarpiece of Gentile di Fabriano (now in the Uffizi), which Ruskin saw manhandled out of the Accademia.[61] The ordinary Italian's idleness and lack of interest – 'lazy, lousy, scurrilous, cheating, lying, thieving, hypocritical, brutal, blasphemous, obscene, cowardly, earthly, sensual, devilish' – roused him to frequent pitches of anger; he actually bought himself a piece of carpet ('it isn't pretty') from the weavers who had run their looms up against Giotto's *Last Supper* in the old refectory of Santa Croce so that it would 'keep me well up to the boiling point against the nation and its ways'.[62]

By his departure from Florence in early July he had again run out of time, interrupted as he was by the 'confounded fetes . . . Buzz-buzz-bang-bang, all day & night, dust & crowd & nuisances of every kind – no getting into any churches'.[63] But he had saved time, he argued, by taking rooms from which he could always gaze at Giotto's tower and Brunelleschi's dome. But after his intensive and not altogether methodical researches in Lucca, Pisa and Florence he suddenly found himself looking forward to a stay among the Alps in order to put his new ideas in some shape – 'I want a little nature to recover tone of mind'.[64] *En route*, he sent his father a long list of Italian artists, categorized into, first, 'Pure religious art. The School of Love';

151

second, 'General Perception of Nature human & divine, accompanied by more or less religious feeling. The School of *Great* Men. The School of Intellect'; third, 'The School of Painting as such', and fourth, 'School of Errors and vices',[65] The system evolves from his idiosyncratic method of studying art: useless to anyone else because so unpredictable and often unhistorical, yet full of strongly affective reactions to what he had seen. Though once he had reached the mountains ('a perfect Paradise for feeling'), the days with pictures in Florence seemed very cerebral and he readjusted his priorities once again in order to assert that 'my *mission* has to do with rocks more than with walls. I fancied I was enjoying myself at Florence & Pisa, but I wasn't at all'.[66]

He established himself at Macugnaga, a tributary of Val d'Ossola. It was isolated and primitive: Couttet took over the kitchen duties from the peasants with whom they lodged, while 'George' was sent on astonishing hikes to the nearest post offices (sixty miles in two days) so that Denmark Hill would receive its regular letter. Macugnaga seemed 'a most delicious hermit life' after the luxuries enjoyed so far,[67] and one that Ruskin, with his love of 'two bournes', would always hanker after for its contrast with his own habitually more luxurious style. He drew its scenery lovingly; one beautifully finished watercolour, contrasting with the bits and pieces of Tuscan building and painting he had been doing so far, triumphantly celebrated the pastoral 'chalets and rocks', 'mountains of all sizes within the stretching of an arm' and 'the roar of cascades without number all about me'. Macugnaga epitomized 'all my childs ideas of felicity', and it was Ruskin's realization of so much childhood delight at the age of twenty-six that prompted Couttet's 'le pauvre enfant – il ne sait pas vivre'.[68]

He 'indulged' himself in this existence, hoping it would 'answer well for my mountain illustrations', for it was difficult to discover any 'drawback to all this'.[69] Yet, predictably, he did. The life was too pure, too unnecessary, to satisfy him for long; the valley did not have sufficient 'horrors' – 'no chasms nor precipices . . . nor powerful torrents, nor ancient woods – the energies of Monte Rosa are turned the other way'. It was as if its lack of full sublimity accused Ruskin's relaxation:

> I cannot now dabble in a streamlet for hours together because now I count the days. I feel life going. I am stingy of moments, & must always be doing something. This is unhappy. Life seems infinite to the child, and what he chooses not to do today he hopes to do tomorrow. Probably he does more, according to his strength, in this way, than the *man*, who measures his time.

So he was made aware of the inadequacy of any sublunary paradise; sooner or later he found, like Rasselas, that some happy valley did not fully satisfy him.[70] Macugnaga preserved, and preserves, its 'romance' only in Ruskin's drawing; but in reality it came to lack the deeper 'association, the home feeling that I have in Chamonix'. Like the child in W. H. Auden's "Mountains" – 'scolded in France / Who wishes he were crying on the Italian side of the alps' – he was often longing to be happier in some other place.

So after just over a fortnight the three of them moved on. They traced a large circle up the Val Formazza, new territory for Ruskin still, to the famous Falls of Toce, then over the pass into Val Bedretto and so back via Airolo and Faido to Bellinzona. The aim was to study the 'Turner Torrent' at Dazio Grande, where Ruskin made the notes on 'M-shaped zigzags of the gneiss' that he would use eleven years later in *Modern Painters* IV.[71] After visiting and sketching other Turner subjects, they settled at Baveno on the western shore of Lake Maggiore.

Here he was again, for a while, enormously contented ('it is delicious beyond imagination'). The sublime Alps offered themselves as backdrop at exactly the right distance, with 'a foreground of Paradise'. But soon the 'effects on the lake and mountains' made him 'miserable', because he could not capture them in his sketches.[72] His recent excursion through Turner's St Gothard territory had revealed to him the master's skill at selection, at getting the visual scene to paper; now he was faced with his own inability to alter and adapt the carefully scrutinized landscape in order to make his own pictures. This crucial recognition – in his own terms, 'I am getting to be able to render what I see with tolerable accuracy, but I can't change – what I alter I spoil' – would be, despite its immediate frustrations, of enormous consequence to later sections of *Modern Painters*.[73]

The arrival of his former drawing master, J. D. Harding, to share Ruskin's travels, brought these anxieties to a head. To start with Ruskin was, or would be, 'actually writing criticisms on [Hardings's] works for publication, while I dare not say the same things openly to his face', yet his

sketches are always pretty because he balances their parts together & considers them as pictures – mine are always ugly, for I consider my sketch only as a written note of certain *facts*, & those I put down in the rudest & clearest way as many as possible. Harding's are all for impression – mine all for information.[74]

Ruskin was caught in the dilemmas of his own constantly developing theories and the various purposes for which he drew. Sketches were memoranda to be used – for engraving or verbal translation – in projected work; but they were also produced by one who still had ambitions as an artist, though gradually dissatisfied with routine picturesque manoeuvres. Further, while artists were to be judged for the accuracy of their reportage, great painters like Turner obviously rearranged their subjects – 'three new bridges, of wood, which Turner has cut out, keeping the [old] one he wanted'.[75] So Ruskin, torn between 'the picture' and 'the interest of the thing' depicted, was 'going all wrong' and generally running out of imaginative energy. He contrasted Harding's industry with his own – 'in a *months* escape from London to Italy which I find will not support one through *six*'.[76] To cap it all, he even seems to have encountered some renewed pressure from home about his book: to John James's rehearsal of the continuing praise for *Modern Painters* I and enquiries for its successor his son responded slightly defensively – 'I am sure nobody ever worked to less selfish ends than I. I will do all I can in the next book . . .'.[77]

And so he moved on to what had all along been envisaged as a brief finale. In Venice he planned to study 'only . . . John Bellini & Titian'; there would be 'little architecture, if any'.[78] The approach was propitious: 'this beautiful Verona – unspoiled as yet, thank God', he added as a postscript to a letter the afternoon of his arrival. The following morning, as he explored further, familiar patterns asserted themselves: another paradise was flawed ('mouldings dashed off the walls, and all made smooth & white with fresh stucco, and nice square windows frames, regular Mr Snell') and he was drawn into architecture yet again in an effort to document buildings before they were totally ruined by restoration – 'careful studies . . . to get the architectural details thoroughly. It is true this will take me a day or two more than I intended . . .'.[79] But he was also firmly determined by now to eschew merely picturesque compositions and get 'all the designs'.

Yet by the time his long and, even by his standards, full journey reached its climax in Venice, he was still not prepared to witness alteration, modernization and the usual lack of respect for an artistic heritage. Though he knew the railway viaduct had been under construction, he still planned to recreate his 1835 approach, by gondola from Mestre down the last stretch of the Brenta until, on a sudden, Venice's towers would rise from the waters, just as they always did in Turner or Byron or Rogers:

There is a glorious City in the Sea.
The Sea is in the broad, the narrow streets,
Ebbing and flowing; and the salt sea-weed
Clings to the marble of her palaces.[80]

Another ruined Eden – 'in the fall / Of Venice think of thine' – but now in 1845 further flawed by some 'Greenwich railway, only with less arches and more dead wall, entirely cutting off the whole open sea and half the city, which now looks as nearly as possible like Liverpool . . .'.[81] Once among the canals and palaces he decided that its delapidation had worsened since he was last there in 1841. And the Grand Canal below the Rialto was adorned with '*gas lamps*! . . . in grand new iron posts of the last Birmingham fashion'.[82] The despair ('thoroughly downhearted') at finding one of his sacred bournes of earth metamorphosed into what he need not travel further than Birmingham or Liverpool to see in England was deeper than could be fathomed by the anger and frustration in letters home. The paradise was ruined – 'weeds, where the garden had been'.[83]

Paradoxically, but so legitimately for Ruskin's temperament now that his careless pleasure at being in Venice was gone, its scope to instruct was greater than anywhere else in Italy.[84] Now it was simply his duty to stay: 'be assured', he advised his parents in terms that perhaps he thought they would understand, 'it is misery to me to stop here'.[85] Yet by the time of his departure he was 'sorry to leave after all – it is a blessed place'.[86] But in an earlier and revealing confession of disinterest, again designed to placate them at home, he explained that he 'never was so violently affected in all my life by anything not immediately relating to myself';[87] it is a remark that reads more selfishly than it was doubtless intended. His parents resented his lingering in Venice, the more so since much of his time and money ('rather expensive work here, gondola all day'[88]) seemed to be spent on matters unrelated to the requirements of *Modern Painters* II. Denmark Hill received only endless 'complaints and execrations' about the state of Venetian buildings. On 14 September, four days after reaching the city, Ruskin told his father that he would 'get my picture work soon done'; a week later he talks only briefly of Bellini and Titian.

His main energies at the start went in a frenetic bout of recording what he took to be some of the most threatened buildings. He drew the Ca' d'Oro, even as workmen 'hammered it down before my face'.[89] The repairs and reconstitution of utterly decrepit buildings were undeniably necessary, yet Ruskin, while rightly condemning the ignorant salvage methods – new windows in the front of St Mark's;

155

whitewash and stucco, then imitation alabaster over old mosaics – seems also to be protesting the destruction of a private vision: 'the modern work has set its plague spot everywhere – the moment you begin to feel . . . you are thrust into the 19th century'; but even Harding dreamt that his gondola was steam driven.[90] The cleaning of St Mark's removed its essential history – 'all the glorious old weather stains, the rich hues of the marble which nature, mighty as she is, has taken ten centuries to bestow'.

'Venice itself is now nothing', he decided on 18 September: it could survive only in Turner's paintings, his own sketches or even Harding's. Yet Ruskin's lamentations over Venice slid characteristically into complaints about his own inability to do enough to record old monuments. His own 'outside drawing takes me a terrible time',[91] so that he was constantly postponing their departure; nor were the specific needs of architectural record always satisfied by what he conventionally produced. Watercolours of Ca' d'Oro and Casa Loredan deliberately face their subjects, eliminating any tempting vistas (though he still draws in a little ruined *cortile* at the right of the first), and rigorously refuse the obvious invitations of a 'hackneyed place like Venice'.[92] Yet they still betray as much picturesque feeling as obligation to architectural record – the Ca' d'Oro is Proutian in its handling of the façade, while the Loredan abbreviates details of the capitals. Ruskin's taste and skill were both for fragments – the right-hand side of the Ca' d'Oro is eloquently vacant, while the erosions, even the plants, in the Loredan are lovingly depicted.[93] He forced himself into more precise detailing of mouldings and capitals on the Ca' Foscari, all of which he measured carefully – so much so that Couttet thought his drawing not so much resembled the subject as 'c'est la même chose'.[94] But he was defeated by the whole building, and one of his best known studies of an upper window celebrates the boarded-up interior more reasonantly than architectural detail.

On 14 September he began to think of employing 'some good young German draughtsman' to draw the details of capitals along the façades of the Doges' Palace in 'severe, true line'; Ruskin would then have supplied the feeling – 'dash in the light and shade'. Eventually with a sense of total excitement, he discovered the daguerreotype's immense possibilities ('a noble invention'). A poor Frenchman sold him prints of some of the palaces – 'examples of the sun's drawing'; what he had 'blundered and stammerd . . . for four days' to sketch was 'done perfectly & faultlessly in half a minute'; 'every chip of stone & stain is there – and of course, there is no mistake about

proportions'.⁹⁶ The plates even discovered details that he had never noticed in the Piazza di San Marco.⁹⁷

But with time running out and with the sense that Harding was side-tracking him with studies of boats and figures, one of the more momentous accidents of Ruskin's casual mode of research took him into the Scuola di San Rocco on 24 September.⁹⁸ 'I have been quite overwhelmed today by a man whom I never dreamed of – Tintoret . . . it is marvellous lucky I came.' From then on he was 'so divided between Tintoret & the grand canal'.⁹⁹ But what was particularly important about the new discovery was how it humbled Ruskin – 'I never was so utterly crushed . . . before any human intellect as I was today, before Tintoret.' Urgent emendments to his classified list of painters were sent to Denmark Hill. Many return visits to the Scuola, to gaze at its walls and ceiling, opened for him a new heaven and new earth. Tintoretto's vision of the natural world and Ruskin's vision of 'new fields of art' seemed to unite his already initiated work on *Modern Painters* – for Turner *must* have studied Tintoretto 'with devotion' – with his increasing preoccupation with Venetian arts and architecture. The whole, electric episode was confidently assessed years later in *Praeterita*:

> Tintoret swept me away at once into the 'mare maggiore' of the schools of painting which crowned the power and perished in the fall of Venice; so forcing me into the study of the history of Venice herself; and through that into what else I have traced or told of the laws of national strength and virtue.¹⁰⁰

But the excitements and added exertions of trying to copy bits of Tintoretto (they, too, were threatened by a leaking roof) made him excessively tired. Couttet noticed the little blue vein under Ruskin's eye that always stood out when he was over-extending himself. At last they left Venice, well behind schedule; the sudden release of pressure was too much for Ruskin and he fell ill at Padua. Couttet nursed him quickly to health and they continued. But after Couttet had been dropped at Vevey, Ruskin managed less well; with renewed soreness in his throat and some despondency he was glad to get safely home.

In his last letter but one, from Beauvais on Sunday 2 November, he expressed himself much satisfied by the 'quickness of eye' he had gained on his journey. But much else, he realized, had also been achieved, though not all of it designed to please those at home. He had, to start with, got on rather well without them;¹⁰¹ their only constraints upon him *in absentia* had been the need to plan his journey

in detail far enough in advance for Denmark Hill to know where letters were to be directed. His tastes, too, failed to coincide with crucial ones of theirs, and he had to set out their disagreements with some force. To his mother, who had packed Bunyan's *Grace Abounding to the Chief of Sinners*, he explained how uncongenial was Bunyan's (as opposed to George Herbert's) religion. To his father, who was still expecting poetry and arranging for what was available to be published in annuals, he declared what he had himself long known, that his verses were poor and could not express him at all adequately and that his life offered few opportunities for the 'living passion' that was deemed apt for poetry.[102] In these judgements Margaret Ruskin apparently concurred, for a rather disappointed John James told Harrison during July that 'I wish that his mother may not be right after all, and our son prove but a poet in prose'.

More positively, Ruskin registered throughout his travels various changes in his own attitudes. The 'Timon' rages were the palpable effect of stirrings of conscience: man's lack of care for great art was of a piece with his greed and commercialism, which everywhere set themselves up in disregard of picture, palace and church.[103] Beneath these clearly recognized and expressed antagonisms lurked Ruskin's unease at his own luxurious selfishness – 'very doubtful whether it were at all proper in me to have [the enjoyment of a sunset] all to myself'.[104] Beggars worried him more, and in a passage of clear-eyed scrutiny of his own comforts he described himself to his father as one who 'gets rid of all claims of charity by giving money which he hasn't earned'. Human distress – 'a poor little child lying flat on the pavement in Bologna' – he could, he realized, evade by treating it as picturesque rather than real – '*delight* at the folds of its poor little ragged chemise over the thin bosom – and gave the mother money – not in charity, but to keep the flies off it while I made a sketch'.[105] But at present these anxieties remained largely quiescent.

He was much more preoccupied with what he took to be his new objective attitude towards Italy: 'I take a far less imaginative or delightful one. I read it as a book to be worked through & enjoyed, but not as a dream to be interpreted.'[106] What he had more dimly intuited in 1840–1, the loss of some imaginative zest, was confirmed in 1845; yet he was pleased with his dispassionate regard – 'interesting matter for study, but it never raises emotion' – and returned frequently to the theme:

> my mind is strangely developed within these two years, but it is developed into something more commonplace than it was, into a

quiet, truth-loving, fishing, reasoning, moralizing temperament –
with less passion and imagination than I could wish, by much.[107]

That was his response to John James's rather grumpy refusal to accept
'the great change you suppose to have taken place in yourself'. But
whether or not Ruskin regretted the lost passion and imagination, he
was certain (as he told Harrison) that, although his daily experiences
were 'less enthusiastic and enjoyable', what he wrote 'has far more
feeling than it used to have'.[108]

Ruskin must have realized that with both his father and Harrison
he was implicitly defending the abandonment of poetry. Doubtless
this also contributed to the new tone, richer style and more serious
scope of *Modern Painters* II, which he settled at last to finish during the
winter of 1845–6. He must have revised the sections already written
and extended them into what *Fors Clavigera* would call 'an outcry of
enthusiastic praise of religious painting'.[109] He took his father's advice
– in a letter sent to Italy on 26 June – and made the new volume an
outpouring 'into the opened Ear of the public, all you have to say –
boldly – surely & determinedly'. The style was planned as a distinct
change from what he would later call the 'nasty, snappish, impatient,
half-familiar, half-claptrap' of the first volume; to prevent any lapse
into this 'pamphleteer style' Ruskin took the model of Richard
Hookers' *Ecclesiastical Polity*, recommended by his former tutor,
Gordon.[110] It was sustained with some imitative skill and its opportu-
nities for purple prose have made some passages particularly, if rather
unrepresentatively, famous. Yet its sonorities consorted aptly with
Ruskin's new seriousness of subject – first, his philosophical discus-
sions of beauty and imagination; second, the high praise of old reli-
gious painting.

He had always proposed to himself some sections on beauty and its
relations to the 'theoretic faculty'; in November 1843 he had warily
surveyed a similar project in a magazine, *Artist and Amateur*, only to
conclude that the field was still wide open for his ideas.[111] His recent
tour now gave him the necessary materials to illustrate and expound
them; from 'rocks and clouds', the *exempla* of *Modern Painters* I, he
graduated to the great artifacts of Christianity. His real subject went,
he realized years later in his Oxford lectures, 'quite beyond' Turner.[112]

Though he came to despise and resent the second volume of
Modern Painters for its presumption and affectation, and though he had
discovered among the depredations of Lucca in 1845 that 'It is a woeful
thing to take interest in anything that man has done',[113] nevertheless
what he wrote during the winter after his return from Italy and

published on 24 April 1846 has its own particular virtues. *Modern Painters* II found rich expression for that high endeavour which he announced in an untranslated 'great sentence' of Aristotle's:

> And perfect happiness is some sort of energy of Contemplation, for all the life of the gods is (therein) glad; and that of men, glad in the degree in which some likeness to the gods in this energy belongs to them. For none other of living creatures (but men only) can be happy, since in no way can they have any part in Contemplation. [114]

Ruskin's own participation in divine energies comes most obviously in his own fine – and influential – discussions of Tintoretto, allied to those of other subjects studied during 1845, Dante, Gozzoli and Perugino. These 'set pieces' show off his 'special function of Interpreter' of others' 'Contemplation'. [115] But if we simply pick these passages to read in isolation we are in danger of settling for as picturesque a fascination with pretty bits and pieces as Ruskin often did in Italian cityscapes. His enthusiastic recreation in this book of his treaty with old pictures grows essentially out of the fabric of theory and general ideas, just as it contributed to it in the first place. Moreover, as he recognized in a new Preface of 1883, his praise of beautiful things ('beautiful . . . for the sake of their beauty only; and not to sell, or pawn . . .' [116]) led directly towards his later work on political economy. Ruskin's passionate defence of the 'spiritual against the material', as one reviewer acknowledged, was a significant voice 'in this age of commercialism and utilitarianism'. [117] It was praise he must have appreciated. And John James annotated a childhood note-book of his son's with 'he has been compared to Goethe, Coleridge, J. Taylor, Burke, Juvenal'.

Part III
'Searching for Real Knowledge'

I, for the present, will but predict that chiefly by working more and more on REALITY, and evolving more and more wisely its meanings; and, in brief, speaking forth in fit utterance whatsoever our whole soul *believes*, and ceasing to speak forth what thing soever our whole soul does not believe, – will this high emprise [revealing Poetic Beauty] be accomplished, or approximated to'.

Carlyle quoting 'Gottfried Sauerteig' in "Biography"

As soon as the second volume of Modern Painters was in press, Ruskin left again for Europe, to spend six months showing his parents some of his discoveries from the year before. But their family journeys would never be the same again. Once he had tasted the freedom of travel without his parents, Ruskin might – out of guilt, nostalgia, sense of loneliness or the convenience of his father's accountancy – still want to share his trips with them. But their presence often proved awkward, becoming especially uneasy when his researches led him further from the kind of work that John James could readily appreciate. The more Ruskin's inclinations carried him away from Modern Painters, not in fact to be resumed for several years, and into architectural theory and research, the more recalcitrant and inhospitable seemed his father's ideas about the shape of his career. He needed – it must have been only a dim apprehension – some more suitable and sympathetic companion. Margaret and John James, too, must have urged him towards thinking of a wife, themselves relying upon a superficial and highly conventional reading of their son's tastes and temperament.

Modern Painters II brought Ruskin increased prominence, aptly mirrored, so his parents thought, in their new house on Denmark Hill, and this led him frequently into society, which he continued to dislike but could not separate from his new celebrity, which he did enjoy. His marriage to Effie Gray in 1848 was in some uncertain respects his response to all these pressures upon him. Undoubtedly he also believed that she – his Galatea – could be shaped into an ideal companion for his peculiar way of life which had by now become firmly established. But all parties concerned in these events acted with an astonishing mixture of deliberation and lack of foresight, of personal concern and public ambition, of conventionality and unusual assumptions about the conduct of social life, especially in its conjunction with John's high commitment to art and architecture. Ruskin's major writings of these years are arguably his most mature contributions to criticism; but The Seven Lamps of Architecture and The Stones of Venice achieved their success against the grain of and at the expense of his emotional life. Understandably, Praeterita looks back to these years with uncertainty, unease and evasion.

Chapter 9

'This Match-Making World': 1846–1848

> very interesting novels are composed out of the misunderstandings
> that compose the web or woof of Human Life . . .
>
> John James Ruskin to his son, September 1847

The Ruskins' 1846 tour was low-keyed and unstrenuous; though it took them back to many familiar, sacred places, it established no particular resonances of its own. Some entries in John's diary proved useful when he prepared a third edition of *Modern Painters* I later in the year. But he had exhausted himself in completing the second volume and was content simply to conduct his parents around the sites of the previous year's excursions. He was also, if Mary Lutyens is correct, in love with Effie Gray, who had stayed with them briefly before their departure: a development from which the Ruskin parents withdrew their son, thereby doubtless intensifying the situation.[1] So he was glad enough to spend the channel crossing alone on the prow of the boat, mesmerized by the plunge and rise of its bows.[2]

His diary records neither the panic and pressures of work nor much other disturbance, contenting itself with innumerable jottings on stained glass, sculpture and architectural detail. He was reading some new books – Willis's *The Architecture of the Middle Ages* and Woods's *Letters of an Architect* – and these, with paintings safely behind him in the pages of *Modern Painters* II, confirmed and extended the architectural absorptions of 1845. He obviously felt at liberty to spend his time on buildings. Especially in Venice he busied himself with elaborate measurements, an activity which John James found particularly baffling, and, as he explained to Harrison, quite unlike his son's former work with which he had been able to sympathize:

> He is cultivating art at present, searching for real knowledge, but to you and me this is at present a sealed book. It will neither take the shape of picture nor poetry. It is gathered in scraps hardly wrought, for he is drawing perpetually, but no drawing such as in former days you or I might compliment in the usual way by saying it deserved a frame; but fragments of everything from a Cupola to a Cart-wheel, but in such bits that it is to the common eye a mass of Hieroglyphics – all true – truth itself, but Truth in mosaic.[3]

John James may have found himself far less in touch with his son's work, but he still manages an independent and shrewd assessment. John's work was indeed dedicated to searching among the mouldings, ornaments and sections of buildings for the 'real knowledge' upon which he could ground his architectural thinking. But, like the Harry and Lucy upon whose example he had based his "Early Lessons", Ruskin was still determined to teach himself the rudiments of a subject; in the journals and sketches of this 1846 journey he collected the fragments, the facts, from which both of his next books issued. It was an activity, too, in which he could absorb himself thoroughly and happily; for, as he wrote later in another context, 'minute knowledge and acute sensation throw us back into ourselves'.[4] His most relaxed moments were obviously those in which he recorded, without any obligation to a pre-existing argument or shape of book, the rich anthology of *trouvailles*: the biblical narratives on the bronze doors of San Zeno in Verona – 'wonderfully archaic . . . and in quaintness and variety of line it would be difficult to match them' – one of which shows a sculptor at work in ways that would come to dominate his ideas of the nature of gothic art; or there were the intricate arrangements of the great portal of Troyes Cathedral and the 'amazing variety of composition' he discovered in the structure of St Marks's on his last evening in Venice.[5] So in diary, in notebook and on separate sheets he collected details. What, however, remained was to find in the 'mass of Hieroglyphics' some grammar, some larger theory, of architectural design, and, having discovered that, to establish the format in which to present his readers with this body of truth. It seemed probable that in 1846, if not for longer, Ruskin was uncertain whether his architectural studies should be cast into a separate study or somehow made part of the *Modern Painters* project. As we shall see, he solved this recurring problem of what form to give his ideas, by opting for both separated and related treatments.[6]

Once back in England he began to interest himself in illuminated manuscripts at the British Museum, while also continuing his studies in the natural history collections which were still housed in Bloomsbury. But no serious and sustained work was possible, because he had as yet no specific book into which to shape materials. And he found an alibi for not writing in a vastly increased social commitment. The publication of *Modern Painters* II had brought him much more into demand as a famous author, answering both correspondence and invitations. John Brown of Edinburgh wrote a letter of appreciation, which inaugurated a life-long friendship; Rogers invited him again, and so did the widow of Sir Humphrey Davy, at whose

home in Park Street were often gathered those who had once known Scott at Abbotsford.[7] Lady Davy even contrived to encourage a romance between Ruskin and Charlotte Lockhart, the daughter of Scott's biographer; but his general *gaucherie* and his determination to talk across his 'charming' companion at dinner to Gladstone did not further matters. Instead, as he remembered it, he sought to dazzle her with a learned review of Lord Lindsay's *Sketches of the History of Christian Art* which her father had asked him to do for the *Quarterly*; so off he went with 'George' to Ambleside to write his piece at the Salutation Inn.

It is unclear whether Miss Lockhart and Ruskin's review for her father's *Quarterly* by themselves occasioned his retreat to Lake Windermere in March 1847. He was presumably already in love with Effie Gray, for he was to tell Effie herself later in 1847 that his mother had explained the previous October that he must 'wait this winter . . . and then you shall see her'.[8] Between that October 1846 and March the following year when he went to Ambleside the 'affaire' with Charlotte Lockhart began. Its extent – Effie was to report that John had only met her rival 'six times at parties in his whole life'[9] – and its reasons – did Ruskin get pushed into it by his parents? – are all unclear. If the promotion of Miss Lockhart was largely the parents' doing, it might have been to try and divert John's attention from Effie, whose connection with both Perth and trade made her variously unacceptable to the older Ruskins; after all, they had tried diversionary tactics before, when he was pining for Adèle.[10] But a match with Scott's granddaughter also answered their huge social ambitions for their already famous son; in the months that followed and led eventually to John's and Effie's engagement, both John James and Margaret Ruskin would express their hopes for some connection with 'the elegant and highbred'.[11] So Ruskin may have been simply honouring his father's wishes, as Mary Lutyens suggests, pretending to court Miss Lockhart or at least pursuing her with less than full zeal, counting upon the announcement of her engagement to another man, James Hope, about whom Ruskin may well have known, thus relieving him of compliance with his father's wishes.[12] The flight to the Lakes, therefore, with the excuse of writing his review ('I could not at all have done it, had I stayed at home'[13]) may have been to buy himself some time. Soon after he returned to London Effie came to stay at Denmark Hill, though when this visit was arranged is not clear – was it part of Ruskin's agreement with his mother in October 1846 to wait the winter? Yet his gloom and lack of ease in Westmorland do not really suggest any eager anticipation of Effie's visit the following month: the

inert landscape of still, black lake waters, on which he rowed for exercise, 'the lonely rocky islets' and the grey skies were conducive only to a rather mechanical piece of writing.[14]

Yet another reason for his flight from London was a need to escape from the fresh bout of socializing. Ruskin's distaste for evening invitations and morning calls, though they were inevitably flattering to his *amour propre*, was firmly established by 1847. It makes his courtship of Effie Gray rather incomprehensible, for at least by the time of his visit to her house in October 1847 he must have realized how much she delighted in and needed a social life. But by then too much else was at stake. During the crucial time of her visit to London it was of course Ruskin who was constantly out and about – 'fevered by the friction', as he wrote on June 15 – and he doubtless came to see her, at a time of great emotional attachment, as the lovely and attentive person to whom he came home to complain ('he hates going out', she told her parents[16]). Ironically, part of his attraction for her was his prestige as an author which opened many social doors ('He is just gone to breakfast with Rogers the poet, he then lunches at the Dean's Dr Buckland, he then goes to Sir Stratford Canning's and dines at Mr Ellis's').

Effie stayed at Denmark Hill from late April till 15 June, with one week away at friends nearby. Her visit was fraught with domestic tension.[17] While the elder Ruskins thought John was somehow committed to Miss Lockhart (one of them apparently told Effie so on her first evening with them[18]), he himself either ignored the obligation or knew how slight it was or simply failed in face of Effie's presence to live up to his father's ambitions. At any rate Effie herself told her parents on 7 May that 'he has not asked her yet' and John himself told Effie at some point that he had been 'refused by another'.[19] Accordingly, he surrendered himself to Effie's charms and she in turn flirted with him. He waited each evening, despite his parents' disapproval, outside her room to take her down to dinner.[20] Sometimes, as she played the piano in the evening, his parents slumbered so that the young people were relatively alone; sometimes, even their public behaviour outraged John James, who was particularly embarrassed at the theatre one evening when Effie and John threatened, as he thought, to scandalize no less a person than Miss Lockhart's father.[21] John James at one point chose to write and ask Effie's father to remove her – it was the first of his (often awkwardly) straightforward letters ('I am glad to exhaust a subject and to get to the end of trouble'[22]). Mr Gray was understandably somewhat surprised, arguing that Effie could simply have been told of John's understanding with (or about)

Charlotte Lockhart; but he agreed to arrange his daughter's departure. However, John James wrote again five days later to say that his wife had indeed told Effie and that things could therefore safely be left.[23]

But what is altogether the more intriguing aspect of an exceptionally puzzling episode is why Ruskin was attracted by the idea of marriage with Effie at all. The explanation lies in a complex mixture of motives – 'many causes have been in operation for many years producing by degrees the distressing effects you at times labour under'.[24] The most deep-seated may well have been his old love for Adèle; the most recent, his experience during 1845 of being alone, freed of his parents' daily presence; the most obvious to himself, some vague wish to please his father and mother by taking a wife and thus furthering his social career ('you will be infinitely more happy and useful married'[25]); and to that last may be coupled his own sense that perhaps a suitable partner could somehow mediate between him and a social life he never greatly relished.[26]

When Effie had first stayed at the new house on Denmark Hill in 1843, she was exactly fifteen – Adèle's age when John had fallen for her.[27] As we have seen, John was gratified by Effie's attention; but when she played the piano for him, he dreamed of Adèle.[28] Even his family were dimly aware that memories of Adèle still kept a tenacious hold on him – John James told Mr Gray in 1847 that 'various journeys abroad have scarcely dissipated his chagrin'. But, more importantly, John James shrewdly noted how 'my son's poetical temperament comes rather in abatement of his Discretion'; later in 1854 he would admit that 'my son had been brought up in a most unusual purity & simplicity'.[29] What with his romantic temperament and his bewildering innocence of human emotion Ruskin must have let his sentimental memories of one frustrated passion colour the next for which he had opportunity. The idea at least of his romance with the French girl had haunted him for years, and its forms were realized afresh or conflated with new ones in 1846–7. Indeed, soon after he was engaged to Effie he told her of his 'strange pleasure of being able to throw my heart open – mixed with incredulity of my own happiness – it seems so like a dream – *so impossible – that I should be loved* . . . '[30] Beneath its conventional rhetoric is implied Ruskin's astonishment that any love of his should be successful; since he had only the one for Adèle, a comparison with that underlies his affection for Effie. When visiting the Grays before the engagement he declared to a Scottish friend, William Macdonald, in whom he confided – perhaps because Macdonald had visited Denmark Hill during Effie's spring visit and had seen what was afoot – that he only wanted to marry her if she returned his love. That

this requirement may echo with memories of an earlier, unrequited love seems clear from a further sentence to the effect that if she refused him 'no disappointment of this kind would affect me *as the first did*'.[31] Other parallels, not of his own devising, may also have confirmed Ruskin's sense of recovering Adèle in the person of Effie; just as his parents had reacted to his nervous depressions about Adèle, among other manoeuvres, by sending him to Dr Jephson at Leamington, they did the same again in 1847.

Effie left Denmark Hill in early June, parting from John in her bedroom; from a subsequent diary entry it is fairly clear they had declared their love to each other.[32] But opposition came strongly from his parents: they thought both young people had behaved atrociously, little realizing that the Lockhart affair was negligible and that John must at some stage have cancelled his mother's warning to Effie by saying that he had not asked Charlotte or by intimating that he had been 'refused'.[33] Moreover, with Mr Gray in some as yet undefined financial trouble, John James suspected not only that Effie was trying to capture a wealthy husband but that attempts were being made to thrust her brother George into the Ruskin firm.[34] Disappointed, too, that John was not making any efforts to link himself with 'a higher walk of life' than Perth represented,[35] they presumably thought that their son could or should be persuaded to forget Effie as he had, so they hoped, forgotten Adèle.

But whatever Effie's personal charms – and she was altogether a pretty, kind and lively girl, easily pleased, who took a quite astonishing amount of criticism from John during her spring visit[36] – she also represented for him some more crucial need, which he was not readily prepared to sacrifice and for which he could well convince himself that he actually loved her. During the 1845 tour in Europe without his parents Ruskin had experienced two distinct, slightly contradictory, emotions: that he was much happier and more self-fulfilled away from his parents; and that, travelling by himself, he often felt alone – nobody 'to come home to tea to' was an early lament, 'I want to see somebody', a later one.[37] The discrepancy could perhaps be resolved by marriage to somebody who would be a solace to him in his leisure hours, more flexible in intellectual and domestic notions than his parents, would defer like 'George' or Couttet but, above all, would appreciate his work. This last Adèle certainly had not; Charlotte had apparently ignored his review for her father's *Quarterly*; Miss Withers had not been won by his essay on "Poetry and Music".[38] But Effie really seemed to be fascinated by his studies, was duly appreciative of the Ruskins' new Turner, *The Grand Canal, Venice*, acquired during

her stay for £850, and had liked *The King of the Golden River*, written for her in 1841. The attraction of Effie's interest is somewhat confirmed by what Ruskin would tell his old friend, Acland, after the marriage had ended in 1854: 'I felt myself in need of a companion – during a period when I was overworked & getting despondent & I found Effie's society [could] refresh me & make me happy.'[39] Perhaps he mistook for love his feelings of gratitude for any attentive appreciation of his work, especially from a pretty girl; his affection for her became an extension of his own egocentricity. Yet the danger that lurked, in however loving a companion, was that John would never consider that his preoccupation with 'work' was at all selfish; he had used it as a protection against his parents and had delighted during his 1845 journey in being answerable to nobody for how he organized his time.

He had also discovered in 1845 how little he saw of 'human life'.[40] It now appears that he recognized this liability when he was contemplating marriage – 'I often wrote to you I was marrying you without *knowing* you – & how often I prayed you not to make me feel that I had been too rash.'[41] But his affection blinded him to the seriousness of this ignorance, and he clung blindly to his passion for the person he determined Effie was or could be. Among other things he ignored Effie's less than good health and how it might well prevent her sharing the life which he had inalienably created for himself by 1846. His mother recognized the dangers: 'when you take a liking to any one', she wrote to him in September, 'you cannot see defects or faults in them and are displeased with and think every one unjust who fear for you and endeavour to point them out'.[42] Sometimes it is evident that the Ruskins argued the case, for on 4 October John James wrote to confess that 'we had been from defects perhaps on both sides in a state of progression by antagonism, each Discussing half the Truth & supposing it the whole'.[43] But just as often John must have sulked in silence: 'It is I assure you', his father explained later, 'no easy matter to draw you out.'[44] There was a simple stalemate at the point when, first Effie and then John left Denmark Hill in June 1847. She left to spend time with other friends; but 'being with the Ruskins it makes one rather particular' and she returned to Perth.[45] John proceeded to Oxford for a meeting of the British Association. But a letter to Denmark Hill spoke of his despondency, his inability to be alone or to accept interesting invitations; if he got away into the Cumnor hayfields, he told his parents, he was plagued by his 'failing sight', while being in his old college rooms equally made him 'miserable'; perhaps memories of Oxford when he finally lost Adèle mingled with his new

frustrations over Effie.[46] Alarmed by his narrative, his parents ordered him to Jephson's at Leamington Spa.

Here he remained a month until mid-August. William Macdonald, with whom Effie had been so impressed when he spent a night at the Ruskins', also came under Jephson's care for a while and perhaps lent John a sympathetic ear. It was to Macdonald's Scottish hunting lodge that Ruskin proceeded from Leamington. But to his diary of 30 July Ruskin confided very little except that on a walk towards Stratford he had thought more of Effie than Shakespeare. He distracted himself with Richardson's *Pamela* and *I Promessi Sposi* (apt reading, had he thought?) and with some of his usual, attentive relish of sunsets and botany: to enjoy 'these simple pleasures', he noted, 'contentment and rest' are required, 'for discontent not only makes us unhappy in the dwelling on the privation we particularly lament, but it shuts out all the pleasures which are waiting round about us to come in'.[47] Since he was, evidently, enjoying them, the particular privation of Effie and no prospect of marriage with her do not seem to have unduly obtruded. More generally he continued his 1845 meditations upon the change that had come over him – 'I own the responsibility and must take the part, or the penalty, of a man'.

Released 'at last' from Jephson's regime, he made for Scotland. Crossing the border at six o'clock on the evening of 18 August, he saw the skies clear auspiciously: 'I never was more touched in my life than by the look of the heathery knolls and wild happy streams. I could not but have felt deeply, after eighteen years' lapse . . . and E G has something to do with it, I doubt not.' But he did not plan to call and see her, having presumably promised his parents not to do so.[48] In Edinburgh he visited Effie's uncle, Andrew Jameson, who afterwards told his niece that 'it was not difficult to perceive how much Mr R's thoughts were occupied with you'.[49] And while changing horses at Perth itself on Wednesday 25 August he saw Effie's brother, George, Mr Gray and his partner and brother-in-law, Melville Jameson, in their office. Effie apparently knew that Ruskin would be unable to come to Bowerswell – 'He cannot come for various reasons', she had already told her mother from London, 'and as you know Mrs Ruskin would be miserable every moment he was in Perth or under our roof which would be much worse.'[50] But it must still have seemed to the Grays awkward, even crass, of John not to linger long enough to call at their house. Once he had reached Macdonald's Crossmount Lodge, between Lochs Rannoch and Tummel, he wrote and apologized to Mrs Gray; but, fluent as he was, his effort is transparently uneasy.[51] Meanwhile he announced to his father on 25 August that he was

miserable: 'utterly downhearted . . . I am afraid of something seizing me in the state of depression'.[52]

Maybe this was a genuine cry of anguish or maybe, even subconsciously, it was articulated in a way that he knew would bring enormous pressure upon his parents to yield on the matter of Effie. His time at Crossmount, once he had opted out of the hunting, was often absorbed in botany or in reviewing Sir Charles Eastlake's *Materials for the History of Oil Painting*, in connection with which he wrote a long letter of questions to the painter, William Boxall, hoping for detailed information which he proposed to use without publicly declaring his debts.[53] But it was his letter to Denmark Hill that initiated a correspondence which cleared away misunderstandings and prepared the way for Ruskin's engagement.

The surrender of the Ruskins to their son's determination was at least based upon their fears, otherwise, for his mental health. But, once having capitulated, they were able to find compensations: Margaret evidently liked Effie, despite the Perth connection, and maybe thought she could replace Mary Richardson (recently married and departed from Denmark Hill) in her household; John James actually confessed that with Effie as daughter-in-law he would 'escape . . . from painful communication . . . with people out of my sphere'.[54] However, his snobbery still required that John should wait a decent interval, for 'I want you to stand well with Lockhart and the Intellectuals I should be sorry to let him fancy that your affections were not at all concerned in your proposals to his Child'.[55] So, from simply resenting Effie and expecting better behaviour towards Miss Lockhart, the parents came quickly by a change of mind. John James had suggested, as a preliminary concession, that his son 'go on with E. G. but not precipitately – If her *health* is good and she suffers little watch her but do not *shun* her for 6 or 8 or 12 months'.[56] Excellent, if too rational, advice for John to accept easily; but its caution was soon overtaken by concern for John's health. John James is soon writing to say that 'having seen great Injury done your health by former French affair and seeing you at a time of Life to be married and not likely to be better suited and Mama now reconciled I am quite agreeable to any step you take'; Margaret agreed that it would not be proper to leave Scotland without seeing the Grays.[57] Ruskin wrote at once to beg Mrs Gray to receive him 'for a day', his facetious tone no doubt designed to conceal his embarrassment at changing his feelings for Perth.

It is unclear what Ruskin hoped to accomplish by his visit to Bowerswell, where, in fact, he stayed a week. It is, however, certain

that it must not have been wholly satisfactory – the young people do not seem to have come to an 'understanding', let alone engaged themselves. For the first time Ruskin saw Effie in her own circle and realized that he was not the only man with whom she might contemplate marriage. There was even, he probably learnt for the first time, some vague 'understanding' with a young officer expected shortly from India.[58] There was certainly, much in attendance, a Mr James Hunter Tasker, encouraged by Effie's parents. Perhaps her family pride, not wishing to appear eager for a rich husband when her father was in financial difficulties, or her natural flirtatiousness made Effie play hard to get. At any rate it touched Ruskin at his most vulnerable. Already both his parents had had to reassure John that he was lovable and now, from Bowerswell, he wrote to Macdonald that 'I love Miss Gray very much and therefore cannot tell what to think of her – only this I know that in many respects she is unfitted to be my wife unless she also loved me exceedingly.'[59] By his departure from Perth he probably did not really know what Effie thought of him. On the way home, spending Sunday alone at Berwick, he was, undoubtedly, 'as miserable as can be'.[60]

Perhaps the only way out of his anguish was to ask formally if she would marry him. Within a fortnight of leaving her and at any rate by 21 October he had proposed – by letter – and been accepted.[61] The engagement was kept secret for a while, presumably until William MacLeod returned from India and Effie could speak – in fact, write – to him.

From this, finally successful, stage of his wooing until the marriage Ruskin conducted his love affair by letter, surrounding Effie, as his mother feared he would, 'in some degree . . . with imaginary charms'.[62] His father's love letters had always been flowery, a borrowed literary language to express the spiritual as opposed to the commercial life. But his son used language differently, inventing images of his own imagination, sometimes with a large measure of the descriptive truth upon which he prided himself, but always with a creative energy that forced what he wrote about into his own terms. His letters over the five months of his engagement shape his romantic ideal – 'My own Effie – my kind Effie – my mistress – my friend – my queen – my darling – my only love'.[63] Yet he registered some discrepancies between this and the reality, for he tried both to direct her spare time so that she would fit more aptly into their future married life and to teach her more discrimination: 'The fact is that you like everbody – and anybody – and that's many bodies too many'; he feared her 'cheerful society' would encourage 'hundreds of people' to

pester him – 'Against their inroads nothing but the most *rude* firmness protects me.'[64]

The engagement did not go altogether smoothly at Ruskin's end. He was over-excited and depressed by turns. A month after returning home he had 'got into a state of nervous & sleepless irritability . . . that I had to retreat here [Pavilion Hotel, Folkestone] & give up work of any kind'.[65] Part of the problem seems to have been that Margaret Ruskin had decided ideas about both the timing of the wedding and the projected visit afterwards to Switzerland. First John wanted Effie to fix a wedding day before Easter; but his mother refused to contemplate a ceremony during Lent; but she also wrote to Effie that 'for some reasons which I do not write about, but your Mama will understand' it was inadvisable to marry until immediately before their travels. Did she envisage, otherwise, Effie getting quickly pregnant and ruining John's Chamonix excursions?[66] John himself probably feared this. In 1845 he had learnt from Couttet the sad facts of married life – that women had a year's enjoyment of the Alps with their husbands and then '*Après* – ah – il leur faut une femme de chambre'; moreover he even repeated the remark to Effie when they were engaged and he was looking forward to sharing with her his bournes of earth. Significantly, he misquotes Couttet, substituting for the suggestion of family commitments the problems of transport ('il leur faut une voiture') after the first bloom of marriage had worn off.[67]

But, on the other hand, he obviously wanted to show Effie around Switzerland, perhaps as a means of watching without shunning her, as John James had suggested; taking her to one of his sacred places even seems to have taken precedence in his mind over marriage. In 1854 John James would tell a correspondent that as his son 'wanted a young Companion he asked Mr Gray to let his daughter travel with his family which was declined; my son proposed marriage . . . '[68] His sentence is not particularly clear and with angry hindsight his judgement of events six years before is not reliable; yet the implication is that John proposed to Effie because otherwise she would not be allowed to travel with them. In February 1848 John was still harping upon that possibility, wishing that 'we weren't to be married till we come back! ! !', a suggestion that neither Effie nor her father could understand.[69] Perhaps as a result of the earlier, abandoned plan, it was decided that both elder and younger Ruskins would travel to Switzerland after the wedding. From an expression John used in arguing for the arrangement in December 1847 it appears that Effie had at least queried the parents' presence – she would find, he wrote, how 'nice' it was 'not to have to take care of oneself' and that they

would give sufficient pleasure to his parents 'that you will not in the end have reason to wish it had been otherwise planned'.[70] A typical Ruskin blend of the selfish and unselfish. It is also clear that Ruskin entertained many uncertainties and unease about marriage,[71] so that his preoccupation with their journey abroad may represent an involvement with a life that was known and held no uncertainties. At any rate, the postponement of their journey to Switzerland, owing to political revolution in France, was a shock from which the marriage suffered from the start.

The news from France reached John on 26 February, over six weeks before the wedding, and was added to other annoyances. Effie was unwell and overworked at home, and thus unable to attend as properly as her fiancé thought she should to preparations for life with him. At the same time he was increasingly nervous of their first encounter for nearly six months. This was planned for mid-March in Edinburgh, where Effie was to attend the wedding of a school-friend and enjoy some social life – not a little of her pleasure coming from being 'known at these parties as the young lady who is to marry the Oxford Graduate'.[72] Meanwhile Ruskin continued to fret about the quality of her affection for him, vicariously relishing the (really rather pallid) love scenes in *Dombey and Son* and recommending them to Effie together with Dickens's description of driving over French roads![73]

Further, more irksome, anxieties emanated from the Ruskin parents. First, although Margaret had implied in a letter to her son of the previous November that they would come to Perth for the wedding, John James wrote to the Grays in February to say that they would not attend; his reasons seem scarcely courteous and maybe gave him qualms, for he was justifying himself some time later.[74] His main excuse concerned the avoidance of excessive excitement and his need to attend to business, especially in the event of a possible absence abroad. But this insistence upon business may also be John James's need to maintain his superiority and distance from Gray's financial troubles. By mid-March the extent of these, communicated in the course of letters between the fathers arranging the marriage settlement, caused John James alternatively to patronize and excoriate Effie's father. The spectre of his own father's bankruptcy, together with pride at his own magnificent rise above it, brought out the worst in John James. His vexation at Gray's lack of wisdom, even his apparently greedy speculation ('concerns promising 30% Intr'), was not made any less severe by the investments having been in railroads, French railroads too. Neither of the Ruskin men could ever quite

countenance this new mode of transport, even when they used it; doubtless they found the horrified fascination with railways in Dickens's *Dombey and Son* particularly congenial. But whereas John James's displeasure at Gray's affront to business probity was extended to include George Gray's education ('rather too much varied and interrupted with pleasure for a man of Business'), John himself wrote with pleasing tact to his future father-in-law, a letter that must have brought much needed sympathy to Bowerswell.[75]

By the end of March John James was writing that he and his wife now had no objection to the wedding taking place before the end of Lent. The Grays chose, in fact, not to wait. Two weeks before Easter John Ruskin and Effie Gray were married at four in the afternoon of Monday 10 April; the ceremony took place in the drawing-room of the house where the elder Ruskins had inaugurated their married life. Accompanied by 'George' Hobbs, John and Effie drove north that evening to Blair Atholl for the first night of their honeymoon.

Neither of them were – as they subsequently confessed – prepared for the intimacies of married life. Yet they were both probably more passionately disposed than their later recollections and rearrangements of the marriage story could understandably recall. What happened to deflect and sour that emotion can only be guessed – even Ruskin himself said it would take more than 'a day's hard work of writing' to rehearse the 'entire history of our married life'.[76] What is perhaps fairly certain is that their drive to Blair Atholl on 10 April was long, an additional strain on top of an already tense fortnight. Effie was upset on account of her father's difficulties and the elder Ruskin's reactions,[77] John – as Mary Lutyens has shrewdly guessed – must have hated the lack of privacy at Bowerswell and the society of curious neighbours; in addition, he had a bad cold. Then, whether by miscalculation (owing maybe to the short notice of fixing a wedding date[78]) or from the pressures and anxieties of the previous days, Effie found that she had her period. Perhaps it was this, rather than the notorious first sight of pubic hair, that upset Ruskin. Less than a year later, he would remind Effie in a particularly affectionate letter how it was only at Keswick, five days into their honeymoon, that she was 'mine own then for the first time'.[79] Since the marriage was never consummated, Ruskin can only be referring to the first occasion on which Effie was able to present herself to him as he thought a wife should be. The 'disgust' which in 1854 Ruskin told his wife her person had aroused in him – a disgust that is now perhaps attributable to Effie's period – may well have tainted the start of their honeymoon. After one night at Blair Atholl they turned round, south, to Aberfeldy, then moved on

(including a stretch by rail from Glasgow to Penrith) for a week in Keswick. John James was on a business trip in Liverpool and was invited to join them in the Lakes and travel south with them. On this occasion he was tactful enough, or had alternative business reasons, to refuse.

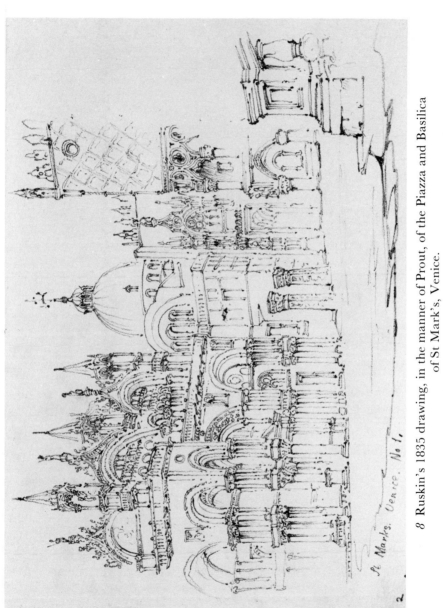

8 Ruskin's 1835 drawing, in the manner of Prout, of the Piazza and Basilica of St Mark's, Venice.

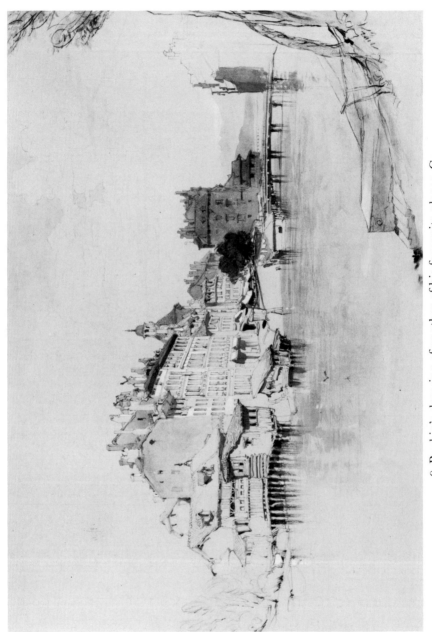

9 Ruskin's drawing of another of his favourite places, Geneva.

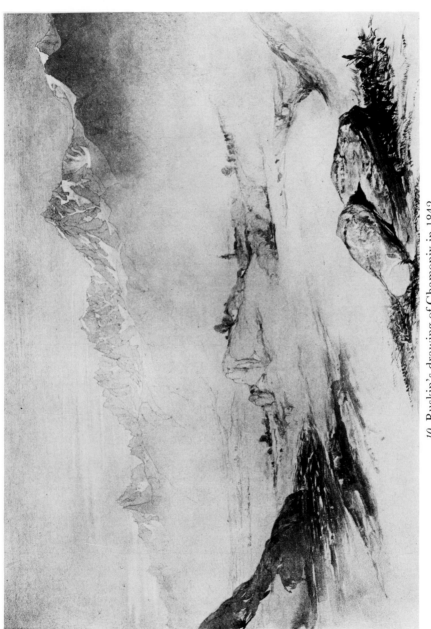

10 Ruskin's drawing of Chamonix in 1842.

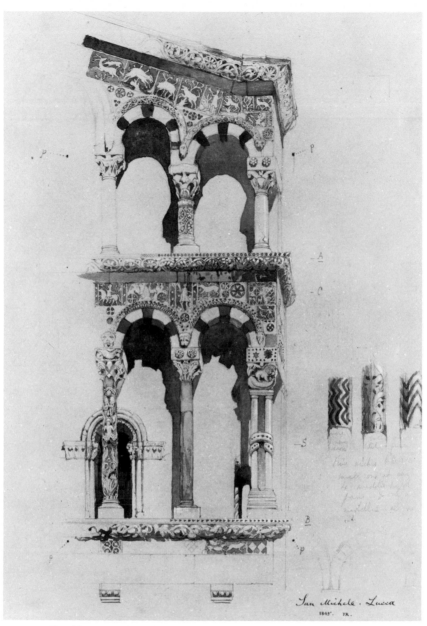

San Michele. Lucca.
1845. JR.

11 Ruskin's studies of the facade of San Michele, Lucca, in 1845.

12 Ruskin's drawing of the valley of Macugnaga, where he stayed in 1845: see p.152.

13a Adèle Domecq, about 1825, some ten years before Ruskin fell in love with her.

13b Effie, painted by Millais on the rocks at Glenfinlas, 1853.

13c Millais, *A sketch for Natural Ornament*, showing Effie in animal and snake skins: see p.87.

14a Rose La Touche, a photograph decorated with
a watercolour vignette of a wild rose.

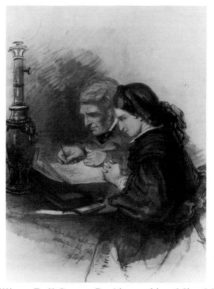

14b William Bell Scott, *Ruskin teaching Miss Mackenzie
to draw at Wallington*, probably July 1857.

15 Ruskin, *Tracery at San Sebastiano, Venice*, probably 1850.

Chapter 10

In Society and in Print: 1848–1849

When we begin to be concerned with the energies of man, we find ourselves instantly dealing with a double creature. Most part of his being seems to have a fictitious counterpart, which it is at his peril if he do not cast off and deny. Thus he has a true and false (otherwise called a living and dead, or a feigned and unfeigned) faith. He has a true and a false hope, a true and a false charity, and, finally, a true and a false life.

The Seven Lamps of Architecture

It proves that talents have been wisely distributed and that a man who can write the Seven Lamps is not fit to choose a fire grate.

Effie, writing from Venice in 1851

After John and Effie had been a month back in London, John James was expressing his pleasure to Gray that Effie got his son out into 'general Society'; in fact, just one of the Ruskins' ambitions in urging their son to marry in the first place. He also boasted that they had dined with the Marquis and Marchioness of Lansdowne, though 'John would rather be in Switzerland'. Still, he hoped that the young couple 'will contrive to be happy and take a due share of Society and solitude – Effie is much better calculated for society than he is – He is best in *print*'.[1]

The honeymoon seems to have been cut short after a week in Keswick.[2] The news from France continued to depress John and from Keswick he wrote to Mary Russell Mitford that 'these are not the times for watching clouds or dreaming over quiet waters, that more serious work is to be done, and that the time for endurance has come rather than for meditation, and for hope rather than for happiness'.[3] True, he was thinking of politics and maybe architecture, but the last phrase reads oddly from somebody on his honeymoon. And they did more than watch clouds and wander beside still waters: they rode up Skiddaw, a fairly standard excursion, but also up Causey Pike, down which they were forced to scramble – a quite astonishing choice for Ruskin to make, but perhaps its barren cone reminded him of Swiss peaks or perhaps it was part of his larger endeavour to shape Effie into the ideal companion.

177

This Pygmalion ambition – a more than usually intense pedagogic energy that always characterized Ruskin's dealings with young people who were impressionable or uncertain – was intense and all-inclusive. His confession of this ('thinking her so young and affectionate that I might influence her as I chose') is the part of his statement to Proctors after the marriage broke up that can best be credited with some objectivity.[4] Teaching his fiancée to draw a circle (a figure of perfection) in Edinburgh before the wedding, and persuading her to refrain from chattering to all and sundry on the honeymoon were part of his general endeavour to instruct Effie in 'the duties of married persons to each other'.[5] Those are Effie's words, also after the marriage had broken up, but, again, they ring with truth: Ruskin delighted to enunciate principles – *The Seven Lamps of Architecture* and *The Stones of Venice*, written during that marriage, are founded upon the habit – and his relationship with Effie obviously gave him frequent opportunities; it even seems possible that those two architectural books, so dependent upon careful formulae and prescription, so often painstakingly pedagogic in style and tone, acquired that characteristic from Ruskin's closeness to a person whom he was in the habit of instructing. And back in London, as they moved in society or attended a Private View of the Water Colour Society, John continued to be 'particular' with Effie, who reported to Perth that her husband 'takes a good deal of trouble in teaching me things'.[6]

The elder Ruskins gave them a grand welcome at Denmark Hill – servants lined up, a bouquet from the gardener, a German band playing outside during dinner. Effie expressed herself 'very happy here' – they were given the top of the house – and was unconcerned whether they stayed or went into some furnished house that John James wanted to rent for them. Their social life from Denmark Hill, as Effie's lively letters home reveal,[7] was all she could have wished – 'three Dukes and Duchesses of Sutherland and Argyll and Northumberland', 'so many people that I almost forgot them but the names of some of the artists you will know'. John James must have recognized an answering snobbery to his own, as he took her on his arm through the Private View. Rogers invited them to breakfast. Turner, once they had got him to answer the door, entertained them to wine and biscuits in a 'bare and miserly' room and showed them his gallery. They heard Grisi in *Norma* and Jenny Lind, saw Windus's pictures and had special tickets for Horse Guards' Parade. John seems to have participated with an ill grace – 'if I go into society at all', he told Effie's mother, 'it is for *her* sake, and to my infinite annoyance'.[8] Perhaps there was, at this stage, some element of playing a role

(disliking society) expected of him, for he also expressed what seems a genuine pleasure at 'seeing her admired . . . by all'. It is possible, too, that part of the 'compact' which he would much later recall having made with Effie – no babies for the first year, 'as he had much travelling and work'[9] – included his participation in the social life which she enjoyed and managed so gracefully. On such occasions, her husband still needed to learn things, maybe to prove himself still the 'Graduate of Oxford': Effie records John's 'long and learned discussion' with the Bishop of Norwich 'upon the migratory habits of seagulls'.

The Ruskins all went to the Kent coast in mid-June, John 'constantly longing to be on the other side of the Channel'.[10] The weather was fine and allowed them to alternate sketching with a love of childish play, which John always relished as an adult ('never tired of being on the beach and throwing stones into the water'[11]). From Folkestone Ruskin took Effie to London for a reception at Lansdowne House, then to Reading and tea with Miss Mitford and then to Oxford for Commemoration; they stayed with the Aclands, and Effie attended parties. Then, though invited to visit Somerset by Pauline Trevelyan, a recent fan of Ruskin's who had taken Effie up, the young couple rejoined the elder Ruskins ('ostensibly we are travelling with them'[12]) at Salisbury.

John had decided upon a tour of English cathedrals, to gather materials for a study of mediaeval architecture, a project that in the following year became *The Seven Lamps of Architecture*. Its Preface tells something of what transpired at Salisbury:

> I could have wished to have given more examples from our early English Gothic; but I have always found it impossible to work in the cold interior of our cathedrals; while the daily services, lamps, and fumigation of those upon the Continent, render them perfectly safe. In the course of last summer I undertook a pilgrimage to the English Shrines, and began with Salisbury, where the consequence of a few days' work was a state of weakened health, which I may be permitted to name among the causes of the slightness and imperfection of the present Essays.[13]

In short, the pilgrimage was not successful. Perhaps Ruskin was wanting to cover up the awkwardness of that Salisbury visit beneath inaccurate generalization ('I have *always* found it impossible . . .'); perhaps *The Seven Lamps* was another book which could not realize his vision of what it might have been and had thus to be excused. Salisbury took the blame in the Preface, just as it took the brunt of

John's frustrations with not being abroad ('cutting poor Salisbury to pieces in comparison to . . . Florence'[14]). Also, though the Preface does not make this very clear, Ruskin had arrived with a cold already caught on the Kentish coast. It grew worse at Salisbury, but how much this was due to the physical conditions of his work in the cathedral, or how much to some psychosomatic cause – annoyance at not being abroad or at his parents' fussy alarms over his health – is unclear. Effie certainly soon came to think 'his health depends so much upon his feelings'.[15] And she told Pauline Trevelyan that a change of air and a few weeks in France would cure her husband; John apparently agreed.[16] Meanwhile she watched the Ruskins with some amusement, though with some resentment also, as they 'concocted all sorts of remedies' for John and, themselves rather poorly, ministered to him in bed for eight days. Effie could read to him, sit sewing in their bedroom (from which Mrs Ruskin banished her at nights[17]), but was otherwise left feeling useless. There had even been a sharp disagreement – to be made so much of later[18] – between the women over whether or not John should take a 'blue pill'. Beginning to feel the restrictions of Margaret Ruskin's presence, Effie must have welcomed the news, on their last day in Salisbury, that a house in fashionable Grosvenor Square had been found for them.

Back at Denmark Hill, things did not seem to go any better. Effie became 'angry' at the Ruskins' complacent strictures on her family: 'talking of what they don't in the least feel or understand, and laying down things about what he might do for himself in Perth which I know to be perfectly impossible'.[19] 'He' was Effie's brother, George. She and John had rashly promised to intercede with John James for some London position for him, which would in its turn help out the parents. But it was the touchiest of subjects at Denmark Hill, so despite pleas from Perth that both Effie and John tried to answer, nothing could be done for George. Effie's helplessness in this as in the matter of nursing her husband had made her 'cry at night' alone in her bed at Salisbury.[20]

After a week at Denmark Hill John and Effie left on a tour of Normandy. 'George' Hobbs, who accompanied them, said that this was 'to make up a little for the disappointment of not having the intended marriage tour'.[21] John James, too, could not forgo some compensation, so he went along as far as Boulogne and, much to Effie's amusement, joined in his son's raptures at being once again in France.[22] It was Effie's first time abroad and 'George', a trifle superior on account of his own previous travels, noted her fascination with French manners and customs.[23] She attended eagerly to their food,

good and bad inns (the Hotel D'Albion at Rouen had a 'nice Piano'), the countryside which she found more beautiful than she had anticipated ('like our richest Highland scenery') and to the Catholic services which the travellers attended whenever protestant rites were unavailable. She professed herself 'confounded with the mixture of the grand and ridiculous' at her first Mass and was astonished by the noise and high spirits of the Feast of the Assumption at Eu after 'the quiet of a Scotch Sabbath'.[24]

Generally the Ruskins found their first extensive trip together relaxed and pleasant. Near its end Effie told her parents that her husband was 'quite well and making some beautiful sketches here. I am trying to do the painted glass, which pleases him very much; we are extremely happy together and have been married half a year to-day'.[25] She saw him for the first time totally absorbed in studying architecture – indeed, he danced 'in rapture with the porch' at Abbeville the first morning after John James had left – and she was 'amused' at 'how happy John is in a place he likes'.[26] She also learnt how dull it could be when her husband went off to work and left her to her own very restricted devices: on one occasion later at Caudebec she and 'George' were reduced almost to a parody of Ruskin's own curiosity – measuring enormous pumpkins in the market.[27]

Ruskin's own realization of the implications of married life were as acute but not, with all the work he was doing, as insistent as Effie's. From the start at Abbeville, where they spent a week, John knew that he had to leave Effie much on her own. He was up at six, read a little and then went out sketching, while Effie stayed to write up the previous day's memoranda; only after their dinner at 1.30 was he 'at Effie's service till four', when he returned to sketching. John at any rate thought Effie 'accommodates herself to all my ways' with perfection; he was even pleased when she remonstrated at the chance of his health being damaged by too much drawing.[28] He recognized how dull many days were for her: she 'would be far better off with Papa and you than with me', he wrote to his mother, 'for I go out on my own account and when I came in, am often too tired or too late to take her out'.[29] A month later he was, perhaps, rationalizing rather more: 'Effie might with reason feel a little dull here, for she is left alone more than half the day but she says she likes it very much – and we enjoy our afternoon's walk the more.'[30]

Yet Ruskin could occasionally become very irritated by Effie's interests: 'I sometimes . . . will not, for fear of losing time, stop with her to look at the shops, the flowers, or the people.'[31] An extended outburst in another of his letters home reveals a more crucial incident.

181

As they were about to leave by diligence from Caen, Effie wanted to be taken down the street to see the house of Charlotte Corday, the French revolutionary patriot who had assassinated Marat. Both Ruskin's political instincts and his superiority about idle sightseeing were offended – 'I at first refused – not being interested – *not caring to appear interested*'; he eventually agreed by finding that he could turn the incident to his own purposes, for Effie told him that the house was described by Lamartine in her Caen guidebook and Ruskin 'went with her to see *how far the description was true* – as I thought it might be the means of testing the man's character by a small thing'. Ruskin then transcribed the French passage at some length, with his own parenthetical and sharply ironic comments, and concluded by urging his father to give Lamartine up entirely: 'it is lying of the most deliberate kind – lying in order to make a romance of murder – and an heroine of an assassin'.[32] The extraordinary vigour of the narration, though not directed against Effie, nevertheless hints at the kind of lecture she must have been subjected to at the time.

He was hardly less tolerant of Effie's physical stamina, though admitting that she 'is amazed at my sensibility to draughts as much as I am at her weakness in anything like heat'.[33] But after his mother's 'excellent walking' Ruskin found Effie's highly disappointing: 'I had no idea of the effect of fatigue on women. Effie – if I take her, after she is once tired – half a mile round – is reduced nearly to fainting and comes in with her eyes full of tears.'[34] So he tried carrying his camp stool on which his wife could rest ('three hours together') while he worked. On other matters not directly impinging upon his daily schedules he was understanding if slightly baffled. Effie's hair – for what reason is unclear – would come out in handfuls whenever she brushed it and various family doctors back in England were asked to advise; Ruskin himself decided it was a symptom of poor health. When she received bad news from Scotland – her father's financial worries continued and, late in September, her beloved Aunt Jessie died – John did his best to comfort her, though all the time aware of his own selfish resentment: 'even when poor Effie was crying last night I felt it by no means as a husband should – but rather a bore – however I comforted her in a very dutiful way – and it may be as well perhaps on the other hand that I am not easily worked upon by these things'.[35] On the occasion of her aunt's death he delayed telling her about the letter from Perth because 'she had been unwell and was just recovering to a day of enjoyment. I will give her [it] this evening when the shock will be less'.[36] How much a part was played, even unconsciously, in that decision by his refusal to let another day's work be interrupted is

unclear; for by this point in the tour Ruskin was as usual running out of time.

The journey to Normandy was designed to collect materials for his renewed architectural interests. Exactly when Ruskin formed the idea and structure of *The Seven Lamps of Architecture*, to be written during the winter following their Normandy tour, is unclear. As early as 1846 or 1847 he was making notes on architectural vocabulary, especially its 'expression' of emotion, ambition and labour; at that stage he was calling them 'Spirits' rather than 'Lamps' and may also have been thinking of discussing them within an enlarged *Modern Painters*.[37] By 1848 he was listing the various 'Lamps' and had probably decided, as a draft of the preface later confessed, that 'they assumed so independent a character as somewhat to interfere with the symmetry [!] of the more comprehensive essay'.[38] Yet on the basis of his daily studies in Normandy it is doubtful whether the shape and scope of *Seven Lamps* became a reality until he was actually writing the book during the winter in London. In his diary for 1849 he noted that 'the most successful books seem to have been planned as they went on'.[39]

Seven Lamps reached back for its materials into the cabinet of Ruskin's mind which had been stored with architectural curiosities even while he was responding so wholeheartedly to Fra Angelico and Tintoretto: the section on how gothic architecture was corrupted by intersectional rib mouldings derived from isolated recognitions of the phenomenon during the 1846 tour; these in their turn were connected to some of his own earlier scribbles in 'the blank leaves of Aristotle's Rhetoric'.[40] As always with Ruskin the major exercise in writing was to relate innumerable memoranda – 'upwards of an hour' spent on a 'couple of crockets' in Normandy, for example[41] – to a general scheme or thesis. So much of the detailed fieldwork was done without any exact sense of its ultimate relevance that he had at some later stage to insert marginal glosses in his notebooks indicating the principle or point which the details exemplified.[42] He had found this dialogue between local sightings and larger schemes frequently baffling during the Normandy tour: at Rouen, he told his father on 15 October, every time he walked into the square it struck him anew.[43] He had himself probably contributed to these problems by his continued accumulation of memoranda, filling eight notebooks with records. He would annotate the 'graceful fragments' of St Lo cathedral, take sections of Rouen cathedral, or embark upon huge and ambitious drawings that always took him longer than anticipated.[44] Another aspect of his difficulties was that, even before coming to the writing of his book, he was divided between architecture criticism and his determination to

record buildings before restorations ruined them. In a famous letter to his father from Abbeville at the start of their tour he exclaimed that 'I seem born to conceive what I cannot execute, recommend what I cannot obtain, and mourn over what I cannot save'.[45] This *mare maggiore* of an architectural heritage in continuous peril forced Ruskin into sketches and annotations which photography would have captured economically and accurately. J. G. Links remarks how surprising it is that he 'took so much trouble over what was purely documentation when he could have saved time by using the daguerreotype'.[46] Why he did not invoke it was almost certainly his commitment to the affective experience of buildings: 'I have not once succeeded', he wrote from Rouen, 'in giving the *true* effect'. This effect – an impressionism at once visual, emotional and mental – was his concern in drawing or writing as much as what the daguerreotype could record; to 'know something about it and understand it a little' contributed a large part to Ruskin's success as an architectural writer as well as to his explorations of a place like Chamonix.[47]

Rouen, especially, was 'a labyrinth of delight'. The metaphor signals something of his happiness as well as his frustration with the city's bewildering riches:

> the walls and gates of its countless churches wardered by saintly groups of solemn statuary, clasped about by wandering stems of sculptured leafage, and crowned by fretted niche and fairy pediment – meshed like gossamer with inextricable tracery . . .[48]

He found his own single-handed attempt to record this richness so dispiriting that he said he wanted George Richmond, Turner and Samuel Prout along to help, implying that Effie's place in the *coupé* (the nicest part of the diligence) would be sacrificed to such a trio.[49] Effie helped as she could, transcribing memoranda and pages of *Proverbs*, as well as reading to him while he sketched,[50] but in the architectural work she must generally have struck Ruskin as a useless passenger. He did acknowledge her occasional talent as a 'capital investigator . . . I owe it to her determined perseverance – and fearlessness of dark passages and dirt in the cause of – philosophy – or curiosity – that I saw the other day the interior of the Abbaye St Armand, certainly the most exquisite piece of wood painting for rooms, I ever saw in any country'.[51]

By the end of a repeatedly extended trip he was under pressure from his parents to return home. The usual guilt about his way of life had reappeared at the very start of the journey through Normandy: to his father he confessed that 'neither of us have chosen our master or

begun our work' and later he wrote of the weight on his conscience of 'Every day that I spend in idleness and you labour'.[52] Compensatory gestures towards beggars ('I shall take him and the doggy some dinner'), gloom at the convicts working calico looms at Mont St Michel, disgust with both French peasantry *and* 'our own congregation of expatriated English – and their fat futile feeble clergy', all culminated in an extraordinary scene at Caen when he tried to persuade some card-playing *copains* in a café that they would be better in church or reading the Bible.[53] He learnt to practise small economies – sometimes at Effie's expense ('I do not find certain economies at all painful, we do without a salon for instance with our two rooms'[54]). By the end of their four-month tour apologies for further delay from John were accompanied to Denmark Hill by thanks from Effie for some extra money which enabled her to buy mourning for her aunt and her husband 'to get some fine Daguerreotypes'.[55]

Their Normandy tour had been all work for John – apart from a fleeting and improvised visit to Paris towards the end, the chance result of deciding to take a Paris train waiting in Clermont station rather than wait three hours for one to Amiens, which was where they planned to go! Effie must have been thrilled by their carriage rides down the boulevards, by hearing Fanny Persiani sing *Luccia di Lammermour* at the Opera and by a visit to the Louvre, though her account took its cue somewhat from her husband's disenchantment with the revolutionary city.[56] After this interlude they headed resolutely for London.

The winter was spent at 31 Park Street, where Ruskin wrote *The Seven Lamps of Architecture* to present his theories of good building based upon his detailed studies abroad. He also did an essay for the *Art Journal* on Samuel Prout, which acknowledged Prout's vital role in recording what, soon, would no longer survive, when 'the stones of the goodly towers of Rouen have become ballast for the barges of the Seine'.[57] During this winter Ruskin must also have conceived the idea of writing *The Stones of Venice*.

So, inevitably, Ruskin was 'very busy with his book', and must have kept his 'study inviolable', as he had told John James from Normandy he intended to do.[58] Effie enjoyed the prospect of being in her own house ('most conveniently situated') in the midst of a busy city ('so much is going on to interest one'), at any rate for a while. But she also told her new friend, Pauline Trevelyan, that they only went out twice in their first six weeks.[59] They entertained a little – the Aclands came to dinner, Effie hired a piano and sat for her portrait to Thomas Richmond, but obviously nothing was allowed to interrupt

Ruskin's writing. Effie seems to have invited people to call whom she thought should meet her husband, and one of then, F. J. Furnivall, has left an account of his visit. Kept waiting by Ruskin, he talked to Effie until her husband

> walkt softly in. I sprang up at once to take the outstretcht hand, and then and there began a friendship which was for many years the chief joy of my life. Ruskin was a tall, slight fellow, whose piercing frank blue eye lookt through you and drew you to him. A fair man, with rough light hair and reddish whiskers, in a dark blue frock coat with velvet collar, bright Oxford blue stock, black trousers and patent slippers . . . The only blemish in his face was the lower lip, which protruded somewhat . . . But you ceast to notice this as soon as he began to talk. I never met any man whose charm of manner at all approacht Ruskin's. Partly feminine it was, no doubt; but the delicacy, the sympathy, the gentleness and affectionateness of his way, the fresh and penetrating things he said, the boyish fun, the earnestness, the interest he showed in all deep matters, combined to make a whole which I have never seen equalled.[60]

It is a fine conspectus of Ruskin's best response to people he liked.

For two weeks at Christmas and New Year John and Effie returned to Denmark Hill. It was a visit that largely determined the elder Ruskins' final rejection of their daughter-in-law and initiated, if it did not hasten, the instability of John's marriage. The cause was trivial, but, coming on top of some other disagreeable exchanges between John James and the Grays while their children were away in Normandy, the consequences were disproportionate to the beginnings. Effie simply fell ill and took to her bed two days after Christmas with a feverish cold and cough. As she said, it 'dulled' her considerably and understandably she felt little inclination to participate in the Ruskins' social life, notably their New Year dinner party for Turner, Severn, Richardson and others. But Mrs Ruskin evidently thought Effie should simply have pulled herself together and not malingered in her room, where John apparently thought she should have stayed; instead she was made to join the company and stay up till after midnight; further, there were battles of will about medicines, which Effie reminded her mother 'I never could stand' but which she forced herself to take 'merely to please Mrs R and Dr Grant'.[61] Effie's feebleness and loss of appetite simply annoyed the elder Ruskins (and even perhaps John, though Effie reports him as sympathetic), as if physical ill-health were somehow comparable to the Grays' financial misfortunes which common sense and rational behaviour in the first place should avert. The Ruskins were in no position to know to what extent Effie's

physical distress was caused by mental and emotional anxieties. But it was above all her refusal to be schooled by them that seemed the final insult: 'if she does not manage herself or allow others to manage her in a very different way from what she has done', Margaret wrote to John James the following February, Effie's health, 'both bodily and mental', would be jeopardized.[62]

For the Ruskins liked to 'manage'. During the Normandy tour, Effie's brother George had once again become the subject of an exchange between Perth and Denmark Hill, which contributed not a little to strained relationships. Mr Gray had proposed to send George to London to some trading house, but John James's precipitate reaction – anticipating a move to foist George upon rich London relations and resenting the prospect of his son's new social prominence at Park Street being spoilt by a brother-in-law in trade – actually prevented the move. Having gained his point, John James was at once conciliatory; but the harm was done as far as the Grays were concerned, while the Ruskins themselves were probably encouraged to believe, with far worse consequences the following spring, that the Grays could be licked into shape with a few strongly worded missives. John James prided himself, as he constantly remarked, upon being 'ever frank with all persons';[63] what this meant in practice was writing what was uppermost in his mind and not considering its impact upon the recipient – 'my Letters often do produce effects which surprise myself – They are too abrupt – because I say all at once that which ought perhaps to be gradually and occasionally uttered'; as the next year would show, one ill-considered remark required 'Volumes of notes to explain'.[64]

After the exchange over George and the contretemps of Effie's Christmas illness, which she could not throw off even after returning to Park Street, came another miscalculation, minor, too, in its local effects, but crucial in the long run. Effie returned to Perth. The reasons for this are not clear, but after a month in Park Street, her health had not improved and her mother, then visiting London, accompanied her back to Scotland. A few days after Effie's departure, John was writing to Pauline Trevelyan that 'I really *am* very busy – my wife had influenza – went to Scotland for a change of air'.[65]

Ever since the Normandy tour there had been talk of John and Effie visiting Perth together – 'It is just what they ought to do', thought Mr Gray; but work on *Seven Lamps* and Ruskin's professed dislike of winter journeys and socializing with Perth neighbours prevented it.[66] How much Effie's 'before we go to Switzerland John and I will pay you a visit' is simply face-saving,[67] knowing that John

obviously did not intend to go, is unclear. His work needed all his time – indeed, after Effie returned to Perth he settled at once into his old study at Denmark Hill to work uninterruptedly and yet still did not have all the book ready by the time he left for Switzerland without Effie in April. The establishment at Park Street, meanwhile, remained unused.

Effie's departure for Perth in early February was undoubtedly connected with her poor health; but her own fairly constrained social life since their return from France and the sense that she had probably been given her own distinctly secondary role in the Ruskin circle that winter also joined to urge her trip. It would later rebound upon her. Once back with her family she suffered the additional distress of the death of her seven-year-old brother, and this must have made her want to stay with her mother. By 4 March 1849 it seems to have been further decided that she would stay in Perth while the other Ruskins went to Switzerland, for then John James was telling her father that

> I hear she may remain with you a few months – whilst my Son goes abroad – I should disapprove entirely of this, were my Son going abroad for his pleasure – but it seems as much a matter of Business as my travelling to Liverpool. I daresay Phemy had enough of this in Normandy and since her Illness at Xmas – I am sure she is not this year able for Swiss Excursions.[68]

It has never been clear how or by whom this arrangement was made. Three days before the Ruskins left England John was writing his explanation to John Brown in Scotland:

> her health has been injured by these repeated shocks [the deaths in the Gray family], and I am afraid to take her with me where living in chalets and walking in snow would be her only means of wifely companionship with me. I trust that she is now gaining strength, and that when she is restored to me or as I feel almost inclined to say, when we are married next time, I hope to take better care of her.

From the Ruskins' frequent justifications of her absence while they were abroad it might be fair to assume that John and his parents were somewhat uneasy about how it had been allowed to happen.[69] Yet from Vevey on 20 May John accused Effie herself of having refused to accompany them – 'you told me "you looked forward to the journey with horror" – because you had no desire to see the places which your husband loved'.[70]

The ostensible reason for this Swiss trip, originally planned as the honeymoon trip, was further study Ruskin wanted to make for the next volume of *Modern Painters*. That was his subsequent rationaliza-

tion in *Praeterita*.[71] But he had already decided upon writing *The Stones of Venice*, for this was announced in May in the first edition of *Seven Lamps*.[72] So, as he left England on 23 April, Ruskin was, in typical fashion, actively preparing the final plates for *Seven Lamps* (he was still working on Plate IX at Dijon), committed to a volume on Venetian architecture as well as heading towards further Alpine studies for *Modern Painters*. In his letters to Effie John emphasized this last task, glad on 24 April of the 'prospect of getting out of . . . [Paris] on the Alp side tomorrow'.[73] He had a bad cold, but hoped 'the sight of Mont Blanc to morrow will put me to rights'.[74] Obviously it did, or the syrup of violets provided by their landlady at Champagnole worked a cure, for he was able to withstand an arduous mule-back ride from Chamonix to Martigny through slushy snow and torrential rain in mid-May;[75] yet he had, it will be recalled, been reluctant to attempt a winter journey to Perth.

The excitements of Alpine excursions were as intense as ever. But Ruskin was intermittently ill at ease with the marriage he had temporarily left behind him. Early on, while still in Paris, he had written to Effie some astonishing lines:

> Do you know, pet, it seems almost a dream to me that we have been married: I look forward to meeting you: and to your *next* bridal night: and to the time when I shall again draw your dress from your snowy shoulders: and lean my cheek on them, as if you were still my betrothed only: and I had never held you in my arms.[76]

She must have found the first sentence saddening and ironic, but the implication of this and another letter Ruskin sent her from Dijon ('I think it will be much nicer next time') is that they had agreed to consummate the marriage on some future occasion, maybe even when he returned from abroad.[77] For Effie's part, she only wanted to fulfil the role she took on with a Victorian marriage: 'she seems to like the idea of keeping house', her husband wrote from Normandy, and she told him by letter in June that she wanted a baby.[78] But Park Street, chosen, staffed, furnished and paid for by the elder Ruskins scarcely realized the first idea, while Ruskin's dislike of babies – 'I wish they weren't so small at first'[79] – must, in part, at least, have expressed his fear of family distractions. And in contrast to his expressions of sexual affection from France, his response to her telling him she would like a baby was to change the subject. So Effie's predictable ambitions for her marriage were frustrated largely by the circumstances she had married into, compounded a little by her own pride which would not allow her to accept married life simply on Ruskinian

terms. She was told this quite bluntly by her husband in an early letter:

> I often hear my mother or Father saying – 'poor child' – if she *could* but have thrown herself openly upon us, and trusted us, and felt that we desired only her happiness, and would have made her ours, how happy she might have been: and how happy she might have made us all.[80]

Otherwise he tried sensibly to share his experiences with Effie, in Champagnole referring her to the sixth chapter of *Seven Lamps* where the Jura's 'fulness of joy or clearness of teaching' is eloquently described, its pastoral intimation of as yet unreached Alpine grandeur quickening the imagination.[81] If she read the passage, when her copy reached Perth, Effie might have appreciated what her husband, soon afterwards in Geneva, was explicitly announcing: 'how hopeless it was ever to wean me' from Alpine places.[82] By the end of the summer, when relations between Ruskins and Grays had deteriorated, it is clear that his Swiss enthusiasm and work – even perhaps his thought of making a home at Vevey, were considered at Perth to be just one of his 'fancies'.[83] Yet he was all the while conscious of how unable Effie would be to withstand either heat or exertion, implicitly contrasting her lack of stamina and her depression with other women's strength and will-power – his mother's, Mary Richardson's ('she used to walk with me in this very place – as far as *I* could – and I never heard her complain of depression') or Mrs Acland's sisters' ('not I believe bodily strong – but on the Alps, all exultation and as unfatiguable as birds').[84]

Ruskin was close to exultation himself – the diary reiterates how 'happy' he is – and his energies, rapidly increasing, allowed him to undertake excursions which proved how much he could do when he wanted. The time was largely spent in drawing, searching the valleys and mountainsides for subjects to sketch and for specimens, botanical and geological, to record in the evenings. Sometimes all the Ruskins travelled and stayed together in the Chamonix valley; at others, Ruskin, with 'George', Couttet, and on one occasion joined by Richard Fell, would range more widely, to Zermatt for instance, while the parents retreated to a rather boring base in Geneva. From wherever they reached in the mountains John sent letters back to his parents and into these rather than his diary went his fullest enthusiasm and delight: on the way to Cormayeur he 'made a memorandum which I do not intend to touch hereafter – as, I fancy few artists can show a careful sketch in colour, made at 8000 ft above the sea when suffering under a violent sorethroat'.[85] But this was also the first

occasion on which Ruskin travelled with his own daguerreotype, which 'George' carted around and, as his diary reveals, much enjoyed using. Back in Perth it must have seemed an odd form of being 'rather busy', even though, or perhaps because, John James insisted that 'my son . . . is here for hard work'.[86]

John's journal, apart from a few passing references to Effie, is exclusively and fully devoted to his mountain studies. At first there were difficulties of application, occasioned by feelings that 'perhaps I should not be again among these lovely scenes . . . a youth with his parents – it seemed that the sunset of to-day sank upon me like the departure of youth'. Such unease he overcame with fresh efforts of concentration, rehearsing the stages of imaginative recovery in his journal with keen and moving introspection:

> Once or twice I flagged a little, and began to think it tiresome: then I put my *mind* into the scene, instead of suffering the body only to make report of it; and looked at it with the possession – taking grasp of the imagination – the true one. It gilded all the dead walls, and I felt a charm in every vine tendril that hung over them. It required an effort to maintain the feeling – it was poetry while it lasted – and I felt that it was only while under it that one could draw or invent or give glory to any part of such a landscape. I repeated 'I am in *Switzerland*' over and over again, till the name brought back the true group of associations – and I felt I had a soul, like my boy's soul, once again. I have not insisted enough on this source of all great and contemplative art. The whole scene without it was but sticks and stones and steep dusty road.[87]

This acknowledgement of the priority of the human soul over the subjects of its contemplation leads Ruskin into one of the many extraordinary passages of which this 1849 diary is full. A celebration of a field of grass behind Vevey, later adapted for *Modern Painters*, was the first of many epiphanies that summer.[88]

Not that Ruskin's time was filled always with such obviously exciting encounters. Often he merely records details of rocks, strata, and notices the fine, changing tone of the hills. Yet the concentrated application at Chamonix – 'the quality of mental and imaginative energy which I could give it'[89] – created for him a vision of this bourne of earth that was altogether as intense as the encounter with the field of grass. Slowly, piecemeal, walking, drawing, measuring, watching, Ruskin put together 'what this place was'.[90] The achievement was not, however, easy, while his attempts at scrupulous self-examination – the central legacy of his evangelical training – frequently called in question these imaginative excitements: how loosely the whole

Alpine magnificence of Montanvert came together for him; how perversely his 'enjoyment' refused to coincide with 'a lovely day' or 'perfect moonlight'; the complexity of his studies; the strange paradox that the 'investigation of strata and structure reduces all mountain sublimity to mere detritus and wall building'.[91]

Doubtless Effie and the problems she posed lay uneasily beneath the surface and did not help. Both he and John James in letters to Perth made it elaborately clear that Effie threatened to disrupt the Alpine work; on the way back in September Ruskin specifically blamed his 'coming home just now, instead of staying a month longer, and perhaps going to Venice' on his husbandly duties.[92] The 'unlucky day' of 5 July when he wrote in his diary that 'my Chamouni work has been most disappointing to me – and humiliating' was the same on which he intervened in his father's correspondence with Mr Gray to deliver a tough, lengthy assessment of Effie's character and conduct.

The tedious and unproductive exchange of letters, by which John James Ruskin, ever eager to 'exhaust a subject' and so avoid misunderstandings, strove to put his son's marriage in order, has been told with skill by Mary Lutyens. Long-distance discussions of such a delicate nature were not helped by postal delays,[93] nor by John James's faith in clear, unequivocal statements. Indeed, the root cause of John's and Effie's unstable marriage – that it had not been consummated – could not be communicated at all to either parent largely because of their children's pride. As a consequence, other explanations were sought by the Ruskins, whose need for clear scrutiny of moral issues only exacerbated matters. Even at the time it is doubtful whether any simple and distinct reasons for Effie's return to Perth the previous February could have been established; but from Geneva three months later, unable to 'understand what it is that is now the matter with you', John told Effie that the 'very simple truth is that it was not *I* who had left *you* but *you* who had left *me*'.[94] Similarly, Effie's not being with them on their Swiss journey became in retrospect for Mr Ruskin another puzzle which admitted of no other explanation than that she preferred Perth to the Ruskins.[95] Since Effie's illness could not be linked to her unfulfilled expectations of marriage, even by John, it was made the topic of relentless cross-examinations and long-distance diagnosis. John James was writing to Gray in May that her 'weakness' was 'entirely nervous and so far a delusion as most nervous complaints are'. He may well have been right, but neither he nor his son seemed to recognize that such states could produce actual physical maladies. John, also to Gray in July, put it even more categorically and unkindly: 'the state of her feelings I ascribe now, simply to bodily

192

weakness: that is to say – and this is a serious and distressing admission – to a nervous disease affecting the brain'; later in the letter this became 'an illness bordering in many of its features on incipient insanity'. During the summer Effie consulted the Edinburgh gynaecologist, Dr Simpson, but his opinion was not reported in sufficient detail to please her husband; later, Effie wrote to say that she thought her depression was caused by 'disorder of the stomach', an explanation that her husband seems readily to have seized, not least because it matched his own state which 'Jephsonian training' had cured.[96]

But if the physical symptoms were found an acceptable explanation, the ill-feeling between Effie and the Ruskins was not resolved by correspondence. John himself told Gray in July that he did not know whether Effie 'can ever now establish altogether the place she might have had in my parents affections'.[97] The letters between the two parents seem in the end to have produced only deadlock – Gray himself thought there had been 'no real ground or cause for offence on either side'.[98] Not surprisingly, it was upon Effie and John themselves that the task devolved of effecting a *rapprochement*. This in itself was not easy at long distance: while John was away climbing energetically around the Matterhorn, his father, doubtless in an effort to save John from wasting his time socializing in Scotland instead of writing, tried to tell the Grays that his son's health could not stand a visit to Scotland to collect Effie after their return to London. Such a visit would have meant much to the Grays, for the two being seen together in Perth would gainsay the local gossip about Effie's long separation from her husband. John himself delivered his wife a lecture on the subject, but agreed to 'come to Perth for you as soon as I get home'.[99] A week later he was making it clear how busy he would be back in England and alerting her, as if she needed such warning, to his misanthropy – 'I will not see anybody when they call on me, nor call on anybody, I am going to do my own work in my own way in my own room, and I am afraid you will think me a more odd and tiresome creature than ever.'[100]

The last part of his time in Switzerland was obviously enjoyed in the distinct knowledge that he would soon return to a marriage that was in many ways a distraction or digression from the current of his life – and this for a person for whom nothing was ever simply a digression. He obtained his father's permission for an extra fortnight by himself in Chamonix after the arduous trip to Zermatt; the recollection of liberties in 1845 actually made him misdate his diary on 29 July '1845'. But he also helped to make his parents' travels comfortable, even washing down the dirty steps that offended his mother at

the inn at Samöens – an incident that would contribute much in later years to Ruskin's autobiographical patterns.[101] What writing he planned to be busy with on his return is difficult to establish. *Seven Lamps* had promised a Venetian book, but the summer in the Alps had yielded studies more apt for another volume of *Modern Painters*: his remark to Effie that 'I must settle down to put some of my materials into form directly' implies the second project.[102] He was later to explain that 'I had been working the whole summer among the upper snows of the Alps and intended to have written something about their more divine architecture before pursuing any further enquiries into the measurable sublimities of man's raising.'[103] The diversity of his interests is clear in his diary: after sustained and often magnificent Alpine memoranda, his visit to the Louvre in September elicited a long, equally alert meditation on the superiority of painting to literature, while a few days later at Amiens his architectural zeal spills over into pages of notes.

But the decision as to what volume would engage him was not to be his. After several months he found his wife, when he went north to bring her to London, 'much better and very desirous of some change of scene.'[104] Making a shrewd gesture of conciliation, Effie asked John to take her to Venice. He agreed at once, though not without seeking his father's consent. John James approved, not without regretting in his turn that the 'Fascinations of Venice' would double John's work on the Alps.[105] But John James seemed to have had a cordial interview with Effie, in the course of which she said he intimated that he sometimes thought John could not make her happy; he agreed to their leaving Park Street and its servants unoccupied for another seven months.[106] On 3 October John and Effie left London for Venice – 'can Venice be inferior to anything?'[107] Twenty-five years later, brooding upon the way that memory often strips the past to 'an enduring skeleton', he admitted that the 'terriblest' of recollections was 'my father's face of grief, as he turned away at the London Bridge Station when . . . I left for Venice, exultant and very happy in a vulgar sense'.[108]

Chapter 11

Venice

les demeures disposées des deux côtés du chenal faisaient penser à des sites de la nature, mais d'une nature qui aurait créé ses oeuvres avec une imagination humaine.

Proust, *Albertine Disparue*

Despite *Praeterita*'s claim that 'All that I did at Venice was bye-work',[1] this 'glorious City in the Sea' which Ruskin first encountered in the pages of Byron and Samuel Rogers was at the very centre of his life. His various responses to it over the years guide us along the graph of his own intellectual development. Sometimes it was in the forefront of his concerns, when he was working on *The Stones of Venice* or *St. Mark's Rest*; at other times, between his second visit with Effie in 1852 and his return seventeen years later, its recession only signals his preoccupation with topics which, nevertheless, traced their origin or vitality to his Venetian interests.

Ruskin's early visits discovered in Venice a world of romance and dream, which he connected, not surprisingly, as we have noticed, with Adèle Domecq.[2] Some of his most powerful associations – Shakespearean, Byronic, Turnerian – were focused for him there; it provided a picturesque theatre for his poetic and Proutian imagination. Though he claimed by 1841 to have 'lost the childish delight in the mere splashing of the oar and gliding of the gondola',[3] it is doubtful whether such pleasures were ever displaced by his more analytical response. Even when writing in 1857 to Charles Eliot Norton, who was staying at Venice, Ruskin ended an amusing catalogue of his vexations and frustrations in Venice with the admission that, after all, there was *one* place where he 'never lost the feeling of joy': moored halfway between the Guidecca and San Giorgio in Alga he could watch at sunset both the Euganean Hills and 'all the Alps'.[4] 'I have got all the right feeling back, now, however', he added, promising to write 'a word or two about Venice yet'.

A major reason why Venice proved so resilient a presence in Ruskin's career was its 'breadth of interest', its ability to cater to his many schemes and moods.[5] The city functioned for him as a compact

museum where his architectural, painterly, mineralogical, botanical, political, social and economic work found its various materials. It was, as it were, another cabinet of curiosities. His diary of 23 November 1849 called it 'this Masque and morrice of Kingdoms and times', and the theatrical imagery is also particularly apt. For Venice was a theatre, not only in that old-fashioned sense of being a collection or conspectus of interesting items, but also a stage where Ruskin – always fond of dramatic representations – could watch dramas of which he was spectator and critic, participant and even author. In public or private writings Ruskin is ever alert to the scenarios that the city offers to him: as architectural historian, he ponders the narratives of the buildings – 'window-sills which didn't agree with the doorsteps'[6] –and, above all, the muddled chronology of the Ducal Palace. As guide to the true spirit of Venetian place, he leads the readers of *The Stones of Venice* first through an English 'scene' and then into a dramatic journey from San Moise down busy alleyways and out into the Piazza before St Mark's, where the visionary spectacle, with its allusions to Shakespeare and transformation scenes, is indeed a huge and grandiose masque;[7] as a private citizen, too, Ruskin acted in the Venetian city-theatre – with Effie in masquerade, or, more sadly and with a shadowy cast of phantoms and memories, during the strange Christmas of 1876–7.

But the drama to which he gave his greatest energies was undoubtedly the rise, fall and decline of Venice herself. The romance and charms of Venice during his early visits were strongly modified first in 1845, when he was so dismayed by the decay and ruin of her buildings and pictures. The 'embodied enchantment, delineated magic', which Turner had revealed in 1836 with his *Juliet and her Nurse*,[8] was defaced by gas lamps and 'fearful dilapidation', a literal de-stoning of Venice.[9] By the time Ruskin left he had 'made up my mind' to the 'evil' of it,[10] by which he means, most obviously, that he hoped not to be so dispirited again by human folly and carelessness. But there also lurks beneath his remark some recognition that Venetian stones announced a larger message of human history; modern disregard for Venice's heritage was only a continuation of the greed and luxury that the Renaissance introduced and which destroyed its gothic Eden.

This perception, to be given full and formal expression in *The Stones Of Venice*, derived substantially from Ruskin's own evangelical training. In succeeding visits of 1846, 1849–50 and 1851–2 he began to assemble the documentation for such a view, the 'truth in mosaic' of which his father complained.[11] The outcome was a fascinating blend of subjective and objective truth: 'The Verities of Venice', he noted in

1849, owe 'so much to the imagination'.[12] So the vision of history which *The Stones of Venice* advanced was symbolic *and* archaeological: first, there had been a model community of people with 'noble individual feeling', 'vitality of religion in private life', 'dignity' in their commercial endeavours and a 'healthy serenity of mind and energy of will', all of which found expression in its architecture.[13] He celebrated the congruence of mediaeval art and human nature at their best in the famous, central chapter of *The Stones of Venice*, which he called "The Nature of Gothic". Then came the 'Fall', when the Renaissance corrupted that paradise with sensuality and show – Venetian Renaissance tombs, Ruskin argues, are simply statements of pride – pride of science, pride of state, pride of system.[14] What Ruskin actually called the 'drama of architecture',[15] namely the changing styles and languages of stone, becomes a metaphor or 'type' of moral history, and Venice herself becomes, as the opening of *The Stones* declares, a 'typical' lesson for Ruskin's contemporaries:

> Since first the dominion of men was asserted over the ocean, three thrones, of mark beyond all others, have been set upon its sands: the thrones of Tyre, Venice, and England. Of the First of these great powers only the memory remains; of the Second, the ruin; the Third, which inherits their greatness, if it forget their example, may be led through prouder eminence to less pitied destruction.[16]

The history of Venice parallels, as Richard Stein has noticed, the progress of Ruskin's own treaty with the city.[17] His youthful dream of the 'city in the sea' was destroyed, but from his loss of innocence he gained new wisdom. So Venice when he was about to leave her in 1845 was indeed 'a blessed place' because she had taught him so much.[18] Out of her ruins – stones and archives, 'plans and figures' – he was building his own three-volumed work, he told his father during the winter of 1851–2.[19] But Venice contributed far more than just *The Stones of Venice*. In a passage of *Praeterita*, already quoted, he saw how his work on Venetian art and architecture had forced him 'into what else I have traced or told of the laws of national strength and virtue'.[20] His writings on political economy of the late 1850s and 1860s extend the Venetian lesson into contemporary British life. If he had been distressed by the 1845 appearance of Venice, which reminded him of nineteenth-century Birmingham and Liverpool, he would eventually carry his crusade into the very centre of British industrial society which 'manufacture[s] everything . . . except men'.[21] An early and significant link between that crusade and his Venetian work was the gift of a copy of "The Nature of Gothic" to each visitor who attended

the inaugural meeting of the Working Men's College on 30 October 1854.[22]

But long before Ruskin had become fully involved in writings about the contemporary state of Britain his Venetian work contributed to the resumption of *Modern Painters*. As early as 1852 he declared that 'All *Modern Painters* together will be the explanation of a parenthesis in *The Stones of Venice*'.[23] But there were more intricate and subtle interconnections. He told Norton that the joy he never lost at Venice was the sight of distant hills and mountains, his other bourne of earth. The stones of Venice, as Ruskin saw them, often spoke of the stones of Chamonix. In St Mark's 'the marbles of a thousand mountains have been laboured', and its sculptured capitals record the Gothic craftsman's keenly observed delight in all natural forms.[24]

Beyond Ruskin's awareness of the 'brotherhood between the cathedral and the alp' which united his work on Turner with that on Venice,[25] in the fifth and final volume of *Modern Painters* these two topics are marvellously and completely entwined. The dragon of Turner's *Garden of the Hesperides* is linked both to Ruskin's study of glaciers (the dragon's body is said to be a nearly perfect representation of glacial movement) and to Venetian history. For the sea dragon is the 'evil spirit of wealth', and this implied comparison with Venetian economic history surfaces when the Goddess of Discord, present in Turner's Hesperidean garden, is glossed by an allusion to Ruskin's earlier discussion of the Ducal Palace – 'remember the inscription there, *Discordia sum, discordans*'. When the analysis is continued into Turner's *Apollo and Python*, the 'worm of decay' is seen to be a major theme in his paintings, an emblem of the evil which destroyed Tyre, Venice and, as Turner saw it, England. Turner's vision, we are told, is increasingly of 'Ruin, and twilight', and at last we are allowed to understand why Turner was so preoccupied with Venice's decline, a type of that 'death which attends the vain pursuit of beauty':

> How strangely significative, thus understood, those last Venetian dreams of his become, themselves so beautiful and so frail: wrecks of all that they were once – twilights of twilight!

The last major contribution of Venice to Ruskin's life and work came in the 1870s. Again, it is apt that new ideas and new themes in his writing have Venetian dimensions. Just as he had stumbled upon Tintoretto in 1845, so in the late 1860s he discovered Carpaccio. To learn more about this painter, guaranteed to appeal to Ruskin's delight in Venice and in careful delineation of things, and planning to lecture

about him when he took up the Slade Professorship of Art at Oxford University, Ruskin returned to the city in 1869, and again in 1872. But this second visit was overshadowed and eventually disrupted by his relationship with a young Irish girl, Rose La Touche. Her death in 1875 only intensified, rather than mitigated, Ruskin's obsession: during the winter of 1876–7 his study of Carpaccio's St Ursula cycle became so entwined with his thoughts of Rose that the virgin-martyr and the Irish girl merged in his precariously stable mind.

His relationship with Venice was always a mixture of personal and public, of British and Italian concerns: 'The illness which all but killed me two years ago', he wrote in 1879, was caused 'by grief at the course of public affairs in England, and of affairs, public and private alike, in Venice.'[26] While he brooded, barely sane, upon Carpaccio's *Dream of St. Ursula*, specially placed for him behind the locked doors of a room in the Accademia, he was also engaged upon a substantial revision and extension of his Venetian writings over twenty years before. The new work brought him once more the joy of Venice: 'I find so much more beauty than I used to . . . doing the technical work of *Stones*.'[27] At the suggestion of Prince Leopold he embarked upon a version of *The Stones of Venice*, which became the "Travellers' Edition" of 1879–81. New discoveries were incorporated in two further works which this fresh bout of Venetian research initiated, a *Guide to the Principal Pictures in the Academy* (1877), the several parts of *St. Mark's Rest*, subtitled *The History of Venice, written for the help of the few travellers who still care for her monuments* (1877–84, and left unfinished). Venice was still, therefore, at the very heart of innumerable, incremental projects – 'My table is heaped with . . . MSS of four or five different books at six or seven different parts of each', he wrote from the Pensione Calcina on the Zattere.[28]

Apart from a pathetic visit in 1888, Ruskin's last and most important association with Venice was also initiated in 1876–7. In 1845 he had been distressed by restoration of the mosaics on St Mark's: these necessary, but insensitively conducted, repairs continued in 1857 and 1865, and by 1876 further restorations were proposed. Local opposition was stoutly supported by Ruskin, who contributed a preface and paid for the publication of Count Alvise Zorzi's pamphlet, *Osservazioni intorno ai ristauri interni ed esterni della Basilica di San Marco*. An enquiry was established as a result of this protest and the planned restorations were stopped. Ruskin continued to campaign in England for the Venetian heritage; photographs, casts and paintings of the threatened city were closely involved in his various projects for the Guild of St George and were displayed at the Sheffield Museum. So

even in his last and most practical attempt to address the condition of England, Venice occupied a central and honoured place.

Throughout his life Venice exercised the two qualities of mind which Ruskin identified as his best – mystery in what it contemplated, analysis in what it studied.[29] Or, as he told Count Zorzi, he was a 'foster-child of Venice', which had 'taught me all that I have rightly learned of the arts which are my joy'.[30] In 1849 he was on his way to inaugurate the first, sustained lesson.

Chapter 12

The Verities of Venice and London: 1849–1852

John and the Austrian walked one way along the shore discussing the formation of sand banks and the theories of the tides, and Charlotte & I went in the opposite direction for above two hours and lastly lay down amongst the long grass and gathered shells until our Handkerchiefs were quite full. The gentlemen then joined us and we had great fun catching little crabs . . . We each caught one and setting them in a row made them run races.

Effie, writing from Venice, 1850

John and Effie travelled out to Venice in October 1849 with Charlotte Ker, the daughter of a Perth neighbour of the Grays. She had originally been invited to spend the winter in London and, with John James's approval, she went to Italy instead. It proved a useful arrangement; for Effie and her friend could between them maintain an interesting social and sight-seeing life and leave John to pursue his researches. When in letters home she sometimes told of the practical consequences of this arrangement, eyebrows, even objections, were raised. Yet Effie and John managed their life together on this trip, however unconventionally, with tact, some real degree of happiness and little friction.

They travelled in two coaches – one for the ladies, the other for John, 'George' and the books and stores. Effie humorously begged her mother not to tell the gossips lest they thought she and her husband were not travelling together.[1] But the convenience afforded both parties was readily seized and obviously appreciated. In Milan, while Ruskin filled pages of his notebook in the cathedral, Effie and Charlotte drove about, enjoying the sight of and much admired by 'Austrians and Croat Soldiery, the best dressed and finest looking men I ever saw'.[2]

Effie, when her health permitted, was a lively and instinctive tourist, responding to the street organs and local colour of Milan, or drawing her husband's attention in Venice to some iron doors at Palazzo Dona that he had missed.[3] But she suffered on the journey.

201

Even in London, after coming down from Scotland, she was tired and nearly fainted at a Sunday service, which she had attended because John James wanted 'us to be seen in Church'.[4] Across Europe she found 'posting two whole days' exhausting.[5] She caught a chill on the Jura; otherwise she responded with proper Ruskinian appreciation to her first view of the Alps.[6] At Chamonix she lacked the strength to do all she was probably expected to do during their brief stay. Charlotte, by contrast, was put on a mule and sent by John with a guide to see the source of the Arveron and the Glacier des Bois.

Effie announced that she was better once they reached Milan, though their more leisurely pace and the excitements of soldiers and society also contributed to reviving her. But the whole of their winter in Venice was dogged by her ill-health, although at first she thought Simpson's recommendation of warmer air had answered her needs.[7] But sore throats continued to plague her and by early January she had taken advice from a Dominican friar, one of the Frate Bene Fratelli who had care over many sick and insane in the city. He – according to Effie – 'agreed with Simpson in directly finding out that the disease was internal and the irritation & blisters in the throat symptomatic'.[8] He made several prescriptions, including the application of leeches, which she allowed after first seeking approval from home. The friar certainly thought her condition improved considerably; with all the attention she was getting (fresh milk every day from the monastery), Effie, too, thought herself better. Yet, later when her marriage was annulled, she confessed that nothing would really have done her good at this time 'till I was amongst good people and my mind at ease'.[9]

Her unease at Venice was deep-seated and did not disturb her conscious enjoyments. Where, if at all, Effie was put to some strain other than by the physical discomforts of her throat and stomach was in maintaining with propriety a social existence that by Perth standards was quite unconventional. Her letters home harp constantly upon both its usualness and the care with which she conducted herself. Indeed, it is clear that some disquiet was often expressed, especially by her brother George; but this simply elicited renewed avowals of how seemly it all was and how unjealous her husband, and she herself, could be.

It began at Verona, where they stopped for one week before continuing to Venice but where John said that he had work for at least six.[10] Two Austrian officers sought an excuse to accost Charlotte and Effie in their hotel and answer their inquiries about a military band and the military commander of the Lombardo-Veneto, Field Marshal Radetsky, whom Effie dearly wished to meet. John heard them talk-

ing, but made no attempt to leave his room and join them, because, as he later told his wife, he was 'very glad we had somebody to talk to'.[11] When the officers promised to organize a tour of the fortifications, John simply did not accompany them, as Effie explained to her mother:

> said he, "What possible interest have I in lines of fortifications? I never intended to go and not having to walk with you today I shall have such a famous drawing day. Count Wimpffen is exceedingly intelligent & modest, a very nice companion for you and Charlotte, just the sort of person who it is good for you to be with and I daresay it makes him happy too. George shall accompany you if you think proper." I said, "Well, John, I don't think you would be understood by the world at all." "Oh, no," said he, "never. I think it very absurd that because I enjoy myself, you & Charlotte should be kept moping in the house." With this he took us down stairs and telling our companion he gave us into his charge, and the young man laying his hand on his heart and making a low bow, we went on our drive . . .

This was the established pattern for most of the Venetian winter, each of them appreciating the benefits of not troubling the other.[12] John took Effie and Charlotte to the Opera at first when they asked him, but by the end of their stay they had come to rationalize their going without him.[13]

The winter, in fact, saw some revision of the standards which Effie had set herself upon arrival in Venice, though without losing the 'sense' and 'discretion' which she boasted of to her parents in December.[14] At first when John urged the ladies to 'walk about chattering with some half dozen [officers] and amusing ourselves', Effie protested that she had 'some ideas of English propriety remaining'.[15] But the chance encounters of sight-seeing ('our handsome friend who rescued us at Santa Maria della Salute'[16]) and the pressing gallantries of the military joined with her husband's specific approbation of one particular officer, Charles Paulizza, to make Effie's original scruples seem inappropriate to the life they were leading. Above all, as John had promised during their engagement,[17] he proved to be totally without jealousy: absorbed in his work he was simply delighted not to have to fulfill some of the usual obligations which the London season, for example, more conventionally forced upon him. Without any capacity for jealousy, he was happy that Effie and her friend were adequately entertained. Above all, he was himself pleased by their two most frequent escorts, Paulizza and Rawdon Brown: both men helped him gain access to particular buildings or archives; Paulizza's drawings and plans of the Lagoon were

impressive and useful; Brown was a fund of knowledge on Venetian history.

The introduction to Rawdon Brown, an English resident in Venice since 1833 and destined to be a life-long friend of both Effie and John,[18] meant increased social opportunities for Effie. She went walking with him around Venice and was 'obliged' to him for showing her 'so much that was new and interesting'.[19] 'He devotes half his day to us, or rather to me', Effie told her mother in January 1850; when she went visiting with him, 'Charlotte never goes because for one thing she cannot speak a word and John prefers my going alone [i.e. without him]'.[20] Through Brown's kind offices and wide contacts she began to meet a few of the Venetian patricians and to be invited to their receptions and concerts – again John would often beg 'to be excused going as he was busy, and of course I did not wish him to lose an evening'.[21] On other occasions he did accompany her, but left on his own before she did; it was apparently after one such incident that Rawdon Brown remonstrated with Effie 'in the gravest colours'[22] that she had allowed Paulizza to take Charlotte and herself home. However, the Ruskins were better pleased, for at Christmas John James recorded that 'Your Mama and I have with pleasure noted that when abroad with Effie you do far more than with us – she has most unselfishly left you to your work.'[23]

Her brother George in Perth, however, protested more than Rawdon Brown. So Effie was at pains to point out, first, that she was pleased, 'considering the work [her husband] has to do, that he can be troubled to be so much with us' and, second, that John 'is perfectly satisfied with my conduct in every particular'.[24] Maybe she protested too much. Three weeks later she was again defending the complete understanding between herself and John: she invoked what Charlotte called her 'heart of ice', her sudden loss of 'any desire to coquetry which John declares I possess very highly' and her lack of talent for 'intrigue'. It all sounds a little too studied – but then we have too much hindsight. But she was openly delighted by being the centre of attraction ('many are the cigars that are taken out of the mouths as we pass') and by being 'made love [to] . . . so cleverly' at Baroness Wetzlar's ball by Count Emile Wimpffen, brother of the officer who had talked with her at the hotel in Verona.[25] She certainly relished the 'excessive devotion' shown her by Paulizza as well as the antics of some poor rival, a Baroness who pined unsuccessfully for his attentions.[26] Yet her loyalty to John, her main contribution to keeping their marriage intact, was a clear expression of her gratitude that he allowed her pastimes ('Polka-ing and Waltzing'). Pleased that he did not show jealousy, it was easy

to give him no cause for it. She even claimed to have acquired a new, mature scepticism of masculine attentions ('Men are really great fools'[27]).

Effie evidently also approved of the slightly eccentric reputation her husband was acquiring in Venice:

> I do not think they have made up their minds yet whether he is very mad or very wise [had she herself?]. Nothing interrupts him and whether the Square is crowded or empty he is either seen with a black cloth over his head taking Daguerrotypes or climbing about the capitals covered with dust, or else with cobwebs exactly as if he had just arrived from taking a voyage with the old woman on her broomstick.[28]

Her reports to Perth of how busy he was were not fictions to explain her unconventional behaviour; nor yet would it be surprising if Ruskin did not use his work as an excuse for things he did not want to do. As he explained to his father and as Effie copied it for her mother, 'Operas, drawing rooms and living creatures have become alike nuisances to me'.[29] On the other hand he was always happy sharing his own interests and enthusiasms with the others: in his diary he records a chance meeting with Effie in the street and taking her with him to the quays facing Murano, where they could savour his two bournes together:

> The sea lay in calm horizontal bars far to the northern horizon: then it suddenly broke to an open, long gulph of amber green; and against this – clear in rainy air – rose the chain of the Tyrolese Alps, one gloomy, serrated rank of purple grey, so clear that every field of snow was seen on their summits . . . at the end of the range, right over Murano . . . burning crests of snow were seen mingled among bars of cloud . . .[30]

On another occasion he took Effie, Charlotte and Paulizza out to Torcello, where they picnicked in the 'little spaces of meadow land' which his second volume of *The Stones* would celebrate so movingly,[31] and which he sketched at some point in 1850, maybe on this visit. Then, in that boyish fashion he had not enjoyed enough as a child, he and Paulizza ran races around the old buildings to show 'that the Champagne . . . had not gone into their heads'.[32]

Similar games helped them keep warm in their rooms at the Hotel Danieli, improving their circulation by playing ball, 'a kind of cricket' and shuttlecock.[33] Otherwise, as Effie told Pauline Trevelyan, John 'sketches and writes notes, takes Daguerotypes and measures [sic] of every Palace, House, Well, or any thing else that bears on the subject

in hand, so you may fancy how much he had to arrange and think about. I cannot help teasing him now & then about his 60 doors and Hundreds of windows, staircases, balconies and other details he is occupied in every day.'[34] The slowness of his progress ('he has only drawn one capital of one Pillar and there is something like hundreds') meant that their original plan to move down to Tuscany for the 'severer months' of the winter was postponed and eventually abandoned.[35]

Indeed it was not entirely clear to Ruskin some of the time for what exactly he was working. Effie was not sure if it was *The Stones of Venice* that he was preparing, while Ruskin himself told W. L. Brown that, through the unexpected opportunity of being in Venice again, the 'sketch of Venetian art', promised by *Seven Lamps*, had blossomed into 'a more detailed survey of the Italian Gothic than I ever hoped to have obtained; finding, however, the subject so intricate that I have forgotten or laid aside everything for it'.[36] The status of the 'sketch of Venetian art' was also exercising John James, who was generally extremely nervous about their whole trip to Venice. He asks whether John plans to have 'a volume on Gothic precede Stones of Venice and Stones of Venice precede 3 Volume [i.e. *Modern Painters* III]'. He continues, always prompt to identify if not sympathize with his son's habits of work, that 'your books will resemble a conjuror's box which you open expecting one thing and find another – cannot you combine all you want to say of Gothic with Stones of Venice?'.[37] This is indeed what would happen, whether or not his father's wishes influenced the matter. Two things in particular preoccupied Ruskin: his own need for clarity and precise documentation on the development of Venetian architecture; his own determination – the fruits of an early autodidacticism – to work out in simple terms the basic syntax of building. The first was endlessly frustrating, as he told Pauline Trevelyan himself:

> Can you conceive that it should be an open question with Italian antiquarians whether the Ducal palace dates from 1350 or 1423? Yet so it is – and among the private palaces the dates are about as fixed as those of the Pyramids.[38]

Rawdon Brown helped him track down relevant documents in the St Mark's Library. But these were themselves confusing and he came to rely increasingly, as *The Stones of Venice* advised its readers, upon his own careful observation of the actual building. He abandoned 'all thoughts of obtaining a perfectly clear chronological view of the early architecture',[39] and taught himself first principles of construction, from the simplest to the more elaborate. When he eventually settled to

composing the first volume of *The Stones* back in London the following winter it took the form, after an initial chapter – "The Quarry" – which confidently surveyed Venice's historical and typological significance – of spelling out some universal laws concerning the necessities of construction and the criteria for decoration of buildings.[40]

But to be in a position to offer these 'laws . . . few and simple' Ruskin needed a fund of particularized detail. Just as he argued in *The Stones* that it 'is the intelligence and resolution of man in overcoming physical difficulty which are to be the source of our pleasure and subject of our praise' of architecture, so his own researches slowly and meticulously stockpiled the facts by which Ruskin overcame his own ignorance of construction and decoration. He begins the exposition in *The Stones* by telling the reader that

> I shall endeavour so to lead . . . forward from the foundation upwards, as that he may find out for himself the best way of doing everything, and having so discovered it, never forget it. I shall give him stones, and bricks, and straw, chisels and trowels, and the ground, and then ask him to build; only helping him, as I can, if I find him puzzled.

His pedagogic method – a teach-yourself-architecture that Charlotte Brontë thought 'very dry and technical'[41] – grew directly out of Ruskin's own self-instruction. He was an omnivorous student, missing no opportunity of tapping Brown's stock of Venetian knowledge, getting 'some valuable hints about Byzantine architecture' out of a chat with Prince Troubetzkoi, or discovering that his 'amiable but commonplace' banker, Carlo Blumenthal, was involved with the management of the lagoons and so could help him.[42]

His less casual methods of work are also clearly established.[43] During the daytime, while he was examining specific buildings, he took measurements, details of capitals, sketches of masonry and so on. For this he used both large sheets of paper, numbered in sequence and sometimes dated, which were especially handy when he was studying one particular building, and small pocket-sized notebooks. Some of these were initially designed to be used topically, for Effie divided them out into themes and categories; but the spaces allotted proving inadequate, the system was modified. Then in the evenings Ruskin would write up his notes into larger books, cross-referenced to the worksheets, and with additional suggestions and impressions. Later still all the Venetian materials were collated and abstracted into another large volume. It was a formidable undertaking, of which he

was later to be rightly proud. In a note he appended to *A Joy for Ever* he describes how he

> gave three years' close and incessant labour to the examination of the chronology of the architecture of Venice; two long winters being wholly spent in the drawing of details on the spot; and yet I see constantly that architects who pass three or four days in a gondola going up and down the Grand Canal, think that their first impressions are just as likely to be true as my patiently wrought conclusions. Mr Street, for instance, glances hastily at the facade of the Ducal Palace – so hastily that he does not even see what its pattern is, and misses the alternation of red and black in the centre of its squares – and yet he constantly ventures on an opinion on the chronology of the capitals, which is one of the most complicated and difficult subjects in the whole range of Gothic archaeology.[44]

That was written in 1857. But in 1849–50 he was still continuing his patient researches, which opened before him a wider sea of facts and figures. Occasionally we see him searching or finding some order and explanation of the 'real knowledge' he was amassing – 'I obtained today for the first time a clue to *the whole system* of pure Venetian Gothic'; or in some reflections upon St Mark's Square committed to the larger notebook he acknowledged the thick palimpsest, 'this masque and morrice of kingdoms and times', to be 'the Sea Change of half a score of centuries' wrought upon 'the fancies of men', a change out of which 'has arisen one wild Sea Harmony'.[45] But the harmonies and wholes just as often fractured into what he called, in the plural, 'Verities of Venice'. It was a city of 'parts and detached groups of buildings', the fragments which his worksheets and pocket-books recorded. Though he lamented as loudly as ever the destruction and decay of beloved buildings – 'my pain from the sight of restorations or ruins'[46], it was the very shards and isolated details of the city that he was every day recording, facing its ruin and making more in his own memoranda.

They left at last, pulling themselves away from the infinite, un-catalogued materials, from Paulizza's pathetic desolation at their departure, from Brown's elaborate farewell luncheon. They travelled steadily, via Genoa and Marseilles, to Paris, where Effie again succumbed to the pressure of such journeys. But she met all the Domecq daughters, whom she described, together with all the other events of their ten days, with verve and her usual sharp eye for detail. By 20 April they had reached Denmark Hill.

The summer and winter of 1850–1 in London, though full of social life and new acquaintances, did not please Effie as much as Venice had

done. John did not like to work at Park Street and most days were spent in his study at Denmark Hill, where he made a start upon *The Stones of Venice*. Effie no longer enjoyed either Charlotte's company or the freedoms that she and John had evolved for themselves in Venice. He must have been obliged to attend gatherings that in Italy he could have avoided; soon after their return to Park Street he was complaining to the understanding ears of his parents about a 'Horrible party last night – stiff – large – dull, fidgety, – strange, – run-against-everybody – know-nobody sort of party.'[47] His caustic narratives must have pleased the old people with their wit as well as their ambiguous testimony to their son's social success which distracted him from writing. They attended a Court reception and were presented to the Queen and Prince Albert, who put, thought Ruskin, 'something like markedness into his bow'.[48] There were dinner parties at Denmark Hill and at fashionable houses in town, and more break-fasts with Rogers.

For Ruskin there were some fresh compensations – meeting Carlyle and joining the groups over evening tea at Cheyne Walk to listen to the sage, becoming friendly with Coventry Patmore through the poet's wife, who was the daughter of his old tutor, Andrews, and being introduced to the painter, G. F. Watts. For a while he borrowed one of Watts's paintings to hang at Park Street;[49] it was *Time and Oblivion*, perhaps a suitable emblem under which to work on his Venetian book. Effie's circle of acquaintance, too, widened con-siderably. She met Edward Cheney, whose palazzo in Venice they had visited with Brown while its owner was in England, Richard Ford, who had written a guide-book to Spain and, more importantly, Elizabeth Eastlake (she became Lady Eastlake that November when her husband, Charles, was knighted upon becoming Presi-dent of the Royal Academy). This lady became a devoted, not to say partisan, friend of Effie's and, later, an implacable enemy of Ruskin, whom she found, in 1850 at least, 'improved upon acquaintance'.[50]

They were away visiting friends, including Cheney and his two brothers, during August and then, after a detour into Wales, went on to Perth. John soon left to have two months alone at Denmark Hill. Effie assisted at the birth of a son to her mother in October before she returned to Park Street. It was being 'so much occupied attending Mama who was confined of a fine little boy . . ., playing with the children, taking care of the house and enjoying myself and getting strong with country walks'[51] that prompted her reflections, in a letter to Brown in Venice:

I quite think with you that if I had children my health might be quite restored. Simpson and several of the best medical men have said so to me and your gracious permission to me against your prejudices amuses me not a little, but you would require to win over John too, for he hates children and does not wish any children to interfere with his plans of studies. I often think I would be a much happier, better, person, if I was more like the rest of my sex in this respect.[52]

Back in London she found her husband 'deep in his Stones and occupied with Printers people who do mezzo-tints and lithographs, spoil some and make more work, and John is delighted with his work'.[53]

Work took precedence during the winter, as he wrote his way through the first volume of *The Stones of Venice*. No longer able to postpone the formulation of a book from his mosaic of minute particulars, he began to build what he called "The Foundations". Working upwards from "The Wall Base", he devoted separate chapters to walls, cornices, piers, shafts, capitals, arches, roofs and various apertures like doors and windows. He followed this with an equal amount of discussion of the ornaments to be allowed on those basic structures. All these "Foundations", as well as being 'the best, though perhaps the dullest way' to lay down a basic architectural knowledge for his readers, were also the necessary 'foundations of criticism',[54] which the next volume of the work would take up. But after four-hundred-odd pages of technical facts, he is still far from returning to the larger perspectives announced in the first chapter, "The Quarry" ('making the Stones of Venice touch-stones').

So the final section – "The Vestibule" – undertakes a different approach by literally recreating Ruskin's own journeys into the Venetian city:

> And now come with me, for I have kept you too long from your gondola: come with me, on an autumnal morning, through the dark gates of Padua, and let us take the broad road leading towards the East.[55]

Through the level plain, beside the Brenta with its sluggish water and empty, gesturing villas, the decadence of Renaissance architecture and the models of English taste, he conducts his readers past Dolo, where older villas sink 'fast into utter ruin, black, and rent, and lonely'. Ruskin allows us to 'rest' at the little, unprepossessing inn at Mestre ('close smell of garlic and crabs'), but soon moves on by gondola down an 'endless canal'. Yet now Venice announces its peculiar ambivalence – is it real or artifice, like its stones or like Ruskin's

210

recovery of them in his prose? The 'narrow street' at Mestre becomes a waterway, the stagnant-black water turns out to be dozens of gondolas, and even these we are invited to enter 'to try if they be real boats or not'. The waters are 'painted', the Alps of Bassano are purple, like dead rose-leaves, and at last the open lagoon is reached. But where we expect to see Venice is the railroad bridge. However,

> at the end of those dismal arches there rises, out of the wide water, a straggling line of low and confused brick buildings, which, but for the many towers which are mingled among them, might be the suburbs of an English manufacturing town. Four or five domes, pale, and apparently at a greater distance, rise over the centre of the line; but the object which first catches the eye is a sullen cloud of black smoke brooding over the northern half of it, and which issues from the belfry of a church.
>
> It is Venice.

It is Ruskin's ambiguous testimony to the city and to his recreation of it out of the 'wide water' of his researches among its confused bricks. But this finale is also his pledge of future discussions which will be more immediately appealing, have more 'Romance', than what he has so far accomplished.[56]

It was published in March 1851. The illustrations had given Ruskin endless trouble, as Effie told Pauline Trevelyan; unlike the first edition of *Seven Lamps*, he employed engravers rather than etched the plates himself. But the intricate connections between word and image which "The Foundations" contribute were an essential feature of Ruskin's bi-focal attention to the Venetian world; his careful attention to innumerable details on the spot had taken the form of sketches and annotations, which are translated, in more orderly fashion,[57] into the published work, so that the reader in some way comes to share the original research.

At the same time as *The Stones of Venice* was published Ruskin also issued a pamphlet entitled *Notes on the Construction of Sheepfolds*; if its title seems to echo the technical work of the Venetian "Foundations", its text is dedicated to the spiritual concerns which his architectural studies still only promised. He makes the connection himself in an opening sentence, as well as cross-referencing his pamphlet in an appendix of *Stones* I. This is typical, not only of Ruskin's ever-increasing concerns (*Notes* is on Christian discipline and doctrine), but of his consequent difficulties as to which readership he addresses at any one time and what form his pronouncements can best take: *Stones* proliferated into appendices and ('for the convenience of readers interested in other architecture than that of Venetian palaces') into *Notes*

on the Construction of Sheepfolds.[58] And, as it also brought Ruskin into correspondence with F. D. Maurice – through the intermediation of F. J. Furnivall, these publications of 1851 were also to lead to yet another major role of Ruskin's career, his teaching, which began at the Working Men's College, founded by Maurice in 1854.

Meanwhile, with the two publications achieved, the demands of society reasserted themselves. They received, Effie said, 'quantities of Invitations', but she limited herself to two a week.[59] What was a limitation to her seemed a surfeit to her husband. In June 1851 she wrote and told Brown that she was disappointed 'not to take so great an opportunity as I have now of seeing a little of London life but Mr Ruskin dislikes it so very much'.[60] Yet Ruskin himself five months later could write to his father from Venice to say he was exhausted from 'being so often up till past midnight last season'.[61] Despite these differences, which must have provided the main tension between her and her husband, Effie managed to pass a fairly lively winter, going out much on her own (without John, but in the company of Lady Charlemont who had presented her at the Palace the previous June). She spent the New Year in Sussex, again without John, happily participating in the family life of her hostess, Lady de Salis. In February Effie herself started her own "At Homes" in Park Street, which she and (on her account) John also enjoyed. The next month she was sitting to both Watts and Thomas Richardson for her portrait.

During April they travelled, first to Cambridge, where they stayed with Dr Whewell, Master of Trinity, and then to Farnley Hall, in Yorkshire, for John to see and arrange dozens of Turners collected by one of the painter's earliest patrons, Fawkes.[62] After a night with the Cheneys again, they were back in London for the opening of the Great Exhibition. John refused to go, sitting in his 'quiet room' at Denmark Hill while 'All London is astir' and preparing 'to enter on the true beginning of the second part of my Venetian work'.[63] But others flocked to the Exhibition. Effie had a season ticket; her parents and brother George came down from Scotland for it and stayed at Park Street for over a month; even Rawdon Brown, for the first time in fourteen years, came back to London. Effie continued to have her freedom, exercised as always with tact. John took his parents to Malvern in July – the night *en route* that they stopped at Leamington Spa Paulizza died in Venice and was buried in the 'cemetry of Murano'.[64] While John was away, his wife would admit no man into Park Street, with the exception of Brown. Her circumspection arose from the rumours about her behaviour with Clare Ford, which her brother, to Ruskin's annoyance, heard from Furnivall. This young

and dissolute son of Richard Ford, whose family Effie had got to know the previous season, fell in love with her, only to be lectured and set upon the path to reformation by Effie's counsels. She defended herself to her mother, assuring her that she valued 'the only fortune I possess, viz – a good name'.[65] However George Gray never ceased to believe that Ruskin had schemed to compromise his wife with Clare Ford.

For two months that summer, prior to their departure for Venice in early August, John was much involved in the affairs of some other young men, one of whom would come to play an altogether more radical role in their lives than Ford. Coventry Patmore, whom Ruskin had recently got to know, asked him to intervene on behalf of a group of young painters, the Pre-Raphaelites, whom the art critic of *The Times* had attacked. Abused for their pictures in the 1850 Royal Academy, they received even more scorn the following year. The terms of *The Times*'s critique must have challenged the argumentative temper of the author of *Modern Painters* I, for it accused the Pre-Raphaelite Brotherhood of 'an absolute contempt for perspective and the known laws of light and shade' and 'a singular devotion to the minute accidents of their subjects'.[66] Prompted by Patmore, who had himself been approached by Millais, Ruskin returned to the Academy to see the offending pictures and, back home, wrote a reply to *The Times*'s art critic. When John James vetoed the first draft, a second was sent, appearing on 13 May. With characteristic enthusiasm for a new topic, Ruskin found that it had led him into a further piece, which also appeared in *The Times*, on 30 May. This second letter was even more critical than the first, and privately Ruskin told Patmore that he was puzzled why Millais had not 'got a bit of olive branch out of some of our conservatories – instead of painting one on speculation . . . and also, whether he has ever in his life seen a bit of old painted glass, near?'[67] But his enthusiasm for other details ('I happen to have a special acquaintance with the water plant, *Alisma Plantago*,' he told *The Times*, 'I never saw it so thoroughly or so well drawn') pleased the Pre-Raphaelites, whose 'splendour of colour' was also singled out, perhaps because it appealed to a taste recently enlarged by Venetian painting. Ruskin ended the second letter by prophesying that the Pre-Raphaelites would, with due care and attention (presumably to the faults he had diagnosed), 'lay in our England the foundations of a school of art nobler than the world has seen for three hundred years'.[68]

The young artists were understandably grateful for the support of such a figure and two of them, Hunt and Millais, wrote to thank Ruskin. When the letter reached him, Ruskin accompanied by Effie

went to call on Millais, from whose house in Gower Street the letter had been addressed. The combination of Ruskin's charm and power to please when he wanted, Effie's attractive manner and appearance and Millais's youthful grace and energy made the visit a success.[69] Millais was soon dining and breakfasting with Ruskin, who tried to persuade the young man to join them in Switzerland that summer; he was on this occasion unable to go.

Meanwhile Ruskin was translating his two letters to *The Times* into a pamphlet on *Pre-Raphaelitism*. Its preface invokes his advice to contemporary painters eight years before in *Modern Painters* I and its opening pages on the necessity of happy work anticipate parts of the as yet unpublished praise of gothic craftsmen in *The Stones of Venice* II. His enthusiasm not only brought these past and present concerns into the pamphlet but led him to enter also upon matters of artistic education, modes of imagination, the state of British painting, and the variety of Turner's oeuvre, of which he promised his readers a catalogue raisonnée in *Modern Painters* III. Into this nexus of concerns his recent interest in the Pre-Raphaelites is rather fleetingly accommodated. The whole piece gives the effect of a control barely maintained over a multiplicity of topics; its composition, he said, gave him 'so much more trouble than I expected' and contributed to the nervous and excitable state he was still in when he reached Venice on 1 September.[70]

Effie, eager to return to Venice, had been planning their visit with Rawdon Brown's help for a long time. In Paris on the way out they met up with Charles Newton, Ruskin's Christ Church friend, and Daniel Moore, the minister at Camden Chapel, Chamberwell, who were accompanying them to Switzerland. Later at Champagnole they met Mr and Mrs Pritchard (she, the sister of Ruskin's tutor, Osborne Gordon), and all of them continued to Chamonix. Here Ruskin 'nearly killed with fatigue his friends',[71] taking them up and beyond the Montanvert. They returned to Geneva and the Ruskins continued with Newton to Vevey, but were too late for the Fête des Vignerons. Both John and Effie had wanted to see it, but when he found out that some of her London friends would also be there he sulked and said he would not go ('I am determined I won't be bothered in my pet places'[72]). And he was irritable and tired for long after they arrived in Venice, where he determined to be a recluse.[73]

In this resolve he succeeded as well as he ever could. Each time he was tempted to go out or to invite people to dine, he felt at once that 'half my day's strength' had left him. He probably appeared more in society than during their previous visit, since Effie did not have

Charlotte Ker as a companion; he did so, he told his father, to show he 'wasn't a *myth*'.[74] Occasionally, when Gilbert Scott came to tea, he enjoyed 'a great architectural séance', but on other occasions he was either boorish (sitting in a corner of a dinner party at the Palazzo Barbaro reading to himself) or rude (abusing one of Effie's Austrian visitors for his belief in priests).[75] He was not, on his own confession, working too hard, but resting a little each day and 'mixing other subjects with my architecture':[76]

> I rise at ½ past six: am dressed by seven – take a little bit of bread, and read till nine – then we have breakfast punctually: very orderly served – a little marmalade with a silver leafage spoon on a coloured tile at one corner of the table – butter very fresh – in ice – fresh grapes and figs – which I never touch; on one side – peaches on the other – also for ornament chiefly – (I never take them) – a little hot dish, which the cook is bound to furnish every morning – a roast beccafico – or other little tiny kickshaw – before Effie white bread and coffee: Then I read Pope or play myself till 10 – when we have prayers: and Effie reads to me and I draw till eleven: then I write till one when we have lunch: then I go out, and sketch or take notes till three – then row for an hour and a half – come in and dress for dinner at 5, play myself till seven – sometimes out on the water again in an idle way: tea at seven – write or draw till nine – and get ready for bed.

But he was working to complete the second volume of *The Stones*, evidently assuming that this would conclude his Venetian studies and allow him to return to *Modern Painters*.[77] He found he was often compelled 'to abridge and simplify my designs'.[78] What he had written in London before they left was tested against and revised in the light of further explorations of the city.[79] He became fascinated with the tides and started a Tide Book; the alternation of *acqua alta* soon after their arrival with exceptionally low water afforded him ' a fine opportunity of studying the structure of the lagoons'.[80] This contributed to the initial chapter of volume two as well as to an appendix, though by 1876 he annotated his text with the observation that 'I perceive now that the tides of Venice are under laws which I might write another 3 volumes on – or four'.[81] By January he was telling his father that the present visit to Venice was barely adequate for all he had to do:

> Take all the time that I have had here – about 12 months in all – in which I have had to examine piece by piece – buildings covering five square miles of ground – to read – or glance at – some forty volumes of history and chronicles – to make elaborate drawings – as many as most artists would have made in the time – and to compose my own book –

what of it is done – (for I do not count the first volume anything) and you will not I think wonder that I grudge the losing of a single day.[82]

He sent bits and pieces of his new chapters, fair-copied by 'George', to Denmark Hill, hoping his father would be encouraged by the tone and contents of the second volume; he also spoke of fresh drawings, 'much more popular in form and manner'.[83]

Three days after Christmas he received his father's letter telling him that Turner ('my earthly master') had died on 19 December. The news elicited various reactions: streams of detailed instructions to John James ('my ramblings about *so many* pictures') telling him which works to buy if any came on the market – 'the chief thing is to get mountains';[84] confident visions of himself, appointed one of Turner's executors, being left alone by the others to organize and build the Gallery which the painter's will wished to be established for the exhibition of his works – typically perhaps, Ruskin at once envisaged it 'in the form of a labyrinth'.[85] But, above all, Turner's death focused sharply for Ruskin his whole career to date – the interrupted *Modern Painters*, dedicated to Turner's defence, and the still unfinished *Stones*, devoted to a city he saw constantly with Turner's eyes.[86] When he had finished these, he declared, 'I shall give up being an author altogether'.[87]

Not only, of course, would his pair of books require between them four more volumes than he supposed in the New Year of 1852, nor be finished until another eight years had passed, but Ruskin would never give up writing. Yet this winter in Venice, where he was studying the political, social and economic factors that shaped Venetian architecture, saw a decided focus of his mind on the very kind of questions that would preoccupy him after 1860: economy and the place of the arts in national wealth. He responded with Carlylean fervour to a newspaper's unconscious emphasis upon the unequal distribution of riches in its casual juxtaposition of 'Fashions for November' with the horrible deaths of a girl and her child.[88] He brooded upon principles of currency and then upon the economy of working in precious materials, finding that an Italian sculptor he took to help him estimate the value of the marble columns in St Mark's could not put a figure on them.[89] Timon-like ('I shall go and live in a cave in the cliff – among crows'), he inveighed against a local proposal to retouch Tintoretto's *Paradise* and continued his crusade against repainting old masters at the end of his second volume, where monetary and artistic values are sharply contrasted.[90] Yet he was also preoccupied with calculating what Turners would be worth to him in the

open market and what he would accept for those he possessed.[91] And as if to reinforce his strictures the Trustees of the National Gallery refused to save two decaying Tintorettos, which Ruskin had hoped they would buy.[92] Drawing all these ideas and reactions together, he composed three letters to *The Times* on taxation, franchise and education; but these were blocked by John James and were never published.[93]

Ruskin meekly accepted his father's judgement, as in so much else. But Effie was displeased, anxious for her own freedoms once they had returned to England. In the matter of where they would live in London her feelings and tastes were not being consulted. John told her that he 'never intended as long as [his parents] lived to consult me on any matter of importance as he owed it to them to follow their commands implicitly'.[94] The question of housing was therefore discussed lucidly, if severely, in letters to Denmark Hill: the parents obviously wanted the young couple to live with them, John himself thinking this 'proper'; but as it was clear that Effie and his mother could not get along in the same house, and as he himself wanted peace and quiet to finish *The Stones of Venice* and *Modern Painters*, which ruled out living in town, the best solution was to take a house near Denmark Hill. Effie, John wrote, 'will mope wherever we are as long as we are quiet – but mope she must: I told her fairly what sort of a person I was before I married her – and she must do as well as she can with her bargain'.[95] The house that John James accordingly leased for them was next door to their old home on Herne Hill. Mr Snell, an upholsterer in Albemarle Street, was paid to furnish it, again without consulting Effie (though she did send word about what sort of bed she wanted); even John was disturbed at the prospect ('I had rather have deal tables and Turners').[96] As their time in Venice drew to a close he looked forward, 'as regards myself', to Herne Hill as much as to Chamonix, which they would visit on their return journey; but he reported that 'poor Effie' avoided referring to her future home, regarded it 'with considerable dislike' and must accordingly be treated as kindly as possible.[97]

Certainly the prospects of being marooned outside London society, surrounded by ugly furniture, with no carriage except when Mrs Ruskin lent hers, compared sadly with Effie's winter in Venice, with a gondola and two gondoliers, her own organization of their quarters including 'a handsome Viennese piano',[98] and access to a great variety of Austrian and Italian society. They had taken rooms in a private house belonging to Baroness Wetzlar on the Grand Canal (what is now the Gritti Palace Hotel), where Effie particularly enjoyed

the projecting window or Belvedere, which she arranged 'very prettily'.[99] Through the kind offices of Lady Sorell and Countess Pallavicini she was chaperoned where necessary and introduced into a wider circle of friends and acquaintances than during their previous visit. Her lively letters home ('John calls me Mrs Scratch he is so tired of hearing my pen scrape across the paper') are full of celebrities met and new contacts made. On the occasion of one of Marshal Radetzky's balls in Verona she talks of 'soon dancing away with people of all nations and tongues'.[100] If she occasionally lamented her husband's sulks at being forced to appear in public,[101] she still managed with tact and circumspection to enjoy herself hugely:

> For everybody is fond of me and pets me: I am the Belle at all the Balls and the people respect me for being virtuous and occupied. The women are not jealous of me because I pay them every politeness in my power and the men adore me, one & all, because, I suppose, I like none better than the other and it flatters their vanity that being admired by Radetzky & the Arch Duke, and complimented publicly by Gorzkowski, the Governor, on my looks and taste in wearing the Austrian colours, and dancing and talking with all & sundry without distinction, I have sufficient means and Liberty to do whatever I choose . . .[102]

At carnival time both she and John hired dominoes and wandered the streets in masquerade – which he did, she said, gravely but capitally.[103]

That particular diversion did not get reported to Denmark Hill. But, as Effie sharply noted, everything else did. The Ruskin evangelical training in self-examination elicited from John lengthy expositions of his physical and spiritual welfare for anxious parents back in England, including a detailed narrative of his health since 1844.[104] John was, in fact, as Effie realized, 'always much better when away from their over care and attention';[105] but his mother had long since decided that Effie was incapable of looking after him. Further tensions arose between her and her parents-in-law as their return approached, not helped by the unilateral decisions about their London accommodation and by John's making his own allegiances clear; he told his father, when a meeting in Switzerland was mooted for the summer of 1852, that Effie 'would not fit with *our* ways' of travelling.[106] John James thought them (by which he meant Effie[107]) extravagant, but neither could he be pleased by her kinds of economy nor see that she must have found the Ruskin expenditure on Turners and casts of Venetian capitals equally extravagant in different ways.[108] John himself was nervous at his expenditures and delayed nearly a month telling his

218

father of the purchase of a Tintoretto 'sketch'.[109] Effie wisely kept her silence as much as she could.[110]

They moved to rooms overlooking St Mark's Square for the last few weeks, when their lease on Casa Wetzlar ran out, and both enjoyed the change as well as some belatedly fine weather. Effie bathed at the Lido and John returned to copying some of his favourite bits of Tintoretto. But their happiness was sadly disrupted, and (to the distress of his parents) their departure constantly postponed by the theft of some of Effie's jewelry. The local police – as well as John and Effie – suspected an Englishman serving with the Austrian army, who had been on friendly terms with them (only afterwards did John recall as significant that the man, Foster, 'was continually attacking the clergy . . . inconsistent with the character of a man of honour'[111]). But the military authorities took the matter into their hands and only with the combined help of Brown, Cheney and the English consul did the Ruskins, after endless delays and the jewels still unrecovered, get permission to leave. At Verona, to augment their troubles, a fellow-officer of Foster's and another of the Ruskins' friends during the winter challenged John to a duel for having maligned his friend. Actually Ruskin and Effie had been scrupulous to do no such thing, having simply told the police the circumstances of the theft, which certainly pointed to Foster (he was eventually cleared by the military authorities). Ruskin's response to the challenge was that 'he sought no man's life & had no intention to risk his own'.[112]

Not surprisingly John was relieved to get away and be once again among the Alps, where Effie was pleased 'to see him enjoying himself so much':

> but then he begun drawing comparisons between what he calls the vice and misery of Venice and the liberty of the Mountains and asked me if I did not think that this was the right sort of Life. I said I supposed it was, and for him doubtless it was much better, but to tell you the truth, the snow makes me shiver and I feel the change excessively from Venice . . .[113]

Venice had provided Effie with the most enjoyable moments of her married life, happy not least in her husband's contentment,[114] and it would be constantly in her thoughts at Herne Hill. Their journey back was rather plagued by some fellow travellers, Lord and Lady Fielding, met in Venice and also on their way home, who made considerable efforts to convert John to Roman Catholicism. When the elder Ruskins came to hear of this, coming on top of some not altogether satisfactory explanations of John's current beliefs in letters from

Venice, they were indignant, and it added to the outrage with which they heard of the challenge to a duel.[115] What John James called 'the Jewel and officer story'[116] eventually got into the English newspapers, which made it seem that Ruskin had accused Foster out of jealousy. John was categorical in his defence of Effie – she 'was at once so kind and so prudent'[117] – but it did not prevent John James writing one of his annoying letters to Mr Gray to criticise his daughter's conduct. Altogether, it was a most unfortunate homecoming.

Chapter 13

The Order of Release: 1852–1854

I have had much to think about in studying Everett [Millais] and myself, and Effie, on this journey, and reading Sir Charles Grandison afterwards, and then reading the world a little bit

Ruskin to his father, November 1853

Even John hated the small suburban house: 'a numberless common-place of a house, with a gate like everybody's gate on Herne Hill – and a garden like everybody's garden on H.H., consisting of a dab of chrysanthemums in the middle of a round O of yellow gravel'. To Effie it was 'inconceivably cockney after Venice'.[1] But at least John escaped each day to his own study at Denmark Hill or took the omnibus into town, where he was sorting through the accumulations of Turner's house.[2] Effie's only chance was when the Ruskins' carriage was put at her disposal on Wednesdays. And with no house servants at first, she and John were required to dine every evening with his mother and father.

Effie had told her parents from Venice that it was 'equally imposs-ible to be fond of Mrs R or to trust Mr R' and that she was made 'perfectly spiritless' by having to get on with them.[3] John James continued to send forthright letters to her father before and after their return from Italy, and it is probable that similar criticisms were aired directly in front of John and Effie. John James feared for Effie's happiness at 30 Herne Hill, though 'Mrs Ruskin is very sanguine'; yet his anxieties were not really on Effie's behalf, for she 'does not lead the Life I could have wished my Daughter in Law to lead'. He was sceptical, too, about the whole marriage – 'They never appeared to me to have more than a decent affection for each other, John being divided betwixt his wife and his pictures and Phemy betwixt her Husband and her Dress.'[4] When John James was not complaining about her extrava-gance or fearing that the scandal over her jewels was causing his son to be snubbed by Eastlake and Rogers, Margaret Ruskin was extremely vocal about the dangers of John turning papist.[5] Effie tried with large success to stay uninvolved, but when her father-in-law forbade her to go to Perth while there was illness in the Grays' house or refused,

when she could go, to let her travel alone her diplomacy was sorely tried. She could, in effect, do nothing to please them, as she complained, still with some amusement, in February 1853. When she did not go out, they wondered why she did not accept the many invitations received; if she were to drag John with her, they would have complained that she 'degraded' him in society.[6] She developed a cautious policy of trying to 'see some of my particular friends when I can, but not to go out without John'.[7]

Ruskin was himself busy all the winter of 1852–3 on *The Stones of Venice*, 'winding off the tangled skein of all my Venetian work'.[8] He was also buying plates of Turner's *Liber Studiorum* and expensive missals, which Effie in her turn thought extravagant. Yet he was himself made uneasy at home, caught, as Effie observed, between hurt vanity when his mother treated him like a child and his own unalienable conviction that he must obey her ('respect for parents being in all ages, less or more, exactly in proportion to the low or noble training of the mind').[9] Where he was perhaps of some help to Effie was in what appears to have been a genuinely unconventional attitude towards normal social expectations. He responded very courteously to Mr Gray's worries about Effie's relationship with Clare Ford, who reappeared that summer, but declared not only that she never showed the 'slightest want of caution' but that she displayed shrewdness and unselfishness in helping the young man. Further, when the Grays were upset and miserably put out by the marriage of Mrs Gray's brother with his housekeeper, Ruskin professed himself 'much less shocked than anybody else by the whole affair' and instead of shunning the couple would have invited them 'to dinner forthwith and [made] much of them both'.[10] This rational approach to social embarrassments and his refusal to acquiesce in Victorian snobberies and cant would sustain him considerably during the next two years, even though it would stretch the credulity of somebody like Effie, who most benefited from it at the time.

The aspect of her husband's behaviour which did disturb her in 1852–3 was what she called – and it is an astute observation – 'His whole desire for knowledge'.[11] When their respective parents were so exercised about John's wavering towards Roman Catholicism, Effie, quite rightly, saw no such danger; but

> what *I* dislike about him is his wish to understand the Bible throughout – which nobody in this world will ever do – and unless they receive it as a little child it will not be made profitable to them. He wishes to satisfy his intellect and his vanity in reading the Scriptures and does not pray that his mind and heart may be softened and

improved by them. He chuses to study Hebrew and read the *Fathers* instead of asking God to give him Light. His whole desire for knowledge appears to me to originate in Pride and as long as this remains and his great feeling of *Security* and doing every thing to please himself he is ready for any temptation . . .

What she diagnosed in her husband was certainly one of the catalysts which would bring their marriage steadily to the point of crisis and, eventually, breakdown.

Meanwhile John did indeed most things to please himself that winter, concentrating largely upon his work and establishing a routine of writing, sketching and walking. He had about seven weeks to himself when Effie was visiting Perth, and did not stir out much when she returned, bringing two little sisters and their governess with her. 'George' Hobbs, with whom Effie was never much at ease, perhaps because his sister was Mrs Ruskin's maid, left to emigrate to Australia; a new manservant, Frederick Crawley, was interviewed by Effie before she left for Scotland and entered their service at about the time she returned. Her father came down to London for the Duke of Wellington's funeral, but John held himself aloof from the 'ridiculous and tiresome pageant'.[12] But he made a point of going out to meet the Brownings, an acquaintance that would ripen much during the next few years.

Perhaps as early as January,[13] but certainly by March 1853 when she was telling her mother about it, Effie was sitting to Millais for his picture, eventually called *The Order of Release*. He found her head, she reported, 'immensely difficult and he was greatly delighted last night when he said he had quite got it'; apart from the hair, which for purposes of contrast in the picture Millais darkened, the head was 'exactly like'.[14] The painting was a great success at the Academy that summer; when Effie sent Frederick Crawley and her maid to see it they could hardly reach it for the crowds. Effie had enjoyed her involvement with the painting and admired Millais's 'talents' and his being 'so extremely handsome'; she presumably pleased her husband with this interest in his protégé, to whom he apparently offered the use of one of the Herne Hill garretts for his painting whenever Millais wanted.[15] John James on the other hand was extremely disagreeable. Effie reported that on their fifth wedding anniversary he indulged in some strange innuendoes by saying that 'he had never seen anything so perfect as my *attitude* as I lay on the sofa . . . and that no wonder Millais etc, etc'. She told her mother she was 'sickened' by such 'nonsense'; but, as she rightly noted, from Mr Ruskin it sounded strange and suspicious. 'There is little doubt', Mary Lutyens con-

cludes, 'that Mr Ruskin had hoped for a long time that she would behave in some way to lower herself in John's eyes.'[16] But John himself was not yet provoked by what others found disagreeable or odd.

In May, once work on *The Stones of Venice* II was complete, they took an apartment in Berkeley Square for the season, when even John planned to exercise himself in public. Significantly, he saw this largely in terms of getting to know 'everybody who has either *Turners* or *Missals* and get invited to their houses'.[17] He went out more than usual, but his tolerance of society quickly palled and despite, or because of, 'lots of invitations' he retreated to what Effie tartly referred to as 'that eternal Denmark Hill'.[18] Her plans, in fact, included as long an absence as possible from its Ruskinian circle – 'till, I hope, Christmas'.[19]

John wished to undertake an extensive northern tour to see more 'Turners and Missals' and, by travelling in the old way by chariot, to 'cut the railways'.[20] His exact projects were constantly being revised and Effie was forced to send fresh directions to her parents, but the basic plan involved a visit to Sir Walter and Lady Pauline Trevelyan at Wallington, in Northumberland, then taking a house somewhere in the Highlands for the late summer, and being in Edinburgh during November when John was invited to lecture before the Philosophical Institution. Effie planned to keep him in the north between their summer wanderings and the lectures; in fact, they were in Scotland until just before Christmas.

The Ruskins were to be accompanied by Millais, Millais's brother William, and Holman Hunt, but the last withdrew from the scheme. Nor did they always 'cut the railways', for they went to Northumberland by train, reaching Wallington on 22 June. Here they spent a most enjoyable week. It was 'the most beautiful place possible', according to Ruskin, and the people were 'dear'.[21] The Trevelyans had stayed a few nights at Herne Hill and spent much of April in the Ruskins' company; they had also met Millais on several occasions.[22] So the party at Wallington was a consolidation and extension of friendships. Pauline Trevelyan had an enormous admiration for Ruskin; he in his turn found both her and Sir Walter thoroughly interesting and interested in his work – no doubt Wallington's cabinet of curiosities, which he told his father contained minerals, stones and birds,[23] confirmed this mutual regard. But Ruskin was also excited about his protégé's enthusiasm for the place – Millais had never seen any countryside like it before ('a peculiar *Northumberlandishness* about – a faraway look which Millais enjoys intensely'[24]) and sketched avidly. He drew pictures of everybody, too, but was so pleased with what he did of Effie that he kept it himself.[25] He stayed behind to draw her

224

when Sir Walter took Ruskin to see his neighbour's, Sir John Swinburne's, collection. Millais thought her 'the sweetest creature that ever lived . . . the most pleasant companion one could wish'.[26]

One of the imponderables of this whole summer is the exact progress and extent of affection and disaffection among the group. As Ruskin told Miss Mitford in October 1854 there were 'questions which very little common sense might have told [people] *never* could be answered'.[27] Years later the biased autobiographical notes of William Bell Scott would have it that Millais and Effie were obviously in love at Wallington and that the Trevelyans tried to alert Ruskin, but 'that innocent creature poo-poohed' it.[28] Ruskin's own unconventional attitudes, already discussed, combined with his 'great feeling of Security' which Effie diagnosed, would have been enough to blind him to what was happening. His delight in promoting Millais as a landscape painter in the Turnerian tradition was also an overriding concern – at Jedburgh, after leaving Wallington, the Millais brothers, according to Ruskin, 'both declared they must *stop there* and paint *that* . . . This is just what I wanted them to feel – and Millais pounced just as I expected on the beautiful modelling of the sand-stone rocks among the trees'.[29] And there were other projects in which Ruskin was proposing to involve Millais ('preserving all the Tintorettos and saying they should like to go to Switzerland next year and then to Venice'[30]).

After two days in Edinburgh, from which Ruskin was impatient to remove Millais into the Highlands, but which Millais according to Effie enjoyed,[31] they moved on to Brig o' Turk in Glenfinlas. Here they put up at the New Trossacks Inn, intending to proceed further north. But Millais was again enchanted by the scenery and within a day, doubtless with Ruskin's encouragement, had fixed upon two locations for companion portraits of Effie and her husband: Effie at one of the windows of the ruined castle of Doune, himself standing by one of the rocky streams.[32] After a week the Ruskins and Millais established themselves at the local schoolmaster's house, William Millais remaining at the Inn.

The teacher's cottage, which Crawley thought would horrify Mrs Ruskin, was cramped, especially when the dreadful weather kept them all in-doors, but intriguing. Ruskin, who drew it for both his father and Furnivall, slept downstairs on the sofa, while Effie and Millais each had a tiny cubicle above. To start with, and despite Millais not feeling well, they all enjoyed it hugely, with games of battledore and shuttlecock, much drawing and sketching, and reading aloud their favourite authors like George Herbert, Dante, Richardson

and Tennyson's *In Memoriam*. Ruskin was working hard on the index for *The Stones of Venice*. The second volume had appeared that July and Ruskin asked his father to arrange a presentation copy, bound in dark green and with silk inside, for Millais. The index and his preparation of the Edinburgh lectures occupied him when the third volume was completed (it came out in October). Ruskin was continually requiring his father to send materials to Scotland from his study at Denmark Hill.

But the main focus of Ruskin's summer was Millais's work. In October he told Furnivall that their extended stay was designed 'to keep Millais company – to keep him up to the Pre-Raphaelite degree of finish – which I have done with a vengeance'.[33] The painting advanced whenever the weather allowed – Ruskin sometimes shielding the artist from the rain with his umbrella[34] – but progress was anyhow extremely slow: Millais 'does it like a minature', Effie told Lady Trevelyan, 'about two inches a day is as much as he can do'.[35] By the end of their stay Millais's increasing unhappiness and ill-health must have slowed the work up even more. The pleasures of Ruskin's patronage began to pall – 'Ruskin . . . is not a very good companion – he is not a man who respects a person more for living with them'.[36] And Ruskin, though untiring in his encouragement of the portrait, began to register how little he could, in fact, shape Millais to his tastes, any more than he had been able to do with Effie. Writing to Denmark Hill in November he meditated upon the unchangeableness of people:

When we married, I expected to change *her*. She expected to change *me*. Neither have succeeded and both are displeased. When I came down to Scotland with Millais I expected to do great things for him. I saw he was uneducated – little able to follow out a train of thought – proud, and impatient. I thought to make him read Euclid, and bring him back a meek and methodical man, I might as well have tried to make a Highland stream read Euclid, or be methodical.[37]

By mid-October Millais's health ('always restless and unhappy') alarmed Ruskin, who nevertheless attributed it to his sadness at Holman Hunt's imminent departure for the Near East; he even tried to persuade Hunt not to go for Millais's sake, a letter about which Effie 'thought it right' that Millais should be told.[38] But Millais was by now obviously tormented not only by love for Effie but by his dismay at the Ruskins' marriage; he even 'spoke to him about his extraordinary indifference to her attractions'.[39] Though gossips (and Millais himself[40]) would later have it that Ruskin's *intention* was to throw Millais and Effie together – a tale impossible to credit now – the two

were inevitably a good deal in each other's company: when Ruskin sprained his ankle or stayed in the cottage working, they were often walking together ('Every evening I take a walk with her'[41]); it was Effie who helped him home the day he crushed his thumb ('He lent on me all the way') and he who supported her home through the mud on at least one occasion.[42] The sketches Millais made that summer and autumn invariably show them together – climbing Ben Ledi or she cutting his hair. His ostensible excuse for this obsession was that he needed preparatory studies for the companion portrait to her husband's. The angels on one of his designs for a window representing 'eternal happiness and the struggle for life' all have Effie's face.[43] He was also teaching Effie herself to draw; he – and indeed Ruskin – were delighted by her progress; 'the only pleasure', he told Holman Hunt, 'is teaching Mrs Ruskin drawing'.[44] Though there was 'much that I could tell you but cannot', he wrote again to Hunt, he harped upon how 'impossible [it would be] to stay here if it were not for Mrs Ruskin who is more delightful everyday'.[45]

Not surprisingly Millais lost his enthusiasm for Ruskin's portrait, which he identified for a correspondent, with unconscious aptness, as 'Ruskin looking into the depths of a whirlpool'.[46] How much, apart from her own considerable unhappiness, Effie was aware of is unclear, as almost all her letters from Glenfinlas are lost. That she did draw sharp comparisons between Millais and her husband is, however, clear from one that does survive: soon after they had settled in at Brig o' Turk she told her mother that

> The Millais make all their letters common property and get very nice letters from their home. John has letters every day from his Father but it never occurs to him to mention what are in them . . .[47]

Nor could she have failed to read something into the ferocious games the two men played, 'hitting with such rapidity' as Millais described it, 'that we hit each other before being able to parry like fencing'.[48] And we know from later correspondence that she must have told Millais about her unconsummated marriage. William left them in mid-August, no doubt making the situation more acute for the remaining three. When one of Everett Millais's pupils, Michael Halliday, visited them in October, he was told at least something of what was going on.[49]

The long Pre-Raphaelite summer school ended in late October. The famous portrait was unfinished; indeed, although the background was almost complete, there was no figure at all in the landscape, much to John James's annoyance. Millais was hopelessly in love, but also

'miserably dampered in body and spirit'.[50] Effie was sufficiently discontented to threaten her husband with the law sometime during November.[51] John was deep in his Edinburgh lectures, in which typically he had involved Millais by getting him to draw architectural examples as well as a tiger's head from the Edinburgh zoo. Although Millais stayed on in Glenfinlas after the Ruskins left in order to continue the portrait, he became more ill, and Ruskin eventually sent Crawley to bring him to Edinburgh. A city he had found 'lovely' in July was now 'awfully respectable and solitary',[52] but he lingered until Ruskin's first two lectures were delivered. He reached London in time to hear that he had been elected an Associate of the Royal Academy.

Ruskin's lectures were given rather against his parent's wishes. John James thought lecturing was demeaning ('I don't care to see you allied with the platform – though the pulpit would be our delight'[53]) and John was forced to argue that he did not 'mean at *any* time to take up the trade of a lecturer'.[54] Even his mother wrote that he should not bring himself 'personally before the world till you are somewhat older'![55] He promised to send the texts of the lectures for approval, but evidently worked upon the drafts he had sent until the moment of delivery.[56]

Probably the real anxiety at Denmark Hill was that John had been away too long and was letting other things get in the way of a resumption of *Modern Painters*. As part of his persuasion of them to let him lecture, he promised the first chapter of the third volume as a New Year's present for his father.[57] After they reached Edinburgh, both Ruskin and Effie were ill; the combination of this with the summer's pressure to review his life promoted another series of self-examinations sent to Denmark Hill:

> All the morality of Richardson and Miss Edgeworth (and the longer I
> live – the more wisdom I think is concentrated in their writings) seems
> to have no effect upon persons who are not *born* Sir Charles's or
> Belindas. Looking back upon myself – I find no change in myself from
> a boy – from a child except in the natural changes wrought by age. I
> am exactly the same creature – in temper – in likings – in weaknesses:
> much wiser – knowing more and thinking more: but in character
> precisely the same . . .[58]

The analysis of his own 'utter unchangeableness' manages to be penetrating and complacent at the same time. And when his mother decided that his poor health in Edinburgh was due to his long absence from Herne Hill, he said that her wishes were father to the thought, that, in fact, he was well only when he was quiet, and that duty required much

which was inconsistent with good health. He instanced a clergyman's and a doctor's lives, but added that as far as his health was concerned 'it might be better that I should declare at once I wanted to be a Protestant monk: separate from my wife and go and live in that hermitage above Sion which I have always rather envied'. He brooded further on his indulgent existence, resolving not to spend so extravagantly on works of art ('I must cut the whole passion short off at the root'). Yet the following February he bought the 'greatest treasure of all my life', what is now known as Queen Isabelle's Psalter and Book of Hours.[59]

The lectures were well received, not only allaying his parents' fears but making them pleased and proud. The first address on "Architecture" was given on Tuesday 1 November in the hall of the Philosophical Institution on Queen Street; the second, on "Decoration", three days later. A thousand people were in the audience; some fainted and were carried out. The *Edinburgh Guardian* of 19 November carried a long notice of the series, the third and fourth of which – delayed because of Ruskin's sore throat – took place on 15 ("Turner") and 18 ("Pre-Raphaelitism") November. The paper reported Ruskin's entrance upon the platform and his delivery:

> The door by the side of the platform opens, and a thin gentleman with light hair, a stiff white cravat, dark overcoat with velvet collar, walking, too, with a slight stoop, goes up to the desk, and, looking round with a self-possessed and somewhat formal air, proceeds to take off his great-coat, revealing thereby, in addition to the orthodox white cravat, the most orthodox of white waistcoats. . . . Mr. Ruskin has light sand-coloured hair; his face is more red than pale; the mouth well cut, with a good deal of decision in its curve, though somewhat wanting in sustained dignity and strength; an aquiline nose; his forehead by no means broad or massive, but the brows full and well bound together; the eye we could not see in consequence of the shadows that fell upon his countenance from the lights overhead, but we are sure it must be soft and luminous, and that the poetry and passion we looked for almost in vain in other features are concentrated here . . .
>
> And now for the style of the lecture, you say: what was it? Properly speaking, there were in the lectures two styles essentially distinct, and not well blended, – a speaking and a writing style; the former colloquial and spoken off-hand; the latter rhetorical and carefully read in quite a different voice, – we had almost said intoned. When speaking of the sketches on the wall, or employing local illustrations, – such as the buildings of the city, – he talked in an apt, easy, and often humorous manner; but in treating the general relations of the subject, he had recourse to the manuscript leaves on the desk,

written in a totally different style, and, naturally enough, read in a very different voice. . . . Mr. Ruskin's elocution is peculiar; he has a difficulty in sounding the letter 'R'; but it is not this we now refer to, it is to the peculiar tone in the rising and falling of his voice at measured intervals, in a way scarcely ever heard except in the public lection of the service appointed to be read in churches. These are the two things with which, perhaps, you are most surprised, – his dress and his manner of speaking, – both of which (the white waistcoat notwithstanding) are eminently clerical. You naturally expect, in one so independent, a manner free from conventional restraint, and an utterance, whatever may be the power of his voice, at least expressive of a strong individuality; and you find instead a Christ Church man of ten years' standing, who has not yet taken orders; his dress and manners derived from his college tutor, and his elocution from the chapel reader.[60]

Many friends were in the audience – the Trevelyans travelled to Edinburgh especially to hear him. Coming so soon after the generally enthusiastic reception of the complete *Stones of Venice*, Ruskin was much lionized.[61] He was pleased with the whole venture, determining to publish the series. Eventually he would make lecturing – its strange opportunity for rhetorical formality *and* colloquial vigour being perhaps the attraction – one of his preferred forms of activity.

Two days after the final lecture he told Denmark Hill that he had actually begun the first chapter of *Modern Painters* III. Next day Effie went to Perth, while John remained in Edinburgh, ostensibly to continue treatment for his throat from a John Beveridge, but he was much courted, too, by society. Wary of it, as always, he was nevertheless pleased to view James Dennistoun's unusual collection of Italian primitives, which were relevant to his current essay on Giotto for the Arundel Society.[62] He had plans, too, for seeing the missal and manuscript library of the Duke of Hamilton, which he did on the way from Perth, further delaying his arrival back home.

His time in Perth was limited to four days instead of the week or ten days originally planned. But it must have been of some moment and marks a change in John's attitudes to his marriage.[63] All we know for certain is that Mrs Gray decided to stop Millais communicating with Effie (though it had been done with Ruskin's knowledge), for two letters from him agreeing to do so and commenting sadly but affectionately on the state of her daughter's marriage have survived. Their implication is that Ruskin had 'complained' of the correspondence, but in what terms and to whom is not stated.

Effie, as her husband duly reported to Denmark Hill, dreaded the

return to London – 'but it is of no use to think about her'.[64] She developed a nervous tic or facial neuralgia, 'the form my weakness takes when I am weary or excited by any distress'.[65] She and John were to bring her ten-year-old sister, Sophie, back with them; Millais, presumably told of this by Mrs Gray, welcomed it as a means of protecting Effie from men who, seeing Ruskin's neglect and uncon-cern, would importune her and give the Ruskins the ammunition they apparently sought. John himself thought Sophie's presence at Herne Hill would be a good excuse to get away more frequently to Denmark Hill, though he may have told his parents this to soften any objections about the extra expense of bringing Sophie. After some final adjust-ments to their schedule, which involved John, Effie and Sophie spend-ing Christmas at Durham, John reached London on Boxing Day at the appointed hour, the others arriving (to John James's annoyance) by a later train.

There was the usual putting of his study at Herne Hill in order on 30 December ('tolerable day'). A week later on 7 January Ruskin's diary again records that his 'two studies' were brought into 'comfort-able order'. Such compulsive tidying could not cope with what was obviously a very precarious private life. It seems clear that by now Ruskin wanted to be rid of his wife, even actively working for her removal; this represents undoubtedly the least pleasant episode in his whole involvement with Effie. Effie herself, after some preliminary efforts to organize a *modus vivendi*, was also soon committed to withdrawing finally and as best she might from the Ruskins. Each of them, under-standably, hoped that the break could be achieved on terms satisfac-tory to his or her dignity, pride and peace of mind. Various weapons were used in these final hostilities – Effie's place in the Ruskins' next continental excursion planned to begin on 9 May, Millais, and, least excusably, the young Sophie Gray.

Over dinner at Denmark Hill on New Year's Eve there were some unpleasant exchanges about that next summer's tour. John had en-couraged Effie to spend the summer with a friend convalescing at one of the German Rhine spas, where she could be dropped off by the Ruskins *en route* for Switzerland. It was made perfectly clear to her now that she was being got rid of so as not to spoil the family tour. That evening, back at Herne Hill, she endeavoured to talk to John ('I did not wish to begin another year in this uncomfortable state'[66]), even offering 'to do anything he might desire and help him in his work'. Ruskin, however, made it brutally clear that his marriage was 'the great-est crime he had ever committed' and that any consideration shown towards her was his duty towards somebody 'so unhappily diseased'.

Effie still assisted with some of the work her husband was doing on a book of Rawdon Brown's, *Giustinian at the Court of Henry VIII*, which was going through the press; she devoted herself to supervising Sophie's lessons and gave some dinner parties, as being the 'only way I can ever see any body'.[67] Yet she evidently did hire a carriage to get up to London, visiting the British Museum twice a week, she told Brown in February.[68]

John's diary records several walks with Sophie. Effie was convinced that her husband and his parents, whenever Sophie went to Denmark Hill, used her sister to poison their relationship further by slandering her.[69] Ruskin, for instance, told Sophie that once they had all returned from Europe later that year he would see 'what harshness would do to break' his wife's spirit. It is, however, possible to see Ruskin, always more at ease with children, hoping to make a confidante of the young girl during a period of extreme distress, even being able to suggest to her what he could not bring himself to tell Effie, that divorce was what he really wanted. His rehearsals to Sophie of Effie's Glenfinlas conversations, which he had noted, and his unfavourable comparisons of them with what she had written during their engagement sounded to Effie, when her sister repeated them, as attempts to corrupt Sophie's mind; yet they might just as well have been misguided, rather pathetic endeavours to seek her sympathy, as years before he received it from Adèle's younger sister.[70] Sophie evidently rather enjoyed her sudden prominence and, as Effie told Mrs Gray, acted the elder Ruskins 'to perfection' in her recitals. It is also evident that Sophie found the Ruskins horrifying humbugs, her childish sharpness seeing through many of their self-delusions and inventions.[71]

Sittings for the waterfall portrait of Ruskin dragged on, much to Effie's distress as well as Millais's, who told Mrs Gray it was 'the most hateful task I ever had to perform'.[72] Ruskin's attitude to his protégé was 'bland and affable'; but Effie was convinced that her husband was somehow trying to get her 'into some fresh scrape' over a drawing of *St Agnes' Eve* – perhaps a significant subject; it had been sent, with Ruskin's approval, by Millais to Effie. Ruskin tormented her with requests to write and acknowledge the gift, then – to see whether she would protest at the loss of such a lovely piece – with saying he would himself send it back.[73] But she refused to give him any hold by communicating directly with Millais herself. And in other ways, so it seemed to her, Ruskin was working against her. He excused himself from a dinner party in town, but, without consulting Effie, told their hostess that his wife would come by herself; when she refused, he

became angry and, in some form of reprisal, ordered her to call off her trip to Germany.[74] Then there was the occasion in April when Ruskin offered Rawdon Brown the use of his study at Herne Hill to facilitate final work on his book; Effie – by now perhaps feeling acutely persecuted – protested that it was an extraordinary suggestion to have another man in the house when her husband was so rarely there; John's response was to say that she should realize that her husband was extraordinary.[75]

Effie's own deliberate calmness whatever the provocations was excessively annoying to her husband. Apart from her letters to Perth, she felt isolated and vulnerable at Herne Hill. Some support was forthcoming from Crawley, who told Sophie that he had heard 'the most dreadful lies about my missus' at Denmark Hill; Effie must have trusted him, too, for he played an important role in the secret arrangements for her departure in April.[76] But by the end of February even Effie's cool head seemed insufficient and she was asking her mother to 'advise me'.[77] Millais, who was kept informed by Mrs Gray, urged her to act: '*Something must be done by you* if she continues to be martyred.'[78] He told Sophie, on her last visit to his studio, that her sister should get 'divorced from John directly' and that he, Millais, would intervene and tell her parents the true state of the marriage if Effie did not.[79] At last on 7 March, after consulting Lady Eastlake, Effie wrote to her father that 'I have therefore simply to tell you that I do not think I am John Ruskin's Wife at all!'.[80] Mr Gray made plans to come to London and confront the Ruskins, once John James returned from a business trip.

Meanwhile Effie told her husband that she would not go to Germany, a visit that had been promoted again by Mrs Ruskin who thought it would be 'odd' if Effie stayed behind.[81] John appeared relieved, but was furious at her calm declaration and tried to discover from Sophie what lay behind her sister's 'change of conduct'.[82] By this time Effie had some moral support to hand, since an old friend, Jane Boswell, was staying at Herne Hill. Miss Boswell disliked the Ruskins and John was hardly ever in the house when she was there; but the siege-like atmosphere got to her in the end ('she feels as if she had lived months instead of weeks here'[83]). John seems to have tried 'a new method of . . .' harassment, but the letter is torn off at the point where Effie is to explain what this involved; we know only that it made her 'quite exhausted' by morning.[84] On their sixth wedding anniversary she required John to sign a document which she drew up and which signified that he fully approved her keeping Millais's gifts of drawings and had no objections to her retaining 'any other thing whatever in my

possession'; John signed, noting that since he had no 'knowledge of my wife's feelings in any respect' he could not have an opinion as to whether it is 'wrong or right in her to accept any present from any person'.[85]

But by this time Effie was very scared, recalling John Thomas Ruskin's madness, and dispatched detailed suggestions as to how her father's interview with Mr Ruskin should be handled. After further consultations with Lady Eastlake and Rawdon Brown, she urged not only that Mr Gray must talk fully with her before encountering John James but that he should consult lawyers of the Ecclesiastical Courts, which alone, before 1857, were empowered to hear divorce petitions. The Grays arrived secretly in London on Good Friday, 14 April. After taking legal advice, they decided not to deal directly with Mr Ruskin. Instead, they planned to let Effie pretend she was returning to Perth, prior to the Ruskins' departure for Switzerland, only advising them after her flight of her intention not to return. She sent luggage in advance, George Gray in Perth hoping that 'J.R. had not suspected any movement when he saw [it] leaving'.[86]

Indeed, it is astonishing that nothing was suspected, for the Grays' departure was postponed for a week on legal advice; Lady Eastlake could scarcely restrain herself from unleashing the gossips' tongues; Effie was secretly in town seeing her parents, and Crawley was evidently in the know. Mary Lutyens wonders whether a letter from Mr Gray to his daughter, which is known to have gone astray, had not fallen into Ruskin's hands.[87] Considering his fascination with Richardson's novels, all of which take the form of letters between the protagonists and occasionally hinge upon the interception of correspondence, I wonder, too, that Ruskin had not used other means than interrogating Sophie to find out what Effie was up to. The previous November he had wished that his wife would imitate the humble and affectionate duty of the 177th letter of *Sir Charles Grandison*,[88] so the thought of his taking other models from these novels is not improbable. But if Ruskin did know of the Grays' plans, he let them proceed.

On the morning of 25 April he accompanied Effie, Sophie and Crawley to King's Cross to see them off. The train's first stop was Hitchin, where Effie's parents were waiting. Sophie, presumably only told what was happening at the last moment, jumped out and her place was taken by Mrs Gray, who continued with Effie and Crawley to Perth.[89] Sophie and Mr Gray returned to London, saw the lawyers, with whom they left a package for delivery to Denmark Hill, and caught the next boat home. That evening John was served with a citation to Court in Effie's suit for annulment of their marriage, while

Mrs Ruskin received the packet containing Effie's accounts, keys and wedding ring. An accompanying letter explained why she had not made her customary good-bye visit to Denmark Hill and gave Mrs Ruskin a brief narrative of her unhappy life with John. She thought he would be 'glad I have taken this step'.[90]

He was probably deeply relieved. John James, of course, was outraged at the whole business, furious at the insult to his son and vituperated loudly against Effie at a Water Colour Society exhibition a few days later, where he also complained about Mr Gray's financial imprudence in investing in railway shares; obviously thinking it totally apt, he wrote to tell Harrison that Effie had 'gone pleasantly away Via the Great Northern'.[91] John kept quiet – Effie thought this was because he was a coward[92] – and left it to his father to instruct solicitors and manage the case. On 27 April he did compose a statement, giving his version of the marriage: his main line of defence for not consummating it was their agreement to defer sexual intercourse, then their growing alienation; he ended by saying that he could prove his virility at once, but that he did not wish 'to receive back into my house this woman who has made such a charge against me'.[93] But the statement was never invoked, since by offering no defence the proceedings could be hastened. They were, in fact, completed in mid-July, earlier than expected. Effie was required to undergo medical examination in London and, with her father, made dispositions to the Courts. Lawyers for both families agreed to expedite matters, since the annulment was now a formality; John, by this time in Geneva, agreed ('I certainly wish the case to proceed with as little hindrance as possible'). He authorized an appearance to be made in court on his behalf; on 15 July the 'pretended marriage' was declared a 'nullity' since 'the said John Ruskin was incapable of consummating the same by reason of incurable impotency'.[94]

The gossip, meanwhile, often with Lady Eastlake's enthusiastic management, flourished exceedingly. 'I continue to hear the same buzz of pity for her and indignation at him', Lady Eastlake told Mrs Gray, 'and I continue to tell the tale whenever and wherever I think the *truth* can do good'.[95] To the indignant, including Effie herself, the extent of Ruskin's culpability was measured by the widespread assumption that he would eventually turn Roman Catholic.[96] Millais hoped the affair would be just 'a nine days wonder', but his own name was inevitably drawn into the speculations.[97] Ruskin postponed the final sittings for the portrait, which Lady Eastlake thought it was absurd to want to finish since '*nobody* will *look* at' it.[98] Only Ruskin's hands and bits of the landscape were now missing; Pre-Raphaelite

principles triumphed over personal considerations and Millais returned to Glenfinlas that summer to complete the rocks, painting as a friend read aloud to him the now published Edinburgh lectures![99] Ruskin gave him the required sittings sometime later that autumn.

Furnivall was one of Ruskin's staunchest supporters, sending him a kind note soon after the news broke. In reply Ruskin told him that 'I shall neither be subdued, nor materially changed, by this matter. The worst of it for *me* had long since passed.'[100] The same sentiment was expressed in a letter to Pauline Trevelyan, thanking her also for writing: 'I received your little note with deep gratitude – fearing that even *you* might for a little while have been something altered to me by what has happened.'[101] Although he told her in another letter that he needed his friends' sympathy, Ruskin's main endeavour was to continue his life as if his six years with Effie were a simple digression, time-wasting perhaps, but inessential. Before he left England he tried to behave as normally as possible, appearing in public and writing – to Lady Eastlake's great indignation – two letters to *The Times* in defence of Holman Hunt's painting, *The Light of the World*, which was in the Academy exhibition together with *The Awakened Conscience*. Then he left for the continent with his parents, as had long been planned, on 9 May.

Only when he was abroad did he write to the one person who might have expected some communication even earlier, Henry Acland.[102] Acland had visited Glenfinlas the previous summer and commented to Millais then upon 'Ruskin's dreadful indifference to his wife'; he had discussed with Millais on several occasions since Effie's flight the 'disunity of his two friends' without apparently trying to judge them.[103] Now Ruskin told him in full the story of his marriage, along the lines of his earlier statement, but with some more candid reactions to its failure: notably, that he would not 'allow the main work of my life to be interfered with' and that, as he came to recognize the 'rottenness' of Effie's support for him, 'My real sorrows were of another kind. Turner's death – and the destruction of such & such buildings of the 13th century, were worse to me, a hundredfold, than any domestic calamity. I am afraid there is something wrong in this . . .' At the end of the long letter Ruskin actually attributes Effie's behaviour in the final weeks of their life together to her passion for Millais.

To spare Ruskin 'the pain of writing such another' account,[104] Acland was asked to send on the letter for the Trevelyans to read. Though Ruskin would contribute some more details to Furnivall, including what amounts to a rather ambiguous denial of 'having

thrown my late wife in Mr Millais way', [105] his fullest efforts at explaining his view of the broken marriage were reserved for Acland and the Trevelyans. Then he settled to enjoying his journey. In his diary for 13 May he remarked how the last time he had travelled the Beauvais-Amiens road had been with his wife on their Normandy tour; then he had been going in the opposite direction, now he was 'happier'. And on 10 July, five days before the formal order of release was granted by the courts, he was in Chamonix once more – 'Thank God . . . feeling it more deeply than ever. I have been up to my stone upon the Bréven, all unchanged, and happy.'

Part IV

'Of Many Things'

I do not intend, however, now to pursue the inquiry in a method so laboriously systematic; for the subject may, it seems to me, be more usefully treated by pursuing the different questions which arise out of it just as they occur to us, without too great scrupulousness in marking connections, or insisting on sequences. Much time is wasted by human beings, in general, on establishment of systems; and it often takes more labour to master the intricacies of an artificial connection, than to remember the separate facts which are so carefully connected.

opening of *Modern Painters* III (1856)

a prevalently
upright tendency

with a capacity
of branching . . .

no words
to tell
of green
fibre into
fitful
change

Thomas A. Clark, *A Ruskin Sketchbook*

After Effie's departure Ruskin resumed what his editors would term 'a new life, which was yet the old one'. This resumption, however, was not without its difficulties and attendant depressions. The exhilaration of rediscovered personal freedom was harnessed to a bewildering range of activity.

Even the completion of Modern Painters involved, as he told Mrs Carlyle in 1855, 'various remarks on German Metaphysics, on Poetry, Political Economy, Cookery, Music, Geology, Dress, Agriculture, Horticulture and navigation, all which subjects I have had to "read up" accordingly'. But the defence of Turner returned to the primary materials of his landscape vision with fresh experience and insight; the critique of paintings drew new authority paradoxically from both his dedicated work with the Turner Bequest and his own, increasingly sharpened personal perspectives. As supplementary texts, glosses upon the main endeavour of Modern Painters, Ruskin initiated his Academy Notes as well as the commentary upon Turner's Harbours of England.

He lectured more and more, taught at the Working Men's College, and – always needing to be, as he would call Pygmalion in Ariadne Florentina, the 'perfect master' – he occupied himself with private pupils. These activities, too, blossomed into books like The Elements of Drawing and found some concentrated focus in his visits to a girls' school at Winnington. Lecturing promoted his interests in social and political economy, as he strove to communicate the practical and moral consequences of his art and architectural work to new audiences, to an ever-widening sea of 'sign painters, and shop decorators, and writing masters, and upholsterers, and masons, and brickmakers, and glass-blowers, and pottery people, and young artists, and young men in general, and schoolmasters, and young ladies in general, and schoolmistresses'.

Renewed work on Turner's careful scrutiny of nature made Ruskin reconsider his botanical studies; he became 'dissatisfied with the Linnaean, Jussieuan and Everybody-elsian arrangement of plants, and have accordingly arranged a system of my own . . .' But systems of his own – and there would be many during the remainder of his life – required new languages, new modes of communication, new forms. To get his ideas across he looked to a school like Winnington, a museum like the one his friend Acland was establishing at Oxford or more fantastical projects for cabinets of curiosities – 'I want to have a black hole, where they shall see nothing but what is bad, filled with Claudes and Sir Charles Barry's architecture.' Such ambitions would eventually discover in his Slade Professorship at Oxford, in the texts of Fors Clavigera and in the Guild of St George more extensive ways of formulating and presenting his vision of the world he wished to bring into being.

Released also, with Effie's departure, from unwelcome social obligations, Ruskin cultivated friendships on his own terms – with Carlyle, Acland, Rossetti, Mrs Browning and Charles Eliot Norton among others. Affectionate

and considerate as he could be when he wanted, he also desperately needed to fix his love upon a fit object and to give himself a permanent abode where he might establish himself independently of Denmark Hill. But his long and indecisive quest for a house for himself was constantly frustrated. And the love which he offered the Irish girl, Rose La Touche, the most sustained and tragic of his searches for some Galatea for his Pygmalion, drew him finally into despair and depression. After the completion of Modern Painters *in 1860 he seemed periodically out of spirits, at a loss for some focus for his existence; the thwarting of his affection for Rose La Touche compounded an already unstable temperament to bring him close to breakdown. He avoided this partly by an access of that energy which he had always given to his work; it merely postponed the storm.*

Chapter 14

'Plenty to do': 1854–1860

my two chief points of enquiry – where I am? and what's to be done next?

Ruskin to Mrs Browning, 1855

– 1 –

What John James called their 'long projected Slow Tour' was a pleasant reaffirmation of old habits without the encumbrance of Effie.[1] John found, as he told Miss Mitford, that 'I am the same person I used to be'.[2] He indulged his established taste for careful analysis of geological strata, for domestic Swiss architecture, and for landscape, while realizing that 'many suffering persons must *pay* for my pictures-que subject'.[3] He planned to write a history of Switzerland, which would join his engraved images of key towns to a letterpress; but the first view, of Thun, took 'the whole of the summer, and is only half done then'.[4] His diary for 18 July noted how 'Every day here [in Chamonix] I seem to see farther into nature, and into myself, and into futurity'. But when a woodsman met by chance in the hills above Thun helped him find a safer path for his descent he accepted the 'lesson . . . not to trust so much to my own knowledge of hills'.[5]

His multifarious projects flourished again, like the moss flower he found on 21 July under the Aiguille Blaitière, its lovely green shape emerging out of the 'decayed leafage of former years'. At a window with a fine view of the head of Lake Geneva he began writing the definition of poetry in the first chapter of *Modern Painters* III.[6] As he drove up the Simmenthal from Vevey in mid-June he read in *The Times* an account of the Queen's opening of the Crystal Palace; the contrast prompted his pamphlet on *The Opening of the Crystal Palace* (on sale in London by 24 July) in which, while he welcomed a museum where workers might find exciting opportunities to extend their knowledge, he was appalled that the 'new style of architecture' was only that of a magnified conservatory. With the mechanical ingenuity that covered fourteen acres of ground with glass he sadly contrasted the neglect of Turner's Bequest, the rotting masterpieces of Venetian painting and

242

the restorations of French cathedrals.[7] At other times he pondered 'the real *uses* of the art of painting', interrogated the meaning of Biblical texts, made notes on Stendhal, on illuminations (to use in a future lecture) and, at the Louvre on the way home, many memoranda on pictures.[8] Of the three measures of great painting – truth, refinement, confusion – he seemed to emphasize the third ('all the greatest men being confused'[9]).

But there was some underlying unease, surfacing rarely in the diary, but unmistakably when he received Acland's reply to his letter explaining the breakup of his marriage: it relieved him 'from the anxiety which I have so long laboured under . . . Deo Gratias. Gloria'.[10] Although he did not look at the final annulment papers when they were sent out to Switzerland by the lawyers,[11] he was clearly far less able than he pretended to resume his life as if nothing had intervened: 'writing, at present . . . puts me into painful trains of thought – and when I am at my pines and aiguilles, I am all right'.[12] As he neared home the proliferation of plans ('I am rolling projects over and over in my head'[13]) must have been his uneasy response to the resumption of his life in London. From Paris on 24 September he wrote to Pauline Trevelyan that 'I am going to set myself up to tell people anything *in any way* that they want to know'; he planned museums, 'an Academy of my own in all the manufacturing towns', an 'opposition' Academy exhibition ('where all the pictures shall be hung on the line'). And 'all this is merely by the way': for he proposed also to continue with 'my usual work about Turner and collect materials for a great work I mean to write on politics – founded on the Thirteenth Century – I shall have plenty to do when I get home'. Yet it is clear that despite the need to finish *Modern Painters*, a project now eleven years old, it was ideas less tarnished by his own past unhappiness that he really wished to pursue.

He was back in London on 2 October. The Glenfinlas portrait was finished sometime before 11 December when it was installed at Denmark Hill ('Father and mother say the likeness is perfect – but that I look bored'[14]). Ruskin's effort to conduct himself as if Effie had not existed encountered its awkwardest moments, inevitably, with Millais. In thanking Millais finally for the portrait Ruskin invited him to contribute designs for his students at the Working Men's College; when Millais did not respond he wrote again – 'Why don't you answer my letter – it is tiresome of you – and makes me uneasy.' Eventually Millais wrote rather stiffly to express his surprise that Ruskin would consider it possible to continue 'on terms of intimacy'; yet he added an unhappy postscript to the effect that he sympathized with all of Ruskin's 'efforts to the advancement of good taste in Art, and heartily

wished them success'. Although Ruskin was well aware of rumours that told of Millais and Effie marrying (this took place in June 1855), he was much offended by Millais's reply; it taught him, he said, another 'lesson . . . of the possible extent of human folly and ingratitude'.[15]

With the loss of Millais as his protégé, Ruskin had more time and energy (of which he needed lots) for Dante Gabriel Rossetti. They had become acquainted just before Ruskin left for Europe during the summer, when he advised Francis McCracken, a Belfast collector, on buying a Rossetti watercolour, which led to a call by Ruskin upon the artist at his studio. Rossetti was impecunious and improvident and therefore interested that Ruskin 'seems in a mood to make my fortune'.[16] Yet he was uncertain of, even overwhelmed by, the other's serious enthusiasms and high praise – 'thoroughly glorious work – the most perfect piece of Italy, in the accessory parts, I have ever seen in my life – nor of Italy only – but of marvellous landscape painting'.[17] Rossetti's response was facetious and highspirited – 'I of course stroked him down in my answer'; but he found Ruskin's praise 'almost as absurd as certain absurd objections he makes'.[18] As usual, Ruskin's approaches were, though gracious and effusive in their patronage, very much on his own terms: he sent 'copies of all I have written' and a 'piece of opal' ('a magnifying glass used to its purple extremity will show wonderful things in it').[19] Quick to anticipate Rossetti's protests, he asked for a drawing in exchange as well as another one 'for fifteen guineas'. Rossetti was grateful, but temperamentally incapable of fulfilling commissions promptly. As soon as Ruskin returned from abroad, Rossetti was invited to Denmark Hill ('and not be *too* P.R.B. as Stanfield is coming too'[20]) and the friendship prospered.

Ruskin involved Rossetti at once in his other major new preoccupation of that autumn and winter, teaching at the Working Men's College in Red Lion Square on Thursday evenings. 'All the men want', he told Rossetti, who was perhaps diffident of teaching, 'is to *see* a few touches done, and to be told where and why they are wrong in their own work, in the simplest possible way.'[21] It was a role that Ruskin himself found congenial and one he filled conscientiously. He approved of the College's encouragement of a wholeness and unity of knowledge and learning.[22] His writing on the historical condition of the Gothic craftsman found its relevant application at the College, and it is no accident that his time there as a regular teacher coincided with the beginnings of his social concerns and his attempts to apply what he had learned from the past to the condition of the present. Yet he was

determined not to encourage false ambitions in his students; again applying his own criteria, he directed his efforts 'not to making a carpenter an artist, but to making him happier as a carpenter'. In this he seems to have been frequently successful. Testimony of his kindness, generosity and consideration, yet without loss of standards, has survived from many pupils, some of whom – like George Allen, his later publisher, Arthur Burgess, John Bunney or William Ward – became associated with Ruskin's projects. He provided easels out of his own funds and searched always to find interesting items for the men to copy as well as to let them see examples of his own work in progress. He took them out into the countryside around London on sketching parties ('Cabs at Camberwell Green, at half-past three. Tea at the Greyhound Inn, Dulwich, at seven'). But above all, as he had shown in other circumstances with Millais and Rossetti, his personal attention to each member of the class was what counted:

> For one pupil he would put a cairngorm pebble or fluor-spar into a tumbler of water, and set him to trace their tangled veins of crimson and amethyst. For another he would bring lichen and fungi from Anerley Woods. Once, to fill us with despair of colour, he brought a case of West Indian birds unstuffed, as the collector had stored them, all rubies and emeralds. Sometimes it was a fifteenth-century Gothic missal, when he set us counting the order of the coloured leaves in each spray of the MS. At other times it was a splendid Albert Durer woodcut, that we might copy a square inch or two of herbage, and identify the columbines and cyclamens. He talked much to the class, discursively but radiantly . . .[23]

Clearly Ruskin expected his students to be absorbed by his own pursuits, able to apprehend the wonders of nature and the skills of attempting to recreate them in exactly the ways which he had followed.

But not content with his teaching in Red Lion Square, Ruskin was also lecturing at the Architectural Museum in Westminster, where his gist was again that, although it takes much talent to be an artist, the gift of laying on simple colour with skill could be enjoyed by many.[24] The whole ambition of the Museum, founded in 1851, to train workmen in crafts lay close to Ruskin's established principles; he made gifts of casts and drawings and visited the Museum after his three lectures to 'direct the students in the study and practice of the Art of Illumination'.[25]

Towards the end of the year he heard from Acland that the gothic designs for an Oxford Museum of Natural History had been agreed ('Veronese Gothic of the best and manliest type'[26]). His joy at the

prospect, not only of another museum, but of his own chance to be involved in its decoration, was extreme: 'the architect [Benjamin Woodward] is a friend of mine – I can do whatever I like with it – and if we don't have capitals & archivolts! – & expect the architect here to day – I shall get all the preRaphaelites to design me – each an archivolt and some capitals – & we will have all the plants in England and all the monsters in the museum –'.[27] He had been up in Oxford earlier in the term about the designs, for Acland had worked hard to involve Ruskin with the Museum, recognizing at once the affinity of his friend's characteristic mental habits with the aims of the museum:

> The whole nature of Ruskin resists the limited study of Nature which takes a part for the whole, which studies the material structure of Man, forgetting the higher aspirations and properties for which that structure seems to exist on earth – to bring him into communion with the Infinite – and through the Infinite to the love of all things living with Man or for him.[28]

This judgement aptly mirrors Ruskin's large endeavour in *Modern Painters*, the third volume of which, entitled "Of Many Things", was progressing in between all the other activities and projects. The fourth as well as the third volume was taking shape and their fifty plates being prepared during 1854 and 1855. Their analyses drew much fresh nourishment from his latest tour in Switzerland, for the unique achievement of this slowly expanding and incremental book was its assimilation and synthesis of many of Ruskin's unconnected interests and then their application to his enjoyment, and explanation of that enjoyment, of painting.[29] 'Great art', *Modern Painters* III argued, 'is produced only by men who feel acutely and nobly; and is always in some measure an expression of their personal feeling.'[30] Ruskin's personal feeling, tutored by Turner's landscape art and by the actual landscapes that art had sent him to explore, set itself to consider the "Moral of Landscape", as one important chapter in the new volume of *Modern Painters* is headed. Ruskin chose to register the fact that 'an intense love of nature is, in modern times, characteristic of persons not of the first order of intellect, but of brilliant imagination, quick sympathy, and undefined religious principle, suffering also usually under strong and ill-governed passions.' Yet the highest attention to landscape of the best painters is 'assuredly indicative of minds above the usual standard of power, and endowed with sensibilities of great preciousness to humanity'. Despite the studied objectivity, this speaks as much for Ruskin himself; the science of aspects – 'the pursuit of science . . . constantly . . . stayed by the love of beauty, and accuracy

of knowledge by tenderness of emotion' – was his especial, if difficult, study.[31]

As if in reaction to the pressures of the year – relief at Effie's departure, muted excitements at new or resumed ventures – his health suffered. A persistent cough throughout the winter was finally cured by a spell of rest in June 1855 under his doctor cousin, William Richardson, at Tunbridge Wells: 'such an odious place', wrote Pauline Trevelyan, 'how can you go there?'[32] Maybe he did not really notice – though the one diary entry that survives for this year records a 'most exquisite' sky on 10 June – for he was engaged, besides recuperating, in writing *The Harbours of England*. He had been asked by the dealer, Gambart, to provide a commentary for twelve Turner views of English harbours, hitherto unpublished. The essay resumed his discussion of sea-pictures in *Modern Painters* I, but now with much more technical knowledge of ships and seas; yet it also anticipated the analyses of "Turnerian Topography" and compositional methods in *Modern Painters* IV. John James considered *The Harbours of England* 'an extremely well done thing'. Indeed, it offers an epitome of Ruskin's critique of Turner that may be recommended today as a far more effective entry into the forest of *Modern Painters* than the customary selection of its best but isolated passages in some anthology.

Modern Painters III was also slowly being completed. In July Ruskin 'resolved to let nothing that I *can* prevent interference with the finishing of this old book of mine'.[33] This resolution doubtless derives from the way in which he had allowed yet another project, the inauguration of his *Notes on the Principle Pictures in the Royal Academy*, published on 1 June, to interfere with the major work. The *Notes* were the first of his attempts to combine a public function as writer and critic of art with a private role of adviser and correspondent: 'I am often asked by my friends to mark for them the pictures in the Exhibition of the year which appear to me the most interesting, either in their good qualities or their failure. I have determined, at last, to place the circular letter which on such occasions I am obliged to write, within the reach of the general public.'[34] The critique of individual, contemporary paintings was a practical application of his theoretical work in *Modern Painters*; the method of noting specific examples had, in fact, been invoked briefly in the second edition (1848) of volume two.[35] The *Academy Notes* were an apt format for Ruskin's characteristically forthright decisions about actual works of art irrespective of personalities. So in 1855 he considered Millais's *The Rescue* 'the only *great* picture exhibited this year';[36] he singled out the young Leighton's *Cimabue's Madonna* for praise and Eastlake's *Beatrice* for some terse

complaints. Ruskin writes confidently, delighting in his authority: 'Twenty years of severe labour, devoted exclusively to the study of the principles of Art, have given me the right to speak on the subject with a measure of confidence.' Yet this confidence slips easily into the arrogance of remarks like – 'the worst policy which the friends of the artist can possibly adopt will be to defend' him.

This mixture of *ex cathedra* judgement and engagingly personal involvement also characterized his increasingly complex relations with Rossetti: 'Now about yourself and my drawings. I am not more sure of anything in this world (and I am very positive about a great many things) than that the *utmost* a man can do is that which he can do without effort. All beautiful work . . . is the *easy* result of long and painful practice.'[37] So he required his commissions to be done 'first and fast', even suggesting half a dozen Dante episodes in an effort to galvanize Rossetti. He wrote him careful, close criticisms of Cayley's verse translation of Dante, because Rossetti's 'taste is as yet unformed in verse'. But Ruskin's promotion and forming of his protégé was often self-indulgent, and he would reserve for himself fine drawings that had been designed for others like Ella Heaton, a new acquaintance and friend of the Brownings, whom Ruskin was advising on picture purchases.[38]

As soon as Ruskin was shown examples of work by Rossetti's mistress, Elizabeth Siddal, sometime in March 1855, he declared them to be better than Rossetti's own and promptly bought them all. He was full of schemes to help them, eventually settling £150 a year on Miss Siddal, just as he agreed to pay Rossetti a fixed sum every year in return for whatever drawings he chose. The exuberance and impulsive generosity were sometimes concealed from John James, and Rossetti was required on at least one occasion to write to Ruskin at the Athenaeum about arrangements for Miss Siddal, otherwise Ruskin's father 'would think I was going to fall in love with her'.[39] But they were invited to Denmark Hill and Mrs Ruskin discussed Lizzie's poor health with her in detail. She was escorted to Oxford for consultations with Acland and eventually helped to go abroad for a rest.[40]

The relationship between the two men was still rather warily conducted on Rossetti's part, especially when Ruskin began inquiring whether Rossetti lacked funds to marry Lizzie and later even urging the course upon him – 'My feeling is that it would be best for you to marry, for the sake of giving Miss Siddal complete protection and care, and putting an end to the peculiar sadness, and want of you hardly know what, that there is in both of you.' In April Ruskin wrote a disarming account of himself to try and reassure Rossetti about

accepting his patronage.[41] These self-descriptions, fruits of his evangelical training in self-analysis, occur increasingly in Ruskin's writings, both public and private; but it seems sometimes as if the act of self-examination itself became an automatic guarantee for him of an accurate diagnosis.

Thus he proposed, he told Rossetti, to 'tell you something about myself' which would in its turn instruct him in 'what you really ought to feel about me in this matter'. He confessed to being self-indulgent, proud, obstinate; yet upright and dedicated to making people happy. He saw himself as somebody who by 'evil chance' and 'foolish misplacing' of affections had them dashed to pieces. He was, therefore, without friendships and loves. Doubtless Ruskin contrived a self-portrait specifically to allow Rossetti to accept his patronage; but his self-dramatizations and even self-delusions ('I . . . never wilfully did an unkind thing') become steadily a part of his own mythology. Yet this must all have satisfied the younger man, who was afterwards writing to his aunt that 'Ruskin was the best friend I ever had out of my own family'.[42] And Octavia Hill approved of Ruskin's methods: not paying for work done, but giving Rossetti the means to do work that he wanted.[43]

The exuberant friendship between the men survived in spite of their temperamental differences. Ruskin, generous yet overbearing: 'You are a conceited monkey, thinking your pictures right when I tell you positively they are wrong.' Rossetti, dilatory and erratic, as Ruskin's, generally humorous, remonstrances indicate:

> If the drawing is sent on Monday, my address is Ship Hotel, Dover. If Tuesday, ditto. If the week after next, Denmark Hill. If next year, I don't exactly know where.

> The carriage will be at your door at half-past twelve on whichever day you choose; so mind you get up in time.

Rossetti's Bohemian existence was an especial trial to the inhabitant of Denmark Hill: 'If you want to oblige *me*, you would keep your room in order and go to bed at night.' Ruskin would send for Rossetti's drawings ('Please don't be ridiculous and say you've nothing fit') to show to Charles Kingsley and convert him to Pre-Raphaelitism; he would ask Rosseti ('a troublesome favour') to list for him the colours Turner had used or be prepared to 'run into Wales and make me a sketch of some rocks . . .'; he required Lizzie – or 'Ida', as he called her after Tennyson's *The Princess* – to read 'most uninteresting' books to keep her calm; he would direct Rossetti with elaborate care how to pack up and send his drawings, 'finished or not', or, which must have

been more irritating, how to improve them: 'Take all the pure green out of the flesh in the "Nativity" I send, and try to get it a little less worsted-work by Wednesday, when I will send for it.'[44] But the problem of dealing with 'these geniuses' was 'most wearying', as he told Mrs Acland.[45] Rossetti, however, had his moments of positive revenge, as Burne-Jones later recounted: finding Ruskin's pupils at the Working Men's College all making studies in blue, Rossetti told them that Mr Ruskin would spoil their eye for colour and that he was confiscating the cupboard-full of Prussian blue; Ruskin laughed enormously when he heard.[46]

Less wearying, presumably, was Ruskin's other new and renewed acquaintance. For a man with 'no friendships, and no loves' he seems to have maintained a wide and absorbing set of contacts at this time. Denmark Hill received a stream of visitors: the Carlyles; the Brownings; Charles Eliot Norton, William Michael Rossetti and William Bell Scott – all to see the Turners, including some new acquisitions; Octavia Hill who was given drawing lessons; plus selected students from the Working Men's College. One of these, James Smetham, has left a long description of his reception and entertainment by the Ruskins: John James telling him how John's prose works were 'pretty good', Margaret Ruskin ('who knows Chamouni better than Camberwell') constantly putting her son down or telling him what treasures to fetch for Mr Smetham:

> And so he kept on gliding all over the house, hanging and unhanging, and stopping a few minutes to talk. There would have been, if I had not seen from the first moment that he knew me well, something embarrassing in the chivalrous, hovering way he had; as it was, I felt much otherwise . . . To *his* study we went at last, and over the fire, with the winter wind sounding, we spoke, as you and I speak, about things I should be sorry to open my heart concerning to scarcely any; only of course he guided the conversation . . .[47]

Contacts were increased outside as well as within the family circle. He resumed his visits to Carlyle ('three years since I had seen you'), engaged in long and self-analytical correspondence with the Brownings, whom he treated to both high praise and detailed criticism of their poetry – 'my busines is to be a critic, and I find it goes against my conscience to be in this matter unprofessional'.[48]

He confessed to Mrs Browning in another letter in April 1855 that 'although I am my own master from dawn to sunset nominally, I find that time and the hour get the mastery of me in the end'.[49] He had Crawley to assist him, for much to Effie's disgust he had returned to

Ruskin and made himself as invaluable as his predecessor, 'George' Hobbs.[50] But this year Ruskin took on the first of many assistants, a young Scots architect, J. J. Laing, whom he had first met in Edinburgh in November 1853; Ruskin explained at length the advantages and disadvantages of Laing's joining him – a kind yet firm letter, promising a small fixed salary in return for copying work and general usefulness.[51] Laing would later spend some time with Woodward, the architect of the Oxford Museum.

The next two volumes of *Modern Painters* were issued in January (III) and April (IV) 1856. Work on their final revisions and plates had kept Ruskin busy during the winter. "The Moral of Landscape", a chapter of the third volume, promised that the 'rest of this work will therefore be dedicated to the explanation of the principles on which [Turner] composed, and of the aspects of nature which he was the first to discover'.[52] The succeeding volume returns firmly to Turner, resuming – though in the light of many more years' study – the geology and mountain interests of *Modern Painters* I.

The effort of completing both new volumes, while maintaining his regular teaching at the College and seeing *The Harbours of England* through the press, tired him.[53] In May he left with his parents for a further European tour. But not before he had produced another issue of his *Academy Notes*, as well as addressed the workmen assembled by Woodward to build the Oxford Museum. The Academy, this year, produced no sharp division between Pre-Raphaelite and non-Pre-Raphaelite work, for the former's battle is 'completely and confessedly won';[54] Ruskin implied that his 'own special work' as art critic has been partly responsible for this. His tendentious criticism ('Note the advancing Pre-Raphaelitism in the wreath of leaves' by Frith) was not always well received. Analyses of individual pictures often seem to mirror his own enthusiasms and justify his principles rather than attend carefully to the actual works. Thus Millais is said to have almost surpassed Titian with his *Peace Concluded, 1856* and was set to become the Turner of figure painting. At the Water-Colour Society, noticed as well as the Academy this year, a Near-Eastern subject by J. F. Lewis was said to be comparable in colour and design to Veronese. The preface to the *Notes* contains a good example of the lively personal tone upon which Ruskin's polemic would increasingly rely: in justification of signing the *Notes* he confessed to having published anonymous reviews of Lord Lindsay and Eastlake in the *Quarterly* but to having abandoned the practice. The *Quarterly* has, he then remarks in a footnote, 'in consequence, sought to amuse its readers by some account of my private affairs: of which – if the writer of the article in

question is not ashamed of *his* name – I shall be happy to furnish him with more accurate details, as well as to recommend him to a school where he may learn what will not in future be disadvantageous to his writings – a little more astronomy and optics'. Lady Eastlake had been the offending reviewer.

Ruskin's instinct for teaching was rewarded more readily by his contact with working men than by his patronage of Rossetti, whose arbitrary behaviour continued to exasperate him. Lizzie Siddal was able to go to the South of France for her health on account of Ruskin's regular contributions, a result of his assumption that a trip abroad always put one to rights. Rossetti, doubtless restless and mercurial in her absence, continued to produce fine watercolours, but annoyed his mentor with endless retouchings and 'scratching-outs' ('I never, so long as I live, will trust you to do anything again, out of my sight').

Far more amenable was one of the pupils at the Working Men's College, William Ward, who was busy working for Ruskin and who took on, that spring, the role of 'drawing *master*, under me'.[55] Ruskin received many requests from strangers to advise them on their drawing and on one such occasion in March he asked Ward to take over the instruction: he was to send to the correspondent a cast of a leaf plus three copies 'drawn with the brush, in *grey*, not in sepia, three times over. The first, to show how to begin; the second, carried further; the third, finished. Explain, as well as you can in a letter, the mode of working'. The pupil would pay Ward two shillings per letter as the course continued.

On 18 April Ruskin addressed the workmen employed on the Oxford Museum, telling them ostensibly about the Working Men's College.[56] But he ranged widely over the condition of working people, inadequacies of contemporary political economy, socialism ('an ugly word to use, but it was excellently applicable if rightly used') and the pride of mediaeval workmen. He urged the modern counterparts to think of their construction of the Museum as a 'fraternity of toil' and as a symbol to a wider group than themselves of the possibility of an organic society. There was nothing in Ruskin's manner, as Norton would note, stiff or reserved, nothing to suggest that he thought of himself as a person of distinction;[57] he addressed himself to the workers directly and without condescension and his appeal to them was strong.

Ruskin was obviously finding, as James Sherburne has remarked,[58] that the best way to evade his father's hostility to any involvement with political economy was to lecture: for in this form he could slip easily from architectural matters into social commentary, as he did at

Oxford in April. Yet he must have aroused Acland's scepticism, for just over a week later he is writing to reassure his friend. The letter takes the form, yet again, of a series of self-descriptions:

> Thirdly. I am forced by precisely the same instinct [for clear mathematical reasoning] to the consideration of political questions that urges me to examine the laws of architectural or mountain forms. I cannot help doing so; the questions suggest themselves to me, and I am *compelled* to work them out. I cannot rest till I have got them clear . . .

> Seventhly. I have perfect leisure for inquiry into whatever I want to know. I am untroubled by any sort of care or anxiety, unconnected with any particular interest or group of persons, unaffected by feelings of Party, Race, of social partialities, or of early prejudice, having been bred a Tory – and gradually developed myself into an Indescribable thing – certainly *not* a Tory.

> Eighthly. I am by nature and instinct a Conservative, loving old things because they are old, and hating new ones merely because they are new. If, therefore, I bring forward any doctrine of Innovation, assuredly it must be against the grain of me: and this in political matters is of infinite importance . . .[59]

It was the rare coincidence of so many qualifications in one person, he argued, that gave his political speculations the chance of contributing to greater good rather than evil. The self-scrutiny is clear-headed, but perhaps too easily satisfied with skilful debating points. Thus he admits that Acland may want to argue that Ruskin's social work is disqualified by his living out of the world and knowing so little about it; but 'I answer, that just because I live out of it, I know more about it. Who do you suppose know most about the lake of Geneva – I, or the Fish in it?'

As if not content with his other activities Ruskin was also planning to produce a 'little book' on the elements of drawing, the kind of instruction course he had arranged for William Ward to perform for an individual pupil; but this scheme had to be postponed till after he returned from abroad.[60] On the journey in 1856 he found himself 'quite exhausted'.[61] The great virtue of the summer ahead, he professed, would be that he had no ideas in his head 'and I don't know where I am going'.[62] Couttet joined them in northern France and shared Ruskin's walks around Amiens and, later, Nancy. Throughout the whole four-month trip he worked, so he calculated for Lady Trevelyan, the equivalent of only fifteen full days.[63] His diary either simply records the place-names of their itinerary or his leisurely strolls around Chamonix. He still planned a book on Swiss history, be-

queathing it 'to foolish posterity, that it may mourn and gnash its teeth in its Hotels'. For there were new threats to his favourite places; the blight of tourism, railways, hotels and general expansion or renovation as well as the continuing improvement of old buildings – Notre Dame, his diary noted at Paris on 14 September, 'exists no more, being entirely restored'. At Chamonix he did make some 'use' of himself by settling the geological dispute as to whether limestone went under gneiss:

> So I had a hole dug under Mont Blanc: and I got fifteen feet down between the limestone & gneiss; and found it all as Studer & Favre & I myself had supposed – only the gneiss was so rotten that I couldn't go on underneath it without regular mining apparatus wooden shield and so on – so I stopped till next year, and if the geologists aren't satisfied, I will dig as deep as they like.

But it was otherwise an uncharacteristically languid summer.[64]

The tour produced, however, two lasting benefits. For it was this year that Ruskin met John Simon and his wife in Savoy, quickly making friends; Simon, a doctor, would later play a crucial role in the medical side of Ruskin's tormented private life. It was also in this summer of 1856 that Ruskin once again met Charles Eliot Norton. This American had called at Denmark Hill the previous October to view Ruskin's pictures, simply one of many such visitors ('saying the same things over and over to the people who came to see our Turners'[65]). Now, in a cabin of a steamer going from Vevey to Geneva, they and their families encountered again: Norton hesitated before reminding Ruskin who he was, then they talked for the rest of the trip and exchanged visits in Geneva and St Martin, where Norton was introduced to the family's favourite walk behind the hotel. It was the start of a long and deep friendship. In 1869 Ruskin would ask his mother if she remembered the day on the Lake of Geneva 'when Norton sat looking at us and at last made up his mind to speak';[66] while *Praeterita* affectionately records its author's high esteem for 'a man of the highest natural gifts, in their kind; observant and critical rather than imaginative, but with an all-pervading sympathy and sensibility, absolutely free from envy, ambition, or covetousness'.[67]

They met several times more in London the following autumn, bright moments in Ruskin's rather dulled existence. Abroad, he had reckoned up the days left to him of his traditional three score years and ten: his diary thereafter counted down their decreasing number and chronicled his despair, even inertia, in the face of wasted time. At Dover on his return he had told Pauline Trevelyan that he had 'done

nothing but ramble in sun, and eat breakfasts and dinners, and sleep', and that he had not benefited as much as he might. His plans were vague – the Swiss History was under pressure from John James who 'began to inquire whether the rest of Modern Painters will ever be done'.[68] He met Rosa Bonheur and called on two Oxford undergraduates, William Morris and Edward [Burne-] Jones, who had reviewed his work enthusiastically in the *Oxford and Cambridge Magazine* of that year.[69] Tidying books in his study on 23 October did not provide the usual incentive. Days slipped by. He had no clear notion of what to do – 'it depends on many things – most of all on what is done about the Turner bequest, which I mean now to make as much noise about as I have voice for'.

– 2 –

When Turner died in 1851 he left a will devised and drawn up by himself. This was contested by his next of kin, and Ruskin, appointed one of its executors in a codicil of 1848, resigned because he was not prepared to get involved in a long-drawn-out legal battle in the Chancery Courts. The paintings and drawings bequeathed to the National Gallery languished, while it was decided whether the will, which asked among other things for them to be exhibited in a specially erected Turner Gallery, was proved. As Ruskin bitterly complained in the preface of *Modern Painters* III, Turner had been buried by his countrymen with 'threefold honour, his body in St. Paul's, his pictures at Charing Cross, and his purposes in Chancery'.[70] A compromise was eventually reached in 1856 whereby 'all the pictures, drawings, and sketches by the testator's hand, without distinction of finished or unfinished, are to be deemed as well given for the benefit of the public' and were handed over to the National Gallery.[71]

Ruskin's interest revived at this point. On 28 October in *The Times* he informed the public of the extent and variety of over 3,000 drawings in the Turner bequest.[72] They would be, if rightly arranged by somebody who knew Turner and Turner's subjects well enough to identify them, 'a perfect record of the movements of the master's mind during his whole life'. Ruskin's own instinct for the interconnectedness of things responded readily to Turner's vision of his whole *oeuvre* being necessary and available for the study of any part of it. Then, though recognizing the 'bad taste' involved in expressing his ability, he thought it his 'duty to state that I believe none would treat these drawings with more scrupulous care, nor arrange them with

255

greater patience, than I should myself; that I am ready to undertake the task, and enter upon it instantly'. He offered to mount a specimen display at his own cost so that the public could inspect and judge his practical proposals. His only condition was that 'the entire management of the drawings, in every particular, [be] entrusted to me'. (In another letter to *The Times* the following year he made it clear – perhaps rather belatedly – that he referred only to the Turner drawings and that the oil paintings were supervised by the keeper of the National Gallery, Ralph Wornum, with a 'patience and carefulness of research in discovering their subjects, dates of exhibition, and other points of interest' that would take a long time to be properly appreciated.[73])

Yet even in the matter of the oils Ruskin was not able to refrain from introducing his own opinions. The National Gallery had on its own initiative selected thirty-four oil paintings for public display in mid-November. Ruskin decided to produce a descriptive and explanatory catalogue, which appeared early in the New Year as *Notes on the Turner Gallery at Marlborough House, 1856*;[74] like the *Harbours of England* it is a succinct and useful introduction to Ruskin's views on Turner. But the work on it cost him much nervous effort and from late November 1856 until the following January he suffered the symptoms of and reactions to over-stimulation. ('shivering, weakness . . . feverish night . . . pricking pains').[75]

His first letter to *The Times* was followed up by private approaches to both the National Gallery Trustees and to Lord Palmerston, who had just become Prime Minister. Eventually, in February 1857, Ruskin was authorized by the Trustees to begin work as he had proposed, selecting a hundred drawings for framing in sliding drawers. Meanwhile, however, the Trustees had decided to follow up the oils exhibition with a temporary show of selected watercolours, which also went on display at Marlborough House in February. In new editions of his *Notes on the Turner Gallery* Ruskin protested against this exposure to light of some of the most important and delicate specimens;[76] once again he explained and amplified the method of care and housing of the drawings that he had originally communicated to *The Times* and urged it again upon the Trustees. By the end of February he was working to put this proposal into effect; his first bout of work with the Turners would extend until May of the next year.

Meanwhile he was lecturing in January and April,[77] giving evidence to the National Gallery Site Commission,[78] finishing *The Elements of Drawing*, postponed from before his 1856 summer tour and

now issued in June 1857, and producing a third set of *Academy Notes*. In July he sought a rural retreat outside Oxford to work at two important lectures he had been invited to give at Manchester, during the Art Treasures Exhibition. He would walk into Oxford to see Acland, who was having his study built to Woodward's designs. Ruskin took the opportunity of getting the bricklayer to give him lessons, but was provoked when his tutor pulled down what he had done; though characteristically he recalled some years later in *Unto This Last* that 'the difference between good and bad laying of bricks' was ' greater than most people suppose'.[79] He also saw more of Norton who was staying in Oxford and who provided an exacting audience for parts of the Manchester lectures:

> He read a great part of the lectures to me, and the readings led to long discussions, of which I now remember only, to use his own phrase, 'an inconceivable humility' on his part in listening to my objections to his views, and an invincible 'obstinacy' (his own word again) in maintaining his opinions. In the main I was desirous to hold him to the work of the imagination, and he was set on subordinating it to what he esteemed of more direct and practical importance.[80]

Norton was, of course, not alone in regretting the movement of Ruskin's interests; not alone, either, in failing to see that the whole momentum of architectural works like *Seven Lamps* and *The Stones of Venice*, the role of lay priest he had adopted, and his dedication to teaching anybody who would accept his instruction in drawing,[81] all led Ruskin into the kind of enquiries of which the Manchester lectures are such crucial examples. What he told his audiences there sprang directly from the kind of existence he had by then established for himself – travelling abroad through the 'great Christian community of Europe' and travelling 'in soul' to appreciate its art; establishing public and private art collections, especially by patronizing contemporary work and ensuring that there were adequate national funds for purchasing old masters; encouraging young talent; contriving better contexts, even communities, for artists; emphasizing the educational needs of much of the population and the role to be played in this by museums. What he offered his Manchester audiences was often a public vision of his own best private endeavours; these lectures, too, sowed the seeds of many later ideas and projects.

The lectures were delivered on 10 and 13 July in the Manchester Athenaeum and published later in 1857 as *The Political Economy of Art* (republished in 1880, they were re-entitled *A Joy for Ever*). Proceeds from the lectures went, at Ruskin's request, to the Working Men's

College. The buoyancy and cheerfulness which Norton had noticed earlier in Oxford communicated themselves to his large audiences, who admired the spontaneity and force of his delivery.[82] He left some passages to the chance of extemporary elaboration and made a point both of using local references – in this case to the "Treasures" exhibition when discussing the wealth of art – and of playing with the reactions of an audience, as he does in the very first paragraph. Indeed the whole theme and emphasis of his discourses, as his editors noted, were calculated to strike that particular Manchester audience as provocative and unusual: to argue for state controls in a city famous for its school of *laissez-faire* economy and to celebrate potential abundance at a time of commercial depression and poverty was knowingly to engage with your audience in a dramatic collision of ideologies.

Despite the air of improvisation, Ruskin had prepared the lectures with great care – even in their revised and published form his deliberate range and control of topic is perfectly apparent; the original audience appreciated 'some main leading idea which permeates and gives consistency to the whole, and which satisfies every hearer that the speaker has a definite purpose in view, and that amidst all discursiveness of thought, affluence of words, and novelty of illustration, it is never really lost sight of, much less forgotten'.[83] Ruskin's 'affluence' of words (the second lecture lasted one and three-quarter hours) was apt for his topic of the nation's resources in art-wealth: it was a theme, of course, which Ruskin had already traced in the generous profusions of gothic sculpture, and doubtless a theme much in his mind after weeks of work among the riches of the Turner Bequest.

In the first lecture, on "The Discovery and Application of Art", he argued that the word 'economy' had assumed a false meaning of 'saving money', whereas its simplest significance was that of managing and administering a household. He required a nation to display this stewardship by managing its labour force properly in the interests of 'splendour' and 'utility'; this presupposes a strong 'authority', and his analogy for a paternal government, utilizing all of its citizens' talents and energies, is the farm 'in which the master is a father, and in which all the servants are sons'. He then applied himself to explaining how the nation might best discover and deploy its artistic talents ('you can't manufacture [the artist], any more than you can manufacture gold'). He suggested 'schools of trial', in which skills and aptitudes could be discovered, criticized and encouraged; none of the nation's money could be better spent than on proper art education. Finally, he argued for the application of talent to varied, not mechanical, work, to work that could be done easily (give sculptors marble not granite to

carve) and, above all, to work that would last. He especially attacked the notion of what we today call 'planned obsolesence' ('wholesome evanescence' is Ruskin's phrase). The second lecture concerned "The Accumulation and Distribution of Art". Ruskin would not argue for cheap art but for opportunities to bring to bear upon good art a 'quantity of attention and energy of mind'. In other words there must be opportunities for more people to possess and contemplate works of art in the same way that they could read their Dante and Homer in cheap editions, for more conservation of artistic heritages on a European not simply a national scale, and for state museums and schools of art, even buildings 'for the meeting of trade guilds'. Well used, the authority of a paternal state will ensure 'this golden net of the world's wealth will be spread abroad as the flaming meshes of morning cloud are over the sky . . .'

After the lectures were delivered he took his parents on a holiday to the Highlands, stopping at Wallington with the Trevelyans on the way north and on the return journey. During his first visit in July he gave drawing lessons to Louisa Mackenzie; this characteristic activity – 'the happiest privilege you will ever have', he told them in Manchester, is helping the young – was captured by William Bell Scott in a charming drawing. He also inspected the progress in decorating the central hall at Wallington – paintings by Scott, about which he was less enthusiastic, and mural designs of massed flowers on the pillars. His own contribution to this venture was undertaken during his second visit in September;[84] unfinished, it can still be seen at Wallington today.

Acland joined the Ruskins in Scotland and they had, John wrote to Norton now back in the United States, 'a wonderfully fine summer'.[85] But he had to return to his teaching at the Working Men's College and, above all, to the Turner drawings. He told the story of this task in the preface to the last volume of *Modern Painters* three years later:

> In seven tin boxes . . . I found upwards of nineteen thousand pieces of paper, drawn upon by Turner in one way or another. Many on both sides; some with four, five or six subjects on each side . . .

he drew what he meant in a letter to Norton of February 1858 –

> some in chalk, which the touch of the finger would sweep away; others in ink, rotted into holes; others . . . long eaten away by damp and mildew, and falling into dust at the edges, in capes and bays of fragile decay; others worm-eaten, some mouse-eaten, many torn, half-way through . . .

> About half, or rather more, of the entire number consisted of pencil sketches, in flat oblong pocket-books, dropping to pieces at the back, tearing laterally whenever opened, and every drawing rubbing itself into the one opposite. These first I paged with my own hand; then unbound; and laid every leaf separately in a clean sheet of perfectly smooth writing paper, so that it might received no farther injury . . . The loose sketches needed more trouble. The dust had first to be got off them; (from the chalk ones it could only be blown off;) then they had to be variously flattened . . .[86]

With the assistance of two pupils from the Working Men's College, George Allen and William Ward, he worked 'all the autumn and winter of 1857, every day, all day long, and often far into the night'. Allen recalled returning to Denmark Hill in the evening after working at the National Gallery and cutting hundreds of mounts for the items chosen for special presentation.[87] Then on 31 December 1857 – with 11,382 days left to him of a notional life – Ruskin recorded in his diary that he had 'Finished my examination of the Turners'. He had still to write his report for the Trustees and to complete his organization of the study collection.

He wanted to take a break and go away, but was worried lest something might happen to him and the drawings be damaged by others' careless handling ('destroyed in a year's wear and tear'[88]). Yet he himself, late in 1858, obviously had little compunction in burning some of Turner's obscene drawings, apparently of copulating lovers.[89] This act of pietistic destruction in order to preserve Turner's 'reputation' was undertaken with Wornum, a disgraceful piece of collaboration to seal what, hitherto, had not been a particularly easy working relationship.[90]

In Ruskin's approach to the selection and presentation of the study collection we may glimpse something of his enormous effort to find an adequate scheme of classification and meaningful arrangement for his Turner 'cabinet'. The trial selection of the first one hundred drawings, their glazing and arrangement in sliding frames in mahogany cases – these last provided at Ruskin's expense – were approved by the Trustees during 1857. Ruskin issued for private circulation a *Catalogue of the Turner Sketches in the National Gallery*.[91] Its first edition contained notes on only twenty-five drawings; the second dropped one of these and added a further seventy-six to make up the hundred. But when the Trustees sanctioned further work on an extended scale – 400 drawings were eventually housed in cabinets – Ruskin broke up his arrangement of the original selection. He had wanted to be in sole charge of the Turner Bequest drawings precisely because his own

260

vision of their coherence, scope and meaning would only be jeopardized by collaboration with somebody else; as he would tell Acland in the 1860s, when asked to help with the Oxford Museum, 'my habits of system could only be of use if I took the thing wholly in hand'.[92] His habits of system had always been unique, a result largely of his autodidactism – like the classification of old masters sent home from Italy in 1845; yet as he learnt more, the previously established system required revision – hence the emendments to the 1845 scheme sent almost as soon as the first version reached Denmark Hill. And so in 1857 and 1858 each fresh selection of Turner drawings needed its own coherence and its own rationale that only Ruskin could bring to it and that changed as the *corpus* of drawings was re-designed. It is no wonder that his relationship with Wornum was occasionally rather strained. He undertook one further arrangement of watercolours to go on permanent exhibition at Marlborough House; it was, he said, 'calculated to exhibit [Turner's] methods of study at different periods, and to furnish the general student with more instructive examples than finished drawings can be'. For this new exercise in art education he also produced a catalogue.[93]

He submitted his report to the Trustees in March 1858.[94] The manual labour, he would assure readers of *Modern Painters* V, had not hurt him; but

> the excitement involved in seeing unfolded the whole career of Turner's mind during his life, joined with much sorrow at the state in which nearly all his most precious work had been left, and with great anxiety, and heavy sense of responsibility besides, was very trying; and I have never in my life felt so much exhausted as when I locked the last box, and gave the keys to Mr. Wornum, in May, 1858.[95]

Meanwhile he had maintained his evening classes at the Working Men's College and brought out another *Academy Notes*, in which he discussed works in four exhibitions and calculated the amount of time required for him to form a judgement of one original painting. He had continued to receive requests for drawing instruction, and William Ward was assigned to take over this correspondence.[96] But when Ward was asked to begin lessons with the young Rose La Touche, her mother, introduced to Ruskin by Lady Waterford, wrote 'two kind & interesting letters' and eventually managed to persuade Ruskin himself to call. He found Mrs La Touche more interesting than he had expected ('not at all too old to learn many things'), and an invitation to visit Denmark Hill and view the Turners was soon taken up.[97] He was too busy to give Rose lessons himself, for he had lectures to give at the

South Kensington Museum, at Tunbridge Wells (on "Iron") and at the St Martin's School of Art.

– 3 –

It was not surprising that when he started on a continental tour by himself, accompanied by Crawley and Couttet, he was in a 'shaky state'.[98] He meandered around Switzerland and northern Italy for four months. In letters home he wrote of enjoying the scenery and of much, not always satisfactory, sketching. But to other correspondents, like Mrs Simon, he wrote of being 'oppressed with liberty' and not knowing how to use it and not 'making up my mind to anything – and when it is made up, [I] undo it again directly'.[99] Some time was spent on identifying Turner's topographical subjects, some on helping Inchbold and Brett with their landscape painting.[100] From Rheinfelden in late May he wrote to Acland the first of two letters on the Oxford Museum, in which he defended the choice of a gothic architecture, explained the spirit of its decorations and reiterated the plea he had made at Manchester for more public patronage of the arts.[101] The whole journey was summarized with a jocular disillusion in a letter to Mrs Browning on his return:

> I went to the north of Switzerland to sketch . . . Habsburg has only a window or two and a rent or two of old wall left; Morgarten is beside the ugliest and dullest lake in all Switzerland. I went on to Bellinzona and stayed there long – six weeks – but got tired of the hills and began to think life in the City Square was the real thing. Away I went to Turin! of all places – found drums and fifes, operas and Paul Veronese, stayed another six weeks, and got a little better, and I began to think nobody can be a great painter who isn't rather wicked – in a noble sort of way.[102]

His casual tone hides what was a fundamental experience that year, a recognition about great artists and, less directly, at least at the time, about his own faith. Ten days after his letter to Mrs Browning he wrote to Norton, to whom he could be a trifle more explicit:[103] six weeks studying Veronese in the mornings and going to the opera at night had taught him 'a good deal – more than I can put in a letter'. The gist of his new perception ('I have been inclining to this opinion for some years; but I clinched it at Turin') was that 'to be a first-rate painter – you *mustn't* be pious; but rather a little wicked, and entirely a man of the world'. Ruskin is surely thinking of Turner's obscene drawings, discovered at the National Gallery. He now realized that

the 'old man's soul had been gradually crushed within him, leaving him at the close of his life weak, sinful, desolate'.[104] The astonishing passages on Turner's *Garden of the Hesperides* and *Apollo and the Python*, which would embody this new, personal response of Ruskin's towards his 'earthly master', and which would form the climax of the last volume of *Modern Painters*, were already perhaps taking shape before he left England in 1858. For in jocular letters to both J. H. Le Keux and Furnivall about his last volume he writes about 'investigating the coils of the Dragon . . . and the awfulness of Squints and Casts in the eye as elements of the Sublime'.[105] But the catalyst for his new insight into the worldliness of great artists was his study that summer in Turin of Veronese's *Solomon and the Queen of Sheba*.[106]

With the clarity of hindsight in *Fors Clavigera* and *Praeterita* Ruskin saw that he had suffered an 'un-conversion'.[107] In the latter narrative, after attending the Waldesian chapel ('languid forms of prayer') Ruskin returned to contemplate Veronese's strenuous and magnificent painting, glowing in full afternoon light:

> The gallery windows being open, there came in with the warm air, floating swells and falls of military music, from the courtyard before the palace, which seemed to me more devotional, in their perfect art, tune, and discipline, than anything I remembered of evangelical hymns. And as the perfect colour and sound gradually asserted their power on me, they seemed finally to fasten me in the old article of Jewish faith, that things done delightfully and rightly, were always done by the help and in the Spirit of God.
>
> Of course that hour's meditation in the gallery of Turin only concluded the courses of thought which had been leading me to such end through many years. There was no sudden conversion possible to me, either by preacher, picture, or dulcimer. But that day, my evangelical beliefs were put away, to be debated of no more.

As he admits, the 'courses of thought' which culminated in this un-epiphany were complex. But we can track some of them during 1858 before he reached Turin.

He had been writing to the Brownings about evangelicalism in January and March,[108] protesting his dislike of the doctrine of Bunyan, Baxter, Calvin and Knox. Perhaps as a result of his attacks on current political economy, he linked evangelicalism with trade ('rather greasy in the finger; sometimes with train oil'). He was 'all at sea myself', finding that beliefs and disbeliefs seemed to make the Creator's voice announce only 'You poor little, dusty, cobwebby creatures, go and lie down in your graves, and be thankful you've come to any sort of end at last.' In the mountains before he reached Turin he was moved by the

girls at Locarno working *on Sundays* to repair their church and singing hymns to the Virgin 'under an oleander tree all burning with blossom . . . till the rocks thrilled again'.[109] It all compared sorrowfully with the disagreeable piety of Turinese protestantism and a 'disgraceful' English service.[110] The 'symmetry, splendour, and lordly human life' of Veronese's painting, 'full of grace and imagination', rebuked and challenged all this insufficient faith.[111]

He wrote endlessly to his father about the painting. He copied two sections, marvelling at its 'glow of colour', at the painter's absorption in the details of observed life – the Queen of Sheba's little dog delighted Ruskin especially – and at the careful use of symbolism to identify Solomon as a type of Christ. Painting from the 'beautiful maid of honour', he was struck by 'the Gorgeousness of life which the world seems to be constituted to develop'; life-wealth, so to say, captured in the riches of the Venetian's art. 'And is this mighty Paul Veronese', he demanded rhetorically of his Denmark Hill audience,

> in whose soul there is a strength as of the snowy mountains, and within whose brain all the pomp and majesty of humanity floats in a marshalled glory, capacious and serene like clouds at sunset – this man whose finger is as fire, and whose eye is like the morning – is he a servant of the devil; and is the poor little wretch in a tidy black tie, to whom I have been listening this Sunday morning expounding Nothing with a twang – is he a servant of God?

He continued with something of an answer to allay his parents' worst fears 'I began to suspect we are all wrong together – Paul Veronese in letting his power waste into wantonness, and the religious people in mistaking their weakness and dulness for seriousness and piety.' But to Augustus Hare, passing the scaffolding from which he was copying part of the painting, Ruskin declared emphatically that 'Paul Veronese was ordained by Almighty God to be an archangel, neither more nor less'.[112]

Back in England the mightiness of that revelation continued to reverberate. He told his audience about Veronese when he inaugurated the Cambridge School of Art on 29 October, annexing the experiences of his summer to another plea for right attitudes to art and art education: 'To be taught to see is to gain word and thought at once.'[113]

He resumed work on *Modern Painters*, confident that the ideal artist will see and register in his art that 'the human creature . . . his happiness, health, and nobleness, depended on the due power of every animal passion, as well as the cultivation of every spiritual

tendency'.[114] He was fed up with architects and architecture, he told Pauline Trevelyan,[115] and his resolutions and projections for the new year, sent to Norton in America, included assembling all the great Venetians – Titian, Tintoretto and Veronese – in 'one great fireproof Gothic gallery of marble and serpentine'.[116]

<div style="text-align:center">

– **4** –

</div>

The winter was spent 'mainly in trying to get at the mind of Titian' and realizing that he would have to visit the art galleries of Germany to see paintings essential for the completion of *Modern Painters*.[117] He continued to lecture, at Manchester once again and for the first time at Bradford; these, together with the texts of some previous addresses were published in May as *The Two Paths*. Another *Academy Notes* also came out in May – the last until a single issue in 1875, although he did not appear in 1859 to envisage its suspension. It severely critized Millais's *The Vale of Rest* and enthused about Brett's *Val d'Aosta*, upon which he had advised the painter the previous summer – 'at last . . . landscape painting with a meaning and a use'.

He continued to be involved with the Working Men's College and to take an active interest, despite the frustrations, in the Museum at Oxford. In January he sent to Acland another letter, this time about the decoration of the building; it gave him some difficulties ('I *could* not make up my mind what to say or do about the imperfect ornamentation'[118]). Acland wanted to issue a pamphlet containing a preface and a lecture of his own, plus Ruskin's two letters on the Museum, the second being composed specially for inclusion; Ruskin earnestly wished to be associated in the support of this project. While he welcomed unreservedly his University's promotion of the physical sciences and therefore the building provided for the purpose of their study, he was uneasy about its decoration which further parsimony could only make worse. But beyond the financial constraints, Ruskin was encountering some of the awkwardnesses of translating his study and dream of gothic ('Here was the architecture which I had learned to know and love in pensive ruins') into modern forms and functions. Yet it was as a direct consequence of his architectural work and his recently established role as public lecturer that his involvement in these practical ventures occurred. In January he was also composing a long letter to advise the physician appointed to accompany the Prince of Wales on a five-month visit to Italy what might be a suitable curriculum for the education of a future king.[119]

Early in the New Year Ruskin received a visit at Denmark Hill from Miss Margaret Alexis Bell, the headmistress of a progressive girl's school north of Crewe.[120] They had been in correspondence for some time, probably since Ruskin's Manchester lectures of 1857, which she may have attended, as she would the one in February 1859. She had evidently submitted examples of her pupils' drawings for his inspection, and was invited to bring some of them to view the Turners. Her visit inaugurated a most important episode in Ruskin's personal life, his connection with her school at Winnington.

Winnington, for Ruskin, came quickly to represent a refuge from the parental circle of Denmark Hill, a place where he could find and be himself and where he need not be lonely. Set in its fine parkland, Winnington was a new Eden or – as he often saw it[121] – a picture, into the ensured beauty and composition of which he could withdraw. It also provided him with yet another, more apt and pleasant, forum for his practical educational ventures; he taught the girls drawing and mineralogy, and took Bible classes. From these developed his regular Sunday letters to them in which he would explore the Bible's meaning, expounding the etymological history of key words; but these letters soon came to include meditations on more than just biblical matters, an early private version of those public letters upon all manner of topics which he would address to Thomas Dixon or 'to the Workmen and Labourers of Great Britain'. Even though he appreciated Winnington as a 'Playhouse',[122] he was never away from his 'work' and characteristically he used its opportunities to discover new audiences for his ideas and new forms in which to express them adequately.

His first visit to the school was early in March 1859, after giving two lectures in the north of England. At Manchester, he told his father, the topic of "The Unity of Art" was more appreciated by his audience than his political economy would have been. He touched nevertheless upon the relationship of art to manufacture before expounding once more the glories and virtues of Venetian painters. Over breakfast the following morning he and his host, Sir Elkanah Armitage, 'formed plans . . . for buying all Venice from the Austrians – pictures, palaces, and everything'. Another museum.[123]

From Manchester, after calling upon Elizabeth Gaskell, he drove in his father's carriage into Yorkshire, mainly to talk at Bradford on "Modern Manufacture and Design", a lecture that had to be postponed briefly when he developed a sore throat. He justified his extended stay in Yorkshire by telling Denmark Hill that he needed more

knowledge of its Turnerian topography.[124] Then he proceeded to Winnington.

He reported to his father that it was 'an enormous old-fashioned house – full of galleries and up and down stairs – but with magnificently large rooms where wanted . . . The house stands in a superb park, full of old trees & sloping down to the river: with a steep bank of trees on the other side . . .'[125] Miss Bell, whom Georgiana Burne-Jones would recall as 'an extremely clever woman of a powerful and masterful turn of mind',[126] was very conscious of, if not scheming for, her capture of such a distinguished visitor, who found his portrait, together with those of F. D. Maurice, Wilberforce and Archdeacon Hare, hanging in the library. He was involved in the children's art work, watched them dancing, heard a candle-lit Mozart concert and attended two chapel services; their dinner reminded him of 'one of the pictures of a "marriage in Cana"'.[127] After he left he sent directions on drawing which he had neglected to finish, having 'very often' forgotten to complete things while he was there.[128]

This brief encounter between a forty-year-old, smiling, public man and thirty-five young ladies, who waved goodbye to him from the bow-window of their drawing-room, stirred old chords. He had fallen in love with Adèle as a young girl; Effie, too, had first been met at this age; he had recently seen the young Rose La Touche for the first time; their images, even memories of little Jessie Richardson in Perth, were revived at Winnington.[129] The attractions of 'graceful bearing', 'gentle voices' and 'faithful eyes'[130] were particularly tempting to Ruskin. He reported to Mrs Simon in that April that his mother was 'a little right' about him and 'women folk':

> My general delight in all beauty, and then total isolation from them in which I live, make them more dangerous to me than to other men of my general power and age. – More helpful as well. They do me immeasurable good when I come across any nice ones.[131]

'Nice' ones were those, presumably, whom he could manage on his own terms. They needed to be old enough to suggest womanhood without imposing its actual demands and constraints. In part they provided the companions he had missed in his own youth, and so were encouraged to treat him as an equal; in part they were eager and absorbed pupils whom he could instruct and form and with whom, therefore, the famous writer and lecturer formed a different relationship. He enjoyed and could largely control the range of the girls' responses to him: their familiarities, which he thought did not come readily enough on the first visit,[132] as well as their deference – there are

glimpses in his letters of the acolyte ministrations of a young teacher, holding his 'colour and palette for me so kindly'.[133] Especially when he was absent from Winnington, which inevitably was the greater amount of time, the pictured images of the girls' ideal beauty ('Silent appearances of young ladies'[134]) worked upon his fancy. Once back in the 'whirlpool – no, that's too grand – into the gutter of London work . . . Winnington has a very unbelieving look'.[135] Writing a line to the 'birds', as he called them, would help him 'get on' through a 'pushing' day with *Modern Painters*, revising his lectures or composing the *Academy Notes*. He encouraged the girls to send him notes – 'without any ceremony or superscriptioning' – to ask anything that came 'into their heads about drawing or anything else'.[136] Their uncritical enthusiasm for his ideas and work was compared favourably with his parents', who 'have no sympathy with what I am trying to do'.[137]

In mid-May the Ruskins left for the continent. During his testimony to the National Gallery Site Commission Ruskin had been asked 'somewhat pointedly' whether he was familiar with the collections at Dresden and Munich;[138] to these, as well as to Cologne, Düsseldorf and Berlin, he now proceeded, not always very content with Germany, but readily absorbed in recording impresssions of its pictures.[139] There were new Veroneses to admire at Dresden as well as other Venetians – Titian and the Bellinis – and a fine Holbein at Berlin, where the arrangement of the museum as well as its contents impressed him.[140] Modern German art like Overbeck and Bendemann he despised and made fun of in his letters;[141] but in practice there were occasional items which he found tolerable, even good. The German section of their tour ended at Schaffhausen. Then they spent a month in the Bernese Oberland, after which, while his parents stayed in Geneva, Ruskin had a spell in Chamonix. He was working, rather patchily, on *Modern Painters*, but told Norton that its final volume would contain 'some deeper truths than I knew – even a year ago'.[142] He was also following the progress of the Franco-Sardinian war against Austria with some concern and dispatched three letters to *The Scotsman* demanding why the 'enlightened Edinburgh evangelicals' did not stir themselves about the state of Italy.[143]

When the family reached London in early October, Ruskin was spurred into completing *Modern Painters* by his father, whom *Praeterita* recollects as saying that if it wasn't finished now he would never see it.[144] Since John James was increasingly in poor health his son readily agreed to the task; the winter was accordingly given, as single-mindedly as Ruskin could manage, to completing the sixteen-year-old project. He paid a visit to Winnington in late October and early

November, where he worked, in fact, upon a companion volume to his drawing manual, *The Elements of Perspective*, which was issued in November 1859. That same month he confessed to Pauline Trevelyan that he was settling to his winter's work on *Modern Painters*, though still not yet 'recovered . . . from calamitous impression of Germany and feeling somewhat languid at all points'.[145] He foresaw the task completed by the spring and having 'my hands and soul so far free'; meanwhile the book seemed, at times, like an albatross 'about my neck'.[146]

It required enormous efforts to finish a work which was, in a sense, essentially unconcludable. He began his very last chapter, entitled "Peace", by saying as much; but the same impossibility is revealed in sections like that on "Invention Formal" (i.e. artistic composition) which were evidently meant to be fuller, that on "Sea Beauty" which was given up altogether, and one on sublimity, promised by the text, which does not turn up.[147] Yet it was not simply that his work on the Turner Bequest and his new 1858 awareness of Veronese had opened 'many new and difficult questions',[148] although that in itself prevented any easy resolution and drawing of conclusions; nor yet that *Modern Painters*, unlike his relatively new interest in lecturing and writing on political economy which John James so resented, was his father's book; but also that he was, as he told Dr John Brown, 'tormented in this volume by having to work out many subjects on which, the more evidence I collected, the less it agreed. I've got something of all kinds, Botany, Meteorology, Mythology, and what not . . .'[149] Writing the last volume of *Modern Painters* was, in effect, ordering the museum of his life's interests, discovering a system into which its many subjects would all fit. It would be easier not writing at all. 'I am never happy as I write', he had told Mrs Browning in January 1859, 'I should be collecting stones and mosses, drying and ticketing them – reading scientific books – walking all day long in the summer.'[150] But since he was required to compose and to organize, Ruskin necessarily forced upon himself decisions about priorities: 'great Art is of no real use to anybody but the next great Artist', he thought by the following November, and it would be better to start 'with moral education of the people, and physical'.[151] Granted that Ruskin was always full of contradictions, never more involved in a problem than when he could see it from many points of views,[152] the completion of *Modern Painters* strained even his capacity for both inclusiveness *and* systematizing ('I may, perhaps, some day systematize and publish my studies of cloud separately'[153]).

Nevertheless the fifth volume at times manages triumphantly to

synthesize his life-long devotion to Turner, his Venetian work, his mountain, plant and cloud studies, his own taste in painting, ideas of beauty, and the 'right economy of labour', whether his own, the great artists', or the English or Italian working man's. The tone is less dogmatic than in earlier volumes, but the most profitable way to read the whole work is still as an oblique but nonetheless sharply-focused autobiographical essay; never does that approach seem more apt than as the work nears its end. Here for the first time Ruskin uses esoteric interpretations of mythology to provide the metaphors which link his own imagination to the other myth-makers – Turner and Venice herself – that have been his critical concerns. The result is closer to poetic vision than critical statement. Concentrating upon two of Turner's paintings,[154] both of which contain in dragon and python a type of the serpent, he explores the mythological ancestry of the dragon-guardian of the Hesperidean Garden, the Garden itself, the nymphs and the Goddess of Discord; we learn that Turner has discovered not only how the myth relates to natural phenomena but how it speaks of 'household peace and plenty' and 'household sorrow and desolation'; how it declares the threat of covetousness, with the dragon's 'evil spirit of wealth' poisoning the Edenic potential of the world:

> The greatest man of our England [i.e. Turner], in the first half of the nineteenth century, in the strength and hope of his youth, perceives this to be the thing he has to tell us of the utmost moment, connected with the spiritual world. In each city and country of past time, the master-minds had to declare the chief worship which lay at the nation's heart; to define it; adorn it; show the range and authority of it. Thus in Athens, we have the triumph of Pallas; and in Venice the Assumption of the Virgin; here, in England, is our great spiritual fact for ever interpreted to us – the Assumption of the Dragon. No St. George any more to be heard of; no more dragon-slaying possible: this child, born on St. George's Day, can only make manifest the dragon, not slay him, sea-serpent as he is; whom the English Andromeda, not fearing, takes for her lord. The fairy English Queen once thought to command the waves, but it is the sea-dragon now who commands her valleys; of old the Angel of the Sea ministered to them, but now the Serpent of the Sea; where once flowed their clear springs now spreads the black Cocytus pool; and the fair blooming of the Hesperid meadows fades into ashes beneath the Nereid's Guard.

In concluding *Modern Painters* he announces, maybe without fully realizing it himself, his own crusade as St George against a tarnished and Mammon-obsessed England. Suitably enough, the last word of

Modern Painters was left in the hands of the girls at Winnington; protected in their meadows from the industrial squalor of Nantwich, they compiled its index.[155]

Modern Painters V was published on 14 June 1860. Ruskin was still tinkering with the final chapters on 15 May, but planning to start for Switzerland on 22 May. Difficult as he had found it to bring to a conclusion and much as he had already envisaged many further projects, he would nevertheless discover that he was almost at a complete loss without both its demands upon him and its capacious form into which could be accommodated so 'many things'.

Chapter 15

'Wrong at both ends': 1860–1864

'Am I not in a curiously *unnatural* state of mind . . . that at forty-three, instead of being able to settle to my middle-aged life like a middle-aged creature, I have more instincts of youth about me than when I was young, and am miserable because I cannot climb, run, or wrestle, sing, or flirt – as I was when a youngster because I couldn't sit writing metaphysics all day long. Wrong at both ends of life . . .'
Ruskin to Norton, 16 January 1862

Ruskin, so he said, 'succeeded in doing a great deal of nothing' during the summer of 1860.[1] He went to Geneva, where he had the American painter, W. J. Stillman, as his guest for part of the time; together they visited Bonneville, St Martin and Chamonix, sketching together, climbing some secondary peaks, playing chess in the evening as well as discussing art and religion.[2] They did not always see eye to eye on suitable subjects to sketch or on artistic technique. When Ruskin proposed a hackneyed, picturesque subject of some huts by the Rhone, Stillman did a quick, bored sketch; Ruskin was upset, because – as he said – that fact that *he* wanted it done should have been enough to make Stillman do it properly. The American replied by saying that to him the hovels 'only suggested fever and discomfort, and wretched habitations for human beings'; whereupon Ruskin acknowledged that his companion was right. Clearly, whenever Ruskin was depressed or exhausted, he tended to revert to visual habits which, because of his new social ideas, he had long since outgrown. In the end they made each other 'reciprocally miserable to an amazing extent';[3] Ruskin's sulkiness made him a less than usually congenial host, and in the end bad weather, his own restlessness and poor health drove him 'into low land Switzerland'.[4]

But this did not stop him working. As he later put it, having received 'the bound copy of *Modern Painters* in the valley of St Martin's in that summer . . . in the valley of Chamouni I gave up my art-work and wrote this little book – the beginning of the days of reprobation'.[5] The reference is to *Unto this Last*, probably the most famous and influential of all Ruskin's books. He may well, as he told Pauline Trevelyan from Bonneville at the end of July, have made 'a point now

16 Ruskin's drawing of the *Great Square at Torcello*, probably 1850: see p.205.

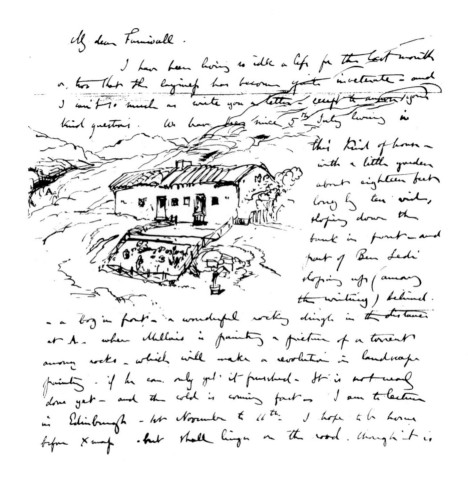

Glenfinlas. 16th October. 1853

My dear Furnivall.

I have been living so idle a life for the last month or two that the laziness has become quite inveterate — and I can't so much as write you a letter — except to answer your kind questions. We have been since 5th July living in this kind of house — with a little garden about eighteen feet long by ten wide, sloping down the bank in front — and part of Ben Ledi sloping up (among the writing) behind. — a bog in front — a wonderful rocky dingle in the distance at A. where Millais is painting a picture of a torrent among rocks — which will make a revolution in landscape painting — if he can only get it finished — It is not nearly done yet — and the cold is coming fast — I am to lecture in Edinburgh — 1st November to 11th. I hope to be home before Xmas — but shall linger on the road, though it is

17 Ruskin, drawing of cottage at Glenfinlas, October 1853, in a letter to Furnival.

18 Ruskin, manuscript draft of first lecture delivered at Edinburgh in 1853.

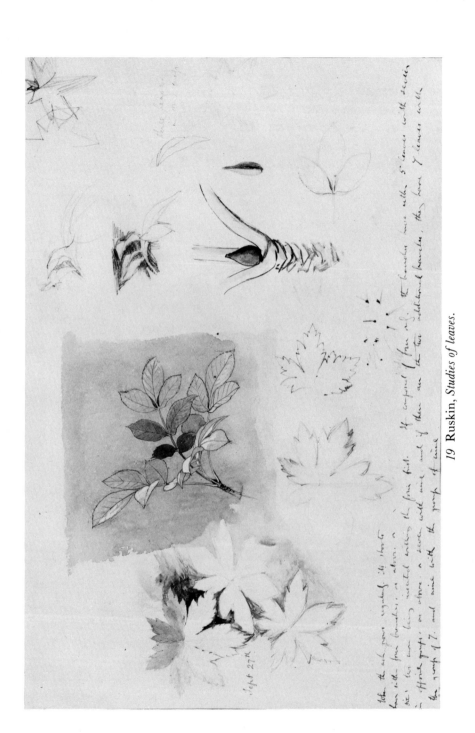

19 Ruskin, Studies of leaves.

of work. a great many leaves
being slighter — some blanks but
a great many also elaborate in the
highest degree — some containing
ten exquisite compositions on each
side of the leaf — thus —
each no bigger than
this —

and with about that quantity of
work in each — but every touch of
it inestimable, done with his
whole soul in it. Generally
the slighter sketches are
written over everywhere. as in
the example enclosed, every
incident being noted that was
going on at the moment of
the sketch —

20 Ruskin's letter to Norton describing his work with the Turner
Bequest in 1858: see p.260-61.

21 Ruskin's 'View from my window, Mornex, where I stayed a year': see p.288.

22 Above A detail from the *Beaupré Antiphony*, once owned by Ruskin; it shows the monk John working in his cell, an occupation which Ruskin himself sometimes pretended to adopt, as for example at Assisi in 1874, when he was allowed to work in the sacristan's cell, which he drew for his friend, Carlyle, *below*.

23a Ruskin, 'English visitors at Calais', from an early narrative of the family tour, 1833/4.

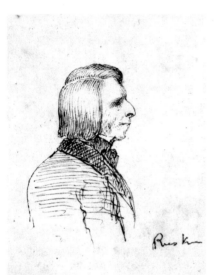

23b Ruskin, self-caricature.

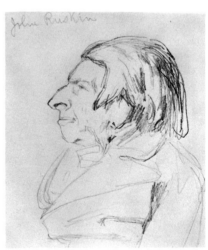

23c A. Cecioni, caricature of Ruskin, sketch for version which appeared in *Vanity Fair*, 11 February 1872.

of planning and promising nothing either to myself or any one else – and just doing any thing that comes to hand';[6] but the essays later published as *Unto This Last*, which he had already started when he wrote to her, sprang logically out of his recent lectures on political economy, even if they were given some stimulus from disagreements with Stillman over picturesque hovels. Despite his weariness and sickness, he wrote with magnificent lucidity and care, revising thoroughly and completely;[7] by the end of June he sent the first batch to his publishers for consideration in their new magazine, the *Cornhill*, edited by Thackeray. Copies, too, went to John James for approval.

Though he feared that his son's inexperience in matters of political economy would lead to a 'Massacre of the Innocents', and though he was, understandably, a trifle dismayed at the unfavourable judgement on 'my Vocation', he seemed to accept the general themes of his son's essays: 'he does well to drag the Merchant Princes from their Pedestal, & place them on a lower & more appropriate shelf'.[8] A month later, when the first essay had appeared in the August number of the *Cornhill* and the second was due out in September, John James was even expressing himself as 'rather proud of these papers' and hoping that they would produce some 'amendment in both men & masters'.[9] Perhaps his enthusiasm stemmed from John's commitment to the family and its household of servants as a model for larger social morality.

The Preface to the published text of 1862 stated Ruskin's aims:

> The real gist of these papers, their central meaning and aim, is to give, as I believe for the first time in plain English, – it has often been incidentally given in good Greek by Plato and Xenophon, and good Latin by Cicero and Horace, – a logical definition of WEALTH: such definition being absolutely needed for a basis of economical science . . .
> Their second object was to show that the acquisition of wealth was finally possible only under certain moral conditions of society, of which quite the first was a belief in the existence, and even, for practical purposes, in the attainability of honesty.[10]

Ruskin chooses to study economic realities from an ethical and practical point of view: not that *Unto This Last* proposes any specific expedients or experiments in social structuring, for its effort is largely theoretical. Seemingly deaf to his opponents' admission of their own deliberately limited view of man, Ruskin argues that 'economic man' is a false and inadequate notion, for it neglects the human soul: 'it is open . . . to serious question . . . whether, among national manufac-

tures, that of Souls of a good quality may not at last turn out a quite leadingly lucrative one'. He affirms the ethical basis of all good life as well as the integrity or the organic fabric of society, in which the merchant has to play a part beyond his own greed for profits: 'It is impossible to conclude, of any given mass of acquired wealth, merely by the fact of its existence, whether it signifies good or evil to the nation in the midst of which it exists. Its real value depends on the moral sign attached to it . . .' There is even the chance, as he had realized when exploring the social significance of gothic craftsmen, that 'persons themselves *are* the wealth'; by the fourth and final essay this becomes the emphatic 'THERE IS NO WEALTH BUT LIFE'. This last part, composed with especial care since he knew it was the last contribution that the *Cornhill* would accept, invokes Ruskin's favourite method of philological enquiry:

> *Valor*, from *valere*, to be well or strong (ὑγιαίνω); – strong, *in* life (if a man), or valiant; strong, *for* life (if a thing), or valuable. To be 'valuable', therefore, is to 'avail towards life'.

And with his characteristically generous sense of the abundance of things Ruskin ends by asserting that wise consumption is a more difficult art than wise production.[11]

The skills and subterfuges of argument ('reduced . . . to simplest or radical terms') are masterly, even in the distortion of the Utilitarians' strong attachment to individual liberty so as to make it seem devoid of morality. His graphic images to depict complex societies or to highlight the obligations of manufacturers[12] are precisely calculated to yield decisive advantages to his side of the debate. Yet it is unclear, either from the text of *Unto This Last* or from his letters about it during 1860, how much Ruskin anticipated that he would convert members of the opposition; his convictions are not in doubt, of course, nor his delight in controversy; but if he thought that his essays would change hearts – as John James seems to have hoped would be the case among 'men and masters' – he was as ignorant of human nature as Effie had remarked in the different context of 1854.[13] Perhaps his hopes for society were too much the translation into political economy of his own career in which, indeed, happy work and wise consummation of wealth predominated over degrading labour and mere production. *Unto This Last* is certainly in other respects frequently self-referential: its author is his own best authority, invoking *The Stones of Venice* and *Modern Painters* directly and indirectly: 'The "Lady of Saving", in a profounder sense than that of the savings bank . . . Madonna della Salute, – Lady of Health, – which, though commonly spoken of as if

separate from wealth, is indeed part of wealth'.[14] The 'little book' of the 1860 summer in Chamonix could not, in fact, divorce itself completely from the earlier art work.

Not surprisingly, Carlyle welcomed Ruskin's further penetration into his territory – he was, he wrote in October, 'in a minority of two, at any rate'.[15] His encouragement must have pleased Ruskin and determined him to proceed with this kind of work:

> I marvel [wrote Carlyle] . . . at the lynx-eyed sharpness of your logic, at the pincer-grip (red-hot pincers) you take of certain bloated cheeks and blown-up bellies. More power to your elbow (though it is cruel in the extreme). If you dispose, stand to that kind of work for the next seven years, and work out then a result like what you have done in painting.

But hostile voices were louder and more numerous. The *Saturday Review* described the essays as 'eruptions of windy hysterics . . . absolute nonsense . . . utter imbecility . . . intolerable twaddle'.[16] The outcry was so general that after three numbers had been published the editor ('with great discomfort to himself', as Ruskin admitted later[17]) said that only one more could be accepted. Ruskin, as well as his father, was much hurt at this snub to what was, by this time, a firmly established reputation. Nor was it much help to have his friends remonstrating too: both John Brown ('so jealous of [Ruskin's] greatness & his unapproachableness'[18]) and W. L. Brown, John's former tutor, expressed their disapproval. To the latter Ruskin replied with further arguments, some of which seemed to glance at his own uneasy feelings towards his father:

> So the poor beasts and wretches who fancy themselves rich in this precious city of ours go on working hard all their days in order to obtain on their death-beds the power of saying – in a palsied manner – £100,000, etc., shall belong to A. or B.[19]

John James had worked extremely hard all his life to provide his son with the opportunities of travel, collecting and writing. John's expressions of guilty gratitude are frequent. The work on Turner that his father had promoted and approved was finished by 1860. What his son now wished most to do only offended John James's deepest principles, however much his paternal pride and critical instinct were satisfied by *Unto This Last*. To complicate this mistrust, Ruskin's father and mother grew increasingly dependent upon his presence at Denmark Hill; the more they needed him and the more he was 'fastened' to their house,[20] the less feasible became his acquisition of a

house of his own, for the symbolic freedoms of which he came to yearn more and more during the 1860s. As if to signal all this, his father had been especially ill while John was away during the summer of 1860, only improving 'miraculously' when he heard that his son would be home earlier than expected and in time for Margaret's birthday.[21] Then, soon after John had returned, his mother broke her thigh-bone in a fall, and he ministered to her as best he could, reading endlessly to her from 'the worst evangelical theology'.[22] It was a fortnight before he found his first 'free day'[23] for resuming his business correspondence, though he had written at once upon his return to congratulate Rossetti and Lizzie upon their marriage, which had taken place soon after he had left England. He got out to Carlyle's, where he met Froude, and tried to keep friendly with Rossetti.

His main need, as he attempted to explain in a postscript to a note of complaint about Rossetti's not liking him enough, was for people to care for him.[24] At home he was needed; but that was no substitute for the affection he craved. Indeed, living at Denmark Hill 'in the way I do' only prevented Rossetti and Lizzie from knowing him 'rightly'. Now, with reason, he was afraid of 'losing hold' of Rossetti and Lizzie, and he envied the beneficent effect that Lizzie worked upon Dante Gabriel ('She cures you of all your worst faults when you only look at her'[25]). Perhaps the summer with Stillman had revealed to Ruskin how valuable others' caring for him was, and how necessary to his own wellbeing was the opportunity to fix his affections. The American had been at best a tolerable companion, but obviously had not reached at all deeply into Ruskin's soul. The latter wrote of this as openly as he could to the distant Norton ('I looked very wistfully often at the door of the room in which you introduced me to your Mother and Sisters [at St Martin], and at the ravine where we had our morning walk'[26]).

But Ruskin's affections were stirred during his time at Chamonix by thinking of the young Rose La Touche, with whom he was corresponding. After meeting her and her family in 1858 Ruskin scarcely mentions them again until November 1859, when he asks Lady Waterford for the La Touches' Irish address.[27] But in 1860, before his summer visit to France and Switzerland, Ruskin saw more of them in London; evidently his own disavowal of Evangelical ideas, very vocal at this time, gave him some bonds with Mrs La Touche, whose husband was beginning to be strongly influenced by the calvinist preacher, Charles Spurgeon. Their daughter was inevitably caught in the midst of these parental religious tensions, and Ruskin probably

threw his weight behind the mother's scepticism and made a big fuss of Rose in the process.[28] In April 1860 he reports to the girls at Winnington that 'I've got a dear little one . . . whom I'm really *very* fond of . . . who writes for me – the prettiest little poems you ever heard – and is full of play besides.' He was 'sulky', he added, because she had just returned to Ireland.[29]

It was Rose – more strongly than the collective 'birds' of Winning-ton – who exercised and shaped his imagination while he was abroad that summer. 'We have had a month', he told Pauline Trevelyan, 'among the Alpine roses'; and to John Brown he wrote of 'drawing Alpine Roses, or rather Alpine Rose-leaves, with little result, but mortification'.[30] And it must have been Rose herself whom he identi-fied with 'a pretty English girl' at the Hotel du Mont Blanc at St Martin's: 'I wanted to get speech of her, and didn't know how'. So he went half-way up the Aiguille de Varens to gather a bouquet of St Bruno's lillies – Rose La Touche's dog was called Bruno – and 'put wild roses all round them as I came down'. But by the time he had returned to the hotel, the girl had gone on to Chamonix.[31] Already, it seems to have been his *idea* of Rose rather than Rose herself which moved him, an idea metamorphosed later while writing *Praeterita* into a picture of 'eyes rather deep blue . . . Lips perfectly lovely in profile . . .'[32]

Back in London in early September and marooned with his parents at Denmark Hill he longed even more for companionship, feeling 'the lassitude of surrended effort and the disappointment of discovered uselessness'.[33] He was unable to write anything or think without getting angry. He dreaded opening newspapers lest he found bad news of the Italian struggle for independence or of Venice and Verona destroyed.[34] He took himself off to the zoo to watch penguins ('one can't be angry when one looks at a Penguin'[35]). Generally, as he reported to Mrs Browning, he was torn between his wish to become involved in human affairs and his selfishness:

I find the study of the figure in art, and of human interests in literature, wholly incompatible with the pursuit of landscape. Natural history will go with landscape, but men are too beautiful and too wicked – the moment I begin to draw them at all intelligently, I care for nothing else; a girl's hair and lips are lovelier than all clouds; a man's forehead grander than all the rocks. If I begin to think and write about the creatures, I get enraged and miserable. If I don't, I feel like a baby, or a brute. I never shall draw thoroughly well, nor write thoroughly well. I believe Natural History would be the best thing for me; but I neither like to give up my twenty years' cherished plans about Turner on the

one side, nor to shrink behind the hedges from the battle of life on the other.[36]

More self-examination did nothing to relieve him and he began the New Year with further introspective analysis of what his own features revealed: his 'pretty feelings – have got all crushed into a shapeless – wide, comfortless, useless philanthropy which will not show in the face'; his 'total want of wit and imagination lowers the forehead'; and 'finally the irregular work of my life & its impulsive character have taken away what firmness there might have been in the mouth'.[37] In such a mood he was bound to respond eagerly to the childish fun of 'Rosie-posie', who called him names and seemed to understand when he was forced to stay at home like a sulky kingfisher – 'Don't be kingfishery dear St. Crumpet'.[38] He saw much of the La Touches that winter when they were in London and advised them busily upon their forthcoming trip to the South of France and Italy.

Ruskin and Rose promised to exchange journal letters during her journey; he wrote first, and her reply, the first long letter he ever received from her, was later enshrined in *Praeterita*.[39] Its high spirits, sharp-eyed reportage and her readiness to tease and respect Ruskin's interests – especially the inefficacy of language in front of sublime scenery ('*You* the author of M-Ps cd describe it Irish roses can't') – all bring alive the 'spiritual little Creature of thirteen'.[40] Ruskin received her letter at Winnington, where he had retreated to solace himself and where the girls' energy and fun as well as their 'trust and affection'[41] took his mind from despondency. Two Irish girls seemed particularly congenial and he danced with them both.[42] But, as he ominously noted for his father, the school was obsessed ('mightily taken') with the dragon of Turner's *Garden of the Hesperides* as Ruskin had analysed it in the last chapters of *Modern Painters*.[43]

John James decided that his son's 'Bible lessons' at Winnington were undertaken to compensate his mother for her anxieties at his frequent visits to Carlyle.[44] Denmark Hill continued to be uneasy in face of Ruskin's social 'Doctrines', the latest manifestation of which was the decision to give forty-eight of his Turner watercolours to Oxford and twenty-five to Cambridge. John James accepted this gesture bravely, for 'I had indeed told him that his costly decorated Walls & large accumulation of undivided Luxury did not accord with his Doctrines. I am now paying for my Speech.'[45] It was also, of course, Ruskin's desire to make the drawings available to students and thereby to expand the accessibility of his teaching which lay behind these gifts.

His lassitude and despondency quickly returned after he left Winnington and his next public lecture, on "Tree Twigs" at the Royal Institution on 19 April, was a poor affair, though significantly Carlyle thought it failed 'from over-opulence (*embarras de richesses*)'.[46] As late as August he was still worrying about it, hoping to 'be able to prepare two or perhaps three very interesting lectures for the Royal Institution (whereat the failure keeps gnawing me, and will, till I efface it)'.[47] The La Touches were back from the continent to cheer him up at the end of April, but by the second week in May they had proceeded to Ireland and his depression returned. In mid-June he decided to go to Boulogne for a 'complete rest'. 'Intense indolence', he later realized, might become a 'healthy feature of my character.'[48]

On the French coast he found 'every kind of interest – boats, figures, sea, and rocks, for its geology is interesting too, and *pictures* of houses in every direction'. This intelligence was translated by John James to Pauline Trevelyan at Wallington – 'He is much better nevertheless of his sojourn at Boulogne with Pilots Mussels & Fisherman's Children – Salt water Rowing & Sea side walking'.[49] What Ruskin did not tell his father was that he learnt to sail a French lugger in which 'a good pilot at last left me alone on deck at the helm in mid channel, with all sail set, and steady breeze.[50] This was the pilot, Huret, whose two-year-old baby boy, later Ruskin's godson, he was befriending.

From Boulogne he at one point planned either to continue to Switzerland or to visit the La Touches in Ireland.[51] He managed in the end to do both. From Boulogne he was writing to Rose (with a copy to his parents) a long, enchanting letter about his expedition to the market, his visit to the Hurets at Portel along the coast where he ate a meal and enjoyed the company of their two daughters, and his meditations upon ears of wheat as he found them in the fields and in the New Testament.[52] The relaxation and renewed absorptions he discovered in writing to her must have contributed to his decision to visit Rose and her family: 'I've let myself be teazed into going to see some people in Ireland', he told Lady Trevelyan from Holyhead on 26 August, where he had come directly. But to Carlyle he wrote two days later of 'the heaviest depression . . . upon me I have ever gone through'.[53] Perhaps he hoped that Rose and her mother would between them help him to escape from 'Bye-path Meadow'.[54]

He had written to Norton in June before going to Boulogne that a little girl of thirteen had 'put her finger on the helm at the right time' and that her mother was 'certainly the ablest and I think the best woman I have ever known'.[55] To their further ministrations he looked forward as he waited for the Irish steamship. Of Ruskin, Mrs La

Touche at least if not her daughter had her own expectations. Before they met in 1858 she had read his writings eagerly; after their first visit to Denmark Hill she had gushingly thanked him, for 'You, who live with, and for Art, will not easily guess how much enjoyment you afforded to me who am wholly unaccustomed to such an atmosphere – out of Dreamland'.[56] Her own husband, whether in his foxhunting days or increasingly in the 1860s in his new-found evangelical fervour, gave her little comfort. She would write, anonymously in 1886, of the visit of any 'intelligent outsider' into their Irish county set as a rare yet, by everybody but one like herself, mistrusted event.[57] So Ruskin's arrival in late August, after she had entertained the Prince of Wales ('such *racketty* people & so reckless'[58]), must have been especially welcome.

Ruskin found the journey disagreeable and his first impressions of Ireland depressing ('Far worse then the worst of Italy', he told John James[59]). The La Touche house and park at Harristown pleased him at first much less than Winnington or Wallington. But during his stay he came to know and like it more. The family took him for walks in the park and to local beauty spots, helped him explore the house, and he accompanied Rose on her visits to labourers' cottages distributing Baptist tracts for her father. Ruskin tried at first, despite Rose's waving at him with her croquet mallet, to keep to his room in the mornings, 'doing letters and geology'; but the excitements of playing with the children – Rose's sister, Emily or 'Wisie', and her brother, Percy – soon distracted him. They built a bridge across the Liffey, rowed on the river, played ducks and drakes, scrambled around rocks and waded through pools. Rose was evidently a tomboy on her home ground, 'half squirrel half water-ouzel', as he told Pauline Trevelyan[60]; but her fearless athleticism had its serious side ('all the deeper for squirreline faculties at rest'), and this combination of intelligence and high-spirited fun which Ruskin had lacked during his own childhood attracted him powerfully. Never at ease with adult house parties, his happiest evening was probably when the La Touches were out and he stayed behind and 'We turned ourselves into Lords and Ladies', dining in state and afterwards playing duets and chess. Before leaving France for Ireland in July he had written to Georgiana Burne-Jones that the attraction of Rose was her childishness. 'Do I want to keep her from growing up? Of course I do.' But he already sadly recognized that 'It's another Rosie every six months now'.[61] So it is no wonder that it is as a picture that he envisages Rose during his stay – 'if one had to paint her hair it would have to be done as Perugino used – with real gold here and there'.[62] He would be far less confident in his later dealings

with a girl who simply would not stay as he wished her to be imaged.

With the adult La Touches he had different relationships. He found the father more congenial than he had expected, though pointedly noted that 'a park with no apparent limit, and half the country round paying rent, are curious Paraphenalia of Christianity'.[63] They evidently remained on rather superficial terms. With Mrs La Touche, however, he had long and serious discussions about his loss of faith, and it was she who extracted from him a promise not to publish any of his new views for ten years. It was probably a disastrous decision, for Ruskin not only thrived on writing and printing what was currently on his mind, but composition and publication undoubtedly had a therapeutic effect. The stimulus of working out his thoughts on paper and then committing them to print released many of Ruskin's nervous tensions, so that the enforced silence on matters of faith, about which his private communications show he had many interesting things to say, must have been as disruptive of his mental stability during the 1860s as his frustrated love for Rose. Even at Harristown in September 1861 Ruskin saw that his attraction for the child-like Rose and his damaged faith were connected: in a letter to Pauline Trevelyan, already quoted, he writes to admit that the little Irish child could readily 'preach me . . . back into second-volume temper'; he refers to the stage of *Modern Painters* where he was most concerned with the spiritual qualities of beauty.

He left Harristown with Crawley on 6 September. They went to Dublin to inspect Trinity College Museum, recently completed to designs by Deane and Woodward, the latter having also been the architect for the Oxford Museum.[64] It was, he reported to Denmark Hill, 'quite the noblest thing ever done from my teaching'. He stopped briefly at Oxford, stayed a week with his parents and then, ever-restless and with little to occupy him, set off for the continent. His state of mind before the visit to Ireland had been one of low spirits ('sad whenever I give myself time to think'[65]); his usual response to such depression was to seek 'rest'. Natural history 'or other peaceful knowledge' seemed his only solace, although even natural history had 'its abysses of life and pain . . . it makes me giddy and desolate'. But it seemed altogether better than the effort and misery of work for anything human. What his Irish visit slowly forced upon him was a consciousness of his own age, his 'unfitness for active life in society' and – above all – the difficulties of human relationships for someone like himself.[66]

He reached Bonneville on 22 September, staying until the middle

of October. 'Everything looks to me nobler than it ever did before.'[67] The Swiss autumn scenery reminded him of Tintoretto and the painted windows of Chartres, 'magnified a thousand times'. With the onset of winter he moved to Lucerne, and he wrote to Denmark Hill with his new 'law' ('As for anybody's coming to Switzerland except in November, it is the merest nonsense') and to Mrs Carlyle about the utter calm of the winter landscape.[68] He sketched, threw stones at icicles in the ravine, read Greek and Latin historians and social commentators with the aim (among others) of 'master[ing] the economy of Athens', and wrote long letters home. He harped much upon the contrast between what is 'ridiculously' called 'Divine Service', with its 'objectionable accompaniment of . . . Preaching', and the alpine chapels and the 'sermons' he derived from handfuls of gentians gathered with Couttet.[69] The Simons visited him at Bonneville.

He seemed strangely preoccupied with not writing – the result, doubtless, of his promise to Mrs La Touche; but that he entertained contrary inclinations is clear from a letter of 6 October where he recounts with enthusiasm Socrates' persuasion of a friend to speak out in public.[70] He teased Pauline Trevelyan about the 'dreadful book I could write, if I chose', but confessed to Mrs Simon that his 'sense of the extreme absurdity of my writing . . . is a good deal the cause of my not writing'.[71] By December he was telling John James that, since he would not be publishing anything for 'years', he would like to gather the *Cornhill* essays on political economy into a book.[72] *Unto This Last*, as it was called, did appear in 1862 and its publication marked the resumption of Ruskin's work in political economy. He needed to write and publish, yet in ways that would steer clear of religious matters ('There is also little use and much harm in quoting Bible now') as well as avoid augmenting his reputation as an elegant writer of pretty passages.[73] This was all that happened, he felt, when Smith, Elder printed a volume of *Selections* from his previous works. Ruskin disliked being chopped up 'into sausages' and requested his father not to send the 'book of extracts to *any*body, that you can help'.[74] John James could obviously not resist, though he compensated by telling correspondents that he regretted the publication; presumably in response to one such disclaimer Carlyle wrote that he welcomed *Selections* warmly, for it was 'altogether a pleasant little companion, and a profitable in these bad times'; it put a Ruskin manual, he was also quick to point out, into the hands of those who could not afford the big expensive editions.[75]

Ruskin's autumn and winter sojourn was partly designed to 'try the climate, with a view to a house in Switzerland'.[76] But his desire to

establish a home of his own was constantly thwarted by his obligation to his parents and, now, by some undefined attraction for Rose. In November he belatedly wrote to console Robert Browning for the death of his wife: for all his own problems, which break through completely by the end, it is a fine expression of his esteem for the Brownings – 'I love you, and there are few people whom I do'.[77]

Whether Rose was among these few loved ones in late 1861 is unclear. Ruskin – looking back six years later – would say that these were 'months . . . when he lived for his love of Rosa'; and in 1874 he would tell Joan Severn that he had lived for his 'weekly letter from R[ose] and vague hopes – at all events possibilities of hope'.[78] But these late formulations after the event are extremely suspect; it seems certain that in the later months of 1861 Ruskin simply did not know how to interpret, let alone act upon, his feelings for Rose La Touche.

He corresponded regularly with both her and her mother, receiving frequent replies from the latter[79] and – on account of her illness – only intermittent ones from the first. Rose fell ill in early October, the result of a nervous disorder that produced some form of hysteria and loss of consciousness. Ruskin's parents feared that John's determination to teach her Greek by correspondence had precipitated the attack and he had, as soon as he learned of her illness, encouraged her in less arduous pursuits, like cooking, and sent her play-rhymes that he composed on his walks.[80] He maintained some communion with her by writing out the 'forms of Greek verb' for her, while he himself slowly mastered the linguistic usages of his classical texts.[81] For a while Rose was forbidden to write letters, but sent Ruskin some shamrock in return for his present of trefoil oxalis. When she did resume writing it is clear that she thought much of him and missed him. One beautiful letter – the 'star-letter' that Ruskin would always treasure – was written from London where the La Touches had gone before Christmas: Ruskin's Christmas letter had reached her on 26 December and though she playfully reprimands him for having taken cold while writing to her she is extremely grateful –

> yet I can't help saying I was looking for a letter, I wanted so much to know what you were doing and thinking (I mean a very little bit of it) this Christmas day . . .[82]

She goes on to talk of their 'thoughts . . . crossing' and of gazing at the star of Venus. This leads to meditations upon the star which guided the Wise Men and she explains with a quiet and intense effort at precision how peace may be discovered on earth if we would only let the Heavenly light direct our search; despite sorrow and pain, 'the Joy

that was His Gift on Earth shall increase and abound to his Glory'. It is a letter of utter sincerity, yet nonetheless written very calculatingly to a man whom she knew to have lost the confidence of his faith. Its appeal to Ruskin, disaffected with his parents' religion yet still deeply nourished by a faith for which appropriate forms did not readily present themselves, was enormous. It must have settled the question which he told Denmark Hill had been perplexing him and delaying his return: 'whether Rosie was what her mother and you think her, an entirely simple child – or whether she was what I think her, – that is to say in an exquisitely beautiful and tender way, and mixed with much childishness, more subtle even than Catherine of Bologna'.[83] Rose's star letter spoke instantly to Ruskin of many of his deepest and complicated needs – the childishness and playfulness he missed from his own childhood, the youthfulness of a person whom he could shape to his own ideas,[84] yet qualities by which he in his turn wished to be moulded – the strong faith which he lacked as well as the vision of St Catherine who, though wealthy, went down among the poor to serve them. In ways which he presumably could never acknowledge, Rose made the appeal that others of her age (thirteen) had made earlier in his life, although now subtly catering for his precise needs of the 1860s. Maybe it was an instinctive rehearsal of the past that led him to promise John James to call upon Adèle and her family on his way home through Paris: except that, for once, he calls her Clotilde.[85]

He reached London on the last day of the year. Having done nothing for six months, he told Norton, 'I feel incapable of ever doing anything any more'; tired of 'benevolence and eloquence and everything that's proper', he would cultivate himself for a change; if anyone so much as talked to him, 'I go into the next room'.[86] A fortnight later he was again writing to America of more *ennui* and discontent about the 'place which ought to be home'. He was distressed by the way in which the fields around Denmark Hill were being built over, by Burne-Jones's illness, by his parents. In February Lizzie Siddal had died, almost certainly by suicide, and Ruskin was allowed by William Michael Rossetti to pay his last respects to the 'Princess'.[87] But he did not see Gabriel, with whom relations still remained rather strained. By the end of April his isolation was even more acute and he wrote again to Norton that 'Where one's friends are, one's home ought to be'; yet America, he knew, would never suit his desire for perfect rest, for he was 'less and less able for change of scene or thought, least of all for any collision with the energies of such a country and race as yours'.[88] By 14 May he was announcing to Norton his departure for Switzerland – 'I must find a home – or at least the shadow of a roof of

284

my own, somewhere; certainly not here'. This was his most pressing, conscious need and he wrote about it obsessively to Rawdon Brown and to the girls at Winnington.[89]

The letters to Norton at this time suggest how much easier Ruskin found it to live with people via letters;[90] Norton's distance made confessions and confidences much easier. During the early months of 1862 Ruskin tried to maintain some semblance of his old existence, working at the National Gallery to remove mildew from Turner drawings, arranging minerals at the British Museum, visiting the Carlyles, entertaining the Trevelyans at Denmark Hill and taking them together with the La Touches to see Turner sketches at the National Gallery. But if his letters to Pauline Trevelyan are anything to go by, he must have been particularly ill-humoured:[91] he was querulous and bored by the American Civil War, grumpy about all the fuss over Prince Albert's death, perversely unpleased by 'pretty places' as by such 'ostentatiously ugly' ones as the Trevelyans' Wallington. Yet he expected Pauline, despite such rude remarks about her home, to 'write & amuse me' and complained to her that Acland, on his visits to London, never came to see him.

Despite happy moments with Rose ('Tea when they all three sat on the floor by me – her mother, Emily and she'[92]), it was obvious even to Ruskin that she did him 'more harm than good'[93] and was 'getting horrid'. In part, this development was simply that, as he realized later in the year, 'Rosie's got too old to be made a pet of any more'.[94] Her gradual loss of childishness merely made him rue his own middle-age the more; he recalled nostalgically in a letter to Rawdon Brown the happy, energetic times of 1845 and 1846 when he worked all day at Venice 'in all the joy of youth'.[95] But Rose also demanded of him religious commitments – 'wants one to keep two Sundays' – which, for all his yearning for some return of faith, hardly answered his needs. Even if only playfully he was telling the Winnington girls that he wished he could be a Roman Catholic and explained that Bellini, Orcagna and Fra Angelico were happier than he would ever be.[96] Maybe it was in a similar mood and to counter the Baptist zeal of Rose and her father that he chose to give her for her fourteenth birthday on 14 February a thirteenth-century psalter which included an Ave Maria ('*Ave rose florie . . .*'). A month later Emily received a fifteenth-century Book of Hours with floral decorations for her birthday; since this gift seems to have been chosen in response to Emily's 'wonderful gift in flower arrangement', the aptness of the earlier present may be clearer.[97] Another sense of unease was that Rose was spoilt, about which he complained to Miss Bell, though of course contributing to it

himself.[98] But is seems clear that two spoilt natures, each fortified at that time with a special sense of its own lack of health, collided more than they coincided. By July 1862 he had even had 'a fine quarrel with Rosie'.[99]

By then he was once again abroad. His main activity before leaving was to finish preparing *Unto this Last* for publication in book form. Then he left for the continent, taking Edward and Georgiana Burne-Jones as his guests. Georgiana had given birth to their first baby the previous October and Edward was struggling against poverty; so Ruskin wanted to give them both a rest and the artist ('destined to be unsurpassed, perhaps unequalled'[100]) a chance to see Italian art. They went first to Paris, then Lucerne and over the Gothard to Milan.

Troublesome relations with the La Touches followed him into France. Before he left England he had received from them the offer of a small house on their estate, obviously in some effort to provide him with the home near friends that he continually harped upon: he told Rawdon Brown that it was

a little cottage dwelling-house, and garden, and field, just beside their own river, and outside their park wall. And the river being clear, and brown, and rocky; the windows within sight of blue hills; the park wall having no broken glass on the top; and the people, husband and wife and two girls and one boy, being all in their various ways good and gracious, I've written to say I'll come, and get the sense of some kindness near me.[101]

The invitation also made it clear that Mr La Touche would, alternatively, build Ruskin a house somewhere else in the park. But in Paris he heard from Ireland that the offer was withdrawn. Later, in October, Ruskin would explain to Miss Bell that the La Touches had decided that their neighbours would not understand the arrangement, though it is clear now that this excuse probably covered other disagreements. At any rate by July he had his 'fine quarrel with Rosie ever since for not helping me enough'.[102]

In Milan Ruskin set to work, rather after the old fashion, copying Luini's frescoes in the Monastero Maggiore, San Maurizio, and making a report for the Arundel Society. Burne-Jones also drew from the frescoes for him. Altogether, despite Ruskin's continuing depressions, the three of them enjoyed each other's company ('they are dear creatures . . . and have done much to help me'[103]). He thought of them as his 'dearest children' and was especially pleased by Burne-Jones's devotion to him and his evident willingness (unlike

Rossetti) to accept Ruskin's commands.[104] He sent the couple off to Venice, Padua and Verona as his guests and followed Edward with requests for copies of Tintoretto and for more help back in Milan.

Besides studying Luini, Ruskin was writing the first essay of *Munera Pulveris*, which Froude had requested for *Fraser's Magazine* (it appeared in the issue for June). Despite the disheartening prospect of his father's further prohibitions on writing about political economy,[105] he set himself in these new essays to be constructive where *Unto This Last* had been largely destructive. The first essay for *Fraser's* draws on Ruskin's 1861 readings in early writers like Xenophon and his enquiries at the same time into classical philology. He returns to sources that are earliest and purest ('for a word is usually well made at the time it is first wanted'[106]); he defines wealth, together with money and riches, not in the current terms of price, cost, desire, demand or mere possession, but in its 'vital' meaning as the life-giving power of things essentially useful to those with the capacity to use them. The second essay, probably begun while he was still at Milan, set itself to consider what was the national store of wealth and how it should be augmented and drawn upon. Many issues were raised and not fully answered, many questions wilfully or casually begged, in *Fraser's*; they receive further, scattered treatment in *Time and Tide*, *Fors Clavigera*, *Sesame and Lilies*, *Crown of Wild Olive*, *Queen of the Air*, the wealth of texts he published in the years following his father's death in 1864. The urge to start writing again, which Froude's invitation had spurred, found him perhaps too depressed and lacking in energy to prosecute his enquiries as strenuously as they required. By the time he came to write a Preface for *Munera Pulveris* in 1871 he rationalized its original essays as being themselves just the preface to a more elaborate treatise.[107]

His work at Milan 'utterly prostrated' him.[108] Despite various pleas, including one from Burne-Jones, to return to London and despite the idle thought, which happily came to nothing, that he might rent a room from Rossetti in Cheyne Walk,[109] he settled himself for the remainder of the summer in the village of Mornex, six miles from Geneva. He had wisely decided against taking over a deserted Savoyard castle, 'Unspoiled, unrestored, arched gateway between two round turrets, and Gothic-windowed Keep', but also decayed and used as a farm building. He established himself first in the villa owned by the widow of a history professor at Geneva ('green chairs, a deal floor, and peace, and my books all about me'[100]). His lodgings were at 'the end of all carriage roads', which suited his need for rest and recuperation. But his rooms, with no view, were soon given up for

some in a little cottage down the hill, with a fine prospect; yet he retained the first rooms, not only because they yielded him shade at noon, but because he was now provided with adequate space for Crawley, Couttet, Allen and, eventually, Allen's wife and children. And here, between his two houses and two gardens, he pottered about, digging, paving a courtyard, taking increasingly longer rambles into the surrounding landscape, rich in geological and botanical material, and working on his essays for *Fraser's*. He was generally so 'happy that it frightens me'.[111]

The contentment of a life on his own terms and filled without any gainsaying by his favourite preoccupations was obviously not without its guilt. There was, first, the 'folly and horror of humanity', against which his own political economy was directed.[112] But, then, there was his father's hostility to that writing and, more generally, increased friction between Denmark Hill and its distant son, whose changes of plan made John James anxious and ill.[113] But keeping his distance and house in Switzerland was Ruskin's way of living 'some of my own way at last'.[114] He deliberately removed himself from a 'form of affection [that] galls me like hot iron – and I am in a state of subdued fury whenever I am at home which dries all the marrow out of every bone in me'. He explained the situation at length before reaching Geneva in a letter to Lady Trevelyan, who often seemed to find herself caught in the midst of father's and son's disagreements:

> my father . . . has more pleasure if I am able to write him a cheerful letter than generally when I'm there – for we disagree about all the Universe, and it vexes him – and much more than it vexes me. If he loved me less – and believed in me more – we should get on – but his whole life is bound up in me – and yet he thinks me a fool – that is to say – he is mightily pleased if I write anything that has big words and no sense in it – and would give half his fortune to make me a member of parliament if he thought I would talk – provided only the talk hurt nobody & was in all the papers.[115]

To John James himself he wrote from Geneva in no less categorical terms, though reasoning at more length; he was particularly insistent that his father should learn to understand and approve his friends such as Burne-Jones. He also defended the language of *Unto This Last* ('much superior to that of the first volume of modern painters') and attempted to reassure John James that it would eventually sell.[116]

His self-imposed exile and seclusion began to have its effects, and his health improved. As much as possible he kept unpleasant things at bay, but could not resist reading the newspapers, was saddened by

news of Rose's further neurasthenic illness, and found himself drawn, if only in correspondence with Miss Bell, into the imminent storm over Bishop Colenso's book on the *Pentateuch*. The Bishop had been staying at Winnington, where Miss Bell gave him refuge and support immediately prior to the book's publication. Ruskin told its author, who wrote to him at Mornex, that he could be counted upon for 'word or sympathy' and that he had discovered himself in recent years how to live without lies or dreams (*Critical Examination of the Pentateuch* proposed that the book contained forgeries). Miss Bell, too, experienced some loss of faith and received warm and urgent support from Ruskin, released by her letter from his own enforced silence: 'for us who have been long deceived, and who have all to forget & forsake, and desecrate – and darken it is dreadful – The world is an awful mystery to me now – but I see that is because I have been misled, not because it need be so'. The 'solitude' of keeping his unbeliefs to himself, bound by his promise to Mrs La Touche, had been 'terrible', as he wrote to Sir John Naesmyth in November that year. Now Colenso had come out with the same ideas Ruskin professed immense relief and ease ('the *indecision* is over'); he would never have promised to keep quiet, he told his father the following year, if he had known that the stir caused by *Essays and Reviews* in 1860 and now by Colenso would have come so soon.[117]

He felt well enough to return to London in November for a few weeks; but 'the moment I got on this side of the sea', he told Miss Bell from Denmark Hill, 'I got ill again'.[118] He lectured on "Reform" at the Working Men's College on 29 November, took Burne-Jones to meet Carlyle (but his determination that all his friends should like each other was not successful on this occasion), and spent some time in other visits. But he would not journey to Winnington to meet Colenso, for, as he explained to Miss Bell, 'I go fearfully farther than he does, and am in a darkness which I don't want to draw anyone into – till I've felt for the way through'.[119] His dutiful return to London, which John James considered 'nearly as bad as not coming at all', merely confirmed him in his resolve to remain away in 'my den in the Alps'.[120] Not without some guilt he left England before Christmas and was back in Mornex for what his diary recorded as 'my wilfully desolate Christmas'. To his father three days later he writes how 'difficult' it was 'to know & feel what one ought to do', but he thought he was right to have come back. He went on with a long, happy description of walking on the Salève, during which he knelt on the turf above the Grande Gorge to thank God for bringing him back safely (a moment of worship he contrasted with that in Camden Chapel).[121]

Just after Christmas he heard from Rose, 'mightily vexed about my heathenism', for Mrs La Touche had evidently let her daughter see parts of Ruskin's letters in which he pursued the theme of his lack of faith.[122] He rather vaunted his paganism at this time – to Norton he wrote that he was 'trying hard to get some substantial hope of seeing Diana in the pure glades'.[123] Yet it seems that just as he chose to avoid Bishop Colenso, so he also arranged his visit to London to miss the La Touches, content not to intrude his current beliefs upon a family already divided in its religious ideas. Fond as he still was of Rose, he seemed willing and able to maintain a friendship with her and her parents at a less intense level; it seems to have been Mrs La Touche[124] who would not lose contact with Ruskin and who may have used his own explanations of unfaith in some misjudged attempt to steer her daughter away from the father's evangelicalism (Rose would write later of 'my Parents, all pulling different ways, or all mixing to puzzle a brain that cannot bear perplexity'[125]). But it was through the mother's initiatives that contact was maintained with Ruskin, both in her regular letters and through her promotion of friendship between Ruskin and George MacDonald.

MacDonald was a Scottish divine who had lost his living because of unorthodox views on salvation and now supported himself by writing and lecturing in London. Rose recommended his friendship to Ruskin, and her mother urged MacDonald to love and help the other man, letting him 'talk – about his pet Rosie if he pleases'. It is clear from her letters to MacDonald how much she was herself deeply involved – 'I don't care what becomes of me as long as anyhow he can be brought to some sort of happiness & life'.[126] Her husband committed himself wholly to the cause Spurgeon preached – La Touche was baptized in the Metropolitan Tabernacle at about this time; her daughter made herself seriously ill in October 1863 by insisting, after her father's ideas, upon her first communion without confirmation;[127] so Mrs La Touche continued to cherish the lonely man, misguidedly isolated at Mornex in what he called the 'stillness of midnight with the light of Paradise'.[128]

Ruskin stubbornly defended his retreat, telling Lady Trevelyan than it afforded him forty minutes more daylight than he would have had at Denmark Hill. His existence was 'a kind of dream', with the 'union of intense light with unbroken silence'.[129] He became more absorbed in his geological studies, partly in preparation for a lecture he had promised to deliver in June 1863 at the Royal Institution. He sent Lady Trevelyan detailed sketches of his discoveries on the Salève, his only annoyance being that he found his drawing skills sadly deficient.

He even invited the Trevelyans out to join him in his two houses at Mornex, but, as he subsequently recognized, the tone of the invitation ('I should just go on as if you weren't here'[130]) betrayed his real desire for isolation. He needed time to himself, for 'after a change of one's opinions – one has to sit in the dust & hold one's tongue for some years'.[131]

He continued to write for *Fraser's*, but not without difficulty. In early January he postponed the fourth essay, since its composition made him 'worry' and 'giddy'.[132] All his previous work, he had told Norton when first settled in Mornex, had been 'done hurriedly and with emotion':[133] now, in reaction, he needed to write with precision and in the clear light of fierce opposition to his ideas. It was perhaps less John James's entrenched ideological objections that concerned him than the knowledge that he was writing what those people he needed to reach would only term 'most fantastical and baseless vagaries'.[134] His father indeed seemed reassured about the fourth *Fraser's* essay, telling Lady Trevelyan that John's 'tread' on this 'new ground' was 'already firmer': the paper was 'so good that I care nothing about any criticism'.[135] Nonetheless, Ruskin's skills of debate were tested in writing this, as it turned out, final instalment (constituting sections V and VI of the published text in *Munera Pulveris*). In trying to reverse the direction of modern social and economic and political thinking ('we are all astray about everything'), he realized that 'the best wisdom' – including his own – 'has been spoken in . . . strange enigmas – Dante's, Homer's, Hesiod's, Virgil's, Spenser's'.[136] He would later seek Burne-Jones's help to provide his text with illuminating emblems of its hard and deep principles:

> I want you to do me a set of simple line illustrations of mythology and figurative creatures, to be engraved and to make a lovely book of my four Political Economy papers in *Fraser*, with a bit I'm just adding. I want to print it beautifully, and make it a book everybody must have. And I want a Ceres for it, and a Proserpine, and a Plutus, and a Plato, and a Circe, and an Helen, and a Tisiphone, and an 'Ανάγκη, and a Prudentia, and a Sapientia, and a Temperantia, and a Fortitudo, and a JUSTITIA, and a CHARITAS, and a FIDES, and a Charybdis, and a Scylla, and a Leucothea, and a Portia, and a Miranda, and an 'Αρητή, and an Ophelia, and a Lady Poverty, and ever so many people more, and I'll have them all engraved so beautifully, you can't think – and then I'll cut up my text into little bits, and put it all about them, so that people must swallow at once, and it will do them so much good.[137]

But, meanwhile, he had had to rely upon his own powers of communication: his logical ruthlessness with cherished Victorian maxims, his

probing into early and purer meanings of key terms, his invocation of literary examples suitably glossed and reconstructed, his direction of readers by footnoted exhortations to read carefully or by subsidiary explanations, were all developed to urge that life was more to be cherished than the mere pursuit of money. Utopian, complex, unorthodox on the question of 'slavery' (and perversely so, given the American Civil War, which annoyed him), Ruskin was constantly frustrated in his search for a language by which to articulate what did not yet exist and what most of his readers would rather not even imagine into existence. Carlyle, before him, had experienced exactly these same problems of language and form for the unspeakable and the unknown.

In April he went off for a month to Annecy and Talloires in search of a permanent house, having decided that Mornex was too near Geneva ('workmen and students . . . out here on the Sunday'[138]). He even wrote to enquire of Rawdon Brown the chances of a 'batchelor's den' in Venice ('somewhere on the Grand Canal or by the Ponte dei Sospiri quarter').[139] But two properties nearer Mornex soon caught his attention. On one, high above Bonneville on the 'top of the barren crag' of the Brezon, he opened negotiations with the crafty local council, who suspected that Ruskin had discovered gold. The other, 'a square mile of Mont Blanc – 2000 feet above Chamouni – with quantities of weeds and stones upon it – and a torrent', under the Aiguille Blaitière, he purchased for £720 – 'and I want to buy a glacier above'.[140] He planned to retain both: the Chamonix site just for itself, a 'picture'; the other, despite its inaccessibility, was where he proposed to build a house. The excitements and projections of future existence quite relieved 'the nervous state of the brain', he reported to John James.[141]

He then returned to England for his lecture at the Royal Institution and to give evidence to the Royal Academy Commission.[142] He stayed with his parents, then went to Winnington, where he took the Burne-Joneses; from there he went to Wallington and a visit to Lady Waterford, visited Yorkshire, returned to Wallington and eventually Winnington. After a few days only in London, he departed once again for Mornex. Throughout his English visit he encountered strong opposition to his proposal to build his house above Bonneville: the Burne-Joneses tempted him with a rival project of a house in England, with a walled garden and tapestries that Burne-Jones would design and the girls at Winnington weave on the theme of Chaucer's *Legend of Good Women*.[143] It seemed very tempting, and by 27 September, back in Chamonix, he told Mrs Simon that he had been 'teazed out of my Brezon plan' and put himself entirely in Burne-Jones's hands.[144] But

his father, too, had been putting pressure on him, even intimating that if John stayed in Savoy he would get a goitre.[145] John James urged a Lake District house and encouraged John's former tutor, Gordon, who was travelling with his son, to subject the site above Bonneville and its proposed dwelling to an objective, not to say cynical, appraisal.[146] In the end it was the exorbitant demands of the local councillors that finally put Ruskin off; but the combined entreaties of so many at home, a renewed sense of being wanted by friends in England and a pleasant recall of the fun and games at Winnington or the happy encounters with such as Constance Hilliard, Lady Trevelyan's niece, at Wallington,[147] tempted him to return. He found his mountain solitudes 'more desolate' now;[148] maybe he could live happily close to, say, the Burne-Joneses, except that 'if ever I've let myself get the least bit fond of people, something always goes wrong, and it hurts so'.[149] After some desultory travelling in Northern Switzerland, he headed for Paris and home.

He spent just a week at Denmark Hill and then installed himself for a month at Winnington, where he had many of his valued possessions. He visited Manchester, where Waterhouse's Assize Courts, nearing completion, were 'much beyond everything yet done in England on my principles'.[150] But such pleasures and the delights of his 'playmates' at Winnington could not efface the realization that he had renounced his plans to live abroad without any other option planned; he would be forced back to Denmark Hill. In November he had promised to submit all letters written to the papers for his father's approval, after having withdrawn a dialogue on "Gold" which Froude had asked him to write for *Fraser's*.[151] He was still required to account accurately and in detail for his expenditures, as a weary note to his father from Winnington also reveals.[152] He was irked by having no home where he could invite any children from the school (his father's reaction to the suggestion that they might come to Denmark Hill, even with the elder Ruskins absent, was that it was 'simply impossible').[153] A few days before his return to Denmark Hill for Christmas Ruskin sent a bitter indictment of his parents' effeminate and luxurious rearing of him; furthermore, they had 'thwarted me in all the earnest fire of passion and life':

> About Turner you indeed never knew how much you thwarted me –
> for I thought it my duty to be thwarted – it was the religion that led me
> all wrong there – for if I had courage & knowledge enough to insist on
> having my own way resolutely, you would now have me in happy
> health, loving you twice as much . . . and full of energy for the future
> – and of power of self-denial.

But, instead, he explained that his power of duty had been exhausted and he 'was forced for life's sake to indulge myself in all sorts of selfish ways'.[154] His parents probably did not need the information; and such bitter recrimination hardly augured a very happy Christmas and new year, even though they were all three once again together.

Chapter 16

'Busy again': 1864–1866

And I am working at mythology and geology, and conchology, and chemistry, and what else there is of the infinite and hopeless unknown to be stumbled among pleasantly . . .
Ruskin to Norton, 10 October 1865

the open Sesame of a huge, obscure, endless cave, with inexhaustible treasure of pure gold scattered in it; the wandering about and gathering of the pieces may be left to any of us – all can accomplish that; but the first opening of that invisible door in the rock is of the imagination only.
Modern Painters II

In late February 1864 John James fell ill; he died, at the age of seventy-eight, on 3 March. Ruskin held his father in his arms through the last day and night of delirium.

His feelings were inevitably mixed, little helped by the conflicting responses of his friends. Froude, for example, evidently wrote warmly about John James and conventionally about Ruskin's behaviour towards him. Acland, 'one of the very few who might have understood' the relationship between father and son, annoyed Ruskin by supposing that 'I ever spoke so as to cause my father much sorrow'. In March Ruskin was altogether aware of how much wrong he had done John James ('all the occasions, and they were numberless, on which I might have given my father pleasure by the mere expression of my love for him, and never did'). His boredom with two business letters which his father had wished him to hear the evening before he fell ill disturbed him in retrospect. But the perplexities of his whole reaction he could only begin to express, even to Acland: 'the loss of a father who would have sacrificed his life for his son, and yet forced his son to sacrifice his life to him, and sacrifice it in vain'.[1]

Ruskin hated funerals, persuaded his mother not to wear the usual widow's cap,[2] and buried his father quietly. After the usual dates on the tombstone he recorded that

He was an entirely honest merchant,
and his mercy is, to all who keep it, dear and helpful.
His son, whom he loved to the uttermost
and taught to speak truth, says this of him.[3]

However much and in whatever complex ways he mourned his father, Ruskin also determined to live up to the personal motto, TODAY TODAY TODAY, which he had chosen the previous year.[4] He had realized then and for some time before that how late he had been in discovering his youth and his choice of life ('Wrong at both ends of life'); now he would commit himself as strenuously as he could to the present. He suddenly found himself head of the family, a position which he had invoked metaphorically to describe the ideal governor in *Unto This Last*.[5] He began to seize its opportunities as well as assume its obligations.

He told the Winnington girls that on 16 March he had, as 'papa', given his first directions to the gardener at Denmark Hill – not to kill or disturb birds, not to prune a tree except for the tree's sake, and to 'go in for *plenty* of flowers'.[6] Such daily rituals of instructing the servants could not be neglected, and when he needed to visit Bradford to lecture in April he even asked whether Lady Trevelyan would come and 'look after the house and the gardeners for a day or two . . . No – it wouldn't do – my mother would bore you'.[7] Instead a seventeen-year-old cousin, Joanna Agnew, 'a good cheerful girl',[8] came for a week and stayed for Margaret Ruskin's and her son's lifetimes. There was much to do which he was 'little used to doing';[9] but Joanna quickly and gradually released him from many of the chores.

Margaret Ruskin took her husband's death with her customary resignation to God's will; but she became her son's major and dreadfully demanding responsibility. With little things – an order of lace from Lady Trevelyan[10] – he was extremely patient; but was sharp and quick to resentment when she criticized his residence at Winnington, which he visited six times that year ('you do not, and cannot understand any of my feelings to the people here . . . you could no more be written to . . . about them than about people in the moon'[11]). She ruled the domestic economy of Denmark Hill so tightly that her son was forced to seek permission to absent himself for evenings up in Town and was occasionally frustrated when he wished to invite friends to visit him.[12] Often, when he was able to receive them, she would treat him like a little boy.

In one department he was now his own master, finances. Except for Denmark Hill itself and a bequest to Mrs Ruskin of £37,000, Ruskin inherited a considerable fortune (more than £120,000 in cash,

plus property and pictures valued at over £10,000). No longer obliged to account in meticulous detail for all his expenditures he began to support causes for which John James would have had little sympathy: he financed some of Miss Bell's needy pupils, sent money to a 'poor . . . mad' preacher who had summoned Ruskin to become an apostle, and with £50 set Miss Bell's German master 'to rights' ('a sadly unsatisfactory way of spending money').[13] It was evident that with the ideas and theories he was articulating in *Unto This Last* and *Munera Pulveris* Ruskin was embarrassed with so much capital; 'voluntarily and involuntarily', as Derrick Leon remarks,[14] he began quickly to disburden himself of it. He soon lost nearly £20,000 in selling stocks and buying defective mortgages, gave away large sums to various members of his father's family not mentioned in the will, and sought almost any opportunity for benevolence. Octavia Hill, with whom he had been friendly for some years, found herself the recipient of one of his more sensible benefactions: needing money to rehabilitate slum dwellings and give back to those who lived there some joy in clean and decent surroundings, she received what she required on the understanding that the tenement be made to pay. For Ruskin was clear that in this case at least his money would further the principles of his political economy: 'that proper use of money would give proper interest' and that new relationships were possible between tenants and landlords.[15]

The main burden of his new existence at Denmark Hill ('We are getting on pretty well', he told Lady Trevelyan in April[16]) was that he could not work. He spent much time in the garden, re-shaping some of it for his convenience.[17] And he put his minerals 'into lovely order – bettering and rejecting as I can'.[18] By the end of June he was getting up to the British Museum 'every other day' to study Egyptian antiquities; by September this 'Egyptian work' had led him 'into such a abyss of things I want to think over quietly'.[19] Visits to Winnington continued to give him solace and an escape from responsibilities at Denmark Hill. He played blind man's buff, plagued 'out of my poor little halfwits' by the girls' exchanging identifying objects, and at term's end he was overwhelmed by their goodbyes ('they've kissed me all to pieces – the prettiest of them make their lips into little round Os for me whenever I like – as if they were three years old'). He taught them a range of subjects, intricately mixing and cross-referencing them, as he would do the next year in *The Ethics of the Dust*, which so evidently captures the strategies and sleights of his teaching at Winnington and about which Carlyle observed that crystallography, the ostensible topic, 'twists symbolically in the strangest ways . . . into morality,

theology, Egyptian mythology, with fiery cuts at political economy'.[21] Ruskin delighted, too, in pleasing as well as instructing them; at his invitation the famous Manchester pianist, Charles Hallé, gave a concert at Winnington, and in *Cestus of Aglaia* Ruskin likened the enraptured audience for Hallé's variations on "Home, Sweet Home" to a della Robbia porcelain of child-angels:

> The wet eyes, round-open, and the little scarlet upper lips, lifted, and drawn slightly together, in passionate glow of utter wonder, became picture-like, – porcelain-like, – in motionless joy, as the sweet multi-tude of low notes fell in their timely infinities like summer rain.[22]

Yet the permanence of artifact was not what his or Miss Bell's teaching could achieve – 'one shapes them all prettily and then they go to pieces'.[23]

Maybe he was thinking of Rose La Touche, his 'old pet', as he put it in December 1864.[24] But it is difficult to believe that she 'filled his thoughts' this year.[25] He grieved at her continuing sickness, and on his birthday in February he wrote to George MacDonald 'my Mouse-pet in Ireland . . . nibbles me to the very sick-death with weariness to see her'.[26] Rose wrote him 'only a short note or two',[27] but his recollection of that fact two years later when his passion for her revived cannot be used to colour the months of 1864 when his main interests seem to have been with the birds at Winnington. His communications with the La Touches continued to be largely through correspondence with Rose's mother, who transmitted messages and little presents from her daughter,[28] but who was herself the promoter of these contacts.

She was particularly interested in Ruskin's early experiences of spiritualism, to which he had been introduced by Mrs Cowper. Despite Carlyle's opinion that 'Spiritualism is real witchcraft',[29] Ruskin was willing to explore it, though at present sceptical. He attended séances conducted by the American medium, Daniel Dunglas Home, but reported to Mrs La Touche that the spirits' messages were trifling. Doubtless she hoped that Ruskin might recover some faith even by this route ('if all this be true, and if Christianity be also true, are not all these phenomena connected?'[30]). Certainly, Ruskin was ripe for some clear affirmation of spiritual life, some declaration in fresh forms of beliefs he still held; but his early comments to Mrs Cowper, though studiedly polite, remained cool. The 'ghosts' were not sufficiently 'explicit' for him and he was particularly unimpressed by their poor spelling ('I expected at least, when I got old . . . that at least I should be able to rightly spell').[31]

Ruskin's energies were channeled now into more lecturing and

political economy, the activities and themes he could pursue without his father's disapproval. Although in April 1864 he had been unable to work, by the end of the year he had apparently recovered something of his old zest and application. He even seemed to have lost an enthusiasm for travelling ('I hate the sound of packing now'), preferring to 'get away home to read'.[32] He lectured at Bradford in April on "Traffic", twice publicly at Manchester on books and on women's education (lectures which became *Sesame and Lilies* the next year) and once to the boys of Manchester Grammar School.[33] Increasingly now the paternal censorship was removed, he sent letters to the newspapers: in late October and early November some particularly controversial ones on the law of supply and demand appeared in the *Daily Telegraph*; there were more in following years. Those for the *Telegraph* were 'games . . . that may take me a good deal of time', he told Lady Trevelyan.[34]

The renewed activity in correspondence columns and on lecture platforms marks the beginnings of a fresh effort by Ruskin to elaborate adequate forms in which to speak to those he hoped would listen and learn. It was a complicated process of adapting topics to audiences, insinuating himself into subjects by familiar or innocuous-sounding routes and then springing surprises on his listeners or disconcerting their expectations. We can see something of his thinking about these strategies in his annoyance after the first Manchester lecture that only 'little ridiculous bye sentences' got reported, whereas he wanted them 'printed directly in full', or in his concern that the second lecture had perhaps 'hit them a little as far as Manchester people *can* be hit', or in his acute awareness that to repeat the lectures at Winnington, as he was required to do, would entirely miss in effect.[35] He was developing a surer sense of occasion, too. At Bradford, where he had been invited to 'talk to [My good Yorkshire friends] about this Exchange you are going to build', he told them he did not care at all about their Exchange because they themselves didn't.[36] Yet he had come, rather than refuse their invitation, in the hope that they would be patient and let him explain. From this disarming introit he set off on what amounts to a recapitulation of all his work to that date, about which his Yorkshire audience might not care either (except that they have heard of him as 'a respectable architectural man-milliner' who might tell them 'the leading fashion') but which was precisely what Ruskin himself wanted them to care about.

The method is both ingratiating and tough – footnotes later added to published versions draw readers' attention to the tone of his writing, to its care, or to similar references elsewhere in his works. The

constant manoeuvre throughout "Traffic" and other similar pieces of the 1860s is to refuse to discuss matters on the expected ground, to shift his territory, but in fact return obliquely to the discarded subject in a context that enlarges the original question and authorizes his barely concealed satire:

> I can only at present suggest decorating [the proposed Exchange's] frieze with pendant purses; and making its pillars broad at the base, for the sticking of bills. And in the innermost chambers of it there might be a statue of Britannia of the Market . . .

and so on, with invented heraldic attributes. It is one of Ruskin's famous outbursts, which is usually applauded at least for its cheap quip. But the suggested iconography of the new Bradford Exchange comes out of Ruskin's reiteration and illustration of his old maxim that 'Taste is not only a part and an index of morality; – it is the ONLY morality'. And another skilfully rhetorical strategy which he employs is to translate abstract into concrete and concrete into abstract in order to prevent his listeners from stereotyped assent to any notion. His very title, "Traffic", which we must wait until well over half-way through the lecture to understand, turns out to be abstracted from 'trafficking'; the innocent and rather vapid idea then gets turned sharply, with ironic respect, upon his auditors – 'you traffickers, and exchangers, and others occupied in presumably benevolent business'. Conversely, he particularizes Joseph's dream, so that some Bradford lad on his way to Carlisle sleeps on the rough ground of Wharnside between Hawes and Brough, whence he sees the ladder ascending into heaven; against this illumination of the spirit at any place or at any time he juxtaposes the chapels and churches of Bradford with their legends, "*This* is the house of God and this is the gate of heaven". And why, he asks, do they build their churches and chapels in the gothic style, but never their mansions and mills ('now you live under one school of architecture, and worship under another')?[37] The tone is always shifting, the address now direct, now more general, the topics seemingly invoked at random and at speed. But Ruskin's own traffic is anything but careless or self-indulgent, as he says theirs is. His whole insistence that taste cannot be divorced from morality nor chapel style from mill style nor architecture from national beliefs and concerns is mirrored, revealed, in his own inclusiveness. His first editors, Cook and Wedderburn, write about Ruskin's range of subject matter at this time of the later 1860s and early 1870s, but neglect Ruskin's determination to make them somehow one:

He talks and writes of books and how to read them; of the sphere and education of women; of soldiers and their duties; architects and their functions; servants and their loyalties; masters and their duties. He discusses now the elements of crystallisation or the denudation of the Alps; and now the merits of the manner in which the Jamaica insurrection was suppressed or the policy of non-intervention in European quarrels. He treats of the mythology of Greece, and of Egypt and devotes much attention to Greek art, but touches also upon the designs of Burne-Jones, the pictures of Phil Morris, the porches of Abbeville, the tombs of Verona . . . he passes from the designs upon Greek coins to the management of railways . . .[38]

But it is just Ruskin's problem that he cannot 'pass' from one to the other; such trafficking simply confirms the fragmentary nature of the modern world and its 'specialisms'. Obsessed as he was with museums in which everything was displayed and with cabinets where all curiosities had equal status, Ruskin urgently sought to persuade others of these absorbing wholes. Yet the very techniques of writing and lecturing frustrated him; he was indeed often forced to 'pass' from one topic to another. In the printed version of a lecture at University College, London, in 1869 he lamented how 'I am compelled, for clearness' sake, to mark only one meaning at a time'.[39] But he was also beginning to develop his resources, as far as it was in the nature of verbal language and syntax, to combat those obligations of sequence. In the 1864 lecture at Bradford he raises most of the issues that Cook and Wedderburn list, and he 'passes' from aesthetics to morality to philology to commerce to mythology and theology. But he is constantly at pains to satirize divisions (recalling Swift's distinction between nominal and real Christianity in *An Argument*): making money is divorced from wise knowledge of how to spend it; 'the Goddess of Getting-on, to a thousand families she is the Goddess of *not* Getting-on'; the ruins of Parthenon or Bolton Abbey (Turner here being silently invoked to rebuke Yorkshire) versus the mills and machinery, endlessly turning; sacred churches versus a disregard for the sanctity of the 'whole Earth'. What he stigmatizes as 'merely ecclesiastical purpose' is shown to be separated from the larger community; gothic architectural style is merely 'the hieroglyphic writing of an initiated priesthood'. In more positive vein he also utilizes his fondness for argument by (often wickedly distorted) analogy and his interest in philology to secure some appreciation of the indivisibility of life. Two neighbours stockpiling arms to maintain friendship in a balance of power over their garden walls, by a shift of emphasis just at the point when the ridiculousness of the imagined scene has sunk in, is used to

describe warfare between nations. The responsibilities of kings and kingdoms, sketched out in such a way as to receive his audience's ready assent to their validity, are switched suddenly to millowners and their empires. By coining words ('hateliness' to oppose to 'loveliness') or by probing their origins Ruskin opens out a topic into many more aspects than it had apparently contained:

> The first Greek idea of deity was that expressed in the word, of which we keep the remnant in our words 'Di-urnal' and 'Di-vine' – the god of Day, Jupiter the revealer.

"Traffic" is a supreme example of Ruskin's effort to unify responses towards a whole life and to bring together nations otherwise divided. But the energies devoted to such a lecture – and no wonder he had so little time for anything but writing at this time – have roots deep into his own life and its history. This need to see unity not division and the search for rhetorical ways in which to communicate the wholeness were an extension and expression of his own resolve, at the age of forty-five, to pull his life together. His remarks at Bradford on the priesthood of all have a familiar ring from the days when he argued himself away from entering the church.[40] But there was a new urgency in uniting aesthetics and political economy, spending and storing, because he was now for the first time in his life, he thought, in the position where he could set a prime example.

Not all his lectures gave such opportunities for drawing upon such a wide spectrum of concerns. But it is important to notice how hard Ruskin worked at such tactics, either in the composition of volumes such as The Crown of Wild Olive, into which "Traffic" was absorbed in 1866, or in the use of a particular, limited occasion to widen his and his audiences' vision. The two Manchester lectures of 1864 took their cue from, first, the need to raise money for a library in connection with the Rusholme Institute and, second, the wish to set up and equip schools in a densely inhabited section of the city. So he talked about books in the one and girl's education in the other, yet used those themes to unlock a wide range of concerns; their interconnections, the indivisibility of his own pronouncements, were made clearer when he put them both together in Sesame and Lilies. But it is also interesting to observe that on the occasion of the lecture "Of Queens' Gardens" he also visited the boys of Manchester Grammar School, where he made quite explicit that he thought of their lives, both in work and in play, as distinct from and yet part of a larger community. Subtly attentive to local contexts (he reminded his Bradford audience that he had asked them a question on a previous visit to which he had received no

answer[41]), he always enlarged a topic far beyond what his audience might expect; yet he had usually given them titles which, in retrospect, if properly understood, should have alerted his listeners to the *mare maggiore* of themes. Yet since only Ruskin himself could unlock the secret of his titles, what the audience gathered from "Of Kings' Treasuries" and what the lecturer eventually made of it are finally one. So another distinction, between taught and teacher, is thereby eliminated.

There were more public appearances in person and in print during 1865. He published, he had told the Manchester audience, so that his voice might be multiplied, carried and perpetuated; a man's writings were – 'in his small human way' – 'his inscription, or scripture'.[42] But it kept him busy again. He stayed at home, and we have a glimpse of him in December 1864 entertaining Alfred Harris, his wife and the lady who would later become the second Mrs Harris:

> He received us in his own study, a charming room overlooking his garden and a more distant extent of country than one wld have expected to see at Camberwell . . . After luncheon (during which he mentioned how he had been lecturing them at Manchester, saying that the ladies by their extravagance in dress and furniture were committing the sin of neglect of their poor, and afterwards incidentally that women had no inventive power in drawing – his niece was doing geometrical drawing!) after luncheon we examined his Titian portrait of the Doge of Venice . . . Then to the study to look at his Turners; he gave me his arm in grand antique-gentleman style and was courteous to the last degree to me . . . [There follows much recapitulation of pictures and art talk] Mr Ruskin talks like he writes, but less poetically – nevertheless it was like a poem being there in that quiet room listening to his dissertations on Turner's merits and there was an inexplicable charm about it all . . .[43]

But he also paid frequent visits to the British Museum, and had evidently given up the thought of any house of his own ('I think I shall live now pretty nearly at the British Museum'). He resisted several attempts by Miss Bell to get him to Winnington; in the end he paid two visits there, excusing himself from others by the work he was doing – 'I'm obliged to think most carefully and undisturbedly'.[44] 'Three or four businesses at once in writing' as well as seeing first *Sesame and Lilies* and then *Ethics of the Dust* through the press ('very tiresome additions and finishings') kept him fully occupied.[45] And with this renewed bout of publishing on larger social and ethical questions he also began to have his first doubts about the custom of

retail bookselling – 'My father never saw his wine sold so', he told the publisher.[46]

He continued the work on comparative religion which he had begun the previous summer, 'endeavouring to make out how far Greeks and Egyptians knew God'.[47] Although he told the architects of the Royal Institute that he was 'weary of all writing and speaking about art',[48] he nevertheless much enjoyed a visit to see Earl Cowper's collection at Panshanger ('it was like breakfasting in the Louvre').[49] And he wrote a series of papers on varying aspects of art ("The Cestus of Aglaia") for the *Art Journal*.[50] He turned down an invitation to talk on poetry at Oxford ('I hate Oxford – and I don't know anything about poetry'[51]). But he lectured elsewhere: to the Camberwell Working Men's Institute, twice at the Working Men's College, at the Royal Institute of British Architects, and to the Royal Military Academy at Woolwich (on "War"). Besides a paper on Alpine denudation in the *Geological Magazine*, he wrote letters to the *Pall Mall Gazette* (on "Work and Wages"), to the *Reader* (on geology) and to the *Daily Telegraph* (on servants, mastership, sonship, houses, and nationalization of the railways). When *Sesame and Lilies* needed a second edition after four months, he invoked the recent tragedy which befell the first climbers to scale the Matterhorn and reflected widely upon the connections between a 'sincere thirst for mountain knowledge' and the contemporary fad for making Switzerland 'half watering-place, half gymnasium'. And as if not content with the year's actual projects, he was planning an engraved treatise on botany – 'I want to turn botany upside down'.[52] To Norton in America he reported that he was at work on 'some botany of weeds'.[53] He was at one point, like old times, tempted by a vacation in Switzerland,[54] but resisted in order to stay and work. By the end of the year he was also involved with Carlyle and others in the defence of Governor Eyre, who had repressed an insurrection in Jamaica with ruthless severity. After a committee had been formed in England to call the Governor to account, a Defence and Aid Fund for him was set up with Carlyle, Tennyson, Kingsley, Dickens and Ruskin among its activists. The final letter Ruskin sent that year to the newspapers appeared in the *Daily Telegraph* for 20 December; in voicing his support for Eyre he aligned himself with 'lordship' against 'liberty' and typically used the occasion to enlarge upon the notions of slavery he had offered in *Munera Pulveris*.[55]

So committed to public life and to publication, Ruskin found his private life less demanding as well as less fruitful. Relations with Rossetti deteriorated further.[56] Some of the Winnington girls were invited to stay at Denmark Hill (quite impossible in John James's day),

and Mrs Ruskin seemed to find their company pleasant; her son, to his chagrin, got a bad cold ('I might as well have sent them to the London Hospital to be nurses'[57]). But it was one way of preventing his mother's jealousy of the time he spent at Winnington.[58]

Rose, too, gradually recovering health after her illness, was 'saying spiteful things of my going to Winnington. I never knew her jealous before'.[59] Vexed that she was not in London with her mother in January, he seemed generally far too busy to pine or even think much of her during the succeeding months. In July he told a correspondent that he was 'pretty well – that is to say, *half* dead, only – enjoying half – hoping one hundreth, and doing about the thousandth – of what I used to be able to enjoy – but I'm pretty well, and have been dissecting peaseblossom all the morning'.[60] He took 1865, as he told them at Winnington, 'day by day'. Perhaps he had simply resigned himself – 'I never care for anybody in the least but they fall ill – or are taken from me, somehow'.[61] Mrs La Touche had enjoyed her visit to London, attending one of Ruskin's lectures with the MacDonalds; but back in Ireland she found her existence extremely tedious and wrote eagerly to know how Ruskin's other talks went.[62] In December all the family came over. Ruskin met Rose for the first time in three years on Sunday 10 December. Six days later he took her to the British Museum. On 21 December she visited Denmark Hill, where he had tidied up the garden in her honour.[63] Ten days of her presence in London made him very nervous – it 'put me out, variously'.[64] One way in which he was put out, as he told Lady Trevelyan, was simply that she distracted him from his mineralogy.[65] But another was the evidently fascinating picture which she presented to him after long absence: grown tall – 'the kind of figure I like best in girls' – Rose combined maturity that hinted of womanhood without losing the girlishness that was Ruskin's strongest memory of her.[66] Her tomboyishness – a constant theme and even anxiety of Mrs La Touche's correspondence in 1865 – was still strongly emphasized in her wild playfulness: when she came to Denmark Hill on 21 December she stole crystals from the bed of a stream Ruskin had constructed among the laurels, loosed the dog 'whether I would or no, and petted the calf in the stable till she drove me wild'.[67] With this tempting 'squirrelness' Rose also maintained a solemn and hungry appetite for spiritual discipline – 'So I went, & I worked for Jesus', as one of her verses put it.[68]

Ruskin was obviously swept once again into a sea of strong feelings. Sometime on or just after 3 January, Rose's eighteenth birthday, when he took her down to dinner, he proposed marriage. All our information about this climactic event is retrospective, inevitably

tinged with Ruskin's habitual manipulation of his biography to suit current mood or idea. Thus in October 1866 he wrote to tell Acland that throughout the three years' absence from each other and despite parental opposition Rose 'held quietly to me, without saying much – but quite steadily – they did not know how steadily – and thinking they had it all their own way, brought her up to London last winter to bring her out. They could not wholly keep her from her old friend'.[69] But both parental opposition and a steady constancy of devotion during those three years seem extrapolations after the event. What *is* clear is that in December 1865 and the early days of January 1866 he and Rose became suddenly absorbed in each other all over again. His account of her birthday dinner, though given seven years later to Acland's daughter, does ring true: Rose was very happy and 'talked to me and nobody else, and I talked to her, and nobody else. (– and her mother put up her eyebrows to Joan every now and then – and looked at us out of the side of her eyes)'.[70]

Ruskin was always eager not only to hold on to the present securely but also to ensure that somehow it was taken forward unchanged into an unknown future. Sometimes he organized this in pictorial visions, as he had often done at Winnington, and as he did in 1866, writing to Burne-Jones with perhaps not altogether unconscious Pre-Raphaelite iconography, about Rose, 'bareheaded, between *my* laurels and *my* primrose bank'.[71] But their mutual absorption on her birthday must have needed, at least on Ruskin's side, some more exacting and formal shape in human rather than artistic terms. The conventional one was marriage, and for all his radicalism of the 1860s Ruskin was the child of unalienably middle-class parents. Denmark Hill itself, where he apparently proposed to Rose, breathed such conventions. So, despite the disparity of their ages – forty-seven and eighteen – he invoked perhaps the only means he could to perpetuate their mutual attraction: he proposed marriage.

Above all, Ruskin wanted 'leave to love'.[72] It apparently mattered less whether that love was returned, provided *his* could find a permanent focus: 'I want . . . the sense that the creature whom I love is made happy by being loved: That is literally all I want . . . I don't care that Rosie should love *me*: I cannot conceive such a thing for an instant – I only want her to be happy in being loved.' After such a frankly selfish confession it is no surprise that his correspondent, Mrs Cowper, needed some reassurance – 'perhaps you have been a little surprised at my not speaking more of the deeper reasons for my love of her'.[73] But even the terms of his reassurance ('the strong, stainless, – grave heart – the noble conscience – the high courage – the true sympathy with me

in all hopelessness') confirms one's sense that his own affection saw itself in terms of pure abstraction. Like the abstractions of his social theories, it needed some specific and concrete realization, which Rose was thought to provide. 'The love of her is a religion to me'[74] also conveys both this ideality and the opportunity Ruskin thought he had at last found to channel his spiritual yearnings into new forms.

Rose apparently did not answer his proposal immediately. But on 2 February 1866 – 'getting me to herself here in the garden' – she asked whether he would wait three years for her answer. Ruskin wanted to know whether she realized what age he would be in 1869, and she said that she did.[75] So, although he later gave her the opportunity to change her mind, they agreed to abide her decision in three years, by which time she would have come of age.

Ruskin spoke to Rose's mother and tried to talk with Mr La Touche; she 'seemed displeased and very reluctant' and he merely evaded the subject.[76] From the one he would have encountered strong opposition on account of their divergent religious views, and in these matters Rose was fully her father's daughter. But when Ruskin heard from Mrs Cowper that what Rose's father most feared was losing her, he simply chose to interpret this obstacle in practical ways ('He might live with us – or have us to live with him') never thinking for a moment that Mr La Touche's anxiety was rather the losing of his daughter to Ruskin's religious persuasion.[77] The hostility of Mrs La Touche arose undoubtedly if unconsciously from jealousy, when she found her own devotion and dedication to Ruskin returned by affection for her daughter. But Ruskin could not understand this new attitude: she puzzled him 'terribly. She *was* ever so nice, once'.[78] Yet the parents did not, as Ruskin wearily complained to Mrs Cowper, prosecute their objections decisively.[79] They gave 'reluctant permission' for their daughter and Ruskin to 'continue in any shadow of our old ways'[80] – significant emphasis, implying his need to maintain *former* habits into the future. But in other, more evasive ways their opposition was made clear, and there began for Ruskin an endless scrutiny of all remarks or chance social actions for some clue as to the final outcome.[81] Every action of Rose's, too, was analysed for its ultimate significance, with Ruskin little realizing how much the girl's own uncertainties and position made her often seem less than fully committed to him: 'She was terribly hard to me yesterday however – only gave me one little syllable of comfort – I suppose it was because her father was watching.'[82]

The three months of 1866 before the La Touches returned to Ireland ('Rosie's going away on 2nd April – and I'm afraid I shall be

very bad'[83]) brought only intermittent happiness to Ruskin. In his search for comfort and for a more satisfactory relationship with Rose's parents he grew more and more to depend upon Mrs Cowper's evident sympathy for his cause. It is one of the ironies of Ruskin's life that she turned out to be that Georgiana Tollemache whom he had been content to worship at a distance in Rome in 1840;[84] now he employed her feverishly to bring him nearer to Rose. He promoted contacts between the Cowpers and the La Touches, suggesting to his English friend how she might engineer her dinner parties so as to eliminate possible awkwardnesses (this meant *not* inviting Rossetti, and not a Captain Drayton, for 'we mustn't have more evangelical-ism') or how she might bring him and Rose together as if by accident.[85] Her intercession, for which he compared her to 'my Madonna and Stella Maris', was not disclosed to Rose.[86] He believed that the La Touches 'treat us so as to give *her* the greatest possible weariness – and me the maximum of pain – contriveable by human art'.[87] Weariness and pain, as well as some dazzling moments of pure delight ('when I can be near her without having to talk'[88]), were to be the staple of his existence for many years, despite the aid of those alternative human arts that friends like Mrs Cowper could provide.

Chapter 17

'Proserpine permitting': 1866–1869

all love is good – even when it kills – for it kills into a pure marble – not into wormy dust

Ruskin to Mrs Cowper, [March 1866]

Si cette enfant m'était confiée je ferais d'elle, non pas une savante, car je lui veux du bien, mais une enfant brillante d'intelligence et de vie et en laquelle toutes les belles choses de la nature et d'art se refléteraient avec un doux éclat. Je la ferais vivre en sympathie avec les beaux paysages, avec les scènes idéales de la poésie et de l'histoire, avec la musique noblement émue. Je lui rendrais aimable tout ce que je voudrais lui faire aimer.

Anatole France, *Le Crime de Sylvestre Bonnard*, a passage marked by Ruskin

Before Rose and her family departed for Ireland in early April 1866, Ruskin had decided 'to run to Venice & back in about six weeks', taking Joanna Agnew as well as Constance Hilliard, if Mrs Hilliard could manage to come too.[1] By mid-April he was talking of 'a run to the Alps to recover a little for she [Rose] is back to her bogs'.[2] A 'little spring wandering'[3] would be a relief after three intense months of emotional excitement and uncertainty. But his mind was to be diverted from his own problems more sharply than he had anticipated.

The excursion was changed in late March to include the Trevelyans, who planned a trip abroad for Pauline's health; they would at least all travel to Paris together; then they agreed to extend the journey to include Switzerland and the Italian Lakes.[4] Lady Trevelyan, unwell before they started, fell ill at Paris; within three weeks of their leaving London, at Neuchâtel on 13 May, she died. Though Ruskin had, not altogether unfacetiously, set out his conditions for travel with the Trevelyans before they left – that he would drink wine if he wanted to, that the two girls, Joanna and Constance, were to be *his* companions, that he disliked talking at meals[5] – he responded with quick and

unselfish sympathy to the tragedy. Ruskin was at her bedside, together with Sir Walter, when she died; when he expressed his gratitude to them for being there, for he had not realized they cared so much for him, Trevelyan replied, 'Oh, we both esteemed you above anyone else'. With an effort, his wife said, 'He knows that', which were the last conscious words Ruskin heard his friend speak.[6] He was able to comfort and keep Trevelyan company for a couple of weeks after Pauline's death. He even returned for a day to sketch her grave, a watercolour version of which, showing Neuchâtel with a prospect of lake and high hills, was presented to Sir Walter and still hangs at Wallington.[7]

Despite this unhappy end to the joint holiday – and there had been further sadness, too, at the very start of their trip, when news of Mrs Carlyle's death reached him (he wrote to Carlyle from Dijon) – Ruskin worked hard and successfully to give his two 'children' an enjoyable first sight of Europe. From a brief visit to Mme Huret, now a widow, and Ruskin's godson at Boulogne, through Paris, and into Switzerland, where the girls were enchanted by peasant costumes, he showed them what he found most attractive. He himself thought almost everywhere was in 'unspeakable degradation'; only Thun, amazingly, was unchanged.[8] Around Giessbach, too, he was enchanted:

> Of immediate pleasantness, in surrounding things, I have enough [he wrote to Mrs Cowper]. This place (–south side of Lake Brientz), is quite a wilderness of Elysian fields in the springtime – and the Swiss people of the valley of Masli are the best I've yet seen – modest – dignified – kind: – and I've two bright girls with me . . . only now that I'm left alone with them every breeze and sunbeam frightens me lest they should get ill . . .[9]

Despite such anxieties he obviously enjoyed the temporary distractions and being away from England; he told his 'secretary', Charles Howell, to send him only the most essential business and, borrowing Pope's words to his friend Arbuthnot, to 'Tie up the Knocker – say I am sick – I'm dead'.[10] He brought the girls safely back by mid-July, but he returned himself to renewed unease and generally poor health.

Waiting for Rose, as he had realized in March, was easy enough; it was the waste of three years which irked him. If she could have 'cast me into the dark at once, without too great pain to herself', he thought it would have been better; but she did not, and the 'languid and anxious' waiting drained him.[11] Above all he was plagued by doubts as

to how he should interpret Rose's actions; as he wrote to Mrs Cowper in March or early April, 'the thing which makes me so unhappy is that I cannot know or discern how far she is acting in mere pity for me – nor do I feel clear in my own conscience as to how far my hope of being able to make her happy would justify me in making final effort to win her, contrary to the wish of her parents'.[12] But his uncertainties were compounded when the La Touches decided to prevent Rose writing to him at all, though what especially provoked him was it had been done for his own good.[13] Now he was dependent 'for a syllable or two – worth a good many words' upon what she communicated to Joan, to Mrs Cowper or, on one occasion, to his mother. But the anguish of rightly understanding such oblique messages was at times acute.[14] To the man so confident in the interrogation of verbal roots and meanings in his public works or before the girls of Winnington, the frustrations over Rose's meaning were agonizing. It explains perhaps the astonishing torrent of letters that he unleashed that autumn upon Mrs Cowper. Tetchy, impatient, importunate, wheedling, fluent in self-pity or exaggeration, as he tried desperately to establish the truth of Rose's love and of her parents' intentions, the verbal bombardment was ultimately directed against the implacable ambiguity of his case. He was shrewd enough at times to realize it; but the passion for certainty where no certainty easily existed drove him on past such moments of insight. At one point he even sent a selection of Rose's *old* letters to Mrs Cowper so that she 'may see a little what the child has been to me for so long'.[15] But the securities of old language could not settle the imponderables of present discourse. So, just as he had wanted Mrs Cowper to *see* the old Rose in her letters, he now wanted her to go to Harristown and find out for him whether he '*ought* to be patient'.[16]

He recognized himself that the La Touches' refusal to let Rose communicate normally with him only increased the uncertainties.[17] Yet he was often unable to act upon that knowledge, or would let half-truths prevail, as when he relied upon Rose's religious 'fancies' being connected solely with her previous illness and therefore eventually liable to pass away.[18] In his helplessness he looked to both Joanna and Mrs Cowper to act as interpreters. The La Touches had fostered a friendship between Rose and Joanna by inviting her twice to Harristown, once before the continental trip, then again in August. When Joanna was with him Ruskin at least gathered scraps of intelligence about Rose; when she was away he seemed starved of news. And by the time she returned from Ireland in mid-September she was more or less engaged to Percy La Touche.[19] So he turned once again to

311

Mrs Cowper and proposed that she go to Harristown and find out how things stood:

> you *alone* can find out for me whether Rosie is acting only in childish love and pity, or whether there is indeed any feeling on her side, deep enough for me to trust to . . . There is yet another element I want to know – the degree of absolute final resistance which the father would offer – and the mode of it . . .[20]

Mrs Cowper evidently protested at the clandestine nature of the proposed spying trip; she might as well have protested against the virtual impossibility of ever discovering answers to such questions. The precisely categorizing temper of Ruskin's social and economic visions of the 1860s, though he must have thought it translatable into the intimacies of human relationships, was incapable of such an extension. Mrs Cowper was in the end persuaded to go; she brought back, as might be expected, little or no definition and clarity. Ruskin received just brief comfort from the thought that she had been and talked to Rose. In more desperation he must have sent further letters from Rose directly to Harristown as proof of her affection.[21] The reply he received from her father was 'insolent' and kept him awake that night.[22] He ended the year in misery: 'The worst Xmas I ever past'.

Since his return from the continent in July he had discovered little consolation at Denmark Hill. Its collections bored him, though he spent much time in putting bookshelves and minerals into order. He was plagued by calls upon his charity ('begging letters all through the week'[23]). He resisted invitations to Winnington, pleading ill-health and inability to talk to the girls if he did come.[24] But he paid and received desultory visits. A vow, communicated to Mrs Cowper in May from Switzerland, that he would write no more for the three years of waiting for Rose's decision, was not entirely observed, especially the next year.[25] True, he declined to let his name go forward for consideration as Professor of Poetry at Oxford in succession to Matthew Arnold; but he spoke to the Eyre Defence Fund Committee in September, spending a long time working on his speech, and he talked on natural science at Harrow School. His diary in November records plans for a new book on geology. At least to the distant Norton, though he confessed to having been 'seriously ill', he also talked of 'working at botany and mineralogy . . . with some success'.[26] Yet, when his mood changed, he could record in his diary for 10 October, 'Nothing done, any of these dates from anxiety and dreaming'. His doctor friend, John Simon, laughed at him for think-

ing himself 'irremediably ill' and assured him that if he would only 'be happy – and not halt between two opinions' all would be well.[27]

At the start of 1867 he was unwell, and the weather was severely cold. On 19 January he decided not to venture out for an appointment with his dentist, instead sending a detailed analysis of his problems accompanied by a sketch to complain about 'all that mahogany bar round my mouth – merely to hold one bit of ivory at *a*' (see illustration in text). He added that it was like the 'chain of the Alps at Turin in summer, when all the snow's gone except for a dot on Monte Viso'.[28]

The facetious liveliness of the note was a trifle forced, caught as he was between the divided opinions that Simon had diagnosed. His ups and downs over Rose were paralleled by his oscillations between the inertia of private despair and the energies, sometimes forced, of public activity. He gave the Rede Lecture at Cambridge on 24 May – his topic being "The Relation of National Ethics to National Arts" – and received an honorary degree the day before. He talked again on science at Harrow School and lectured to the Royal Institution on "The Present State of Modern Art". Papers on "Banded and Brecciated Concretions" appeared in the *Geological Magazine*. But he was, much more frequently, listless, weary, with slightly impaired vision ('floating sparks in my eyes'), even haunted:

The sense of demons in the dark air, and in the cold – joins strangely with my own bitterness, as if all the black cold [of bad March weather] were sent for me only. And it might have been all so sweet & right & worthy of us all – but for the mere, sheep-like – stonelike stupidity of these Irish people.[29]

The La Touches came to London in February, but forbade any communication between Rose and Ruskin, despite some happy exchanges earlier in the New Year.[30] 'R perhaps within four miles of me', he put in his diary on 5 February. Because of Joan's engagement to Percy she was allowed to see the La Touches, which, while it gave Ruskin news he desperately wanted, made him even more wretched. At the risk of hurting Joan's relationship he wrote to Mr Le Touche begging to see his daughter, but received only a frosty reply; these sharp exchanges continued during the summer.[31] One effect of them was to strengthen Ruskin's determination not to accommodate himself unduly to the La Touches' standards: in a mixture of shrewd self-appraisal and typical egocentricity he wrote to Mrs Cowper that

If our faiths are to be reconciled, it seems to me quite as reasonable to expect that an Irish girl of 19, who cannot spell – reads nothing but hymn-books and novels – and enjoys nothing so much as playing with her dog, should be brought finally into the faith of a man whom Carlyle & Froude call their friend, and whom many very noble persons call their teacher, as that he should be brought into hers; The difference of age is an evil – but *it* never troubles me. It is difference of temper and of general habits of life which are really the things to be considered. I have never seen an unhappy marriage between a girl & old man, when the marriage was really one of affection – the question is – *is* there the affection? For the relations with the Father & mother – the breach *cannot* be wider – on my side at least – and if you have lately had any communication with them – I should think you must have seen it was sufficiently wide on theirs – There is no possibility of reconciliation – contemptuous endurance is all that either of them can have from me – Rosie must come from her country and kindred for me, like Ruth or Rebekah – so she is not worthy of the love I bear her – and she shall see it perish in white ashes rather than ignobly given to her.[32]

Perhaps if he had not been so obsessed with the value of his love his assessment of the difficulties might have more happily won the day. When soon after her return to Ireland Rose fell sick, he tried to reach her by letter, yet was rebuffed by Mrs La Touche. He began then to invent other forms of communication.

314

First, he returned to regular, but unsystematic, Bible readings, randomly seeking directions and messages for the conduct of his life in chance openings in the Book. His diary throughout 1867 notes the particular passage upon which his attention was focused each day: 'it is strange. It seems always to strike me where I need to be struck, & to comfort me when I need comforting (more than always)'.[33] The meticulous interpretation of Biblical language for the Winnington girls, itself the fruits of his own mother's daily Bible study with him as a young boy, now seemed to yield some security to his troubled emotions. He thought that he could follow Rose's direction of his life by careful scrutiny of the chance messages which the Bible communicated. It is an occupation, as anyone knows who has tried to cast a horoscope in the *trouvailles* of library shelves, that becomes compulsive. Soon he extended his search for the secret cyphers to other literary works like *The Bride of Lammermoor* or *Atalanta in Calydon*.[34] More confident now, if fitfully, of the strength and reliability of the word, he started carrying one of Rose's letters between thin sheets of gold in his pocket.[35] And he found her and her messages everywhere: sometimes his dreams resisted easy explanation; but in young girls encountered by chance on a visit to the Lakes that summer or in otherwise unrelated accidents of language and syntax he recovered a Rose otherwise inaccessible to him.[36]

While these were his ways of letting Rose communicate with him, he also devised means of talking to her and her parents. In the public letters he was addressing to Thomas Dixon, a Sunderland corkcutter, and sending to various newspapers he found he could argue his point of view on the scriptural matters on which he and La Touche and his daughter differed. But this method of carrying forward his debate with them, even when they denied him access in letters, is part of Ruskin's larger reassessment of his literary career at this time.

Many factors were involved. For some time, and not just for personal reasons to do with his love for Rose, he had been exercised about the future of his writing: his vow to Mrs Cowper in 1866 to write no more for three years and his telling Margaret Bell that the 1867 Rede Lecture would be a 'present ending of words'[37] were indications of a basic dissatisfaction with the forms and conventions of lecturing, writing and publishing that he had so far employed. The preface to *The Crown of Wild Olive*, one of the most important statements of this time and one which he was particularly pleased that the public orator at Cambridge singled out for praise in conferring the honorary degree,[38] had announced his real difficulties with addressing

audiences; when he did not know their assumptions about basic ideas he could not gauge their reactions to what he would say and this in its turn affected the whole discourse. It is a familiar problem for all lecturers; but Ruskin's eagerness to talk to large gatherings, yet treat them as if they were small groups of children he could be teaching in a study, made the dilemma more acute. Yet he now also rejected both the private tuition he had often given and the work at Winnington.[39] Significantly, what he had come to regret about the latter was that his teaching had never permeated much beyond the classroom:

> There was great interest and excitement at the time, – but they did not go on with anything by themselves at home – Perhaps I am unjust and less might have been done otherwise – but I was wholly disappointed – they would all draw – or break stones, or do anything in the world, as long as I looked after them, – but it was only in affection, and ceased, when they were left to themselves.

The need to spread his personal influence more widely, beyond the immediate social occasion which authorized it, was therefore an urgent need. And finally, among this complex of reasons which led him to reassess his career, was the sense that somehow his love for Rose and the dilemmas which it posed had accentuated a deplorable division between his public and private selves.

He had never hesitated in the past to invoke private events and themes in his public utterances. *The Ethics of the Dust* had translated into public fiction the facts of the private teaching at Winnington. Since his father's death had removed domestic censorship from his public pronouncements, he had found them a congenial form of often highly personal expression. During his recent attempts to purchase land in Chamonix he had apparently upset local opinion; his reaction had been to 'write a simple statement of the facts, and of my feelings to them [the local inhabitants], and have it put in good French and print it, and send it for whosever cares to read it'.[40] Now in 1867, when Thomas Dixon wrote asking him for more information on his political economy, he chose to answer publicly. At first he used the columns of the *Scotsman*, then of the *Leeds Mercury*, the *Manchester Daily Examiner and Times*, and the *Pall Mall Gazette*; the revised letters were published in book form in December, 1867, with the title *Time and Tide*. Only later did he extend the method, as he had proposed with the Chamonix letter, and issued the letters of *Fors Clavigera* on his own initiative and expense, retaining 'complete command over the mode of publication'.[41]

Thomas Dixon was something close to Ruskin's ideal of the working man: a skilful craftsman, an enterprising businessman who made enough to retire, a generous benefactor despite limited means, interested in literature and art and eager to introduce young people to them, and willing to extend his own knowledge by correspondence with eminent men.[42] To such a man Ruskin felt able to expound his views in public yet with all the freedom of a private correspondence. And into their dialogue, for Dixon responded to Ruskin's letters, he was also able, as has been mentioned, to introduce something of his other current preoccupations with religious belief. The tone was set right from the start:

> My dear D———, I have sent you the four papers I wrote for *Fraser's*
> . . . I told you I was writing something that would interest you . . .
> but I am too ill at present to do any serious work rightly, and the thing
> has come to a standstill, which I am sorry for; and, besides, there are
> several points in these books of mine which I intended to add notes to,
> and it seems little likely I shall get that done, either . . .[43]

So he writes to Dixon, glossing *Munera Pulveris* (as it would be known in 1872) as the spirit moved him, but also as chance directed ('it chances strangely – as several other things have chanced while I was writing these notes to you'[44]). The directions of chance guided both these letters and his other communications with Rose through the Bible texts.

There was, inevitably, some inconvenience about carrying his private life and contacts so conspicuously into the public domain. Especially in the later publication, *Fors Clavigera*, it gave wide circulation to often embarrassingly private matters. In 1867 an account of a conversation with Carlyle about the bad temper of the London populace was used by Ruskin in one of the letters to Dixon; a workman from Rochdale wrote to Carlyle making further inquiries; Carlyle's reply was published in the *London Express* and a public quarrel flared up between Ruskin and Carlyle, with whom he had developed such close ties during the Eyre Defence work. Ironically, it was precisely one of their personal conversations which Ruskin misinterpreted in public that nearly caused a final breach of the good friendship.[45] It seems to have been quickly resolved.

In mid-year he heard rumours that Rose might be marrying somebody else; but the single rose that he received from her, to show that she had refused her other lover,[46] reassured him. Despite his own problems, Ruskin was especially kind to Joanna Agnew. Her engagement to Percy La Touche ran into difficulties in late February and was

finally broken off in September. He took her out frequently to the theatre early in the year and, while they and Margaret Ruskin were undertaking a 'rest cure' with a Dr Powell at Norwood in September, accompanied her to some dreadful concerts at the Crystal Palace ('to keep her from thinking').[47]

In the middle of the year he took his own form of distraction, spending nearly two months in the Lake District. Surprisingly energetic, he explored extensively, climbing both Langdale Pikes on a 'dreadfully hot day', 12 August. He was, he told his mother, 'absolutely in want of fresh air and idleness'.[48] Although he pretended to be on vacation, and finding interesting stones would give them to Crawley for packing 'without ever *thinking* about it', he was always delighted to discover 'pieces of mountain scenery hitherto unknown to me, and very truly noble – buttresses of rock on the flanks of Grasmoor', which gave a good 'motive for one's walks'. Newspapers particularly annoyed him and he tried to 'think of nothing at all – but Rose – who is everywhere all day long, quietly'. He had with him the Denmark Hill gardener, Downes, to be shown the Lake country. At one point he was tempted enough to inspect a bit of ground where he might have a house built; but the land gave a view of Windermere railway station, so that he realized his study would have to be built facing '*up* to the rocks and the wild-roses'. Among his strange dreams was one of 'getting a house in Cumberland for a pound a year!'[49]

He passed the winter at Denmark Hill. In December Rose was under doctor's care in Dublin, which perhaps explains why she did not send him a promised Christmas letter. Two months later he would tell Mrs Cowper that by failing to reach him then Rose had 'cursed the day for ever to me into darkness with her broken faith'. He roamed 'giddy & wild' on Christmas Day and Boxing day; but he reassured Mrs Cowper that she 'need not be afraid to come & see me though – I am quite at rest – now – writing the history of flint – I shall never write more gentle words'.[50]

The violence and then the flinty calm of that Christmas were the prelude to his third year of waiting for Rose. Now elevated, now depressed, by her own wavering instincts, he was living out more than he had realized the mythical implications of calling her Proserpine. 'Proserpine permitting', he had written to Burne-Jones in happier days:[51] when his loved one was 'with him', all was summer and calm; when she descended into the depths of her own illness or was, as he thought, held down by the hostility of her parents, then all was winter and darkness for him. The year of 1868 saw these vacillations continue and intensify. If his brief moments of content were stronger, brighter,

his despair was blacker, and for the first time he began to criticize Rose severely. This latter mood unleashed upon the patient Mrs Cowper another flood of urgent letters, which their editor aptly describes as characterized by 'disappointment, confusion, false accusation, desperation – temporarily allayed by transient happiness'.[52]

In March he was invited to lecture at Dublin in May. Since he had decided to 'honour the Law of Omens',[53] he knew that it might be a chance of meeting Rose as well as the opportunity, yet again, of using a public event to utter personal messages. Rose was sending occasional words of encouragement and during the weeks before his visit he went through a typical see-saw of emotions. In Easter week she returned a letter of his, which annoyed him; but a fortnight later inscribes the simple word, 'Peace', in his diary, followed, two days later still, by 'Long letter from Rose . . . very happy'. Soon there was another 'Letter from Rose, with all good'.[54] He then told his mother that Rose 'had free leave to write now, what she will' and that she planned to try and see him; 'all as right and nice between us, now, as can be'.[55] But then in Dublin on the morning of his lecture, together with two rose-leaves,[56] came a message that her parents had again forbidden their correspondence, so that he nearly backed off from the lecture; yet at its conclusion he was presented with a mysterious bunch of flowers, 'a large cluster of the Erba della Madonna, in bloom . . . enclosed in two vineleaves and in the midst of it, two bouquets, one a rose half open, with lilies of the valley and a sweet scented geranium leaf, –the other a pink, with lilies of the valley, and a green and white geranium leaf'.[57] He chose to accept this apparently intricately symbolic message as intended to reassure him, the mute equivalent of Rose's remark, even as she tells him she cannot write any more, that this has been 'a happy May for me'.

Faced with Ruskin's persistence and Rose's strong if unstable affections, the La Touches decided in advance of Ruskin's arrival in Dublin to seek from his former wife something that might be used against their daughter: Effie Millais's reply (now lost) apparently suggested that a second marriage for Ruskin would throw doubts upon the validity of the degree of nullity which had separated them and that she would have to make its terms public if such an event occurred; Mrs La Touche responded that they had all been 'saved . . . from so much misery' by Effie's disclosures. In addition, the La Touches took legal advice, which chose to interpret a very tangled point of law as meaning that if Ruskin were to remarry and have children from the second marriage such an event would declare null and void a separation obtained on the basis of his

impotency and therefore make the children of that second marriage illegitimate.[58]

It was in the midst of these dismal exchanges that Ruskin arrived in Dublin to lecture, on 13 May, to a large audience. His theme, "The Mystery of Life and the Arts" (later to be added to *Sesame and Lilies*), must obviously have been written with his difficult relationship with the La Touches in mind; he may even have assumed, during its composition, that they or at least Rose would be there. He incorporated a passing reference to Mrs La Touche's brother ('a man of superb personal beauty and of noble gifts of mind'); but implicitly throughout he glanced at matters of moment between them, from the opening refusal to take notice of 'any separations in creeds', through a meditation upon the relation of words to meaning, to the difficult mysteries which life presented to one who had 'lived long enough to form such just estimate' and was accordingly able to keep disappointments in perspective.[59]

After his lecture he stayed in Ireland, partly because he was in touch with people who saw a great deal of Rose and her family.[60] He even contemplated wandering around Harristown 'on the chance of meeting her on a walk'; but contented himself with prospecting for houses to buy in the vicinity of Dublin. And he proposed taking up Froud's invitation to come and stay with him in Kerry at a later date.[61]

He returned to London, as he had come, via Winnington, which gave him some accustomed pleasures; it turned out to be his final visit. By his arrival in London on 2 June Mrs Cowper had heard from the La Touches of Effie's views. His response to the development of his former marriage and its annulment being used against him was to say, 'all is over'. He struggled hard to convince his friends that he was not indeed impotent, confessing his masturbatory habit ('Have I not often told you I was another Rousseau') to Mrs Cowper as well as to MacDonald.[62] Harristown remained impervious to any approaches; indeed, by the end of the year even Mrs Cowper was receiving harsh letters from Mrs La Touche; when Rose became ill again, Joan and Mrs Cowper were told to communicate no further.

Ruskin had by mid-year steeled himself to 'keep living'; when he could steadily hinder himself from thinking of anything else, he was 'working chiefly at my botany'.[64] He had planned, according to his diary of 17 March, a 'run to Verona', but towards the end of August he left to go as far as Abbeville. Here he stayed, with the exception of an excursion to Paris, for two months and abandoned the Verona Plan. He had Crawley, of course, with him and, for shorter visits, William

Ward and once again Downes, to whom he took pleasure in showing another of his favourite places. He won a precarious battle for some peace of mind largely by 'resuming [some] of my old drawing and architecture work on better and sounder foundations'.[65]

At Winnington on his way back from Dublin in late May he had written to tell his mother that he simply could not decide 'what is best for me to do':

There is so much of misery and error in the world which I see I could have immense power to set various human influences against, by giving up my science and art, and wholly trying to teach peace and justice; and yet my own gifts seem so specially directed towards quiet investigation of beautiful things that I cannot make up my mind, and my writing is as vacillating as my temper.[66]

For the moment the quiet investigation of beauty was the mainstay of his months in northern France; yet he nevertheless – such was his abiding refusal to separate his interests – used some of the time at Abbeville to compose *Notes on the General Principles for the Destitute and Criminal Classes*, which he had printed for private circulation that year.[67] Otherwise he resumed serious drawing ('It isn't Turner – and it isn't Correggio – it isn't even Prout – but it isn't bad'[68]). On 9 September he told his mother that he was planning a book to be called the *Stones of Abbeville*; three days later he agreed with her that the 'quaint title' would not do, but thought 'it likely that . . . I shall give a very thorough account, eventually, of all that is left of northern French cities'.[69]

The first fruits of this determination were embodied early the following year in a lecture to the Royal Institution on "The Flamboyant Architecture of the Valley of the Somme";[70] another fragment of that ambitious and never-realized project was *The Bible of Amiens*, begun twelve years later. Further research he was conducting at long distance, writing to George Allen at Thun with firm instructions to 'Get a ruled book of good thick paper' and record in it his 'diagrams of the country on each side of the lake . . . work out the lie of the beds, bit by bit, as far as you can make it out'.[71] Perhaps as a means of encompassing and housing these renewed absorptions he wrote to tell his mother that, since their Herne Hill house was now tenantless, he proposed to 'keep it myself for my rougher mineral work and mass of collections': his own cabinet of curiosities – 'very simple . . . and calculated chiefly for museum work and for store of stones and books'.[72]

Another of the pleasures of this summer was the return of Norton,

with his wife, to Europe. Ruskin had responded grumpily to the news of his friend's marriage – 'I don't want her to [like me]. – I want her to be jealous of me, for ever so long yet.'[73] But he was entirely won over when he met her in the summer of 1868, and the friendship between the two men flourished once again (the American Civil War, about which they had also disagreed, being over made things easier, too). Norton came to visit him in Abbeville; though he found his old friend 'mentally more restless and unsettled', Ruskin responded to his visit by finding himself 'Stronger in feeling, altogether'.[74] They went to Paris and here Norton introduced Ruskin to Longfellow, a meeting which pleased Ruskin considerably; he was especially happy with the letter he received afterwards from the American poet. Once they were back home, Norton also arranged for him to meet Charles Darwin, who lived in the Kentish village where Norton and his family had established themselves for their time in England. He recorded the encounter later:

> Ruskin was full of questions which interested the elder naturalist by the keenness of observation and the variety of scientific attainment which they indicated, and their animated talk afforded striking illustration of the many sympathies that underlay the divergence of their points of view.[75]

Back from France, Ruskin knew that he had 'three dark months' until his fiftieth birthday and until the time when Rose was supposed to give him an answer.[76] Though he told Mrs Cowper bravely in December that he was able to 'seal the stone of [love's] sepulchre',[77] he was quite unable to release himself from his compulsion for Rose. The first chapter of his *Proserpina* (1875 onwards) is actually dated 3 November, 1868. He may have plunged himself into extensive committee work on matters of unemployment[78] and have existed superficially with more peace of mind ('no disgusting or serpent dreams lately', his diary for 27 November noted); but the pressure had been driven below the surface. Before he left Abbeville he had a brief but severe bout of illness; during one long, feverish night the wall-paper patterns turned into faces.[79]

Even if he had once loved Rose distinctly for her own person, she had now clearly become an idea. Ruskin recognized the tendency in others at least, for in June 1869 he asked Norton whether 'it is really me, or an ideal of me in your head, that you love'.[80] And, too, Rose became even a cause to be fought for, far from the now almost irrelevant intercessions of his friends and in modes which sometimes only he could recognize. In the new year he was working on the

lectures which became *The Queen of the Air* and in them he told Mrs Cowper 'there's a word or two here and there – which only ϱ will understand'.[81]

After his Abbeville lecture on 29 January he devoted the next weeks to two lectures on Greek myths, delivered on 9 and 15 March at University College, London, and the South Lambeth Art School. These may be seen, in one way, to take up the concern with mythology displayed in the final chapters of *Modern Painters* V; this would be consistent with the declaration to his mother from Abbeville that he was resuming some of his old interests. It was also to be increasingly characteristic of Ruskin to write an extensive gloss upon some former, misguided notion, in this instance that there was 'no spirit power' in the Greek goddess Athena.[82] These lectures also intensify his fascination with meaning, already deepened beyond its early philological scope by the constant need of recent months to penetrate the intentions and meanings of the La Touches. Yet *The Queen of the Air* lectures are also fundamentally an attempt to discover a mode of writing in which he need not be 'torn by various dispositions to work in fifty ways at once'.[83] When Ruskin's editors, Cook and Wedderburn, came to reprint *The Queen of the Air* in their Library Edition of his Works they deemed it necessary to attach a summary of its contents, for the book is 'discursive and difficult'; even Norton, left to revise and see the text through the press when Ruskin went to Italy in late April, could not readily accept its habits of inquiry. Carlyle, however, recognized immediately the symbolist and poetic penetration of its imagination.[84] The ever-personal inclination of Ruskin's response to natural phenomena, intense enough even in the most 'scientific' pages of *Modern Painters* I, had always been clear. At last in *The Queen of the Air* this finds appropriate expression. For he insists that myths must discover an answering sensibility in their interpreter as he constructs, deconstructs and reconstructs the matrix of their hieroglyphs. In such mythical language Ruskin discovered a supreme vehicle for talking about any of his countless interests. It is not in the end the accuracy of his analysis of mythic shape and roots that matters as the essentially poetic way in which their analysis becomes his vision. He earned for himself that 'crown of Parsley, first, and then of the Laurel' with which in the closing sentence of the book he hoped that 'Hercules and the Muses' would favour his readers as well.

The ostensible reason for his visit to Italy that summer was to prepare studies of tombs in Verona for the Arundel Society.[85] But inevitably he entertained other projects, including one about which he wrote enthusiastically to his friends. He had noticed in the upper

Rhone valley how barren and pestilential the terrain was; he decided that with some proper irrigation 'the entire valley' could be turned 'into a safe and fruitful and happy region'; by trapping the melting snow and rainwater and then releasing it down the hillsides where and when it was needed he proposed to 'make the lost valleys of the Alps one Paradise'. If the Alpine Club in London would not help him, he would buy a hillside and set about matters himself. Norton obviously thought he was 'mad'. And to Mrs Cowper in a series of almost visionary letters he outlined a further proposal for a company of men and women dedicated to oppose modernism by their refined beauty of manner and thought, their order and precision. It was his first projection of what would become the St George's Guild.[86]

Even in Italy the work of recording the tombs of Verona seemed to incorporate a plenitude of interests. He wrote to his mother that 'The only mischief of the place is its being too rich. Stones, flowers, mountains – all equally asking one to look at them – a history to every foot of ground.' And again, 'I ought to do some wonderful work, joining my geology and art and political economy together, in this essay on Verona.' When he got to Venice, for the first time since being there with Effie in 1852 ('I am much surprised to find how great pleasure I can take in this place still'), he was delighted with St Mark's being 'one precious mineralogical cabinet'.[87] On 19 July he wrote to his mother –

> I have been in the sacristy of La Salute, all the morning – it is very a dream, again, to me, this Venice – the fair sea and sky and listless motion – and being able to stop almost at any instant and walk into a place where there are Titians or Bellini's – or Tintorets – one after another – Church after church, and room after room – all precious. And all inhabited by people who know no more of them than the fish of the sea.

He was often very lonely, though he had the help of assistants, Arthur Burgess and J. W. Bunney, with his work for the Arundel Society. He had for a while, too, the company of a young artist, Arthur, son of Joseph, Severn. And of course after many years he met Rawdon Brown again. There were chance and happy encounters with Longfellow and his young daughter at Verona and with Holman Hunt at Venice, where they studied the Tintoretto *Annunciation* together in the Scuola di San Rocco. But he was generally querulous with the thrusting modernism of the world – 'in perpetual Hades of indignation'[88] – and Norton was the recipient of some grumbling letters. Rose La Touche still lingered strongly behind his daily

routines and interests: re-reading *The Stones of Venice* he recollected how proud he had been in writing of the Bassano Alps that they were 'Of the colour of dead rose-leaves'.[89] When he came for the first time upon Carpaccio's series of paintings of the St Ursula legend, they opened 'a new world' for him, he told Burne-Jones.[90] Part of their appeal, to be more fully worked out in later years, was the parallel he intuited between Rose and this young Christian saint who pledged herself to a heathen provided he was baptized and gave her three years in which to make a pilgrimage to Jerusalem.

During his four months abroad he got word of his appointment to the Slade Professorship of Fine Art at Oxford. The first to be elected, he characteristically interpreted his duties so as to involve as many of his interests as possible. He returned to London at the end of August and throughout the autumn and winter prepared for the start of his professorial duties.

Part V

The Slade Professorship of Fine Art

'The teaching of Art . . . is the teaching of all things'
Fors Clavigera, letter 76

'Of such aims we in Oxford have had a great, an inspiring example. We have seen a man in whom all the gifts of refinement and of genius meet, and who has not grudged to give his best to all; who has made it his main effort – by gifts, by teaching, by sympathy – to spread among the artisans of Sheffield and the labourers of our English fields the power of drawing the full measure of instruction and happiness from this wonderful world, on which rich and poor can gaze alike.'

Prince Leopold, speech in support of the London Society for the Extension of University Teaching, 1879.

The years 1870–8, when he first held the Slade Professorship, were among the busiest of his life. Combined with his constant emotional involvement with Rose La Touche and with his reactions to her death in 1875, it is hardly surprising that he broke down early in 1878. It would be the first of many attacks, increasing in frequency and intensity, which would silence him almost completely after 1889.

In his diary for 12 February 1872 he wrote that his 'head was too full of things and don't know which to write first'. In both his work at Oxford and in the letters he started to write in 1871 to the "Workmen and Labourers of Great Britain" he sought not only to range over wide and different topics but to relate them to each other as well. His audiences at Oxford, and the larger, different readership which he hoped to reach by the publication of Fors Clavigera, gave him the attention he had been seeking in order to expound ideas. He experimented with new ways of publishing, issuing Fors in monthly parts, and eventually transferring all his publications under the management of George Allen, whom he set up as his publisher and sole distributor. Many new projects were initiated in serial form, but at the same time he started selecting from his previous writings books that he now wished to establish, after revision, as his Collected Works.

Both Oxford lectures and Fors Letters, however, needed extension into practical work. For the first there were the drawing lessons and the study collections to be established and catalogued; for the second another museum was set up at Sheffield for the Guild of St George, which after some difficulties Ruskin organized both to embody his utopian scheme for a new England and to initiate some few of its visions. There were attempts, too, at beautifying the countryside or keeping London streets clear of mud.

Between these ambitious endeavours and often to seek rest from them he resumed his old extensive travelling into Italy, sometimes by himself, sometimes taking parties of friends to share the sights with him. Inevitably these excursions promoted fresh projects, and the 1870s saw the initiation of new guidebooks for Venice and Florence. Something of this restlessness was stilled when he finally found for himself a house, overlooking Coniston Water in the English Lake District, which became his major base whenever he was not at Oxford. But it was a home in which at first he acutely felt the loss of his father and of his old nurse, who died in 1871, and of his mother, who died after long illness that same year. Altogether, the resumption of much, varied work, of travelling, of single-handedly proposing a new order for the blighted condition of his country, combined with the emotional readjustments to a life no longer centred on his mother and on Denmark Hill, as well as the fearful oscillations of spirit that the prolonged affair with Rose brought upon him, drew him steadily towards a breakdown. The very work by which he tried to stave off collapse finally ensured it.

Chapter 18

The Extension of Education: 1870–1874

and I have failed too utterly largely in getting the harmony and order
that I meant & planned in the Oxford things, & have to change and
lose – at the last – enough – without losing myself altogether in Irish
clouds

Ruskin to Mrs Cowper-Temple, probably April, 1870

When Ruskin heard of his election to the Slade Professorship he wrote
from Giessbach to Acland, who had played a large part in securing the
post for his friend, to say how honoured he felt at the invitation; he
would endeavour not to offend the university authorities by saying
things 'either questionable . . . or offensive'; he would put 'much fire'
into the work; above all, he felt that the 'last ten years have ripened
what there was in me of serviceableness'. To Liddell, the Dean of
Christ Church and another supporter of his nomination, he also
repeated his promise not to pronounce from university platforms
what might give offence to its authorities. But he still reminded the
Dean of his recent pleas for the 'extension of education'.[1]

What obviously attracted Ruskin about the Slade Professorship
were the opportunities it afforded to 'extend' his own scope as an
educator and to signal to others how he felt that education must
expand its range. In 1867 Acland had tried to persuade his friend to
accept the curatorship of the Oxford University galleries, but Ruskin
had not been very enthusiastic, probably because the post gave little
scope for his projects. Similarly, when he accepted the Professorship
in 1869, he also made it quite clear that he was not 'going to be the
Oxford drawing master'. What he envisaged was work that would be
'the main business of my declining life'.[2]

He was obviously full of ideas by the autumn of 1869; not only his
Verona work but the dream of restoring the paradise garden of the
Rhone Valley and the formation of some company of special believers
to recover the lost wealth of life were all enthusiastically canvassed,
elaborated and promulgated among his friends. Yet on top of these
obsessions and often in indirect ways related to them, he was working
on botany and mineralogy, translating and editing French ballades

and Chaucer's "The Flower and the Leaf" so that they might form the first of a new 'series of standard literature for young people'³, and slowly planning how he would use his Oxford professorship. To Acland, once he was back at Denmark Hill, he wrote in September that he had not 'thought out anything rightly of what is to be done'; once he had any plans formulated he promised to come to Oxford and discuss them. However, he was confident that what could 'be done at Oxford in any wise depends on wide matters'.⁴

Yet he was barely at peace with himself that autumn. Dreams of astonishing perplexity and pain, recorded scrupulously in his diary, gave him little repose at nights, and he would awake tired and drained:

> the most horrible serpent dream I ever had yet in my life. The deadliest came out into the room under a door. It rose up like a Cobra – with horrible round eyes and had women's, or at least Medusa's, breasts. It was coming after me, out of one room, like our back drawing room at Herne Hill, into another; but I got some pieces of marble off a table and threw at it, and that cowed it and it went back; but another small one fastened on my neck like a leech, and nothing would pull it off. I believe the most part of it was from taking a biscuit and glass of sherry for lunch . . .⁵

The causes certainly lay deeper than indigestion. He determined to get on with his work, 'absolutely refusing', as he told Mrs Cowper-Temple as she was by now known, 'to allow my mind to stay on anything that pains it . . . while I am conscious of a darkness about me on all sides, I can yet avoid looking at it so as to trace its evil spectres'.⁶

But Rose persisted in disturbing him. In October she sent a botanical book via the Cowper-Temples, with specimens pressed inside: he needed at once to know 'what she meant by sending me that book – (there was a bit of my own weed – and a single rose-leaf (*green* leaf only) laid together into the page about the Dioscoridae)'.⁷ If such communications proved frustratingly gnomic, he continued himself to discover clearer references to Rose in almost everything he worked on. If he proposed a history of flints, it would begin with the species 'Achates Rosacea' and remind him that he had years ago presented her with a 'pretty piece of rose-quartz . . . a type of her,.⁸ When he probed the texts of fourteenth-century French songs and embarked upon extraordinary philological trails of discovery they led invariably to Rose. Explicitly or implicitly she occupied the spaces of all that he explored:

Courtois is a very curious word. Its *own* cour – comes from the cour meaning court – Italian Corte – the *Enclosed* place, – where the King is throned. But the 'cour' in courage is from Cor, the heart, and 'Courtois' *reads* it own cour *into* that when it becomes 'courteous' in the deep sense of it in this line.[9]

And the botany of *Proserpina* provided further occasion for metaphorical classifications: 'Do you see what Proserpine spells – if you take P (for pet) – and R – (next the Rose) away from it? Ros-Epine.'[10]

The pain of the last four years, which he thought nothing would efface,[11] was suddenly intensified in an unexpected meeting with Rose at the Royal Academy on 7 January 1870. He tried to speak to her, but she eluded his grasp. But instead of leaving, she remained in the Academy rooms 'quite cheerful and undisturbed'. So he tried once again, offering her the gold-enclosed letters from her which he always carried. She said, simply, 'No'. He was exercised immediately whether she had understood the meaning of his gesture.[12] In the next weeks Rose wrote to him twice, but he responded in some fury, telling her that he would inscribe her copy of his first Oxford lectures with

> To the woman
> Who bade me trust in God, and her,
> And taught me
> The cruelty of Religion
> And the vanity of Trust . . .[13]

Before she returned to Ireland she wrote again, first via Mrs Cowper-Temple who decided not to forward the letter, and then direct. This letter was greeted by Ruskin with the words 'She has come back to me'.[14]

These renewed oscillations of emotion throughout his first term of duty at Oxford inevitably broke 'the current of your days with a new trial', as Norton told him in dismay when he heard of these developments.[15] But Ruskin maintained his work with some resolution. In February at the Royal Institution he lectured on "Verona and Its Rivers", in which he used both an imaginary panorama of the city to declare graphically its multitude of interests for him and the River Adige which flows through that city to link Veronese art and culture with his present obsession for restoring Alpine valleys.[16] A few days later, on 8 February, he began his inaugural series at Oxford.

For both his lectures at the Royal Institution, this year and in 1869, Ruskin had prepared an exhibition of drawings and photographs to illustrate his text. The same procedure, much elaborated, became a

staple feature of his Oxford work. For his first set of lectures in Hilary Term 1870 he prepared examples of art to which he could refer.[17] He provided most of them himself, but hoped that public patronage would also make the series 'no less splendid than serviceable'. He also drew up a catalogue, 'pointing out my purpose in the selection of each'. The gradual amassing and cataloguing (and recataloguing, once fresh systems of display were devised) of these materials would take up considerable time in later years. But for this first set of lectures it was what he had to say and the range of his topics that preoccupied him most: in January he was complaining that 'My lectures are giving me great trouble. I have to think over so many things before saying *one*, – and it's so difficult to say all one wants in any clear order.'[18] The plan of topics to be covered which he outlined to Norton the previous November was revised by the following January, and the original proposal for twelve lectures was followed for the first series only.[19]

The inaugural lecture itself was attended by such a huge audience that it was transferred at the last moment to the Sheldonian from the Museum lecture theatre. Ruskin said nothing new. He reiterated his long-established notion that the 'art of any country is the exponent of its social and political virtues'. Yet from its characteristic, if muted, opening moment of autobiography to its final sketch of an 'impossible ideal' for England it must have surprised some of the audience with its vision of what Ruskin hoped he might achieve with his professorship. Not content with wishing to 'establish both a practical and critical school of fine art for English gentlemen', he confessed himself interested in the long-term evolution of educational practice, looking forward to Schools of Agriculture and Mercantile Seamanship. The wide range of reference he proposed for himself did not exclude such crafts as metal work, even if his major examples would be taken from painting and sculpture; while in the drawing classes he promised to relate the practical exercises to students' other studies in history or natural science – this last because he thought 'the vital and joyful study of natural history quite the principal element requiring introduction, not only into University, but into national, education, from highest to lowest'.

There were six further lectures, and they were all published together by the Clarendon Press later that year. After the second, on "The Relation of Art to Religion", Acland, who had received some quite ferocious blasts of Ruskin's 'heathenism' in recent years, was 'relieved from the fear of my saying anything that would shock people'.[20] Other lectures considered art and morality ('the first morality of a painter is to know his business'), art and utility, line, light and

colour. After the first he refused to move out of the smaller lecture theatre, where the examples he displayed to illustrate his points could be seen, with the result that some lectures were delivered twice, first to a university audience and then to a general one.

Some years later, in *Fors Clavigera*, he would write that, after his first lecture, university friends had remonstrated against the introduction into fine art lectures of 'irrelevant and Utopian topics'.[21] Yet it was, of course, precisely these topics that concerned Ruskin most. But he persuaded many, if not to accept his notions, at least to give them a hearing, because of the vivacity and skill of their delivery. He was by all accounts an inventive and sometimes extremely funny lecturer, as well as the spell-binding aesthete (complete with blue cravat) that Mallock's *The New Republic* has made so famous: 'that singular voice of his, which would often hold all the theatre breathless, haunts me still . . . There was something strange and aerial in its exquisite modulations that seemed as if it came from a disconsolate spirit, hovering over the waters of Babylon and remembering Zion.'[22] In that register of disconsolation and the suggestions of a prophetic type were probably identified the compelling feature of Ruskin's lecture style at its most spacious.

He stayed behind in Oxford after term to continue work on the series of items for display, but by the end of April was on his way abroad for a rest: 'after the hard Oxford work, I find the reaction considerable, and . . . I am very languid and unwilling for the least mental exertion'.[23] He took Joanna, their friends Mrs and Miss Hilliard and Downes, the gardener, whom he wished to consult on his Alpine schemes, and in part the whole excursion was a revisitation of sacred places that his companions might see and share with him. They were at Vevey, where Downes was shown the fields of flowers. They went on into Italy, where at Venice Ruskin copied the 'Red Parrot' nibbling at a spray of vervain in Carpaccio's *Baptism of the Sultan* and he announced that 'my mornings . . . make me feel young again'. They continued to Florence and Pisa, then to Siena to stay with the Nortons and to be dazzled by the fireflies. On the return journey he had the encounter with the snake at Giessbach which he put into a later lecture in 1872.[24] Joan's journal of this trip survives, very chatty, readily pleased with it all – 'Such views & such blossoms – such a sky & such mountains – & such everything' – and happily if unstrenuously responsive to her cousin's guided tour – 'Coz's explanations about everything so charming – & all the subjects of his lovely drawings so interesting.' Ruskin himself inevitably used his holiday for work. He planned to ask Count Borromeo ('he's sure to have some crags &

fields Simplon way') to let him have land with which to inaugurate his scheme to save Alpine valleys.[25] He thought much and made notes for his next Oxford lectures, discovering rich possibilities of subject in the pictures he saw again – especially Tintoretto's *Paradise* – and in new discoveries ('this Filippo Lippi has brought me into a new world').[26]

Back at Denmark Hill after two months away, forced back in part by the developments in the Franco-Prussian war, he tried to settle to writing his next set of Oxford lectures on Greek art. But Rose began to pull again. He corresponded with Mrs La Touche's sister-in-law and, with the encouragement of the Cowper-Temples, was apparently attempting to clarify the legal position about his marriage. The La Touches took alarm and once again invoked a reluctant Effie Millais; she wrote bitterly about her years with Ruskin ('he is quite unnatural'), and this letter, shown to Rose, swung her back.[27] Ruskin's response was released into the new preface he was then composing for *Sesame and Lilies*: 'the chances of later life gave me opportunities of watching women in states of degradation and vindictiveness which opened to me the gloomiest secrets of Greek and Syrian tragedy'.[28] But he was nevertheless still drawn to at least his *idea* of Rose. He had told Norton, dismayed at the resumption of contacts, that she had made his life 'far better than it was'.[29] That he was torn, terribly, there can be no doubt, and chances, to which he yielded his life these days, pulled his emotions one way and another. Before his journey abroad he had received, indirectly, a volume of Rose's poems and he had commented to Joan that it was 'almost as difficult to bear the misguiding and forming in wrong way of her mind . . . as the separation from her'.[30] On his return he told Norton that his experience of the 'limits of insanity' was not yet 'wide enough' – only about Rose and Turner had he been entirely insane.[31] He continued to find, now in his new manuscript of the *Roman de la Rose*, parallels to 'all *my* Roman'.[32]

That autumn, too, there came other threats to his concentration upon Oxford work. Arthur Severn, recently a frequent visitor to Denmark Hill, sought permission to court Joanna Agnew. The attachment between her and Ruskin was curiously intense: in part, simply, she had released him from many obligations towards his mother, for which he was grateful; in part, however, she was another young girl whom he had been able to teach and shape by his influence and whom he was shocked to find wanted to grow up.[33] Their intimacy had already established itself on one level as the exchange of affectionate baby-talk, and this coincided perhaps with Ruskin's increasing tendency to think of himself in terms of his youth ('worked

once more in that old house [Herne Hill], going through the room where I lay in the morning looking at my first watercolour painting'[34]). So that Joan's proposed marriage to Severn – she announced her engagement to Ruskin after his second Oxford lecture in November – threatened not only the established economy of his domestic life, but in more obscure ways his emotional life as well. The first difficulty was solved by giving them the Herne Hill house, close enough for her still to be a presence at Denmark Hill. The second was far less readily accommodated; two nights after Joanna told him of her engagement he dreamt of flirting with a 'nice girl' but being disturbed by a 'horrid witch'.[35]

His lectures that autumn were on "The Elements of Sculpture", later published as *Aratra Pentelici*; the decision to switch his subject from Italian painting to a largely Greek topic was taken once he had come home from his travels. The autumn was spent in studying coins at the British Museum, for he intended not only to utilize examples which would photograph well, but also, I suspect, to make a covert point about the essential connections between good art and good economy.[36] He was still determined, he told his audience, to relate the fine arts to 'the great interests of mankind . . . [and to] social duty and peril'.[37] But typically he began by redefining the function and scope and therefore the terms by which the arts are customarily known. A ploughshare was exhibited to represent the type of architecture ('wherever complex mechanical force is to be resisted'); then his breakfast plate, to illustrate the union of 'graphic and constructive powers'. And with similarly inventive and suggestive disregard for the traditional and simply aesthetic parameters of his subject, he ranged over its technical, psychological and mythological aspects. Greek coins, by their reproduction of animals, became, as it were, the reverse of zoology; representation itself, the obverse of man's child-like compulsion to depict his own world and its objects. Much that the drafted lectures contained he did not in the end use, though in publishing them in book form in 1872 he revised some of them for inclusion, even as he omitted one lecture on Florentine sculpture which he had delivered.[38]

These compulsive readjustments of his *oeuvre* were one of his major concerns now. So, too, once he had successfully started his work with Oxford undergraduates, was his determination to widen his audience: on 15 December 1870 his diary records – 'Plan letters to workmen'. That Ruskin contemplated *planning* his *Fors Clavigera* will amuse most of his critics; indeed, it is hard in surveying the remainder of his working life to believe that he envisaged any coherent schemes

for his writings. But Ruskin intuited coherences for which available literary forms proved unsuitable, just as public museums perhaps are forced to destroy or revise the schemes of private cabinets of curiosities. What Ruskin set himself was to discover ways of presenting himself that would, on the one hand, give expression to whatever he wanted to say when he wished to say it and, on the other, establish an overall pattern in his thinking. Further, what he wrote had also to be realized beyond words – in deeds.

The monthly letters he began publishing in 1871 were designed to give formal implementation to an earlier perception, of 25 May 1868, that 'My writing is so entirely at present the picture of my mind'.[39] *Fors Clavigera* took its topics and its occasions from Ruskin's daily life and contacts – things he read, people he met and conversations he overheard, places he visited. The accidents of his external and internal life were rehearsed in seemingly casual fashion so as to obtain for them, properly seen and understood, more significance. Typically, he explained that the English language would not help him:

> the Letters will be on many things, if I am able to carry out my plan in them; and that title means many things, and is in Latin, because I could not have given an English one that meant so many . . .[40]

Fors involved Force, Fortitude, Fortune; *Clavigera* was club, key, nail or rudder; together they allowed various ideas, including the strength and courage of good work, the patience who is portress at the gate of Art and Promise, the iron power of Law, of Necessity and the orderings of Chance.[41] Under the auspices of these variegated powers, but above all of the last, Ruskin conducted his dialogue with those he could not meet in lecture halls. Just as he was considering in January 1871 giving his Oxford lectures 'at intervals of a fortnight – explaining in the interval what has puzzled anybody',[42] he also welcomed the opportunity to debate with correspondents; the second *Fors* letter printed a remonstrance Ruskin had received as a result of the first and then proceeded to answer it. He enjoyed the rhetorical demands not only of specific conflicts of opinion but also of creating for himself in *Fors* a *persona*, often but not always in touch with his own character. Bits of his autobiography were carefully calculated for their effect; but this public figure, objective commentator, indignant satirist, scorner of false values, was in Ruskin's own words a 'mask'; his Harlequin may have been going slowly mad behind his public face, but the face itself had been chosen deliberately and with the skill of an established public performer.[43]

His Oxford professorship gave him a prominence which he used

to advantage in *Fors*. He had told his mother in 1869 that the university post 'will enable me to obtain attention, and attention is all that I want to enable me to say what is entirely useful instead of what is merely pretty or entertaining'.[44] Yet even his Oxford lectures, attracting large numbers of those who still believed in a pretty and entertaining stylist, provided too small a constituency. So the *Fors* letters were addressed, on the model of the earlier series to Thomas Dixon, "To the Workmen and Labourers of Great Britain". Though it became clear that anyone of whatever class, being yet dedicated to action and positive deed, might be included, Ruskin wanted to speak to those who would readily understand what he said of misery, poverty, the *illth* not wealth of life. His frequent use of phrases like 'as one of yourselves' hinted at his need to identify with this very different audience. The first letter of *Fors* connects quite explicitly its role with that of the Oxford work:

> I have been ordered to endeavour to make our English youth care somewhat for the arts; and must put my uttermost strength into that business. To which end I must clear myself from all sense of responsibility for the material distress around me . . .

This was the same theme, announced in suitable Oxford tones, of his fourth lecture in 1870; '*You cannot have a landscape by Turner, without a country for him to paint; you cannot have a portrait by Titian, without a man to be portrayed.*'[45]

Both at Oxford and in *Fors* Ruskin was not content to stay only with talk; each occupation had to be given a practical extension. In *Fors* this involved his announcement, first, that he would set aside 'regularly some small percentage of my income, to assist, as one of yourselves, in what one and all we shall have to do'.[46] By the fifth letter this vision of 'a National Store instead of a National Debt' had been elaborated into a project that applied to England the plans he had entertained in 1869 for the redemption of the Rhone Valley:

> I am not rich (as people now estimate riches), and great part of what I have is already engaged in maintaining art-workmen . . . The tenth of whatever is left to me, estimated as accurately as I can (you shall see the accounts), I will make over to you in perpetuity, with the best security that English law can give, on Christmas Day of this year, with engagement to add the tithe of whatever I earn afterwards. Who else will help, with little or much? the object of such fund being, to begin, and gradually – no matter how slowly – to increase, the buying and securing of land in England, which shall not be built upon, but cultivated by Englishmen, with their own hands, and such help of force as they can find in wind and wave.

The legal and practical problems of this Utopian scheme were endless, dragging on for years before the St George's Guild, as it became, was established; even then, its success was slight, a sadly diminished embodiment of the hopeful vision of 1871.

The practical extension of his lectures on art at Oxford, perhaps because it was a more limited project and because it stayed for a while under Ruskin's direct control, was more speedily accomplished and more successful. The existing facilities for drawing which Ruskin found upon taking up his appointment at Oxford were soon to prove inadequate for his 'system of art-study'. So he proposed to the University that he be allowed to endow a drawing mastership, a benefaction accepted by Convocation in November 1871. This, however, as Ruskin's own personal experience with teaching drawing directed, required the establishment of a collection of items for study and copy. In March 1871 he was writing to Acland about making the University Galleries into 'an instructive and pleasant museum of art for persons of all ages'.[47] To this end he contributed money and energy in considerable quantities during his first tenure of the Slade Professorship.

The Ruskin Drawing School and the Ruskin Art Collection together were designed to combat the art education available at either the Royal Academy schools or the 'Kensington' schools run by the Government, one branch of which was housed in the University Galleries.[48] Like the St George's Guild proposals, Ruskin intended his system as a positive and practical critique of existing inadequacies. The ninth letter of *Fors* drew attention, in fact, to the parallel Oxford enterprise:

> after carefully considering the operation of the Kensington system of Art-teaching throughout the country, and watching for two years its effect on various classes of students at Oxford, I became finally convinced that it fell short of its objects in more than one vital particular: and I have, therefore, obtained permission to found a separate Mastership of Drawing in connection with the Art Professorship at Oxford; and elementary schools will be opened in the University galleries, next October, in which the methods of teaching will be calculated to meet requirements which have not been contemplated in the Kensington system.

Ruskin's main objections to that system ('open hostilities with Kensington'[49]) were its separation of design from art, of simply technical skills from larger educational aims, its mechanical forms of instruction and its competitive examinations as the means to monitor students' progress. The master of this school at Oxford, Alexander MacDonald, himself uneasy in the system, became Ruskin's first

drawing master. The endowment provided funds previously furnished from Kensington.

As the scheme evolved from 1871 onwards it grew in complexity. There were two kinds of classes – for undergraduates, and for 'general students, who do not intend to become artists, but wish to obtain such knowledge of art, and such experience in the practice of it, as properly rank among the elements of liberal education'.[50] Four kinds of materials were eventually made available to these students: the *Standard Series*, as its title implies, provided '*standards* to which you may at once refer on any questionable point, and by the study of which you may gradually attain an instinctive sense of right, which will afterwards be liable to no serious error . . .' (four hundred items were planned for this, but only fifty were ever arranged, and it became in practice muddled with the next); the *Reference Series*, being the slowly accumulating materials to which the professor's lectures referred; the *Educational Series* was intended for the university students whom Ruskin hoped to attract and consisted of twelve cabinets, each with twenty-five examples, of everything from elementary Greek design, through gothic architecture and landscape, to foliage, rocks, water and clouds; the *Rudimentary Series*, a less difficult collection, provided general students with items from heraldry to natural ornaments. Cabinets were constructed to house these at Ruskin's expense and on the models of those he had provided for the National Gallery Turners in 1858. Catalogues for all four collections were established and, in some cases, revised, as the materials invariably were altered and amplified. When Ruskin presented his Collection to the University in 1875 (previously it had been on loan), the terms of the gift required the Drawing Master to 'make, and . . . at all times keep perfect and complete, one or more catalogue or catalogues . . .'[51] But the Collection was so much the creation of one man, who frequently introduced new material which required revision of the catalogues, that stability was only precariously achieved. Ruskin disliked systems over which he had only partial control, and he tried at first to exert his influence to its fullest over the 'complete plan of rooms':[52] on 23 October 1871 he sent a memorandum to MacDonald which included instructions for

> Pretty presses for keeping casts out of sight . . .
> Every student to have a case of good instruments . . .
> Cover the Elgin sculptures with curtains, that the eye may not be wearied and jaded by them.

The whole presentation, it will be noticed, was not cheese-paring: in

1869 he had recognized that the 'chief mistake made by modern philanthropy is in giving cheap, imperfect education'.[53] But not only did his collection of material have to be perfect, he resented those who dabbled in rather than submitted rigorously to his system of instruction. By April 1872 MacDonald was asked

> to put a stop to the entrance of students who only wish to copy a drawing here or there at their fancy. The same course must be gone through by every person who enters the school, young or old.

The Oxford collection would eventually be complemented by the smaller museum Ruskin established for the Guild at Sheffield in 1875.[54] But the random and eclectic nature of the teaching collection at Oxford was already paralleled by the 'jumps and juxtapositions' in the text of *Fors Clavigera*,[55] for in both museum and letters Ruskin sought to express himself and his ideas with as little as possible mediation by convention or tradition. Yet, as he told a correspondent who wrote to him about *Fors*, this apparent artlessness was altogether the product of careful craft:

> a series of letters, and intended to be – as letters should be – personal. If people want treatises, let them read my *Munera Pulveris*; if lectures, I have written enough, it seems to me. These letters I write for persons who wish to know something of me, and whom I hope to persuade to work with me, and from beginning to end will be full of all sorts of personality.[56]

If his instinct was often for a wholeness, a completion allowed nowhere else, with opportunities for unexpected and unknown relations between parts, Ruskin was also an artist escaping unity, avoiding a final system by means both of accretion and by deliberate incompletion. Both of these, contrary, impulses may be seen in the last of his projects that were initiated in 1871. As the *Fors* letters evolved month by month until March 1878, moving forward into fresh events and themes with each issue, their momentum was complemented by the revision and reestablishment of what he had already written for a *Collected Works*. Any writer may be expected to organize and present his life's work; but Ruskin's attempt was more radical than most. In May 1871 he issued *Sesame and Lilies* in a series designed to collect works so as to 'form a consistent course of teaching'; by consistent, however, he did not mean that 'the progress or arrangement of it will be on any regular system'; rather that he would not

> say the same thing oftener than is necessary to gain attention for it; and that I will indicate the connection of each subject with the rest, as it,

indeed, existed in my mind always, though I have been forced by mischance to write copiously sometimes on matters about which I cared little, and sparingly of what was, indeed, much in my thoughts.[57]

The connections were to be facilitated by numbering the paragraphs of each volume in the Collected Works consecutively with a view to cross-references. But Ruskin nowhere saw the sequence and texts of these volumes as anything but a selection or thorough reorganization of his earlier writings. Much of *Modern Painters*, *Seven Lamps* and *The Stones of Venice* would never be reissued, since he now rejected its 'fine writing' and its religion. That *Sesame and Lilies* happened to become the first volume in the Collected Works was 'chance' and its text was altered: 'I now detach the old preface, about the Alps, for use elsewhere; and . . . I add a lecture given in Ireland on a subject closely connected with that of the book itself.' *Munera Pulveris* became the second volume, reissuing the essays written for *Fraser's Magazine* in 1862–3, *Time and Tide* another, as Ruskin moved to establish the *oeuvre* by which he wished to be known.

With all these schemes it is scarcely surprising that in his diary for January 1871 he wrote: 'Terribly mixed work in my head – sentiment, art, and economy.' A year later he was proposing to keep the left-hand page for 'a calendar of many things'. Early in 1871 he became a member of the Mansion House Committee, formed to send help to Paris, besieged in the Franco-Prussian War. That war figured prominently in early numbers of *Fors*, where his main energies as a writer and correspondent were directed. By September he noted that *Fors* took 'more time than I like'; but the next month it was the same with the preparation of an 'entire system of elementary teaching' for the Oxford drawing classes.[58] He gave three lectures on landscape in January and February and then returned to rest at Denmark Hill. There, on 31 March, his old nurse, Ann Strachan, died.[59]

Joanna married Arthur Severn on 20 April 1871. The following day Ruskin settled bravely to work on the May *Fors*, which seems to glance obliquely at her departing from him. On that day, too, for the first time since 1866, he discarded the gold-encased letters from Rose. Though he knew it would 'destroy both health and usefulness if I allowed hopes to return', he was tempted still by the prospect of marriage with her; for that reason, and also perhaps because he wished to relieve his *amour-propre*, he continued to explore the legal implications of the 1854 decree of nullity.

He gave one lecture only at Oxford – in June on "The Relations Between Michael Angelo and Tintoret", in which he scandalized

established public respect for the former by attacking his mannerist virtuosity. Burne-Jones was especially offended when the lecture was read to him in advance. It is one of these pieces that reveal much about their writer, little to nothing about the subject. Ruskin employed his considerable rhetorical powers (for he knew precisely how much Michelangelo was esteemed) to put put down mere effects of art as he saw them – 'picturesque and palpable elements of effect' – and to champion instead both careful vision and spiritual humility. Michelangelo failed to satisfy the requirements, long since established in Ruskin's writings, for sound craft and clear, moral vision. But the painter offended, too, against his current need for 'good work' and 'peace' and against his hope that God blessed rather than cursed mankind.[60]

From Oxford he journeyed to Derbyshire, where he planned to meet Joan and Arthur Severn after their extended honeymoon. He had worried the previous January about who might nurse him if he fell ill, asking Mrs Cowper-Temple whether she would – otherwise he would not bother to inform her whenever he was sick![61] With Ann Strachan dead, with Joan married and his Mother 'more than slowly sinking, now'[62] he seemed deprived of the care and attention which he had usually enjoyed. Then at Matlock in July he fell seriously ill, 'within an ace of the grave'.[63] The Severns were alarmed, and both Mrs Cowper-Temple and Acland were summoned to nurse him, often in delirium and with some severe internal inflammation. So his anxiety about care and attention was fully allayed. Yet during his convalescence he was annoyed by the prescribed diet and took matters into his own hands, demanding 'cold roast beef and mustard at two o'clock in the morning'.[64] He told Acland afterwards that he had been fully aware of the exact extent of his illness, but had not realized how frightened all of his friends were.[65] Carlyle, in the Highlands and unable to communicate, had also been alarmed, until he learnt from the newspapers that the worst danger was over.

While recovering at Matlock Ruskin received final word from his lawyer cousin on the legal question of his marriage: 'For all practical purposes, you are free to marry again'.[66] He had been wanting that summer to deal directly and straightforwardly with Rose once again, 'so that we may not be separated by lies'.[67] Now, in the knowledge of the legal opinion and of his own assured confidence in his bodily competence, he wrote immediately to William Cowper-Temple, who had continued to be active on his behalf, and to Rose herself, asking her to 'rationally determine if it will be advisable to marry or not'. Whatever he expected from the poor girl, 'for folly, insolence, and

selfishness [her reply] beat everything I yet have known produced by the accursed sect of religion she has been brought up in'; it shocked even Joan, who was asked to return the letter and to promise the return of all of Rose's previous ones as soon as Ruskin returned to Denmark Hill. Ruskin told Cowper-Temple that 'I am entirely satisfied in being quit of her, for I feel convinced she would have been a hindrance to me, one way or other, in doing what I am more and more convinced that I shall be permitted to do *rightly*, only, on condition of putting all my strength into it'.[68] Among the projects to which he wished to devote himself was the St George's Fund, of which he persuaded Cowper-Temple and Sir Thomas Acland to become trustees.

Back in London after his recovery he heard of a property for sale overlooking Coniston Water in the Lake District; he bought it, sight unseen. Later in September he travelled up to inspect it, reporting quickly to Norton of his pleasure:

> I've had a lovely day. The view from the house is finer than I expected, the house itself dilapidated and rather dismal . . .
>
> . . . a small place here, with five acres of rock and moor, a streamlet, and I think on the whole the finest view I know in Cumberland or Lancashire, with the sunset visible . . .
>
> Here I have rocks, streams, fresh air, and, for the first time in my life, the rest of the purposed *home*.[69]

In his diary for 14 September he resolved to 'make the best of this, at last'.

With a home of his own finally, he was nevertheless bound to Denmark Hill that autumn, not offering any lectures at Oxford, and watching his mother's decline. She died, aged ninety, on Tuesday 5 December. He was more surprised than he expected to be by the sense of loneliness four days afterwards.[70] But never one to waste time or words over grief, he occupied himself in ways that may have been an unconscious memorial to Margaret Ruskin's domestic efficiency.[71] In going to the British Museum in poor autumn weather he found himself 'sticking' to the dirty streets and he determined to 'organize a squad of broom men . . . *to show what a clean street is*'.[72] In December he noticed in the *Pall Mall Gazette* some discussion of London's filthy streets and wrote himself to promise that in the New Year he would, out of St George's Fund, pay three sweepers to do what they could to maintain a street in Seven Dials. The scheme gradually lost ground both to the indigenous mud and to the sweepers' truancy; neither

Downes, appointed foreman, nor Ruskin's own occasional visits to the site kept the crew to their task. Another scheme, more specifically dedicated to his mother's memory was the cleansing of a spring between Epsom and Croydon and planting it with grass and flowers. But this, too, did not survive local neglect.

With his mother's death he decided to give up Denmark Hill. He retained for occasional use whenever he was in London his old nursery room at the Severns' on Herne Hill. In Oxford he was granted a set of rooms in Corpus Christi College, from where he wrote to Joan on 7 February – 'It is very pleasant to me, the room – and the feeling of all – in a quiet, sad way. Thirty-five years since I sat down first in my own rooms in college, not two hundred yards from the spot where I write.'[73] He moved finally from Denmark Hill at the end of March.

That term he had been lecturing and dealing with what seemed an ever-increasing spate of correspondence. In *Fors* 16 he told those who intended to write to him to make their letters short 'and very plainly written' or they would not be read. He added that 'in general, I cannot answer letters'.[74] But those to whom he did choose to respond were often treated in ways that forced them to take the initiative in thinking what it was they wanted ('tell me which of my writings you have read; why you admire them, and why you wish to read more').[75] The lectures delivered that term concerned the relations of art and science (or knowledge, as he carefully pointed out); without revision they were published later in 1872 in the Collected Works as *The Eagle's Nest*. In many ways they revert to the themes of *Modern Painters*, that what the artist draws is more important than how he draws it ('you never will love art well, till you love what she mirrors better'[76]).

Once term was over he left on a three-month visit to Italy, taking the Severns, Mrs and Miss Hilliard, and the artist, Albert Goodwin. He was tired after an unsettling winter and did not always seem to enjoy the travelling and sights as much as usual, though he took memoranda for future Oxford lectures, being impressed by both Botticelli and Perugino in the Sistine Chapel. Yet the pages of *Fors Clavigera* which he wrote during the journey abroad reiterate complaints about destruction of monuments and the offensive behaviour of Italians. Rome in particular, where he met Arthur Severn's father once again, was 'more repulsive than ever' and he told *Fors* readers that only in Rome and Edinburgh had he ever been 'hindered from drawing street subjects by pure human stench'.[77] In Pisa he had to be forcibly restrained first from molesting the workmen who were restoring his

favourite Spina chapel and then from haranguing the obsequious *padrone* of their hotel about the awfulness of letting such restorations happen just opposite his establishment.[78] In Venice he was offended by the 'accursed whistling of the dirty steam-engine of the omnibus for Lido'.[79] But he was able to absorb himself again in the work of Carpaccio, whose *Dream of St Ursula* was described for *Fors* readers with happy precision; he stressed its details and its painter's absorption in 'the evident delight of her continual life. Royal power over herself, and happiness in her flowers, her books, her sleeping, and waking, her prayers, her dreams, her earth, her heaven'. He compared her with two American girls, encountered on the train to Verona, with 'their sealed eyes and tormented limbs'. But he might well have contrasted her with Rose.

That summer Rose got in touch with George MacDonald, who had some years before cut off contact in disgust at the La Touches' behaviour towards Ruskin. Rose, evidently, felt totally isolated from her parents and needed to unburden herself on social and religious issues to somebody who might be sympathetic. Life at Harristown was intolerable: 'If it could have been so that I might have kept the *friend* who has brought such pain & suffering & torture & division among so many hearts – if there had never been anything but friendship between us – how much might have been spared.'[80] After sending a stream of overwrought letters, she was presumably invited to visit the MacDonalds and Cowper-Temples, while Ruskin, unaware of it all, was still abroad. When on this visit she saw some of his old letters, confessing among other things to his practice of masturbation, her outcry and anguish were poured into a letter for the man 'who is your friend, and was mine'; wisely MacDonald did not forward this. But somehow, and for reasons that seem at this distance incomprehensible, the MacDonalds considered that this sick and tormented young woman could be helped by meeting Ruskin once again. She agreed, and MacDonald wrote to Ruskin in Venice.

Ruskin's first instinct was that he would not give up his work nor stir 'unless in certainty of seeing her'. He suggested that they all meet in Geneva and then perhaps return to Venice. Eventually, he agreed to return to England earlier than planned, though his decision occasioned a quarrel with the Severns. He was extremely loath to jeopardize the precarious stability he had recovered in his emotional life:

> Your telegram said you wanted to know my wishes. I wish that I could recover lost years, – and raise the dead. But not much more. I do

not wish Rose to die. What can in any wise be done for her peace – or – if she be still capable of it – happiness – I am ready to do – for my part – if she will make up her mind, and tell me when she has, face to face (I will hear her no otherwise) . . .
If R. chooses to be friends – she may – but may wait a fortnight, I should think, after keeping me waiting – six years instead of three since February 2nd of 1866 . . .

But he was obviously more deeply stirred by those appeals from England. Telegrams and letters, with their frustrating ambiguities, went to and fro. Ruskin, as often in moments of uncertainty, insisted on precisions that human behaviour could never yield –

Kindly set down, without fail (by return post if you can), in the plainest English you know – the precise things R. says of me – or has heard said of me . . .
write briefly in plain English *what* was to be put out of the child's head . . .

At last he started back across Europe, making more and more haste as the urgency of Rose's illness and of his unconscious desires grew upon him.

Back in England he could see how seriously ill she was ('her entire soul and body have been paralyzed by the poisoned air'). She had lingered in England to meet him, although her parents wished for her return.[81] First at the MacDonalds', then at the Cowper-Temples', Ruskin and Rose shared a few days together, '*clear* gain out of the ruin'. These blissful moments rescued from grief were ones he would always remember – 'the trust, which I had in all things being – finally well – yet the noble fear mixed with the enchantment – her remaining still above me, not mine, and yet mine'.[82] Ruskin seems to have recognized that all that mattered was for them to steer each other towards some tranquillity – 'she is at peace with me, and I may help to save her'. Yet the language of courtly love ('I vowed loyalty to her, to the death, and she let me kiss her'[83]) was insufficient. Perhaps the urge to translate the joy into something 'precise' could not be resisted. Yet how could she be 'changed', how realized – he invoked Pygmalion when it was all over,[84] how fixed?

So he apparently proposed marriage once again in the grip of joy which his diary recorded on 16 August. Rose at any rate thought this was the pressure still upon her:

I cannot be to him what he wishes, or return the vehement love which he gave me, which petrified and frightened me . . . But we are

346

separate and free from one another as far as all outward relationships are concerned . . .

They had another meeting, at Rose's earnest beseeching, on her way back to Ireland. Further letters were exchanged that summer, but the impasse – the inability to translate their love into forms acceptable to each of them – remained. By mid-September Rose's own state revolted and she returned one of his letters unopened with a 'fierce' one of her own. Ruskin realized and recorded in his diary on 8 September that 'It is finished'. But as Rose had asked Mrs MacDonald earlier that troubled summer – 'what is "it" and what "is ended"?'

He moved into Brantwood, as his Lake District house was known, on 13 September ('the beginning day'). There were several visitors before he departed for Oxford at the end of October. Work was, he knew, his way to recovery,[85] though excessive work, too, always had its own dangers for him. Writing *Fors* 23 at Brantwood he brooded upon labyrinths; while at Oxford, lecturing on "Sandro Botticelli and the Florentine Schools of Engraving" during the Michaelmas Term, he spoke of 'the instincts for the arrangement of pure line in labyrinthine intricacy, through which the grace of order may give continual clue'.[86] His writings at this time hint sufficiently of his own recognition that he must extricate himself from the maze of bitterness and despair in which Rose's rejection after all that summer gladness had created. Or, as Carlyle shrewdly put it, his friend had 'fallen into thick quiet despair again on the personal question'.[87] Slowly he traced his path back: there were 'divinest walks' around his new home and on the last day of 1872 his diary noted that he was, 'on the whole, victorious, and ready for new work'.

But his hopes were not fully realized. He was 'overworked, and under-couraged'.[88] There were days of fights and doubts, days when work gave him no satisfaction or when, despite 'useful new thoughts', he was still 'down and languid'.[89] The sorrows of the past year had destroyed, he felt, his 'higher power of sentiment'.[90] Yet he yearned ('It would be mere selfishness') in a general way for somebody to love.[91] Rose still haunted him – occasionally in erotic dreams when she 'gave herself to me – as sweetly in body as Cressid to Troilus'[92] – but he was disciplined or wise enough to refuse the chance of seeing her again in August 1873 when she was staying with the Cowper-Temples.

The year was largely divided between Brantwood and Oxford geographically and between *Fors* and his Oxford work creatively ('this printing and lecturing eats up my life'[93]). Putting Brantwood into

order and fitting Denmark Hill into it obviously tried him emotionally. As he told the readers of *Fors* in February (letter 28), he missed his parents and his old nurse. Their loss left him 'without any root, or, in the depth of the word, any home'; what pleasant things he had around him were 'only a kind of museum' which he was putting into order to leave as a bequest.[94] The associations that his father would have given Brantwood seem especially to have been regretted. And it is about this time that Carlyle assumes the role in Ruskin's life as a surrogate father – 'Ever your loving disciple – son, I have almost now a right to say'.[95]

Fors continued haphazardly to explore the deeper connections among Ruskin's interests. During 1872, the second year of letters, he admitted that the siege of Paris the year before 'necessarily broke up what little consistency *of plan* I had formed'; but he argued that in 'speaking of so wide a subject' as his whole vision of a new society implied it was not possible 'to complete the conversation respecting each part of it at once, and set that aside; but it is necessary to touch on each head by little and little'.[96] Now in the letters he writes during 1873 the same advance across a broad line of topics, sometimes, but not always, connected, continued. And it was a method that affected other work: in June he told Norton that the new elements of drawing were 'too large for arrangement' and had to be done 'piece by piece'.[97] He teased his readers about the *Fors* method, asking whether they thought a recipe for Yorkshire Goose Pie, with which he began the year, was not 'irrelevant to the general purposes of *Fors Clavigera*'. At other times his own misjudgements of time, space and materials ('I have no space in this number . . . to say what reason there is for my taking notice of this book, or the glacier theory, in connection with the life of Scott') were less calculated.[98] He grew despondent, too, about the lack of any large response from the British workmen and labourers to whom *Fors* was addressed.

He continued to be plagued by letters 'from madmen and fools, whom I am mad and foolish enough to try and mend'.[99] By far the most satisfactory mending was the physical work he did at Brantwood: alterations to the house and to the lodge (to house Crawley and his family), a terrace at the top of the garden, and a harbour on the lakeside. 'I actually enjoyed myself', he wrote in the diary for 22 April, 'harbour-digging and planning garden terraces.' He spent much time rowing on the lake, chopping his own wood or exploring the surrounding territory – colonizing it after his usual fashion with private names. There were new neighbours to visit – he liked the Beever sisters especially, when he first met them in September. He

was, in fact, growing to like the Lakes. Once, after crossing the Lancaster Sands under a spectacular, thundery sunset, he told Carlyle that he would rather have drawn that 'than any I ever saw from Venice'.[100] Guests continued to come to Brantwood, the Burne-Joneses, the Cowper-Temples, Alfred Hunt and family, and the Severns; yet he began to find the consequent influx of children disquieting ('They never fix themselves properly to anything'[101]). But he began to resent having to leave Coniston for his duties in Oxford.

He lectured there twice: in March and May upon English and Greek birds as the subjects of art – later this became *Love's Meinie* – and in the Michaelmas Term on Tuscan art. This second course was published soon afterwards in 1874 as *Val D'Arno*, because he had the lectures already in type before they were delivered, an arrangement that he decided was not very satisfactory. He was also displeased by the small audiences which this series attracted. What with these two Oxford courses, monthly *Fors* letters, work on a paper about miracles for the Metaphysical Society and much publishing activity he was tired and dispirited by the year's end. Despite some visits to Margate to try and recuperate by studying Turnerian skies, it was a 'Confused beginning of year'.[102]

Yet what had been finally accomplished in 1873 was the quite momentous reorganization of his whole publishing strategy. With the first *Fors* of 1871 he had set up his assistant, George Allen, as his publisher. Allen distributed Ruskin's works from his home in Orpington, all at a fixed price whether to individuals or booksellers (the latter then had to add whatever percentage they chose); this pre-emptive strike at the whole system of credits, discounts, commissions and even at advertising was later modified to allow fixed discounts to the trade, but it pioneered a commercial practice later adopted in large measure by the Net Book Agreement.[103] Gradually more and more titles were transferred from the old publishers, Smith, Elder and Co., until by the end of 1873 Allen was responsible for all Ruskin's publications. The spate of writing and publishing in which Ruskin and Allen had engaged in 1873 was in part designed to consolidate Allen's role.

There were other practical endeavours to set examples, not always as shrewd or as influential. Ruskin's 'road-mending' at Hinksey, with teams of undergraduates including Oscar Wilde, Arnold Toynbee and his future editor, Alexander Wedderburn, was and has been the object of much mirth. But it was not as silly a project as it has been made to sound: it was a practical plea for keeping the countryside beautiful. In

his walks around Oxford Ruskin had noticed that carts cut across a pleasant green in front of some cottages simply because there was no proper track for them. This, with the landowner's permission, he proceeded to construct in the spring of 1874. What distinguishes Ruskin from the many who deplore rural eyesores is that he tried to do something about it. Undergraduates were invited to Corpus for the 'diggers' breakfasts' and then proceeded to work, under the supervision of the versatile Downes. Perhaps with recent memories of his happier hours chopping wood at Brantwood, Ruskin was motivated, too, by the need to remind undergraduates of 'the pleasures of *useful* muscular work' as opposed to what he considered the wasted energies of the sports field.[104] And with typical concern for precision of work of any sort, he urged the diggers on by stressing that 'Even digging, *rightly* done, is at least as much an art as the mere muscular act of rowing'.[105]

Another scheme seems less obviously sage, and that was his experimental teashop at 29, Paddington Street, Marylebone. Two old servants of his mother's, Harriet and Lucy Tovey, for whom he felt responsible, were installed as shopwomen to sell pure tea in quantities as small as the poor customers desired and without making a profit on that subdivision (an important aim in days of fluctuating tea-duty). The principle, which always concerned Ruskin far more than the practice, was – as with the publishing venture – of not exploiting commercial transactions with the poor. After two years, when one of the sisters died, he turned the scheme over to Octavia Hill.

During the Lent Term of 1874 Ruskin remained dispirited. Lectures on mountains and glaciers he had planned to deliver in March were cancelled owing to 'various anger and distress'.[106] A large part of this unhappiness was that Rose was once again in England for treatment by a Norwood doctor and evidently a thoroughly sick woman. Joanna was seeing her regularly and Ruskin himself, despite the breach of the previous autumn, received messages and verses. His 'old deadly anger'[107] revived against Rose's father for subjugating his daughter's spirit and thwarting her affections. Retreating from Oxford in mid-term he roamed the Coniston fells, angry at the vile weather, which yet answered his moods.

By February he had planned one of his traditional continental journeys to set himself to rights; at the end of March he crossed to Boulogne. He would be abroad for nearly seven months. It was an uneven experience. As he wrote to Carlyle from Naples, 'every time I come abroad, I have a deeper sense of the advancing ruin of every country'.[108] He worked hard, sometimes pushing himself with 'mani-

fold work' to the point where he had to warn himself to take things 'prudently, or shall break down'.[109] But work, study and the countless discoveries of an extended tour, which gave him a good deal of time in Rome and took him to Sicily for the first time ('To all intents and purposes I have been in Greece') could not allay his 'doubts, infinite sadnesses . . . and such disgraces'.[110]

There were undoubted excitements. In an early Christian church out in the Campagna he 'saw exactly how far the first thoughts of Christianity changed the temper and work of the Roman'; but since 'all things have become to me so ghastly a confusion and grotesque mistake and misery', he *felt* nothing.[111] At Assisi he was 'altogether amazed at the power of Cimabue, before wholly unknown to me', while again in Rome he gloried over Botticelli:[112] as usual he taught himself about these painters by laboriously copying details of their works. But the delights of the art at Assisi were offset by the beggars ('the stupid and vile ones come at me like wasps at a rotten nectarine'), by the noise and filth (he made the monks wash the cloister one day), and by the decay and dissolution of so many art works.[113]

It was the constant threat of restoration, 'the stains of ruin and blotches of repair' on Giotto's frescoes in the upper church of Assisi, that made him turn down the RIBA gold medal. When he had first heard of its award to him before he left England, he had thought it 'nice';[114] now he manipulated the honour into a *Fors* gesture, refusing it as a protest against, and to draw attention to, the destruction of fine architecture. He was, generally, very divided at this time between *Fors* work and his art studies. The visit to Assisi was designed to study the Giotto frescoes for the Arundel Society, and an assistant was copying them. But the insistent clamour of the beggars recalled him to other concerns. Writing to Norton, whom he knew did not enjoy *Fors* and saw no more in it than a monthly letter, he spoke of his 'daily maddening rage, and daily increasing certainty that *Fors* is my work – not painting – at this time'.[115] But three days later he was writing to tell his new friend and neighbour in Coniston, Miss Susan Beever, that 'one of my chief troubles at present is with the quantity of things I want to say at once'. At least *Fors* provided something of an opportunity for that.

Readers of *Fors* 46 (August 1874) were told of him sitting in the Sacristan's cell at Assisi, which he drew also for Carlyle. He argued happily with the monks and was tempted by the idea of a hermit life, perhaps upon the model of the Beaupré Antiphony which he owned and which depicts a Brother John working contentedly in his cell.[116] But as he also told his readers he felt intellectually isolated ('I am left utterly

stranded, and alone, in life, and thought'); work was the only bulwark against a madness which he felt this solitude would otherwise bring.[117] So he completed 'a furious six months' work'.[118] Writing almost daily to Carlyle ('I am going to write . . . as I used to write to my own father'), he confessed in the end to a precarious balance of emotions, borrowing from one of his favourite authors, Pope, the couplet, 'Never elated, whilst one man's opprest / Never dejected while another's blest'.[119] And before he left Florence, where there were further exciting discoveries in Santa Maria Novella, he was planning a guidebook to Florence as a counter-blast to Murray's guides.[120]

During the final stages of his long trip letters were arriving from Rose and making him happy. His excitements over Botticelli's Zipporah ('She's as pure as [Carpaccio's St Ursula], but altogether a different sort of girl, and has fallen quite irrecoverably in love with Moses'[121]) were perhaps intimations of his genuine, if cautious, need for the *rapprochement* which Rose herself initiated in late summer.[122] The La Touches gave permission for their daughter to meet Ruskin and two days after he reached England he saw her once again. That Michaelmas Term he divided his time between lecturing at Oxford and seeing Rose in London. There were many happy occasions, but overshadowed by the cloud of her severe illness and the girl's own fear of offending her parents. She returned to Ireland in December and, according to Ruskin, was shut up by her father with a doctor in Dublin. Ruskin continued his lectures – those during the Michaelmas Term on "The Aesthetic and Mathematical Schools of Florence" were more successful than the *Val D'Arno* series, while the second set, postponed from before his continental trip, was on mountain form and glaciers. He took more part in Oxford life, had his diggers to breakfast and, now that work was actually begun at Hinksey, went there himself and revealed an astonishing skill at breaking stones. But behind everything was the dull pain of knowing that Rose was dying. With what is by now a characteristic interfusion of public and private pronouncements, he told the readers of *Fors* in January 1875 that 'the woman I hoped would have been my wife is dying'. Sometime in February, when she returned once again to London for medical attention, they met for the last time. She was quite out of her mind and Ruskin alone could calm her.[123] He was consumed by a mixture of guilt ('if I had let her alone at once – as perhaps I ought . . .') and fury ('she was killed in youth by religious gloom and folly') as he tried to exist during the final months of her life.[124] She was removed to Dublin once again and died there on 25 May 1875. In one way he was perfectly

prepared for the outcome and managed to 'live in the outside of me and can still work'; but to Norton he confessed how Rose's death made 'much of my past life at once dead weight to me'.[125] Even in death she continued to crush him.

Chapter 19

'Gloomy Fight with Things and Myself':
1875–1878

A wreath of wild roses is not so easily disentangled.
Rose la Touche to Ruskin, 1862

Ruskin struggled throughout the succeeding months not to be overcome by sorrow, depression and ill-health. 'That death [Rose's] is very bad for me, *seal* of a great fountain of sorrow which can never now ebb away; a dark lake in the fields of life as one looks back'.[1] Yet, as his imagery implies, he managed his grief in part by bottling it up. His eyes in particular gave him trouble, swimming with 'zigzag frameworks of iridescent light'.[2] He had always been, as he said in 1863, 'down with the barometer';[3] increasingly he objectivized his own gloom in the weather, complaining savagely against 'perpetual darkness':[4] 'Nature herself sick', he wrote in the diary for 5 December 1875, and three months later on 15 March, 'I really cannot read or work this morning in mere horror at the gloom and diabolical rage of the sky.'

His work proceeded more patchily, though with little diminution of its scope or range. *Fors* announced in November 1875 that he had seven books in hand at that moment: besides *Fors* iself, *Ariadne Florentina*, *Love's Meinie*, *Proserpina*, *Deucalion*, *Mornings in Florence*, and a project to extract the best from his earlier art and architecture books including *The Elements of Drawing*, which was recast into *The Laws of Fiesole*. In addition, two of his Oxford pupils, Collingwood and Wedderburn were translating Xenophon's *Economist* for inclusion in the St George's Guild library of standard works. Most of these projects, like *Fors*, were published in instalments, which allowed him to write on them by turns as he wished. If some were to be 'grammars of geology, botany, zoology' for Guild members, as *Fors* 67 argued, something like *Mornings in Florence* was aimed at a far wider audience, whom he considered were ill-served by Murray's guides. His Florence book, to be followed in 1876 with a similar project for Venice, had been planned during his previous visit to Italy: it was issued in stoutly-backed canvas covers, each part comprising one morning's activity as

opposed to the daunting and sketchy inclusiveness of Murray. Both in the sometimes brilliant 'practical criticism' of art works and in the intimate and pedagogical tones readers discovered an altogether different experience than other guidebooks afforded ('Do not let anything in the way of acquaintance, sacristant, or chance sight, stop you in doing what I tell you'[5]). Yet with so many projects proceeding simultaneously – another *Academy Notes* appeared, too, in 1875 – it was no wonder that he failed to make adequate progress; even *Fors* got behind; in May, just before Rose died, he reported that 'Everything – botany, glacier and all – in disgusting arrears'.[6]

After the two courses of lectures between October and December 1874, he lectured less at Oxford, giving nothing at all during the term when Rose was dying and at the beginning of March even having to fight 'with weak thoughts . . . about giving up Professorship'.[7] He made over to the University the whole collection at Oxford, from the Turner drawings given in 1861 to the materials assembled since he assumed the Slade Professorship. In the aftermath of Rose's death he was obliged to go through various ceremonies and dinners in connection with this Ruskin Art Collection. The following autumn he presented a series of commentaries upon Reynold's *Discourses*, but, although re-elected to the Slade Professorship in 1876, he was excused from its duties; they were, in fact, not resumed until November 1877. He gave a few occasional talks at the Royal Institution on glaciers and at the London Institution and elsewhere on the heraldry of stones. But his energies were largely diverted into St George work.

Another means by which, largely unconsciously, Ruskin sought to minimize his depression and ill-health was by reverting more and more to selective memories of his childhood. *Proserpina*, the first number of which came out in 1875, was subtitled, *Studies of Wayside Flowers / While the air was yet Pure / Among the Alps, and in the Scotland and England which my Father knew*. The papers of *Fors* were now frequently devoted to autobiographical reminiscences: 'having already prepared for this one [letter], during my course of self-applause taken medicinally, another passage or two of my own biography'.[8] Some of the other publishing ventures might also be construed as an effort to resume earlier interests ('My old work haunts me'[9]).

When Mrs Cowper-Temple offered him a permanent room at their house, Broadlands, and some maternal care and affection, he responded enthusiastically: 'it is so precious to me to be thought of as a child, needing to be taken care of'; and forthwith he listed his daily habits which they would have to tolerate ('you must let me keep

child's hours').[10] These visits to Broadlands released him into a world where, on one level at least, he could resume a childlike existence, even taking up such Harry and Lucy activities as he had enjoyed as a boy. He told his friends of going to the Broadlands kitchens, where 'the servants are all nice, the cook especially, and she makes creams and jellies for me, and I . . . make experiments on glacier motion in valleys of napkin . . . with jelly and cream and blanc-mange, and I got two quite terrific crevasses opened today'.[11] And this is also the period when an inclination for baby-talk became an ineradicable habit: Joan was Di-Ma, an abbreviation of Dearest Mama, Carlyle was his Papa, and Mrs Cowper-Temple was 'Grannie' and he her 'poor loving little boy'. It was a tendency which Mrs Simon analysed acutely some years later in a letter to Joan Severn:

> the much more manly way of habitual speech & manner had been exchanged for the 'baby-talk' & 'small talk' & a 'talk-down-to-lower intellects' style had begun [in the 1860s]. It *could* always be thrown off . . . but he *ought* never to have left the constant association with his equals, men of the time in their spheres, as he in his – Strength comes by intellectual wrestling – not by uncontradicted talks to a set of adorers & adorers who did not, moreover, understand the true divinity of the God they worshipped. Poor Rose . . . & that horrid Miss Bell etc have led on to this – I am sure . . .[12]

To Ruskin England was full of his childhood: 'all my old scenes, life of sad association now'.[13] He revisited many of those places in 'the old fashioned way' of his youth, with a coach and horses.[14] In his diary he contrasted the old with the present experiences – 'Now, misty and impure sunlight on whitewashed rude Westmorland houses once so dear to me', and 'sad all the way, thinking of old times and the different joy, between Penrith and Poolley bridge'.[15] The coach itself was specially built to provide what seems like a moving cabinet, with 'cunning drawers inside for all kinds of things we might want on the journey'.[16] First they drove via Yorkshire and Derbyshire to Coniston in July 1875; their progress in this atavistic contraption, needless to say, was greeted everywhere by astonished and wondering crowds. Then, in the following April, a similar journey took them via Sheffield to Brantwood. Having always hated railways (doubtless with memories of Mr Gray's bad financial speculation in them before the marriage with Effie) and being involved by the end of 1875 in opposition to extending the railway line from Windermere to Ambleside and Rydal, Ruskin's reversion to posting was also a part of his desire to recover something of a world uncontaminated by

modernism;[17] it was as much an expression of his St George's crusade as of his longing for his childhood.

The summer of 1875 was spent more cheerfully at Brantwood, despite the frequently dispiriting weather. Collingwood and Wedderburn helped to dig the harbour in the intervals of their work on Xenophon; Arthur Burgess also came to assist Ruskin with his botany. Coventry Patmore was another visitor, but he noticed how Ruskin's usually 'courteous and obliging' manners were easily put out by a 'little scratch or contradiction'.[18] Occasional moments of pure peace and poise were the more cherished for being so rare:

> I am very thankful to have seen the windhover. It was approximately at a height of eight hundred feet: but being seen over the cliffs of Gordale, I had a standard of its motion, and when it paused, it was pause absolute. No bird fixed on a wire could have stood more moveless in the sky, so far as change of place was considered, but assuredly both wings and tail were in slight motion all the time. It had two modes of stopping, one holding the body nearly horizontal, with rapid quivering of wings, the other holding the body oblique, with very slight movement of wings and tail. Of course it stands to reason that the motion of these must be in exact proportion to the force of the wind, otherwise it would be blown back.[19]

It was perhaps the St George's Company that, despite being his consuming interest and his equivalent of a 'happy family',[20] caused him most irritations. In January of this year he told Mrs Cowper-Temple that, 'if I am to do any great thing in St George's way, I needn't expect to do it without trouble'.[21] In the same letter he alluded to the gift of some land and cottages at Barmouth, on the shores of Cardigan Bay, presented by Mrs G. T. Talbot. But it was by the realization of his ideas in such tangible forms that difficulties arose, for the legal arrangements whereby the Company could assume the land were complicated and drawn-out. A draft constitution was published in July 1875. But membership of the Company was disappointingly small, with relatively few privileged people offering themselves. And Ruskin found himself constantly required to offer direction and advice to those who did join and who 'then gradually get dependent on me'.[22] He was working hard for so little result, preparing texts like *Proserpina* or *Deucalion* for 'our school libraries' which did not yet exist or have any pupils.[23] But in October 1875 a characteristically Ruskinian focus was established for his various visions and schemes: he purchased a cottage and land at Walkley, just outside Sheffield, 'the germ (he told readers of *Fors* 56) of a museum arranged first for workers in iron, and extended into illustration of the natural history of the neigh-

bourhood . . . and more especially of the geology and flora of Derbyshire'. It was into this part of the St George's enterprise that, not surprisingly, Ruskin began to channel his energies. The Walkley Museum was his own version of the proposal he would put to Miss Miller a few years later in 1879: 'I should *like* you to be able to buy a little freehold land and build a little, cloistral school on it – and therein have all your way and mine.'[24] The 'freehold' was crucial also to Ruskin's need to be 'master', not only over the property itself but over its use and organization.[25] He noted with pleasure that the museum at Walkley would be 'on the top of a high and steep hill', thus discouraging idle visitors and aptly symbolizing the efforts which he required of students ('A museum is . . . not at all a place of Entertainment'[26]). The elevation was, furthermore, 'practically sanitary'.

In October he first availed himself of the invitation to Broadlands under the conditions he had set out for himself as a 'child' there ('tea in my room', etc) and found it a 'great relief . . . to be where I've nothing to manage, and can go out in the garden without being asked what is to be sown, or cut, or sold, or bought, or burnt, or manured, or drained, or fenced, or carted, or –something or other . . .'.[27] Then he went on to Oxford to give the lectures on Reynolds, which he considered 'made rather an impression'.[28] In December he was back at Broadlands.

Here in some further spiritualist séances he found his earlier scepticism confounded. A society medium, who would never have seen Rose La Touche, described her ghost besides Mrs Cowper-Temple and Ruskin on several occasions, sometimes whispering to him.[29] His diary for 14 December records 'the most overwhelming evidence of the other state of the world that has ever come to me'; the event left him 'like a flint stone suddenly changed into a firefly, and ordered to flutter about – in a bramble thicket'. A few days later he exclaims that the 'truth' which, though blind, he had sought for so long had been shown to him at last. Back at Brantwood in January he seemed less confident about the medium's testimony and the intellectual likelihood of Rose's apparition. Yet his recovery at that same time of 'the most precious of the letters [Rose] ever wrote me' seemed propitious and he wrote at length to Norton about his renewed faith;[30] he also resumed carrying Rose's letter between gold sheets in a pocket next his heart. In letters to Mrs Cowper-Temple the following month and in May his old thoughts of Rose can be seen reviving and he allowed the chance discoveries of items formerly connected with her to renew his involvement with her memory.[31] Before Rose's death he had hoped that she would have sufficient 'strength of will . . . to join me in

all Fors plans . . .'[32] Now her ghostly presence began to preside over his multifarious yet ultimately unified projects, sometimes hampering his swift work, sometimes setting it (as he thought) in perspective. He told Furnivall, soon after his return from Broadlands to Brantwood in the new year, how despondent he could be: 'But no shadow of death on myself has ever prevented, as far as I know my clear estimate of right and wrong, in the surrounding world and the destruction of Oxford or Verona & Perugia would have been just as terrible to me, if everything in my own little home had been of Paradise.'[33]

Dreadful weather and overwork are obsessive leitmotifs in the diary for the new year, 1876 ('Today wild wind and black rain, miserable; and I spiritless and empty, more than weary'[34]). Yet occasionally, as on 19 February, he found 'Things going with strange rightness, just in moments of need'. He was mostly in Oxford that winter, maintaining the momentum on various projects as best he could – 'accounts . . . Xenephon, snails, and Sir Thos. Moore [sic]'.[35] 'Fighting through', he decided on 5 March, was the only thing for him; but the St George's accounts gave him perpetual trouble.[36] He took some social diversions by calling upon Carlyle whenever he was in London, staying with an Oxford pupil near Arundel and watching hounds, or taking Cardinal Manning to view Burne-Jones's paintings.[37]

He posted northwards in April, revisiting the monuments and picturesque spots of his childhood travels, but also stopping at the new Walkley museum and having 'Two hours and a half pleasant talk' with a group of working men whom Henry Swan, the museum's curator, had gathered to meet the master.[38] As in his previous museums, real or simply imagined, Ruskin was now fully absorbed in creating in this one an image of the world in its fullness, mending (he told Norton) *fractus orbis* and *fractum coelum*.[39] Everything he undertook either seemed or actually involved the integration into system of whole earths and heavens. The 'overwhelming quantity of thoughts' which such an enterprise stirred were 'all good' if only 'they would stay' and he could render them in some form; but just composing 'a most careful preface to Xenophon' in his rooms at Corpus Christi, before leaving for the north, had made him 'giddy with the lot of things that focus, now, *out of past work*'.[40] The mental worlds, past, present and projected, which he was bent upon ordering had their physical manifestation in his own surroundings at Brantwood. After a visit that summer from Leslie Stephen and his sister-in-law, Thackeray's daughter, the latter noted her impressions of Ruskin leading them through the house,

while his audience, laughing, delighted, follows with scrambling thoughts and apprehensions and flying leaps, he meanwhile illustrating each delightful, fanciful, dictatorial sentence with pictures by the way – things, facts, objects interwoven, bookcases opening wide, sliding drawers unlocked with his own marvellous keys – and lo! . . . We are perhaps down in the centre of the earth, far below Brantwood and its surrounding hills, among specimens, minerals, and precious stones, Ruskin still going ahead, and crying 'Sesame' and 'Sesame', and revealing each secret recess of his king's treasury in turn, pointing to each tiny point of light and rainbow veiled in marble, gold and opal, crystal and emerald. Then, again, while we are wondering, and barely beginning to apprehend his delightful illustrations, the lecturer changes from natural things to those of art, from veins of gold meandering in the marble, and, speaking of past ages, to coins marking the history of man.[41]

This ineluctable mixture of concerns is nowhere better seen in miniature than his inscribing the names of those who had come forward to join St George's Company in the blank leaves of an eleventh-century manuscript of the Gospels.[42]

To Henry Swan and his wife, Emily, at Walkley were dispatched materials for the museum and detailed instructions for their display ('there are always so many things to be decided'): engravings of St George, other Durers, endless minerals, illustrated bird books, some of his own drawings of 'a peacock's breast feather, real size', an early manuscript Bible. Ruskin began collecting materials expressly for Walkley and continued to do so for the rest of his life. Specifications for frames for the engravings and drawings, which would slide into portable boxes, each containing ten, to be pulled out by leather handles, were sent for construction by local carpenters. For the mineral cabinets he hesitated endlessly between 'absolute rightness, or present rough use', opting first for one cabinet 'in any recommendable common wood' (see illustration in the text):

> in four compartments, each containing nine drawers, measuring, *inside*, each 3ft. long by 1.6 wide, and the four upper ones 3 inches deep. The three middle 4 inches deep, the two lower 6 inches deep.
>
> With strong make, and stout frame of cabinet, this will give us the whole cabinet some 3½ feet high – and nearly 7 ft. long by 3 ft. 2, or thereabouts in depth. On top of this, frame of sloping plate glass, with glass sides – rising from front 2 in. to 6, back – altogether we shall have – with a little ledge of base to keep lowest drawer free of ground. I have marked one division in the glass only – we may have three, above drawer divisions if it makes the glass plates much cheaper and stronger.

The dots mean handles, but perhaps a stout round leather strap in front would be better. Each cabinet to lock all its drawers in each compartment at once – but by some simple and solid wooden bar – no springs or jackanapes patent things.[43]

The drawers were to be lined, however, with 'richest silk purple velvet' and the numbers 'worked . . . in gold thread, by my young lady friends'. In parts of *Deucalion* issued in November and December 1876 he also explained the twofold system of mineral arrangement and nomenclature which he proposed for Walkley. There would be one for the general public, 'addressed [more] to the convenience of memory than to the symmetries of classification' and arranged by himself; the other would be 'for chemists, and advanced students in physical science', to be left 'to any good chemist who will undertake it'.[44] And for the Library, as has already been noticed, he was preparing not only grammars of key subjects, but a series of books to be called the *Bibliotheca Pastorum* or *Shepherds' Library*, the collection of essential written texts for the Company. Xenophon's *Economist* was to be followed by Sir Philip Sidney's *Psalter*, a Swiss novel of peasant life – Gotthelf's *Ulric*, and a Life of Moses; but this project of encompassing the world's great books in little space would falter before the vastness of the undertaking.

No wonder there were depressions – constant languor is what the Brantwood diary records monotonously that summer;[45] but it equally reveals his constant preoccupation with *Fors* and the pottering about the estate whenever his spirits and the weather allowed. By the end of July he was sorry to be leaving for Venice and went wandering around Brantwood 'wistfully'.[46] When he left he proceeded first to Barmouth, to inspect 'the tenants on the first bit of ground – noble crystalline rock, I am thankful to say, – possessed by St George in the island'.[47] His train journey into Wales was described in *Fors* with characteristic humour and skill in turning casual encounters into symbolic lessons of social polity. The 'crowd of living creatures' who shared his compartments or whom he observed in refreshment rooms while changing trains presented between them not 'one happy face' nor the ability 'to conceive any good or lovely thing in this world or any other'. His own dispirited sense of alienation from mankind was equally registered in his confession that he had encountered not one human being that whole day 'to whom I could have spoken a word on any subject interesting to me, which would have been intelligible to them'.

Especially after his happy ascent of Cader Idris, the leaking roofs of the Barmouth property further depressed him – 'a weary sight for heart and eyes' – and less than a week after reaching Barmouth he was 'disconsolate' enough to consider 'the abandonment of St George's Company'.[48] The bright spot to his visit, however, was meeting one of the tenants, Auguste Guyard, the exiled French reformer and philanthropist, to whom Victor Hugo had once entrusted his best-loved Persian cat. Guyard's horticultural patience and inventiveness at Barmouth especially endeared him to Ruskin, who must have seen in him something of an ideal St George's companion.[49]

The visit to Venice, where he stayed in the end for nine months, was largely inspired by Prince Leopold. The Prince had visited Venice early in 1876 and told Rawdon Brown to persuade his friend to prepare a new edition of *The Stones of Venice*. Ruskin apparently received 'the counsel as a command'.[50] But the relatively simple task of preparing a new edition of *The Stones*, a task to which he settled on his very first morning, Friday 8 September, was inevitably elaborated into a handful of projects. Besides the Travellers' Edition of *The Stones*, as the revision would eventually become in 1879–81, he embarked upon a guide book, *St Mark's Rest*, a *Guide to the Principal Pictures in the Academy* as well as much sketching, copying and memoranda of buildings which he saw threatened by restoration; casts and photographs of some favourite capitals were made, discussed in *Fors* 77 and selected items were dispatched to the Sheffield Museum.

By December he confessed to Burne-Jones that he had 'scarcely begun my work yet on the old Stones, having been taken up with [Carpaccio's] St. Ursula and trying my strength in old sketching'.[51] The previous month, in one of many letters to Joan Severn, he spoke of never yet having been in

Such a state of hopeless confusion of letters, drawings, and work, chiefly because, of course, when one is old, one's *done* work seems all to tumble in upon one, and want rearranging, and everything brings a thousand old as well as new thoughts. My head seems less capable of accounts every year. I can't *fix* my mind on a sum in addition – it goes off, between seven and nine, into a speculation on the seven deadly sins or the nine muses. My table is heaped with unanswered letters – MSS of four or five different books at six or seven differents parts of each – sketches getting rubbed out – others getting smudged in – parcels from Mr Brown unopened, parcels *for* Mr Moore unsent; my inkstand in one place – too probably upset – my pen in another; my paper under a pile of books, and my last carefully written note thrown in the waste-paper basket![52]

Attempts to regulate his daily programme as of old were unsuccessful ('The accurately divided day rushes round like a paddle wheel'[53]). Beyond what he could hope to accomplish in practice on even good working days was a whirlwind of 'A thousand things in my head pushing each other'.[54] Too much work was incomplete and behindhand; new projects were announced – a complete guide to the work of Carpaccio and a sequel to the Laws of Fiesole on the principles of Venetian colouring – but none would ever be realized. He invoked Tintoretto's 'Sempre si fa il mare maggiore' at the year's end with renewed appreciation.

This Venetian trip, in part designed to allow him to rest as doctors had ordered, not only grew overburdened with new projects but was also threatened by emotional stress. Rose still haunted him in memories and in the person of Carpaccio's St Ursula, whom he had been seeing for the first time in 1872 when Rose summoned him home and which he was copying now. Recollections of past visits to Venice, travels with his parents, all preoccupied him beyond simple nostalgia. Already on the journey out, writing for his various publications as he went, he found the landscapes imbued with countless associations which pressed upon him the more strongly for his being alone and in less good health than on previous journeys.[55] In the village of Simplon on 2 September he wrote the chapter of *Deucalion* entitled "Thirty Years Since". The piece is typical of Ruskin – in its composition *en route* 'in the little one-windowed room . . . of the Hôtel de la Poste', in

its allusion in the title to his favourite Scott novel, and in its narrative of the Ruskin family's meeting with James Forbes, the glaciologist, years before at the same inn. With the compulsive twining of topics which was increasingly his response to the pressures of past work and by a doubling back of his exposition to include other details of youthful Alpine adventures, he links his reading that very day of 1876 in Viollet-le-Duc's explanation of Alpine forms in *Massif du Mont Blanc*, explanations contrary to Forbes's, with his long-standing contempt for those who cannot understand mountains.

Once at Venice the same, fraught pattern of old memories and pursuits interwoven with new, often unpleasant encounters, continued. There were still the dramas of sunset and sunrise ('S. Giorgio in Aliga at sunset . . . a blaze of amber passing up into radiant jasper'), the refreshment of rowing on the lagoon, trips to Verona, sightings of the Alps from the square before S. Zanipolo, the daily readings in Plato 'as in old days'.[56] But the 'sorrow and horror' of modern Venice disturbed his sense 'of home'.[57] He told Carlyle that he was unhappy in his work and did not 'want to write about Venice, now, but about Sheffield'.[58] The oscillations of temper and response to his surroundings intensified. Yet he extended his stay repeatedly.[59] There were happy accidents of research, as when he discovered the early inscription in San Giacomo di Rialto: beneath a cross of St George were the words, so resonant now for their discoverer, 'Around this temple, let the merchant's law be just – his weights true, and his arguments guileless'.[60] Above all, there were the resumed friendship with Rawdon Brown ('Papa' now to Ruskin) and the company of various English and American friends or research assistants like Charles Fairfax Murray and J. W. Bunney, who introduced him to Italians like Giacomo Boni and Angelo Alessandri, who in their turn contributed to his work.[61] It was through another Italian assistant that he came to know Count Alvise Zorzi, who had written a pamphlet in protest against some already completed and some proposed restorations to St Mark's Basilica; Ruskin paid for its publication in March 1877 as well as contributing a preface. The campaign which he thus joined was eventually successful in stopping restoration work until, in 1880, a commission of inquiry upheld the protesters' case.[62]

Ruskin's private energies were fixed most intently during that autumn upon Carpaccio's *Dream of St Ursula*; he told a correspondent that the painting was 'now called in Venice "Il quadro del signior R"'.[63] On 18 September the painting was especially removed from its place for him to copy more easily. Shut up in a room of the Academy, he filled himself with its painterly delights, copying its details com-

pulsively and slowly conflating its details with his own images of Rose:

> Fancy having St Ursula right down on the floor in a good light (he wrote to Joan Severn) and leave to lock myself in with her . . . There she lies, so real, that when the room's quite quiet, I get afraid of waking her! How little one believes things, really. Suppose there *is* a real St Ursula, di ma, taking care of somebody else, asleep, for me?[64]

The sleeping saint and the 'sleeping' Rose La Touche merged fitfully in Ruskin's mind. The painting seemed so real that he could at times convince himself that it *was* Rose, simply sleeping. As autumn declined into winter and he became oppressed with work, his mind tottered briefly upon the borders of sanity.

It happened at Christmas, just over a year after 'the series of teaching at Broadlands', when Rose was said to have appeared to him.[65] Much bound up with his work on copying the Carpaccio, which was not going particularly well,[66] concerned with trying to behave better towards friends and acquaintances, and above all desperately looking for 'a new sign from Rose', Ruskin interpreted a series of events between 23 December and 2 January as a miraculous manifestation of Rose's presence and help.

The events were, in themselves, slight. First, a day of happy accidents, as they seemed to him at the time: the gift from Lady Castletown, an Irish friend in Venice, of flowers similar to those depicted on Ursula's bedroom windowsill by Carpaccio; the receipt from England of some dried vervain, the verbena held in the beak of the scarlet bird in another Carpaccio painting in the Scuola di San Giorgio, where he happened to stop and make that discovery on Christmas Day; a letter from Mrs La Touche, who was visiting Joan Severn at Herne Hill and whom Ruskin now felt Rose wanted him to forgive; a gift from the Bunney children of shells identical with some he associated closely with earlier episodes in his affair with Rose; Rawdon Brown talking on Christmas morning of precisely the solution to the Easter Question on which Ruskin had been writing earlier; meeting the widow of his former gondolier whom he had baulked from visiting; then the delightful visit to his present gondolier's family. Then suddenly, Christmas Day turned bad: there was a disturbing encounter with a red-eyed boatman who tried to tempt Ruskin into his filthy boat; thick fog in which he was twice lost on his way across the lagoon; unsatisfactory visits to an American friend's family and to Lady Castletown, followed by an attack of physical pain which caused him acute discomfort and alarm. And then in the days immediately

following Christmas a series of heightened encounters or activities which seemed to speak to him of more than usual significance.

What further distressed him was his inability to recount the events of Christmas Day in his diary – his inability at first to see pattern and point in events which his own strange state embued with obscure purpose. But the more he pondered and the further he got from them, the more he was elated at discovering 'a succession of helpful and sacred suggestions, presented so as to connect themselves with the best feelings and purposes of my life'. He worked out their meanings in lengthy letters to Joan Severn.[67] The contrasting elements of his Christmas Day were, he now realized, a psychomachia, a battle between good, evil, and human powers. In his acutely excited state he read the events in the manner of an old Italian Catholic, acknowledging the Madonna's appearance in one of his gondolier's children and the Devil's, in that ugly red-eyed boatman.[68] From that point, his work went well, he learnt and practised humility and tenderness towards others and was generally confirmed in 'good purpose and holy thought'; local irritations such as steamboats or scaffolding on the Ducal Palace ceased for a while to disturb him. As he sat up late on 2 January to see in Rose's birthday, he registered the 'many branching details' of his recent enlightenment, when he went 'wandering into past life, in Venice and elsewhere – incoherently'.

That Ruskin's mind did not break under these physical and spiritual assaults during Christmas was in part due to the old evangelical habit of self-examination and his constant need 'to set in order'.[69] Although Joan evidently reacted nervously upon receipt of the first batch of letters, Ruskin himself – with typical attention to the coherence of all details – found the experiences explicable in terms both of the topography and place-names of Venice itself and the patterns of his own writings: 'I saw in the most perfect chemical solution, as it were, every one of the movements of my own mind.'[70]

In his diary these events were only dimly understood; in the letters to Joan Severn he teased the whole 'Christmas tale' out into parable. In *Fors* 74, the beginning of which is dated that Christmas Day 1876, he recounted parts of the events, emphasizing the mythology of St Ursula's plants and the strange symbolism of her 'personal message' to him, and drawing into his account more of that Christmas, Venetian world, in the form of sculptures on the Doges' Palace, the story of Tobit's dog, Venetian laws respecting the sale of fruit and their relevance to Sheffield. No wonder in the next *Fors* he said that 'some of my "most intelligent readers" can make nothing of what I related'. He advised them that 'all great human myths are conditions of slow

manifestation to human imperfect intelligence'.[71]

In February 1877 Ruskin moved his lodgings from the Grand Canal ('*too* expensive') and established himself at the Calcina, on the Zattere; 'commanding sunrise and sunset both . . . I look along the water instead of down on it, and get perfectly picturesque views of boats instead of masthead ones, and I think I shall be comfy'.[72] A tablet now marks his stay at the Calcina, which must have also determined upon another commemoration of their English guest after his death in 1900, for one can still find in Venetian bric-à-brac shops a postcard with portraits of the 'Master' at all stages of his Venetian career. At the Calcina he was probably as 'comfy' and as content as his work and health would allow. In his circle of friends and assistants he stayed on until late May. The 'harmony of all my coming work', which the New Year had augured after Rose's messages, was not always fulfilled; he fought 'piggish disbelief' and depressions which brought all his plans in jeopardy ('all in crumbs when I expected loaves'). Yet sometimes the 'dismal . . . time of reaction and doubt', the loss of confidence in Rose's messages to him the previous Christmas, were temporarily banished and his spirits improved.[73]

He left for the Alps having accomplished, not only the regular *Fors*, but his *Guide* to the Academy pictures, the completion of *Mornings in Florence* and of Sir Philip Sidney's Psalter, published as *Rock Honeycomb* that July; *St Mark's Rest*, interrupted in order to help and preface Zorzi's pamphlet on the restorations, was inaugurated in April with the three first chapters. He spent a fortnight in the mountains, meeting George Allen and his son for a spell at Domodossola. But anxiety about his physical and spiritual health continued. Back in Herne Hill on 17 June he was cheerful, even about his eyesight; but the very next day, miserable with disappointment at his Turners, he was melancholy and idle.[74]

He spent some time in Oxford and London, including a visit to the Grosvenor Gallery where the sight of several of Whistler's beautiful *Nocturnes* led Ruskin, in the *Fors* he was then composing at Herne Hill in mid-June, to make his notorious accusation of that 'Cockney impudence' whereby 'a coxcomb [could] ask two hundred guineas for flinging a pot of paint in the public's face'.[75] Doubtless he was exhausted by his journey home, and his precarious eyesight, which was often nowadays producing sparks and dancing lights, suddenly discovered in Whistler's flickering canvases a horrid intimation of its own physical condition.[76] But the pictures also violated the standards of fine art which he had been so long promoting, though the affinity between late Turner views of Venice and Whistler seems to have

escaped him. So *Fors*, where he had become accustomed to say whatever came to him, delivered his judgement accordingly; he had, after all, passed a similar judgement on Whistler's 'absolute rubbish' in one of his published Oxford lectures.[77]

But Whistler or Whistler's annoyance was not Ruskin's most pressing problem. Not only was St George's Company still experiencing legal snags in establishing itself, but William Cowper-Temple and Thomas Acland had resigned as trustees of the Fund after Ruskin announced in *Fors* for March 1877 that he had authorized the sale of £1,200 of stock to buy more land near Sheffield for allotments. New trustees were appointed, and Ruskin made his northward journey to Brantwood in July via Birmingham to meet one of them. George Baker, the mayor of Birmingham and a local manufacturer, had given a piece of wooded land at Bewdley, where at one stage Ruskin projected another museum.[78] Ruskin viewed the land, met some of Baker's fellow manufacturers gathered to meet him ('couldn't say a word I wanted to anybody') and then, visiting a cottage of two women nail-makers, the creator of *Fors Clavigera* was shocked into attacking the two-class system of masters and workers in the August number.[79] His dismay at the practical issues of St George's work, his irritation with obstacles to his idealism, burst out in a letter to William Cowper-Temple, asking not to be bothered with financial details and to be left alone: 'I am doing a larch bud – and don't mean to leave off . . . please think of me as dead – in, and to – all such matters – unless you want me to be dead to all others, too.'[80]

The Brantwood summer wavered between more larch buds, exploring the Coniston valleys and fells with visitors and their children, and anxieties about his dim sight and giddy head. 'Overwhelmed under the quantity of things which must be kept in my mind', he feared even for his sanity.[81] *Fors* had to continue; so did *St. Mark's Rest*; *The Laws of Fiesole* must be completed for the Oxford students by the Michaelmas Term; there was a lecture to deliver locally on Coniston geography, and a whole course to prepare for his resumption of the Slade lectures in the autumn. He wrote to tell Norton at the end of July that he was 'nearer breaking down myself than I mean voluntarily to have run, – owing to the extreme need for doing all I could at Venice this winter'.[82] Perhaps under the tuition of Joan Severn, who had been obviously dismayed by his Christmas letters, he began to refer to the 'Venetian mischief [from which I] am now nearly recovered'.[83] But his summer, restful in comparison with his time abroad, scarcely revived him. Before he left for Oxford in November, Joan herself had a miscarriage and her illness gave him a 'terrible fright', left him

24 Photograph of the upper room of the Museum at Walkley.

GEORGE OF ENGLAND

I AM the bravest knight of all
My armour is of gold
Oer all the field death spreads his pall
When I my wrath unfold

2
Of beauteous purple is my crest
A dragon on my shield
With greatest wrath my foes I prest
And bloody was the field

My purple plume was stained with gore
Of all the foes I hate

25a Ruskin's first enthusiasm for
St George, drawn in a manuscript
booklet of 1829, *The Puppet Show*.

25b Ruskin's adult crusade on behalf
of St George drew him to the
Venetian painter, Carpaccio's *St
George*, here in Ruskin's rough copy
of 1872.

25c Ruskin's copy of another Carpaccio painting,
The Dream of St Ursula: see pp.364 ff.

26a Ruskin, drawing of broken capitals of one of the
fourteenth-century windows of Ducal Palace, Venice.

26b Venetian postcard of Ruskin and the Pensione Calcina: see p.367.

27 Ruskin's letter to Susan Beever just before his first attack of mania, 22-3 February, 1878: see p.370.

a Collingwood, 'J.R. in contemplation of a mediaeval town'
(mistakenly dated '1884').

b Ruskin, 'Results of Contemplation' – i.e. St Urbain.

29 Laurence J. Hilliard, *The view from Brantwood*, 1880.

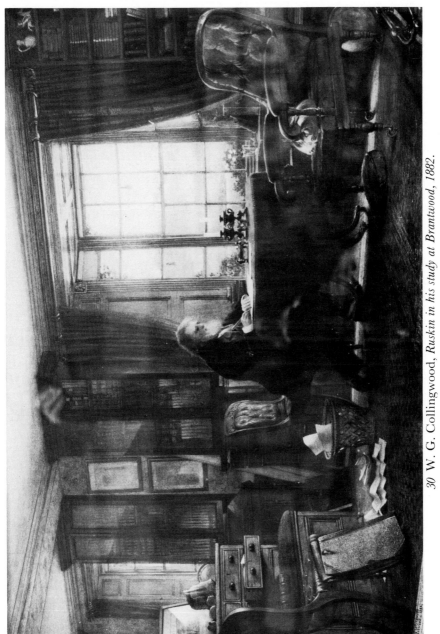

30 W. G. Collingwood, *Ruskin in his study at Brantwood, 1882.*

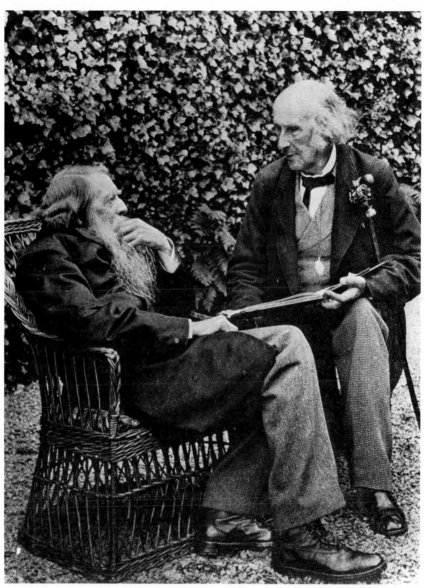

31 Photograph of Ruskin and his old friend, Henry Acland, taken by Acland's daughter in the grounds of Brantwood, 1 August, 1893.

'stunned . . . and giddy' once again, and startled him into realizing how 'I was too dependent on her, as I used to be on Rose'.[84]

At Oxford he gave "Readings from *Modern Painters*", what he called 'this course of lectures on myself'.[85] Huge audiences evidently enjoyed the return of the Slade Professor. After a pre-Christmas dinner at Herne Hill with the Severns and the family of Henry Stacy Marks, he left his room there 'ankle deep in unanswered letters' to return to Oxford for Christmas, enjoying the services in Christ Church Cathedral, where as an Honorary Student of his old college he had his stall, and dining with the Aclands.[86]

The New Year saw him the guest of Prince Leopold at Windsor Castle; but the visit irked him – he disliked the view from his room into the castle yard 'as if I was in a big modern county gaol with beautiful turrets of modern Gothic', and the Leonardos were 'too much for me'.[87] There followed, soon afterwards, another 'official' visit, to the Gladstones at Hawarden; here his diary records that he felt ill, but guests remembered his lively conversation at dinner, under-shot with 'an utter hopelessness; a real, pure despair beneath the sunlight of his smile, and ringing through all he said'. But Ruskin took to Gladstone's daughter, Mary, to whom afterwards he wrote (per-haps more warmly than he exactly felt) about her father. Gladstone's terse judgement was that 'In some respects [Ruskin was] an unrivalled guest'. Ruskin only became fully animated, apparently, when he discoursed of Carpaccio and showed fellow guests some of his copies.[88]

Back at Brantwood with his secretary, Laurence Hilliard, he started to compose the introduction to a catalogue for an exhibition of his Turner drawings which were to be exhibited late that year at the Fine Art Society Gallery. He felt alone, depressed, utterly subdued by the wasted opportunities of life:

> Morning breaks as I write, along those Coniston Fells, and the level mists, motionless, and grey beneath the rose of the moorlands, veil the lower woods, and the sleeping village, and the long lawns by the lake-shore.
>
> Oh, that some one had but told me, in my youth, when all my heart seemed to be set on these colours and clouds, that appear for a little while and then vanish away, how little my love for them would serve me, when the silence of the lawn and wood in the dews of the morning should be completed; and all my thoughts should be of those whom, by neither, I was to meet more![89]

Precisely the recognitions which he felt Turner to have made of an

unsatisfactory world – 'a discovery contemporary, probably, with the more grave one that all was not right within himself' – were Ruskin's own:

> about the year 1825 . . . he shows clearly the sense of a terrific wrongness and sadness, mingled in the beautiful order of the earth; his work becomes partly satiric, partly reckless, partly – and in its greatest and noblest features – tragic.

Besides this work on the Turner catalogue, he was anxious to complete Part II of *The Laws of Fiesole* and had plans for rearranging the Oxford collections; this in its turn required additional notes for users, which he was dictating to Dr Chase, the Principal of St Mary's Hall, before he left Oxford.[90] Though he knew that he needed rest, once at Brantwood he also worked on a preface for the essay on dragons which J. R. Anderson, another assistant, contributed to *St. Mark's Rest*, wrote a preface for W. H. Harrison's *Notes and Reminiscences* at the request of his widow and drafted what would turn out to be his last *Fors* until 1880. But he told his readers, writing on 15 February, that he was 'in a dream state . . . not knowing well what I was doing'.[91]

The accumulations of ill-health, overwork, annoyance with what he took to be Octavia Hill's hostility to his St George's Company,[92] and continuing obsession with Ursula/Rose, all concentrated in his first break-down. With typically keen self-analysis the stages of his illness, probably an attack of paranoid schizophrenia, were later rehearsed to many friends and correspondents.[93] To George Richmond he said that it 'was on the WHOLE a sifting examination of me, by myself, on all the dark sides and in all the dark places . . .'[94] His experience in evangelical self-examination was, besides the form his hallucinations sometimes took, also clearly an underlying contribution to his mania.

It began perhaps on 20 February, though a month before he noted, '*brains in litter too*', like his work table;[95] 'disorderly and discreditable' dreams, bad weather, intense interrogation of the text of *Galatians*, a sense of the devil having got the better of him – all are recorded in his Brantwood diary, which surrenders itself more and more as February advanced to the flow of free associations ('I must put it all down as fast as I can'); his mother and Rose, whom he thought he had married,[96] play interchanging parts, and 'messages one after another [were] crowding in – so fast – so innumerably'. One of his last entries was a transcription of Tintoretto's 'mare maggiore'. Also at some final stage of this attack he had attempted to write to Susan Beever, misdating

'23rd February' presumably in error for the preceding day.[97] It shows both that he was still measuring the inroads of mania – 'All is quite right as far as this' – and then his fragmentation of purpose, as Effie, Wordsworth, Miss Rigbye, Rose and his 'breadmaker' all crowd into the scattered scribbles. Then during the night of 22/23 February, as he later recalled,

> I became powerfully impressed with the idea that the Devil was about to seize me, and I felt convinced that the only way to meet him was to remain awake waiting for him all through the night, and combat him in a naked condition. I therefore threw off all my clothing, although it was a bitterly cold February night, and there awaited the Evil One . . . I walked up and down my room, to which I had retired about eleven o'clock, in a state of great agitation, entirely resolute as to the approaching struggle. Thus I marched about my little room, growing every moment into a state of greater and greater exaltation; and so it went on until the dawn began to break . . . It seemed to me very strange that that, of which I had such a terrible and irresistible conviction, had not come to pass.
>
> I walked across towards the window in order to make sure that the feeble blue light was really the heralding of the grey dawn, wondering at the non-appearance of the expected visitor. As I put forth my hand towards the window a large black cat sprang forth from behind the mirror. Persuaded that the foul fiend was here at last in his own person . . . I darted at it . . . and gathering all the strength that was in me, I flung it with all my might and main against the floor . . .
>
> A dull thud – nothing more. No malignant spectre arose which I pantingly looked for – nothing happened. I had triumphed! . . . I threw myself upon the bed, all unconscious, and there I was found later on in the morning in a state of prostration and bereft of my senses.

The illness, which continued until early April, was physical as well as mental. He refused all food until the night of 28 February, and his life was feared for. Fantasies about the devil continued, mixed with other spectres. Sometimes he was unconscious, sometimes abusive of Joan Severn, who had come north, as did Dr John Simon, to nurse him. Upon her he seems to have transferred most of his unconscious and conscious animosities. She was upset at the violent hatred he seemed to show towards her; but he also signalled out the Queen, whom he thought was plotting with the Simons to take away his property.[98] 'He *raves*', wrote Acland to the Gladstones in March after a visit to Brantwood, 'in the same clear voice and exquisite inflection of tone, the most unmeaning words – modulating them now with sweet tenderness, now with fierceness like a chained eagle – short discon-

371

nected sentences, no one meaning anything, but beautiful to listen to for the mere sound . . .'[99]

Meanwhile, in London, Henry James was visiting the exhibition of Ruskin's Turner drawings in the Fine Art Society's Galleries in New Bond Street and read the 'telegrams and bulletins relating to his condition' that were on display. Consulting the catalogue, the pages of which appeared to James to 'bear the marks [of Ruskin's illness] to a degree which makes it seem almost a cruelty – an irony – to have published them', he meditated upon Ruskin's art criticism. The catalogue

> is extremely characteristic, containing, as it does, amid much exquisite criticism and much that is a genuine help to enjoyment, many of those incongruous utterances of which the illustrious art-teacher has of late been so prolific . . . Turner's transfiguring vision . . . is often such as to make the reader of the catalogue admit those ultra-metaphysical intentions which Mr Ruskin attributes to him.

James ended his critique by acknowledging how Ruskin 'is the author of the most splendid pages in our language' and that he had spent his life in a passionate ('a too passionate') endeavour to right wrong and 'establish his rigid conception of the right'.

Ruskin recovered surprisingly quickly, and on 8 April he took his first walk, picking Joan a spray of ivy which she preserved.[100] His gratitude to her for bringing him through the illness was intense, but he was also much chastened by his dependence.[101] He became 'timid and irresolute' in face of the 'vision . . . of my selfishnesses, prides, insolences, failures'. He especially lamented 'my failure in duty to my father, and . . . the pain I had caused him'.[102] But he wrote warmly to Margaret Raine Hunt and other friends, thanking them for their part in organizing and contributing to a fund to buy Turner's *Splügen Pass*, the drawing which had eluded him in 1842; yet he was grieved that his friends 'had been brought into this costly expression of their care for me by my folly in making myself ill! Why should I be rewarded by all manner of pretty sayings & doings for having driven myself crazy . . .'[103] Joan told Mrs Simon that Ruskin had been 'astonished and touched beyond all words' when the Turner reached Brantwood on 14 May.

Not one to be idle unless capable of nothing else, Ruskin slowly resumed those activities which would not, to his mind, disturb him: some 'Botany and Geology, and . . . a *little* Turner work'.[104] But *Fors* was stopped for a while and St George's work, because all 'policy or charity' would excite 'grief and passion'.[105] He worked a little at the

National Gallery in July on the Turners which were to be loaned to Oxford; he then toured Yorkshire with Arthur Severn before going into Scotland to stay with William Graham and his family. At their house he was delighted to find Rossetti's *Annunciation*, Millais's *Blind Girl* and a drawing by Burne-Jones, upon which he promptly wrote an essay, "The Three Colours of Pre-Raphaelitism", which appeared at the end of the year in the *Nineteenth Century*.[106] Then there was another visit to the Gladstones, and his host recorded that 'Mr Ruskin developed his political opinions . . . All in his charming and benevolent manner'.[107]

But it was decided that it would be unwise for him to appear at the hearing of Whistler's case for libel, which came up on 25 November; instead, Arthur Severn went on his behalf. Burne-Jones, together with W. P. Frith and Tom Taylor of *The Times* gave evidence for Ruskin, while Albert Moore, W. G. Wells and W. M. Rossetti gave theirs on Whistler's behalf. Burne-Jones and Rossetti were especially embarrassed by the positions they were forced to take up; the former because he was both a friend of Whistler's and Ruskin's and because the offending essay in *Fors* had used his paintings to contrast with Whistler's careless workmanship. Ruskin on 26 November wrote to Norton from Brantwood about 'the comic Whistler lawsuit', and regretted that he had been unable to answer for himself in court.[108]

Whistler certainly enjoyed himself there; his most famous remark – that he asked two hundred guineas, not for knocking off a canvas in two days, but for 'the knowledge of a lifetime' – repeated a favourite point of Ruskin's, who had indeed used it only that year when writing about Turner's vignettes for Rogers's *Italy*; perhaps Whistler was even invoking it ironically, for we know that he knew Ruskin's work.[109] The jury found for the plaintiff; but their award of only one farthing damages and their refusal of costs could be construed as their judgement that, while technically libellous, Ruskin had offered substantially fair criticism in his *Fors* letter. Whistler wore the farthing on his watchchain, and Burne-Jones sent Ruskin a quarter of a halfpenny stamp, 'to my blessed oldie for any possible injury I have done to his cause'.[110] Whistler issued a pamphlet, *Whistler v Ruskin: Art and Art Critics*, later incorporated in *The Gentle Art of Making Enemies*. Ruskin wrote "My Own Article on Whistler", never published in his lifetime, in which he tried to make clear the basis of his critique.[111] Friends quickly collected funds to pay for Ruskin's costs in the libel action; but Whistler himself was eventually forced into bankruptcy. Despite his cheerful bravado at the time, Ruskin was certainly hurt by the court's decision, and he invoked its technically adverse judgement as an

excuse for resigning his Slade Professorship at the end of November. He wrote to Dean Liddell: 'I cannot hold a Chair from which I have no power of expressing judgement without being taxed for it by British Law.'[112]

Part VI

Saint George

Never was a soul more open and accessible to immediate impressions, never one that responded with more sensitiveness or more instant sympathy to the appeals of nature or of man. It was like an Aeolian harp, its strings quivering musically in serene days under the touch of the soft air; but, as the clouds gathered and the winds rose, vibrating in the blast with a tension that might break the sounding-board itself.

Charles Eliot Norton

I will not cease from mental fight,
Nor shall my sword sleep in my hand,
Till we have built Jerusalem
In England's green and pleasant land.

William Blake

Freed, at least for a while, from his Oxford work, Ruskin could not be idle. But with precarious health and much disturbed by the intermittent bad weather, he could never achieve all that he wished. He was torn between the past and the present. Work for St George's Guild, the means of registering his concern for the present, was channelled into the resumption of Fors Clavigera and, mostly, into organizing the Walkley museum. Here and in related teaching he could exercise his love of influence, pedagogy and mastership, needs which he satisfied also in a large correspondence. But for his own pleasures he returned increasingly to selected reminiscences of his own best past, a nostalgic search for an adequate serenity, hopeless wherever it tried to involve Rose La Touche, successful when it issued in the serial parts of his autobiography (1885 onwards).

But with both museum work and Praeterita the consuming and ultimately defeating problems were the need to honour wholes as well as parts, the wrestle with diversities of material and the refusal to surrender any one topic for others. Serial publication continued to provide some precarious order for his manifold writings; but compromise, selection and eventually disorder were forced upon him through recurring attacks of mania, illnesses which were themselves responses to the vastness of Ruskin's vision and enterprises.

Deaths of friends – Dr John Brown in 1882, Rawdon Brown in 1883, Mary Beever the next year, even and more harshly Laurence Hilliard in 1887 – left him defeated by the insufficiencies of life. And the pattern of his illnesses forced the Severns to confine and restrict him in ways which further underlined the lack of time and energy available to him. But their care also challenged his authority and threatened the command of himself and his concerns. His active life closed with him pathetically torn between his need of affection and protection and his efforts, steadily more eccentric, to reaffirm his independence. After the struggle ended, eleven years before his death in 1900, he remained at Brantwood; his work and ideas stopped completely, passing beyond his control into those of his professed admirers; Ruskinian became Ruskinite.

Chapter 20

'Monsoons and cyclones': 1879–1889

The Ends of journies are always at first sorrowful – one hoped to do so much, and one has done so little, and there are such accumulations of failure even at the best.

Ruskin in a letter to his mother, 25 July 1869

– 1 –

That winter was spent at Brantwood. Ruskin enjoyed sliding on the frozen lake. But it was a meandering year of recuperation, still punctuated with giddiness and devilish oppression, but also fitfully dedicated once more to work. He told a correspondent in June that 'I don't change, but I die; and if you expected me, after being all but stark dead and *all* stark mad, of inflamed brains, to come up . . . again all that I was before – it was truly a pleasant fiction of your fancy.'[1] The midsummer weather was exceptionally depressing. Candles were required for dinner on 17 July, 'the blackest dinner the devil has yet brought on us, – utterly hellish'.[2] Yet he struggled to work as before; periodically he set himself to put his rooms in order, sorting minerals as they arrived from Oxford (and sending some choice examples to be admired at the Thwaite), establishing 'my fixed library', and happy by mid-year that 'all my rooms and books and drawings [were] in better order than they've been for years'.[3]

He worked on *The Laws of Fiesole*, *Proserpina* and *Deucalion*; he translated Plato regularly ('Jowett's translation is a disgrace to Oxford'[4]); he projected a book on Horace and a life of Scott, originally planned to be incorporated in *Fors* instalments.[5] He also undertook to begin his *Letters to the Clergy*, addressed to the Vicar of Broughton-in-Furness when Ruskin was unable to take up an invitation to speak to the Northern Clerical Society in person.[6] Some of his work was therapeutically self-indulgent, as in the personalized flower descriptions in *Prosperpina*; some was done after the old Harry-and-Lucy mode, as he explained to Susan Beever: 'calm into my mind today, after a sleepless night, merely by watching a duck in a bucket on my study table – I've found out more than in all [my] sixty years of former

377

life, about ducks, and hope to get *that* at least set down'.[7] And, despite his resolve the previous year to refrain from *Fors* or St George's work, he became more and more engrossed in it as 1879 wore on.

Immediately after his collapse and recovery in 1878 the allotments bought in 1877 at Abbeydale, near Sheffield, had needed expert direction; so Ruskin had yet again invoked the faithful and versatile Downes, who was sent there with 'whatever authority I could have myself'. Swan was also advised that Downes was 'an excellent accountant, and will look into whatever needs eyes, in the current money matters'.[8] Ruskin hoped 'to be of some little use yet to the St George's Company but everything depends on my not troubling myself'. But by the following year he was increasingly eager to get involved again; first, he was drawn once more into the Walkley museum plans; then, as Frances Graham shrewdly remarked about Ruskin's personal relationships, he 'loved power'.[9] In the Guild, as it was now called since the granting of a Board of Trade licence in October 1878, he could exercise that power even *in absentia* through Downs or through his first Master's Report, written in February 1879 and read on his behalf at the first meeting of the Guild in Birmingham that March.

He was busy classifying minerals for Walkley in June, 'important as the first practical arrangement ever yet attempted for popular teaching'.[10] Even earlier, in February, his diary has notes for a *Fors* on the museum, and the next issue which did appear in March 1880 announced that 'the proposed enlargement of the museum at Sheffield' would probably attract more support than the 'agricultural business of the Guild'. He envisaged

> such a museum . . . not dazzling nor overwhelming, but comfortable, useful, and – in such sort as smoke-cumbered skies may admit, – beautiful; though not, on the outside, otherwise decorated than with plain and easily-worked slabs of Derbyshire marble, with which I shall face the walls, making the interior a working man's Bodleian Library, with cell and shelf of the most available kind, undisturbed, for his holiday time.[11]

In his Master's Report he also sketched his plans for a 'botanical garden for the orderly display of all interesting European plants'. As Charles Gatty, curator of the Liverpool Free Public Museum, remarked after a visit to Brantwood in August, 'He has great ideas about Museums'.[12] In October Ruskin went himself to Sheffield to prepare for a visit to Walkley by Prince Leopold. He stayed in a worker's

house and was sufficiently impressed to consider removing there for part of the time. He signalled this fresh involvement with the Guild by naming the Bell crag on the eastern side of Coniston Old Man, 'St George's Crag'.[13]

Ruskin was nonetheless watched anxiously by his friends, no doubt an irksome scrutiny whenever he detected it. The year at Brantwood was made as unstrenuous a time as possible for him. At its most successful he could relish the pleasure of reading Prince Leopold's remarks about his educational work in a speech delivered at the Mansion House in February (used in part as a motto for Part Five above). And he responded warmly to news of the Ruskin Society of Manchester.[14] Guests came, like his goddaughter Constance Oldham, a 'bird' from the Winnington days, and Coventry Patmore; Charles Darwin paid a couple of visits. At Easter with some ceremony they launched the Brantwood boat, *Jumping Jenny*, which Ruskin had helped Laurence Hilliard to design with a narrow stern seat and a Lake Garda bow ('my first essay in marine architecture'[15]). In the autumn he visited London and sat for his portrait to Hubert von Herkomer. Back home in the Lakes he decided to buy a della Robbia *Madonna and Child*, of which Murray had sent him a photograph from Florence; by the next February it was hanging marvellously in his study.

But that January, 1880, was 'quite . . . the most miserable January I ever passed'.[16] And when he fell and hurt himself sliding on the lake ice, even that pleasure was stopped and he became jealous of the others amusing themselves. Partly the weather upset him, continuing until the spring and summer to torment him with its 'curse' ('this devil in the wind and clouds and light'[17]). In August the storm clouds lay over the fells like the Hesperides dragon of Turner's painting. But all year he had been pondering serpents – dragon meant the beholding serpent[18] – first, for the lecture he gave in London on 17 March, St Patrick's Day, and again by popular demand on 23 March, and then, for its inclusion in *Deucalion* that July. This lecture, entitled "Living Waves", involved his jumping up on the desk and helping Arthur Severn's two brothers at either end of a giant boa constrictor skin mimic the predatory action of the reptile.

The harmless re-enactment of a fragment of his dream life ('not ugly at all'[19]) was but one of a tangled skein of endeavours. He began the year much strengthened, as he thought, by chance commands and directions: random openings of the Bible made him 'thankful for the clear guiding . . by Fors order'.[20] So on New Year's Day he began the first *Fors* since his illness, typically using the letter to rehearse for his readers that decline into mania almost two years before:

The group of ten years, in the beginning of which these letters began, will I trust, not close upon *their* work undone, though it may very easily close upon mine, done to the end allowed me But the check I received in it / two years ago / is / I hope / rather to be read as a sign that no more was needed for my purpose than – (which was my own first interpretation of the lesson) that I was too feeble and faultful to carry it through.[21]

The second draft – 'done twice over . . . fatigues and confusions'[22] – was dated on his birthday. Although by early April he realized that in heeding what he took to be special commands he had overtaxed his strength much too soon after he had recovered it, he was nonetheless plunged into innumerable tasks. He had written early in the year a response to the Bishop of Manchester's letter on usury, itself a belated reply to Ruskin's challenge to him on that topic in 1875; there was a new preface to be written for *Seven Lamps of Architecture*, another for *A Joy Forever* (as the reissue in his "Collected Works" of *The Political Economy of Art* was now called); he composed an Epilogue for his *Letters to the Clergy*, a manual on prosody for the *Bibliotheca Pastorum*, an enterprise which had grown out of work on Sidney's Psalter.

Perhaps like the Elijah upon whom he would preach a sermon to the boys of St David's School, Reigate, a few years later, he accepted the 'comfort that is given to every man – "Go & do thy work"'.[23] But it is doubtful whether he derived much comfort. The six letters on the function and form of a museum or picture gallery, published in the *Art Journal* for June and August, were nearer his heart, and his Brantwood diary notes on 12 June that he had contentedly 'planned museum all day' with a visiting architect. But more often he was closer to that sense of Elijah 'as one of ourselves – overworked, overwhelmed – the strain of anxiety too great – the thought of loneliness over powering him'. The most ambitious project of the year, essays on "Fiction, Fair and Foul", published serially in the *Nineteenth Century*, succumbed to his fitful work and lack of concentration. Essentially they were a form of the long-projected discussion of Scott; but they tended to absorb whatever other topics occurred to him during the summer, so that, after the first which brilliantly diagnosed a new genre of city novel, the second was side-tracked into his current work on prosody, and Byron, Browning and Wordsworth crowded Scott out; by the autumn, when he had already started upon a new book, *The Bible of Amiens*, the fourth "Fiction" essay invoked an account of Barbarossa more appropriate to the other work. It is perhaps in this tired and harassed series of essays that Ruskin most obviously digresses in the

ways that his commentators habitually blame him for; despite his fascination with museums into which all topics could be introduced, he was for once not able to discover its literary equivalent.

Apart from the trip to London for the serpent lecture and two visits to Sheffield, which displeased him this year, he remained at Brantwood until early August. Then, with a short stay in London, where he had a delightful day at the zoo, but was dismayed by the 'look of blight and neglect' in the Herne Hill garden,[24] he went over to France with some of the Hilliards. This return to some of his earliest haunts – for more and more he thought of excursions with his parents – was obviously a great joy to him. He sketched in Beauvais, 'where all is so differently delightful, as if we were on the other side of the world', while in Paris he had 'everything to amuse me'.[25] But these remarks were written to cheer the Beevers at the Thwaite, who missed his visits from Brantwood across the lake; in his diary he was perhaps less enraptured, oscillating between renewed affection for his favourite places and disgust at the 'accursed destructions of all that was lovely in my poor old subjects'.[26] Paris tired him in the end, and he noted 'discontent and languor' as inevitable effects of a journey's coming to a close.[27] He had, in fact, been working hard, writing what he considered a most important *Fors*, directly addressed "To the Trade Unions of England". He chose to write to them on this occasion, having noticed that *The Bingley Telephone and Airedale Courant* of 23 April (St George's Day) had urged him to 'write more to and for the workmen and workwomen of these realms'. But besides exhorting them to appreciate and realize their potential in the state and sending hundreds of free copies to trade unionists, Ruskin was also envisaging a book, like he used to write, to do with the cathedrals of northern France.

The visit to France had been planned, so he told Miss Beever,[28] to last just over a month. Perhaps the renewal of the trip, with different companions, was arranged when he returned to Canterbury in early October to attend the christening of Joan's next baby. After a week, at any rate, he was back in Amiens, where on 17 October he notes in his diary that he has begun *The Bible of Amiens*. Despite intermittently poor health and depression and besides giving Arthur Severn's nieces, who had accompanied him this time, a happy introduction to his beloved places, he was also shaping a lecture on Amiens to be given at Eton soon after his return to England in early November. His diary records him planning the lecture as an explanation of the meaning of 'Cathedral – Duomo – Église – and church'. So it is likely that this project, proceeding simultaneously with his drafting of the first part

of *The Bible of Amiens*, which appeared that December, influenced the scope of the larger undertaking in which the Amiens book was designed to be the first section: *Our Fathers have told us.* / *Sketches of the History of Christendom* / *For Boys and Girls* / *who have been held at its fonts.*[29] Ruskin describes Amiens as the 'Venice of Picardy', thus associating his new topic and his methods in the 1880s closely with those of thirty years before; as in *The Stones of Venice*, the reader/traveller is encouraged not so much now to observe as rather to listen to Ruskin explaining the meaning of Amiens. With some trenchant, satirical glances at popular, modern historiography, he slowly establishes the true significance of Amiens in a cluster of legends, in a brisk adumbration of national as well as local geography and finally in the detailed sculpture of its cathedral, the Bible of the title. Not, as Philippe Jaudel has remarked, an elementary history for the schoolboy as much as for Marcel Proust;[30] yet the stones of Amiens served Ruskin's imagination as vitally as had their Venetian predecessors.

He was back at Brantwood early in December, but by the end of the month was 'Much beaten and tired, and must positively take to the rocks and grass again for a while'.[31] He found a letter from Kate Greenaway waiting for him – their correspondence had begun nearly a year before, when he was surprised to find that she was a reader of *Fors*; now he told her that he had carried one of her letters in his desk throughout the recent French journey.[32] He began a careful arrangement of the pictures in his bedroom, a systemization which has been read as some form of piety towards his parents: for he gave pride of place to John James's own watercolour of Conway Castle, to a William Henry Hunt that had hung in the Herne Hill breakfast room and to the first Turner, a *Vesuvius*, he had ever seen reproduced.[33]

He told Dr John Brown that his 'constant thought' these days was of past time; those around him, 'as *they* go on in the ways of the modern world', did not notice how much 'I go *back* to live with my Father and my Mother and my Nurse, and one more'.[34] The past came alive, too, in less pleasant ways. The bookseller, F. S. Ellis, decided not to bid for the manuscript of Scott's *Guy Mannering* when the price went beyond what he thought it was worth; but Ruskin was '*really* angry with you for being so much of a Papa'; the parallel with the loss of fine Turners or Blakes in his youth was sadly close.[35] And his surrogate father, Carlyle, died on 5 February, a day which Ruskin marked with a cross in his diary. As with the loss of John James, Ruskin worried that he had not loved Carlyle enough; yet his sorrow

was less strong than his sense of the need to throw himself into the fulfilment of Carlyle's work ('greater responsibility brought upon me by Carlyle's death').[36]

All these events, with sleepless nights and, as he later explained to Norton,[37] 'a steady try if I couldn't get Rosie's ghost at least alive by me, if not the body of her', contributed to another 'month of terrific delirium'.[38] Unlike the first attack, this second was not preceded by any visible signs of impending mania; Hilliard telegraphed Joan Severn to come on Sunday 20 February, the day after the illness began. But it was still marked by violence, threatening behaviour towards anybody around him, but specifically towards Joan: once he locked the cook in his room, because he thought she was the Queen. He continued to believe that he was somehow dispossessed of his authority and would storm about the house shouting 'I *will* be Master in my own house'. Joan having broken her ankle soon after arriving and the household 'terror stricken', the Severns engaged the services of a 'trained attendant'. Ruskin himself recalled more dreams, 'much meaner visions of dragons and spectres'.[39]

He was back in his study, restored to sanity, on 22 March. The following day he wrote to Mrs Cowper-Temple to say 'the issue of the matter is that I must be much alone this summer'[40] evidently the see-saw of first needing the Severns and then wishing to be quite independent of them had emerged from the mania into the relatively healthy periods. He resumed work in a meandering fashion, quick as always to overestimate his strength. But the second illness had badly sapped his concentration; no longer did the old tenacity in guiding a theme through several apparently unrelated issues and topics show itself. In October Hilliard told Norton that Ruskin found it difficult to maintain 'any settled train of thought or work, and it is sad to see him entering almost daily upon new schemes which one cannot feel will ever be carried out'.[41] Ruskin's diary, too, scatters its impulses more incoherently than before. Yet by December the successful completion of more instalments of *The Bible of Amiens*, *Proserpina* and the series on fiction are recorded.

Soon after his illness Joan reported to Dr Simon that Ruskin had insisted upon writing to George Baker at Birmingham to resign the Mastership of the Guild and wanting 'to have the Affairs of the company wound up – adding he'll never more have *anything* to do with it'. Her own lack of sympathy for the whole enterprise is signalled by her adding that 'I'm heartily glad if it *is* carried out'.[42] But Ruskin soon changed his mind. A second Master's Report was completed by the year's end, with some astringent asides about the Board

of Trade's requirement of an annual general meeting. He announced that he was working on plans for the extension of the Walkley museum, on the extension of all its holdings and a grammar of crystallography. As the space in his report devoted to the museum suggests, this aspect at least of St George's work continued to absorb Ruskin. He was buying lavishly – Scott and other manuscripts – and on 30 November he wrote to tell Swan of getting Mary Queen of Scots's missal for £500 ('I think Sheffield will be a little proud of having saved it from going to America').[43] Pending the establishment of new museum buildings at Walkley (or at any rate, using that as his excuse), he drew upon Guild funds to provide some of his standard display cases for a girls' college, Whitelands, where he started to dispatch items for what came to be known there as Ruskin's cabinet.[44]

The inability to work, especially when kind old ladies intimated that they were so glad he would not be publishing any more,[45] aggrieved him most. He was tetchy with correspondents like his assistant, Murray, whose 'confused and ill written letters' were sharply reproved. Murray's copies of pictures were found unsatisfactory and became occasions for simple lessons on painting hair and drapery.[46] Indeed, there is a marked tendency to turn unwelcome correspondence into an opportunity for instructing others in a more thorough knowledge of their own ideas and their supposed admiration for Ruskin's. Had any of his girls, he demanded of the Principal of Whitelands College, 'ever read my "Strait Gate" [*Mornings in Florence*, pt v] with any vestige of attention?'[47] And another unfortunate, one Edward Clodd, who happened to think that Ruskin might be interested in one of his books, was told that 'your book makes me so angry every time I open it' and otherwise was grumpily cross-examined.[48] More and more cut off by his illnesses and their aftermath from meeting and instructing people, he transferred his pedagogical energies into his letters. Only such correspondents as Mrs La Touche, who visited Brantwood that summer and who could perhaps be counted upon to soothe Ruskin's (obviously rather selective) recollections of the past, were spared this newly-awoken instinct. Even Kate Greenaway got her postal lessons in accurate drawing. When George C. Haité wrote to him, the letter being forwarded by Arthur Severn who 'never reads my books himself and did not know what he was about', Ruskin expressed his annoyance at being bothered by people who neglected to read even 'ten sentences of any of my books before writing to me'.[49]

The fluctuations of work and the disturbing uncertainties of

weather continued. 'St George's work getting into order', his diary noted on 12 January 1882, 'and [I] enjoy minerals; but all the life taken out of nature by the diabolic weather'. Despite his earlier resolution to be alone at Brantwood, he decided to take himself to Herne Hill when the time of year of his two attacks came around. By early March he was impatient with the constant demands upon him from various people, requests for his 'instantly superintending the arrangements of their new Chapel, or Museum, or Model Lodging-House, or Gospel steam-engine'.[50] Soon afterwards he suffered a third attack. Joan was pregnant and unable to cope; so a professional nurse, Ruth Mercier, joined the household, together with other helpers like Sara Anderson, a valued secretary, and Martha Gale, one of Severn's nieces. At first Ruskin took the nurse for Death – 'which shows how stupid it is for nurses to wear black'[51] – but she was pretty, and he grew fond of her. After his recovery he told Henry Swan that the

> last attack of delirium, though in itself slighter has left me more heavy and incapable than the former ones. *They* left me full of morbid fancies, but able to write or think, *though* morbidly; this attack has both alarmed and stupified me, so that I am afraid to work in the morning, and can't, in the afternoon; but what I do seems to me perhaps of more useful quality, from its very caution.[52]

As an example of his caution, he told Joan Severn who was up in Brantwood, that 'for the first time in my life I have sought company as a distraction; for he attended a dinner for (later Sir) Richard Burton on 14 June, given by Bernard Quaritch, and was particularly pleased with the brief speech he had been required to make to the guest of honour on the 'benefits and advantages' of travel![53] He also started taking music lessons this summer. In late May he received a visit from the May Queens of Whitelands College, the 'order' he had suggested should be instituted instead of the usual competitive prizes; he wrote to report to their Principal upon the girls' musical skills. In July he went to Sheffield to discuss with the corporation the chances of a larger museum for the St George's Collection, having earlier in the year issued a *General Statement* on the Guild's activities at that point. Although the agricultural ambitions were 'nearest my heart', his best capabilities would go to the completion of his Museum; he directed readers to his various pronouncements in the past on museums, adding only that the 'primary *principle of exhibition*' to be observed was 'that the collection must never be increased to its own confusion'. Yet the outlines of an extended museum which he went on to sketch were ambitious enough, inclusive of much which it was obviously easier to

arrange in theory than in practice.[54] He was excited in June by the offer from the head of minerology in the British Museum to number some of its specimens for purposes of cross reference in the Sheffield catalogue; yet eventually he would make very little use of this opportunity.

Ruskin set off for the continent in mid-August in the company of Collingwood and his valet, Baxter, who had replaced Crawley some years before. The Severns went to Brantwood to enlarge the accommodation; this work was designed to give the Severns more room for their family in the event – as seemed altogether likely now – of Ruskin's needing continued nursing; but his funds were so depleted that he was obliged to sell Meissonier's *Napolean 1814* to pay for the work. He told Joan that his brokers were elated that for once he was buying rather than selling stock.[55] And though he travelled in Europe that summer and autumn in the style he had always been used to, he was only intermittently happy.

The trip was partly to inspect the various artists who were working at copying art for the Guild, partly to retrace his youthful journeys. The past was inevitably his largest burden, mingling in his dreams with future hopes: at Avallon he dreamed 'of my special Valley of Chamouni with the steeper sides, and of being with my mother at Geneva in a new garden of St George's company'.[56] He would lovingly note whenever he stayed in his former rooms in old hotels, writing especially to tell Crawley from Talloires about being 'settled by my wood-fireside in my own room here' and about having taken his present companions to Mornex.[57] Yet from his first step ashore ('I never saw Calais so dismal') and throughout the whole journey he was chastened with disappointments, as his memories were confronted with their restored or devastated originals. Pollution, too, had violated the lower air at Mornex and obscured the view of the alps from Turin. At Pisa the 'penny whistles from the railroad [were] perpetual', and at Florence 'Every where paviours, masons, ruin, degradation, folly and noise: and the wretched Germans, English and Yankees busy upon it like dung-flies.' Fiesole and Lucca alone seemed to be spared and therefore soothed him; a longish stay at the latter in October put him 'in good heart'. Yet for one who had found Carlyle's *Past and Present* the 'only book I could get help from during my illness', it was not surprising that the unfavourable contrast of present-day Italy with earlier, romantic souvenirs of his past visits to her cities should in fact sustain him.[58]

The past deepened, too, with the deaths of friends. Dr John Brown had gone before Ruskin left England ('What business have people to

die like that, like a candle snuff?'[59]). Now in Lucca he heard that Bunney had died in Venice, having just completed the large picture of the *West Front of St Mark's* for the Guild; the loss 'ends many things for me'.[60] Yet his skill and delight in sketching remained, and his eye for architectural analysis, in a letter to Noton from Pisa[61] was still shrewd and practical. And new friendships were established to replace the lost ones. In Florence he met Mrs Alexander and her daughter, Francesca, Americans living in Italy. Francesca had collected and illustrated peasant songs in Tuscany, which enchanted Ruskin. He bought them and her *Story of Ida* to issue in 1883 and 1885 with his own prefaces as examples of 'the truth of Italian peasant character animated by sincere Catholic religion'.[62] His correspondence with mother and daughter would provide some of his best comfort in succeeding years.

Back in London he also met Kate Greenaway for the first time on 29 December and wished that some of the children in her illustrations had bare feet and the 'shoes of the others weren't *quite* so like mussel-shells'.[63] He also lectured again, on Cistercian architecture at the London Institution. It was something of a trial run for his proposed resumption of the Slade Professorship. Feeling so much improved after this third illness ('I've been quite amazingly rational lately'[64]), he had enquired from France on 22 October whether he might not be re-elected. As he told Alexander MacDonald, the Oxford drawing master, he had 'left so much unfinished in the plan of the schools'; he was determined to reaffirm his principles of art education; he also thought that 'the course of elementary examples [see above p. 339] has never been enough systematized'.[65] He was prepared to resume his work at Oxford 'whether as Professor or not'; but in the event he was re-elected to the Professorship in January, William Richmond, the son of his friend, George Richmond, having resigned to make way for him.

– 2 –

Ruskin's life during 1883 was nonetheless centred upon Brantwood. He travelled to Oxford on three occasions to give his series of lectures; and in the autumn he spent ten days north of the border visiting Scott country. Otherwise he was carefully allotting his resources to the various projects which still absorbed him. Besides the necessary preparation for Oxford, he was editing Francesca Alexander's books and in the midst of revising *Modern Painters*. The reissue of this work, no

longer entirely agreeable to him, was 'not without comment and epilogue'.[66] The endeavour of glossing his former with his later self – usually in extensive footnotes – spilled over into a *Deucalion* essay on "Revision", where he tried to clarify his 'theology or natural philosophy' throughout his various works; and in his diary for 10 January he entered a capsule guide to the 'whole end and aim of my labour': namely, 'to shew that no supreme power of art can be attained by impious men, and that the neglect of art as an interpreter of divine things has been of evil consequence to the Xtian world'.[67] But he was also trying to concentrate on further instalments of *Love's Meine*, an earlier Oxford lecture series on birds in fine art; to this and to his geology he turned for rest and comfort rather than to the current Oxford lectures.[68]

Throughout the year he exercised extraordinary care, pacing himself and rationing his energies ('I won't force myself to work' . . . 'if I can only manage myself'[69]). Nevertheless by September he was again 'giddy with the quantity of things I've in hand'.[70] Part of the reasons for his success in surviving the year as well as he did without any further attacks was undoubtedly the choice of subjects for his Oxford lectures; here he deliberately opted for either the celebratory and nostalgic – Rossetti, who had died the previous year, and Holman Hunt – or the simple and undisturbing – Kate Greenaway and Leighton, the latter having won his heart by painting some extraordinary pretty girls.[71] However much Oxford was pleased to have him back – the lectures were mobbed and had to be delivered twice to accommodate his audiences, they cannot have been to the discriminating anything but mildly disappointing. Swinburne's enthusiastic approval, after reading a report of the lecture on Burne-Jones, of Ruskin's 'authority and eloquence'[72] is sometimes cited as testimony of Ruskin's continuing skills upon the resumption of his Oxford lectures; in fact, the lecture on Burne-Jones and Watts is bland, largely general in its reiteration of Ruskin's basic ideas on realism and myth, and offers very little actual commentary upon the paintings and drawings. But Ruskin was obviously more at his ease than he had anticipated in this series, which was continued with further reminiscent commentaries on Leech, Tenniel and Copley Fielding in the autumn rather than, as originally planned, a new series on *The Pleasures of England*. His various references to the renewal of his lecturing at Oxford had, in fact, always been to their unstrenuous nature: that his audiences 'will be quite content to hear me read *Proserpina* or anything else I am doing'.[73]

Ruskin was much concerned that year with his capacities for

helping people. Though he eagerly wrote a note for Collingwood's *Limestone Alps of Savoy* on 'my visit to a Live Hermit', he was himself concerned that 'Christian men ought not to be hermits, but actively helpful members of society',[74] He was delighted to chair William Morris's lecture at the London Institution, when Morris announced his commitment to socialism and echoed Ruskin's own despair over the industrial squalor of England. He himself lectured to the Mechanics Institute in Coniston just before Christmas on the 'management of Indian gypsies and banditti'[75]. And he continued to devote himself to Guild activities. He laboured heavily through a report on Guild finances ('irreconcilable sums'[76]). Surrounded at Brantwood by 'more treasures than I could ever use in fifty years',[77] he also worked to ensure that some of them were enjoyed elsewhere. He sent one hundred minerals, together with his catalogue, to a boys' school at Reigate, and to the Dalbeattie Mechanical Institute in Scotland two consignments of his own drawings, architectural photographs and other illustrations. Distressed by the conduct and displays of national museums, he was determined that his own major endeavour at Walkley should be better. Visiting London from Oxford he had been severely disappointed by the new premises for the Natural History collections, the removal of which from the Bloomsbury site also annoyed him as separating what he always took to be a necessary conjunction of topics. He wrote twice to Swan that winter to urge Sheffield to out-do London:

> They have made such an accursed mess of the Nat. Hist. Brit. Mus. at Kensington that I'm rather piqued to show what can be done with proper light and illustrations at Sheffield . . .

> The Bird Gallery in the British Museum is a *total* failure in the new building wholly the Architect's fault, and I hope to get the help of the head of Zoological Department, Dr Gunther, to help me in arranging one in our new Museum as it should be . . .[78]

Despite difficulties, not entirely unconnected with Ruskin's continental travels and his refusal at other times to be bothered with business details, by the end of 1883 it looked as if a new museum would be built on some land, provisionally earmarked. Hence his buoyancy and desire to emulate London.

There were welcome guests at Brantwood throughout the year. Kate Greenaway came for a month and evidently fell in love with Ruskin; he commented in his diary that she 'went home . . . I fear not much wiser for her visit', presumably a reference to her evident fondness which Joan Severn found 'tiresome' and Ruskin himself had

to urge her to control – 'I feel this affection you bear me puts me in a place of most solemn trust over you – but I do hope you will manage to get it put into a more daughterly and fatherly sort of thing.'[79] Though he wrote to her often at this time, it was her pretty visions of little girls and the opportunities to meet her real-life models at tea whenever he was in London that Ruskin really preferred.

Later, after a separation of ten years, Charles Eliot Norton, together with his eldest son, came to Brantwood at the start of a European tour. He found his old friend much aged, stooping a good deal, no less perverse and irrational, but full of his old sweetness, too: 'He still remains one of the most interesting men in the world.'[80] Less settling for Ruskin, though he reacted with warmth, even perhaps with exaggerated enthusiasm, was the visit that summer of Mr and Mrs La Touche. Although they had been in large part responsible for widening the gap between him and Rose, Ruskin seems to have welcomed their arrival as somehow healing that breach; during his second illness he had thought he was about to leave, barefoot, on a pilgrimage to Harristown to seek Mrs La Touche. Now she participated in Ruskin's botanizing, enjoying herself so much that she returned to Brantwood in 1884 and 1885. But the pressures which such visitations brought upon Ruskin can only have been harmful. In 1885, when she brought her nineteen-year-old grandchild, the daughter of Rose's sister Emily, it obviously precipitated another collapse.[81]

The summer of 1883 had been blessedly free of devil-sent, black weather. But its renewal during the winter spurred Ruskin to contribute his famous analysis of weather and pollution in two lectures at the London Institution in February 1884. *The Storm-Cloud of the Nineteenth Century* was Ruskin's last great pronouncement in his Timon-vein.[82] His diagnosis of the moral implication of the extraordinary weather which he had been noting for many years was (and is still sometimes) greeted with hilarity and scepticism. But, as he triumphantly explained in the Preface to the published version,

> I am indeed, every day of my yet spared life, more and more grateful that my mind is capable of imaginative vision, and liable to the noble dangers of delusion which separate the speculative intellect of humanity from the dreamless instinct of brutes . . .[83]

He drew upon his own diary's detailed observations of the weather to chart a phenomenon that was undoubtedly an objective fact.[84] Yet it is also true, as Emerson wrote, that 'The ruin or the blank, that we see when we look at nature, is in our own eye'.[85] What distinguishes Ruskin's *Storm-Cloud* is its affecting mixture of objective and subjec-

tive, intermingled to the extent that the status of neither is clear. This conjunction can be seen strikingly in the text, especially when it was printed: it ranges throughout his own private experience (mainly diary entries), invokes a variety of his public utterances as well as gesturing towards such public events as the Franco-Prussian war which had left 'a moat flooded with waters of death between the two nations'; at one point these various texts occupy three levels of print on a single page.[86] He manages some characteristically lucid expositions of difficult phenomena, pedagogical skills distantly indebted to his youthful tutor, Mr Andrews, and his use of the fork to display Neptune's role (see above p. 35). Then, too, there was some not altogether sound satire of modern science, notably its inability to observe and explain adequately what needs, as opposed to what is susceptible of, explanation. In the process he reiterates his prejudices against artificial aids to seeing as against 'eyes "unmuzzled by brass or glass"'. He is at his most effective and persuasive when he mocks the verbal imprecisions of scientific writers, in contrast to which his own prose is lucid, brightened with visionary descriptions of clouds. Obsessed with and consequently hyperbolical about the evil weather of his later years, he could argue that 'no book such as *Modern Painters* ever would or *could* have been written . . . [without] . . . the beauty and blessing of nature'. This makes clear how the exhortations and denunciations of "The Storm-Cloud" in London that winter were a further extension of Ruskin's incessant comparison of past and present; but the delivery and publication of the lectures seems to have exorcised the despair and intensity,[87] for within a few months he was telling Allen that 'I am entirely minded to do a short account of my life and its work and intention . . . it will be an extremely plain statement . . .'[88] Thus *Praeterita* emerges from the storms of the late 1870s and 1880s.

After the lectures at the London Institution Ruskin was taken up in the 'bustle' and 'whirl' of social visits and museum work.[89] He visited Kate Greenaway or sent her notes, but could not obviously satisfy her need for affection: 'so far as you grieve for my absence', he told her on 5 March, 'or feel hurt by my being different when I am there, from what you would have me, you 'tempt' Heaven to take away from me the power of pleasing you at all'.[90] His best pleasures came from arranging a section of silica for the Natural History Museum and writing a descriptive catalogue for their display: he noted in its postscript, perhaps with unconscious self-reflection, that irridescence in quartz is 'always owing to irregular fissures with close surfaces'.[91]

The summer at Brantwood was a precarious attempt to maintain control over 'all my books'.[92] There were guests to entertain: Norton as well as Mrs La Touche returned, and in September Benjamin Jowett who had received a tetchy letter the previous February about the University of Oxford's apparent slowness in enlarging the Ruskin Art Collection; Jowett was impressed by his kind welcome, and his host thought it all 'very nice'.[93] Yet in June that year Ruskin had revoked the bequest of his books and some pictures to his *alma mater*, made in a will of the previous October, because the purchase of two Turners and the enlargement of the Drawing School had been turned down by the University.

The preparation of lectures for the Michaelmas Term went slowly and was incomplete by the time he went into residence. Maybe his own scattered energies and the very topic chosen ultimately prevented their composition. Under the title, *The Pleasures of England*, he had determined to review the 'phases of national character' and their distinctive art forms; these would be the pleasures of learning and faith, through fancy and truth, to sense and nonsense.[94] It was calculated to encourage his least creative discursiveness and to promote too many opportunities for unscripted violence of feelings. As the series proceeded, he trusted more and more to improvisation, but was occasionally hard put to finish the hour. It was an altogether painful episode for his friends; after one incident even the national press protested about the 'academic farce'.[95] Ruskin had contrasted Carpaccio's St Ursula as a type of Catholic faith with two specially chosen examples of the spirit of Protestantism; these – evidence at least of *some* preparation – turned out to be Bewick's pig and Ruskin's own drawing of a Salvation Army musician. His two final lectures, when he proposed to assail science, in particular the proposal to establish a physiological laboratory in Oxford, were replaced at the entreaty of friends like Acland; as well as regretting Ruskin's intervention against vivisection which they supported, friends also feared for his sanity on the occasion of the lecturers' delivery. He substituted milder discourses on "Patience", largely readings from earlier books; but he told Susan Beever that 'the scientists slink out of my way now, as if I was a mad dog'.[96] They were his last utterances as Slade Professor. He lectured twice more in Oxford, to the Guild of St George and to the Anti-Vivisection Society, and then left for a few days in Cheltenham.

Before returning to Brantwood he made a long-planned visit to Farnley, delighted as ever to revisit one of Turner's sacred places. *En route* he also stopped in Matlock, sleeping in the very room where he had been ill in 1871; he told Kate Greenaway that he wished he 'were in

it again, past recovery'.[97] He was listless and unwell over Christmas ('Badly off the rails', he confessed even before reaching Brantwood). He prepared for press some of the lectures given that term and had every intention of delivering the others on the pleasures of sense (science) and nonsense (atheism). But on 10 March the University of Oxford passed its 'vote endowing vivisection'[99] and Ruskin promptly resigned his Professorship. 'I cannot lecture', he told Joan Severn, 'in the next room to a shrieking cat nor address myself to the men who have been – there's no word for it.'[100]

– 3 –

He was deep in despair, not unexpectedly, as he told Norton in a letter of 2 January; but 'after some more misery and desolation of this nature, I hope, however, to revive slowly'.[101] He was, in fact, soon busy on various projects; the list of part-publications which his editors give for the years 1885 and 1886 is, when a severe attack of mania in each year is also taken into consideration, astonishing.[102] In retrospect it is clear that it would all prove too much for him; but at the time he was careful to pace himself ('Must try not to drive things'[103]). The main task was *Praeterita*, occupying him from the very start of 1885 – 'I must try and do a little bit of account of myself every day now', he wrote in his diary for New Year's Day. The first instalments were issued in July and continued until the same month four years later.

Both Ruskin and his commentators have seen *Praeterita* as calm interludes in the midst of encroaching storms of madness. After his next attack he told a correspondent that '*Praeterita* . . . gave me no trouble'.[104] It was an emphasis which he also contributed to the Preface, written in his old Herne Hill nursery on his father's birthday, 10 May:

> I have written . . . of what gives me joy to remember, at any length I like . . . passing in total silence things which I have no pleasure in reviewing . . .

Avoiding anything 'disagreeable or querulous', Ruskin hoped to guide himself as well as his readers through serene reminiscences; within the text of the autobiography he succeeds marvellously. Borrowing the first two chapters virtually unaltered from *Fors Clavigera*, he proceeded through the scenes of his past life where he could relish without disquiet the satisfactions and recollections of his best moments. His chapter titles declare his preoccupation largely with places

not people; his prose is at its most redolent when he recaptures the spirit of his favourite bournes of earth, and the arrangement of the work so much around these spots of Ruskinian topography must have been his main mode of control over past things. Events such as his marriage were neglected entirely and some sections on his parents, though composed, were never used. Though the title of his autobiography should accurately be translated as 'first things', leading presumably to others, he told Kate Greenaway that 'Praeterita means merely Past things'.[105]

But, as the careful control over deleting disagreeable bits in his draft reveals, Ruskin by no means found work on *Praeterita* easy. In June of the following year he told Kate Greenaway that the 'vividness of detail' which delighted her in it was the result of 'my analytic power of fastening on the points that separate that scene . . . from others'. And he added, 'of course this is not unconscious nor without effort'.[106] The effort is clear from his diary. First, he was obliged to look over old journals and letters which frequently gave him 'displeasure' or a 'terrible day of chagrins and difficulties';[107] and it is clear that he did not pursue such researches very thoroughly; when he did, he was 'desperately sad after two days of headache and sorting and destroying'. Second, the mass of materials which even his selective attention produced was dismaying: the process of 'finding' and then 'sorting into more and more confusion' was recreated in nightmares of 'earthquakes and finishing unfinishable drawings of cathedrals that couldn't be got at'. During another night he dreamed of 'having to find my way along a beach in pitch-dark night, by keeping in the waves, at last losing the sea . . .' Even the *mare maggiore* of past things seemed itself to be no guide. Yet gradually he ordered, 'planned things courageously', though with relapses when 'things [got] out of hand' again, and *Praeterita* emerged, incredibly tranquil, out of the huge endeavour. But no wonder it cost him his sanity once again. The next attack came in July.

Earlier he had spent some hectic weeks in London, during which he managed to fit in a visit to Bedford Park where he had at the start of the year accepted to be 'Patron – or Dux – or anything you like to make me' of a young persons' society against cruelty to animals. At a general meeting especially convened to listen to the famous personage Ruskin solemnly considered questions from the floor on corporal punishment for recalcitrant donkeys and on the permissibility of shrimping.[108]

Back home in Coniston he paid visits locally and received them, including that of Mrs La Touche and her grand-daughter, while his

work continued. He had often remarked, in his careful and continuous self-scrutiny, that 'every half hour of mental application is just so *much* of quickened pulse with coldness of hands & feet'.[109] Now the reaction to his work and to the visit of the La Touches, the 'strain' of which he confessed to Francesca Alexander, was extreme. This attack was far more severe than the earlier three, lasted longer and entailed a more difficult recuperation. Ruskin told a correspondent in September that, while after his previous illnesses he had been 'weak, but quite myself', now he felt a 'distinct injury – a feeling not of the pleasant weakness of new life which means true recovery, – but of persistent illness, – feebleness of thought – and feverish disturbances of the nerves'.[110]

The pressures of another period of nursing a difficult patient, who alternated between violent abuse and depressive inertia, forced Joan Severn to take greater precautions for the future. Ruskin's work and correspondence were carefully monitored; he was required to dictate his letters, though he sneaked at least one of his own, to Norton, in October while 'the Dragon' was out.[111] At first, as a neighbour, Albert Fleming, wrote to the Alexanders in Italy, 'the poor overworked brain' rested quietly, 'sheltering itself under merciful silence, from all outside worries and vexations'.[112] While Ruskin enjoyed the protective regime which the Severns attempted to organize around him, he also resented Joan's domination as that of another Margaret Ruskin. Maternal solicitude like Mrs Alexander's, was more congenial, because it soothed without proscribing his activities: she sent 'a present so truly *maternal* – my dear mother's recipe for chicken jelly' as well as one of her own knitted *camicuiole* or flannel waistcoats.[113] Eventually, of course, Ruskin refused to be completely managed by Joan, and by the end of the year was absorbed once again in his work, chiefly in *Praeterita*. Not that he did not watch himself with renewed and extra care ('warned once more'); but his enforced leisure simply provided occasions for brooding or for reading newspapers, which in their turn redirected him towards forbidden topics: 'Politics so fearful now in the papers that I'm like a dog in a chain – like the dog in the woodyard that can't get at Mr Quilp.'[114]

He was reluctant to relinquish St George's Guild work entirely. His report for 1885 was issued early the next year; in it he discussed his abandonment of the plan for a larger building at Walkley, owing to his refusal to make over the collections to the city, as the Sheffield authorities had wished. He still hoped for private funds and promised (though he never did do so) to complete during the coming year the catalogue for the museum as it would now have to be.[115] He was nonetheless active on the Guild's behalf during 1886, maintaining

his correspondence with the various artists copying pictures for its collection; a selection of these Guild drawings was shown, with a catalogue by Ruskin, at the Fine Art Society in May and June, 1886.[116]

Presented with a complimentary address at Christmas 1885, he had been pleased with its mention of his political ideas.[117] He still sought every opportunity of explaining or realizing these, despite his determination not to 'let myself be drawn in'.[118] Yet he did write to the papers, and private correspondents, too, were involved in his interests: HRH the Duchess of Albany was told of the Guild's weavers in the Isle of Man and invited to accept a dress made by them; Professor J. S. Blackie was given instruction in the Homeric and mythological sources of Ruskin's ideas, while Professor Oliver Lodge, with whom he had been exchanging letters on recent scientific developments, was asked why it was 'still impossible to get into any human head at your universities that the economic crisis is because people will dig iron out of the ground, and build ironclads, – instead of raising corn and wine and giving them to whoso needs them'.[119]

Ambitious as ever to understand new developments, Ruskin was often now defeated by the materials to be mastered, as his exchange of letters with Lodge in 1885 had shown. The reading of an address to the Geological Society made 'everything I thought I *know* of minerals . . . mere cloud and bewilderment', so that 'all my final purposes of writing . . . [are] broken like reeds'.[120] He was the more distressed because minerology was his preferred recreation – 'Art is in the upholsterers & harlots hands' and 'Politics – will go their own way down hill and I hope up again'.[121]

He did not, however, relinquish the encyclopaedic scope of his attempted education of pupils at the Coniston school. In November 1886 he talked to Robert C. Leslie about his ideas on education in village schools, having watched 'the little miserables in ours': 'Slates – & sums – and grammar' would be abolished, and the room filled 'all round of coloured pictures, & bird's feathers and boat models – and pretty stones and moss'.[122] At Coniston he organized the boys into 'a corps of little gardeners' to make the best of a 'neglected bit of earth' that was the school's garden.[123] But with the girls he embarked upon a more eclectic curriculum; as one of his pupils later recalled, the lessons ranged

> from the varying shapes of fir-cones to the correct position on the map of 'Riblah in the land of Hamath', probably followed by a disquisition on 'the god Bel or Baal' as represented 'on the cast of a coin – Italian – Greek – finest time'. Sometimes he would read Shakespeare to them;

396

but whatever else was included, the Bible and some botany formed part of the lesson.[124]

But as he reported in *Christ's Folk in the Apennine*, another of Francesca's books he was editing by the end of 1886, he found that the Coniston girls 'cared to know less than I expected'.[125] They as well as their instructor, however, enjoyed tea afterwards: 'He's a foony man is Meester Rooskin, boot he likes oos to tak a good tea'.[126]

His delight in young children, though Joan Severn watched the parties of little girls on Saturday afternoons rather warily, was part of his own regimen for taking care of himself. Distinguished visitors, like Froude or Aubrey de Vere, bored or even annoyed him now and counted far less towards his tranquillity than the young and the teachable. In the early 1870s he had told Margaret Hunt that 'the older I grow – the younger I like faces to be'.[127] He even enjoyed pretending that Susan Beever, born thirteen years before himself, was a young girl – 'You really are – for 12 years old – 13 next year – the most delightful baby about stones that ever was'.[128] The 'flirting'[129] which he enjoyed with Susan Beever and his genuinely younger pupils was, for the most part, a harmless and affectionate exchange with those whose demands upon *him* could be firmly controlled; another mild exercise in his 'love of power'. In return he shared his own choicest subjects with them. He had sent some mineral specimens to the schoolmistress at Coniston in 1882, 'pleasing to children with eyes'; but he also presented a magnifying glass 'to be general school property'. During 1886 he devised a loan-scheme of his sketches to please the house-bound Susan Beever: she started with 24, exchanging 12 each week for another set carefully selected at Brantwood and delivered across the lake.[130]

But the 'monsoons and cyclones of my poor old plagued brains' were renewed.[131] The Severns stayed at Brantwood after his 1885 attack until the following spring, when they thought he was again well enough to be left. In May he decided, he told George Allen, to select some of the terrifying volume of primary materials which he was using for *Praeterita* for separate publication in a companion serial, to be called *Dilecta*. Then one day in walking up from the lakeside he had 'an interesting encounter with a biggish viper'; when he called a young gardener to dispatch it with a scythe, the snake 'became a glittering coil more wonderful than I could have conceived, clasping the scythe and avoiding its edge. Not till the fifth or sixth blow could Tommy get a disabling cut at it. I finally knelt down and crushed its head flat with a stone, – and hope it meant the last lock of Medusa's

hair for me.'[132] The following day his 'fit of craze' returned. The delirium lasted throughout July, and as usual he afterwards reviewed its 'terrible and sublime' conditions: 'I learn a lot in these fits of the way one sees, hears, and fancies things, in morbid conditions of nerve . . .'[133]

The aftermath involved renewed tensions and quarrels with Joan, from which he would retreat by himself into the garden or up the neighbouring fells, where 'nobody cared a — slate boulder about anything'.[134] Although he got away to spend a week at Heysham on Morecambe Bay, he was infinitely bored ('I've nothing to do and I can't think of anything to think of'[135]) and inevitably returned to the same, often uncongenial, conditions. He could still solace himself with work; his temperamental inability to be idle is suggested by his remark in October 1887 – 'I don't desire quiet! Quiet desires me – and nearly got me, too, this last time of quietus-making'.[136] By March 1887 he was writing fifteen to twenty letters a day, working on *Praeterita*, helping Albert Fleming edit his letters to Susan Beever for *Hortus Inclusus*, but not feeling up to writing 'anything spiteful'.[137] Then there was his Coniston schoolwork: he planned a 'botany class book' on the model of *Ethics of the Dust*, with chapters headed "Libbie on Lettuce" or "Kate on Kale"; he seems even to have projected having working models of various birds made to show their flight power in comparison with oars and windmills. But he hoped he would not 'go off my head this summer again and lose the wild roses'.[138]

He did not, but there were some 'fierce quarrels' with the Severns.[139] His black rages were partly due to frustrations with their restrictions, when he wished for the privileges of old age ('to feel that we ought always to have all our own way – to have no scruples whatever about taking it when we can get it – to be able to kiss anybody whenever we like . . .'[140]); they were partly due to the old paranoia and fear of dispossession by the Severns. It is clear that there was provocation on both sides. Ruskin must have been a difficult patient, physically violent and abusive, and it says much for the Severns that they were prepared to nurse him and let him remain in familiar surroundings. But, equally, he readily felt their basic lack of sympathy with his work and its methods, shown most obviously in Joan's insensitive censorship of his correspondence;[141] it was the more galling in that his public, if not yet all his private, life was now conducted virtually by letter.

Things came to a head at Whitsun, 1887. Ruskin had for some time been exercised about his estate and had discussed it on two occasions

with his solicitor, H. P. Mackrell, as well as by letter.[142] Whatever
Ruskin in fact wanted to do with his property was, in the opinion of
the lawyer, 'beset with difficulties'. At the end of May 1887 the
problem of who would inherit his estate and the rights to it during his
lifetime in the event of his being incapacitated flared up again; there
was a row with the Severns and Ruskin quitted his house, as he
explained to the Layton family:

> There is tragedy going on here, & very deeply – comfortless and I am
> more alone than for many years. Joan Severn came down a fortnight
> ago, resolved to stop me in my teaching the children music – and that I
> should rather be put under restriction again than get any good from
> other than her. Her husband – long getting more defiant of me in
> proportion to the benefits I heaped on him, encouraged her – and the
> end of it was I had to leave my house and come to the Waterhead
> [Hotel in Coniston] to avoid scenes that were like to kill me.[143]

The problem revolved around 'voluntary deeds of conveyance on Mr
Ruskin's part', as the solicitor put it to Albert Fleming; these had
apparently been undertaken, but could be 'avoided through Mr R. not
having had independent advice before executing them'. It seems prob-
able that at least Ruskin – his solicitor, though loyal, maintained due
legal scepticism – thought the Severns were pressing him to make
over his property in return for their services to him. Again, the truth
was certainly more complex: the Severns were undoubtedly rather
mercenary, yet they were also concerned to save both Ruskin from his
own worst excesses and something for their own troubles at the same
time. His main local ally was Albert Fleming, who lived at
Loughrigg, near Ambleside. A lawyer and Companion of the Guild,
who had got in touch with Ruskin in 1873 ('You certainly have read
some of my books'[144]), Fleming was a devoted and industrious dis-
ciple, editing the Ruskin-Beever letters and re-establishing a spinning
wheel industry in Cumberland.[145] It was he who wrote as a stranger to
the Alexanders to tell them of Ruskin's previous illness (see above
p. 395) and during the awkward days of 1887 he corresponded with
Margaret Raine Hunt about 'Joan's ingratitude' as well as taking the
matter up with H. P. Mackrell on Ruskin's behalf.[146] Eventually
Ruskin calmed down, the Severns did not 'claim any right to remain
[at Brantwood] against the Professor's wishes' (or so Mackrell was
advised) and first Ruskin and then Joan returned to the house.

But Mackrell had raised more serious problems in his letters to
Fleming: who, he wanted to know, would be looking after Ruskin?
This was important in the light of 'some very unpleasant rumours . . .

current in the neighbourhood [of Coniston] and [which] had been talked of among the local magistrates who were resolved that if any complaint came before them, to treat our Friend exactly as they would any other person in a Similar case'. The implication was clearly that 'prison or a lunatic asylum may be the end of it', and Fleming was advised to put matters squarely to Ruskin and to see that he was protected, 'that is to *ensure* that no such visitor as could be mixed up with the subject referred to in your letter, passes the threshold of his house and that he has with him a suitable companion whenever he crosses it himself'. Perhaps even before Fleming received that advice, he had raised the topic with Ruskin and found himself counted, if only briefly, among the opposition: 'It is entirely wonderful & dreadful to me', Ruskin wrote on 6 or 7 June, 'that you leave me or that after what I said to you, you so much as open one of Arthur Severn's letters. I have not a friend left now but who qualifies – temporizes – more or less deceives me . . .'[147] At the same time he was complaining to George Allen of the 'quite fearful antagonism in those quarters where I most looked for help'.[148] Clearly both Fleming and Joan Severn, each for different reasons, were concerned to protect Ruskin from unpleasant interpretations of his fondness for little girls and the privileges he considered he enjoyed ('to be able to kiss anybody whenever we like'). Ruskin evidently considered any questioning of his conduct as a breach of loyalty. Joan Severn, for her part, seems to have resented 'any good' coming to her cousin from sources other than her own ministrations, though there were good as well as selfish reasons for her jealous watchfulness. And, as Ruskin ruefully admitted to Joan the following autumn, when she thought he was himself, he was only 'sad and submissive'.[149]

In August he travelled south with Baxter and accompanied by Arthur Severn, apparently *en route* for a continental tour. But they got no further than Folkestone, where Ruskin was amazed by the antics of day trippers and recovered his old love of the sea:

> Yesterday [he recorded in a fragment of diary[150]] made the acquaintance of the Captain and his men, on board the rough-sea barge lying high and not dry on the mud of Folkestone harbour. And obtain the following measures taken by the men themselves, with great delight, with my old architectural tape – thank God in service once again, when I had never expected to unroll it more . . .

Some weeks later he and Baxter moved to Sandgate, where he stayed until late May of the following year, 1888. It was a period of vacillating health, physical and mental; Joan was forced to come and attend

him, together with Kate Greenaway, during one excessive attack in February. Baxter could not stand the strain and left for a while. Ruskin engaged other servants, including a strange character called Edwin – 'horsey, boozy, boaty – a little billiardy' – who taught him the meaning of slang words like 'blooming'.[151] He got a local craftsman to make and rig various model boats and paid an organist to entertain him with Bach, Corelli or Rossini. Music, together with pure colour, were suddenly soothing; 'I suppose . . . that neither are to express any passion . . . They are beautiful and right in themselves, as the forms of beautiful clouds, or of mountains, unconfused by characters exciting terror or amazement.'[152] But he was often bored, finding the local circulating library no substitute for the infinite riches of his own library at Brantwood. Between his 'dull room' and 'the wild sea' there was nothing to amuse him, and even the sea could get as 'dull as the Regent's Canal'.[153] Friends came down to see him, like the young Sydney Cockerell who had first appeared at Brantwood early in 1887 and who now visited Sandgate with his sister, Olive. Such new disciples maybe compensated a little for the sadness caused by the death of Laurence Hilliard of pleurisy while sailing in the Aegean. And old friends welcomed him in London, whenever he got up to Town. He was especially pleased by his reception at the Old Watercolour Society Exhibition in April; but Margaret Hunt told Albert Fleming that

> He is very much changed. He has grown so crocked & so much older and there were moments when he does not seem to know what is being said or who the speakers are. But he was for the most part very like his old self. I got Browning to go & speak to him and they had a nice talk.[154]

On one of his trips to London he was at the National Gallery and met a young art student who was copying Turner's *The Sun rising in a Mist*. Kathleen Olander knew some of his work and was much pleased when he praised her efforts. With her parents' approval she became Ruskin's pupil – 'But the first condition of my being able to help you is that you begin to work in the way I have always taught'.[155] They were soon very fond of each other. Ruskin told her that Rose had sent her to him; it was as if 'one of Perugino's angels had walked out of the frame . . .'. She provided him with companionship whenever they could meet in London, although her father refused to take her for a visit to Sandgate at Christmas, and she lent a fully sympathetic ear to his troubles with Joan ('many of my letters have been stopped of late'). Kathleen, eager, talented and deeply religious, was dismayed by his

religious beliefs; he, for his part, loved her 'sermons'. He meditated 'one love letter after another'; she dreamed of becoming his secretary.[156] 'Innocently obtuse', in the words of the editor of Ruskin's letters to her, she failed to see the intensity or the direction of his affection, even after Constance Oldham had hinted that she 'should not take things too seriously'. Ruskin channelled his emotions, as so often, into teaching her drawing; but the Olander parents became suspicious and, when he offered their daughter twenty guineas to copy Turner's *Hornby Castle*, a fee which they thought preposterous, for a while forbade any communication.

In April Ruskin resisted Joan Severn's suggestions of a trip abroad, though he realized she was motivated 'partly [by] affection – but – It would leave too much by far in her power'.[157] By June he seemed more amenable, telling Kathleen that Joan 'wants me any way out of my surrounding, *here* – and while I am able, to get into the old interest of a French town'. It was eventually agreed that the tonic of a visit across the Channel, after the illness and his struggles to continue work on *Praeterita*, was to be tried again. His fears of being laid up in the dull room at Sandgate were the final inducement to leave.[158]

Other solutions to the problem of where he might live had been mooted that spring, largely as a result of George Allen's hostility to the Severns and their mercenary ways. Ruskin's publisher had considered giving Ruskin a southern base in his house at Orpington, even making some alterations to that end. When Ruskin came to visit them in May, he received what Allen called a 'disturbing letter' from Mrs Severn, fearful that he would be 'too comfortable' there. Later, when Allen tried to see him at Sandgate, a 'lunatic attendant' refused him admittance – it is implied that this was on Joan Severn's instructions – and Allen sought advice from Ruskin's solicitor. With Joan tightly controlling Ruskin's spending, he was borrowing from Allen until Allen stopped the advances – 'it was only for other people to spend'. In fact, as Allen notes, Ruskin had 'got through all that money [John James] left and [was] solely depending on . . . his books'.[159] Before Ruskin left for France he confirmed the deed of gift whereby Brantwood and its contents went to the Severns; he refused, however, to accept their legal responsibility for him.

Arthur Severn accompanied him to Abbeville and to Beauvais, where on 12 July he resumed his diary with 'Restored, D.G. . . .' Three days later during the carnival he wanted to ride the hobby-horse on the roundabout.[160] By a happy coincidence Sydney Cockerell and a young architect student, Detmar Blow, were also visiting Abbeville, so that Ruskin recovered some of his spirits by showing them around

his favourite places. He began work again on *Praeterita*. By the end of July he was sufficiently his old self to leave for a more extended tour, accompanied by Detmar Blow. Blow, he wrote to Joan Severn from Paris, was 'exactly the companion I wanted – eagerly enjoying everything – absolutely obedient – and an entirely skilful measurer and surveyor – with the *taste* of a painter which I am fast developing in him'.

He greatly enjoyed Paris and after booking 'beautiful rooms' there at £20 a month for the winter set off on 'my own, old way to Geneva again'. On the way, at Dijon, he started writing the chapter of *Praeterita* in which he introduced Norton. When he reached Geneva, the Rhone was 'still clear', though smoke hung over the lake ('every village has its manufactory chimney'). At Bonneville he took his old room, found the inn unchanged and was delighted to be recognized by the landlady from twenty-four years earlier. Yet he was also quick to perceive that these Alpine places were not as exciting as before:

> I feel my own power and use far more among pictures . . . than mountains. I can neither paint nor understand them for all the trouble I've taken – but I find my knowledge of Greek vases & Gothic sculpture now – though I say it – consummate – & very pleasant to use in teaching.

Detmar, whom he delighted to treat as a son and encouraged to 'call me "the Governor" seriously', was instructed in ways of viewing these scenes and through his energy and liveliness of response Ruskin recaptured something of his old joy. The past was revived, too, in the village square of St Cergues, where among the dancing children was one, about eleven years old, '*so* like Rosie though of course not so pretty – but like her extremely in profile and with just the same spirit of brightness'. And at Chamonix, 'beneath the cloudless peace of the snows', he wrote his "Epilogue" to *Modern Painters*; here he reaffirmed its 'vital teaching' – 'the Personal relation of God to man as the source of all human, as distinguished from brutal, virtue and art'.

To Kathleen Olander he wrote increasingly ardent letters. When, after receiving from her a particularly happy reply, he dreamt of marrying her in the Sainte Chapelle upon his return to Paris, his explicit reference to this ('it is *terrible* for any creature of my temper to have no wife') at last brought home to her his ultimate meaning. Yet it does seem uncertain whether Ruskin was fully conscious for much of their correspondence of what he was implying. The Olander parents could object that Ruskin's letters were 'quite irrelevant to the purpose of art studies', whereas he had himself never cared for such distinc-

tions; the enthralled teaching of an attractive student often seemed consonant with great personal and spiritual intimacy. But his thoughts eventually took the form which his conventional upbringing had once before imposed upon his uncertain passions, and he proposed marriage. Interestingly, once Kathleen had realized his intentions and, hearing the story of his 'impotence' with Effie, had recovered from her initial horror at the thought of bearing his children, her own projections of what form their love could take were far less conventional. But her parents had by then put a stop to their correspondence. They were, however, able to exchange a few more letters and Kathleen continued to write when she could to Brantwood, even though she realized that Joan Severn was probably intercepting her notes.

Ruskin's affection for Kathleen Olander was also in some way a search for alternatives to Joan's supervision of his life. He looked forward to Kathleen nursing him 'next time'. And he was determined to act without reference to any desires but their own – 'you and I will have it our own way . . .' Once he had received her grieving letter in response to his about their marriage, Ruskin put away 'my vain thoughts of what might have been' and begged her forgiveness of 'the deeper sorrow they have caused you'. His 'old despondency' returned and he was forced to think once again of returning to Joanna's care.

He and Detmar Blow had travelled into Italy and were visiting the Alexanders at Bassano when he suffered a reaction to his frustrated visions of life with Kathleen. He was 'overwhelmed'[161] with the goodness of the Alexanders' friends and retreated to Venice, where he seemed vague and abstracted. The excitements of visitors and the old associations at Venice were too much in their turn, and he started northwards, stopping a while on the lake of Thun. Detmar Blow, a young man of nineteen, found himself increasingly unable to cope with Ruskin's deepening depression, so he and Baxter urged him homewards as fast as possible. By Paris he was close once more to madness, with fits of shaking and frequent delusions, so Joan Severn was summoned by telegram to come and help him. Eventually he was steered back to England, first to Herne Hill and after a while to Brantwood.

He had once written to Susan Beever of his pleasure at 'coming back from London, [feeling] the train stop at Carnforth and then at Ulverston, and then to see poor Joe Milligan waiting for me and to have him drive me up beside the lake – and see [it] gleaming as we trotted down the hill from Water Park. And then my own dear field and "wooded rocks"'.[162] These pleasures of a journey's end were no

longer to be his; apart from a visit to Seascale in the following summer, 1889, he remained at Coniston for the remainder of his life. During his visit to the Alexanders in Italy he had been writing the chapter of *Praeterita* that introduced the young Rose La Touche; now during the early summer months of 1889 he struggled to compose a chapter he entitled "Joanna's Care", which would treat of Joan Severn's place in his life.

He was by now entirely in Joanna's care. After their visit to the Cumberland coast, where he tried to work as he always had been able to do on his journeys but found that now he could only get 'lost among the papers scattered on his table',[163] he had another, total breakdown. From August 1889 until his death in 1900 it was as if the sea had closed over him.

Chapter 21

His Long Home: 1889–1900

infin che'l mar fu sopra nei richisuo (until the sea closed over us)
Inferno XXVI, quoted by Ruskin in a letter to Norton, 21 June 1869

Desire shall fail, because man goeth to his long home.
Ecclesiastes XII 5, quoted by Ruskin in a letter to Dr John Brown, 22 June 1879

It was almost a year before Ruskin had recovered enough from his attack in August 1889 to leave his room. By then even he knew that he must refrain from the work which excited and depressed him; he could tell Allen on a visit to Brantwood in the late 1890s that it was probably better that he could no longer hold a pen between his fingers since 'they have brought me into so much trouble'.[1] After 1889 he wrote virtually nothing, barely able at times to concentrate upon signing his name. He managed a shaky note to Susan Beever while she was dying in 1893, but failed to get beyond the first phrase of a letter to Mary Gladstone five years later after her father's death.

Rose's 'text', he had told Kathleen Olander in September 1888, was 'The Night cometh when no man can work'.[2] Often he had acknowledged the inevitability of that nightfall; but now it was a reality and a finality. In 1884 he could explain to Susan Beever that he was 'having total *rest* – & letting the grey, useless hours glide by, without trying to make them go faster – I suppose the tide will come up again over the flat sand of life'.[3] But now it was indeed a total rest without any hope of refreshment from the changes of the sea. He became literally the exemplification of his dictum to Emma Oldfield in 1875 that 'no man's word was anything after he was seventy'.[4]

Just as he had looked backwards in *Praeterita* and written a version of his life's best, least disturbing episodes, so he seemed in his last eleven years to fulfil some of the wisdom he had acknowledged as a younger man. From Como in 1845 he had quoted for his father the lines Michelanelo assigned to his statue of Night in the Medici Chapel of San Lorenzo:

Grato m'è'l sonno, e *piu* l'esser di sasso
Mentre che il danno, e la vergogna dura.
Non veder, non sentir, m'è gran ventura
Pero non mi destar. Deh – parla basso.

(Sleep is sweet to me, sweeter is to be of stone
While injury and shame continue.
Not to see, not to feel, is my great advantage
So don't disturb me. Sussh – speak low.[5]

At the time Ruskin had claimed they were 'Beautiful lines – & too true'; now perhaps he acknowledged truly the wishes of his own night. Except occasionally to his friends and except for his habit of muttering reiterated phrases to himself he did not speak. The image which Walter Crane retained from his visit to Brantwood in August 1897 was of a shadow: 'He had a benign expression', as he sat in his arm chair looking out over the lake, 'and looked venerable and prophetic, with a long flowing beard, but he seemed disinclined to talk, and when I spoke of things which might have interested him he only said yes or no, smiled, or bowed his head.'[6] Sometimes even his sight wearied him, like Cosimo de' Medici reported in Macchiavelli's *History of Florence* and noted in Ruskin's diary for 8 October 1882: when his wife asked him why he was keeping his eyes shut, he replied 'To get them into the way of it.'

But he took pleasure still in frequent strolls with Baxter or Joan, played a game of chess and appreciated Joan's music or singing. In April 1893 he even got down to the village to attend a concert of the Coniston Choral Society, an appearance duly noted in the *Westminster Gazette*. He enjoyed being read to – Baxter would read the newspapers and Joan would introduce him to new works by writers such as Kipling. And there were visitors, carefully screened and rationed by Joan. George Allen, still suspicious of her influence over Ruskin, came in the autumn of 1891, but never got to be alone with his friend: the 'old dragon sat opposite and never budged an inch'.[7] Kathleen Olander was turned away from the door by a servant after sending in her card one day when she had eluded her mother during a visit to the Lakes: she had to be content with a glimpse of him 'at the first French window, sitting alone' while the rest of the household were dining in the next room.[8] Others were more privileged and allowed in. Sydney Cockerell found his 'smile subdued, his eyes less bright'; whereas two years later in 1894 Kate Greenaway, still enormously fond of him, thought that he was 'of course not his old self, yet even at times there really seemed no difference'.[9] In 1893 Acland had come to see his old

407

friend, and his daughter took photographs of the two old men in the garden on 1 August.

But largely the world passed Ruskin by. His works and reputation were now beyond his control; he was a legend and an 'influence' before his actual death. On the occasion of his eightieth birthday in 1899 there were complimentary addresses from many learned societies and telegrams from all over the world. A group of disciples were admitted to the presence at Brantwood to deliver an Address, read by J. H. Whitehouse, who would later purchase Brantwood and promote Ruskin's good name.

In the last year of his life Ruskin ceased to take the air and was confined to his bedroom and the adjoining turret room. In January 1900 several of the Brantwood servants succumbed to influenza; on the 18th, when Joan Severn went up to read him the newspaper accounts of the Boer War, she found him shaky and painful 'all over'. Though he revived briefly the following day, he had insufficient strength to resist. In the middle of the afternoon of 20 January his breathing gradually faded; he died with his hand in Joan Severn's and in the presence of Baxter and his old doctor, Dr Parsons.

The world press responded with fulsome eulogies, Italian newspapers in particular praising his attention and services to their country. The English press became immediately involved in a campaign to secure for him a burial in Westminster Abbey: *The Times* and the *Daily News* published petitions and Brantwood was deluged with telegrams. Someone in the Coniston Post Office wrote out dozens of messages, the big sprawling hand making rather heavy weather of the roll-call of famous names who sent to express both their sorrow and their hopes for a suitably formal resting-place.[10] But Joan determined to observe Ruskin's own desire, to be buried at Coniston unless his death had occurred at Herne Hill when he had wished to be buried with his parents.

On 24 January Ruskin's body was taken from Brantwood to lie in state in Coniston Church, where he was buried in the churchyard beside his old friend, Susan Beever, on the following day. The coffin was covered with a pall given by the Ruskin Linen Industry of Keswick; lined with crimson silk and embroidered with wild roses, it bore the motto "Unto this Last". Flowers and wreaths came from many, known and unknown. Caroline Turner, a pupil at the Exeter High School for Girls, wrote to Joan Severn to say that 'all the truest and best influences of my life have come from his and from Carlyle's teaching'; she ventured to send 'a few violets and snowdrops – February flowers' in the hope that they could lie near him 'if only for a

few minutes'.[11] William Knight, of St Andrews University, who seems to have prided himself on having attended the funerals of Browning, Tennyson and Gladstone, sent for a 'crown of wild olive' from Hadrian's Villa at Tivoli, though it arrived too late for the funeral. But G. F. Watts sent a wreath of olive from the tree in his garden which had been cut before only for Tennyson, Leighton and Burne-Jones.[12] While the funeral was taking place in Coniston, a memorial service was held at Westminster Abbey.

Somewhat over a year later, on Ascension Day 1901, there was raised upon his grave the elaborately decorated monolith, carved by a local craftsman from designs by W. G. Collingwood. Its intricate symbolism offers a conspectus of Ruskin's lifework:[13] unhappily, it divides his artistic and architectural activities (on the eastern side, facing the grave) from his social and ethical (surmounted by St George on the western side, looking towards Coniston Old Man). Yet the two narrow edges may be said to link those main faces: on one is imagery of wild roses and animals, to signify his love of the natural world, a common denominator of all his work; on the other is simply an interlaced pattern, 'symbolical of the mystery of life' and therefore of those ineluctable connections between its diverse aspects for which Ruskin's whole life and work had been a crusade.

Chapter 22

Postscriptum

Quick eyes gone under earth's lid
Pound, *Personae*

The words of a dead man
Are modified in the guts of the living.
W. H. Auden, "In Memory of W. B. Yeats"

It requires another book to treat adequately of Ruskin's influence. Many are the people who would need to echo Georgiana Burne-Jones's testimony, that 'It is to him that I owe the beginning of almost every lasting thought of good that has helped me through life'.[1] Yet, as she indicates, Ruskin often only initiated ideas in others; so that an adequate discrimination of Ruskinisms, of the diffusion and manipulation of his work, would require careful attention to how his writings are susceptible to interpretation and how his words were modified in other's mouths. Inevitably, there are the important influences – the enormous hold which *Unto this Last* exercised upon members of the Labour Party in the new parliament of 1906 is perhaps the most famous example; then there are the trivial repercussions of Ruskin's career – the invocation of his name for everything from cigars to fireplaces.[2] But the connections between these essential and inessential Ruskinisms are instructive.

During his active lifetime Ruskin manipulated his influence with deliberation.[3] The public appearances and pronouncements, the sale and distribution of his books through George Allen, the blurring of distinctions between public and private utterances, the constant cross-referencing of his ideas and the invention of new forms by which to present them were all part of a careful strategy of self-construction. One of the most striking attitudes towards his own work is his repeated dissatisfaction with previous writings: thus, in writing to Oliver Lodge in 1885, he could suggest that 'all the work of my best years on political economy was made useless by the vanity which gave *Munera Pulveris* its pretentious form, and in letting my own fancies or feelings free, left *Fors* no force at all'.[4] And as that letter shows, he took

410

especial pleasure in responding to correspondents by refusing to behave towards his own work as they supposed he would; or he would direct them to various key pronouncements elsewhere in his works, as if only some sense of his total *oeuvre* would give particular items their adequate context. Above all, he was determined that his influence should be received and distributed intelligently, by people who were informed not simply enthusiastic: hence his wariness with the early Ruskin societies or reading guilds and his deflection of their homage. When the President of the Liverpool Ruskin Society wrote to convey his greetings for Ruskin's sixty-eighth birthday he was asked to 'remember also that birthdays are no pleasure to me any more than milestones on the road to one's country. Every day is a birthday to me that rises with sunshine; every end of day, a part of death'.[5]

But once his health deteriorated, Ruskin was unable to exercise such a strict and lively control over his followers. The conduct of his affairs passed into the hands of the Severns, whose understanding and appreciation of his career were above all not attentive to its subtleties. Even before Ruskin surrendered to his last, eleven-year silence, he had been forced to abandon plans for the wholesale revision and reconstitution of his *oeuvre*. Writing the Epilogue to *Modern Painters* in 1888 he confessed that the book's religious attitudes still dismayed him, but that he was obliged to issue it again in its previous text because 'my plans of better things in the same direction must be abandoned'.[6] The reissue of his works by George Allen, largely at the Severns' urging, was a betrayal of Ruskin's own social and economic principles: his writings became simply a commodity by which to earn money rather than a weapon in St George's fight with the dragon. Without Ruskin's scrutiny of how his work was used and invoked, it was pillaged to provide 'authority for almost any kind of anti-industrial social melioration, a rallying place for an extraordinary diversity of ruralist, progressive, liberal, reactionary or anti-Victorian views, many of them never remotely mindful of the original intentions of his work'.[7] The exploitation of Ruskin when his own active supervision was removed had its American counterpart, owing to the lack of copyright regulations, even before he fell finally ill. Such a fussy boudoir octavo as H. M. Caldwell Company issued in New York in 1878, entitled *Pearls for Young Ladies*, denied some of the essential ideas and integrity of the Ruskinian text. But it was symptomatic of ways in which the Ruskin 'industry' in England would also move. Its irrelevance and insensitivity may be gauged readily by contrasting it with Ruskin's own *Frondes Agrestes*, where Susan Beever's selections from *Modern Painters* are firmly absorbed into his larger concerns and

411

the distractions of fragments countered by his instinct for shaping another whole ('the reciprocal bearing of their fragmentary meanings'[8]).

Ruskin is not an easy writer, nor does he allow his readers any short cuts. 'And what's the use of telling me you don't like my polemics', he wrote to John Simon in August 1884, 'you might just as well tell Turner you didn't like his vermilion . . .'[9] His own convictions on the wholeness or inter-relatedness of his works were not shared even by those who were among his closest friends. We have seen (above p. 5) that Charles Eliot Norton thought the Library Edition of Ruskin's *Works* need not have been so 'complete': 'If it depended upon me, there would be no further word of Ruskin or about Ruskin given to the public. Enough is known. He printed or allowed to be printed far too much.'[10] Yet matters are not so simple. Even Ruskin might have agreed with Norton about the publication of an illustrated edition of his poems in 1891, while at the same time approving of the first publication in book form of an essential early text, *The Poetry of Architecture*, in 1893. Similarly, when his editors, Cook and Wedderburn, decided to include everything in their Library Edition, Ruskin might have applauded their effort to see him whole; whether he would have accepted their final arrangement, whereby the sporadic, serial publications were given coherence in single volumes, is not so certain. Ruskin's own 'selections' and arrangements of his life for *Praeterita* have been an unfortunate example for those of his readers who wish to retain, say, his art criticism or his fine prose and reject his 'polemics'.

It is perhaps typical of the life which Ruskin's ideas have had to lead after he himself lost control of them that in the very first year of his last illness the Walkley Museum was removed to another site and building at Meersbrook Park, Sheffield, where it was arranged without Ruskin's supervision, a supervision which would undoubtedly (when one thinks of his detailed correspondence with Henry Swan) have shaped the new museum in different ways. An even more unhappy fate eventually overtook Ruskin's own last cabinet of curiosities, his home at Brantwood. The Severns were selling some of Ruskin's drawings in the United States within months of his death. Despite Joan's determination to 'keep a full & characteristic collection of everything the Coz had – Pictures, manuscripts, minerals &c &c books, & all else',[11] and despite Ruskin's will which requested his heirs 'never to sell the said estate of Brantwood or any part thereof', items were gradually sold to maintain the Severns' funds. After Joan's death in 1924, Arthur moved to London and the house was neglected,

abandoned to the ignorant supervision of the Severns' youngest daughter, Violet, who vouchsafed to a visiting scholar, Helen Viljoen, that the footnotes of the Library Edition 'were only confusing . . . by the time you finish reading One of them you've forgotten what the text is about'.[12] Yet despite the despoiling of the contents of Brantwood, thirty years after Ruskin's death when the remaining contents were dispersed in a sale organized by some local dealers, Mr and Mrs Telford, one of them confessed that 'I never saw a house so crammed with things'.[13]

Like his former house, Ruskin's life and work are crammed with things, so that it is not perhaps too surprising that he has survived piecemeal. The famous testimonies to his influence on Gandhi, Tolstoy or Proust, for example, all concern the impact of selected items, *Unto this Last* or *The Bible of Amiens*.[14] Perhaps it was no accident that Venice provided the occasion for one of the first attempts after Ruskin's death to see him whole. At the Congresso Artistico in September 1905 the French critic, Robert de la Sizeranne, noticed how difficult it was to label Ruskin – neither artist nor archaeologist nor historian nor madman would do; he then proceeded to ask why Venice had exerted such an appeal for Ruskin. His answer sketched the range and interpenetration of Ruskin's works and his life. Venice, argued de la Sizeranne, provided a reconciliation of beauty and social activity that Ruskin could not find in England; Venice was also a religious city, apt for his believing spirit, and an artistic city, where its treasures belonged to everybody and where the appeal of colour and the 'law of asymetry' were dominant. The celebrations to honour Ruskin ended, as he would have keenly appreciated, under clear skies after days of stormcloud and in the Garden of Eden, created by an Englishman of that name on the island of the Guidecca. The newspaper, *L'Adriatica*, reported that the congress participants were welcomed in the garden by Miss Eden, 'inglese di nascita, veneziana di animo, ruskiniana per cultura'.[15]

That Ruskin could be among those whom Marcel Proust called 'directeurs de conscience'[16] is due largely to his determination and skills as a teacher. Having been in most important respects self-taught, he sought always to instruct others. The texts by which he conducted that instruction are all in vital ways the products of his life, for what he encountered throughout a life of wide travelling and reading and other contacts was translated into the fabric of his books. His writings retain the qualities of personal enthusiasm and magnetism of which those who experienced them directly always spoke. We tend to neglect the humour, the satiric energy and zest of his arguments, because we have

concentrated upon his theories and morality. Furthermore, we have probably lost a sharp enough sense of how well he *looked*, how keenly he saw everything from paintings to stones, partly because those generations that he instructed seem to have made his example redundant. Indeed, ideas which he may be said to have inaugurated have been absorbed into a wide range of modern concerns – social welfare, ecology, restoration of ancient monuments, education, vocational training – and Ruskin's contributions to them are now lost behind their subsequent elaboration.

The difficulty, though, with annexing him to later causes in our anxiety to trace influence is that he submits only awkwardly to their retrospection. He was a complicated man, as various in idea, emotion and mood as the range of his writings suggests; this variety has often been obscured by the caricatures of him or his supposed followers (D. H. Lawrence's 'The deep damnation of self-righteousness . . . lies thick all over the Ruskinite, like painted feathers on a skinny peacock'[17]). Perhaps the last word is best given to the photographer who captured the most suggestive, subtle likeness of him. During a visit to Brantwood, probably in September 1873, the Whitby photographer, Frank Sutcliffe, took the picture of Ruskin which has been used on the cover of this book. But as well as its eloquent visual image of a man pausing in the midst of a world of keenly focused things, the rocks, leaves and trees of one of his essential habitats, Sutcliffe also left a verbal impression: in it he talked of 'the heavenly blue eyes of a dreamer and the strong nose of a warrior'.[18]

Notes

idiot that I am! and was, never to be able to put a reference right
'Brantwood' diary, 25 May 1876

As explained in the Introduction, these notes, besides providing the usual references to works cited, are also designed to indicate the deep hinterland of further materials and ideas for which the main body of the text seemed unsuitable.

All quotations from Ruskin's writings, unless otherwise noted, are taken from *The Library Edition of the Works of John Ruskin*, edited by Edward Tyas Cook and Alexander Wedderburn, 39 volumes (London, 1903–12), being the only established text to use for that purpose. Yet since it is far more likely that readers will own other editions of separate works, and need to know the titles signalled by a volume number, I summarize below the main contents of the most important volumes in the Library Edition:

 1 *The Poetry of Architecture*, and other early prose
 2 Poetry
3–7 *Modern Painters*
 8 *The Seven Lamps of Architecture*
9–11 *The Stones of Venice*
 12 *Lectures on Architecture and Painting*
 14 *Academy Notes*
 16 *A Joy For Ever; The Two Paths*
 17 *Unto This Last; Munera Pulveris; Time and Tide*
 18 *Sesame and Lilies; The Ethics of the Dust; The Crown of Wild Olive*
 19 *The Cestus of Aglaia; The Queen of the Air*
 20 Early lectures as Slade Professor, 1870s
 21 Ruskin School at Oxford
 25 *Proserpina*
 26 *Deucalion*
27–29 *Fors Clavigera*
 30 Guild of St George
 35 *Praeterita*
36–37 Letters

Further, the following abbreviations have been used for works frequently cited in the subsequent notes:

 BD *The Brantwood Diary of John Ruskin*, edited and annotated by Helen Gill Viljoen (Yale University Press, 1971).
 D *The Diaries of John Ruskin*, selected and edited by Joan Evans and

John Howard Whitehouse, 3 volumes with continuous pagination (Clarendon Press, 1956).

EV Effie in Venice, edited by Mary Lutyens (John Murray, 1965).

FL The Ruskin Family Letters, edited by Van Akin Burd, 2 volumes (Cornell University Press, 1973).

JRRLT John Ruskin and Rose La Touche. Her unpublished diaries of 1861 and 1867, edited by Van Akin Burd (Clarendon Press, 1979).

LV Ruskin's Letters from Venice 1851–52, edited by J. L. Bradley (Yale University Press, 1955).

MR Mary Lutyens, *Millais and the Ruskins* (John Murray, 1967).

MT The Letters of John Ruskin to Lord and Lady Mount-Temple, edited and with an introduction by J. L. Bradley (Ohio State University Press, 1964).

NL Letters of John Ruskin to Charles Eliot Norton, 2 volumes (Boston and New York, 1905).

RF Reflections of a Friendship. John Ruskin's Letters to Pauline Trevelyan 1848–1866, edited by Virginia Surtees (Allen & Unwin, 1979).

RG Mary Lutyens, *The Ruskins and the Grays* (John Murray, 1972).

RI Ruskin in Italy. Letters to his Parents 1845, edited by Harold I. Shapiro (Clarendon Press, 1972).

WL The Winnington Letters of John Ruskin, edited by Van Akin Burd (Allen & Unwin, 1969).

References are not given in the notes for either diary entries, the dates of which are indicated, or for letters in *Fors Clavigera* identified by number.

Finally, unpublished materials are referred to by abbreviations of the collections where they are held (only the most frequently cited are given in this way):

Bembridge The Ruskin Galleries, Bembridge School, Isle of Wight

Bodley The Bodleian Library, Oxford

Coniston The Ruskin Museum, Coniston

HEH The Henry E. Huntington Library, San Marino, California

'Kent' A private collection in Kent, England

NLS The National Library of Scotland

PML The Pierpont Morgan Library, New York City

Princeton The Princeton University Library

Rosenbach The Rosenbach Museum and Library, Philadelphia

Yale The Beinecke Rare Book and Manuscript Library, Yale University

By way of Introduction

1 See *NL* I 183–5, which is obviously Ruskin's response on 11 September 1868 to Norton's suggestion that he write an autobiography. It was Norton's suggestion, too, that the autobiographical letters for *Fors* be transformed into something more extensive – see W. G. Collingwood, *The Life of John Ruskin* (3rd ed., 1900), p. 379.

2 **35**.46.

3 Ibid, 49.

4 Ibid, 124.

5 **2**.382.

6 PML, Sharp Collection, letter of 7 September 1888.

7 On the relation of preface to what it precedes see the preface of John T. Irwin, *Doubling and incest/repetition and revenge: a speculative reading of Faulkner* (Baltimore, Md., 1975).

8 *LV*, 177.

9 PML 2010, 429.

10 See **35**.lv.

11 Ibid, 17 and 122.

12 NLS 2624. Ruskin was in fact writing to Carlyle, whose clothes metaphor from *Sartor Resartus* he is perhaps adopting.

13 *LV*, 141.

14 See **6**.180.

15 In the brief preface to *Dilecta*, **35**.

16 See **25**.xxv; **4**.27; **16**.318; *D* 926; and *BD* 101; see also p. 363 above. Ruskin's editors translate the Italian as 'greater sea' (**24**.xliii).

17 I owe this point to Brian Maidment, 'Interpreting Ruskin 1870–1914', in *The Ruskin Polygon. Essays on the imagination of John Ruskin*, ed. John Dixon Hunt and Faith M. Holland (Manchester, 1981). One of the great stimulations to my work on Ruskin was the Ruskin Symposium which I organized at the Humanities Center, The Johns Hopkins University, in April 1978, of which *The Ruskin Polygon* (as it will be referred to in subsequent notes) is in part the published papers. The stimulation derived from the various participants and, later, from the contributors to the volume has been of considerable effect in my work on this book.

18 Yale MS Family Letters, vol. II, letter of 2 November 1849.

19 Valéry's stimulating essay, 'Introduction to the Method of Leonardo da Vinci' (1894), may be found in *Paul Valéry. An Anthology*, selected and with an introduction by James R. Lawler (Princeton, N.J., 1977), 33–93.

20 Quoted Robert Hewison, *John Ruskin. The argument of the eye* (London, 1976), p. 205.

21 *NL* I 178.

Part I

Chapter 1

1 *MT* 31. The original is in the 'Kent' collection.

2 See Helen Gill Vilhoen, *Ruskin's Scottish Heritage* (Urbane, Ill., 1956), hereafter referred to as Viljoen, and *FL*. Although I shall not give detailed references to either of these works' accounts of Ruskin's Scottish connections, it will be obvious throughout how much I am indebted

to these two prime sources. Some minor editorial completions and guesses in *FL* have been silently absorbed.

3 *FL* 10; the final phrases, only partly in quotation marks in the original, are annotated by the editor as a probable allusion to *Hebrews* 5:9. See also *FL* 46 and 67 note for just two of many other invocations of God by Catherine Ruskin in her family connections. For a sight of her pride in family circumstances, especially in bad times, see *FL* 27 et seq.

4 **35**.62.

5 Quoted Viljoen 55.

6 On the exact implications of this move to the New Town, see *FL* 4.

7 The quotation is given in Collingwood's *Life* 7. Raeburn's portrait of John James is reproduced in Viljoen figure 12.

8 Viljoen, pp. 127 and 235–6; also *FL* 33; see below p.18.

9 'Very late in his life, my Father on occasion of a drive with me to Croydon, first showed me my mother's birthplace, with a gentle sadness, not unmixed with shame' (Viljoen, 78, quoting from the MS of *Praeterita*). There were similar shames, too, for Ruskin himself later; in February 1885 he had 'a terrible day of chagrins and difficulties – finding my Croydon Grandmothers lost letters to my mother . . .' (D 1099).

10 *FL* 57.

11 Ibid, 18.

12 **35**.137.

13 See, for example, *Memorials of Edward Burne-Jones* (1904), I, 252 & 300.

14 *FL* 68–9.

15 See ibid, 34n.

16 Ibid, 75.

17 Ibid, 74.

18 Ibid, 74 and 76.

19 Ibid, 20 (a protestation of 1808, some years before).

20 Ibid, 21.

21 Ibid, 48 and 49–50.

22 Margaret would years later recall buying religious books with every farthing she possessed: see *FL* 453.

23 Viljoen's phrase, p. 57. A famous story illustrating Catherine's early high spirits is that of a friend who surprised her 'dancing a threesome reel, with two chairs for her partners; she having found at the moment no other way of adequately expressing the pleasure she took in this mortal life, and its gifts and promises' (**35**.62). See also Viljoen 57 for Catherine's account of maintaining 'myself and the two children on twenty pound'.

24 *FL* 22–3.

25 Ibid, 33–4. For the endorsement by John Thomas, see editor's headnote to the letter. The editor does not consider it likely that his parents thought John James would marry his cousin (*FL* 35).

26 By Viljoen, 125.

27 See ibid, 59–60 and 64.

28 *FL* 57. But it is equally clear that in later years he would speak to his son 'with pain of . . . early Edinburgh recollections' (*RI* 163).

29 Viljoen, 69, quoting Lord Brougham on Dr Adam.

30 **35**.38–9.

31 *FL* 57. John James also apparently attended some of Coleridge's lectures on Shakespeare and Milton – see *NL* I 20.

32 His mother hints at this reason: 'had it pleased God his temper had been such that you could have settled at home (*FL* 6).

33 Viljoen 111. This and the following quotation are taken from letters by John James to George Gray at the time of John's marriage to Effie.

34 Ibid, 115.

35 *FL* 16.

36 Ibid, 21–2 and 16–18.

37 Ibid. 26.

38 The nine years without holiday which Ruskin was to emphasize in *Praeterita* (**35**.19).

39 See *FL* 39 and 43n.

40 See ibid, 64n–65n and (for Telford) 72n–73n.

41 Viljoen 137 (further quotations from the letters mentioned in note 33).

42 Ibid, 144.

43 Ibid, 132.

44 *FL* 80; see also, for his first and second reactions to the news, 78ff.

45 Ibid, 21.

46 **36**.xix.

47 **35**.171. See also Viljoen's discussion of this in chapter 13.

48 *FL* 55 and 56.

49 Ibid, 57.

50 PML MA 1993.5 (letter dated 12 September 1874). This manic depressive pattern – often the excitements of work, followed by extreme lassitude – continued throughout his life.

51 *FL* 6.

52 Ibid, 81. His father's debts 'preyed upon my Mind, weigh'd down the Spirit of my Youth' (ibid, 17); Catherine warned her son not to destroy himself 'by a constant dread of future Evil' (ibid, 21).

53 Ibid, 86.

54 Ibid, 85.

55 See ibid, 82–3.

56 Ibid, 86–7.

57 See below, pp. 174ff.

58 Viljoen (161ff) discusses Margaret's religious faith at this stage of her life.

59 Derrick Leon, *Ruskin the Great Victorian* (1949: reprinted 1969), p. 8. Leon based this on interviews with descendants of the Grays, who were to occupy Bowerswell next, and whose daughter, Effie, would marry

John Ruskin in 1848; Leon's letters to the Hon. Clare Stuart Wortley, Effie's daughter, are among the Bowerswell paper at the PML.

60 Viljoen 167–8, quoting from the same Leon papers (see previous note). There is also the family tradition that Margaret looked up from her work to see John Thomas standing in her room with his throat cut and kept the wound closed with her hands till doctors came.

61 Collingwood, *Life*, p.18.

62 **35**.127. There seems to be some doubt even here – see *FL* 588 where John James writes, 'I never knew which was our marriage day'.

Chapter 2

1 Leon, *Ruskin*, p. 8. The house is illustrated in E. T. Cook, *Homes and Haunts of Ruskin* (1912), facing p. 4, and in *FL*, plate x.

2 *FL* 102 (4 April 1821). The whole letter is couched in this Byronic style. See also ibid, 211 for a later example.

3 Ibid, 93 (26 March 1819).

4 Ibid, 98 – another reference, perhaps, to Hannah's Samuel (see note 12 below).

5 **34**.393.

6 **35**.30 and 64–5.

7 'She had a natural gift and specialty for doing disagreeable things . . . She had also some parallel specialty for *saying* disagreeable things; and might be relied upon to give the extremely darkest view of any subject, before proceeding to ameliorative action upon it. And she had a very creditable and republican aversion to doing immediately, or in set terms, as she was bid; so that when my mother and she got together, and my mother became very imperative and particular about having her teacup set on one side of her little round table, Anne would observantly and punctiliously put it always on the other; which caused my mother to state to me, every morning after breakfast, gravely, that, if ever a woman in this world was possessed by the Devil, Anne was that woman' (**35**.30–31).

8 *Memorials of Edward Burne-Jones* (1904), I, 300–1. And there is some evidence of John's childish preference for Ann over his mother (see *FL* 109), but perhaps no more than would be usual towards his constant companion.

9 'considering what I suffered with John' (*FL* 96).

10 *FL* 91–3.

11 Respectively, *FL* 92, 95, 98 and 233.

12 I Kings 8 13; the story is told by Ruskin in *Fors Clavigera* 52. He also recorded how the pages of the Bible from which, on his mother's directions, he memorized this passage, were 'worn somewhat thin and dark' (**35**.42).

13 *FL* 93. Elsewhere she addressed her husband as 'a being so superior' (ibid,

106). And just as she strove to live up to John James, he in his turn seems to have idealized her worship. See also *FL* 144–5 and 251.

14 *FL* 98.

15 Ibid, 93.

16 Ibid, 98 (my emphasis).

17 Huntington MS 31088 and *FL* 100.

18 Ibid, 109. Cf., 'the general sense of Spiritual power is not a bad notion to get well into a child's head, otherwise in these days there's a chance of his thinking all the world is only a magic lantern' (Huntington HM 31090).

19 *FL*, 108. Typical of his own determination to contrive different fictions years later in *Praeterita*, compare: 'I was . . . never allowed, on my visits to Croydon, to go out with my cousins, lest they should lead me into mischief; and no more adventurous joys were ever possible to me there, than my walk with Ann or my mother where the stream from Scarborough pond ran across the road; or on the crisp turf of Duppas Hill' (**35**.90). Does 'crisp' represent his tendentious organization of landscape to conform with the patterns of his mother's supposed regimen?

20 Ibid, 127–8. His father wrote every other day while away on his travels (see ibid, 95), and his mother presumably wrote with equal regularity whenever she had addresses to direct to. Her agonies while waiting for delayed letters are feelingly expressed (ibid, 120).

21 Ibid, 96.

22 Ibid, 116.

23 Ibid, 128.

24 Ibid, 148.

25 **35**.20.

26 *FL* 118 for the sheep and the dog.

27 I am indebted for this point and for some later discussion to Professor Michael Brooke, who kindly lent me a copy of an unpublished essay on Ruskin's childhood in which the teachings of Maria Edgeworth on children's upbringing are explored.

28 Huntington MS 31088.

29 *FL* 126.

30 Ibid, 186. She would always *write* to him about disagreeable things, she said, so that his return would be as pleasant as possible (ibid, 92). They also exchanged their dreams (ibid, 93 and 106), a habit of self-analysis practised later by their son.

31 Ibid, 239 – he had just recounted his meeting with Senator Preston of South Carolina, 'a very agreeable *American* . . . a friend of Sir Walter Scott'. I am indebted to Professor Brooke (see note 27) for the suggestion about the family circle which follows.

32 **35**.21.

33 Huntington MS 31088.

34 Illustrated in **34**, plate II and in *FL*, plate xiii. Another Northcote

painting in which the young Ruskin was used as a model is described immediately afterwards in *Praeterita* and illustrated in **35**, plate III.
35 **35**.21–2.

Chapter 3

1 **35**.36. Further quotations in succeeding paragraphs are also from this second chapter of *Praeterita*, unless otherwise noted. For his nursery see **35**.34n. The house was demolished in 1906 (see *Illustrated London News*, 6 September 1906).
2 The loss of paradise quickly becomes a leitmotif in Ruskin's imagery (see index). The theological insistence upon the imperfections of human life, the ruination of the Garden of Eden, encountered and adumbrated on each daily Bible reading, became a matter of conviction that permeated all of Ruskin's thinking; see my discussion of the picturesque motif of ruins in 'Ut pictura poesis, the picturesque, and John Ruskin', *Modern Language Notes*, 93 (1978), 794–818.
3 'The Puppet Show', p. 4. This manuscript booklet composed by Ruskin in 1829 is now in the PML.
4 *FL* 200.
5 Ibid, 178 and 197 respectively.
6 Ibid, 191 and 193.
7 'A Tour to the Lakes in Cumberland', manuscript in PML. See below pp. 44ff.
8 *FL* 173; see also 178–9.
9 Ibid, 152–3.
10 Ibid, 209.
11 Ibid, 222.
12 See ibid, 149 and 142n. The servant, Thomas Hobbs, accompanied John to Oxford and the family to the continent.
13 **2**.326.
14 *FL* 179. To which might be added his tool kit and compasses (ibid, 211).
15 **27**.421.
16 *FL* 157: see also 141 ('he sends his love and will be so glad when you come home he did not at all like sitting down to dinner last Sunday') and 232.
17 *FL* 236.
18 Ibid, 224 and 233. In later life Ruskin was himself to criticize the practice of young people writing verses – 'Don't let any child you have to do with write *poetry*: If it does, call it a fool, and throw the verses into the fire without reading them and you will find it will write no more' (Huntingdon HM 31088).
19 See below, *passim*, or the birthday poem written for John James in May 1831 (see *FL* 255–6).
20 Ibid, 170.

21 Ibid, 187 and 190. For another example of his father's fulsome praise see *FL* 264–5.

22 **1**.xxvi.

23 On Margaret's readings see *FL* 228 and 230; on her sense of its elevating role see *FL* 208 (my italics).

24 *FL* 186. John was ten at this date. For his cousin Mary see below.

25 **35**.144. Besides the index entry for Ruskin's reading, already mentioned, see *FL* 168, 187–8 and 260 for lists of the father's book purchases.

26 Ruskin talks of these in the third chapter of *Praeterita*, where he also reproduced some of his imitations.

27 *FL* 170 – 'but at length I gave it up on considering how many different things were wanted'.

28 PML MS of 'A Tour to the Lakes of Cumberland', f.6.

29 All examples in this paragraph are drawn from the early notebooks at Yale; his remark to Image comes from PML MA 1707(i).

30 *FL* 227. The editor writes of Andrews as 'one of the best Greek scholars of the time' (*FL* 200); but Leon says that Andrews had 'little Latin and less Greek' (p. 20). *Praeterita*'s fourth chapter seems to support Leon.

31 **36**.3.

32 *Praeterita* says these summaries were written out on Sunday afternoons (**35**.72); but *FL* 178 shows that Ruskin sometimes postponed the task till as late as the following Saturday.

33 The extant notebooks in which sermon paraphrases occur are listed in *WL* 60n. A specimen page is reproduced in **35** facing p. 72 as well as in Collingwood, *Ruskin Relics*, p. 199. My quotation is from one of the notebooks, Coniston.

34 **2**.326.

35 **35**.83–4.

36 *FL* 261n.

37 **1**.xxxii note and **35**.76. These drawing lessons and their consequences are discussed in the first chapter of Paul H. Walton, *The Drawings of John Ruskin* (Oxford, 1972), where the implications of watercolour versus oil are discussed as they affect Ruskin's amateur status and the writing of *Modern Painters* I.

38 *FL* 261, 272–3.

39 Ibid, 259.

40 *WL* 26 and 27.

41 The point is made as regards his drawing by Paul Walton, op. cit., p. 8; as regards his verses, it is easy to trace the originals in a variety of eighteenth-century poems – some are noted by the editors in **2** – of which Ruskin strove to compose pastiches. See also the editors' comments on the absence of invention in *The King of the Golden River*, composed later, in **1**.xlix. The adult imitations, however, did not involve any adult emphasis on exact scholarship or concentration.

42 Respectively, **35**.21, **35**.78, Leon, p. 19, and 'Kent' collection.

43 **35**.18 for his grandfather and for riding lessons *Iteriad*, ed. J. S. Dearden (Newcastle upon Tyne, 1969), p. 93n.

44 **35**.36 and 37. He notes as exceptions 'a sociable bird or two'!

45 *FL* 178. For the following *Praeterita* reference, **35**.45.

46 See *FL* 139–40

47 Ibid, 186.

48 Ibid, 217.

49 Ibid, 253 and 220.

50 An older Perth cousin had been helped earlier and had lived briefly at Herne Hill (see *FL* 134 and 144). For Ruskin's own later sketch of Mary see **35**.71, from which the next sentence is quoted.

51 **35**.67–8.

52 *FL* 148.

53 Ibid, 166 and **35**.72.

54 'The most difficult task which I suppose every parent has, is to manage their children's vanity. On this point my mother most Utterly and absolutely failed . . .' (Huntington 31088). And he considered that he had been 'one of the most conceited young monkeys in England' (ibid). He also recalled in *Praeterita* (**35**.72) how he would paraphrase Andrews's sermons 'to show how well I could do it', while his cousin Mary did it 'dutifully'. On the unevenness of his learning Ruskin would tell his father from Venice in 1851 that 'there are a good many things which nearly all schoolboys know – and *I* don't' (*LV* 34).

55 *FL* 190.

56 He would also lament in later years that he was not allowed to be more athletic, more 'Manly' (Huntington, loc. cit.) For the following quotation, *FL* 174–5. Facetiousness still continued to obtrude in *The Poetry of Architecture* and had to be eliminated from the manuscript – see **1**.31n, for instance.

57 *FL* 172.

58 Ibid, 176. A biographer has good cause to echo Margaret Ruskin's lament on her son's fluency and facility with letter writing.

59 *FL* 179.

60 NLS MS 555/49. See also, for his recollections of supper after the pantomime when he was young, **2**.xxxi.

61 **38**.339. On the dates of their first visit see *FL* 119–20. The editor of *Iteriad* says the first visit to the Lakes was in 1824 (pp. 10 and 15). In a letter of *c*. 1850 he credits his mother with 'early carrying of me to the Lakes of Cumberland' and so with his 'very intense love of and happiness in natural scenery' (Huntington 31088).

62 **35**.15–6 and 29ff. Partly because this annual travelling was so evidently central to his whole life and its happinesses, *Praeterita* treats largely of the topic.

63 **2**.285. His reaction to her death as recounted in *Praeterita* (**35**.70) is more selfish.

64 Yale Notebook V (the numbering is that of Ruskin's editors, see **2**.529–34).

65 For the poems see **2**.265–8 and the edition of *Iteriad*.

66 In the PML there is an early sketchbook (1831–2) which depicts a tower of Dover Castle; a much more complete drawing at Vassar College is probably from *c.*1835 – see Oliver Tonks, 'English Architectural Drawings at Vassar', *Art in America*, XVIII (1930), 71–3. On the sublime see S. H. Monk, *The Sublime* (Ann Arbor paperback, 1960) and M. H. Nicolson, *Mountain Gloom and Mountain Glory* (Ithaca, N.Y., 1958); on the picturesque, C. Hussey, *The Picturesque* (1927) and Martin Price, 'The Picturesque Moment', *From Sensibility to Romanticism*, ed. F. W. Hilles and H. Bloom (New York, 1965). For a thorough but slightly schematic account of Ruskin's relation to these fashions see George P. Landow, *The Aesthetic and Critical Theories of John Ruskin* (Princeton, N.J., 1971).

67 **35**.80–81.

68 The 'nobler scenery of that earth . . . has been appointed to be the school of . . . minds' (**1**.132). This emphasis, which Margaret Ruskin echoes in one of her letters (see *FL* 203), may well be a response to William Gilpin, the famous picturesque theorist, who averred in his *Three Essays* (1792) that 'picturesque travel' should not be brought 'into competition with any of the more useful ends of travelling' (p. 41).

69 Yale Notebooks used by John Ruskin as a child (MS Vault / Shelves / Ruskin), no. 1.

70 *FL* 248. *Praeterita* describes this chariot, **35**.29, and one is illustrated in *Iteriad* between pp. 32 and 33.

71 Yale Notebook III, f.3.

72 *FL* 253. See also, 'O papa we are making you out such a tour in Wales. . . Abbeys, castles, and Druidical remains, innumerable' (*FL* 220).

73 **1**.xxv and *Iteriad*, p. 19. Cf. the remark of 1885 – 'have lived in inns all my life and am really more at home in them than at home!' (Sheila Birkenhead, *Illustrious Friends*, 1965, p. 315).

74 Yale Notebook III, f.10. The date of their visit to Tintern was 1831.

75 *FL* 203 and 259.

76 Both 'sources' of his style are acknowledged in the poem – Butler's *Hudibras* directly at IV 138 and Byron's poem obliquely at IV 187. All references are to book and line, quoting from the edition cited in note 43.

77 *FL* 234.

78 *Iteriad*, I 359–60 and IV 627. Is the second example not perhaps a practical echo of the family's favourite poet, Alexander Pope: 'Grant but as many kinds of mind as moss' (*Epistle to Cobham*, line 18)?

79 The editor of *Iteriad* suggests this prose 'Tour' (the manuscript of which is in the PML) was written at Cheltenham during the final stages of their return trip: pp. 22–3.

80 Leon, pp. 25–6. The distinction between the early foci of these in prose and verse is my own emphasis, not Leon's.
81 **5**.365.
82 Cf. *Iteriad* I 387ff. This, as other moments in the poem, are prophetic of several analyses in *The Poetry of Architecture*, though they are also clichés of picturesque taste.
83 Again, this is reported better in the prose version from which I quote; the full passage is printed, with some transcription errors, in *Iteriad*, p. 122.
84 Ibid, II 469–76.

Chapter 4

1 *FL* 253.
2 Ruskin admitted later that these tastes 'belonged to the age' (**35**.115).
3 *FL* 286 cites an entry of 5 guineas in John James's accounts for April 1833; Ruskin's version of the purchase is in *Praeterita* **35**.79.
4 **35**.112.
5 *FL* 563 which cites account books. *Praeterita* tells of a Prout 'watercolour . . . of a wayside cottage, which was the foundation of our future water-colour collection' (**35**.75) and of an engraving after Prout's 'Sepulchral monument at Verona', which Ruskin saw in an annual of 1827, given him as a present by his Croydon aunt (ibid, 91).
6 Quoted by Leon, op. cit., p. 23. Ruskin's account, quoted in the previous part of the sentence, is from **35**.79.
7 **35**.117. The autobiography goes on to say that he 'had no idea then of the Renaissance evil in them'; nor did he when he wrote some of the best analysis in *The Poetry of Architecture* (see especially I 77ff.), which is more acute than his later prejudices could ever allow.
8 *FL* 268. The drawing of Dover Castle is reproduced as plate 35 in *FL*; see also chapter 3 note 66 above.
9 *FL* 274.
10 *FL* 276. John James is writing to Richard Gray. That these ideas were present in the Ruskins' thinking is clear, not only from the losses that Jessie suffered (see above, p. 23), but from Catherine Ruskin's early letter (*FL* 49) in which she tells her future daughter-in-law that 'We ought to be very Carefull how we grieve for the death of an Infant if they are taken we are sure they go to Eternal happiness and God only can tell whether they may be spared for A Blessing or for A Curse'.
11 Ths editor of *FL* discusses the father's fondness for Johnson (pp. xxxix–xl) and quotes his son's later estimate of him as an 'entirely sincere' writer (**35**.225). *Praeterita* not only uses a resonant and central Johnsonian phrase – 'merely to fill vacancies of fancy' (ibid, 103) – but it also ends chapter VI by saying that 'We did not travel for adventure, nor for company, but to see with our eyes, and to measure with our hearts . . .

the things in which I have been least deceived are those which I have learned as their Spectator'.

12 PML, MA 2231.8, writing to his mother from Verona on 25 June 1869 about S. Fermo.

13 Unless otherwise stated, all quotations in this section of my discussion are from *Praeterita*, chapter VI, titled 'Schaffhausen and Milan'.

14 Effusions of John James and his son respectively, as they are imagined in one of John's charades.

15 **35**.81

16 The diary is at Bembridge.

17 **2**.345.

18 **2**.343 and **2**.353. The Cologne reference gets repeated in *The Poetry of Architecture* (**1**.56); the later reference to 'rabid and utterly false Protestantism' is from the 1880 Preface to *Seven Lamps* (**8**.15).

19 **2**.341, **2**.343 and **2**.347. The *Modern Painters* reference in the next sentence is from **5**.366. Cf. 'There is so much in all that concerns the arts, dependent on early association that I sometimes question whether anybody even understands exactly what it is that the person beside them is enjoying – or even perceiving' (PML MA 2274.28).

20 **36**.541.

21 **2**.354.

22 Ibid, 367.

23 **8**.28. Cf. 'the Universe in the most literal sense is his written language' – S. T. Coleridge, *Lecture on the Slave Trade* (1795).

24 The references in this paragraph are to **2**.349, **2**.355, **2**.371 and **2**.373. Some similar, suggestive references would also have been read later by Ruskin in the Preface to Lindsay's *Sketches of the History of Christian Art*, where Paradise is said traditionally to be a mountain (p. xxi) and where fragments are read in order to reveal wholes (p. xi).

25 **7**.260.

26 The words 'reflection' and 'speculation' (from *speculum*, mirror) announce this connection still.

27 See below, pp. 287ff.

28 **2**.381–2.

29 Letter to Walter Brown, quoted Cook, *Life*, I. 129.

30 **2**.392.

31 **35**.175.

32 Ibid, 85.

33 *FL* 278.

34 **35**.113.

35 *FL* 278–9, my italics.

36 **35**.326–7. Cf. an earlier piece on rushing river waters, **1**.192.

37 **1**.195–6.

38 *FL* 305 and 281–2. John's distaste for this latter activity perhaps shows in his verses on 'The Invention of Quadrilles' (**2**.394).

39 See *FL* 299 for details. On Dale see *Fors* 94 and *Fiction Fair and Foul* (**34**.365ff.).

40 **1**.lii & **35**.83, from where the subsequent quotations are also taken.

41 For instance, *FL* 302.

42 See **35**.101.

43 **1**.xxvii–xxviii.

44 Ibid.

45 **1**.xxxvii. Loudon was writing in November 1838. He is described as 'a friend' by John Ruskin in verses of four years earlier (*FL* 285); later, in one of his catalogues for the Oxford Drawing Schools, Ruskin also acknowledged Loudon's early assistance (see **21**.243 note).

46 'A fact always tells better when it is brought forward as proving a principle, than where it is casually stumbled upon', Ruskin to Loudon, September 1838 (Yale, Letters, vol. I, 43).

47 **5**.386–7. Cf. perhaps his Geometry Exercise Book (Huntingdon 6103), with its titlepage decorated with an angel's head caught up in the whirls of copperplate hand decoration, and two pages (ff. 28v and 29r) where doodled landscapes have been created from unfinished geometry problems.

48 **35**.92–3, from which the other quotation in this paragraph is taken.

49 Leon, p. 31.

50 On Charles, see **35**.90 and 135–7.

51 See 'My First Editor' (i.e., W. L. Harrison, who took over from Thomas Pringle), **34**.93ff.

52 His own words in *Praeterita* (**35**.140). On Rogers see R. E. Roberts, *Samuel Rogers and his circle* (1910).

53 *FL* 550.

54 **34**.95.

55 **35**.137.

56 I owe this point to Leon, p. 34.

57 **35**.93–4. Cf. later works like *Deucalion*.

58 *FL* 297.

59 Ibid, 305.

60 **2**.448.

61 **35**.152.

62 Ibid, 166, as also for the next quotations.

63 Ibid, 156.

64 **2**.401.

65 Ibid, 398.

66 All *Praeterita* quotations are from chapter IX (**35**.153ff.) unless otherwise noted.

67 Reproduced **2**, facing 404; the Rouen sketches are **2**, facing 400 and in *D*.16.

68 *D*.6 and 8.

69 **1**.31.

70 *D*.8–9, my italics.

71 **6**.368.
72 **2**.411.
73 *D*.10. Cf. 'matters of any consequence are three-sided, or four-sided, or polygonal' (**16**.186).
74 *D*.15. See his more extended perspectival discussion of Mont Blanc (ibid, 30) or of the Wetterhorn (ibid, 59).
75 *D*.16.
76 *D*.29.
77 See *D*.31–2 and 37–8 respectively. Cf. 'Chronicles of St. Bernard' (**1**.523), for a fictional version.
78 *D*.41.
79 *D*.32.
80 *D*.22 and 50. Does this kind of emphasis constitute a spill-over from his Byronic stance, where the reader is constantly invoked and harangued (see **2**.417)?
81 *D*.70.
82 Princeton MS 3915.1.379q., last 4ff. Ruskin begins this preface by saying inaccurately that he saw Venice first in 1833.
83 This would remain a division basic to his needs: in July 1879 he contrasted the distress caused by 'every word anybody says, if I care for them' with working at 'botany and minerology' with 'cotton in my ears' (PML 2457.20).
84 **35**.180; and for following quotation ibid, 179.
85 **1**.303.
86 **2**.18.
87 **35**.180.
88 The last two quotations are respectively from **35**.182 and **2**.466.

Part II

Chapter 5

1 *FL* 330–1; yet he continues in true Byronic-Hudibrastic mode to debunk it. His father advised a visit to a friend of Loudon's in the Temple 'where he will see some rooms like College' (ibid, 379).
2 Ibid, 344, 353 and 333; first italics mine.
3 Ibid, 329. Picture purchases that John James made are noted by the editor of *FL* at 326n and 330n.
4 Ibid, 302; see also ibid, 282.
5 Ibid, 375, and for examples of John's letters to his father see ibid, 325, 327 and 353.
6 Ibid, 324. For the father's inflationary appreciation see ibid, 404–5.
7 **2**.461.
8 See, for example, *FL* 356, where a view from Dales's study window is presented as 'a minerologist might . . . describe' it. For the logic courses at King's College see ibid, 346; also ibid, 411, 416 and 319n.

9 **35**.215–16. For purchase of the Copley Fielding see *FL* 314n.

10 *FL* 389 and 390n.

11 Margaret's phrase – ibid, 320. In 1837 he went to Yorkshire and the Lakes; in 1838 to Scotland; and to Cornwall in 1839.

12 She tells her husband that 'after the first term or two if John has a trustworthy servant we may be satisfied to leave him some part of every term so that I may be more with you' (*FL* 372).

13 See his facetious dramatization of this, **1**.513, and the end of his diary entry for 15 July 1835 (*D*.26).

14 *FL* 401.

15 See ibid, 373, note 3.

16 **20**.283. The lecture was delivered in 1870 and referred to a disagreement between father and son about a watercolour of Como by John.

17 *FL* 388.

18 Ibid, 403.

19 Dale's own letter to John James, quoted ibid, 395.

20 The essay for Dale is reprinted in **1**.357–75. The editors provide some of the cross references to later works mentioned briefly here.

21 **1**.367.

22 **3**.637–9.

23 H. G. Liddell, a Christ Church tutor, quoted in *Praeterita* (**35**.lxii–lxiii).

24 *FL* 423.

25 Ibid, 447–9 for letter of 9 March. For other disappointments for Margaret see ibid, 454, 467, 475 and 522.

26 Ibid, 435; 'I would not rest where I could not see him daily' (ibid, 432).

27 **35**.185.

28 Ibid, 33.

29 *FL* 435. It is his mother writing, but presumably on the basis of information received. On another occasion Margaret sends details of yet another gathering, but notes that 'John says he hopes letters cannot be intercepted he would not like such details seen, but by yourself' (ibid, 483), which indicates perhaps some embarrassment on John's part with his father's snobbery. Similarly, see ibid, 428.

30 Ibid, 428 – surprising and perhaps a reassurance designed to satisfy rather than the entire truth.

31 Ibid, 469, her italics. The editor of *FL* quotes memoirs to show that 'the chief amusements of rich non-reading undergraduates were hunting and shooting . . .' (430, note 5).

32 Ibid, 447.

33 Ibid, 426.

34 See ibid, 421, 424, 455 and (for late 1838) 548.

35 Ibid, 460.

36 Ibid, 456.

37 Ibid, 490–1.

38 Ibid, 443.

39 Respectively, ibid, 436 and 461.

40 Ibid, 543. Obviously such consequences were more habitual than not.

41 All passages quoted from ibid, 543–4.

42 **35**.193.

43 On geometry **35**.201 and trigonometry *FL* 476 – Margaret writing. See also *FL* 470 for John's assiduous preparation of work in these subjects.

44 Ibid, 596. Cf. 'John you know expressed . . . his desire to be more with the Elders of the College' (ibid, 580) and 'At Water Colour many High people . . . great miss to John' (ibid, 606).

45 Ibid, 429. But he actually confessed that 'he heard some things quite new to him' at some of Buckland's lectures (ibid, 436).

46 Ibid, 448.

47 Yet see Cook, *Life*, I, 31–2, for John James's later pride in John's geology.

48 *FL* 572, 576 and 584. See Ruskin's own essay on this theme, 'Was There Death Before Adam Fell, In Other Parts of Creation?' (**1**.480ff.).

49 *FL* 657.

50 Ibid, 462–3.

51 *D*.74–6, as also for the following quotation.

52 The Buckland story is noted in Cook's *Life*, I, 76. See also the essay on Ruskin's serpent imagery by Marc Simpson in *The Ruskin Polygon*.

53 *FL* 543, 478–9 and 590.

54 For the chess remark (quite early, in February 1837) *FL* 436; on the picturesque view, ibid, 478–9.

55 **35**.lxiii.

56 Cook, *Life*, I, 56.

57 *FL* 528.

58 Ibid, 611.

59 Ibid, 585; for John James's continuing annoyance with Croydon, see ibid, 500.

60 Ibid, 429.

61 **35**.197–8.

62 Ibid, 622.

63 Yet his mother obviously thought that this work for J. C. Loudon interfered with 'his more important studies' (*FL* 492).

64 A notable exception, to which I am indebted in this section, is Harold I. Shapiro, '*The Poetry of Architecture*: Ruskin's preparation for *Modern Painters*', *Renaissance and Modern Studies*, XV (1971), 70–84. See also my own article, '*Ut pictura poesis*, the picturesque, and John Ruskin', *Modern Language Notes*, 93 (1978), 794–818.

65 **1**.137. See above chapter 3 note 68.

66 **1**.xlii. On these two tours see J. S. Dearden, *Facets of Ruskin* (1970), chapters 6 and 7.

67 **1**.45 note.

68 **1**.68.

69 **1**.153.

70 Ruskin's emphasis upon the mind's involvements in landscape recalls Humphry Repton's theories (see my 'Sense and Sensibility in the Landscape Designs of Humphry Repton', *Studies in Burke and His Times*, 19 (1978), pp. 3–28). And Loudon was also Repton's editor, including one of Ruskin's essays in his edition of *The Landscape Gardening of Humphry Repton* (1840, reprinted 1969), pp. 32–8 note. If indeed there were some influence on the young Ruskin from Repton's writings, via Loudon, it confirms my own sense of what has never been remarked in Ruskin's attitudes to landscape, the huge role that landscape gardening played in shaping his early visual theories. Simply by those annual family excursions from one country estate to the next, he would have seen landscaped parks, with buildings integrated with scenery specifically designed to appeal to feelings and the mind; his essays show that it was from these as much as from paintings that he transferred to country scenes a particular habit of response. So, for instance, when he writes of a group of Swiss mountain chalets that they 'produce a very pleasing effect . . . uniting well with surrounding objects, and bestowing at once *animation* and *character*' (I 33 my italics), he is saying what every visitor to an English landscaped park said of its design; in addition he is using (in those italicized words) technical terms of the landscape gardening movement. Ruskin follows Repton, too, rather than the extreme picturesque practitioners of landscape design, in his admiration and perceptive analysis of the 'formality' introduced around Italian villas on Lake Como as a necessary 'link between nature and art' (**1**.86).

71 **1**.18, and for following quotation, **1**.19.

72 **1**.73. See Dearden, *Facets* (above, note 66), pp. 59, 57 and 55.

73 **1**.148.

74 Ibid, 15.

75 Ibid, 16.

76 Ibid, 31 and 80 note.

77 Ibid, 5.

78 Ibid, 279.

79 Ibid, 276. Cf. Bulwer-Lytton who, Ruskin wrote, 'gives Nature a spirit that she had not before' (**1**.370).

80 PML MA 2274.28.

81 *LV* 144.

82 For instance, 'Now, all landscape must possess one out of four distinct characters. It must be either woody, the green country; cultivated, the blue country; wild, the grey country; or hilly, the brown country' (**1**.67). It is an essentially eighteenth-century penchant for categories, and Ruskin establishes the 'character' of different topographies exactly as Thomas Whately distinguished between 'moods' and relevant visual forms of garden scenery: see *Observations on Modern Gardening* (Dublin, 1770), pp. 119–20.

83 **1**.31 note is one instance.

84 Ibid, 8.

85 **1**.6.

86 *FL* 502.

87 **1**.148 note.

88 Ibid, 167 note. Here he unconsciously stumbles upon a critical theory of prime importance; however intermittently and uncertainly, it will be a central theme in his career, formulated most forcibly many years later in the preface to *St. Mark's Rest* (**24**.203–5). The theme establishes some affinities between Ruskin and modern criticism which reads any artifact, not for its formal and expressive potential alone, but for what it tells of deeply rooted structures of belief and social ritual which in their turn have informed the arts: 'so that in every domestic building evidence will be found of the kind of life through which its owner has passed, in the operation of the habits of mind which that life has induced' (**1**.127).

89 **1**.9.

90 Ibid, 80 note.

91 **35**.224 and, for the following quotation, **35**.525.

92 *FL* 521.

93 **1**.105.

94 Ibid, 48.

95 *FL* 460.

96 **1**.48.

97 Respectively, ibid, 69 and 50.

98 Ibid, 59.

99 Ibid, 75–6. Influencing taste, not prescribing designs, will always be his preferred role: see the essay by Edward Kaufman in *The Ruskin Polygon*.

100 *FL* 492.

101 **1**.xxxvii, as also for the following quotation.

102 *FL* 612 note.

103 Ibid, 550.

104 Ibid, 627–8.

105 Ibid, 661 note.

106 Ibid, 666.

107 Ibid, 379.

108 Ibid, 566. The first italicized *We* is Margaret's; the second, mine.

109 Ibid, 574.

110 Ibid, 648.

111 Ibid, 667.

112 Ibid, 665. However, John James had been put to much trouble of mind and extra correspondence by various domestic and business problems among the Domecqs, which had nothing to do with his son's affection for Adèle, and this may partly explain his outburst.

113 Ibid, 568.

114 Ibid, 587.

115 Ibid, 562 note.

116 Ibid, 602 (as reported by John James).

117 Ibid, 497.

118 Ibid, 388. John James complained to Harrison about his son's refusal to 'polish' (**2**.xxiv–xxv).

119 See *FL* 514 note 5.

120 See ibid, 556 note. The successful poem is in **2**.90ff.

121 *FL* 619 note. For the college Censor's speech in praise of the Newdigate prizeman see the passage quoted as motto to this chapter; it is taken from *FL* 631–2.

122 Ibid, 481.

123 Ibid, 532 note. And see the following chapter for their obvious disagreements about pictures.

124 **1**.371.

125 In August 1839 John James confessed to W. H. Harrison that he probably overvalued his son's verses, but nevertheless he did 'indulge a hope that he may, if spared, become a full grown poet' (Bodley MSS Eng. lett. 32, f.35). In 1847 to the same correspondent he rehearsed his son's conviction that 'all his poetry [was] the mere effect of reading – mere Imitation – nothing original' (ibid, f.255). As late as 1852 John James still needed consolation for his son's failure to be a poet, for after the publication of *The Stones of Venice* I Mary Russell Mitford writes that, 'If your son had never written a line of verse in his life he would still have been among the greatest of English poets': *Mary Russell Mitford. Correspondence with Charles Boner and John Ruskin*, ed. Elizabeth Lee (London and Leipzig, 1914), p. 215.

126 **35**.259.

Chapter 6

1 **1**.493–5. Dated provisionally 1840 when first published, Ruskin's editors thought it more likely to be 1843 (see **1**.493 note); but their argument is not particularly convincing.

2 *D*.77.

3 **1**.420. TB was never actually diagnosed.

4 Ibid.

5 **1**.391 note.

6 Ibid, 376–7.

7 Ibid, 382.

8 Ibid, 381.

9 Ibid, 382.

10 Ibid, 388.

11 *D*.196. The *Praeterita* reference is to **35**.297.

12 One of the two letters not reprinted in *Letters Addressed to a College Friend* (1894), and here quoted from Huntington 6106. The description of a

clergyman's duties is borrowed, Ruskin says, from a clergyman friend of his father's, Croly.

13 **1**.434.
14 Ibid, 71.
15 Ibid, 68–9.
16 *Praeterita* also recorded that *Modern Painters* had not yet 'been dreamed of', but was probably wrong in adding 'nor any other book' (**35**.285).
17 **35**.281; see frontispiece to this book. *D.* 151 for following example.
18 'Tiresome' is Ruskin's own word (**35**.297). The footnote on p. 286 records how the work of 'Coeli Enarrant' – actually a distillation of the sky studies in *Modern Painters* – had begun 'practically' at this time. Other annotations of his career to show how later work (*Seven Lamps* and mythology, essentially) may also be credited to this otherwise barren time occur on pp. 289 and 291.
19 **35**.285.
20 Ibid, 298.
21 Ibid, 268 and *D.*110.
22 Ibid, 282–3 and *D.*116–17.
23 Quoted from *D.*129; also, but abbreviated, in **35**.283.
24 *D.*146.
25 Respectively, *D.*88, *D.*126 and *D.*185; for further discussions of the Venetian disappointments see below pp. 131ff. and chapter eleven.
26 It may be correct, in the light of Ruskin's later treaty with scenery, to say that 'Ruskin never accepts the romantic view of the imagination as genuinely creative' (Elizabeth Helsinger, 'The Ruskin Renaissance', *Modern Philology*, 73 (1975–6), p. 169). But in 1840–1 his whole endeavour was exactly to determine his own position vis-à-vis predecessors and his own potential.
27 As his own diaries virtually acknowledge occasionally: see 'bored with my chest again a little today, but believe it is more fancy than anything else' (*D.*125).
28 **35**.281.
29 **35**.166.
30 *D.*165.
31 Ibid, 119 and 129.
32 Ibid, 113 note – this being the recollection of a year later. See, similarly, *D.*98 note ('Wanted to sketch'), *D.*109 ('sketching hard in Pisa') and *D.*164–5 for the frustrations of not having enough time at Amalfi.
33 Ibid, 152.
34 Ibid, 146. See also 'I shall never be satisfied with my drawings here' (ibid, 150).
35 P. Walton, *The Drawings of John Ruskin* (1972), p. 38; but see all of his chapter.

36 **35**.624.

37 Respectively, *D*.103, *D*.159 and *D*.143. See, among many other similar annotations, *D*.91, *D*.132, *D*.180 and *D*.185.

38 Ibid, 137.

39 **35**.290.

40 **1**.456.

41 See, for example, *Apollo* (June 1974).

42 *D*.125 and **35**.277, from which 'Rome' chapter the following quotations are taken. Prout's own later comments on Ruskin's Roman sketches were fulsome; in particular 'the finished sketch of the poor quarter at Rome is, in *my* opinion, the most perfect architectural sketch I ever saw or ever shall see ('Kent', n.d., but marked as 1845).

43 *D*.175, *D*.170 and *D*.182 respectively.

44 **35**.291.

45 *D*.187.

46 **35**.292.

47 *D*.131, compared (say) with *D*.124.

48 This and the succeeding quotations are from the chapter in his autobiography called 'Cumae'.

49 *D*.187. The sculptures represent Adam and Eve eating the apple, and the Drunkenness of Noah. This recognition at Venice late in his journey maybe signifies some maturity gained during it; for at Carrara the previous November when the Ruskins had brought some statuette 'whom I took for Adam and Eve', he told Clayton, 'but everybody else says they are Bacchus and Ariadne – *tant mieux*' (**1**.431).

50 Respectively, *D*.96, *D*.100 and *D*.161. Maybe his affection for these dogs stemmed from the fact, as John James explained later, that dogs had 'never been admitted to any degree of Intimacy' in the Ruskin home (*RF* 170).

51 Ibid, 166.

52 Ibid, 165 and 166.

53 Ibid, 160.

54 Ibid, 127.

55 Respectively, ibid, 176 and 183.

56 Not counting, when he was in England, his fairly extensive moving around. See 'I never found myself settled for six months in any place that I liked' (*LV* 20), and for other reflections on this home versus abroad dichotomy during this trip see *D*.189, 139 and 115 note.

57 For further amusing tensions between two bournes of earth see his diary where, first, he nearly vows never to go to Italy again now he is in Geneva (199) and then, a page later, finds the neatness of the Swiss 'quite intolerable after Italy'.

58 Respectively, *D*.94, 171 and 192.

59 Ibid, 183.

60 Ibid, 200.

61 See ibid, 121, 124, 180 and 196. See also below the line of Auden quoted p. 153.

62 Leon, *Life*, p. 23. The girl, Miss Tollemache, was the future Mrs Cowper-Temple, for whom see below.

63 See *D*.127, 128 and 140.

64 Ibid, 165.

65 Ibid, 183.

66 Ibid, 185.

67 At least he registered this in somebody else, for the Ruskins were taken in Venice to see the work of a watercolourist, James Holland, and John found it 'more completely laid all over . . . than any subject I ever saw improved' (*D*.184).

68 Ibid, 192.

69 Ibid, 199, as for the following quotation.

70 The diary at this crucial point is annotated by Ruskin a year later with 'exactly the same fit came on me in the same church next year, and was the origin of *Turner's Work* [i.e. *Modern Painters*]'. It is then further annotated – at an unspecified date – with 'The most important entry in all the books' of his diary. In this third note I believe Ruskin to have been absolutely right.

71 The examples in the text are from the diaries: 83, 94, 99, 107 and 112. Others may be found at 101, 114, 120, 135, 141, 142, 153, 158, 160, 161–2, 164, 167, two examples on 168, 170, 172, 174, 181, 193, 203 and 204.

72 Ibid, 152.

73 **1**.440–1.

74 **1**.450–1.

75 *D*. 185.

76 Ibid, 207. Earlier he had acknowledged that 'it must be a good memory indeed to retain any distinct idea of a scene lasting five seconds' (ibid, 173).

77 Ibid, 150 and notes.

78 Respectively, **1**.381 (my italics), *D*.118 and *D*.102 and 138 (on various picturesque effects in landscape recorded in his diary).

79 Ibid, 119.

80 Ibid, 120. Walton, *The Drawings of John Ruskin*, p. 42 and plate 25, implies that this drawing represents Ruskin's fresher response to baroque architecture; it strikes me as a redaction of the baroque to Proutism. Even the tiny pointing figures are a picturesque cliché.

81 Ibid, p. 33.

82 *D*.158.

83 **1**.452.

84 Ibid, 389.

85 Ibid, 452.

86 This was, in fact, the second time Effie Gray had stayed with the

Ruskins; the first occasion was in 1840 just before they left for Europe, when she was on her way to school at Stratford-upon-Avon.

87 **35**.299.

88 The diary consists of one rather chastened entry made at the time and another, from which I quote, made a year later (*D*.209–11).

89 **35**.300, and for the following two quotations.

90 *D*.212–14. For his annotations of the previous tour while at Leamington see particularly 215 (on Clermont), 216 (on Le Puy and Brionde) and 217 (St Etienne and the descent to Argenthal).

91 **35**.301–2.

92 See **24**.222ff.

93 The text is printed in **1**.313ff.; my quotations are from pp. 327, 341 and 346–7.

94 **1**.395–8 gives the text of the whole letter.

95 On his love of argument see **1**.433 and 444 ('I am rather fond of quarrelling – arguing, that is – and perhaps, sometimes persist in it when I am undecided in my own opinion, for the sake of an argument'). See also John Hayman, 'John Ruskin's Unpublished Letters to his Oxford Tutor on Theology', *Etudes Anglaises*, 30 (1977), 194–206.

96 *D*.218.

97 **35**.306 and *D*.219.

98 *D*.220, *LV* 109 and **35**.307.

99 *D*.220.

100 Ibid, 217.

101 See *Praeterita*, **35**.309ff. The drawing was eventually given to Ruskin as a gift from a group of friends in 1878: see above, p. 372.

102 See **22**.243 and *Fors* 9.

103 **1**.383–4.

104 **35**.311.

105 **25**.454.

106 *D*.223.

107 Ibid, 231. See Van Akin Burd, 'Another Light on the Writing of *Modern Painters*', *P.M.L.A.*, 68 (1953), 755–63, to which I am indebted in what follows, although with some slight differences of interpretation.

108 *D*.224.

109 As Ruskin might have told one of his later lecture audiences, these are difficult but necessary terms, which I have derived respectively from Stephen Daedalus's aesthetic theory (and ultimately from Aquinas) and from Duns Scotus (who passed his ideas into Gerald Manley Hopkins's notion of *inscape*). There is no suitable and common word for the idea of a thing's essential being, its 'thingness'. For some treatment of allied ideas in the nineteenth century see Patricia Ball, *The Science of Aspects* (1974).

110 **3**.665.

111 **35**.311 and 314–15.

112 **5**.333.
113 **4**.344. The epilogue was added in 1888.
114 **1**.381.
115 See *D*.199 note. He refers, of course, to *Modern Painters* as 'Turner's Work'.
116 After all, the Geneva entry of 1841 actually says that this self-reproach occurred 'Several times about the same hour on Sunday mornings' (*D*.199), so that the 1842 occurrence itself may only retrospectively have been translated into a single incident. On the frequency of these sabbath broodings see his letter to Gordon, quoted on p. 130
117 See below pp. 130ff. and **3**.666.
118 *D*.230, and ibid, 231, for following quotation.

Chapter 7

 1 **34**.470. For more on this concept of digression, see my essay in *The Ruskin Polygon*.
 2 **3**.666.
 3 See Jeffrey Spear's essay on *Fors*, also in *The Ruskin Polygon*, as well as my own discussion below, pp. 335ff.
 4 Selections from their reviews, which supposedly set Ruskin in a rage at Geneva, are quoted in **3**.xxiv–xxv. On attitudes to Turner more generally, see Van Akin Burd, 'Background to *Modern Painters*: the Tradition and the Turner Controversy', PMLA, 74 (1959), 254–67.
 5 **3**.680.
 6 **22**.153. See 'education and accident operate to an unlimited extent' upon our senses (**3**.109).
 7 **1**.143ff.
 8 **1**.124. More of these seminal ideas are all rehearsed in various letters to Clayton: see especially **1**.420ff. and 496–7.
 9 The remark is Leon's, *Life*, p. 77. Leon tries to rescue *Modern Painters'* aesthetic as a permanent contribution to our understanding of art; I have, by contrast, chosen to read the work as a formal and public vehicle for much of Ruskin's personal absorptions and, as we might say nowadays, 'hang-ups'.
 10 'each great artist conveys to you, not so much the scene, as the impression of the scene, on his own originality of mind Still less are you to count stones, or measure angles. You are to imbue your mind with the peculiar spirit of place . . .' (**1**.421).
 11 **3**.278–80.
 12 Ibid, 92. Cf. his later Oxford lecture of 1870 in **20**.73ff.
 13 For clouds, **3**.415–16; for Schaffhausen, **3**.529–30. The first passage, significantly, derives from a passage of verse (see **2**.435–6); the second, from two watercolours of 1842, now in the Fogg Museum, one of which Turner professed to admire (see **3**.529 note).

14 **3**.547, the phrase, 'as which . . . named it', being in parenthesis.

15 *FL* 599.

16 Information from the 1843 and 1852 inventory of pictures (Bembridge MSS 28 and 29). On the exchange of the Penley picture see *FL* 635.

17 **1**.7.

18 *FL* 606–7. Ruskin senior was legitimately proud of his 'power of buying a *living* artist's work' (my italic).

19 **3**.221.

20 *FL* 609. Holland and Taylor are both discussed in *Modern Painters* I (see **3**.529 note and **3**.120).

21 *FL* 663, my italics.

22 This seemed abundantly clear when the *Winchelsea* was exhibited at Agnew's in 1979; see also, on Turner's English views, Eric Shanes, *Turner's Picturesque Views in England and Wales* (1979).

23 **35**.256.

24 **36**.32. The letter is tentatively dated 1843 and is addressed to George Richmond, a friend of Blake's, who had died in 1827, when Ruskin was eight. Ruskin met Richmond in Rome during the winter of 1840–1: see above pp. 110ff.

25 Years later he told John Brown that this attitude of his father's 'made me give up my Turner work and go into Architecture, politics, etc, but worse than that, destroyed all my respect for my father's judgement . . .' (Yale, letter of 12 July 1871).

26 **1**.428–9.

27 *D*.209.

28 Ibid, 247.

29 **3**.666.

30 **3**.xxxv, as also for some further reactions.

Chapter 8

1 *D*.240. For the other events noted in this paragraph, ibid, 239–40.

2 Ibid, 241 and 239 respectively.

3 Ibid, 241.

4 Ibid, 245.

5 Ibid, 246.

6 Ibid, 248.

7 In his diary for 22 November he draws his own attention to 'the account of Marmontel's apathy'.

8 *D*.254 and 249.

9 **4**.362ff. Harold Shapiro (*RI* xviii) says we 'must not take too seriously Ruskin's later declaration that, as a result of the tour of 1845, his second volume was not at all what it was originally intended to be.' But it is clear from the diary for 1843 that Ruskin was encountering difficulties. The MSS which Shapiro invokes to 'show very clearly that its first

two-thirds . . . was very much the sort of thing he had intended' are presumably later than 1843.

10 **4**.364.

11 *D*.249.

12 Ibid, 254.

13 **3**.16–17, as for following quotation.

14 He was drafting these at about the same time: see **4**.365–81.

15 **3**.34ff.

16 Ibid, 22.

17 Ruskin himself told Prout and the Richardsons, none of whom had suspected that he was the author.

18 *D*.264–5.

19 Ibid, 274.

20 Ibid, 280.

21 Ibid, 277.

22 Ibid, 280.

23 Ibid, 279 and 282.

24 Ibid, 277, 278, 278, 285. Leon's phrase for this 1844 experience was Ruskin's finding 'God's hand in the mountain' (*Life*, p. 91).

25 *D*.304.

26 Ibid, 293. The imagery of altar and incense was dropped from the diary entry when it was quoted years later in *Praeterita* (**35**.333).

27 *D*.296 note.

28 Ibid, 313.

29 See *RI* 53 and passim.

30 Bodley Acland MS d.72 (letter of 27 November 1844). See also *RI* 1 note 1 on Ruskin's current interests in anatomy.

31 A brief note on the Swiss political situation is given in the valuable *Turner in Switzerland*, introduced by John Russell and with survey, notes and checklist by Andrew Wilton (Zurich, 1976), pp. 34–9. See also *RI* 6 note 2. It is conceivable that part of Turner's opposition – recounted in *Praeterita* (**35**.341–2) – derived from a realization that Ruskin's company would be denied him (they had been seeing each other often enough). See also **4**.xxv.

32 **35**.343–4 and 345.

33 *RI* 40. Shapiro's work with these letters which Ruskin wrote home during this 1845 trip makes it the best modern edition of any of Ruskin's correspondence. The reader is referred to it for larger accounts of this journey than I have time for here.

34 *RI* 41; see also 49.

35 *RI* 33. He actually tries to make it sound a dull and disappointing event ('a precious ugly view I had of it'). There seems also to have been another occasion a week earlier at Annecy – 'Had a walk up a decent bit of a hill today, & enjoyed it exceedingly – after reading the church servide bang through to George' (*RI* 18). Maybe this modest extension of Sabbath

activities became fairly general during the trip and so explains his mistake in *Praeterita* about the location of his main 'infringement' (see *RI* xv and its comment on **35**.346).

36 *RI* 53–5.
37 Ibid, 42.
38 Bembridge MS 5A.
39 *RI* 44
40 *RI* 49.
41 Ibid, 51.
42 Ibid, 54.
43 Ibid, 54–5. The description belongs in fact to his account of a typical daily schedule, already quoted. In 1888, when he added an Epilogue to *Modern Painters* II, he recalled both the 'inlaying of San Michele' and Ilaria's statue as crucial events in his artistic education (**4**.346–7).
44 *RI* 51 and 52. He wistfully projected heavenly mansions and pictures 'that shan't want repairs' (*RI* 63). For the following Timon references see *RI* 76 and 77.
45 **4**.350 and *RI* 66.
46 *RI* 60.
47 *RI* 62 (for Rossini) and 71 (for Frenchmen).
48 Ibid, 101, and 130 for following quotation. In all fairness, it should be recalled that he later (*RI* 106) realized that the Uffizi would need a little more time.
49 Ibid, 65.
50 Ibid, 76.
51 Ibid, 63; few of the paintings are now attributed to those artists. On the Renis purchased by the National Gallery and on attitudes towards old masters generally see the fascinating book by David Robertson, *Sir Charles Eastlake and the Victorian Art World* (Princeton, N.J., 1978).
52 *RI* 88.
53 Ibid, 85. On Ruskin's lifelong and extraordinary fascination with these fireflies, see the essay by William Arrowsmith in *The Ruskin Polygon*.
54 *RI* 124 and 129–30. It is typical of Ruskin that he 'plunged in a sea of botanical difficulties' as an approach to old Tuscan painters.
55 Ibid, 106, 101 and 121.
56 **1**.500 – explaining his bad handwriting.
57 *RI* 109 – further advances in this pictorial knowledge are chronicled also on pp. 92, 96–7, 98, 108–9. In Florence he also acknowledged how much Richmond had taught him to feel the '*quality* and *tone* of individual colour' (91).
58 Ibid, 104–5.
59 Ibid, 128.
60 Ibid, 119.
61 Ibid, 134–5.

62 Ibid, 228 (on Italians) and 102 (on tapestry). The *Last Supper*, now in the Museo dell'Opera, is by Taddeo Gaddi.
63 *RI* 127.
64 Ibid, 144.
65 Ibid, 144–5. But revisions had to be made after the discovery of Tintoretto in Venice later in the trip: see below p. 157.
66 Ibid, 159. He would draw upon this mountain work in *Modern Painters* IV.
67 Ibid, 161, as for all the following remarks about Macugnaga.
68 **4**.xxv note. Ruskin himself realized that this childhood delight came rather late.
69 *RI* 160 and 161. The following remarks are also from these same letters of 24 and 27 July 1845.
70 Johnson's character and his 'Happy Valley' were actually in Ruskin's mind and invoked in another letter home (see *RI* 163).
71 **6**.27–47.
72 *RI* 179.
73 The recognition of this at this time is recorded in ibid, 172 and 180. See his discussion of Turner's Faido in **6**.33ff.
74 *RI* 189. It is important, I think, that this remark is made about *landscape* at Baveno (pace Robert Hewison, *Ruskin and Venice* [1979], p. 45, where the remark is made to apply to Venice).
75 *RI* 175.
76 Respectively, ibid, 187, 182 and 195.
77 Ibid, 192.
78 Ibid, 167 and 197.
79 Ibid, 196–7. Snell was a London upholsterer, who (ironically) was used by John James in 1852 to furnish 30 Herne Hill for John and Effie (see *EV* 288).
80 See Hewison, *Ruskin and Venice*, p. 8.
81 *RI* 121. Cf. the 'Vestibule' chapter of *The Stones of Venice* (**9**.406ff) and below, pp. 211ff.
82 *RI* 198–9.
83 Ibid, 201.
84 Ibid, 200 and 205.
85 Ibid, 208.
86 Ibid, 220.
87 Ibid, 200–1.
88 Ibid, 205.
89 Ibid, 209.
90 Ibid, 201. Some hint of the wretched state of Venetian buildings may be gathered from an almost contemporary photograph of Fondaco dei Turchi in A. Zorzi, *Venezia Scomparsa*, 2 vols (Venice, 1972), II 205. See also Ruskin's own drawing of an upper window in Ca' Foscarini (*RI* plate 9).
91 *RI* 207.

92 Ibid, 219.

93 Both watercolours are reproduced in Hewison, *Ruskin and Venice*, colour plates X and I, as is the drawing of the window mentioned in note 90. On plants growing in the ruins, see *RI* 207 and 209.

94 *RI* 206.

95 Ibid, 204.

96 Ibid, 220; also reported in *Praeterita* (**35**.372–3).

97 *RI* 225.

98 At least that seems to be the crucial date, though he was enthusing about Tintoretto the previous day, but with examples from the Accademia not the Scuola (*RI* 210–12, from where all other quotations in this section are taken). Perhaps the works in the Accademia led him the next day, 24 September, to the Scuola di San Rocco.

99 *RI* 213. By 'grand canal' Ruskin implies his architectural sketches of palaces along it. On Ruskin and Tintoretto see the essay by N. Penny, *Apollo* (April, 1974), 268–73.

100 **35**.372. The 'new fields of art' is a phrase from *RI* 221; for Turner's study of Tintoretto, ibid, 223.

101 Not something he could spell out, but see *RI* 186–7, where he speculates on their future travels together with both some guilt about past behaviour with them and, I think, some sense of how it will be rather more difficult in future after his time alone. He also occasionally noted doing things that his parents would not like (see ibid, 15 and 74).

102 His mother: on two occasions (*RI* 17 and 34) these disagreements are set out quite savagely, which must have been as well received by Margaret Ruskin as his announcement that he had 'heard such a desperate sermon at the English chapel today, and missed a beautiful mass for it' (ibid, 43). His father: see ibid, 92, 107, 112 and 142. For his father's complaints about John's 'inferior' poetry see **4**.xxxiii–xxxiv; and for Margaret's agreement about the poetry, cited next, see **2**.xxviii–xxix.

103 See, among many other references, *RI* 88, 119 and 177.

104 Ibid, 13 – typical egotism, in a way, to assume that no one else watched it! But these were undoubtedly the early stirrings of a social conscience, as an important book notices: F. G. Townsend, *Ruskin and the Landscape Feeling* (Urbana, Illinois, 1951), p. 32.

105 *RI* 142, but see also 57–8, 86 (for beggars) and 211 (for his distress at newspaper reports of conditions in an Andover workhouse).

106 Ibid, 143.

107 Ibid, 119 and 168 in reply to John James's letter (ibid, 244).

108 Ibid, 239. For a contrary view about the sacrifice of 'the energy & joyousness of the childish time' see ibid, 149.

109 **19**.87.

110 Gordon's recommendation is discussed in *Praeterita* (**35**.414); Ruskin's judgements on *Modern Painters* I are from **3**.668 and 669.

111 See **4**.xxii.

112 **22**.512.

113 **4**.3 and *RI* 52 respectively.

114 **4**.145. It was only translated in the 1883 Preface – see **4**.7.

115 For one set piece see perhaps **4**.262ff. On his role as 'interpreter' see *Love's Meinie* (**25**.112).

116 **4**.4.

117 The reviewer's remark and John James's comment are cited in **4**.xlii and xxvi respectively.

Part III

Chapter 9

1 This is clear from John James's letter to Effie's father on 28 April 1847 (*RG* 27). Mary Lutyens has suggested two occasions on which Effie stayed at Denmark Hill and Ruskin fell in love with her – March 1846 (in *RG* 24), which seems more probable, or October 1846 (in *EV* 6).

2 **35**.415.

3 **8**.xxiii.

4 **35**.404.

5 *D*.336, 346–7 and 341–2.

6 For his various proposals see **8**.xxiii–xxiv and his preface to *Seven Lamps* (his first architectural book), **8**.3 as well as a MS reprinted in **8**.280.

7 The spectacular increase in Ruskin's social connections at this time is touched upon frequently in *RG*: see, for example, 46, 47 and 53. On Lady Davy and the dinner talk with Gladstone see **35**.422.

8 See letter quoted in William James, *The Order of Release* (1947), p. 63

9 *RG* 37.

10 See above pp. 99ff. for Adèle. On Effie's unacceptability, see *RG* 27 (re Perth) and 32 (re trade); her father was a lawyer but also engaged in trade. Ruskin's own subsequent uneasiness over Miss Lockhart is reflected in a long letter to Lady Davy from Leamington, 13 August [1847]: PML 2007.

11 *RG* 35.

12 A most plausible suggestion: see *RG* 37 note.

13 **8**.xxv.

14 Ibid. His review is reprinted in **12**.167ff. In a letter of 23 March 1847 he also complained of the 'mere humpy mountains, mighty desolate' (Yale MS Family Letters vol. I, section 2, no. 1).

15 'I have most foolishly accepted evening invitations, and made morning calls, these last four months, until I am fevered by the friction' (**36**.72).

16 *RG* 35, as also for the following quotation.

17 For Ruskin's subsequent account in the following December, see *RG* 78.

18 Though there is some confusion as to when exactly Effie was told: see *RG* 35 (Effie's version) and 30 (John James's). See also note 23 below.

19 Ibid, 56 and 37. Ruskin's remark could possibly refer to Adèle; it is anyway at second hand that we have it, quoted by John James presumably from one of John's letters, now lost.

20 James, *Order of Release*, p. 73. That they did meet rather furtively is confirmed by a later letter which talks of there being, once married, 'no fear of any one coming up stairs!' to disturb them (Sotheby's Catalogue for 17 December, 1979, p. 155).

21 *RG* 38 and *EV* 12.

22 Ruskin's business tone to Gray is easily explained, for they were businessmen and also in touch with each other about some trust (see *RG* 13); but the remark quoted is directed to his *son* – *RG* 55.

23 Either there was some failure of communication between Margaret Ruskin and John James or, as Mary Lutyens suggests (*RG* 30), John made so much of a fuss about the idea of sending Effie away that his father white-lied about the time of her having been told of Miss Lockhart. See also note 18 above.

24 Margaret to her son, 29 August 1847 (*RG* 49).

25 Ibid, 53.

26 See ibid, 84 note; his mother had also said the same – 'a wife would be invaluable to you for you cannot go out of the world altogether and in your intercourse with it she would be indeed a helpmeet for you' (ibid, 52).

27 This point is made by Mary Lutyens, *RG* 20, but she makes little more of Adèle's lingering role in John's emotions.

28 *D.*255. Mary Lutyens writes '*with Effie gone* his thoughts turned to Adèle . . .' (*RG* 22, my italics). For the next, ibid, 27.

29 Ibid, 30 and PML MA 1571.

30 See Mary Lutyens, "From Ruskin to Effie Gray", *TLS* (3 March 1978), p. 254 (my italics). The letters discussed by Miss Lutyens were sold at Sotheby's on 17 December 1979.

31 *RG* 61–2, my italics. However, Leon thinks that this refers to an earlier proposal which Effie refused (*Life*, p. 113). See also note 68 below.

32 *D.*364 and James, op. cit., p. 75 (for their parting).

33 *RG* 37 and 56.

34 Ibid, 53 and 54. Effie herself found she could not raise the question of George with Mr Ruskin (ibid, 32).

35 Ibid, 35.

36 See ibid, 52 and 58 note. And these critiques continued – see 'all the faults which I have distressed you by finding in you' (letter of 10 June 1849 – Lutyens, *TLS*, loc. cit.).

37 *RI* 2 and 178.

38 **35**.221 and Leon, *Life*, p. 54, who suggests that Ruskin's parents cut short this last romance before it got too serious.

39 The need 'primarily for a companion is a retrospective judgement', says Jeffrey Spear, who recently discovered the Acland letter (*TLS* 10

February, 1978, p. 163). But the judgement is supported both by his psychological needs at the time and by his letters to her encouraging her to prepare herself for life with him.

40 *RI* 142. Used in fact to justify to his father the cessation of poetry.

41 Lutyens, *TLS*, loc. cit., letter of 22 May 1847.

42 *RG* 53.

43 Yale MS Family Letters, vol. 2, letter of 4 October 1847.

44 *RG* 55.

45 Ibid, 39.

46 **8**.xxv–xxvi.

47 *D*.352, and 354 for following quotation.

48 Yet he seems to have wavered; see his 'fits' of 'failure of duty' and 'the home duty more flat' at Dunbar on the way north (*D*.362–3).

49 *RG* 69.

50 Ibid, 42. Among the 'various reasons' was *not* that she knew Ruskin's parents prevented his proposing to her, according to Mary Lutyens (ibid, 43).

51 See ibid, 44–5.

52 Ibid, 43.

53 See M. J. H. Liversidge, 'John Ruskin and William Boxall. Unpublished Correspondence', *Apollo* (January 1967), 39–44.

54 See *RG* 31 and 36 for Margaret Ruskin and 49 for John James.

55 Ibid, 50.

56 Ibid, 50.

57 Ibid, 55 and 57. For Ruskin's letter to Mrs Gray see ibid, 57–60.

58 See *Letters of Mrs Gaskell*, ed. J. A. V. Chapple and A. Pollard (Manchester, 1966), p. 287. Ruskin himself made the same claim in later years (see *RG* 67).

59 *RG* 61 and for his parents' reassurances about his lovableness see ibid, 50 and 51. After the engagement he was still writing in these terms to Mrs Gray ('if she can but love me half as much as I do her' – ibid, 73).

60 Ibid, 62.

61 The date is established by the letters Mary Lutyens discusses in *TLS*, loc. cit.

62 *RG* 71.

63 Ibid, 65. Ironically he would come to think Effie did the same thing: on 8 March 1848 he wrote to her, 'The question that comes across me always, is whether you love *me* myself, or an imaginary John – imagined by yourself' (*TLS*, loc. cit.).

64 *RG* 81 and 84 note.

65 PML MA 2007, letter dated 24 November 1847. But he tells his correspondent that it was the Highlands which had 'acted too violently as a tonic and one breaks down afterwards'. See also *LV* 170.

66 *RG* 76 for her possible allusion to this. John himself must have thought

the same, for he implies (ibid, 94 and note) that there would be ten years of child-bearing for Effie unless they determined otherwise.

67 *RI* 162 and *RG* 65.

68 PML MA 1571. Is Mr Gray's refusal, noted here by John James, the 'first' refusal mentioned in the letter to MacDonald quoted above p. 168 and note 31?

69 *TLS*, loc. cit., for Ruskin's letter; *RG* 96 for the Grays' reaction.

70 *RG* 78.

71 He had expressed 'fears . . . of wedded Life' to his father, who had reassured him only in rather general terms (ibid, 50). Even to Effie's mother, after the engagement, he was uttering a somewhat strange, but prophetic projection of how irksome 'retired life' could be to a wife not strengthened by real affection for him (ibid, 74).

72 Ibid, 96. Pauline, Lady Trevelyan called upon Effie in Edinburgh at this time (*RF* 3).

73 *RG* 95.

74 Ibid, 71 for Margaret and 90–1 for John James, whose later excuse for not leaving home was 'alarm in London about the Chartists' (ibid, 125).

75 Ibid, 104 for John James; 99–101 for John's letter.

76 *An Ill-assorted Marriage': an unpublished letter from Ruskin to Furnivall* (1915).

77 See *RG* 109–10.

78 The actual date was only fixed on 6 April, four days before the ceremony (see *RF* 4).

79 See *TLS*, loc. cit. and Mary Lutyens's commentary. It is also probable that pubic hair was not the shock it was supposed to have been for Ruskin, since he had written of 'drawers filled with pictures of naked bawds' in rooms of some Oxford acquaintances (see *RG* 108 note).

Chapter 10

1 James, *Order of Release*, p. 102.

2 *RF* 5 implies that a longer stay was contemplated.

3 **36**.87.

4 J. H. Whitehouse, *Vindication of Ruskin* (1950), p. 15.

5 *MR* 155: for the drawing, see *RF* 4, and for Effie's talking 'to everybody she can make stand still', Yale, Family Letters, vol. 1, section 2, letter of 13 April 1848, partly quoted by Leon, *Life*, p. 117.

6 *RG* 116. Ruskin had reported from the north on 13 April 1848 his pleasure that Effie did well without a maid and was 'always ready on time'. He added, significantly, 'it is a much pleasanter kind of travelling this than my solitary tours' (Yale letter cited in previous note).

7 Reprinted in *Order of Release*, pp. 102–10, from which other otherwise unidentified quotations are taken. This author, a grandson of Effie,

occasionally edited material, as Mary Lutyens has shown; but on this occasion may be relied upon.

8 *RG* 114, as for following quotation.

9 *BD* 369 (Mrs Severn, presumably reporting Ruskin's later accounts in 1886). For Ruskin's dislike of babies in 1848 see *RG* 120 and 126.

10 *RF* 7.

11 Ibid, 6. Or see the account of Effie and John romping in the hay at Denmark Hill, when the parents were away, *RG* 120.

12 *RF* 8.

13 **8**.6. In a letter a little later (9 August 1848) about this Salisbury visit Ruskin commented that 'Romanism is very dreadful and wrong of course – but wax candles and plenty of incense are good things in themselves and I only wish we had a little more of them for Protestantism is marvellously damp' (PML 2007).

14 *RF* 9. And cf. how this issued in *The Stones of Venice* (**10**.78ff) as the famous contrast between an English cathedral city and Venice.

15 *RG* 130.

16 *RF* 10 – this *after* returning to Denmark Hill.

17 *RG* 128 note.

18 See ibid, 232.

19 Ibid, 130.

20 Ibid, 127. On George Gray see ibid, 110, 113–14 and 144 note, and *passim*.

21 PML MA 2539 f.167 (incorrectly transcribed by Links – see next note).

22 J. G. Links, *The Ruskins in Normandy* (1968), p. 13. Further references to this volume, on which I have drawn in preference to the less complete chapter in *RG*, will be to Links.

23 PML MA 539 f.167. On 'George's' superiority, see his idea that Boulogne, where they landed in 1848, provided 'a tolerably good idea of France', but like his master preferred Calais (ibid, f.177).

24 Links, 26, 25, 21 and 19.

25 Ibid, 73.

26 Ibid, 14 and 16.

27 Ibid, 67. 'George' also recorded this pastime (f.173), but subsequently lost his figures.

28 Links, 39.

29 Ibid, 27.

30 Ibid, 53.

31 Yale, Family Letters, vol. I, section 2, letter of 20 August 1848 to his mother.

32 Links, 59–61, my italics throughout.

33 Ibid, 53. Effie confirmed this in her own letters (see ibid, 38).

34 Ibid, 27–8.

35 Ibid, 41.

36 Ibid, 72–3.

37 **8**.xxiii.
38 Ibid, 278–80.
39 Quoted ibid, xix.
40 Ibid, 87–99: cf. *D*.326–7 for some of those earlier notations.
41 **8**.xxix.
42 Thus he notes principles suddenly arrived at – 'I have never thought of it before, that slender shafts must have spreading capitals' (Links, 50). By the time he was working at Venice in the early 1850s he had devised a more sophisticated system of classifying the scores of memoranda: see below p. 207–8ff.
43 **8**.xxxii.
44 Links, 54, 74 and on the drawings 74 and 57.
45 Ibid, 14.
46 Ibid, 15.
47 Ibid, 71. See, on this general topic, the excellent discussion by John Unrau in *Looking at Architecture with John Ruskin* (1978). One imagines, too, that Ruskin's habits of 'work' were also establishment in ways that would ensure his greatest pleasures of wandering about and sketching.
48 **12**.311.
49 Links, 36: facetious perhaps, but nonetheless revealing.
50 Ibid, 46–7 and *RF* 13.
51 *RG* 134.
52 Links, 33 and *RG* 155.
53 Respectively ibid, 35, 44, 57 and 62–3. On Ruskin's gloom about the French political situation, see his letter to Harrison in **8**.xxxiii.
54 Links, 55.
55 Ibid, 75.
56 On this Paris interlude and their various reactions see ibid, 80–4.
57 **12**.305ff. The Prout essay appeared first in the *Art Journal* for March 1849 and was reprinted in *On the Old Road* I in 1885.
58 Effie reporting to her parents, *RG* 169, and John to his father, *RG* 137.
59 *RF* 14. They had moved into Park Street on 2 November, after a week at Denmark Hill.
60 **8**.xxxiv.
61 *RG* 174–5 for Effie's account. A later one by Ruskin himself, less sympathetic than she thought he was at this time, is ibid, 233.
62 *RG* 177.
63 Ibid, 135.
64 Ibid, 159 and 155.
65 *RF* 17.
66 Mr Gray's remark, *RG* 176; Ruskin's excuses, ibid, 163.
67 Ibid, 166.
68 Ibid, 180. And for the following explanation by John, Yale, letters to John Brown (15 April [1849]). John James also lamented – not simply

conventionally – that his son was forced to travel for his work and told Gray he looked forward to the young couple settling down in some 'Dulce Dulce Domum'.

69 See *RG* 188, 189, 193.
70 Mary Lutyens, *TLS*, op. cit.
71 **35**.437.
72 *The Stones of Venice* was announced as 'uniform' with *Seven Lamps*, which leads Mary Lutyens to argue, probably rightly, that Ruskin intended only a relatively small book (*RG* 199 note). It would of course swell into three larger volumes with an accompanying volume of plates.
73 *RG* 184.
74 Ibid, 187.
75 *D*.374 and *RG* 207.
76 *RG* 185.
77 *EV* 31. Ruskin's Dijon letter was in response to one of Effie's (now lost) in which she wrote an 'account so long and kind – of all your trial at Blair Athol'. For their 'next' bridal night, seemingly an accepted idea between them, see above p. 189.
78 *RG* 152 and 220.
79 Ibid, 220.
80 Ibid, 187. Perhaps a reference, among others, to the 'blue pill' episode at Salisbury: above, p. 180
81 **8**.221–4. And see his attempt (in a recently discovered letter) to explain what he was up to in Switzerland – Sotheby's catalogue (see Chapter 9, note 20), p. 154.
82 *RG* 191.
83 See ibid, 220–1. John James had told his son in August that the Grays 'cannot see the meaning of your pursuits' (ibid, 247).
84 Ibid, 223–4. Mary (Richardson) Bolding was much in their minds then because news of her death had just reached the Ruskins in Savoy.
85 These letters are now at Yale.
86 *RG* 199 and 215; and see note 83 above.
87 *D*.381. Cf the 'loss' of imagination several years before – above, pp. 107ff.
88 **5**.289, utilizing *D*.382.
89 *D*.384.
90 Ibid, 431.
91 Respectively, ibid, 387, 395 and 402, 404, 416. The 'very painful self examination' (*D*.421) was a constant Ruskin habit, but the self-interrogation was especially evident this summer; see also *RG* 162.
92 *RG* 249. Effie shrewdly took the hint about Venice – see below, p. 194. For further examples of Ruskin's grumbling about disruptions to his work for marital reasons see *RG* 212, 215 and 216. There seems to have been little awareness that these distractions derived from *his* contributions to the marriage's unease.

93 For instance, if Mr Gray could have known that his son-in-law's kind letter to Effie of 28 June (*RG* 223–5) was on its way and did much to soften John James's of 13 June (ibid, 212–15), then he might himself not have responded as he did on 22 June (ibid, 217–18).

94 Ibid, 201. Ruskin was actually contradicting the remark of a Miss Boswell, passed on to him (presumably) by Effie. Of Miss Boswell, a friend of Effie's who much disliked Ruskin, more later.

95 *RG* 214 – with some justification perhaps: see above p. 188 and note 70.

96 Ibid, 252; for other quotations in this paragraph, ibid, 208, 231 and 234, 209–10, 251. On Ruskin's identification of Effie's illness with his own later that year after he had himself talked to Simpson, see *EV* 59 note. There is, however, some contradiction between what Simpson must have told him and Mary Lutyens's earlier assumption that Simpson 'no doubt' extracted from Effie the real truth about their unconsummated marriage (see *EV* 32 note).

97 *RG* 235. One notes how one-sidedly the opportunity for remedy seems to appear to him. See also *RG* 163 note for John James's attitudes as reported by Effie in 1852.

98 *RG* 230–1.

99 Ibid, 250.

100 Ibid, 253.

101 **35**.434 and 437, and **18**.184.

102 *RG* 252.

103 Letter to Lady Davy of 25 October 1859, PML MA 2007.

104 **36**.104.

105 *RG* 255.

106 Ibid, 257.

107 From letter cited in note 103.

108 Yale, letter to John Brown, June 1874.

Chapter 11

1 **35**.156.

2 See above, pp. 81ff.

3 **1**.453.

4 *NL* I 32–8, where the letter is dated 1857. Ruskin's editors date it two years later in **9**.xxvii.

5 **9**.18.

6 NL I 33.

7 **10**.78–83. A justly famous passage, totally spoilt by Ruskin's editors' placing a photograph of J. W. Bunney's painting of the West front of St Mark's at the very point in the text where one turns the last page of Ruskin's description! For Bunney, a protegé of Ruskin's, see Hewison, *Ruskin and Venice*, passim.

8 **3**.639 and above, pp. 91ff.
9 *RI* 198.
10 Ibid, 219.
11 See above, p. 185.
12 *D*.455. It was of course a perception that he had also come to about Turner's landscape paintings.
13 **9**.24 and 27.
14 **11**.46.
15 **9**.395.
16 Ibid, 97. On Ruskin and typological symbolism see George P. Landow, *The Aesthetic and Critical Theories of John Ruskin* (Princeton, N.J., 1971), chapter 5, and his *William Holman Hunt and Typological Symbolism* (New Haven, Connecticut, 1979).
17 *The Ritual of Interpretation* (Cambridge, Mass., 1975), p. 74. Stein's chapter 3 is the most successful attempt yet to come to grips with Ruskin's fascination with Venice. (But as this book was in press, Jeanne Clegg, *Ruskin and Venice* (1981) presents itself as a more searching study of this topic.) A catalogue-chronology of Ruskin's treaty with Venice is presented in Robert Hewison's book, already cited.
18 *RI* 197.
19 See *LV* 225, also 197, 250–1 and 261 (two examples).
20 **35**.372, the famous 'mare maggiore' passage on Tintoretto.
21 **10**.196.
22 J. F. C. Harrison, *A History of the Working Men's College 1854–1954* (1954), p. 31.
23 **10**.xlvii. The parenthesis referred to (**10**.207) is Ruskin's fairly casual explanation of how the Renaissance diverted man's love of nature from architecture into landscape painting.
24 *D*.453, and for the natural material of ornament **9**.265ff.
25 **10**.188. The chapters referred to in the following passage are pp. 389ff. of this final volume of *Modern Painters*, but the comparison begins even earlier in the chapter that compares Turner's boyhood with the Venetian painter's, Giorgione's (pp. 374ff.).
26 **24**.412.
27 Ibid, xxxvii.
28 Ibid, xxxviii.
29 **3**.666.
30 **24**.405.

Chapter 12

1 *EV* 41–2.
2 Ibid, 52.
3 Ibid, 86.
4 Ibid, 42.

5 Ibid, 45.

6 Ibid, 46. Years later, however, Ruskin recalled that others among his favourite sites were not appreciated: see *D*.444.

7 *EV* 64. It is, however, rather unclear what precisely Simpson had diagnosed and prescribed.

8 Ibid, 109.

9 To Rawdon Brown in 1855, quoted *EV* 123 note.

10 Ibid, 58.

11 Ibid, and for the next quotation 60.

12 'I find I am much happier following my own plans & pursuits and never troubling John, or he me' (*EV* 99).

13 See ibid, 144. John James even congratulated his son on saving himself 'from entanglements & poor attraction & frivolities of Foreign Society' (ibid, 139 note).

14 Ibid, 99.

15 Ibid, 71.

16 Ibid, 74. About another friend, Count Paulizza, Effie remarked in a further letter on 'the peculiar way in which I first became acquainted'. John James reprimanded his son for not providing Effie and Charlotte with more adequate escorts than 'a scamp of a Valet de Place' (ibid, 74 note).

17 See ibid, 75 and note.

18 As Mary Lutyens comments, 'no small achievement after the annulment' (ibid, 90). For a note on Brown see **9**.420 note and *Apollo* (Nov., 1979), 364–7.

19 *EV* 119.

20 Ibid, 118.

21 Ibid, 121.

22 Ibid, 136 note.

23 Yale, Family Letters, vol. II, letter of 25 December 1849. Yet compare note 16 above.

24 *EV* 133–4.

25 Ibid, 54 (in Milan) and 137 (in Verona). But it was equally a pleasure which Effie received on all their behalfs – 'We are all sorts of characters in our way and receive great attention' (ibid, 132).

26 Ibid, 149 and 139–40.

27 Ibid, 99.

28 Ibid, 146.

29 Ibid.

30 *D*.450.

31 **10**.19, but see the whole chapter on 'Torcello'.

32 *EV* 147. Effie's comment on Paulizza elsewhere (ibid, 105) could also apply to her husband – 'Like many men of mind, he has also something at times of childish simplicity'. Did she see any covert rivalry between these two men in their races, I wonder?

33 Ibid, 84 and 64.

34 *RF* 23.

35 *EV* 69. At least in October the plan had been to 'go to Venice for some further noting of its architecture, to Florence for the same purpose and then to Pisa . . . that I may be under the influence of its solemn yet bright seclusion while I endeavour to put into form a few general ideas about the Italian Gothic' – Ruskin to Lady Davy; see above chapter 10, note 103. For other confirmation of plans that involved leaving Venice for the winter see *RF* 19 and 21, and **36**.105.

36 *EV* 75 and **36**.104.

37 Yale, Family Letters, vol. II, letter of 2 November 1849. John James was extremely nervous about this whole Venetian trip, as other letters in the Yale collection reveal.

38 *RF* 28.

39 **9**.6.

40 See especially chapters 2 and 3, from which quotations in the following paragraph are taken. See *LV* 69, where he talks of learning details slowly before he could make vignettes and 'Turnerize'.

41 Quoted **9**.xlv.

42 Respectively, *EV* 142 and 94 note; the remark about Blumenthal is from *LV* 21.

43 See Hewison, *Ruskin and Venice*, pp. 54–5 and the following illustrations of Ruskin's notebooks and worksheets. Hewison differs somewhat from the account of Ruskin's editors (**9**.xxv), though without any explanation, and his division of Ruskin's work methods into 'stages' is somewhat ambiguous.

44 **16**.126–7 note; the publication by Street referred to is *Brick and Marble in the Middle Ages: Notes of a Tour in the North of Italy* (1855). Ruskin would later comment on how all his Venetian generalizations 'are wrought out in this same patient way' (letter to W. L. Brown of 9 January 1858 – Bodley MSS Eng. lett. c. 34, f.12). Cf. Henry James's character in *The Aspern Papers* who remarks that 'There could be no Venetian business without patience'.

45 *D*.451 (another example is *D*.458) and *D*.453–4.

46 *RF* 27. See also **9**.xxix.

47 **9**.xxxi, where the very amusing narrative is given in full.

48 Ibid, xxxi–xxxii.

49 M. S. Watts, *George Frederic Watts*, 3 vols (1912), I, 90.

50 *Journals and Correspondence of Lady Eastlake*, 2 vols (1895), I 252. On Eastlake himself see David Robertson, *Sir Charles Eastlake and the Victorian Art World* (Princeton, N. J., 1978).

51 *RF* 32.

52 *EV* 170–1. What is clear from this letter is, not only that children were an open topic between Effie and Brown, but that Ruskin's initial bargain with his wife (see above, chapter 9, note 66) was indefinitely extended.

53 *RF* 32.

54 **9**.57, as for the next quotation. In October 1851 Ruskin wrote to his father from Venice that this first volume proved 'firm foundation for all manner of unexpected truth' in its sequel (*LV* 40).

55 The passage discussed is in **9**.412–15.

56 It is evident from both general reactions to *Stones of Venice* I and from his father's later response that it was not as appealing as the first two volumes of *Modern Painters*: see *LV* 119, 184–5 and 141. More generally on this topic, see John Jump, 'Ruskin's Reputation in the Eighteen-fifties', PMLA, 63 (1948), 679–85.

57 See one of the appendices to *The Two Paths* (**16**.421), where he discusses these 'translations' of on-the-spot memoranda into finished work.

58 See **12**.509–58 for *Notes* . . . and **9**.437 for the cross-reference from which I quote. Ruskin's exchange of letters with F. D. Maurice is printed in **12**.561–8.

59 *RF* 34.

60 *EV* 173. My account of Effie's social life during 1850–1 is based upon ibid,171–6.

61 *LV* 67.

62 For the Cambridge visit, see **8**.xl. Ruskin's host at Farnley was the son of Turner's patron, for whom see the excellent catalogue, *Turner in Yorkshire*, York City Art Gallery (1980).

63 *D*.468.

64 *LV* 112 and 86 and *EV* 205.

65 See *EV* 175.

66 *The Times*, 7 May 1851. The Pre-Raphaelites' side of this story is chronicled by William Michael Rossetti in *Pre-Raphaelite Diaries and Letters* (1900).

67 B. Champneys, *Memoir of C Patmore*, 2 vols (1900), II 288–9.

68 **12**.319–27.

69 See William Holman Hunt, *Pre-Raphaelitism and the Pre-Raphaelite Brotherhood*, 2 vols (1905), I 257. For Millais's account of their subsequent meetings that summer see J. G. Millais, *The Life and Letters of Sir John Everett Millais*, 2 vols (1899), I 116.

70 *Pre-Raphaelitism* is in **12**.339–93. For its composition see *LV* 57.

71 *EV* 181.

72 Ibid, 182.

73 *LV* 27.

74 Ibid, 72. See also 104 and 123.

75 Ibid, 44 and *EV* 238 and 243. See his praise of Radetzky's ball that 'a library for the readers' was provided, 'so that instead of having to stand with my back to the wall in a hot room the whole time, I got a quiet seat – and a book of natural history' (*LV* 154). See also *EV* 255 for his lack of sociability on a train ride and ibid, 306 for a comparison with Effie's similar behaviour achieved with tact.

76 *LV* 72, and for the following quotation 22. The regime was slightly altered by the next February (see *LV* 172–3).

77 See ibid, 66, 97, 106 and 50 where he talks of giving the 'next volume' an index, which of course appeared in the third.

78 Ibid, 50.

79 Ibid, 1, 128 and 96.

80 Ibid, 67 and 90.

81 **9**.11–14 and 443–4.

82 *LV* 140.

83 Ibid, 42; see also 69 and 188.

84 Ibid, 127 and 113.

85 Ibid, 121. The full description of his proposed Turner gallery suggests, in fact, a very modern and exciting design. But by February he was asking his father to get him out of the executorship (ibid, 183).

86 See ibid, 124–5 and *EV* 69 for seeing Venice with Turner's eyes.

87 *LV* 138. The editor is surely mistaken when he glosses 'these two books' as *Stones of Venice* II and III.

88 *LV* 56–7. On his similar attention to revealing juxtapositions see also his scrutiny, during the earlier visit to Venice, of the second-hand bookstalls in the doorways of St Marks (*D*.463–4).

89 *LV* 91 and 94–5. On the connections generally between art and economy see the stimulating, if rather difficult, chapters dealing with Ruskin in Marc Shell, *The Economy of Literature* (Baltimore and London, 1978).

90 *LV* 128 and **10**.435–9.

91 *LV* 145–9 and 168.

92 On buying the Tintorettos see ibid, 281ff. and *EV* 303ff.

93 Two of them are printed in **12**.593–603.

94 *EV* 264.

95 For their discussions about a home once back in London, including the letter quoted, see *LV* 108–11 and 135 and (Effie's views) *EV* 264 and 288.

96 *LV* 229 and 220.

97 Ibid, 263 and 222.

98 *EV* 208. Effie was a devoted admirer of Mendelssohn (see ibid, 242), a fact which Ruskin always held against her (see Bodley MSS Eng. lett. c. 34, f.67) and Mendelssohn.

99 *EV* 207–8. The window room no longer exists in the Gritti Palace Hotel; indeed, they are quite rare in Venice now, but a similar one may be seen on the opposite side of the Grand Canal on Palazzo Loredan, immediately beside Camp S. Vio.

100 *EV* 271 and 257.

101 Ibid, 190 and 260.

102 Ibid, 264–5. For examples of her tact see 235, 268 and 280.

103 Ibid, 271.

104 *LV* 168–73: see also 179–81 and 293.

105 *EV* 213.

106 *LV* 137, my italics.
107 See *MR* 5 and 6.
108 *EV* 249, 245 and 251.
109 Cf. *LV* 272 and *EV* 293. Now in the Fogg Art Museum, Cambridge, Mass., the work, *An Allegory of Fidelity*, is attributed to Domenico Tintoretto. Ruskin significantly called it *Diana and her Dogs* (Hewison, *Ruskin and Venice*, p. 77).
110 'I never speak on these subjects unless I am obliged' (*EV* 251).
111 *LV* 304.
112 *EV* 331. A slightly different version of the whole episode was, not surprisingly, narrated by Lady Eastlake.
113 *EV* 335.
114 See ibid, 249 and 336.
115 G. Paston, *At John Murray's 1843–1892* (1932), p. 111, for Lady East-lake's comment on Ruskin's possible move towards Rome; on his beliefs at the time, see **10**.xl. The Ruskin parents were not told of the challenge to a duel until after John and Effie had returned home.
116 *MR* 13.
117 *EV* 343.

Chapter 13

1 **36**.142 for John's reaction; *MR* 9, for Effie's. It was, in fact, no. 30, Herne Hill. Effie herself told Rawdon Brown that it was 'a small ugly brick house partly furnished in the worst possible taste and with the most glaring vulgarity' (*MR* 8).
2 See *RF* 39.
3 *EV* 297.
4 *MR* 4–5
5 Ibid, 6, 13 and 16. John even wrote a rare letter to the Grays declaring his continuing protestantism (see ibid, 19–21).
6 Ibid, 30. She ironically proposed sending all her invitations to Denmark Hill for them to decide on her behalf.
7 Ibid, 31.
8 Ibid, 26.
9 Ibid, 16 and Sotheby's catalogue (17 December 1979), p. 156.
10 On Effie, ibid, 14–15; on Melville Jameson, ibid, 21–2.
11 Ibid, 17. For an example of this 'whole desire' see her husband's diary for the previous November (*D*.481).
12 *MR* 26.
13 According to the diary of G. P. Boyce, *The Old Water-Colour Society Club*, 19th annual volume (1941), p. 17.
14 *MR* 38–9. The painting is in the Tate Gallery.
15 Effie on Millais, ibid, 51; on the loan of the Herne Hill attic, Bodley MSS Eng. lett. c. 33, f.110.

16 *MR* 42–3.
17 Ibid, 40.
18 Ibid, 48.
19 Ibid, 51.
20 Ibid, 40 and 41.
21 **12**.xix and **36**.148.
22 See *RF* 41–2, as for Lady Trevelyan's admiration for Ruskin.
23 **12**.xx. The museum still exists, at the top of the house which is National Trust property.
24 **12**.xix.
25 Yale letter, quoted Leon, *Life*, p. 181.
26 *MR* 55; see also 59.
27 **12**.xxxvii–xxxviii.
28 *MR* 276–7.
29 *RF* 44.
30 *MR* 56.
31 *RF* 47.
32 *MR* 59.
33 **12**.xxiv–xxv. The original is in the Berg Collection, New York Public Library.
34 *D*.479.
35 *RF* 51.
36 *MR* 89; cf. ibid, 69.
37 Leon, *Life*, p. 190. Millais himself told Holman Hunt that 'I never heard a man contradict himself like he does' (quoted *MR* 89).
38 Ibid, 100–2.
39 Millais writing to Mrs Gray that December, ibid, 122.
40 Ibid.
41 Ibid, 80.
42 Ibid, 71 and 95. For the sketches mentioned in the following sentence see ibid 67 note and plate facing 98.
43 Ibid, 81 and plate facing 147 (also reproduced in *The Ruskin Polygon* by kind permission of Mary Lutyens).
44 *MR* 78 – for Ruskin's reactions see ibid, 72, and for Millais's again, 71.
45 Ibid, 89 and 88.
46 Ibid, 68.
47 Ibid, 65.
48 Ibid, 72.
49 Ibid, 93 note.
50 Ibid, 75.
51 See ibid, 156.
52 Cf. *RF* 47 and *MR* 103.
53 Quoted from a Bembridge *MS* in *RF* 59 note.
54 **12**.xxvi.

55 *MR* 83. Ruskin was, of course, aged 34!

56 See **12**.xxxiv.

57 *MR* 107.

58 Ibid, 107–8. And p. 109 for the following quotation. Another piece of self-examination of this time was sent to his old tutor, Brown: see **36**.152–8.

59 **12**.lxix and lxviii. The Psalter is now in the Fitzwilliam Museum.

60 **12**.xxxi–xxxii.

61 On Ruskin's expectations of friends and artists in the audience see **12**.xxxvii. On the reception of *The Stones of Venice* prior to these lectures see **10**.xliv–xlvi.

62 See **24**.1–111.

63 See *MR* 120–6.

64 Ibid, 114.

65 Ibid, 119 and 133.

66 Ibid, 128–9, including the following quotation. For Effie's account of the New Year dinner party see ibid, 128.

67 Ibid, 133, but see Effie's letter cited in previous note and John James's animadversions on the subject of Effie's going out in his letter to her father (ibid, 134–5).

68 See ibid, 136 and 133.

69 See ibid, 140–1 as well as for the following incident. All remarks of course were passed to Effie by Sophie.

70 I owe this point to Jeffrey Spear.

71 See, for example, *MR* 142, 139–40 and 165.

72 Ibid, 145 and 150.

73 Ibid, 144 and 147. He also adversely criticized Millais's self-portrait in the *St Agnes' Eve*, though Effie was much struck by it (ibid, 148). Ruskin is also supposed to have told Sophie that he would treat his wife so harshly she would be forced to write to Millais (ibid, 147).

74 Ibid, 145.

75 Ibid, 173–5. For the letter to Brown see **36**.152–8. Rawdon Brown had been admitted by Effie to their house in 1851 when Ruskin was away (see above, p. 212).

76 See ibid, 142–3 and 177.

77 Ibid, 146.

78 Ibid, 150.

79 Ibid, 151. It was Sophie's last visit – she had earlier been sitting for her portrait – because Effie put a stop to them lest Sophie told Millais things which would make him angry and precipitate a crisis.

80 Ibid, 155.

81 Ibid, 149.

82 Ibid, 158 and 160.

83 Ibid, 165.

84 Ibid, 162. What this new form of harassment could have been is intri-

guing – knowing Ruskin, it might well have been non-stop sermoniz-
ing, but then he, too, would have been exhausted by the morning.

85 Ibid, 171–2.

86 Ibid, 179.

87 Ibid; see also 181.

88 Leon, *Life*, p. 190. The 177th letter is the 48th of the third volume of *Sir Charles Grandison*.

89 We know the details from Effie's letters to Rawdon Brown (*MR* 181ff.). A different version, attributable to Crawley, is given in Violet Hunt, *The Wife of Rossetti* (1932), p. 85. Mary Lutyens seems to me a little too severe on Rawdon Brown's conduct at this time (see her comments in *MR* 170, 176–7, 205 and 207); he was after all understandably eager to maintain friendship with both parties.

90 *MR* 184–6.

91 Ibid, 199–200 and 201. Effie had said in earlier letters that 'Old Mr R thinks they will lose caste' (ibid, 166).

92 Ibid, 200. Rather unfair, that.

93 Ibid, 188–92; also in Whitehouse's *Vindication*.

94 *MR* 230.

95 Ibid, 198; as Millais said, 'Lady Eastlake thinks much worse of him than any other person I have met' (ibid, 205).

96 Ibid, 221

97 Ibid, 197, 211 and 215; when Millais and Effie married in 1855 Ruskin wrote to F. J. Furnivall – 'I do not say that Millais does wrong *now* – whatever wrong he may *have* done. I am not sure but that this may indeed have been the only course open to him; that, feeling he had been the Temptation to the woman, and the cause of her giving up all her wordly prospects, he may from the moment of our separation – have felt something like a principle of honour enforcing his inclination to become her protector. What the result may be, to him, I cannot conjecture; I only know that if there is anything like visible retribution in the affairs of this life there are assuredly, dark hours in the distance, for her to whom he has chosen to bind his life' (Huntington MS FU 776). The Millaises were not visited by at least any discernible retribution during their conven-tionally happy marriage.

98 *MR* 199. She changed her mind when she saw it completed (ibid, 246).

99 Ibid, 210 and 225 note.

100 Ibid, 202. As Jeffrey Spear writes, 'Ruskin took the concept of annul-ment literally and behaved for the rest of his life almost as though his marriage had never taken place' (*TLS*, 10 February 1978).

101 *RF* 78 and for the later letter, 81.

102 This letter was discovered and published by Jeffrey Spear (see note 100 above), and my quotations are taken from that text. A year later the Acland letter was also published in *RF* 270–4, but without any acknow-ledgement to Spear.

103 *MR* 205 and 211.

104 *RF* 80. And for Lady Trevelyan's response to reading this Acland letter, as we glimpse it in Ruskin's letter to her later, see *RF* 81–2.

105 *MR* 232. It should be remarked that he seems to have been scrupulous and solicitous of Millais's reputation (see ibid, 231).

Part IV

Chapter 14

1 For John James's remark, see *MR* 201. Millais told Effie by letter that July that she had done Ruskin a service, for 'you were nothing to him but an awful encumbrance' (ibid, 234).

2 **12**.xxxvii.

3 *D*.493.

4 **35**.483 and see **5**.xxxii.

5 *D*.497.

6 **5**.24–5 and **35**.483.

7 **12**.417ff.

8 *D*.495 – a note by Ruskin says that the real uses of painting were 'not worked out till architectural paper in 1865'; the transcript of his diaries in Bodley reveals very clearly the variety of his current interests.

9 *D*.511.

10 Ibid, 503. That it took long for Acland to reply is clear from *RF* 85. Virginia Surtees speculates that this response in Ruskin's diary may refer to Acland's 'now unwavering support of Gothic revival for the new museum' at Oxford (*RF* 87 note): but the context of his exclamation seems to be clearly that of his personal affairs, not the battle of the styles.

11 He reports this in 1871: see *MT* 295.

12 *RF* 85; the second part of his remark refers to drawings he was doing.

13 This and the following quotation from *RF* 89. An earlier part of this letter, listing the different audiences he wants to get at, is quoted above in the preamble to Part Four.

14 *MR* 247.

15 For the whole episode see ibid, 248–51. For a reaction by Ruskin to rumours of Millais's marriage to Effie see above chapter 13 note 97.

16 *Dante Gabriel Rossetti: His Family Letters with a Memoir*, ed. W. M. Rossetti, 2 vols (1895), I 180.

17 J. C. Troxall, *The Three Rossettis* (Cambridge, Mass., 1937), pp. 25–6.

18 *Rossetti Family Letters*, loc. cit., and Amy Woolner, *Thomas Woolner: His Life in Letters* (1917), 179–80.

19 *Ruskin, Rossetti and Pre-Raphaelitisim*, ed. William Michael Rossetti (1899), p. 3.

20 Ibid, p. 32.

21 Ibid, p. 52.
22 See Harrison, *History of the Working Men's College*, p. 24 and, generally, **5**.xxxvii, from which other references are drawn.
23 The writer is Thomas Sulman: quoted **5**.xl.
24 **12**.482. These lectures were reprinted in *The Builder* for 18 November and 2 December 1854.
25 **12**.lxxi.
26 J. B. Atlay, *Sie Henry Wentworth Acland, Bart: A Memoir* (1903). p. 207. On the Oxford Museum see the forthcoming study, *Ruskinian Gothic*, by Eve Blau (Princeton University Press).
27 *RF* 95.
28 **16**.239. It is a later formulation, of course, from his pamphlet on the Oxford Museum.
29 On the Swiss tour and *Modern Painters* III and IV see **5**.xxxiv.
30 **5**.32.
31 Ibid, 360–1 and 387.
32 *RF* 102.
33 Ibid, 104.
34 **14**.5.
35 See **4**.333–42.
36 **14**.22. The remaining quotations come from pp. 5 and 35 of the same volume.
37 *Ruskin, Rossetti and Pre-Raphaelitism*, pp. 28–9. Their correspondence is largely printed here; further quotations are from this text; the letters are also printed in **36**.166 and passim.
38 See *Sublime and Instructive. Letters from John Ruskin to Louisa, Marchioness of Waterford, Anna Blunden and Ellen Heaton*, ed. Virginia Surtees (1972), pp. 162ff.
39 Bodley MSS Eng. lett. c. 33, f.199. See, similarly, **36**.208.
40 For the visit to Acland see **36**.204–9.
41 This letter is in *Ruskin, Rossetti and Pre-Raphaelitism*, pp. 70ff. A similar attempt at reassurrance was sent to Lizzie Siddal – see **36**.203ff.
42 *Rossetti Family Letters* II 137.
43 See E. S. Maurice, *Octavia Hill. Early Ideals* (1928), p. 121.
44 Respectively, **36**.190, 202, 224, 208, 220 and 227.
45 Ibid, 217.
46 *Memorials of Burne-Jones*, I 192.
47 *Letters of James Smetham* (1891), pp. 54–5: note Smetham's final emphasis. For another account of a visit to see the Ruskin collection, Derek Hudson, *Munby. Man of Two Worlds* (1974), p. 31.
48 Berg Collection, New York Public Library, letter of 6 April.
49 **36**.195. The original is in the Berg Collection.
50 *MR* 194 and 208.
51 See **36**.186–8. Laing's history was told later in *Fors* 9.
52 **5**.387.

53 **7**.3.

54 **14**.43–84. When Sir Walter Trevelyan used these *Notes* at the exhibition later that year he found them 'most flippant & in great part untrue' (*RF* 112).

55 **36**.233, as for the following letter.

56 The speech is reported in **16**.431–6.

57 *NL* I 5.

58 *John Ruskin or the Ambiguities of Abundance* (Cambridge, Mass., 1972), p.71.

59 **36**.237–40.

60 See ibid, 240 and 241.

61 Ibid, 242.

62 *RF* 112.

63 Ibid, 114. All further quotations in the text are from this letter, written at Dover on his return and summarizing the journey.

64 His editors give a rather different picture – 'full activity and enthusiasm' (**7**.xx) – which seems a rare misinterpretation on their part. Digging the hole, he told Norton, gave him 'acuter sympathies with those who have to dig all day long' (**36**.255).

65 *NL* I 4, quoting **35**.367. *Praeterita*'s account of their meeting is **35**.519–20.

66 Bodley MSS Eng. lett. c. 37, f.67.

67 **35**.521.

68 Ibid, 484.

69 See *D*.524 and **17**.lii. Morris and Burne-Jones dined at Denmark Hill on 12 December 1856 according to the latter's *Memorials* I 147. Ruskin wrote to Rossetti to ask if he knew who had written the lines of Ninevah in the *Oxford and Cambrige Magazine* (**36**.243); Rossetti was himself the author.

70 **5**.4.

71 For a brief account of this complicated affair, still without entirely satisfactory resolution in 1982, see **13**.xxx ff.

72 **13**.81–5.

73 Ibid, 87–8.

74 Ibid, 91–191.

75 *D*.525 and 526.

76 He was also writing to Sir Walter Trevelyan to persuade him to get his neighbours, the Swinburnes, not to expose their Turners to the light of an exhibition room (see *RF* 122).

77 See **16**.xviii for further details.

78 See Robertson's book on Eastlake, already cited, Appendix C.

79 **36**.263 and **17**.34 for *Unto This Last*.

80 **16**.xxxiv. Norton was writing in the 1891 preface to an American edition of the lectures.

81 For examples of his private correspondence about drawing (and of his

inability to keep strictly to that matter) see the letters in *Sublime and Instructive* (note 38 above).

82 See **16**.xxxv, in which volume the lectures are reprinted.
83 Quoted **16**.xxi.
84 See *RF* 128 note and Raleigh Trevelyan, *A Pre-Raphaelite Circle* (1978), pp. 131–2.
85 **36**.268.
86 **7**.4–5, as for the next passage quoted.
87 **13**.xxxvi.
88 *RF* 129.
89 'I am satisfied that you [Wornum] had no other course than to burn them, both for the sake of Turner's reputation (they having been assuredly drawn under a certain condition of insanity) and for your own peace . . . I hereby declare that the parcel of them was undone by me, and all the obscene drawings it contained burnt in my presence' (quoted from National Gallery archives by *RF* 131 note; see also Robertson, *Sir Charles Eastlake, etc*, p. 303, and *JRRLT* 43). It is interesting in the light of Ruskin's comment on Turner's 'insanity' to note that this destruction of the Turner drawings haunted him during his own mental breakdowns of the late 1870s (see *BD* 98 and 112).
90 See **13**.xxxvii–xxxviii; also **36**.255.
91 **13**.183–226.
92 Bodley MSS Eng. lett. c. 36, f.94.
93 **13**.227–316.
94 **13**.317–25.
95 **7**.5.
96 See **36**.281 7 282. For Ward and Rose La Touche, **36**.276.
97 *Sublime and Instructive*, p. 20. For a full account of the Ruskin-La Touche relationship see *JRRLT*, passim.
98 Bodley MSS Eng. lett. c. 34, f.77.
99 See ibid and **7**.xxix and xxxvii as well as **36**.xxxviii for these wanderings.
100 See **14**.xxiii–xxiv as well as the letter cited in note 98.
101 **16**.211–17.
102 **36**.292. For a similar letter to Pauline Trevelyan, *RF* 131–3.
103 **36**.293, but hardly 'frank' as Hewison says in *John Ruskin. The Argument of the Eye* (1976), p. 125.
104 **36**.292. That Ruskin invoked his sense of Turner's 'sinfulness' in different ways at different times is clear from an 1873 letter to Furnivall, in which he saw the painter as 'one of the Children of God', who 'lived a partly sensual life redeemed by (?) sternest industry' (Huntington FU 788).
105 Ibid, 274. Ruskin's editors suggest 1858 as the date of this letter.
106 This is illustrated in **16**, facing 186; a detail in colour is reproduced in Hewison, *Argument*. But commentators who see this as a sudden con-

version to Veronese forget Ruskin's comments in the Louvre on several earlier occasions (see *D*.511).

107 **29**.89 and **35**.495–6. As Landow (*Aesthetical and Critical Theories*, pp. 281–4) has pointed out, the version in *Fors* moves from the painting to the chapel for its climax and that in *Praeterita* from chapel to painting. Both accounts are presumably constructions of some less coherent sequence of events. For some aggressive letters attacking evangelicalism in 1859 see PML 2186.

108 **36**.275–6 and 279–80.

109 Emphasized in his letter home (**36**.284). His diary for 23 May, when he made studies of purple orchis, is annotated ten years later with 'the first I ever made on Sunday: and marks, henceforward, the beginning of total change in habits of mind'.

110 **36**.288 and 290.

111 Accounts to his father are in **16**.xxxvii–xl; others, delivered in public, are in **16**.185–6 and **7**.293–4.

112 A. J. C. Hare, *The Story of my Life*, 6 vols (1896–1900), II 107–9.

113 **16**.180.

114 **7**.296–7. He would gloss this in *Fors* (**29**.88) by saying that he then realized that only by resolving to be good human beings – at our peril – would we lay sound foundations for any religion.

115 *RF* 134. The Oxford Museum, short of funds to do all that Ruskin wanted, was the primary cause of this despair with architecture.

116 **36**.296. He also included Reynolds in this number, having been excited by his work at the Manchester Art Treasures Exhibition the previous year.

117 **7**.6.

118 **16**.lxiii. The text of the letter is reprinted also in this volume; its publication took place in April.

119 **36**.297–301.

120 The fullest collection of materials and commentary on Ruskin's involvement with Winnington School is *WL*. To its scholarly example and fund of knowledge I am much indebted.

121 He frequently, as the editor notes, compared Winnington to a picture (*WL* 23 and 27).

122 *WL* 412.

123 **16**.lxv. For his letter to John James, *WL* 97, and for the text of the lecture, **16**.293ff. On his inclination to find lectures a more effective form of communication, see **16**.xxi (remark of February 1859).

124 See **7**.xlvii. But, amusingly in the light of his recent lectures on modern design, Ruskin found himself in the centre of an almost Chaplinesque farce of modern life when he stayed during this Yorkshire tour at a modern house in Knaresborough, from where he reported 'gas and cocks and plugs and iron blinds and every conceivable convenience – so that I dared not stir a foot in my room for fear of setting something going

& not being able to stop it' (Yale Family Letters vol. II section 2).

125 *WL* 99 and 100.
126 *Memorials*, I 263–4.
127 *WL* 104. In the next letter (ibid, 105) he invokes Venetian art again.
128 Ibid, 107 and 109.
129 See ibid, 121. He was much conscious of being 40 years old – see **36**.292 note.
130 Ibid, 111 and 112. The last adjective is particularly suggestive of their appeal for him.
131 Bodley MSS Eng. lett. c. 34, f.121. It is perhaps worth recalling in the context of my following discussion of such an attitude that puberty occurred rather later in girls at that era than nowadays.
132 See *WL* 116.
133 Ibid, 119.
134 Ibid, 116.
135 Ibid, 119.
136 Ibid, 123 and 110.
137 Ibid, 120–1.
138 See **7**.1.
139 Besides *D*.540–7, see **7**.488–95.
140 **7**.lii (a letter to Clarkson Stanfield).
141 See, for example, *RF* 137–8. To another correspondent he reported that the 'most hateful work in my own business I ever waded through namely the examination of modern German art at Munich. Is it possible that these people can write good music?' (PML MA 2045.1).
142 **36**.311.
143 **18**.537–45 (for text); the letters were apparently first sent to another newspaper, which refused to use them (see **36**.331 note).
144 **35**.485.
145 *RF* 138.
146 *NL* I 91 (also in **36**.327). Ruskin does not specifically refer to the Ancient Mariner's albatross, but the implication and allusion are clear.
147 See **7**.lxiii–lxiv, lviii and lxiv.
148 *RF* 141. Compare what he says to Norton on 15 May 1860 (**36**.334–5). Things might have been easier for him and 'less perplexing if Ruskin had known more about art when he began [his work on Modern Painters], or learned less in the course of its composition' – John Rosenberg, *The Darkening Glass* (N.Y., 1961), p. 2.
149 Bodley MSS Eng. lett. c. 34, f.231, where it is obviously misdated '1863/4'.
150 Berg Collection, New York Public Library, letter of 15 January 1859.
151 **36**.348.
152 See **16**.187.
153 **7**.169 note. A paper on Reynolds and Holbein, intended for *Modern*

Painters, got crowded out and appeared separately in the *Cornhill* for March 1860 (see **19**.xvi). On Ruskin's sense of the fragmentary nature of *Modern Painters V* see *WL* 290.

154 I have discussed these chapters on Turner's paintings more fully in an essay in *The Ruskin Polygon*.

155 **36**.362.

Chapter 15

1 *RF* 152.

2 See **17**.xxi–xxiv, as also for what follows. Among the topics they debated was Sabbatarianism.

3 Ruskin to Norton, **36**.339.

4 See *RF* 152–3 and 155.

5 **22**.512, from 'Readings in *Modern Painters*'.

6 *RF* 153.

7 See *Fors* 48. Of his change of style he wrote later in December 1867 that the 'pretty language of the earlier books is worked up in a curious mingling of vanity with sincerity – a correct desire to speak truth, weakened by a vain one, to say it gracefully' (Princeton AM 12375).

8 *RF* 150.

9 Ibid, 157.

10 **17**.18 and 19. Ruskin's place in the traditions of economic thinking is lucidly set out by James Sherburne, *The Ambiguities of Abundance*, already cited. His chapters 5 and 6 mostly concern *Unto this Last*.

11 Quotations in this paragraph are respectively, **17**.56, 52, 55, 105, 84 and 98.

12 See **17**.109–110 and 42. The preceding quotation in parenthesis is from **17**.64.

13 'I don't think, poor creature, he knows anything about human creatures' (*MR* 156).

14 **17**.85–6.

15 Ibid, xxxii–xxxiv.

16 Ibid, xxviii.

17 In the preface to *Munera Pulveris*, ibid, 143.

18 Reasons given for his disapproval: see *RF* 156.

19 **17**.xxxv.

20 *WL* 272. He told another correspondent, Sir John Naesmyth, that 'for the present I am – it seems prisoner' and that 'you cannot mend my mothers broken thigh; nor make my father dependent on any other face than mine at the breakfast-table' (Yale, letter of 28 April 1861). A far less despondent letter to the same correspondent, obviously after they had just met each other, expresses Ruskin's 'great delight' at Naesmyth's expression of liking for him – 'I have few friends; for my work casting me among painters, who either hate me, or in various degrees are

disposed to resent this or the other opinion, and "society" being in all sorts of ways suspicious of me, and people who trust me being generally unwilling to put themselves – as they suppose – in my way. I am left for the most part alone.' (Huntington 7596).

21 *RF* 149–51.

22 Ibid, 158. On his attitudes towards his parents at this time, an obsessive theme, see **36**.356.

23 **36**.346.

24 **36**.342–3, also for the following remarks, *Ruskin, Rossetti and Pre-Raphaelitism*, pp. 253–4; yet, ironically, the main part of his letter accuses Rossetti of being 'in little things habitually selfish'.

25 Ibid, p. 246. Ruskin refers specifically to Rossetti's 'faults' of draughtsmanship. In this context it is perhaps not surprising that Ruskin greeted Patmore's *The Angel in the House* with delight (**36**.344 and xxxi).

26 **36**.339.

27 Ibid, 325. But the La Touches had visited Denmark Hill earlier, in April: see *JRRLT* 43.

28 See *JRRLT* 44–5 specifically, except that the presentation of the fifteenth-century, catholic Primer was hardly the 'reassurance' of his orthodoxy that the editor says (ibid, 45).

29 *WL* 250.

30 *RF* 152 and **36**.340.

31 He tells the story in *Proserpina*, from which I quote (**25**.204). But he also wrote of the incident to Lady Trevelyan (*RF* 153); in this account nearer the event she is a 'girl' not the 'lady' she had become in the later version; Ruskin also tells of cutting the thorns off the wild roses in the bouquet.

32 **35**.525.

33 **36**.348.

34 Ibid, 350.

35 Ibid, 346. The original letter to Norton is in the Pennsylvania State University Library.

36 Ibid, 350. See also letter cited in following note.

37 *RF* 163.

38 **35**.531. 'St C stands for all sorts of things – if I'm good for Chrysostom – if I'm bad, for Crusty and all manner of things' (Huntington 31093).

39 **35**.529–32, from which I quote next.

40 John James to Lady Trevelyan, *RF* 169.

41 Quoted from his thank-you letter, *WL* 291.

42 Ibid, 282 and 284.

43 Ibid, 282–3.

44 *RF* 165.

45 Ibid. See also **17**.xxxvi.

46 Carlyle to Ruskin's father, 'Carlyle's letters to Ruskin', ed. C. R. Saunders, *Bulletin of the John Rylands Library*, 41 (1958), p. 218. Ruskin himself wrote of the lecture that 'I broke down . . . Had not to leave the

desk – but lost all power of thought – & had to give up the subject & go on to general talk' (Yale, letter quoted in note 20 above). What Ruskin did not record, but what Arthur J. Munby noted in his diary, was that Ruskin broke down because 'in the middle of his lecture' Millais and Effie came in and took their seats immediately in front of him (see Derek Hudson, *Munby, Man of Two Worlds*, p. 97).

47 **17**.xxxvi and note; and for further worries, see *WL* 305. The girls at Winnington had helped prepare the illustrations for this lecture.

48 **17**.xxxvii, writing to his father from Bonneville the following October. The decision to go to Boulogne, as he explains to Lady Naesmyth, was to combine getting away and staying 'within reach of London in an hour or two if my mother or father should want me' (Bodley MSS Eng. lett. c. 34, f.318).

49 Respectively, *WL* 326 and *RF* 169.

50 **36**.367; see also *RF* 172 and note.

51 According to John James, *RF* 168.

52 **36**.368–72.

53 *RF* 171 and **36**.382.

54 **36**.367, the reference being to *The Pilgrim's Progress*. But as his letter to Norton continues it is clear that escape had to be on Ruskin's own terms.

55 **36**.357.

56 *JRRLT* 25.

57 Ibid, 30.

58 Ibid, 53.

59 **36**.384. Other details of his stay, unless otherwise noted, are from this letter.

60 *RF* 174, as for the next remark.

61 **36**.375.

62 *JRRLT* 62.

63 Ibid, 59.

64 See the forthcoming study by Eve Blau, cited in chapter 14, note 26.

65 **36**.374 and 380 for what follows.

66 The quotations come from a letter to his father dated 23 [December, 1861] in ibid, 401.

67 **17**.xliii ff. for this and succeeding references unless otherwise noted.

68. **36**.394. He also instructed Norton on the need to go to Switzerland in November (*NL* I 122).

69 See **36**.397 and 398 and *D*.556 and 558.

70 **17**.xlvi and a similar emphasis is in *WL* 339.

71 Respectively *RF* 182 and **36**.389.

72 **36**.399.

73 **17**.1 and see **18**.146.

74 Ibid, li and see also *WL* 343.

75 **17**.li–lii for a John James letter to Simon on these *Selections*. For Carlyle's response, *Bulletin of the John Rylands Library*, 41 (1958), pp. 219–20.

76 *RF* 176 and see *D*.556.

77 **36**.392.

78 *JRRLT* 62, quoting unpublished letter of 25 October 1867, and ibid, 63, also quoting unpublished material.

79 See the conversation reported to his father in **36**.399.

80 *JRRLT* 64ff. for an account of these months in their relationship.

81 See *D*.553 and **17**.xlix.

82 *JRRLT* 71–2, printed from corrected proofs of a *Praeterita* chapter which was never issued.

83 **36**.402, though I accept Van Akin Burd's emendation of 'Bologna' for 'Boulogne' (see *JRRLT* 74 and note).

84 In 1860 he considered it a piece of good advice to 'pick up a couple of children out of the street . . . and have my own way with them and see what I could make of them' (*RF* 161). See also his plans for Emily La Touche (*WL* 342).

85 **36**.402. Whether he did so is unclear. But he called on the family in Paris on his way to Italy in 1862 (see ibid, 408–9).

86 *NL* I 121–3, as also for the following quotations.

87 *Rossetti Family Letters*, I 224.

88 *NL* I 127.

89 Ibid, I 128 and **36**.408 and *WL* 354.

90 He in fact said so to Lady Trevelyan in July 1862 (see *RF* 188).

91 Ibid, 183–7 for what follows, unless otherwise noted. Yet he could write in a more friendly way once he got abroad again (see ibid, 188–9). On his general grumpiness see *WL* 347.

92 *D*.560.

93 *WL* 350.

94 Ibid, 381.

95 **36**.408.

96 *WL* 351.

97 See *JRRLT* 76–7 and *WL* 342 for remarks about Emily.

98 *WL* 356.

99 **36**.414; also *RF* 188 and note.

100 Quoted Leon, *Life*, p. 315. Cf. *NL* I 215.

101 **36**.408.

102 *WL* 382. For Van Akin Burd's speculations on other reasons see *JRRLT* 78–9.

103 **36**.411 (Ruskin to Rossetti!). For Ruskin on Luini see **19**.lxxiii–lxxv.

104 *Memorials*, I 247: see also *RF* 188–9.

105 Ruskin claimed that interference with his work (as opposed to his father's suppression of it lest it make John James ill) caused him to be more depressed and tired than the work involved in writing did (see **36**.315).

106 **17**.148. An exacting and full account of *Munera Pulveris* may be found in Sherburne, *Ambiguities*, pp. 124 ff.

107 **17**.143.

108 *NL* I 128.

109 **36**.412.

110 **17**.liv ff. for the Mornex episode, unless otherwise noted.

111 Ibid, lx.

112 **36**.437 – a letter of the following March, 1863.

113 *RF* 190–1.

114 D.566; see also *RF* 193. A further, practical reason for no longer being at Denmark Hill was, according to Ruskin, that it offered inadequate space for his collections (see *WL* 372).

115 *RF* 188.

116 *WL* 369–71 and **17**.xxxii.

117 To Colenso, *WL* 386–7, to Miss Bell, ibid, 380–2, to Naesmyth, ibid, 387; on his silence, ibid, 457.

118 Ibid, 388.

119 Ibid, 391. Another testimony to Ruskin's religious beliefs at this time, actually confessed in public at the Working Men's College, is recorded by Arthur J. Munby who heard Ruskin on 29 November 1862: see Hudson, *Munby*, p. 141.

120 *RF* 197 for John James's remark: the 'den' remark is from a letter of the following year (see **36**.425).

121 *WL* 390–1. But he wrote a happy enough letter to the Carlyles on the evening of Christmas Day (**36**.427).

122 See *WL* 391. Rose was evidently caught in her parents' disagreements (*JRRLT* 87).

123 *NL* I 132. See also *WL* 398 on his 'reading heathen books'.

124 See *JRRLT* 83.

125 Ibid, 87. There is even perhaps the chance that unconsciously Mrs La Touche wanted to put her daughter off a man she herself felt deeply for.

126 Ibid, 87, as for the following quotation.

127 Ibid, 85–6 and 89.

128 **36**.430 (letter to John James on 3 January 1863).

129 *WL* 395.

130 *RF* 207 and 209.

131 *WL* 400.

132 Ibid, 394.

133 **36**.423.

134 The phrase is W. J. Stillman's in *Rossetti Papers 1862–70*, ed. W. M. Rossetti (1903), p. 26.

135 *RF* 211.

136 **17**.lxxvi.

137 This proposal for Burne-Jones illustrations came to nothing: *Memorials*, I 271. His urgent need for clear statements of mysterious problems is revealed the next year when after a friendly debate with Spurgeon,

Ruskin reported himself as rejoining, 'You have not a simple clear idea attached to any one word you have used' (*WL* 464).

138 *RF* 209.
139 **36**.440.
140 *RF* 214. On these Alpine locations for possible homes see P. Jaudel, 'Les chateaux de Ruskin en Savoie', *Confluents*, 1 (1978), 55–82.
141 **36**.445.
142 See **14**.476 ff.
143 See *Memorials* I 266–7 and **17**.lxxiii–lxxiv.
144 **36**.455.
145 *WL* 414. But Ruskin himself in January 1864 offered the same reason to George Allen for not resuming his Swiss plans (see **36**.462).
146 *WL* 435 and **17**.lxxv.
147 See *Sublime and Instructive*, pp. 51–2.
148 *RF* 223. He rationalized that 'The people in Savoy were such pigs that I found I couldn't live among them' (Huntingdon HM 31095).
149 Ibid, 225.
150 *WL* 453.
151 See **17**.491 and *WL* 439.
152 *WL* 443.
153 Ibid, 447 and note.
154 Ibid, 459.

Chapter 16

1 For the Acland letters see **36**.468–71.
2 *Memorials of Burne-Jones*, I 278. For Ruskin's dislike of mourning, **37**.695.
3 **17**.lxxvii.
4 In January 1864 he wrote of having chosen his motto ten years before 'chiefly to try and cure myself by that and other helps of procrastination' (Bodley MSS Eng. lett. c. 35, f.162).
5 See above p. 273.
6 *WL* 483.
7 *RF* 231.
8 *WL* 509. But within a few years he was making sure Joan knew 'how I value you' (**36**.549).
9 *RF* 230.
10 See ibid, 232 ff.
11 *WL* 521.
12 For instance **36**.476 and, apropos the following sentence, see a letter to Carlyle of 18 July 1865, in which he talks of his mother always snubbing him and making him impertinent in return: 'she is always saying things which look as if she was the most conceited person in the world. She is really very uncomfortably humble' (NLS **555**.22).

13 See *WL* 477, 481, 507 and 522 respectively. John James had always considered Miss Bell 'a bad risk' (ibid, 639).

14 *Life*, p. 334.

15 See C. E. Maurice, *Life of Octavia Hill* (1913), pp. 213–14 and 221; and E. S. Maurice, *Octavia Hill; Early Ideals* (1928), pp. 162–80.

16 *RF* 231.

17 *MT* 33.

18 *RF* 232. In 1865 he would buy over a thousand new examples, paying for them by selling four large Turner watercolours (see *WL* 546).

19 *RF* 232 and *WL* 515. He called it his 'fit of Egyptian mythology, which had made me forget everything' (*Sublime and Instructive*, p. 63).

20 *RF* 235 and 242.

21 Quoted by Van Akin Burd, who also makes the point about *Ethics* reflecting Ruskin's Winnington teaching (*WL* 479).

22 **19**.78–9. For his own preference of 'Home, Sweet Home' over Hallé's rendition of classical repertoire earlier in the programme he was forced to apologize to the pianist: see **36**.476–8. Burne-Jones was also translating the Winnington girls into art ('The Burne-Jones cartons/ Have preserved her eyes', as Pound put it) – see *WL* 482 and 493–4 for his tapestry designs on themes from Chaucer's *Legend of Good Women*.

23 *WL* 533. He also apparently took them to the National Gallery (see ibid, 509–10).

24 *RF* 241.

25 As the editor of *WL* claims, 477; see also ibid, 480.

26 *JRRLT* 90, where the birthday appears to be that of 1864 (cf. *WL* 479–80, where the letter is placed by the same editor a year later); see also 'Rose's so ill – you can't think' (*RF* 231).

27 *MT* 82.

28 See *WL* 519.

29 **36**.464; also *MT* 29. At that point Ruskin thought Carlyle 'might be right'.

30 Quoted *JRRLT* 91.

31 *WL* 488 and *MT* 30.

32 *RF* 238–9.

33 A talk he said he'd have enjoyed if he hadn't been tired to begin with (ibid, 241).

34 *RF* 524. For the text of these letters see **17**.499–502.

35 *RF* 239 and 242, and *WL* 489 and 530.

36 Reprinted, with emendations, in *The Crown of Wild Olive*, **18**.433 ff.

37 The Bradford Exchange was eventually built in Venetian Gothic style (see **18**.lxxv).

38 **18**.xviii–xix.

39 **19**.307 note. This explains, I believe, why he was in future so eager to link his various works, as if only by our keeping them all in mind at the

same time, would one of the awkwardnesses of having to say only one thing at a time be evaded. See *Fors* 78 on *The Stones of Venice* (**29**.137).

40 See above, pp. 121ff.

41 Cf. **18**.453 and **16**.337. That he carefully planned such local, topical references is clear from the lecture he prepared some years later for delivery in the theatre of the Royal College of Science, to which he alluded even when the venue had to be altered (see **18**.lviii).

42 **18**.64.

43 I am grateful to Edward M. Wilson, Emmanuel College, Cambridge, for transcribing this section from his grandmother's journal for 18 December 1864; she was Anne Meryon, later to become Alfred Harris's second wife. For the following parenthetical quotation about the British Museum, *RF* 246.

44 *WL* 535. That these were not mere excuses can be gathered perhaps from his saying the same to Lady Trevelyan (see *RF* 245 and 248).

45 *WL* 537 and 538.

46 **36**.499. For his later ventures in publishing and book distribution see below.

47 **18**.xxxiv, writing to Acland.

48 **19**.23.

49 *RF* 245. The visit was arranged by Mr William Cowper.

50 See **19**.49 ff. Some of this material was reused in *The Queen of the Air* (1869) – another testimony to his belief in the interconnections of his work – and the remainder reissued in *On the Old Road* I (1885).

51 *RF* 247–8.

52 Ibid, 248.

53 *NL* I 150.

54 *WL* 536.

55 See **18**.550–1.

56 See *Rossetti Papers*. pp. 132 ff.

57 *WL* 549 and 551.

58 See ibid, 551.

59 *WL* 555.

60 Huntington MS 31097.

61 *WL* 536 and 550.

62 See *JRRLT* 94.

63 *RF* 251.

64 *WL* 577.

65 *RF* 251. Two months later he said 'I was really quite happy examining the angles of calcite, before she came this time' (*MT* 60).

66 *RF* 251. He addressed her in verses written for her eighteenth birthday in January as 'sweet lady, child no more' (*Ah, Sweet Lady*, priv. printed. Bembridge. The Yellowsands Press, 1968). But it was 'a child's playfulness' (*MT* 68) that he still loved in late 1866.

67 *RF* 251.

68 Quoted *JRRLT* 94.
69 Quoted ibid, 95.
70 Quoted ibid, 95–6. It is unsurprising that, for different reasons, each should be so absorbed in the other: Ruskin, for reasons to be discussed soon; Rose, happy to have a new and old companion.
71 **36**.504. *JRRLT* 97 note now dates this February not April 1866.
72 *MT* 64, as for the following quotation. See for a later, similar confession *MT* 139.
73 Ibid, 68.
74 Ibid, 60.
75 *JRRLT* 96.
76 Another retrospective account of 1886 – see *JRRLT* 96–7. In February 1866 he reported that Mrs La Touche's response had been 'never – never' (*MT* 60).
77 *MT* 59–60.
78 Ibid, 66. For Ruskin's sense of Mrs La Touche's jealousy see ibid, 85.
79 See ibid, 68–9.
80 Ibid, 52.
81 See for example *JRRLT* 98, *MT* 60 the postscript and 67.
82 *MT* 68.
83 *RF* 254. The reference is to Ruskin's being 'bad' on a planned trip to the continent with the Trevelyans; see next chapter.
84 See above, p. 114.
85 *MT* 50.
86 Ibid, 65.
87 Ibid, 69.
88 Ibid, 66.

Chapter 17

1 *RF* 253.
2 *WL* 589.
3 Ibid, 587.
4 See *RF* 254–7.
5 Ibid, 257. Sir Walter was a strict and ardent teetotaller.
6 See Raleigh Trevelyan, *A Pre-Raphaelite Circle*, p. 234.
7 Reproduced in *RF* facing 177.
8 For letters home from this journey see **36**.506 ff. and **18**.xxxvii ff.
9 *MT* 73.
10 **36**.506. Howell, the engaging but unscrupulous 'man for fortune', was helping Ruskin manage his affairs at this point.
11 *MT* 69 and *RT*.261. Something of his intense dislike for waiting and wasting time appears toward the end of the preface to *The Crown of Wild Olive*, published in May when he was abroad (see **18**.393 ff.).
12 PML MA 2541. The letter is not in *MT*. In the Morgan Library it is

attached to an envelope postmarked 26 March 1867, but it seems clear that it dates from the March of the previous year (this is based upon the contents of the long letter and his claim at the end that he is 'going abroad in ten days').

13 *MT* 81 and, for the following remark, 71.

14 See almost at random, but especially *D*.595 and 599; *JRRLT* 102–3; *MT* 107.

15 *MT* 81. During June he had written to Rawdon Brown from Switzerland to say she could stay his 'child pet' (**36**.509), as if sometimes the past were an easier option. Similarly see *MT* 82.

16 *MT* 78.

17 See ibid, 81.

18 Ibid, 72.

19 *JRRLT* 101. Percy visited Denmark Hill that November.

20 *MT* 77–8 and 86.

21 *JRRLT* 104.

22 See *MT* 102 and *D*.602.

23 *D*.598.

24 *WL* 594 and 595.

25 *MT* 71.

26 *NL* I 160 and 159.

27 *MT* 101.

28 PML 2228.

29 *D*.615 (on his eyes) and *MT* 112.

30 See *D*.608.

31 See *MT* 109 and *D*. passim.

32 *MT* 114.

33 Ibid, 110. For an interesting letter to Joanna Agnew on the Bible giving the word of God '*directly* to different people in different ways' see **36**.539.

34 *JRRLT* 111.

35 *D*.619.

36 For dreams see especially *D*.628; for the girl who resembled Rose, ibid, 626; for her name hidden among other words – Mel*rose* (*MT* 120), and 'by which she [i.e. Venice] *Rose*' (*WT* 596).

37 *WL* 602.

38 See **36**.528.

39 See *WL* 605 and 599; ibid 605 for the following quotation.

40 **36**.513–14. This was another, unrealized project.

41 See discussion of *Flors Clavigera* below, pp. 335ff. These new projects for fresh forms in which to address readers maybe explain the coolness with which he received the idea of starting a conventional magazine (see Leon, *Life*, pp. 384–5).

42 See the chapter on Dixon in William Bell Scott, *Autobiographical Notes*, 2 vols (1892), II. 264–72.

43 I quote from the original, not later book version (**19**.315 note).

44 **19**.451.

45 Ibid, 481–2.

46 **36**.531.

47 *D*.635.

48 This and succeeding quotations from letters to his mother (Bembridge B VI), dated 30 June, 4 August, 2 July, 23 July and 30 June. But he was still disturbed by the La Touches' behaviour, as a letter to Joan of 19 July makes clear (PML MA 1571); in it he talks of going for walks to shake off his ill-humour, yet finding he got 'angrier and angrier every moment, till at last I had to stop in climbing a hill, breathless and trembling slightly with the angry chill'.

49 *D*.625.

50 *MT* 129.

51 **36**.504 (probably April 1866).

52 *MT* 123.

53 *D*.644. He told Miss Bell that ths invitation to go to Dublin was 'in a very grave way . . . opportune' (*WL* 614).

54 *D*.647.

55 *WL* 618 and 622.

56 'I tried to fancy the difference between getting a note with two roseleaves in it, & getting none' (*MT* 156).

57 *MT* 155–6. Yet only that March he had been saying 'What I chiefly need is to know . . . what she *means*' (*MT* 130, his italics).

58 See Mary Lutyens, 'The Millais-La Touche Correspondence', *Cornhill*, 1051 (1967), pp. 1–18. By far the longest narrative of these manoeuvres, though with mistakes of dating, is Leon's.

59 **18**.145 ff.

60 *WL* 625.

61 *MT* 163 and 162.

62 Ibid, 167 and G. MacDonald, *Reminiscences of a Specialist* (1932), pp. 100–1.

63 *JRRLT* 117 and Leon, *Life*, p. 414.

64 *MT* 170, 172 and 171.

65 Bembridge MS B VI, letter of 27 September.

66 **19**.xxii–xxiii.

67 See **17**.lxxxi and 541–6.

68 Bembridge MS B VI, letter of 20 October.

69 Ibid.

70 Reprinted from Ruskin MS Notes in **19**.243–67.

71 Bodley MSS Eng. lett. c. 36, f.313.

72 Ibid, f.324.

73 From the unpublished Norton letters, *The Ruskin Polygon*, p. 242.

74 *NL* I 177 and *D*.658.

75 **36**.553 note.

76 *D*.660.
77 *MT* 180.
78 See **19**.xliv and **36**.558.
79 *D*.659.
80 **36**.572.
81 *MT* 197. Van Akin Burd tells us (*JRRLT* 117–18) that Rose marked these passages of *The Queen of the Air* unsympathetically in her copy.
82 See **4**.330 for that earlier idea. On Ruskin's glossing of earlier remarks and writings see my essay in *The Ruskin Polygon*.
83 **36**.563, writing to Norton on *The Queen of the Air*.
84 **19**.lxvii (Norton) and lxx (Carlyle). Significantly, Ruskin at this time considered that Carlyle's most 'symbolist'/idealist book, *Sartor Resartus*, 'belongs to me . . . more than any other of your books' (**36**.365). On Ruskin's work in *The Queen of the Air*, the best, though brief, commentary is Harold Bloom's introduction to *The Literary Criticism of John Ruskin* (N.Y., 1965).
85 See *Ruskin a Verona*, catalogue by Terence Mullaly for the exhibition of 1966.
86 **36**.566–9 and *MT* 201 ff. See also other outlines of his thoughts in *WL* 655–7 and 660–1. On the Guild, see below, passim.
87 Bembridge MS B VI, letters of 3 June, 5 July, 11 May and 31 July. For the following letter to his mother, PML 2327.1.
88 *MT* 205. His meeting with Longfellow and his daughter excited his mother more then anything since his birth! (letter from Margaret to John Ruskin, 23 August 1869, 'Kent' collection).
89 *MT* 203; the passage is quoted above, p. 211.
90 **4**.356.

Part V

Chapter 18

1 **20**.xix–xxi.
2 *MT* 219.
3 See **36**.597 and *MT* 236–7.
4 **36**.592 and 594.
5 *D*.685. For a discussion of Ruskin's obsession with serpents see the essay by Marc Simpson in *The Ruskin Polygon*.
6 *MT* 238.
7 Ibid, 236. The editor explains that *Dioscoridae* is a heart-shaped plant.
8 Ibid, 255.
9 Ibid, 233. For the whole series of letters on these French songs see ibid, 221 ff.
10 Ibid, 235.
11 Ibid, 230.

12 The story is recounted in ibid, 247.

13 Ibid, 273.

14 Ibid, 268.

15 Quoted *JRRLT* 121.

16 See **19**.429–34 and 445–8.

17 For this and for subsequent quotations, unless specified, from his opening lecture see **20**.17 ff.

18 *MT* 257.

19 See **36**.598 and **37**.2–3. The change of plan for the second series was doubtless because the requirement to deliver twelve was waived by the Dean of Christ Church (see **37**.3).

20 **20**.xlviii.

21 **28**.92.

22 *The New Republic* (1879), pp. 16–17. Ruskin met Mallock in 1873 (see *D*.770). For other accounts of Ruskin as a lecturer see **20**.xxiii–xxvii.

23 **37**.5.

24 See **20**.l–li and **22**.196–7. The following quotations from Joan Agnew's journal in the Sharp Collection, PML, make me think of Auden's lament for Yeats concerning the 'parish of old women' in which he – and here, Ruskin – was obliged to exist.

25 *MT* 276.

26 He wrote to Norton that he would really prefer 'to go home quietly and write down what I have got – else I should learn too much, and get nothing said' (*NL* II 6).

27 See Lutyens, *Cornhill*, op. cit.

28 **18**.47; and see *JRRLT* 122–3 for quotations from a MS draft.

29 Quoted *JRRLT* 121.

30 Bembridge MS L 35.

31 *NL* II 13.

32 Ibid, 17. In his copy of *Le Roman*, 5 vols (Paris), now at Bembridge, there are other annotations: for example in I 191 he has underlined 'O benoiste soit Esperance'.

33 He told Lily Armstrong many years later that he could never think of her as 'past seventeen' – though she was then a mother of 37 years! (*WL* 646 and 705).

34 *D*.700, for 9 August 1870.

35 Ibid, 708. See Sheila Birkenhead, *Illustrious Friends* (1965), p. 188, for an equally strong expression of love for Ruskin by Joan herself.

36 This connection is not discussed by Marc Shell, *The Economy of Literature*, where he explores Ruskin's treaties between writing and coins.

37 All quotations from **20**.199 ff.

38 See **20**.lviii.

39 *WL* 627. But he also would tell Albert Fleming two years later that *Fors Clavigera* was 'the outcome of them all' (i.e., his other writings): Yale, Ruskin Letters Box F–H, letter of 29 October 1873.

40 *Fors* 2 (**27**.27). The following discussion of the title derives from Ruskin's explanation in this same letter and his editors' annotations of the same. Page references will not be given to letters, the numbers of which are given in the main text.

41 See Jeffrey Spear's discussion of the way Ruskin's chance readings in newspapers affected the structure of *Fors* letters (*The Ruskin Polygon*).

42 Bodley MSS Eng. lett. c. 38, f.7.

43 The imagery is Ruskin's: **28**.513.

44 **19**.lix.

45 **20**.107. The italics of the printed version of this lecture are perhaps a tonal device borrowed in turn from *Fors*, which has a distinctly conversational manner.

46 **27**.13–4.

47 **21**.xx. Unless otherwise stated, all further information about the Oxford collections is taken from this volume, where Ruskin's editors provide a lucid, if somewhat pietistical, description of the four series of materials.

48 See Hewison, *Argument*, pp. 170 ff. for a succinct summary and history of Ruskin's hostility to these other schools.

49 **37**.30.

50 **21**.165.

51 Quoted by Hewison, *Argument*, p. 174, from the *Oxford University Gazette*, 193 (June 1875).

52 *D*.713.

53 *WL* 655. The 'Elgin sculptures' were, of course, casts.

54 See below, passim.

55 An excellent point made by Hewison, *Argument*, p. 175.

56 **37**.48.

57 I quote from the 'Advertisement' added in September 1872 (see **18**.10). The succeeding quotation is from the 1871 Preface. In 1873 he wrote to explain to Bernard Quaritch that he proposed to publish 'what portions I like of the older books [I] will include, in altered forms, much of the 3rd, 4th, and 5th vols of Modern Painters – some of the Seven Lamps – and perhaps the half of the Stones of Venice. For this edition of my own, I shall prepare entirely new plates and woodcuts' (*Letters of Ruskin to Bernard Quaritch*, ed. C. Q. Wrentmore (1938), p. 8).

58 **37**.37 and 40.

59 *D*.711. That same day he asked Dr John Simon for 'just a line saying you know she had cancer, & must die someday – to show the women' (Huntington 7602).

60 The lecture was printed separately, with some defensive annotations, that same year.

61 *MT* 286.

62 **37**.40.

63 **37**.34. Joan Abse, in her recent biography, suggests very plausibly that

the illness was caused by food poisoning (*John Ruskin, The Passionate Moralist* (1980), p. 250 note); that supports Ruskin's friends, who (he complained later to Susan Beever) 'said it was all "natural"' (Huntington JR 239). On his dreams during the illness see *Ariadne Florentina*, where he recounted some of them (**22**.444–7).

64 **37**.33–4.

65 Cook, *Life*, II 217.

66 Cited *JRRLT* 123.

67 *MT* 293.

68 This and the previous quotation, ibid, 310.

69 **37**.35.

70 **37**.44.

71 Cook, *Life*, II 224 also makes this point.

72 **37**.43.

73 **37**.49.

74 'Many letters', he recorded at the end of December 1871 (D.714).

75 I am grateful for this point to Brian Maidment: see his essay in *The Ruskin Polygon*. My example comes from **37**.50.

76 **22**.153. He conveniently summarizes his themes at the start of the ninth lecture (ibid, 239–40).

77 *D*.725 and **27**.312.

78 A. Severn, *The Professor*, ed. J. S. Dearden (1967), p. 57.

79 **27**.328. For his Carpaccio letters see **27**.342–4 and 347.

80 Quoted *JRRLT* 124. See also Leon, *Life*, pp. 484 ff., from whom all quotations, unless otherwise stated, are taken, The recent biography of Ruskin by Joan Abse speculates (pp. 262–3) on Rose's *anorexia nervosa*; it also summarizes most aptly the poor girl's predicament – 'trapped in a faith which seemed to give her so much cognisance of the next world and so little guidance as to how to attend to the realities of this' (ibid, p. 259). There are a series of letters, written this summer of 1872 to George MacDonald (Yale, formerly in Leon's collection), which reveal strikingly the turmoil and oscillations of Ruskin's reactions: on 11 August, for instance, he exclaims 'three days of heaven' and then on 8 September notes 'she is mad'.

81 Leon (*Life*, p. 494) says Rose actually returned briefly to Ireland; her recent biographer makes no mention of this (see *JRRLT* 125).

82 *MT* 339 (written in the following October).

83 Ibid, 332.

84 Ibid, 333.

85 *D*.732.

86 **22**.451. The lectures were published at intervals between 1873 and 1876; in 1876 they were collected with a title, *Ariadne Florentina*, which hints at that 'clue' to the 'labyrinth'. He still thought of himself in a maze in August 1874 (see **37**.136). Mrs La Touche also wrote to Joan sometime in the early 1870s about her difficulties with Rose – 'the complications

and worries she makes by her misrepresentations to other people, are
like a labyrinth of thorns around us . . .' ('Kent' collection).
87 *New Letters of Thomas Carlyle*, ed. A. Carlyle, 2 vols (1904), II 293.
88 *D*.746.
89 Ibid, 737, 743 and 764.
90 Ibid, 748.
91 *MT* 348.
92 *BD* 353.
93 *D*.763.
94 **37**.42.
95 Ibid, 75.
96 **27**.382, my italics.
97 **37**.69.
98 **27**.447–8 and 636. But the subtle connections and intertwinings of
theme in *Fors Clavigera* are not easily apparent, and it has been one of the
least studied of Ruskin's major works. One of the best accounts of it is
still that by Ruskin's editors in their introduction to **27**.
99 *D*.744.
100 **37**.61.
101 *D*.753.
102 Ibid, 771.
103 See F. L. Mumby and F. H. S. Stallybrass, *From Swan Sonnenschein to
George Allen & Unwin Ltd* (1955), especially pp. 68–9.
104 **20**.xli.
105 Ibid, xliii. He told Carlyle later that year that 'I believe my class in *that* art
[i.e. digging] will be the good ones' (*NLS* 556.75).
106 *D*.778. In February he told Carlyle that Rose was 'half mad and half
starved' (*NLS* 556.70).
107 *D*.775.
108 *NLS* 556.71.
109 *D*.809.
110 **37**.95 and *D*.808.
111 *NLS* 556.77.
112 **37**.112.
113 *NLS* 556.83 (and 85) for beggars and cloister; **37**.98, 111 and 136 about
the care of buildings, and for the succeeding quotation on the Giotto.
114 *D*.778; for his letter of rejection see **34**.513.
115 **37**.130.
116 I am indebted to this point to Alice Hauck, who has been working on
Ruskin's collection of illuminated manuscripts.
117 **28**.14 and 206.
118 **37**.145.
119 *NLS* 556.72 7 96.
120 See **37**.139 and *D*.808.
121 **37**.102.

122 See *JRRLT* 128–9, as for other details invoked in this paragraph.
123 Leon, *Life*, p. 500. See also on this occasion, *BD* 107.
124 From letters to Mrs Margaret Raine Hunt (Huntington HM 30358 and 30360). In another letter (Huntington JR 31) he says that 'Whenever you find me raging against the Evangelicals, it's all that child's fault'.
125 **37**.168 and 170.

Chapter 19

1 **37**.168.
2 See *D*.834 and 854. Perhaps 'frameworks' in the first quotation should read 'fireworks', though the manuscript does not really support this.
3 Huntington HM 31093.
4 *D*.850. In a letter of January 1875 he wrote to Miss Beever of 'the cruelty and ghastliness of the *Nature* I used to think so divine' (**37**.154).
5 **23**.312. But there were less enthusiastic judgements, like Henry James's resentment of 'the strangest falsetto key' of *Mornings in Florence* (*Portraits of Places* (Boston, 1884), p. 67).
6 *D*. 869 and 844. Months later in Venice he even considered stopping *Fors* (see **29**.xxi).
7 *D*.833.
8 **28**.271.
9 **37**.179.
10 Ibid, 173. See also 'it is so precious to me to be thought of as a child' (*MT* 360).
11 I have conflated two accounts written to Norton and to Joan Severn: **37**.183, **24**.xxi and **26**.162, 177, 232 and 259. But in all fairness it ought also to be emphasized how difficult it *is* to experiment geologically. John Elder, Professor of Geophysics, discussing ways of teaching his subject in *The Bowels of the Earth* (Oxford, 1976), admits that 'the kitchen abounds with opportunities' (p. vii).
12 Letter of 1 April 1878 (PML 1771).
13 *D*.858.
14 Severn, *The Professor*, ed. cit., p. 87. See also Ruskin's nostalgic account of his childhood coaching travels in *Fors* 56 (**28**.389–91). Letters also show him posting earlier in that year (**37**.155).
15 *D*.898. To Norton he descanted miserably upon a changing England (see **37**.204–5).
16 *The Professor*, loc. cit.
17 See **28**.612 note and *Fors* 49, with his explanation of his abuse of railroads (**28**.247–8), and his linking it with his St George's work.
18 **23**.xxvi–xxvii.
19 *D*.861.
20 PML 1763.
21 *MT* 358.

22 *Bulletin of the John Rylands Library*, 43 (1960–1), p. 530. And see also his complaints about legal problems at the end of *Fors* 67.
23 **28**.647.
24 Yale, letter of March 1875 with MS of *Fors*.
25 See Rosenbach, Ruskin to Swan letters, I (23 July 1875).
26 See **28**.448–51, as also for the following quotation.
27 **37**.183.
28 Ibid, 186.
29 The various versions of this event, apart from his diary quoted next, are **24**.xxii ff., **37**.188, *NL* II 124–9, Leon (quoting George MacDonald) *Life*, p. 507.
30 For the full text of the letter, originally suppressed by Norton, see *The Ruskin Polygon*, pp. 272–4.
31 *MT* 367–8 and 371.
32 Yale, letter to John Brown, 19 October [1874].
33 Huntington FU 790: 'home' in that remark is Ruskin's substitution for a deleted 'world'. See also his letter on the spiritual Rose of 17 August 1876 (**24**.xxiv–xxv).
34 *D*.892, but see also *passim*.
35 Ibid, 886.
36 See *MT* 372 and *D*.388.
37 See **24**.xxvi.
38 *D*.896 and *Fors* 59. Papers in the Rosenbach Museum and Library indicate that he gave a talk on 'Communism and Art'.
39 The first phrase, broken earth, is Horace's; the second, broken heaven, Ruskin's own (**37**.198).
40 *D*.893 and **37**.194 (my italics).
41 Quoted **24**.xxxii.
42 See *D*.891 and **28**.657.
43 The unspecified quotations in this paragraph are from the Ruskin to Swan correspondence, preserved in ten volumes, at Rosenbach.
44 **26**.197 ff.
45 *BD* 8–9, for example.
46 Ibid, 25.
47 **28**.687 ff., as also for what follows.
48 *D*.900.
49 **30**.xxx.
50 **24**.xxxiv.
51 Ibid, xxxviii.
52 Ibid, xxxvii–xxxviii.
53 *D*.911. His simile is taken from one of his Venetian *bêtes noires* that autumn, winter and spring – the steamboat.
54 Ibid, 923.
55 'I'm greatly vexed to find the high Alpine air more directly provoking bilious headache than ever' and 'It is very curious that the stomachic

despondency is often intensely *sublime* giving a wild, lurid, fever struck grandeur to grand things which, thank God – today I shall see none of, for I put myself on chicken and dry toast' (Yale, letter to John Brown from the Simplon Inn, 2 September 1876).

56 D.908 and 902.

57 Ibid, 909 and **37**.208.

58 **37**.213. To Henry Swan, on 29 January and 7 February, he wrote that 'I am hard at work on my little history of and guide to Venice – which will dovetail into Fors very curiously' and 'I am entirely set just now on Venetian work and can attend to nothing else. It is all Sheffield work in the end' (Rosenbach 1877–8 vol. II).

59 On 15 September he told Susan Beever that he would stay in Venice for 'a month at least' (**37**.208). On 24 October he told Joan that he had 'not the least idea at present when I shall get home' (**24**.xxxvii). He told E. B. Nicholson at the London Institute on 3 November that he was 'obliged to stay in Italy the whole winter' (Yale, Ruskin Letters Box N–Z), which suggest that he simply concealed from Joan the length of his proposed stay. At the end of his visit he gave himself 'yet another fortnight' because of the pressures of Venetian work (D.950).

60 Reported in *Fors* (**29**.99), where it triggers off a long discussion of his father's mercantile experience. For another use of this discovery in *St Mark's Rest*, see also **24**.417.

61 On the latter, see J. Clegg, 'John Ruskin's Correspondence with Angelo Alessandri', *Bulletin of the John Rylands Library*, 60 (1977–8).

62 Ciro Robotti, 'Le Idee di Ruskin ed I Restauri della Basilica di S. Marco attraverso le "Osservazioni" di A. P. Zorri', *Bollettino d'Arte*, serie V (1976), 115–21; also, the relevant chapter in R. di Stephano, *John Ruskin interprete dell'architettura e del restauro* (Naples, 1969), pp. 71–99.

63 To Miss Rigby, Yale, Ruskin Letters Box N–Z.

64 Bembridge MS L 41. See also *Fors* 71 and 72 for his account of the picture.

65 D.919 and see ibid, 920 ff.

66 In November he had written 'Very thankful should I be for some of those Danieli days again – I can't sketch myself and write too; nor now do my eyes serve me as of old' (Yale Ruskin Letters Box F–H). In the following January he said that he found 'my only refuge and rest in healthy copying. Then, one has no strain on the brain or heart; but the enjoyment of a lovely thing, and the steady sense of progress' (Huntingdon HM 30364).

67 These letters ('The Christmas Story') are in the PML (Sharp Collection); they are due to be edited at some point by the Ruskin authority, Van Akin Burd, who has summarized their narrative in *JRRLT* 137 ff. My three brief quotations in this section are from these letters.

68 He wrote to Susan Beever to say that if he told her the 'Christmas Story' she would think 'I was going to be a Roman Catholic' (**37**.217); yet he

told readers of *Fors* 76 that they needn't fear that this would happen – 'I can no more become a *Roman*-Catholic, than again an Evangelical-Protestant' (**29**.92).

69 *D*.920.

70 For instance, he told Henry Swan in Sheffield that St Ursula/Rose 'fulfilled for me the three dreams which I published in Ariadne, unmistakeably' (Rosenbach, 1855–76, vol. III). Similarly he advised Joan Severn that in his renewed copying of Carpaccio, St Ursula made him realize that her greatest loveliness was 'the line of the skull. Another great and humiliating lesson for me; – because I have violently declared that the great painters never thought of the skull' (PML, Sharp Collection, 10 January 1877). All these Venetian 'dreams' of 1876/7 illustrated Ruskin's own confidence that immediately prior to total collapse his 'states of more & less excited temper . . . much quickened thought' were 'entirely healthy, and in the full sense of the word "sane"' (**29**.381–3, written in 1880 of his first breakdown in 1878). And H. G. Viljoen's careful analysis of his diary entries prior to the collapse of 1878 (see *BD* 104–32) suggests how almost all of his apparently random, 'mad' jottings may be tracked to and explained by the dense texture of his writings. So in the Venetian Christmas story, Ruskin reveals his command of the movements and allusions of his own mind.

71 **29**.54. The 'most intelligent readers' were presumably the Severns.

72 **24**.xxxvi.

73 All references in this paragraph are to his diary, viz: 928, 929, 945, 949, 956, 950.

74 *D*.962.

75 **29**.160.

76 As long ago as 1846 'the new black serpent appeared in my left eye' (*LV* 169): see also 'black spots' of a few years later (ibid, 259). For another important explanation of Ruskin's *political* reasons for attacking Whistler, see David Craven, 'Ruskin v Whistler: The Case Against Capitalist Art', *Art Journal*, 37 (1977–8), pp. 139–43.

77 See *Val D'Arno* III (**23**.49).

78 **30**.xxvi. 'Being somewhat interested . . . in Museums', Ruskin also gave details of others not of his own devising (see **28**.722–3).

79 See *D*.965 and **29**.170 ff.

80 *MT* 375.

81 **37**.227 and **29**.591. Viljoen cites a psychologist to the effect that the Brantwood diary entries of this period show that 'Ruskin consciously faced the possibility that he was threatened by insanity' (*BD* 27).

82 **37**.223–4.

83 Ibid, 227.

84 Ibid, 227 and 229.

85 **22**.511.

86 **37**.233–4.

87 Ibid, 236 and *D*.972–3.

88 Ruskin, *Letters to M.G. & H.G.* (N.Y. and London, 1903), pp. 4, v and 19.

89 **13**.409–10; as for succeeding passage.

90 *D*.974 and **21**.xxiii. He was also trying to borrow Turner drawings from the National Gallery for display at Oxford, a task he accomplished later in 1878 after his illness (see **37**.255 note).

91 **29**.374.

92 See ibid, 354–60.

93 The central accounts of his illness are (i) those by Ruskin himself in *Fors* 28 (**29**.381ff.), in his diary for 1880 (*BD* 218ff.), and in 'Mr Ruskin's Illness Described by Himself', *British Medical Journal* (1900), also in **38**. 172–3; (ii) Joan's account in letters to Dr Simon, in *Dearest Mama Talbot*, ed. M. Spence (1966), pp. 77–95; (iii) Birkenhead, *Illustrious Friends*, pp. 262–7.

94 **37**.246–7. The examination of himself was instilled at the earliest age when Margaret Ruskin would read them Adam Smith's *Theory of Moral Sentiments* as 'a means of making [John and Mary] . . . observe something of the working of their own minds' (*FL* 186).

95 *BD* 80 – fact he never returned to using this table (ibid, 83).

96 Leon, *Life*, p. 510. On the relationship of Rose and his mother in his mind at this point see *BD* 69.

97 Huntington JR 198. Whether or not the choice of Miss Beever as a correspondent at this precise stage was an intimation of the animosity towards Joan Severn which the mania itself revealed, we do know that in 1875 Joan had been jealous of Susan Beever (Huntington JR 37). On the mis-dating of this letter to her, see *BD* 403 note, where her reply to his 'odd note' is dated 23 February.

98 Abse, *Passionate Moralist*, pp. 286–7, has an interesting explanation of Queen Victoria's presence in Ruskin's 'dreams', beyond her obvious role as yet another domineering woman-mother.

99 Quoted *BD* 66. Poor Ruskin – even in his madness it was his eloquence that was noticed. For the following reflections by Henry James, see *The Painter's Eye*, selected and edited by John L. Sweeney (1956), pp. 158–60.

100 'Kent' collection has the envelope in which she preserved the ivy; it is marked with a note of the occasion and time (3 o'clock).

101 Huntington JR 286 ('I do wish I weren't quite so dependent upon her!').

102 **37**.248, 244 and 246.

103 From letter to Margaret Raine Hunt (Huntington HM 30666). A group of materials relating to this gift of the *Splügen* to Ruskin is in the 'Kent' collection, and Joan's remark, cited next, is taken from them.

104 **37**.253. Various remarks to Swan (Rosenbach, 1877–8, vols II and III) make the same point.

105 **37**.251. But see the beginning of Chapter Twenty for his interest in Sheffield nonetheless.

106 Republished in *On the Old Road* and in **34**.145–74.

107 *Letters to M.G. & H.G.*, p. vi.

108 **37**.266 and **29**.xxii.

109 For the remark about Turner, see **13**.515; for Whistler's knowledge of Ruskin's works see **29**.xxii and **36**.xlviii–xlix.

110 PML, Sharp Collection, 26 November 1878.

111 See **29**.585–6. Also Francis L. Fennell, 'The Verdict in Whistler v Ruskin', *Victorian Newsletter*, 40 (1971), 17–21.

112 **29**.xxv. Not of course entirely fair, since his remarks on Whistler for which he had been taken to court were made in a printed communication.

Part VI

Chapter 20

1 Huntington HM 30367.

2 *BD* 182, but see also 146 and 191–2.

3 **37**.279 and *BD*179.

4 **37**.292.

5 See *BD* 163 and **37**.291 respectively.

6 See *BD* 144 and **34**.177–233 (for text).

7 Huntington HM 233.

8 Rosenbach, 1877–8, vol. III, as for the following quotation.

9 Frances Horner, *Time Remembered* (1933), p. 55. To Swan at Sheffield he wrote that 'I wonder when my friends in general will come to understand that they can't give *me* the least pleasure [except] by doing what I tell them . . .' (Rosenbach, 1879–87, vol. I).

10 **37**.287; see also ibid, 288.

11 **29**.396–7. To Swan he wrote : 'I'll soon design it, and set Creswick to carve. I mean to do it. St Mark's way – Brick with marble casing, so I can get my inner walls built and dry at once, and go on at leisure adding panel by panel of decoration' (Rosenbach, 1879–87, vol. I).

12 **37**.293 note, and for the 'botanical Museum' see **30**.20.

13 *BD* 171. Part of an extensive colonizing by personal names of the Coniston locality: see end maps to *BD*.

14 See **37**.283 and **34**.539–40.

15 **37**.279.

16 *BD* 216.

17 Ibid, 228. For other connections of the devil and the weather see ibid, 217 and 239.

18 **26**.302 and 332. A year or so earlier, when Susan Beever had sent some oranges up from her cottage, he had replied that the Thwaite was the Garden of the Hesperides – 'these showers of oranges cannot but mean that I've beaten the dragon at last' (Huntington JR 252).

19 Huntington JR 298.

20 *BD* 215.

21 Quoted *BD* 215 from a MS in PML, Sharp Collection; I have corrected Viljoen's transcript and added the indications of the draft in Ruskin's hand – words between upright dashes are those added above the line.

22 *BD* 226.

23 This MS is quoted by Viljoen (ibid, 212–13) to gloss the events of 1880.

24 **37**.321 (for the Zoo) and *D*.982.

25 **37**.323 and 324.

26 *D*.982; he means the subjects of his picturesque sketches.

27 Ibid, 986. But see below for the extension of his excursion, which is often misrepresented as being *planned* as a 'prolonged Trip' (e.g. Abse, *Passionate Moralist*, p. 293).

28 See **37**.326. He could, conceivably, have been concealing from her length of his absence, since she missed him in Coniston.

29 I quote it as recorded in his diary when the idea first seems to have come to him (*D*.995–6).

30 *La Pensée Sociale de John Ruskin* (Paris, 1973), p. 394 note. For Proust's interest in Ruskin see the lengthy analysis by Richard Macksey in *The Ruskin Polygon*. *The Bible of Amiens* continued to be issued in parts throughout the first half of the 1880s.

31 *BD* 254.

32 **37**.309 and 331.

33 *BD* 250–1, and 259–60 for Viljoen's commentary.

34 **37**.348; this was written in March after recovering from another attack of mania. He was also deriving comfort from Saussure and Maria Edgeworth, two books of his youth (see *BD* 267 and 547).

35 **37**.348 and see above pp. 155 and chapter seven, note 25.

36 **37**.341, 345 and 361.

37 Ibid, 355.

38 *BD* 268.

39 See his own later recapitulation in 1883 (*BD* 296ff.) and Joan's letters (ibid, 545ff.).

40 Ibid, 502.

41 *NL* II 171.

42 *BD* 552. See also Ruskin directly challenging Joan on this matter, Birkenhead, *Illustrious Friends*, 288.

43 **37**.346 and Rosenbach, 1879–87, vol. II (for the remark about USA!).

44 See letters to its Principal (**37**.359, 368 and 377), where he also discusses with great enthusiasm the establishment that year of the College May Queen ceremony.

45 See ibid, 350.

46 PML 2150.92.

47 **37**.350.

48 Ibid, 377–8 and 382. On other occasions he would refer correspondents

to his published writings or make them commit themselves on their attitudes towards his work ('I Can't quite answer your letter unless first you read my account . . . in last *Fors*' – to Miss Rigbye, n.d., Yale, Ruskin Letters Box N–Z). In 1883 Ruskin received a letter from a Robert J. Whitely, Charles National Boys' School at Plymouth, which stated that 'I am a poor student of art, and knowing you to be rich and celebrated in the Art World, I write to ask if you will kindly help me on in my studies, by sending me a copy of one or two of your works on Art. By doing this you will materially help me, by giving me a sound knowledge of Art. I ask you to do this because I am only 17 years of age and my father is very poor.' Ruskin sent the letter to Grace Allen, who helped her father and Ruskin in various matters, saying, 'I don't quite like leaving this foolish letter without reply. Could you ask him what the Charles National Boys' School is – if the master cared to have a "Laws of Fesole" for the boys, one might send it' (University of London Library, Allen letters, vol. ii, letter 28).

49 Letter of 27 February 1882 in Ruskin Museum, Coniston.
50 **37**.388.
51 Ibid, 406. He also connected her with Rose (see *BD* 297).
52 Rosenbach, 1879–87 vol. III. And in a subsequent letter (Rosenbach, ibid) he distinguished between the first illness as being caused by too much thinking of Rose and this third, which took the 'form of Judgement by my Father for his own shortened life'. And he added that these things 'are all quite *normal*; the inevitable sequences of spiritual law, and of course – affect the lungs – liver – and all the rest of it!' See *BD* 269 for yet another explanation.
53 **37**.404 and 398–9.
54 See **30**.51 ff.
55 **37**.403.
56 *D*.1019.
57 **37**.419, with punctuation corrected from original in Huntington.
58 Respectively in this paragraph: *D*.1014, 1025, 1027, 1029, 1031, 1035; **37**.361. Of course, he had read and enjoyed *Past and Present* much earlier in 1859: see George Allan Cate, 'Ruskin's Discipleship to Carlyle', *Carlyle and his Contemporaries*, ed. J. Clubbe (Durham, N.C., 1976), p. 242 and passim.
59 **37**.396.
60 Ibid, 412.
61 Ibid, 418–19 where there are also facsimiles of the sketches.
62 **32**.343. Also see ibid, xviii ff. and *John Ruskin's Letters to Francesca and Memoires of the Alexanders*, ed. L. G. Swett (Boston, Mass., 1931).
63 M. H. Spielman and G. S. Layard, *Kate Greenaway* (1905), p. 110.
64 To Mrs La Touche, PML 2008.
65 **37**.421, as for the next quoted phrase.
66 Ibid, 441.

67 **26**.335 and *BD* 288.
68 See *BD* 288, 324 and 313.
69 Ibid, 301 and *D*.1050. See also *BD* 312 and **37**.441.
70 **37**.467.
71 Ibid, 442. The lectures on 'The Art of England' are in **33**.259–408.
72 *The Swinburne Letters*, ed. Cecil Y. Lang, 6 vols (New Haven, Conn., 1959–62), V 20; cited, for example, by Viljoen, *BD* 276.
73 **37**.434.
74 Ibid, 447 and **26**.574 and **33**.248.
75 *BD* 342 note.
76 **30**.69.
77 *BD* 287.
78 See **37**.463 and Rosenbach, 1879–87, vol. III.
79 Quoted *BD* 278–9.
80 *NL* II 150.
81 This point is made by Viljoen, *BD* 283.
82 See above pp. 148ff and *RI* 52.
83 **34**.3–80.
84 Witness the weather before and during his lectures, which seemed only to confirm his diagnoses, the letters about similar observations which he received and printed in the published version, and (more recently) W. J. Burrough's analysis of weather patterns in *The Times*, 8 October 1980.
85 R. W. Emerson, *Orations, Lectures and Essays* (London, 1866), p. 74. Cf. 'The fallen human soul, at its best, must be as a diminishing glass, and that a broken one, to the mighty truths of the universe round it' (**11**.181).
86 See pp. 119–21 of the original edition of 1884.
87 Point made by Rosenberg, *Darkening Glass*, p. 216.
88 Yale, 25 July 1884, Ruskin Letters Box A–E.
89 *D*.1058. He listed his ever-multifarious projects for Norton on 25 February 1884 (see **37**.475).
90 PML 2010.106.
91 **26**.397–414.
92 *D*.1080; also ibid, 1068.
93 For tetchy letter, **37**.476–7; for Jowett at Brantwood, Cook, *Life* II 474.
94 **33**.413–520.
95 *The World*, 19 November 1884.
96 **37**.501.
97 PML 2010.251.
98 *D*.1089.
99 Ruskin's phrase in letter to *Pall Mall Gazette* (**33**.lvi).
100 Unpublished letter quoted by Abse, *Passionate Moralist*, p. 311.
101 **37**.505.
102 See **35**.xxii.
103 *D*.1094.
104 **37**.541.

105 PML 2020.329.

106 Quoted by Cook, *Life*, II 500 (original letter in PML). See also *D*.1136 on the 'extreme care' needed in writing *Praeterita*.

107 *D*.1114 and 1099; subsequent quotations are respectively from ibid, 1102, 1099, 1100, 1115, 1096, 1101, 1113.

108 The whole episode is narrated by Katie MacDonald Goring, 'The friends of Living Creatures and John Ruskin', *The Fortnightly Review*, 82 (new series, 1907), 373–90 and 592–609.

109 See *LV* 3 notes. For the following quotation on the La Touche visit *Letters to Francesca*, p. 95. Mrs La Touche's correspondence with Ruskin in 1883–5 is in the PML, Sharp collection, and shows how coyly she behaved '('Here I come again. Do you wish you hadn't whistled?').

110 **37**.540.

111 Ibid, 544.

112 Letter of 30 August 1885 from Lucia Alexander, 'Kent' collection.

113 'Kent' collection, letter of 27 August 1885; in a previous letter of 12 August Francesca is said to have called a prayer meeting to pray for Ruskin.

114 *D*.1126 and 1123. Cf. 'Dangerous fighting just now with anger and vexation and general excitement of dangerous sort . . .' (ibid, 1121).

115 See **30**.97–8.

116 See ibid, lxii ff. for extensive quotations from this correspondence with Guild artists like T. M. Rooke and Frank Randel. For the catalogue, **30**.161 and 177–80.

117 **34**.733.

118 *D*.1128.

119 **37**.549, 550 and 562; see also ibid, 554.

120 Yale, 15 June 1887 to Dr George Harley.

121 Yale, 15 May 1886 to George MacDonald.

122 Yale, 20 November 1886 to Robert C. Leslie. He even projected opening a drawing school for Kate Greenaway (see **37**.572).

123 **37**.574.

124 **35**.xxvi.

125 **32**.287. And sometimes the lessons went awry and he had to seek Susan Beever's recipe for sugar candy when their inventive cookery proved a disaster (see **37**.574). Perhaps Ruskin's own need for such activities is aptly summed up by one of his local pupils, Jane Anne, who is reported as saying 'We should be lost without our lessons' (*D*.1141).

126 **35**.xxvii.

127 Huntington HM 30350.

128 Huntinton JR 23. Doubtless the old lady enjoyed these fancies too.

129 A word used in a letter to Susan Beever (Huntington JR 7), which Fleming had annotated on the typescript with 'mustn't print'.

130 **37**.566.

131 Ibid, 568; see also ibid, 370.

132 Ibid, 570.

133 Ibid, 569.

134 *D*.1132 and 1135. See also **37**.573 ('I've been quarrelling with so many people lately').

135 **37**.570–1.

136 Letter to John Simon, 1 October 1887, 'Kent' collection.

137 **37**.580.

138 Ibid, 585, 578 and 587.

139 *D*.1139.

140 **37**.587–8.

141 See Brian Maidment's essay in *The Ruskin Polygon*. An example of her censorship at a later date, after Ruskin's final attack, is clear from Lewis Carroll's letter of 8 January 1890 asking her whether a copy of his *Sylvia and Bruno*, sent the previous month, had reached him (*The Letters of Lewis Carroll*, ed. Morton N. Cohen, 2 vols (1979), II 776).

142 Letters from Mackrell to A. Fleming of 31 May, 2 June and 9 June 1887 (Huntington JR 808–10).

143 Letter of 27 May 1887, Princeton AM 15328. This whole episode seems to be erroneously dated 1885 in *BD* 379 note.

144 Yale, Ruskin Letters Box F–H, letter of 29 October 1873.

145 See **29**.511, **30**.328–30, and H. D. Rawnsley, *Ruskin and the English Lakes* (1902), pp. 137–40.

146 See Huntington JR 803–6 for Fleming letters; for Mackrell see note 142 above.

147 Letter dated 'Friday', Yale – as in note 144.

148 Letter of 12 June 1887, Yale ibid.

149 Bembridge L. 48.

150 *BD* 356 (the original is in PML, Sharp Collection).

151 Ibid, not quoted in *BD*. For the description of Edwin see Margaret E. Spence, 'Ruskin's Correspondence with his God-Daughter Constance Oldham', *Bulletin of the John Rylands Library*, 43 (1960–1), p. 528. This correspondent was the daughter of his old friend, Edmund Oldfield, with whom he had designed a window for Camberwell church years before.

152 From fragment of diary, see notes 150 and 151.

153 **37**.596 and 599.

154 Huntington JR 803–6. He told Norman Forbes on 20 April 1888 that he had attended the show in order to 'stop all rumours or whispers about my need of a physician' (Huntington HM 32007). On his pleasure at the exhibition see *The Gulf of Years*, ed. Rayner Unwin (1953), pp. 41–2.

155 This and all following unidentified quotations are from the short collection of his letters to Kathleen Olander in *The Gulf of Years*.

156 Though at precisely the same time he was telling Norman Forbes, a young man who proposed to leave his job to help Ruskin, that 'I never shall need secretary more' (Huntington HM 32010).

157 Huntington HM 32007.
158 Letter to Joan Severn of 5 June 1888, PML, Sharp Collection.
159 PML 2540.
160 This and other descriptions of his European tour are taken from the letters to Joan Severn in PML, Sharp Collection. See also O. W. Ferguson, 'Ruskin's Continental Letters to Mrs Severn, 1888', *JEGP*, 51 (1952), 527–36.
161 *D*.1150.
162 Letter of 31 January 1875, 'Kent' collection.
163 Collingwood, *Life*, p. 298.

Chapter 21

1 Quoted **35**.xl.
2 *Gulf of Years*, p. 74. See also **35**.391, where it is also quoted.
3 Huntington JR 432.
4 Quoted *BD* 186 note.
5 *RI* 154, my translation.
6 Quoted **35**.xl.
7 PML 2540.3.
8 *Gulf of Years*, p. 88.
9 *Friends of a Lifetime: Letters to Sydney Cockerell*, ed. Viola Meynell (1940), p. 59, where he also reports discussing briefly with Ruskin the Kelmscott Press edition of *The Nature of Gothic*; *Kate Greenaway*, p. 199.
10 These are all in the 'Kent' collection.
11 Ibid.
12 Ibid for Knight; for Watts, Cook, *Life*, II 539.
13 See **35**.xlvii–xlviii for details on which I have drawn.

Chapter 22

1 PML, Sharp Collection, letter of 21 January 1900.
2 J. S. Dearden, 'Ruskin – From Cigars to Fireplaces', *Facets of Ruskin* (1970).
3 For instance: he told Jean Ingelow in September 1878 that he was planning a 'circular letter to my friends; by way of a new Fors . . . there will be some things in it meant for the wise ones, – some for the level-witted ones – some for the underwitted ones' (Princeton AM 12375).
4 **37**.542.
5 Ibid, 579.
6 **7**.461.
7 Maidment, *The Ruskin Polygon*, p. 170.
8 **3**.677.
9 Letter of [August 1884], 'Kent' collection.

10 *NL* II 291–2.
11 Birkenhead, *Illustrious Friends*, p. 364.
12 Quoted ibid, 8.
13 Ibid, 16.
14 On Tolstoy and Gandhi see Leon, *Life*, p. 303; for Proust, Macksey's essay in *The Ruskin Polygon*.
15 *L'Adriatico* for 21, 22 and 24 September 1905.
16 Quoted Macksey, loc. cit.
17 *Letters*, ed. J. T. Boulton (Cambridge, 1979), I 81.
18 Michael Hiley, *Frank Sutcliffe* (1974), pp. 26–9.

Index

Note: italicized sections at the beginning of each part have not been indexed.